A Biography of the Pixel

Leonardo

Roger F. Malina, Advising Editor

Sean Cubitt, Editor-in-Chief

See http://mitpress.mit.edu for a complete list of titles in this series.

A Biography of the Pixel

Alvy Ray Smith

The MIT Press
Cambridge, Massachusetts
London, England

The MIT Press would like to thank the anonymous peer reviewers who provided comments on drafts of this book. The generous work of academic experts is essential for establishing the authority and quality of our publications. We acknowledge with gratitude the contributions of these otherwise uncredited readers.

This book was set in ITC Stone Serif Std and ITC Stone Sans Std by New Best-set Typesetters Ltd. Printed and bound in the United States of America.

Library of Congress Cataloging-in-Publication Data

Names: Smith, Alvy Ray, 1943– author.
Title: A biography of the pixel / Alvy Ray Smith.
Description: Cambridge, Massachusetts : The MIT Press, [2021] | Series: Leonardo | Includes bibliographical references and index.
Identifiers: LCCN 2020029699 | ISBN 9780262542456 (paperback)
Subjects: LCSH: Computer animation—History.
Classification: LCC TR897.7 .S52 2021 | DDC 777/.7—dc23
LC record available at https://lccn.loc.gov/2020029699

10 9 8 7 6 5 4 3 2 1

To
Alison, my beloved wife
Sam and Jesse, my dear sons
and
Leo, Attie, Georgie, Augie, and Evelyn, my adored and ornery grandchildren

Contents

Series Foreword

Leonardo/International Society for the Arts, Sciences, and Technology (ISAST)

Leonardo, the International Society for the Arts, Sciences, and Technology, and the affiliated French organization Association Leonardo, have some very simple goals:

1. To advocate, document, and make known the work of artists, researchers, and scholars developing the new ways in which the contemporary arts interact with science, technology, and society.

2. To create a forum and meeting places where artists, scientists, and engineers can meet, exchange ideas, and, when appropriate, collaborate.

3. To contribute, through the interaction of the arts and sciences, to the creation of the new culture that will be needed to transition to a sustainable planetary society.

When the journal *Leonardo* was started some fifty years ago, these creative disciplines usually existed in segregated institutional and social networks, a situation dramatized at that time by the "Two Cultures" debates initiated by C. P. Snow. Today we live in a different time of cross-disciplinary ferment, collaboration, and intellectual confrontation enabled by new hybrid organizations, new funding sponsors, and the shared tools of computers and the internet. Sometimes captured in the "STEM to STEAM" movement, new forms of collaboration seem to integrate the arts, humanities, and design with science and engineering practices. Above all, new generations of artist-researchers and researcher-artists are now at work individually and collaboratively bridging the art, science, and technology disciplines. For some of the hard problems in our society, we have no choice but to find new ways to couple the arts and sciences. Perhaps in our lifetime we will see the emergence of "new Leonardos," hybrid creative individuals or teams that will not only develop a meaningful art for our times but also drive new agendas in science and stimulate technological innovation that addresses today's human needs.

For more information on the activities of the Leonardo organizations and networks, please visit our websites at http://www.leonardo.info/ and http://www.olats.org/.

The Arizona State University–Leonardo knowledge enterprise provides leadership to advance ASU's transdisciplinary art-science research, creative practice, and international profile in the field: https://leonardo.asu.edu/.

Roger F. Malina

Advising Editor, Leonardo Publications

Beginnings: A Signal Event

Figure 0.1
Walking boar, Altamira, ca. 20,000 BCE.

> Thou shalt not make unto thee any graven image, or any likeness of any thing that is in
> heaven above, or that is in the earth beneath, or that is in the water under the earth.
>
> —Exodus 20:4, King James Version

In the beginning—predating scriptural taboo, surely—a flame-lit graven image appeared
to move. A picture on the walls of Spain's Altamira Cave was a walking boar *AND* the
rock on which an ancient artist painted it *AND* the charcoal and ochre pigments used
(figure 0.1). For 20 millennia or so there was no other place in the world to see that pre-
biblical pig. Only there in the flickering firelight of a Paleolithic movie theater could
you see its legs move and head bob.[1]

Even as late as 1800, just two centuries ago, a picture of Napoleon crossing the Alps *AND* the canvas on which Jacques-Louis David painted it *AND* the oil paints he used were an integral unit. Imagine that you wanted to share Napoleon's delightfully hagiographic picture (figure 0.2) in Europe with a friend in New York. There were no cellphones or video cameras yet, not even such a thing as a photograph. The only way to display him in New York was to transport the one physical painting there—if you dared. An engraving, etching, or sketch might help, but those were only better or worse copies—new images that would never fully and faithfully capture the original.[2]

Through all that time a painting and its medium of creation were inseparable. No one even conceived of separating the two. What could a picture be, independent of its medium?

Then in the early nineteenth century photography was invented, ushering in the world of what we now call "the media." Faithful reproduction was upon us. Movies followed in the late nineteenth century and television in the early twentieth. All media then were analog—smooth and continuous. And a picture could be transferred from one medium to another—a hint that something, after all, about a picture floats separate from its medium.

The notion of the digital—discrete and spiky—didn't fully exist until 1933. At mid-century, 1950, there were only a couple of digital pictures in existence. The few people who knew about them actually thought they were frivolous distractions from the more serious projects of digital computers. All the other pictures in the world were made and viewed with analog means—oil on canvas, ink on paper, and chemical emulsion on photographic film, to name a few.

But at the millennium, 2000, there was an unheralded event—the Great Digital Convergence: a single new digital medium—the all-encompassing bit—replaced nearly all analog media. The bit became the universal medium, and the pixel—a particular packaging of bits—conquered the world. It became possible to remove a painting, so to speak, from its canvas. As a consequence, most pictures in the world are now digital. Analog pictures have all but vanished relative to ubiquitous digital imagery. Museums and kindergartens are among the few reliable places to find the analog.

This book heralds that signal millennial event by celebrating Digital Light—the vast realm that includes any picture, for any purpose, made from pixels. It extends from parking meters to virtual reality, from dashboards to digital movies and television, from CAT scans to videogames to cellphone displays, and many, many more—*anything* mediated by pixels.

What's puzzling about the new medium is that you can't see it. Bits, and pixels made of bits, are invisible. Pixels are not to be confused, as they often are, with the little

Figure 0.2
Jacques-Louis David, *Napoleon Crossing the Alps*, 1801.

glowing areas on a screen, called display elements. The technical heart of this book is the explanation of how to make pictures composed of invisible stuff visible—how to convert digital pixels to analog display elements.

That the Great Digital Convergence happened at the millennium was just a coincidence, but a convenient one. Pixar released the first digital movie, *Toy Story*, in 1995. The first broadcast of the new high-definition television (HDTV) signal was in 1998. A digital camera of sufficient quality to threaten film cameras astonished the market in 1999. The digital video disc, or DVD, debuted in 2000. Apple introduced the ubiquitous iPhone in 2007. What had been ink and paper, photographs, movies, and television became—in a blink of the historical eye—just bits. The change was so fast that young people today may have never experienced non-digital media—outside those last bastions of the analog: art museums and preschools.

We are all now aswim in an ocean of pixels. I carry billions of them on my person, and I suspect that you do too. But curiously there's been little serious notice taken of this pervasive change in our daily experience. Perhaps this is because most people haven't realized that Digital Light is a single unified technology. The notion is new. Making it clear is a major purpose of this book.

Foundations: Three Great Ideas

Just three ideas—waves, computations, and pixels—underlie all the apparent complexity of Digital Light. Each idea is intuitively simple, profound, and beautiful. These are the technological cornerstones of our modern world, and you don't need mathematics to understand them. The first three chapters (part I of this book) present these foundational ideas with the surprising and fascinating stories of the people who made them possible.

Waves are an analog idea. You probably know that music is made of simultaneous sound waves of different frequencies (pitches) and amplitudes (loudnesses). Two centuries ago the Frenchman Joseph Fourier extended that notion to *all* our sensory experience. Everything we see and hear is a sum of waves. It's all music. In this book I show you how to see the music in a visual scene.

Computers are a digital idea. Machines that make computations go fast are the very exemplars of the digital in ordinary life. But the idea of computation dates back only to 1936 when the Englishman Alan Turing invented it to capture the notion of a careful, precise process. That might sound plodding and boring, but the consequences are anything but. Computers are humankind's most malleable tool. And their awesome speed

is the most consequential engineering miracle of all time. With that speed, computers amplify what we puny humans can do by unimaginable amounts.

But all of the mind-boggling, world-changing power of computers really reduces to a careful flipping between two states, often named 0 and 1. Computation is all bits. That may sound trivial, but I hope to inspire you with the unexpected beauty—and mystery—inherent in computation. Again, no mathematics required.

The most important but least known of the three fundamental ideas is the underlying theme of this book: you can pass back and forth between waves and bits—between the analog and digital worlds. The idea dates back only to 1933 when the Russian Vladimir Kotelnikov established it as we know it today. Its formal name is the Sampling Theorem. This entire book—being a biography of the pixel, with *pixel* being our name for a sample of the visual world—is about sampling. Pixels are invisible bits that represent visible waves. My fervent intent is that you understand this piece of magic and be amazed by how it works. No mathematics is required here either.

Now that I've said *no math required* three times in two pages, you might be thinking: *But what if some of us care about the math?* For you—but really for all my readers—I provide an online annotations site at http://alvyray.com/DigitalLight. There you will find additional details about people, places, and events that would have made this book too unwieldy to fit between its physical covers—and you will find as well mathematical equations to support the magic of Digital Light and the pixels that make it possible.[3]

There's a common misconception that a pixel is a little square of color. But in fact, the pixel is a profound and abstract concept that binds our modern media world together. It's the organizing principle of Digital Light.

A visual scene consists of an infinite number of points of color. Infinite is, by definition, too large to deal with. So how can we replace a smooth visual scene with only a finite number of discrete bits—the pixels—and not lose an infinity of information between them? The Sampling Theorem tells us how to do it. It's the secret that makes the modern media world work.

Sampling, which depends on Fourier's waves, was created almost simultaneously with computation in the mid-1930s. Sampling met computation and conceived a child, Digital Light, the subject of this book.

Contributions: Two High Technologies

Part II of the book is devoted to the history of two high technologies that shaped Digital Light: computers and movies. As in part I, I present each technology intuitively and

give the history of its invention—debunking some common myths. The true stories are invariably more intriguing, inspiring, and complicated than the myths.

In Digital Light we can *take* pixels from the real world—from cameras on the International Space Station, say, tracking the latest hurricane. But more importantly for this book we can also *make* pixels from scratch. That's where computers come in and why I present the development of that high technology in such detail.

One of many surprises from my research for this book was the discovery that the first pixels occurred on the first computers. They were born together. So by establishing which computers were the first in the world, we also learn who had the first pixels in the world. That's why the chapter on computers in part II is called "Dawn of Digital Light: The Quickening." It features the first picture made with pixels, in 1947. And it introduces a driving concept of enormous force, called Moore's Law:

Anything good about computers gets better by an order of magnitude every five years.

Despite its simplicity, that statement is revolutionary. What was a factor of 1 in 1965, when Gordon Moore announced it, is about 100 billion now, and will reach 1 trillion by 2025. It's an exploding supernova. Moore's Law is the astonishingly powerful dynamo behind every development of computers for over 50 years—including Digital Light.

The digital movie part of Digital Light derives from classic film. The chapter titled "Movies and Animation: Sampling Time" reviews this pre-digital moving-image technology. It also helps to further illustrate sampling: the familiar "frame" of flickering film is actually a sample.

The verbs *take* and *make* apply to film movies too. We take a classic film movie from real-world sets with a camera. We make a classic animated movie from drawings of a non-real world. The central mystery of both kinds of movies is why they should work at all. How does a sequence of still frames deliver both motion and emotion? The Sampling Theorem helps explain motion, at least. The first digital movies—such as Pixar's *Toy Story*—are digital heirs to classic animated films.

The Rise and Shine of Digital Light

The Digital Light story is too large to cover in a single book, so this one necessarily has to focus. It covers Digital Light from the first pixels at midcentury to the first digital movies at the millennium. Unsurprisingly, I have chosen to write about the particular technologies, people, and history I know best from personal experience. I was born before computers—and pixels—and my career was principally devoted to creating the

first digital movies. But that chosen path can help explain how Digital Light came to be more generally. Videogames and virtual reality aren't that far removed.

The three chapters of part III pick up the story of Digital Light after its dawn (told in chapter 4) and those first midcentury pixels. Moore's Law of 1965 cleanly separates them into Epoch 1 of Digital Light, before Moore's Law, and Epoch 2, after. The chapter titled "Shapes of Things to Come" is devoted to Epoch 1. The other two chapters, "Shades of Meaning" and "The Millennium and The Movie," cover the massive changes wrought by Moore's Law in Epoch 2.

Epoch 1 was the era of monstrous, but ponderously slow, computers. A few lucky individuals got access to those expensive beasts. From this period came the Central Dogma of computer graphics: a fictitious world is described inside a computer with three-dimensional Euclidean geometry and Newtonian physics. Then it's observed by a virtual camera that renders its view of the world into two dimensions in Renaissance perspective for display.

I cover Epoch 2 until 2000, more or less. The culmination at the millennium was the rise of three great digital movie studios, Pixar, DreamWorks, and Blue Sky. Their stories are intertwined.

I don't expect you to be able to create a digital movie after reading this book, but I hope you might understand how it's possible. It's like a music-appreciation course: After you learn the principles of music, you won't be able yourself to compose a Bach suite for cello, but you'll better understand the components and so love Bach even more. Understanding just how a modern movie like *Toy Story* is made can have the same effect.

How to Talk about High Technology

Several common themes emerged from my research on the technological histories in this book:

Theme 1. Conditions for progress: An idea, chaos, and a tyrant The conditions for the progress of a new technology appear to be an excellent idea, a disruptive chaos that demands and drives the idea's development, and a tyrant or tyranny that—often unknowingly—protects the creators while they advance the idea.

To give just one example, Joseph Fourier had the great idea that a continuum, such as a visual field, is all music. It's just a sum of waves. The chaos of the French Revolution ushered him onto the world stage in Paris, and the rise of Napoleon gave him his chance to work. Napoleon himself was the tyrant who exiled Fourier to the countryside

to keep him out of Paris. In this protected place for a protracted time, Fourier developed his idea into the theory of waves that eventually returned him to Paris. His idea has influenced all subsequent science and technology—and Digital Light in particular.

Theme 2: The "high" in a high technology guarantees its history cannot be a simple narrative I've been dismayed repeatedly to discover that the received history of a technology almost always has it wrong. And it's not because there isn't evidence about what actually happened. The culprit seems to be our human love of the simple narrative based on the trials and tribulations—and ultimate triumph—of a single creative genius hero. There are departments of the history of science in many universities, but the history of technology seldom receives such scholarly scrutiny. This leaves the received stories to the individuals, companies, or countries that profit from self-aggrandizing versions. The tyrant typically claims the credit. There are numerous examples in this book.

To avoid this simplistic narrative pitfall, I rely on genealogy. For the history of each technology, I've designed a family flow chart—a graphical device, which seems fitting—for the persons, places, ideas, and machines involved. The chart shows who got what from whom (whether by hook or by crook) and the often-dense interplay of the cast of players. There's hardly ever a single person from whom all else derives. The flows from one chart proceed to another and then to another. We watch as the different strands braid together in different ways to influence the next generation. Each chapter thus becomes an extended caption for its flow chart, enhanced with detailed stories of the people involved and intuitive presentations of their ideas.

Theme 3: Technologies come from the interaction of different kinds of creativity Two classic errors in telling the story of high technologies are to pit scientists against engineers, and technically creative people against artistically creative ones. I call the former the battle between the (ivory) *tower* and the (chemical) *stinks*. Theory does differ from engineering, but the level of creativity isn't higher in one than the other. It's just different. Digital Light wouldn't have happened without the idea of the stored-program computer, a mathematical concept *and* Moore's Law, an engineering miracle. Equally pernicious is the belief that artists are creative but technical people aren't—or vice versa. Again and again we find that it's the interactions between equally creative scientists, engineers, and artists that lead to breakthroughs.

Let's now commence our two-century tour, at about the time commemorated by David's famous painting—but with a substantially less flattering portrait of Napoleon.

Foundations: Three Great Ideas

1 Fourier's Frequencies: The Music of the World

> There was a celebrated Fourier at the Academy of Science, whom posterity has forgotten.
> —Victor Hugo, *Les Misérables*[1]

Do you know Fourier?

The answer divides us. If you say yes, then you're probably in the sciences or technologies. You might have used his great idea this very day. If you're in the arts or humanities, you've probably never heard of him. Yet his idea is beautiful, elegant, and pervasive. And it changed our world.[2]

But even if you did answer yes, you probably know nothing about the man himself. So Victor Hugo got it right in that regard. Posterity *has* forgotten Fourier.

Few know, for example, that Joseph Fourier almost lost his head in the French Revolution. Or that Napoleon Bonaparte took him to Egypt on the expedition that discovered the Rosetta Stone. Or that he mentored Jean-François Champollion in its decryption. Or that he introduced the study of Earth's greenhouse effect. Or that he championed one of the earliest women mathematicians, Sophie Germain, when women just didn't do math.

Technological breakthroughs often occur, as I mentioned in the introduction, when the following ingredients are present in some degree: a great scientific idea, chaos of some sort, and a tyrant or two.

Fourier formulated his great idea in a life of turmoil. His defining tyrant was Napoleon, who first promoted him and then exiled him. The promotion gave Fourier the incentive to think about his great idea. Exile gave him the space to work it out.

His idea began as a single scientific seed, as a theory of heat. Then it blossomed during the subsequent two centuries into thousands of technological solutions. It's the central idea behind the pixel.

It's All Music

Fourier's great idea was this: The world is music. It's all waves.

This musical insight led to radio, which isn't a surprise perhaps. But it also led to television. In fact, among its many progeny are all media technologies—all the varied media that recently coalesced during the Great Digital Convergence. In short, Fourier's great idea stormed the world and fostered all the thunder and lightning of modern media.

But it's even more pervasive than that, reaching far beyond just media. Hardly a branch of science and technology is untouched by it—electricity and magnetism, optics, X-ray diffraction, probability theory, earthquake analysis, and quantum mechanics. The list goes on and on. It's no exaggeration to say that Fourier changed how we understand the world.

Regardless of which side of the culture aisle you sit on, you probably know Isaac Newton and Albert Einstein. The world recognized Newton's theory of gravitation and Einstein's theory of relativity in their lifetimes. But for the past 200 years, only physicists and engineers have kept Fourier's flame alive. They knew that Fourier was paterfamilias and celebrated him accordingly. And their work, in many diverse fields, demonstrated the greatness and universality of Fourier's wave idea.

Fourier himself took only the crucial first step. He was the first to formulate the idea mathematically and test it experimentally. Although he planted the explanation from which thousands of solutions would grow in nearly all fields of science, he himself cultivated only the first flower, his solution to heat flow in solids.

That unromantic specialty is a good reason for his delayed recognition. He was the "celebrated Fourier at the Academy of Science" for his theory of how heat flows. It doesn't ring of poetry like Einstein's concept that gravity is a warp in spacetime.

Yet Fourier's great idea is far more fundamental to the modern experience than Einstein's. Stated in its musical form, it's as lovely as spacetime warps—and more intuitive. There's no reason for it to remain hidden behind its usual cloak of impenetrable mathematics.

It's high time to reverse Hugo's assessment and celebrate both the man and his great idea. The ubiquitous modern technology of Digital Light is the right vehicle to finally give Fourier his due.

A Lust for Immortality

Jean Joseph Fourier was born on March 21, 1768, in Auxerre, an ancient provincial capital about a hundred miles southeast of Paris. Within ten years both his parents

were dead, leaving him and his fourteen siblings orphaned. Revolution was in the air. The new American country was only a year old and Benjamin Franklin was charming them in Paris with his coonskin cap and flirtatious ways.[3]

There was something special about the orphan Fourier, and the good people of Auxerre made sure that the talented child was educated. They placed him in a school run by Joseph Pallais, who was noted for having been Jean-Jacques Rousseau's music teacher. Alas, there's no evidence that the man who discovered the music of the world was musical himself.

Fourier then attended the École royale militaire in his hometown Auxerre (there were 11 such branches of the école in all of France). Local supporters helped subsidize him again. These military schools uniformly stressed science and mathematics, and Fourier especially took to math—maniacally so.

At 13 he collected candle stubs to light a large "cupboard" and extend his study of mathematics into the wee hours, past "lights out." The suffocating—and surely cold—cupboard compromised his health for the rest of his life. Perhaps that cupboard first gave him his peculiar interest in heat.

But the candlelit extracurricular training in the cupboard soon paid off. He won a student prize in math. This skill launched his scientific career and ultimately made him immortal. And yet he also won a first prize in rhetoric, enabling his political life and leading directly to an early brush with mortality. His speaking skill almost killed him before the mathematical skill had a chance to develop.

The danger wasn't obvious at first. Further military school training might have led him directly to the army, but he certainly wasn't the military type. He was sickly for one thing, and a math geek. So, after completing his studies at the École royale militaire, he entered the church. He became a novice at an abbey in Auxerre and taught mathematics to the other novices there. He sanctified his name at about this time to Jean Baptiste Joseph Fourier, the form that he used thereafter.

Fourier disappeared into the cloisters on the very eve of the French Revolution. The few letters of his that survive show he was vaguely aware of it, but indifferent. He was more worried about his fame and the state of an algebra paper than the state of France. "Yesterday was my 21st birthday. At that age," he anguished in a March 1789 letter, "Newton had acquired many claims to immortality."

In September he wrote another letter, bemoaning the fate of his algebra paper. In the time between the two letters, the Revolution had begun. But the September letter said nothing about those tumultuous events.

Nevertheless, Fourier's private world did begin to change after that. He presented a paper on "algebraic equations"—presumably the paper that had worried him so much—before the Academy of Science in Paris in December.

And he departed the abbey without taking his vows. The revolutionary government soon suppressed religious orders anyway.

Yet Fourier wasn't a revolutionary for the next three long years. He taught math in Auxerre instead. In particular, he didn't sign the petition from the revolutionary Popular Society of Auxerre to the National Convention in Paris demanding the trial of King Louis XVI.

But in early 1793, just a month after the king's beheading, we begin to hear from Citizen Fourier.

> Bliss was it in that dawn to be alive,
> But to be young was very heaven.
> —William Wordsworth, *The Prelude*[4]

The dawn of the French Revolution famously enthralled Wordsworth, and young Fourier exulted in that very same heaven once he belatedly embraced it. His words were clumsier than the poet's: "It was possible to conceive the sublime hope of establishing among us a free government exempt from kings and priests." But he was just as passionate: "I readily became enamored of this cause, in my opinion the greatest and the most beautiful which any nation has ever undertaken."[5]

Fourier didn't have to leap far from these sentiments to politics itself. He gave a rousing debut speech in February 1793 to the revolutionary commune in Auxerre. He had a plan for raising local recruits for the Army of the Republic. Favorably impressed, the Popular Society of Auxerre adopted his plan and invited him to join. The Reign of Terror was now in full play—with ultimately over ten thousand beheadings of suspected enemies of the state. He wisely accepted the "invitation."

But naive Fourier—the recent novice—immediately blundered, and his timing was about as bad as could be. That rhetoric-trained tongue of his got him into serious trouble. Unwisely he used it to defend three citizens of Orléans. Unwise because they were already on Robespierre's enemies list, and Robespierre was the Terror's "tsar."

The revolutionaries promptly relieved Fourier of all duties outside Auxerre. Miserable at not being able to further the Republic, he trekked to Paris and met with Robespierre himself to plead his case. This bold tactic seriously backfired. His support for the Orléans prisoners had earned him a spot on Robespierre's short list of enemies. With the contorted logic of the Revolution, and despite protests from the always supportive citizens of Auxerre, the very Terror that Fourier had championed threw him into jail on July 17, 1794. It was effectively a death sentence.

"I experienced every degree of persecution and misfortune," he said. "None of my adversaries have run more dangers, and I am the only one of our compatriots who was condemned to death."[6]

The next stop, within days, would've been the Revolutionary Tribunal in Paris and a rubberstamp to the guillotine. He was justifiably terrified. He couldn't have known that just ten days later—July 27, or 9 Thermidor, French Revolutionary Time—Robespierre would fall hard. He who bade heads fall and never had enough—to channel Wordsworth again—tasted the guillotine himself. Lucky for the future of science, and the pixel in particular, Robespierre's head saved Fourier's.[7]

The Wave

Was that algebra paper of 1789—the one that pushed the Revolution from Fourier's mind—the first public glimpse of the great scientist? Did it contain keys to his great idea? Surely it sharpened his mathematical skills and increased his "mathematical maturity," as mathematicians say. But we don't know what was in it.

We don't know, in particular, when Fourier first began to use the *wave*, the fundamental shape in his great idea. But by 1807 he had gone public with it. It's the shape you get by unwinding a perfect circle, so it's a revolutionary form. And it's elegantly simple. The pixel has a noble heritage.

To get a picture of Fourier's wave, start with a circle (figure 1.1). An old-fashioned analog clock face serves the purpose. The tip of its second hand moves steadily around that circle, from a single minute mark to the next one, second by second. The lower picture shows the upper clockface, three seconds later.

The larger, red dot traces out the wave. An animated movie would be especially instructive here, but short of that, imagine the passage of time as movement to the right, as shown by time's arrow. There's a tick mark along the arrow for each tick mark along the edge of the clock. Imagine that the red dot is always tethered to the tip of the second hand by a taut horizontal band. The band lengthens toward the right as time passes, and the path traced by that red dot is the wave.

The important points here are, simply, what the wave looks like and, intuitively, that it's intimately related to the circle. The details of that intimate relation aren't as important as the intuition, but a few more details might help to register the intuition more memorably.

Consider the centerline of the clock—the line that connects 9 o'clock to 3 o'clock. The red dot always marks the current height of the tip of the second hand above or below that centerline. At the (purely arbitrary) moment chosen for the upper illustration, the

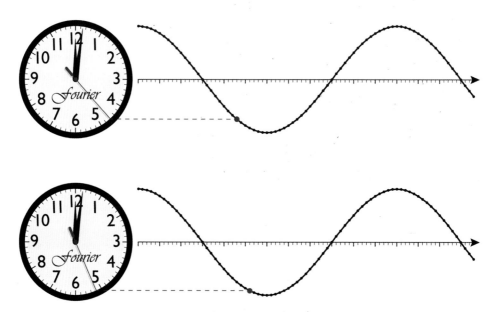

Figure 1.1

red dot has traced through twenty-three positions since the first position recorded, because twenty-three seconds have elapsed since then. During the next tick the red dot will move right to the next dot on the wave. And two more ticks after that yields the lower illustration. So as the second hand ticks its way around the clock, again and again, its tip—actually the red dot attached to the tip—traces out the wavy path shown, up and down, up and down . . .

The second hand makes one revolution after another every minute, so the wave traced by the red dot heads to the right forever. It extends to the left forever too. The wave in the figure appears to start one minute after noon—another purely arbitrary choice—but obviously the clock's been ticking off the seconds as far back as you might care to trace.

The wave in the picture is one of Fourier's waves. He didn't invent them, but he made profound use of them. These are the components of his music. Mathematicians call this particularly lovely circle-made wave a *sine* wave. Since this is the only kind of wave we need, I'll usually refer to it simply as a *wave*.

Everything about Fourier's wave is simple, beautiful, graceful, perfect. Scientists and engineers have a formal term for Fourier's solution for heat flow, and for his great musical idea generally. They describe it as *harmonic*.

That wave shape is everywhere, and with you all the time. The voltage of the electrical current coming out of any outlet in your home or office is a wave. It's called alternating current, AC, because of its wave nature. It often originates with the turning of a rotor, by water behind a dam for example. The circle of the rotor unfurls into AC, or wave, current. A motor turns that rotor right around. The wave-shaped current enters a motor and furls the energy back into circular mechanical motion. An electric fan takes a wave in and puts a circle out.

Another familiar sine wave comes from the media world. It's the call number of your favorite FM radio station. Mine is 91.1 for KCSM jazz in the San Francisco area. The number 91.1 officially designates the wave assigned by authorities to KCSM for its sole use in broadcasting. It describes the electromagnetic wave that station uses to carry its music to listeners.

Although all Fourier's waves have the same shape, they differ in two ways—how fast they wiggle (called *frequency*) and how high they crest (*amplitude*). In the clock figure, how frequently does the second-hand wave crest? It crests once every minute, so that's its natural frequency—one complete wave cycle per minute. *Cycle* is exactly the right word. As the second hand cycles around the clock face once, the red dot attached to its tip paints out one complete cycle of its wave in time. One revolution around the circle yields one wave cycle.

The tip of the clock's minute hand traces out a curve of exactly the same smooth shape, but more slowly. The minute-hand wave crests only once per hour. Its frequency is one cycle per hour, sixty times slower than the second hand. A third one is the hour-hand wave. It has the lowest frequency of the three, one cycle per half day.

You've also met frequency in KCSM's call number; 91.1 is the frequency (in millions of cycles per second) of the wave used by that radio station. And those ubiquitous AC electrical outlets each deliver a wave with a frequency of 60 cycles per second (in the US).

The second-, minute-, and hour-hand waves differ in amplitude as well as frequency. I drew the minute hand slightly shorter than the second hand, so the wave crests for the minute hand are slightly lower. Since the maximum height of a wave's crest is its amplitude, the amplitude of the minute-hand wave is lower than that of the second-hand wave. The hour hand is even shorter, so the hour-hand wave's amplitude is the lowest of the three.

For Fourier's purposes a wave can have any frequency and any amplitude so long as it's a sine wave—an unfurled circle. The clock figure (figure 1.1) yielded three such waves, and figure 1.2 shows three more, all gracefully shaped and differing from one another only in wiggle speed and height—frequency and amplitude. They all have the

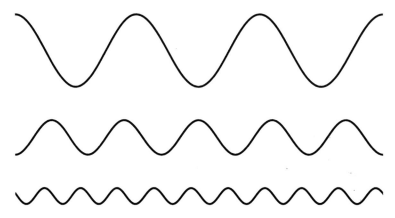

Figure 1.2

same shape, in the sense that all triangles have the same shape. A triangle only has to have three straight sides to be a triangle, and a wave has only to be an unfurled circle to be a wave.

Notice one other thing about the waves in this picture: different points in their cycles are aligned with the left edge of the picture. The crest of the top wave aligns with the edge, the trough of the middle one, and somewhere in between for the bottom wave. If you slide any wave left or right, its frequency and amplitude don't change, but its position relative to another wave does. This is important because Fourier has us add waves together. You get different sums if the waves are aligned differently.

We use the word *phase* to describe the position of a wave. The moon's phases famously tell us where the moon is in its cycle. It's a full moon or a new one, or it's waxing or waning between full and new. A wave is cyclic, so it has a phase too. In figure 1.2 the top wave is cresting (full moon) at the left edge of the picture, and the middle wave is troughing (new moon) there. The bottom one is just starting to wane from its full crest to its trough. Changing the phase of a wave shifts the entire wave left or right. But notice that if you shift it by an entire cycle, then the wave is exactly the original wave. There's no way to tell them apart. So, specifying one place in a single cycle—which is what a phase is—is enough to specify the position of an entire wave. For Fourier's purposes a wave can be in any phase.

A first glimpse of Fourier's great idea is now possible: a vast number of patterns of the world—including everything we can see or hear, but also many, many more—can be described exactly as a sum of waves of this type *and nothing else*. Fourier's frequencies are the frequencies of the waves in such a description. Their harmony is the music of the world. This idea is so large and counterintuitive that it may be hard to grasp. So

let's start with music itself, a familiar physical reality that helps make intuitive sense of Fourier's profound idea.

Sound

Music is composed of—and only of—waves of different frequencies, called sound waves of course. The strings on a violin vibrate at different frequencies, and the same for a piano. Compared to a clock's pokey second-hand frequency of one cycle per minute, a piano's middle C is a speed demon of a sound wave from a string vibrating at 262 cycles per second. A clarinet or a flute resonates at certain frequencies, as does each of a pipe organ's pipes. Lyric coloratura sopranos sing at a higher frequency than do altos and much higher than baritones or basses. We say sopranos sing at a higher *pitch* rather than frequency, referring to our brain's perception of the music rather than to the physics of its creation, but it amounts to the same thing. A chord is essentially several waves—say three or four—played simultaneously, or added together, as we say. A choir consists of many voices at different pitches, and an orchestra comprises many instruments at different frequencies, from string basses to piccolos.

The dynamics of music, from pianissimo to fortissimo, reflect the amplitudes of the waves in the music. The higher the amplitude, the louder the sound. The massive double diapason organ pipe—with the foot pedal maxed to the floor—shakes a cathedral with the awfulness of the Almighty. Strike the piano key harder or turn up the volume on a radio to increase the amplitude of the waves. It's no surprise that the principal component of a radio or a stereo system is its amplifier.

Fourier's idea seems only natural when you're describing music, but the power of his idea starts coming into focus when you consider that all sound—not just music—is composed of audio waves. We speak of low-frequency rumbles and high-pitched whistles. Dogs famously hear higher pitches than we do. Our most visceral intuition of Fourier's big idea is that any sound or music is composed of audio waves of different frequencies all added together and interpreted by our ears and brain as a Stravinsky rite, a beloved child's voice, or even construction site noise.

Figure 1.3 shows the word *yes* as Fourier waves of various frequencies and amplitudes (time proceeds to the right). The "y" part at the left contains the lowest frequencies and the highest amplitudes—it's the accented part of the word. The "e" part in the middle has lowest amplitudes and mixed frequencies. The "s" part at the right has lower amplitudes and highest frequencies—the hiss of the "s."

Sound waves are actually made of—their "stuff" is—rhythmic compressions of air, or pressure waves. Consider the woofer in your speaker system—the big one that you can actually feel vibrate on loud bass tones. It's easy to imagine the woofer's fast-moving

Figure 1.3

membrane shaking the air in front of it. This pulsing air moves from the woofer's surface—pushed along by it, so to speak. A louder sound causes higher compression of the air in each, larger vibration.

We understand these pressure waves directly. Think of a lowrider humping slowly down Crenshaw Boulevard in Los Angeles with its massive boombox shaking nearby windowpanes.

A very loud and low sound wave converts those high-pressure waves into physical vibrations, seemingly of the earth itself. But actually, those earth-shaking waves are exactly the same as the waves that enter our ears and make our eardrums vibrate in unison with the woofer, boombox, or double deep organ pipe. Then a clever system of little bones—the delightfully named hammer, anvil, and stirrup—pass these vibrations to the inner ear where thousands of tiny hair cells respond to the different frequencies. They pass the frequency information directly into the brain.

The normal young human ear can hear all frequencies between 20 cycles per second and 20 thousand cycles per second. Modern usage shortens "cycles per second" to "Hertz" (abbreviated Hz), but I'll stick with the longer phrase to preserve its intuitiveness. There are other sounds outside the human ear's capability, like the ultrasonic whistle the dog can hear but we cannot.

Figure 1.4

But what are the waves in vision—the ones that lead to pixels? At what frequencies does vision vibrate?

Napoleon Bonaparte

Just over a year after Fourier's birth, Nabolione Buonaparte was born on Corsica, an island in line with Paris and Auxerre but about a hundred miles southeast of mainland France (figure 1.4). Corsica had become French in the interval between the births of the two boys, so Buonaparte was just barely French. His name caught up only later, in his twenties, when he Frankified it to Napoleon Bonaparte.[8]

Bonaparte attended the École royale militaire in Brienne-le-Château. This was in the same system of schools attended by Fourier, who was at the one in Auxerre about 60 miles away. So Bonaparte received essentially the same training in science and mathematics as Fourier. It was enough to give Bonaparte an abiding interest in math. He

was to interact with mathematicians all his life, and not just Fourier. There's even a geometry theorem, Napoleon's Theorem, named for him.

Bonaparte moved deeper into the military establishment with further schooling at the elite École militaire in Paris. Details of his training there don't concern us, but his final exams do. His examiner described Bonaparte as having "a thorough knowledge of mathematics." He was Pierre-Simon Laplace, sometimes called France's Isaac Newton.

In a move that boggles the mind of a contemporary American, Bonaparte was later to make Laplace a member of the French Senate. A noted mathematician and physicist as senator!

Fourier Meets Bonaparte

After Robespierre's fall, the revolutionary French government not only freed Fourier from jail but awarded him a plum job as professor at the newly formed École polytechnique in Paris—now France's MIT and Caltech combined. Finally, he was professing mathematics in Paris and meeting its leading lights, such as Laplace. This positioned him nicely to catch the eye of the ambitious Bonaparte who was looking for "savants" to accompany him on a trip to Egypt. And to catch a lot more heat—physically and politically.

Bonaparte had recently conquered Italy in a fight against the Austrians and returned to Paris a hero. With such acclaim, and an army in tow, the French government rightly perceived him as a threat. They were not unhappy to see him (never mind his army) set off in 1798 for Egypt and a fresh conquest. This departure finally brought Fourier and Bonaparte together.

In emulation of his hero Alexander the Great, Bonaparte took a team of French intellectuals (his savants) on the invasion, including the young professor Fourier from the École polytechnique. Again, the contrast to our times is striking. Imagine a team of leading mathematicians and archaeologists on the first plane into Iraq or Afghanistan.

The Egyptian expedition was a military flop, but a soaring intellectual success. The discovery of the Rosetta Stone was a famous high point. Egyptology sprang from those beginnings. Bonaparte himself founded the Institut d'Egypte while there and was its vice president. Fourier soon became its permanent secretary. He contributed to the lasting scholarly reputation of the Egyptian campaign by writing, over the next decade or so, the introduction to the massive (twenty-plus volumes) *Déscription de l'Egypte*—with overly fulsome praise for Bonaparte. Bonaparte even dropped in a few edits here and there in an effort to snatch an intellectual victory from the jaws of military defeat.

After several initial French victories—at Alexandria, Cairo, and the Great Pyramids—Admiral Nelson and the British destroyed the French fleet at harbor in Egypt. Despite British control of the Mediterranean, Bonaparte managed to sneak across it to France, after a little more than a year in Egypt, leaving nearly everybody else—and much unfinished military business—behind.

His motivation was to take a shot at controlling France—which of course he accomplished. He made himself First Consul of a new government just before the end of the eighteenth century—the first step on his march to become emperor.

When his savants attempted to follow him home, they weren't so lucky. The British allowed them through the naval blockade but kept the Rosetta Stone. It's still a highly visited treasure in the British Museum.

Bonaparte's hasty and opportunistic departure from Egypt left Jean Baptiste Kléber in the lurch with a military mess. Bonaparte made him general in charge of the army in Egypt, informing him of this via mail so he couldn't refuse. With this trick Bonaparte gained the scorn of Kléber, who was left to mop up.

Now Fourier made his second major political mistake. He became too closely identified with the unhappy general. Kléber made him a bureau director in Egypt. Then when a student assassinated Kléber in Cairo, Fourier gave the general's eulogy. That gifted, but troublesome, tongue was wagging again: first he'd offended Robespierre, now Bonaparte.

Bonaparte clearly didn't want Fourier propounding Kléber's views in the capital. He didn't want France to know the less-than-noble military details of his Egyptian campaign. Fourier had hoped that after Egypt he could resume his prestigious position in Paris, at the center of the intellectual action. Instead, Bonaparte exiled the outspoken Fourier to Grenoble.

But in doing so, he chose his words euphemistically, "requesting" that Fourier take the job as prefect of the Isère department, governed from Grenoble. In other words, Bonaparte "asked" him to become the provincial governor (prefect) of a province that was closer to Corsica than Paris—a long way from the action.

Fourier accepted. Bonaparte was now the most powerful man in France. It *was* exile, however, and that's how Fourier perceived it. He was the only leading mathematician and physicist in France who wasn't in Paris in the decade after Egypt.

Vision

You are probably comfortable thinking about what you hear as a sum of waves, but you don't think about what you see that way. This next step, then, is going to take a bit

more explaining. Fourier's great idea is that the visual world, just like music, is made of a summation of waves. But in the case of vision, the waves are space waves. They're two-dimensional. It takes a little practice to see them, but once you get in the habit of looking for them, it's not hard at all. We'll get used to seeing them, and then make the leap that Fourier did.

The second-hand wave in the clock diagram (figure 1.1) actually depicts a space wave. It *represents* a time wave proceeding along time's arrow, but what I've actually drawn is a space wave extending left and right. Fourier's great idea covers both space and time. The kind of wave depends on the physical process. If it proceeds through time, like sound, light, or the second-hand wave, then the waves are time waves and the frequencies are cycles per second. The *picture* of the second-hand wave is a space wave, and its frequency is expressed in cycles per inch, roughly one cycle per 3 inches as drawn. If I were to draw a picture of the minute-hand wave at the same scale, its frequency would be sixty times less, or roughly one cycle per 180 inches. The hour-hand space wave would have roughly one cycle per 2,160 inches, twelve times less than the minute-hand wave.

The waves I'm calling vision waves are not to be confused with light waves. A light wave is a mechanism for exciting the rods and cones of our eyes so that we can see. It's a wave that varies in time at extremely high frequencies, such as 500 trillion cycles per second. So light waves are the means of seeing, but vision waves are what we see. Light waves vary in time, vision waves in space.

Evidence of visual space waves is everywhere. Just look at the page you're reading. The letters, including the spaces as characters, appear more-or-less uniformly placed across the horizontal dimension of the page. In *frequencyspeak*, they appear at a more-or-less constant frequency across the page, and the lines of text appear at a definitely constant frequency down the page. You can think of the text as the crests and the space between the lines as the troughs of some kind of "wave." Books on a bookshelf repeat at a fairly constant rate horizontally. And the shelves themselves repeat at a fairly predictable frequency vertically. None of these is a beautiful smooth wave à la Fourier, but they all hint at the notion of spatial waves in the visual field.

In fact, if you can perceive a "wave" of some frequency in your visual world then the Fourier version of it will feature a wave of that frequency. I just measured the distance between the bottom of one line of text in a book I'm reading to the bottom of the next line to be a quarter inch. So the musical version of that page, which is a picture if you think about it, must have a Fourier space wave of that frequency, four cycles per inch.

Roof beams "ripple" across the ceiling at a constant beat, and a hardwood floor has boards repeating at a familiar frequency in one dimension. A tiled floor has tiles repeating

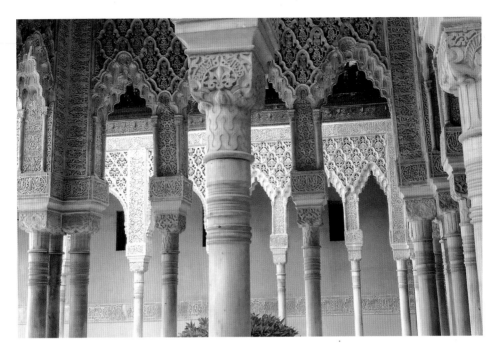

Figure 1.5

at the tiling frequency in both dimensions, and a tiled roof does too. The Alhambra (figure 1.5) takes tiling—of floors, walls, ceilings—to stunning heights of delight.

The punch line is that you can represent all these spatial rhythms with Fourier's waves alone. All visual patterns, no matter how apparently irregular, can be described as a combination, a sum, of Fourier's beautiful regular waves.

But what about the natural world? The same is true there, although less obvious—except for ocean waves. The blades of grass in a lawn or meadow repeat at a characteristic frequency. The leaves of a tree do too, although the rough spacing between leaves depends on the species of tree. The spacing of trees in a forest has a characteristic frequency, also dependent on species. Mountain ranges peak in a sort of frequency. Mother Nature's frequencies are much less uniform than ours. She has more randomness in her repeating patterns. Yet mountain peaks don't occur at, say, two crests per inch or at two crests per million miles. There is a range of frequencies, which is more-or-less what we expect of mountain ranges, more like two peaks per ten miles. Again, all these visual rhythms beat to Fourier's tune.

The purpose of figure 1.6 is to show you how to look for spatial frequencies in the world—as an alternative way to view it. It's a picture of my succulent garden in

Figure 1.6

Berkeley, California. There are spatial frequencies everywhere in it. Once you begin to see them, here or anywhere, then it isn't so difficult to make the leap that Fourier made—that waves and their various frequencies are *all* you need to completely describe a visual scene.

Consider the terracotta pots, some of the manmade constituents of this scene. Observe how they are on a loose grid. They aren't regularly spaced *exactly*, but they do have a repeat pattern that's loosely regular—say a pot every one inch or so. In the Fourier equivalent of this part of the picture there is a group of waves with slight departures from that frequency of pot placement to account for the slight departures from strict regularity.

The patterning on the pots is regular too. Consider only a single line through the picture, say a line aligned with the pots and indicated by the lower pair of arrows, line a. In other words, constrain your attention to the regular frequencies along one line at a time—as if the light intensities along that line were the sound amplitudes in a passage of music. Can you imagine a yes spoken by your garden's light intensities?

Starting from the left on line a, in detail, there is the medium frequency of the spiraling grooves on the pot there, then the high frequency (but low amplitude) dirt between the pots, then a medium frequency of the grooves on the second pot, then the low frequency of the wave defining the curve of the largest pot, then two slightly higher frequencies for the two other pots, and so forth.

The plants too have frequencies. The different cactus and succulent species have various frequencies of branch or leaf placement. To see this, constrain your attention to the almost regular frequencies at places along the line b. The line cuts through (the image of) two cacti of starburst-like structure. Along that line the "leaves" of each species occur at an almost regular frequency. (The cactus spines are actually its leaves. The "leaves" are its branches.)

The next line up, line c, intersects the large balls of hydrangea flowers, each composed of hundreds of tiny florets. The florets intersect the line at a higher frequency than any other plant yet discussed. The next line up (line d) intersects the leaves of the hydrangea. They occur along that line at a lower frequency than the florets do along line c. That's to say, there are about two leaf widths in the same space as there are dozens of floret widths. The florets are denser than the leaves or, stated in frequencyspeak, they occur at a higher spatial frequency.

The four lines through the picture are shown parallel to one another, but Fourier doesn't require that. You might exercise your intuition by looking for repeating patterns in lines through the picture at other angles, even perpendicular to the ones shown. For example, you can probably see the regular structure of the bumps on the large flat oval

"leaf" of the prickly pear cactus near the center of the photo. Those bumps are where its spines are located. You could draw two waves more or less perpendicular to one another through the bumps in the two dimensions. That's more or less what the two-dimensional Fourier idea does.

Back to the manmade parts: The brick patio has repeat frequencies in width and breadth. The fence in the background (difficult to see) has its frequency of board repeats, and so does the trellis weaving above it.

We could continue this analysis for every part of the photograph. A line through the tree bark would produce a wave with high frequency detail because of the roughness. The pea gravel in the pots occurs at very high spatial frequency. And so forth. Gardens are symphonies of spatial music.

Fourier's legacy is that *everything* we see—the visual world presented to our retinas, whether it appears to have repeated patterns or not—is a symphony of spatial music. It can be represented with two-dimensional space waves of all frequencies and amplitudes. It's all music. It works just like music but in two dimensions for our eyes instead of one for our ears. We need this intuition about the wave nature of the visible world in order to explain pixels in the next chapter.

Rosetta Stone

Jean-François Champollion was a citizen of Grenoble while Fourier was prefect there, at Bonaparte's "request." Fourier introduced young Champollion to the Rosetta Stone (figure 1.7) and the mystery of the ancient Egyptian hieroglyphs that occupy its top third. Over the next two decades Champollion deciphered the hieroglyphs using the ancient Greek equivalent in the bottom third of the stone as an important source.

Fourier's special relationship with the First Consul made this possible. Champollion was drafted several times, but in every case Fourier successfully appealed directly to the chief Egyptophile at the time—Bonaparte—to exempt the young man. Thus free to pursue his passion, Champollion cracked the Rosetta Stone's code and established the field of Egyptology.[9]

Fourier's great idea—*the world is music, it's all waves*—is the Rosetta Stone of science, and Fourier was its Champollion. Scientists, engineers, and technologists of all ilk speak Fourier's frequency language today. It's the lingua franca of sound, image, video, and on and on—including many of the most common physical processes, and particularly the media technologies. Fourier showed how to translate back and forth between his frequency language and the ordinary languages of, say, colors across space or sound amplitudes through time.

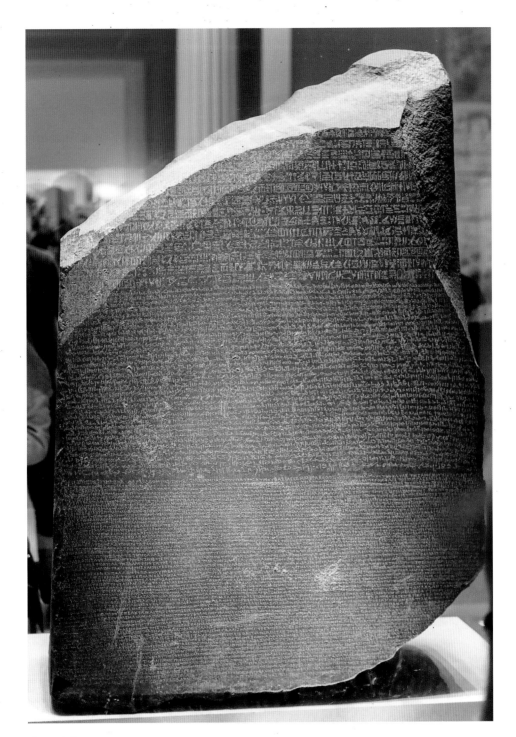

Figure 1.7
Photo by Claudio Divizia.

You've perhaps heard someone say, "I haven't got enough bandwidth," in casual conversation. If you're technical, you'll immediately know what it means. If you're not, you've probably deduced that it means something like "capacity," but you don't have a clue why. It's a Fourier frequency word, that's why.

Bandwidth is, technically, a measure of the capacity of a communications channel. The young human ear, for example, can hear sounds of 20,000 cycles per second down to 20 cycles per second. So its bandwidth is the difference of the two, the width of the band of frequencies that are meaningful to the ear. In casual speech bandwidth is used metaphorically to mean something like your capacity to process information.

Frequencyspeak like this is one of the separators of the two cultures. It's Greek to the arts, so by the Rosetta Stone metaphor, frequencyspeak (Fourier's wave language) must be the hieroglyphs. Now let's see how Fourier's hieroglyphs—his waves in two-dimensional form—can represent pictures.

Corrugations and Furrows

What exactly is a two-dimensional wave? We've only looked so far at one-dimensional waves, like those used for sound. Fourier's idea applied to the visual world needs a two-dimensional version of his wave.

A one-dimensional wave is an unwound circle. A two-dimensional wave is an unwound cylinder. To visualize a wave in two dimensions, imagine the clock's second-hand wave extruded perpendicular to the page. What you get is a corrugated surface, like a furrowed field. A corrugated metal building is composed of sheets of two-dimensional space waves. Some porch roofs are made from corrugated plastic panels (figure 1.8). Certain ruffled potato chips are corrugated. The wavy layer between the flat surfaces of what we call corrugated cardboard is another space wave. A Mediterranean-style red tiled roof is another.

So, a corrugation is a two-dimensional space wave. Look at its edge—a cross-section—to see a one-dimensional wave. In fact, any straight cross-section of it is also a one-dimensional wave.

Fourier's big idea is that all of the visual world can be represented as a sum of—only—corrugated space waves of all frequencies and amplitudes. The only added twist, to handle the second dimension, is that the waves can be rotated to any degree of orientation. The furrows can run north and south, or east and west, or northeast by southwest, or at any other angle, especially important for the natural world. The "stuff" of the space waves might be galvanized iron or, as the figure here suggests, plastic.

Figure 1.8

Engineers use Fourier's idea to describe all the complex patterns in the real and man-made world—made of all the stuff the world is made of.

But to understand the pixel we need to consider the point of view of someone looking at that world. The world may be made of iron and plastic and potatoes, but what we see is a pattern of colored brightnesses—a field of light and dark hues and shapes. The stuff of Fourier's waves for the world we see is the intensity of light as it varies across the visual field.

How might we even imagine such a field? One obvious way to explain the world that's presented to the eye would be to describe the light intensity at every point of the visual field. But this means *every* point in the visual field. A visual field is a continuous thing—every possible point is colored with light. There are no breaks between these points. No matter how close together the two points we choose, there's always another one in between. There's an infinite number of points and that's a lot of points to specify.

Fourier offers us an alternative way: to think of the visual world as a sum of spatial waves that add up to be the same as the point-by-point description. The picture in the top row of figure 1.9, for instance, could be described in the obvious way by giving its gray value at every point, or it could equivalently be described the Fourier way by specifying just one wave. The one space wave that "adds up" to this picture has a frequency of, say, about two cycles per inch, and its brightnesses wiggle between dark and light horizontally. Just a handful of values specifies this entire picture—one frequency and one maximum amplitude—instead of an extremely large number of grays, one for each point in the picture.

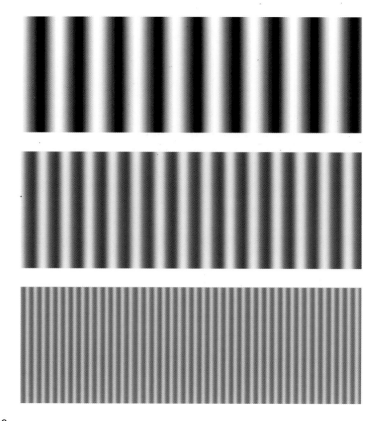

Figure 1.9

By the way, that top-row picture shows (part of) one of Fourier's corrugated waves seen from above. So, not too surprisingly, that very wave is the complete description à la Fourier of this image. Notice that you can see the vibrations of the waves that make up the visual field, just as you can hear the vibrations of those that make up sound. The "stuff" of the wave in this figure is light intensity (or brightness)—perceived as a shade of gray. High parts of the wave are lighter grays, and low parts are darker. (This figure is a two-dimensional counterpart of the wavy lines in figure 1.2.)

Amplitude corresponds to the brightness of a visual scene, just as it corresponds to loudness in the case of sound. Frequency corresponds to the amount of detail in a scene, the sort of thing people refer to when they talk about a high-resolution picture or a high-definition video. High amplitude means bright, and high frequency implies detail.

Color information is there too, when color is available. Our eyes have three types of color receptors—the cones—one type each for red, green, and blue light intensities. If a

point on a cellphone or television screen displays red, green, and blue light intensities, then our brain takes in the relative strengths of these three signals from our cones and perceives a color from them. Emitted light from electronic displays mixes colors in a different way than does reflected light from an oil painting, let's say, or a printed page of colored inks. For emitted light to appear yellow, we must turn on the red and green parts and turn off the blue part. But for light reflected off a white page to appear yellow, we must block the blue part of the white light and let only the red and green through. Regardless of the display technology, it all amounts to the same thing at the eye. I'll nearly always use *emitted* (not *reflected*) light terminology.

So imagine the grayscale wave in the top row of figure 1.9 as a wave of color instead—say a yellow wave. Where the crest of the wave shown is a gray somewhere between mid-gray and full white, the crest of our colored wave is a yellow somewhere between mid-yellow and full yellow. You can think of a colored wave as *three* waves at the same frequency but of different amplitudes, one each for our red, green, and blue receptors. So our yellow wave consists of three waves, one like the grayscale wave shown above for the red receptor, another just like it (at the same amplitude) for the green receptor, and a third like it but with zero amplitude for the blue receptor. With equal parts red and green and no blue, our brain sees a yellow wave.

The pictures in the middle and bottom rows of figure 1.9 show additional two-dimensional waves to familiarize you with what they look like. Just as for the one-dimensional case, the three waves are at three different frequencies with three different amplitudes. For the waves shown, the highest frequency wave (bottom row) has the lowest amplitude (mid-gray), and the lowest frequency wave (top row) has the highest amplitude (near white). But that doesn't have to be the case. A wave can have any frequency at any amplitude.

Here's the intuition to take away from these figures: the fine detail in a picture must come from the high-frequency waves in its Fourier description. They are the only waves that change fast enough. Computer graphics whizzes say things in frequencyspeak like, "There are lots of high frequencies in *that* scene," meaning—without explanation, of course—that it has many tiny details and sharp edges.

The latter remark about edges refers to a handy fact you should know. It's certainly not intuitive. It's a direct consequence of Fourier's math: the sudden transition at a sharp edge requires very high frequencies in Fourier's world; a really sudden change requires a really high frequency.

Here's my formulation of Fourier's punch line again:

Any visual field—let's call it a picture or a pattern—is a sum of, and only of, gracefully undulating waves such as those shown, all unfurlings of perfect cylinders.

The visual world as waves is no more mysterious than sound—or let's say it's just as wonderfully mysterious. The Gettysburg Address can be described by the intensity of sound pressure at each moment during Lincoln's speech or it can be described as the sum of the sound waves of various frequencies and amplitudes that add up to the same thing. Fourier taught us that both descriptions are equivalent.

Scientists and engineers love Fourier's version because, by using the nonobvious frequency description, they can solve problems in the real world that resist solution in the obvious, equivalent point-by-point description.

Instead of talking about a thousand points of light, we talk in frequencyspeak about the frequencies and amplitudes of the waves of light intensity that add up to the points. Fourier's transformative teaching is that these two descriptions are equivalent. The point-by-point visual field is the Greek text. The Fourier wave musical equivalent is the hieroglyphs. For a geek, hieroglyphs are easier to read than Greek. The Rosetta Stone is Fourier's proof that the two are the same.

Fourier's critics didn't believe he was right, but the math said it was true. That's the magic of the idea—and the awesome, intuition-breaking power of math. Adding up waves of different frequencies really will give you a picture of . . . anything! Of my succulent garden, or the page you're reading, or of your child, for instance. That's Fourier's great and very large idea.

A Need for Heat

Fourier survived the Terror, and he even came to rule in France—if only as a provincial governor—thanks to Bonaparte. But neither his early anti-aristocratic stance nor his association with the emperor were handy credentials when the king returned to power—twice. Nevertheless, Fourier was a survivor in this dance of regency and empire, as he had been in the Terror. He managed, with considerable political skill, to remain prefect of the Isère department for almost thirteen years, and only the last year was dicey.

For 12 years, April 1802 to April 1814, Fourier made the best of his exile as an accomplished governor in Grenoble. He negotiated an agreement with *40* communes to drain the massive swamp of Bourgoin in Isère, quite a coup since all previous attempts at negotiation had failed. He pushed through a new road from Grenoble to Turin. He purchased books for the library, championed young men of his department—most notably Champollion—and worked on *Déscription de l'Egypte*, finally published in 1810. During this interval Fourier somehow found time to develop his wave theory. He didn't get there from listening to Mozart or observing the Alhambra but by thinking of heat in

terms of waves. Perhaps his *théorie de la chaleur* (his theory of heat)—and with it his great harmonic idea—was his master plan for readmission to Paris.

Fourier himself said about his extraordinary interest in heat, "The question of terrestrial temperatures has always appeared to me to be one of the greatest objects of cosmological studies, and I have had this subject principally in view in establishing the mathematical theory of heat." He was looking for an idea as big as Newton's.

Victor Cousin, a man who knew Fourier, had a different take on his motivation. He wrote that when Fourier came back to Grenoble from Egypt, he never went outside, even in the hottest weather, without an overcoat and another in reserve. He'd developed a physical need for heat that sounds eccentric at best, but which amounted to a disease.

The French have a word for him that we lack in English: Fourier was *frileux*. He felt the cold terribly. He was very sensitive to cold, perhaps painfully so. The word also carries the connotation that he was incapable of personal warmth. People may have thought that Fourier was chilly in more ways than one.

Nobody knows when Fourier first started his work on heat, but he was engrossed in the theory while in Grenoble, just a couple years after Egypt. A flawed draft version probably completed in 1804 or 1805 contains the first known appearance of his waves. He presented an enormously improved version of that manuscript to the academic public in a late 1807 "memoir" called *Theory of Propagation of Heat in Solids*, now considered to be the paper that established his idea. During the time between writing the two versions, he had become familiar with the actual physics of heat and performed experiments to test and verify his mathematical results.

In Fourier's words, the whole process "contributed to give the theory an authority which one might have been inclined to refuse in a matter still obscure and apparently subject to so many uncertainties." That's classic science. Use theory to hypothesize. Use experiment to verify. It proves that Fourier was both a mathematician and an experimental physicist. He wasn't afraid to get his hands dirty.

Fourier realized that he could describe the complex pattern of heat flowing through a solid object as a sum of his waves. That meant that he could predict how (and how long) heat would flow from, say, the touchpoint of a cannon to its mouth.

So, for perspective, between 1803 and 1807, while he was perfecting his theory of heat and performing the supporting experiments, he was also negotiating the swamp-draining contracts, building roads, mentoring young men in his department, and working on the Egypt publication. Where did Fourier get the bandwidth?

Fourier navigated the politics of empire and revolution. He used his personal knowledge of Napoleon—as Bonaparte the emperor was called—to get the big road project approved based on a one-page proposal, which Napoleon granted in two days. But

Fourier had a harder time with the even fiercer politics of academia, perhaps because Fourier in exile was alienated from the hurly-burly of academic goings on in Paris.

Among the official Academy of Science readers of the 1807 "memoir" was Laplace, Napoleon's senatorial appointee, who had known Fourier since his days at the École polytechnique. Laplace was uncomfortable with the mathematics of Fourier's great idea. The first public attack on it came from Laplace's protégé, Simeon Denis Poisson, who assumed Fourier's chair at the École polytechnique when Fourier became prefect of Isère. The outcome of the long and acrimonious controversy was that the memoir was never published. Eventually, Laplace came to support Fourier, but Poisson—Fourier's implacable enemy—never did.

To posterity's mind, Fourier had established the theory in his memoir of 1807—making 2007 the idea's uncelebrated bicentennial—but he had to pass through another gauntlet before it was truly accepted. Probably because of the prolonged controversy, the academy announced that it would award a grand prize in mathematics in 1811 on the subject of . . . the propagation of heat in solid bodies. Cheeky! Fourier responded with what is known as his Prize Essay, the extended version of the 1807 paper that kept the principal contributions of the earlier memoir in place.[10]

So let's summarize what Fourier did while he was preparing the Prize Essay: Swamps. Roads. Mentoring. *Description de l'Egypte.* Again, where did he get the bandwidth?

One of the extensions of the Prize Essay beyond the 1807 memoir speaks to Fourier's Newtonian ambitions. He applied his theory of heat flow to a sphere—a planet-sized one—and so was the first to study the terrestrial phenomenon now known as the greenhouse effect. Sunlight that passes through Earth's atmosphere heats the Earth's surface, and the atmosphere holds some of the heat nearby. It's an imperfect metaphor but the atmosphere resembles the glass of a greenhouse, which allows sunlight in but doesn't let all the heat out. The heat of the natural greenhouse-effect warms the Earth and makes it the place for life as we know it. Fourier, despite his brilliance, couldn't have foreseen the unnatural greenhouse-effect heat that currently threatens life on Earth.[11]

Despite the academy shenanigans, Fourier won the prize with his Prize Essay. But again, he didn't get the full support of the academy commission who read it. In particular, Laplace voted against it.

"The manner in which the author arrives at these equations is not exempt of difficulties," the commission said in its report. "His analysis to integrate them still leaves something to be desired on the score of generality and even rigor."

Lacking rigor in math is the ultimate insult. The academy dragged its heels in publishing the Prize Essay as it had for the memoir.[12]

It wasn't until after Napoleon's final exile, to Saint Helena in 1815, and Fourier's return to Paris, that he managed to get his Prize Essay published. It still came under withering fire from the implacable Poisson. But Fourier found an elementary error in Poisson's writings and a false claim in his competing theory of heat. Fourier demolished both in a letter to Laplace. That was the coup de grâce to his opposition, finally bringing Laplace to his side.

Dancing with Tyrants

Triumphant scientific progress wasn't matched by glorious political success. Fourier's continuing dance with Napoleon upset his thirteenth and final year as prefect of Isère. Napoleon abdicated in April 1814, and Louis XVIII was restored as king. The ex-emperor headed for his first exile in Elba, an island about thirty miles straight east of Corsica and southeast of Paris. It was natural that he would pass through Grenoble on his way there. Under normal circumstances it would also be natural for Fourier to greet the man who had "given" him the job. The prefect would have to greet the ex-emperor. But the times were hardly normal. It promised to be an embarrassing encounter.

The restoration of the king had left Fourier's position provisionally intact, but would Napoleon consider his bow to regency a *volte face*? Fourier wasn't about to hang around to find out. Behind the scenes he engineered a detour in Napoleon's travel route to bypass Grenoble, citing potential harm to the ex-emperor. It worked. Napoleon side-stepped Fourier, and the new royal government proceeded to confirm Fourier as prefect. The king's brother, who would become Charles X, paid him a visit, consummating the deal.

But that wasn't the end of the dance with Napoleon. On March 2, 1815, Fourier received this frightening letter from a neighboring prefect:

> I have the honor to inform you that Bonaparte at the head of 1,700 men disembarked yesterday at Gulf Juan . . . [and] is heading for Lyon by Saint-Vallier, Digne, and Grenoble. No matter how extraordinary this news may seem to you it is entirely true.[13]

Napoleon returned from Elba for his final Hundred Days of power, displacing the king again. He returned along that fateful southeast-northwest corridor joining Elba and Corsica to Grenoble, Auxerre, and Paris. Fourier was going to have to deal with Napoleon again, just when he had managed to pass himself off as a loyal royalist.

He prepared the prefectural residence for occupancy by the returning emperor. He left a nice note there for him, giving him a personal welcome. In it he stated clearly his new loyalty to the king and explained his conflict. But he was hightailing it out the back gate of Grenoble to Lyon as Napoleon entered the front gate of the city.

Highly displeased, Napoleon fired Fourier. How could a usurper—Fourier's own word for Napoleon—fire anybody? It's a measure of the man's power that he not only did so, but that Fourier and the citizens of Grenoble perceived he had the authority to do so.

Advisers mollified Napoleon by showing him Fourier's laudatory "Historical Introduction" to *Déscription de l'Egypte*. His anger cooled, and he asked to see Fourier. They met in Bourgoin, where Fourier had drained the swamps. It's difficult to understand the dynamics at this remove: A soft spot for mathematicians? Old Egyptian comrades? But Napoleon not only forgave Fourier, he made him prefect of Rhône, governed from Lyon!

The Rhône appointment occurred on March 12, 1815, just ten days after the letter announcing Napoleon's return from Elba. Things were happening very fast. Napoleon's Waterloo was June 18, and the second restoration of Louis XVIII was July 8.

Napoleon's second imperial effort lasted only the famous Hundred Days, but Fourier's second prefecture was even shorter, about sixty days. One of Napoleon's last acts as emperor was to grant Fourier a retirement pension just two weeks before Waterloo, to go into effect two weeks after it. Of course, that pension was never honored. So, when Napoleon was finally exiled to Saint Helena, Fourier was left without a job or pension and with a soiled political reputation.

But at least his exile was finally over. He could return to Paris and establish his musical theory of heat.

Joseph and Sophie

Did Fourier have a life? Perhaps not in provincial Grenoble but surely back in the capital? We could wish for the father of the world-as-music concept a dramatic romance, like Benjamin Franklin's about a decade earlier with the widowed *hôtesse* of a renowned French salon.

Perhaps it was those strange afflictions again, but there was no Madame Helvétius for Fourier. In fact, sadly, there seems never to have been any romantic interest at all. The only hint we have of an intimate relationship—and it was surely platonic—was his deep friendship with the noted mathematician Marie-Sophie Germain. She had won an Academy of Science prize, the first woman to do so, and had disappointed "a very large crowd that doubtlessly had been attracted by a desire to see a new kind of virtuosity," by not showing up to receive the prize. But that hadn't sufficed to get her an invitation to meetings. She only received a standing invitation to attend *séances*, or meetings, of the academy seven years later after Fourier became permanent secretary. Fourier made it happen.

There is one surviving cache of letters from Fourier to Marie-Sophie. All are formal except one, probably written in his last years, given the broken handwriting,

addressed to "Ch. S" (Chère Sophie) and signed "Jh" (Joseph). But Fourier wrote a letter to a doctor seeking his confidential help for a dear but unnamed friend in medical trouble:

> She is worthy of all your interest by reason of the rarest and most beautiful qualities. For myself, who love her tenderly, in so much as this entirely unforeseen event may bring to nothing the feelings which I have had for her, I would be most deeply grateful for anything you could do for her and for me.[14]

We don't know for sure who this woman was, but Germain did die of breast cancer. What *something* might the feelings he'd had for her, if indeed she was Sophie, have brought?[15]

Becoming Immortal

The Academy of Science in Paris finally made Fourier a member (figure 1.10). Shortly after Napoleon's death in 1821, the full version of his theory was finally published as the *Analytical Theory of Heat*. The accolades began to accumulate. The academy elected him permanent secretary, and Newton's Royal Society made Jean Baptiste Joseph Fourier a Foreign Member in November 1823. He had so envied Newton at age 21, but at 55 he was at last, in his final decade, treading the road to immortality himself. He became an official *immortel* of the Académie française in 1826, and Gustave Eiffel placed his name on the famous tower in 1889.[16]

Napoleon's death also finally made a pension possible. At first, the king's government wasn't happy that Fourier had accepted Napoleon's appointment to the prefecture of Rhône in the last Hundred Days. He first tried for a pension from the monarchy just after Napoleon's exile to Saint Helena. His request was rejected. He tried again in 1816, 1818, and 1821, each time rejected. Only his next attempt, after Napoleon had died, was successful.

The political battles were over, but not the ones related to health. He was never free from some physical plague or another. As an aging man he was so bothered with breathing problems that he had a special box built for himself to hold him upright when he was writing or speaking—or sleeping!—with only his head and arms protruding. The breathlessness might have dated back to the asphyxiating cupboard of his teenage years, or it might have been congestive heart failure.

Fourier died of a heart attack in 1830, having outlasted Napoleon by only a few years. His grave in Paris's famed Pére Lachaise Cemetery features the wave and Egyptian motifs (figure 1.11). To either side of his bust is a lily with a very long stem that is the axis of a wave. Each of the lilies is topped by a rearing cobra crowned with a solar disk.

Figure 1.10
Julien-Léopold Boilly, *Academician Fourier*, 1820.

If Egypt did induce Fourier's obsession with heat, then his monument's symbology celebrates both the cause and effect.

The younger Grenobloise, Jean-François Champollion, the first professor of Egyptology, followed Fourier to Pére Lachaise only two years later. His brother, Jacques-Joseph Champollion-Figeac, wrote one of the earliest biographies of Fourier. And Fourier's dear friend Sophie Germain—he hardly seems *frileux* when it comes to her—was also buried in Pére Lachaise shortly after him.

One of Germain's final acts was contributing to the fund for Fourier's Pére Lachaise monument. Poisson, enemy of them both and recalcitrant to the end, did not contribute.[17]

Fourier's troubles are reflected in the fate of his original 1807 masterpiece, the "memoir" that first announced his great result. The manuscript disappeared for over 160 years, finally rediscovered lying in the library of the École nationale des ponts et chaussées, the National School of Bridges and Roads. This is not as strange as it may first seem. The school is the oldest civil engineering school in the world, older than Fourier.[18]

Figure 1.11

The Nature of Genius

Why did Fourier's great idea meet with such resistance? The problem, as his critics saw it, was this: How could a highly irregular pattern—like an arbitrary song or painting—be equivalent to a sum of highly regular waves?

In mathematics something is proved or it's not, or it's provably unprovable. Fourier himself didn't attain this pinnacle of truth for his theory, although his intuition was remarkably sound. It fell to young Peter Gustav Lejeune Dirichlet to close the remaining mathematical gaps. He came to Paris in 1826 and met and admired Fourier. With the older man's guidance, Dirichlet firmly established the theory—with full rigor—and published it in 1829, the last year of Fourier's life.[19]

Nevertheless, some mathematicians are still troubled by the esoteric backwaters of Fourier's math. But engineers aren't. In the late 1960s I took a remarkably influential foundation course on Fourier techniques from Ron Bracewell at Stanford. He took special pains to emphasize the mathematical difficulties at the edges of Fourier theory and to teach the strict limits of its applicability. But he also emphasized how those mathematical niceties don't apply to analyses of real-world phenomena. Or rather he made clear that the real world falls within the limits established by mathematicians like Dirichlet.

Mathematicians must deal with all possible patterns, not just the patterns we actually find in the real world. Mathematicians deal in abstracts, but engineers deal in physical realities—heat, light, sound, roads and bridges, and images. To engineers Fourier's frequencies and amplitudes are as "physical" as the physical world they describe. If Mother Nature produces a pattern, then Fourier's great idea almost always works to describe it.[20]

Newton and Einstein knew that they were addressing the universe, and so did their admirers. Fourier didn't or couldn't foresee how universal his great musical idea was—nor did others at the time. We don't have a word for genius accumulated through time, or genius by ramification. Our usual notion of genius is local to a lifetime—both in accomplishment and in recognition.

Yet for two centuries engineers have made successful and massive use of his harmonic idea for our comfort and enjoyment. All of modern media depends on it. The pixel and the story of Digital Light is just one of the latest examples.

Surely Fourier has now arrived at his deserved position, whether we choose to call it genius or not. It only remains to reach across the aisle separating the two cultures and make him known and respected on both sides.

2 Kotelnikov's Samples: Something from Nothing

There was a vague, unverified legend, unconfirmed by anybody, that you might nevertheless hear in camp: that somewhere in this Archipelago were tiny paradise islands . . . and the only work was mental work—and all of it super-supersecret. And so it was that I got to those paradise islands myself (in convict lingo they are called "sharashkas") and spent half my sentence on them. It's to them I owe my survival.

—Aleksandr Solzhenitsyn, *The Gulag Archipelago*[1]

The man who invented the pixel and started the digital revolution was Chairman of the Supreme Soviet of Russia. Not at the same time but the same man, nevertheless. His name was Vladimir Kotelnikov. In 2003, when he was 95, another Vladimir—Putin—knighted him in the Kremlin. By then he sported most of the merit badges of Soviet Russia, including two Stalin Prizes and six Orders of Lenin, and was twice a Hero of Socialist Labor. He had survived the 1917 October Revolution and all the purges and wars that since define modern Russia. He had barely avoided the Gulag—the very island in it where Solzhenitsyn had toiled—protected by the powerful wife of one of Stalin's bloodiest henchmen. He warned Americans about Sputnik and mapped Venus with digital images—pixels from space.

Kotelnikov was honored in America too, with the Alexander Graham Bell Medal in 2000—befittingly as the Great Digital Convergence transpired. Yet he's largely unknown in the States. He rarely gets credit for his greatest discovery—the Sampling Theorem—the idea that lies at the heart of the entire digital media world. That crown usually goes to Claude Shannon, a famous American engineer and mathematician, even though Shannon never claimed it.

Like Fourier's story, Kotelnikov's features three drivers of technological breakthrough: a great scientific idea, the chaos of revolution and war that turns it into a necessary invention, and tyrants who protect the scientists and promote their technology.

Figure 2.1

Kotelnikov's great idea—which led directly to the pixel—is intertwined in the remarkably parallel life stories of obscure Kotelnikov and famous Shannon.

The Spreader

Here's the idea: digital can *faithfully* represent analog. The discrete and separated and spiky can accurately represent the smooth and joined and curved. The broken continual can truthfully represent the unbroken continuous. If this doesn't surprise you now then I hope to provoke your amazement soon, because it appears that we can throw away an astounding amount of information—an infinite amount, in fact—without losing anything. This is the key idea that makes Digital Light (as well as Digital Sound) possible. It's the fundamental truth that enabled the Great Digital Convergence and hence the modern world.

Just as the wave is the shape that represents Fourier's frequencies, there's a shape that signifies Kotelnikov's samples (see figure 2.1). We'll soon see that it's intimately related to the "shape" of a pixel. Mathematicians call it a *sinc*, and engineers a *reconstruction filter*. Because both those names are nonintuitive, I call this lovely shape a *spreader*. You'll see why shortly.

Notice that a spreader resembles one of Fourier's waves with its crests and troughs progressively squeezed until they're ultimately reduced to nothing in either direction. In fact, that's exactly what it is. The associated wave has an amplitude everywhere as high as the central hump, and a frequency the same as the spreader's frequency of up and down wiggles (figure 2.2).

The spreader comes from mathematics, not the real world, but it might remind you of a pebble dropped in still water, with ripples radiating outward, their height decreasing with increasing distance. Like a wave, a spreader continues to wiggle in each direction forever. But the crests at some distance from the central hump are so low that they don't matter. That's important in the real world, as we'll see. The earliest picture of the

Figure 2.2

все D_k, кроме одного, равны нулю. Такая F (t) очевидно будет состоять из одного члена ряда (1). Значит и наоборот: если F (t) состоит из одного, любого члена ряда (1), то весь спектр ее частот заключен в пределах от 0 до f_1. А поэтому и сумма из любых отдельных членов ряда (1), т. е. сам ряд (1) будет всегда состоять из частот, заключенных в пределах от 0 до f_1, что и требовалось доказать.

Figure 2.3

spreader that I've found, in correct context, appears in the classic 1933 Russian paper by Vladimir Kotelnikov (figure 2.3).[2]

I first learned this chapter's great idea in the early 1960s in an electrical engineering department. We heard that it came from Harry Nyquist, an American hero to us electrical engineers. He worked in the fabled Bell Labs at AT&T—where we all dreamed to be someday. But in the late 1960s, when computer science finally emerged as a separate discipline, at Stanford in my case, the great idea became Claude Shannon's. Shannon was our new hero when it came to all things digital. He was the guy who had first used the word *bit* in print. And he worked at Bell Labs too, as Nyquist's younger colleague.[3]

But that's just the American version, and here's where Stigler's Law of Eponymy comes into play: "No scientific discovery is named after its original discoverer." (This law, by the way, was not discovered by Stigler.) So in Russia, with no hesitation, full credit for the idea always goes to Kotelnikov. In Japan, credit goes to Isao Someya. In England, to Sir Edmund Whittaker. In Germany, Herbert Raabe. Come to think of it,

Nyquist was born in Sweden. Only Shannon was a true-blue, Michigan-born American. Is the Shannon tag just crude nationalism? All these men beat Shannon to a version of the idea except for Someya, and he followed by only a few months. The naming honor presumably reserved for the first discoverer went instead to almost the last—in the United States anyway.[4]

Despite the attribution tangle, the facts are clear: the great idea—as it's used in Digital Light—was first clearly, cleanly, and completely stated and proved by Kotelnikov in 1933. Westerners may find it hard to believe that such a fundamental idea was invented during the worst days of Stalin's Russia. We were taught during the Cold War that Russian science was, if not bogus like Lysenko's biology, at best derivative or just propaganda. It's time to warm up to the fact that Kotelnikov deserves the credit.[5]

Pedigree, Papers, and Positions

Vladimir Aleksandrovich Kotelnikov was born in 1908 in Kazan, an ancient city on the Volga about 500 miles straight east of Moscow. It's difficult to think of another scientist with such an impeccable mathematical pedigree. His great-great-great-grandfather, Semyon Kotelnikov, was a student of Leonhard Euler, one of the greatest mathematicians who ever lived. Some of the mathematics that Fourier used might have come from Euler. In 1757 Semyon became an early academician of the St. Petersburg Academy of Sciences, founded by Peter the Great and now called the Russian Academy of Sciences.[6]

Vladimir's grandfather, Petr Kotelnikov, was a mathematician at the University of Kazan. Lenin and Tolstoy were two of the most famous students there, but Lenin was expelled, and Tolstoy quit. Among those who stayed the course was the famed geometer Nikolai Lobachevsky. He challenged the ancient Greek geometry of Euclid by suggesting that its fifth postulate about parallel lines was not necessarily true—a startling idea at the time that eventually found a home in Einstein's general theory of relativity. Grandfather Petr was Lobachevsky's assistant and then champion.

Not surprisingly, Vladimir's father Aleksandr Kotelnikov was also a mathematician at the University of Kazan. But when Aleksandr decided to leave Kazan and move his family to Kiev for a new teaching position, Vladimir's story really began.

The Kotelnikovs, with six-year-old Vladimir, arrived in Kiev on the very day in August 1914 when the German army broke through that city's defenses. The population panicked and rushed from the city, sweeping the new arrivals with them. With enormous difficulty they managed to endure the 850-mile retreat to Kazan. The family had ridden right into the first blasts of World War I. It was the first of many wars that would define Vladimir's life and career.[7]

His next two wars were the October Revolution of 1917 and the subsequent civil war between Reds and Whites. Russia was transformed. Young Vladimir was too—but it wasn't the wars that changed him. In the midst of the chaos he heard, for the first time, a radio broadcast.

"How does it work?" he asked his father.

"It's something you can't understand yet."

That challenge focused him, at age 10, on a life in radio. He would spend most of the next nine decades in radio and communications engineering, a career coincident with the rise, turmoil, and fall of the Soviet Union.[8]

"Great was the year and terrible the Year of Our Lord 1918, the second since the Revolution had begun." So begins Mikhail Bulgakov's *White Guard*, his account of the terrible, destructive, anarchical world of Kiev. In their second case of bad timing, the Kotelnikovs picked exactly this unfortunate moment to move to Kiev again and experience Bulgakov's nightmare firsthand. The professor boiled soap, and the children unraveled curtains for the thread—anything to sell to drive away the hunger.[9]

In 1924 Aleksandr moved his family yet again, this time to Moscow. He took a new position at the Moscow Higher Technical School. Part of the school would soon metamorphose into the Moscow Power Engineering Institute (MEI in Russian) and become one of the leading technical universities in the world. Think of it as the Moscow Institute of Technology.[10]

Vladimir, our Kotelnikov, was one of MEI's first graduates. They wouldn't accept him initially because of his intellectual pedigree—he wasn't of worker or peasant stock—but a fortunate rule change allowed him to enter, and he never left. His 1931 diploma was in electrical engineering, with a specialty in radio. He would be with the institution for 75 years.

Then it happened—his annus mirabilis. The year 1932 saw Kotelnikov create two papers on his own, with no apparent supervision, each of which would have established him in the annals of engineering forever. One of them was "The Theory of Non-Linear Filters" and won't further concern us. But the other contained his great idea, the Sampling Theorem. He submitted it in November, and it was published the next year with the unpromising title, "On the Transmission Capacity of 'Ether' and Wire in Electric Communications."

When he submitted it to the MEI faculty, one of them said, "It appears correct, but sounds more like science fiction." Something from nothing. Nevertheless, they approved it, launching him on an academic trajectory toward a deanship at MEI.[11]

In 1933, with a lectureship at MEI, Kotelnikov also began working for the People's Commissariat for Communications (NKS in Russian). Communications are of utmost

Figure 2.4

importance in war, so it's no surprise that the Bolsheviks had created NKS on the very day they seized power in Red October 1917. Kotelnikov became a communications engineer there and eventually headed his own institute. He would always have one foot in the ivory tower and the other in the real world of politics and war.[12]

He was on his way, with two important papers and positions in two prestigious organizations. He was poised for rapid advancement in both academia and government. On both paths Kotelnikov would have to dance with tyrants, as Fourier had.

Digital and Analog Infinities

Let's not be shy about the word *infinite*. There are actually many different kinds of infinity, but the only two we need here are the digital kind and the analog kind. The familiar diagram (figure 2.4) of the clock's second-hand wave will help make the difference clear.

You'll recall that there's one round black dot on the wave for every minute mark on the clock's face during each and every cycle the second hand makes around the dial. As the second hand progresses around and around the dial, the dots unfurl to the right forever. How many of them are there? Well, you can count them—one, two, three, and so forth—but you'll have to count forever. That's digital infinity. There's always another one. Mathematicians call it countable infinity, for the obvious reason.

The second kind of infinity, analog infinity, isn't so easy. Consider two successive dots on the wave. How many points are there on the wave between the dots? Answer: there are so many you can't even count them. Analog infinity is larger than digital infinity—as strange as that sounds. The mathematician Georg Cantor proved it was true, and here's what he meant:

Between any two points on the wave, there's always another point on it. For example, there's the point—on the wave—halfway between the two points. Now think of

Figure 2.5

that midpoint and the left of the two original points. Is there a point between them? Yes, always—for example, the point halfway between them. Now repeat for this one-quarter point and the left of the two original points. And so on, ad infinitum, as the expression goes. The difficulty is that you can never divide finely enough to reach an end to the dividing process. In other words, you can never get to a place where you can even start counting. Mathematicians like to call it uncountable infinity, but I'll stick with analog infinity. Both work: Smooth things have an analog or uncountable infinity of parts. Discrete things have a digital or countable infinity of parts. In a profound way, digital is lesser than analog—even if you use lots of dots to represent the smooth thing.

But Kotelnikov's great idea appears to be—and here's the surprise—that digital is equivalent to analog. Nothing is lost by going digital. A discrete digital thing can faithfully represent a smooth analog thing. Figure 2.5 shows a snippet of sound, say, or of a visual scene along a horizontal line through it. Kotelnikov's idea works in either case. The straight line along the bottom is the zero loudness or zero brightness level—completely silent or completely dark. The curve is the changing loudness of the sound as time passes, or the changing brightness of the visual scene as you move to the right along one line through it. In either case the big dots highlight equally spaced points along the snippet. We'll build intuition with this one-dimensional example, then gradually extend to the two dimensions that a full visual scene actually requires—just as we did for Fourier waves in the first chapter.

Figure 2.6 is what you get if you omit all the points on the smooth curve except the ones at the big dots. Between these points all we have now is the straight line, the zero loudness or zero brightness level. It's not hard to imagine what the two-dimensional version would look like. Think of an uneven bed of nails, equally spaced horizontally and vertically. Their heights would vary according to the brightnesses on a corresponding smooth surface that was a visual scene. And the bed of nails would be a "surface" that is zero everywhere except at the nails.

Figure 2.5 is analog, and figure 2.6 is digital. The spikes in the latter are called, naturally enough, *samples* of the analog curve. In the bed-of-nails case for two dimensions,

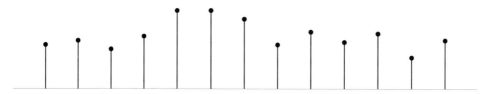

Figure 2.6

the nails are the samples of the corresponding analog surface. Kotelnikov's great idea says that we don't need the full smooth curve to represent a sound or the full smooth surface to represent a visual scene. We need only the samples. In other words, the analog infinity of points between the highlighted points in the first figure can be ignored! He appears to say that nothing *can* represent something. How could that be? The answer lies hidden, of course, in the "appears to."

You might imagine that if you simply used more samples and placed them "close enough" they would *become* the analog sound curve. It's the same intuition many people have that pixels—whatever they are—spaced closely enough together would *become* the visual scene they represent. But this intuition is wrong. You can't get close enough. You can't make digital infinity ever reach analog infinity. You can't count what's uncountable. Yet Kotelnikov appears to say you can. What gives?

Furthermore, his idea says that in the second figure the dots shown *are* close enough—that you gain no advantage, no additional information—by taking more closely spaced samples. Are you puzzled yet? I hope so because we're getting to the crux of the matter—and its elegance.

With these questions quivering in the air, we're almost ready for a first pass at Kotelnikov's great idea. But first let's revisit Fourier's idea, since Kotelnikov's depends on it. Fourier taught us that an analog sound or visual field can be represented by a sum of waves. Figure 2.7 shows one of the waves in the sum of waves for the analog snippet we've been using, repeated at the top (designating the sample locations with dots) for convenience. You can *see* that nothing in the snippet wiggles up and down any faster than this wave, so this wave is the one with the highest frequency. All the other waves in the Fourier sum for the snippet have lower frequencies, otherwise you would see a faster wiggle somewhere in the snippet.

Here's Kotelnikov's great idea: if you sample something smooth at twice its highest Fourier frequency, then you can always *exactly* recover the smooth something using only the samples. The samples are discrete, disjointed, separated from one another—definitely *not* smooth. This is the first part of his idea—the great Sampling

Figure 2.7

Theorem—the part that says it's *possible* to substitute digital disjointedness for analog smoothness. The second part tells us *how* to go about the actual recovery of the original analog from the digital samples.

Kotelnikov stands on the shoulders of the giant Fourier. Fourier's frequencies capture how fast an analog picture changes across a field of view. Then Kotelnikov's great idea tells us how to digitally represent Fourier's waves. Astonishingly, only two samples suffice for each cycle of the fastest changing wave. It takes two, intuitively, because one sample represents the cresting part of that wave and the other the troughing part.

The Pixel

There's a name in the digital world for Kotelnikov's samples of a visual field. We call them *pixels*. There it is! That's the definition of pixel. It's intimately associated with both Fourier and Kotelnikov. Kotelnikov's sampling is what makes Digital Light possible.

Pixels are *not* little squares! This may surprise you because *very* often they're represented that way—so often, in fact, that many people *equate* pixels with little abutting squares of color—which is perhaps the most widespread misunderstanding of the nascent digital age. The word *pixelation* has even institutionalized the misconception.

In fact, pixels have *no* shape. They're just samples taken on a regular grid—the uneven bed of nails. They exist only at a point, so they have no extent, no width, zero dimensions. You can't see them, and they have no visible color. They just have a number *representing* a shade of gray, or three numbers *representing* a color. It's the recovery of analog from digital, using Kotelnikov's idea, that appears to give a pixel shape, as we'll see.

The word *pixel* itself had to fight for existence. Pixels were called many other things at first—*spots*, *point arrays*, *raster elements*, *picture points*, and *picture elements*, for example. *Picture elements* won, but then came a battle over representing the term in shorthand. For many years IBM and AT&T made an effort to contract it to *pel*. But with their candidate *pixel*, the vibrant young image-processing community of the mid-1960s

Since the
information band-width goes to 200 KC, by the sampling theorem, we must
sample at least 400,000 samples per second. We have chosen to sample at
a 500 KC rate and we define each one of these samples as a picture-element
or a pixel.

Figure 2.8

triumphed over the efforts of the giant corporations. In fact, it was a point of counter-culture honor among computer graphicists like me, who came of age in the tumultuous 1960s, to disallow Big Blue's and Ma Bell's *pel*. Richard Lyon, in a careful history of how and when the variant words were used, found the earliest appearance of *pixel* in a 1965 document by Fred Billingsley of Caltech's Jet Propulsion Lab, specifically in its Image Processing Lab (see figure 2.8, and note that KC means thousand cycles per second). The earliest public use of *pel*, according to Lyon, came from a 1967 paper by the MIT professor William Schreiber.

Many patents were issued in the 1970s containing *pixel* or *pel*, with the number of *pixel* patents greatly exceeding the number of *pel* patents each year. Most of the *pel* patents of this era were unsurprisingly assigned to IBM or AT&T's Bell Labs. If Nyquist or Shannon had used a word for the pixel—they didn't—it would surely have been *pel*, Ma Bell's word.[13]

The pixel directly invokes the Sampling Theorem; sampling and pixels were joined at birth. Oddly, there's no word like *pixel* for a sound sample, despite the fact that the same trick, Kotelnikov's sampling, is what makes Digital Sound possible. Unfortunately, *sampling* has a different meaning in audio. In hip-hop, for example, it means to borrow whole chunks of other people's music, several seconds worth, and put them together, or mash them up. A distinct word is quite handy in this book, so I use *soxel*—a contraction of *sonic element*—as the name of the sound sample.

Name Games

A more serious naming issue arises because in the United States today, Kotelnikov's Sampling Theorem is nearly always attributed to Shannon. If you ignore the rest of the world, it's easy to see why. Claude Shannon is a towering name in America. In his 1948 paper, "A Mathematical Theory of Communication," he stated the Sampling Theorem. In his massively influential and classic 1949 paper, "Communication in the Presence of Noise," he stated and proved the Sampling Theorem in the form now used throughout

the digital world, particularly in Digital Light. His stature grew as he won many top awards in the United States—for example, the National Medal of Science and the Medal of Honor of the vast Institute of Electrical and Electronic Engineers (IEEE). He was the first recipient of the eponymous Claude E. Shannon Award of the IEEE Information Theory Society, for the field he established. Internationally, he won the first Kyoto Prize, an equivalent of the Nobel for mathematical sciences.[14]

Claude Elwood Shannon was born on April 30, 1916, in Petoskey, Michigan. He grew up in nearby Gaylord where he reputedly crafted a crude telegraph line from the barbed-wire fences between his house and a friend's. He loved juggling, secret codes, and chess. He was a playful genius. He rode unicycles through the halls at Massachusetts Institute of Technology, where he got his PhD, and later through the halls at Bell Labs, where he invented information theory. He built a machine in a box that did one thing: when you toggled a switch on its side, the lid opened, an arm reached out, and toggled off the switch.

Shannon was a master of cryptography and wrote a classified paper in 1945 called "A Mathematical Theory of Cryptography." During World War II he analyzed the X System that was used for secure communications between Franklin D. Roosevelt and Winston Churchill. Shannon was able to prove mathematically that its encryption scheme was unbreakable. Shannon was also a heavyweight in the field of communication in the presence of noise, the title of his 1949 paper in fact. He showed how to send digital messages across the solar system in such a way that corruption occurring en route from cosmic noise could be removed to reveal the original message. Shannon's ideas made it possible to reliably send movies of Mars all the way from the *Curiosity* rover to your laptop—so it was natural that Shannon's name was attached to the Sampling Theorem. But it wasn't Shannon's idea. He said so himself.[15]

"This is a fact which is common knowledge in the communication art," he wrote in the 1949 paper. "It has been given previously in other forms by mathematicians but in spite of its evident importance seems not to have appeared explicitly in the literature of communication theory."[16]

But somebody from the communications world *had* stated the Sampling Theorem—in the right form and with the full proof—long before Shannon. Kotelnikov had done so in 1933, well over a decade earlier. Why didn't Shannon mention him? Perhaps because the earlier paper had been published as part of obscure Russian conference proceedings, and Shannon simply didn't know about it. But as we'll see, the reason for his silence is hard to determine. He could have learned about Kotelnikov's Sampling Theorem in the context of the very secret science Russia and the United States shared during World War II. But the bitter Cold War division between the countries would

Figure 2.9

have prevented Shannon either from making his knowledge of the theorem public or from learning about it during those years.

Here are the two giants, side by side (figure 2.9). Kotelnikov is on the left—with the wilder hairdo—in 1932 at age 24, a year before he proved the Sampling Theorem. On the right is the slender Shannon at an undetermined age, but perhaps about 32, near the time of his proof in early 1949. Both men were leaders of digital communications in their respective countries—especially communications in the presence of noise or encryption. Both received the highest awards. And both stated and proved the Sampling Theorem as it's used today in Digital Light.

We can't help but wonder if there was cross-cultural leakage. Curiously, the younger Shannon often paralleled Kotelnikov's intellectual achievements a few years later—but I've found no evidence that Shannon knew Kotelnikov's work. In any case, it's no surprise that Russians call the great idea Kotelnikov's Sampling Theorem. Shouldn't we?[17]

Spread and Add

The second half of Kotelnikov's idea—the great Sampling Theorem—tells us how to reconstruct a smooth picture from non-smooth pixels, and to do it accurately. The

Figure 2.10

surprise about digital is that almost no information seems to exist in a digital image—an analog infinity of points has simply been omitted between each pair of pixels. The same goes for digital audio and each pair of soxels. The second half of the Sampling Theorem tells us where those missing infinities can be found.

Here's how to recover the analog from digital. Spread each pixel with the spreader, the shape fundamental to this chapter. Add up the results. That's it. The Sampling Theorem tells us that this spreading and adding process accurately reproduces the missing infinities between the pixels! As with all great theorems, such deductions aren't at all obvious. We have to trust the math.

The running example will help again, but with only two soxels shown for simplicity (figure 2.10), the two central ones. (We'll extend it to pixels shortly.) Recall that a soxel is a sample of an analog sound curve, where the height of the curve above the zero line represents its loudness. So the height of a soxel represents the loudness of the curve at just that point sampled by the soxel. The soxel at the right is less loud—quieter—than the one on the left.

First we'll *spread* the left soxel with the spreader, which we saw in figure 2.1. Recall that it wiggles at the same frequency as the Fourier wave with the highest frequency of the original snippet. Its maximum amplitude (loudness), at the central hump, represents the volume turned all the way up. To do the spreading replace the left soxel with a copy of the spreader (figure 2.11). I like to say that this spreads the soxel from no shape (nothing) to the shape shown (something). Its highest point—the peak of its central hump—has the same loudness as the soxel it replaces. The two soxels are shown dashed. In particular, this makes clear that the height of the spreader—its maximum loudness—matches that of the left soxel. In this example, that loudness is 80 percent of full volume. Imagine that you have a knob for that loudness adjustment.

Now move another copy of the spreader into place over the right soxel (figure 2.12) and twiddle the knob until its maximum loudness matches that soxel's loudness, in this example 50 percent of full volume—hence spreading the second soxel.

And here's the result (figure 2.13) of adding these two "spread soxels" together. At each horizontal position take the two heights of the spread soxels there (light gray),

Figure 2.11

Figure 2.12

Figure 2.13

measured from the zero-loudness line, and add them together to get a point on the bold curve.

I've ignored reality so far. The spreader—this chapter's featured shape—doesn't exist in the real world. It's infinitely broad. It continues to ripple left and right forever. Obviously, no real-world spreader can be that broad, so real-world spreaders by necessity have to be approximations of the ideal spreader.

A popular, practical, and remarkably accurate spreader is called a cubic spreader (figure 2.14). Note how closely it resembles the middle part of the ideal spreader, including the presence of two lobes going negative (below the zero-loudness line). The cubic spreader is zero everywhere beyond two samples left and two right of the central sample—the one spread by the spreader. In other words, it has a finite width, so it can exist in the real world.

Figure 2.14

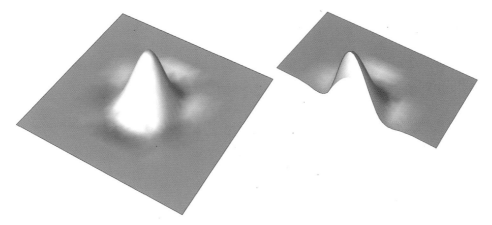

Figure 2.15

What I've described so far is one-dimensional spreading. Sound varies in one dimension only (of time) so it's an accurate picture for soxels, but not for pixels. A pixel spreader must spread in two dimensions since images extend in two dimensions (of space), often called horizontal and vertical. A pixel spreader must spread each nail (pixel) in a bed of nails so that each "spread pixel" contributes to a two-dimensional surface that we can see. You can think of the preceding figures as accurately showing the cross section of a pixel spreader in the horizontal dimension, keeping in mind that the cross section in the vertical dimension is exactly the same. But we can do better.

Figure 2.15 shows a full two-dimensional pixel spreader. Drop a guillotine through its brightest point—so that the blade slices the little mountain in half, from its peak to its base as shown. Then the bleeding edge revealed is exactly the cubic spreader above. You'd see the same edge if you cut the little mountain in half the other way. Since this pixel spreader is a cubic spreader in each dimension, it's called a *bi*cubic spreader. It's



Figure 2.16

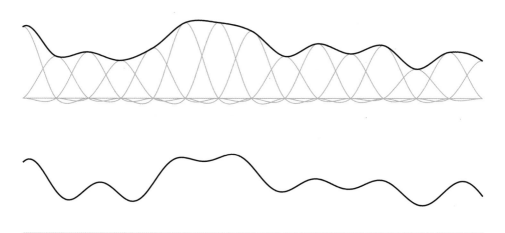

Figure 2.17

the kind built into Adobe's Photoshop (one of the oldest and most popular pixel apps) for changing the size of a picture.

So now let's spread and add a row of pixels, but let's do it by using this bicubic spreader instead of the ideal one. For simplicity and consistency, we'll do this in cross section. But imagine that each spreader is actually a little mountain like the one we've just seen—and that the uneven bed of nails extends in the other dimension with a little mountain at each of its nails. First, we spread the pixels (figure 2.16).

Then we add them all up to get a resulting brightness everywhere. Figure 2.17 shows that result along one horizontal line through a visual scene. The bold brightness curve reconstructs the original analog snippet, which I repeat just below it for ease of comparison. It's not perfect—just an approximation—since we've used a less than ideal spreader, but it's close. It's like a worn or duplicate key compared to the original. The teeth of either open the lock.

You can imagine that these figures—already complex for just a dozen or so pixels—would become hopelessly complex for, say, a million pixels. The important point is

that each step is simple: move a spreader into place, adjust its brightness, and add it to the others. We have a beast that can repeat an easy step over and over and not become confused or bored—the computer, of course. That's why the next two chapters are about the computer and its marvelous ability to Amplify (with a capital A!) a puny human step—spreading one pixel, say—by a millionfold or billionfold, and to do it very fast, not to mention adding up all those spread pixels. One addition is simple—even a human can do that—but it needs to be repeated a million or a billion times. That's why we need computers to actually realize Digital Light even though Kotelnikov's and Fourier's math shows that we can do it in principle.

Let's step through the magic again. Someone took a video of an event, an opera perhaps, or an audio recording of a sound, maybe a concert, somewhere far away—in Beijing say—and threw most of it away, preserving only samples of it. Perhaps that stream of pixels or soxels was bounced off a communications satellite thousands of miles above the Earth or shipped across the World Wide Web to you in San Francisco. The stream may have lived in a computer file or on a DVD somewhere for years before you accessed it. During all that journey through space and time, the analog infinity of the original was missing. All that existed of it was pixels or soxels you couldn't see or hear. Even when you finally downloaded them onto your computer or cellphone, the analog infinity was still missing, and you still couldn't see or hear them. Then the magic happens: You decide to look at the pixels or listen to the soxels. There, at that moment, the spreading and adding I just described—the reconstruction—happens and you witness the full analog infinity of information that the person in Beijing did, many miles or years ago.

The missing infinity only reappears when it's displayed on the screen or the speaker—and not before. We think we're carrying around the picture or the sound, but we aren't. We're transporting a highly compressed form of it. The old media of the last century—film and video, for example—*did* preserve the analog infinity all along the path from the source through the communication channel to the display. The new medium abbreviates it to digital samples and only reinvents the original analog picture or sound at the last possible moment.

So here's the secret of the Sampling Theorem, and why it's not really something for nothing. Any spreader that we use, whether it's the ideal one or not, is an analog shape: it has an analog infinity of points. By putting a spreader at each pixel—little blobs of infinity—and adding up the results, we effectively reintroduce analog infinity everywhere. The apparent nothing between pixels is covered by the something carried in the pixel spreader. It's a *very* neat trick. The Sampling Theorem repackages infinity. The power of mathematics to free us from the bounds of our intuition is at full play in Kotelnikov's great idea.

Figure 2.18

Pixels Are NOT Square

Pixels have no shape until they're spread by a spreader. I've often drawn them for pictorial convenience as a side view, or in elevation, as spikes of the appropriate height. Figure 2.18 (left) shows the center two pixels of the running example.

Another way to represent pixels is by looking at them from above, so to speak, so that you can "see" them in a natural way. But we can't see pixels. It's spread pixels that we see. So what does a spread pixel look like from above—that is, as we actually view pixels? Figure 2.18 (middle) is a picture of the two pixels, as spread with Photoshop's bicubic spreader. It's two little mountains as seen from above their peaks, looking down. The lighter spread pixel on the left is barely visible, but it's there, overlapped by the darker one.

The two spread pixels certainly *don't* look like the abutting squares in figure 2.18 (right).

If you *must* give a shape to a pixel, then use the blobby image of spread pixels as your guide and remember the overlap with neighboring pixels. But really, truly, a pixel has no shape. It's a point with zero diameter. Only spread pixels have shape. If it's a pixel you can see—if it has a visible shape—then it must be a spread pixel.

It's easy to understand where the little square notion comes from. Common apps support the illusion. I made this—tiny—figure 2.19 (left, look carefully) in Photoshop. It's a cluster of 14 gray pixels on a white background, and too small to see easily. Of course, you're not actually seeing 14 pixels here. You're seeing 14 spread pixels.

Nearly all pixel apps have a feature called Zoom, or some variant. Zoom purports to show you what a picture looks like up close, as if it were viewed through a magnifying glass. Figure 2.19 (middle) shows the result of using Photoshop's Zoom In to make the 14 pixels 16 times larger.

Figure 2.19

Surely then the pixels must be little squares, right? Not at all. Zoom uses a quick-and-dirty—and inaccurate—trick to make you think it's "magnifying." Zoom simply repeats each pixel 16 times horizontally, and then repeats each row of 16 identical copies 16 times vertically. The result is that each original pixel is replaced with a 16 by 16 square array of pixels of the same color. So each array looks—what a surprise—like a square of that color. But each square is definitely *not* a picture of one of the original pixels close up. It's a picture of more than *200* (spread) pixels for each original pixel, arranged in a square. The Zoom trick was useful back in the bad old days of slow computers, but in the modern world it is simply misleading. It's time to scotch the notion that pixels are little squares. It never was true.

Figure 2.19 (right) shows you what the original picture looks like really, when Photoshop does a proper magnification by 16 (with a feature called Image Size). The second half of the Sampling Theorem explains why you see blobs, each with the original gray in the center but softening rapidly in every direction to whiter shades of gray, partially overlapping neighboring blobs.

The Great Terror and Its Tyrants

Stalin's Great Purge—the Great Terror—lasted from 1934 to 1939. It was implemented by the notorious NKVD (People's Commissariat for Internal Affairs), predecessor of the KGB. Many were condemned to death in the infamous show trials, and hundreds of thousands, perhaps millions, of Russians were sent to the prison camps—the islands—of the Gulag Archipelago. It was Solzhenitsyn who taught us about the Gulag and the unfolding tragedy that "was unprecedented in remembered history."[18]

Two tyrants for Kotelnikov emerged from this horror. Robert Conquest, the definitive historian of the Great Terror, described four powerful young Stalinists who led the purge as "particularly murderous." Among them were Kotelnikov's tyrants Georgi Malenkov and Lavrenti Beria.[19]

Malenkov's report to the Eighteenth Party Conference in Moscow in February 1941 kicked off yet another purge, Stalin's Secret Purge, second only to the Great Purge. Malenkov revealed that industrial capacity was plummeting, and incompetence was rampant. So just before Hitler invaded Russia in June, dozens of the People's Commissariats (NKs in Russian—what we might call Federal Bureaus or National Departments) were decimated, including in particular the People's Commissariat for Communications (NKS). The entire NKS was disbanded—except for Kotelnikov's lab, which was left untouched because of its wartime importance.[20]

During World War II, Stalin headed a committee of five that ran the country: Malenkov and Beria were both members. Beria also ran the NKVD with the assistance of a deputy, Viktor Abakumov, a third Kotelnikov tyrant. When Stalin created SMERSH (yes, you Ian Fleming fans, this counterintelligence organization really existed), he put Abakumov in charge.

After World War II Malenkov became powerful, second only to Stalin at first. Stalin's technique for keeping Malenkov and Beria under control was to raise Abakumov to a still higher position. So Beria and Abakumov ran the state apparatus that controlled the Gulag slave labor camps. They organized massive executions of their rivals in Leningrad and had thousands more sent to the camps. And when Stalin died in 1953, Malenkov became Premier of the Soviet Union.

But Malenkov's importance for Kotelnikov lay principally in his wife, Valeriya Golubtsova. She would be the defining force in Kotelnikov's career—his protectress.[21]

Golubtsova had a first-rate revolutionary pedigree. Her mother, Olga, was one of the Nevzorov sisters—Zinaida, Sophia, Avgusta, and Olga—who were part of Lenin's inner circle when they were all young, long before the October Revolution. Two of the sisters married men with connections: Zinaida and her husband Gleb Krzhizhanovsky had spent exile in Siberia with Lenin and his wife during their courtships and early marriage years. Gleb was Lenin's friend and one of the oldest figures in the revolutionary movement, a Party member since 1893. Sophia's husband, Sergei Shesternin, was the man Lenin trusted with top-secret Bolshevik finances.[22]

Golubtsova was brilliant—a student at Moscow Power Engineering Institute (MEI) herself when women engineers were almost unheard of anywhere. She was also powerful, difficult, and cool. A determined organizer, she became MEI's longtime director and turned it into an academic powerhouse. When she spotted an intellectual star for her institution—such as Kotelnikov—she could and would make sure he stayed there and not in the Gulag. If not exactly a tyrant herself, she used her tyrant-in-law status very effectively to get what she wanted.[23]

How Digital Light Works

Kotelnikov worked out the theory of sampling, and he designed the ideal way to spread a pixel into a picture. But he had no idea at the time of the way those ideas would actually come to be used in practice. For one thing, there's a huge practical assumption in the modern digital world: an actual device, and not just a theoretical wave, will be at the other end to do the spreading and adding necessary to restore the analog light your eye requires.

Digital Light works because it assumes that the missing information will magically appear—in the form of an appropriate pixel spreader—somewhere in the process, at the moment of display. Digital Sound works the same way. It assumes there'll be a device somewhere later that will spread the soxels into the original analog sound that your ear requires. The display of sound is a speaker system and the amplifier that feeds it. Display, in fact, *is* the act of reconstructing the analog original—the form your brain needs—from samples.

Display is a fundamental assumption of the modern world. The Great Digital Convergence depends on the fact that the same pixels—the same abstract representation of an image—can be displayed in myriad ways by myriad technologies.

If you take a picture with your cellphone and then look at it on your computer screen, chances are that you're seeing two different pixel spreads. If you view it on paper, there's no question that you're witnessing a different spread. The only thing that's constant is the actual pixel behind the display, the invisible one that's reconstructed by the display, a point with a number attached—or three numbers if it's colored. One of the unsung accomplishments of Digital Light is the reduction of the vagaries of different display technologies—and many more to come, no doubt—to a thin layer of hardware called the display and its software called a display driver. Each manufacturer makes its own displays and drivers. We users never have to worry about anything but the pixels themselves. Our displays do the spreading. This is the Great Digital Convergence at work.

It's a convergence that divides. It drives a wedge between the creation and display of pixels. In Creative Space, pixels are simple, pure, and universal. In Display Space, the rubber meets the road. All the nastiness of actual real-world technology comes to bear on the problem of spreading the pixels that are supplied from Creative Space. Here's where the engineering expertise of thousands of manufacturers is focused on high-quality approximations of the ideal spreader within the real-world limitations of actual physical stuff—plasmas, liquid crystals, phosphors, inks. All we users need to worry about are the platonic pixels of Creative Space. That's why I've urged that the spread

pixel, which can be perceived, should not be confused with the actual pixel, which cannot. Let's not conflate thin Display Space with vast Creative Space.

Often display manufacturers call the little glowing elements in their displays "pixels." But this confuses the spread pixel with the pixel. These should be called display elements, not pixels. The glow—the emitted illumination, high at the center, diminishing to zero away from center—of one of these display elements is the spreader for a particular display device. A pixel goes into the display element, a spread pixel comes out, and that's what you actually see. Generally, the glowing shape is unique to the manufacturer and can even vary from product to product at the same company.

So, here's how Digital Light works: It extracts pixels from the real world, even from Mars or Venus—or from unreal worlds inside computers, as we'll see—and sends them all over. These pixels carry only discrete position and intensity (or color) information. The actual light that seems to come from a pixel is only produced by a display device at the last possible moment before you see it with your eyes—not at any of those intermediate places around the world or among our sister planets. The smoothness of the original picture only reappears in the display. If the original creation of the pixels is done well, as per the Sampling Theorem, and if the reconstruction of those pixels into an analog display is done well, also per the Sampling Theorem, then what you see is an accurate representation of the original. We *do* get something from nothing. The pixel is the nothing—it has no dimension—and the displayed colored blob of light of the display is the something. The Sampling Theorem enables this scheme. The digital world wouldn't exist without it.

Spies and Scramblers

"The idea of the scrambler is to reproduce the human voice by artificial means . . . to reproduce it by adding together at least the main harmonics, each transmitted by a separate set of impulses. You are familiar, of course, with Cartesian rectangular coordinates—every schoolboy is—but what about Fourier's Series?"
—Aleksandr Solzhenitsyn, *In the First Circle*[24]

Kotelnikov's paper—the one with the Sampling Theorem—was rejected in 1936 by the *Electrichestvo* (*Electricity*) journal when he tried to get it into wider circulation. But there was a far more intriguing event that year: Kotelnikov visited the United States! I picked up a hint of this and was able to find an image of his disembarkation record. It reveals that he had a 60-day visa, his trip was paid for by the Soviet government, and his destination was the Amtorg Trading Corporation in New York City.[25]

Armand Hammer had formed Amtorg in 1924 to facilitate trade between the USSR and the US. He was a fascinating man, son of a founder of the Communist Party USA, who named him after the "arm and hammer" logo of the Socialist Labor Party of America. Armand was a noted businessman (head of Occidental Petroleum), philanthropist, and art collector.

But Amtorg was more than a trading company. It was a hotbed of industrial and military espionage. In fact, a declassified NSA (National Security Agency) report reveals that the United States expended major effort in 1931 trying to crack the codes that were used between Amtorg and Moscow. The US effort failed because "the Russians were using a one-time pad for their encipherment."[26]

This is particularly interesting because the one-time pad encryption system, which depends on a one-time, pre-shared key, wasn't *proved* effective for another decade. Amtorg spies obviously trusted it without proof for that long at least. Although we don't know exactly what Kotelnikov was doing there in 1936, creating and breaking codes seems a lot more likely than trade.

Or perhaps he was gathering data on one-time pad usage—because the man who proved the reliability of the one-time pad system was Kotelnikov. He submitted his proof just three days before Hitler's June 22, 1941, invasion of the Soviet Union. Perhaps not surprisingly, Shannon also proved the reliability of the one-time pad system; it appeared in a classified publication in 1945 and publicly in 1949.[27]

Kotelnikov must have done his one-pad work in his lab—the only remnant of the NKS communications commissariat after Stalin's Secret Purge. The lab had survived because its classified work on radio communication was urgently needed by the military. But as the Germans fast approached Moscow in late 1941, Kotelnikov took no chances that they might break through. He evacuated his lab to Ufa, about 300 miles further east even than Kazan, so 800 miles east of Moscow.[28]

During the battle of Stalingrad, the Russian front had depended on wire communications and had suffered gravely when, inevitably, the wires failed. Kotelnikov's lab produced secure devices that communicated via radio rather than wire, and by 1943 armies in the field were using the equipment. He received his first Stalin Prize that same year for its development. Then later, in May 1945, authorities used the lab's equipment to connect Moscow to the Soviet delegation at the signing of Germany's capitulation. Kotelnikov received his second Stalin Prize the following year.[29]

When the lab returned to Moscow from Ufa, it fell under the control of the NKVD. At this dangerous moment Golubtsova, the new director of Moscow Power Engineering Institute (MEI), stepped forward and proposed that Kotelnikov might like to return to

her institution, his alma mater. He leapt at this chance. Her intervention saved him, as head of a top-secret project, from the NKVD's prison system.[30]

The Sharashka System

Success was dangerous in the Soviet Union. Accomplished scientists and engineers were sharashka fodder. A *sharashka* was one of the infamous secret scientific research and development prisons run by the NKVD in the Gulag. Solzhenitsyn taught us about them too. They were his *paradise islands*. Many scientists and engineers were imprisoned in paradise to ensure that a particular missile, plane, or nuclear bomb was devoted only to Mother Russia. Prisoners sent to the horrendous labor camps in the bitter cold of remote Russian provinces were starved, frozen, and worked to death. The "privileged" prisoners in sharashkas were well-fed and warm. But they were in prison nevertheless, often for decades. These are the most surprising prisons yet devised by man—prisons for the best and brightest, with little hope that they could ever leave.[31]

The Marfino sharashka (figure 2.20), in the former Monastery of the Epiphany in the northern part of Moscow, was devoted to secret communications equipment and security systems. Kotelnikov would probably have ended up there if Golubtsova hadn't

Figure 2.20

rescued him. Other members of his Ufa lab certainly did, becoming its principal scientists and designers. And Aleksandr Solzhenitsyn did too. His novel *In the First Circle* is an account of life in this very sharashka, where he lived from 1947 to 1950.[32]

In the First Circle is a roman à clef. Solzhenitsyn himself is represented by two of the characters, and Stalin appears as himself. It also features Beria, who was responsible for the system of sharashkas, and Abakumov, the head of the MGB—a descendant of the NKVD and forerunner of the KGB. The novel contains an intriguing character, Vladimir Chelnov, a mathematician, professor, and Academician, with a special relationship to the MGB—surely representing Vladimir Kotelnikov. Consider the following two quotations from *In the First Circle*:

> Professor Chelnov was the only prisoner at Marfino excused from wearing overalls. Abakumov himself had been asked to authorize it.

> Chelnov had been sent to Marfino to work out the mathematical principles for a foolproof scrambler—a device of which the automatic rotation switched banks of relays on and off, thereby confusing the order in which electrical impulses were sent out and so distorting the sound of human speech over the telephone that not even a hundred monitors equipped with a hundred similar devices would have the slightest chance of unscrambling the conversation.[33]

Vladimir Kotelnikov, a mathematician, professor, and (future) Academician, with a special relationship to the MGB—meaning, protected from it by Golubtsova—was an expert in voice scrambling devices. He acknowledged that he had used a 1939 vocoder, or voice coder, paper by Homer Dudley of Bell Labs as the basis for scrambler development in Russia.[34]

The next quotation from the novel ties it all together:

> "What? What d'you mean, artificial speech device?" a prisoner reported to Abakumov. "Nobody at our place calls it that. They changed its name during the campaign against kowtowing to foreign science. It's a vocoder. Voice coder. Or scrambler."[35]

In 1947 the real Abakumov called Kotelnikov to his MGB office and outlined to him a Specialized Laboratory for "absolutely security-restricted" radio telephone equipment. *In the First Circle* suggests that the special equipment was a direct request from a paranoid Stalin, and that prisoner Solzhenitsyn worked on it at Marfino. Abakumov proposed that Kotelnikov be the prestigious head of the Specialized Laboratory, and he sweetened the deal with perks and privileges. Stunningly, considering the murderous man he was dealing with, Kotelnikov declined the offer.

"Well, that's a pity," responded Abakumov, and ended the meeting.

Abakumov was terrifying, even Beria was afraid of him. Deathly frightened by that closing remark, Kotelnikov went immediately to Golubtsova and told her what'd happened.

"Well, what do you yourself want?"

"To work at MEI."

"Then continue to work calmly as before," she advised.[36]

She had saved him again.

Developments in Russian Rocket Science

What Kotelnikov actually did instead of—or in addition to—Stalin's scrambler follows from an account of a 1947 meeting in Golubtsova's MEI office. Boris Chertok, a famed Russian rocket scientist, reported to her about the needs of his missile development sharashka.

"Within a short time, the results of this meeting exceeded our most optimistic expectations. Thirty-nine-year-old Professor Vladimir Kotelnikov was in charge of developing the ideas I had posed," he remembered. "Literally about ten days after my meeting with the MEI scientists, Golubtsova's office issued a governmental decree signed by Stalin on the creation of a special operations sector at MEI. A year later, the collective that had rallied around Kotelnikov was already developing the Indikator-D system, which we used during the flight tests of the first R-1 domestic missiles in 1948. Beginning with this development, all subsequent missiles were equipped with MEI radio systems during test flights."[37]

The R-1 was the Russian version of the V-2, Wernher von Braun's rocket used by Germany to pound London.

"In 1951, the MEI collective entered a competition for the creation of telemetry systems, and the first R-7 intercontinental missile was equipped with its now legendary Tral system."

The R-7 was their first intercontinental ballistic missile (ICBM).

The MEI "collective that rallied around Kotelnikov" was the sharashka known formally by the Russian acronym OKB MEI, presumably led by him from his protected position just as Chertok ran his sharashka, NII-88. Thus began Kotelnikov's contributions to the space race.[38]

Getting Digital Representation Right

So far I've talked as if pixels could represent any brightness level whatsoever. But a point on an analog curve is an analog value, meaning it can have any of an analog infinity of values. Strictly speaking, an analog sample of a picture's brightness isn't a pixel. It only becomes a pixel when it's converted to bits and only then will it be spread to become the glow you see on a display. A digital sample, such as a pixel, can take only certain discrete values, a finite number of them.

Some "computerspeak" is handy here, before we get to computers in the next chapters. Famously a bit can have two values, usually called 1 and 0. Think of a bit as a light switch. It has two positions, often called up and down. Consider two light switches. How many positions can they be in? Well, they can both be up, or both down, or one up and the other down in two different ways. So the answer is four. In other words, two bits (light switches) can have four values. Three can have eight values. The third switch can be up or down, and the other two switches can be in four different positions, as we've already noticed. Two times four is eight. In general, as the number of light switches increases by one, the number of different positions the switches can assume doubles. To save you the trouble, I'll simply tell you that 8 bits (light switches) can hold 256 values (positions), 10 bits can hold 1,024 values, and 16 bits can hold 65,536 values.

In the first decades of computer graphics it was common to limit a pixel of a black-and-white image to 8 bits. It meant that a pixel could represent one of only 256 shades of gray. For example, values 0 and 255 could represent black and white, respectively, with 254 other grays distributed in between. But the actual value on the analog curve might be 49.673. What's to be done? Well, the closest available gray value, 50, would be attached to the pixel for that point, hence introducing a small error into the picture when it's reconstructed later onto a display. How bad is that tiny round-off error in brightness? Is 50 "close enough" to 49.673 to not matter? What is "close enough" for pixel brightnesses?

Here's a case where we really can choose values that are "close enough." Doctors, particularly radiologists, read CAT scans and MRI scans on displays and base their diagnoses on what they see. Display manufacturers for the medical profession, therefore, have measured human grayscale perception precisely. A chart they provide shows that normal humans can distinguish 630 shades of gray on my particular desktop display. So two things are clear. First, the 8-bit pixel of yore with only 256 possible values isn't good enough. But, second, a 10-bit pixel, with over a thousand possible values is more than good enough. The human eye can't see the error that's introduced when you round off to the nearest value among a thousand-plus choices. Modern digital images now use 16 bits for a grayscale pixel, with over 65 thousand shades of gray. That's easily more than enough to fool the human brain—any human for any display. The same goes for 16-bit soxels in the display of sound.[39]

Have you heard audiophiles say that LPs (or vinyl) are better than CDs? In the visual world the claim is that digital photography will never match the subtlety of film photography. Such claims are often held with great passion. Is there substance to them? Well, of course there is. There are several ways that digital sampling can be done incorrectly—not enough values per pixel or soxel, a lousy spreader, or insufficiently

high sampling frequency. But many adherents of these claims believe they are criticizing something *intrinsically* wrong with digital, when what they're really criticizing is poor execution. If an engineer set her mind on making a CD that replicated exactly what was on a vinyl long-playing (LP) album, the theory says that she could do it. Similarly, if another engineer set his mind to making a print from a digital image that duplicated a filmed photographic print, the theory says that he could do it. It wouldn't be easy in either case. The theory would have to be practiced as near ideally as possible, but it would be possible.

Some audiophiles claim to be able to distinguish recordings made at higher sampling rates than the 44.1 thousand soxels-per-second CD (compact disc) standard which features 16 bits per soxel. Recall that the human ear can hear up to 20 thousand cycles per second—the highest Fourier frequency—so the Kotelnikov (or Nyquist) sampling rate is 40 thousand soxels per second. CDs exceed the minimum required by Kotelnikov for perfect analog sound reconstruction from soxels. So, if the theory is to be believed, then nobody should be able to detect an improvement over a CD with a system using a higher sampling rate.

The other kind of error that an expert might be able to detect is round-off error—an insufficient number of values of loudness for a soxel. But as already mentioned, no human ear can make finer distinctions than those provided by the 16-bit soxel of the standard CD—with about 65,000 possible loudness levels per soxel. So nobody should be able to detect an improvement over a CD with a system using more bits per soxel.

Two standard digital audio systems that exceed the CD in both sampling rate and bits per soxel are Super Audio CD (SACD) and DVD-Audio (DVD-A). A carefully controlled scientific test came to this conclusion:

> We have analyzed all of the test data by type of music and specific program; type of high-resolution technology; age of recording; and listener age, gender, experience, and hearing bandwidth. None of these variables have shown any correlation with the results, or any difference between the answers and coin-flip results.[40]

In other words, even audiophiles couldn't distinguish CDs from SACDs or DVD-As. But—and this is telling—the same experimenters reported that "virtually all of the SACD and DVD-A recordings sounded better than most CDs." After searching conversations with the recording engineers, they found that this was because they used the Sampling Theorem much more correctly than the engineers who create the typical CD recording. The lesson is that digital can be an accurate representation of analog, but it has to be done correctly. Or stated another way, there is nothing *intrinsically* inferior about digital.

Spearheading the Space Race

> Yesterday evening we forgot to arrange with a friend for a trip into the country. We pick up from the bedside table a small object resembling a cigarette holder. It is a receiving-cum-transmission television set for private use such as every inhabitant of our planet possesses. We give the call signal of our friend and press a button. . . . We shall certainly have these tiny television sets which will go in the waistcoat pocket.
> —Kotelnikov, predicting the mobile phone, 1957[41]

Kotelnikov visited the United States a second time, on August 27, 1957, just before the launch of Sputnik—an event that shocked America to the bone. It was the International Geophysical Year, marking the end of the Cold War interruptions in scientific exchange. Kotelnikov was now a full member of the USSR Academy of Sciences, and he was carrying information from Russia for the Americans. He told a conference in Boulder, Colorado, that the Soviets would soon launch a satellite that would broadcast at frequencies of about 20 and 40 million (mega) cycles per second. He was ignored. Americans wouldn't believe that Soviet science had progressed so far. But on October 4, Sputnik launched and broadcast at 20.005 and 40.002 megacycles per second. The space race was on in earnest, and Kotelnikov was there.[42]

He was there too when it ended, almost two decades later. At a 1971 meeting in Moscow, Kotelnikov, the newly appointed acting head of the USSR Academy of Sciences, announced to surprised US diplomats that the proposed Apollo-Salyut Test Mission wouldn't work for technical reasons, but that the USSR was ready to pursue instead the renamed Apollo-Soyuz Test Project. The Apollo-Soyuz joint spaceflight project, which began in July 1975, was one of the most powerful symbols of the détente between the two countries.[43]

Spearheading the space race was just one of Kotelnikov's achievements. He accomplished the radio location of the planets Venus, Mercury, Mars, and Jupiter and got a Lenin Prize for it. Then, MEI-equipped missions to space, Veneras 15 and 16, mapped the northern part of Venus for the first time—sending pixels across the solar system. An asteroid, *2726 Kotelnikov*, honors his many contributions to the Russian space effort.[44]

Getting Rid of High Frequencies

Kotelnikov's great sampling idea tells us what it means to have pixels spaced "closely enough" together. Bad things happen if this rule is violated. You've probably seen the results: stair-stepped edges, wagon wheels rotating backward, moiré patterns on

striped neckties, or unpleasant background shimmer in videogames. These artifacts are the bane of the early days of the Great Digital Convergence. "Are," not "were." I recently watched DVDs of the director Michelangelo Antonioni's great films *l'Avventura* and *La Notte*. In *l'Avventura* the stunning Monica Vitti's polka-dot dress was marred because of incorrect sampling. Her dress blinked on and off irregularly as if the polka dots were little lights toggled randomly. And almost every frame of *La Notte* glittered at the edges of windows and buildings that were incorrectly sampled. Not only are such digital artifacts unnecessary, they're unacceptable. They're not intrinsic to the digital world, but they are signs of uninformed use of the Sampling Theorem. Or, in the case of videogames, of game computers without enough power to do sampling correctly.

These unpleasant artifacts occur if you don't sample at a high enough rate. The Sampling Theorem says you have to sample a visual scene at twice the highest Fourier frequency in it. So, either you have to sample at a higher rate to be rid of the ugly artifacts, or you have to get rid of the too-high frequencies in the scene before you sample. Practicality usually dictates the latter path.

The frequencyspeak intuition is that sharp edges mean high frequencies. Very sharp edges mean very high frequencies. How high? Infinitely high for perfectly sharp edges—that is, frequencies so high you can't possibly deal with them. Certainly you couldn't sample often enough to accurately represent them. So practicality steps in again. In general, to represent a scene with pixels, you first have to get rid of its too high frequencies, its too sharp edges. Window edges are good examples. The producers of the flawed *La Notte* DVD clearly hadn't followed the Sampling Theorem. They didn't get rid of the too high frequencies before they sampled, and the result is ugly—or at least distracting.

There's an easy way to remove too high frequencies from a visual scene. Simply defocus the picture slightly—but not so much that you can actually perceive that the picture is going out of focus. This subtlety "schmudges" out all the edges. The Sampling Theorem tells you just how much defocusing is enough.

Dancing around Tyrants

The most disgraceful episode in Kotelnikov's life—at least to many Western eyes—was the Andrei Dmitrievich Sakharov affair of 1975. Sakharov, one of the fathers of the Soviet H-bomb, had renounced the use of nuclear weapons and campaigned actively for their nonproliferation. Both he and Solzhenitsyn, another dissident, were vilified in the Soviet media. But Sakharov received the Nobel Peace Prize for 1975. In response members of the USSR Academy of Sciences issued a statement denouncing him and

the prize. As acting president of the Academy, Kotelnikov submitted a report about the event to the Politburo:

> We hereby report that seventy-two members of the Academy signed the statement of Soviet scientists protesting against the award of the Nobel Peace Prize to A. D. Sakharov.[45]

The report also listed the five Academicians who refused to sign the statement, including Vitaly Lazarevich Ginzburg who was another of the fathers of the Soviet H-bomb. In response the Politburo forbade Sakharov to go to Oslo to receive the Nobel, and on October 25, 1975, the statement signed by the scientists was published in *Izvestia*, the official newspaper of the Soviet Union. Ginzburg wrote about Kotelnikov's role in the affair:

> Our conversation was rather peaceful. V. A. [Kotelnikov] was pleading with me, instead of threatening or intimidating me. On the whole, he was carrying out the assignment without enthusiasm, but that was his usual manner. I refused to sign.

Ginzburg continued, contrasting current times (1991) to the very harsh ones under Stalin:

> I think I would have signed the letter under physical coercion . . . [but] there was obviously no danger of being beaten up or arrested, and it is still a mystery to me why so many people signed a letter of that kind.[46]

Indeed Ginzburg and the other four were never punished for their refusal. Were Kotelnikov and the other signers still suffering from Stalinist-era fears? Whatever the motivations for it, the letter only increased support for Sakharov's dissent in the West and made him a hero.[47]

To put the Sakharov affair in perspective, it's worth remembering that something similar happened in America in the 1950s. Fellow academics turned on J. Robert Oppenheimer, father of America's A-bomb, who shared Sakharov's views on the further use of nuclear weapons.

Kotelnikov, like Fourier, had to dance skillfully with his tyrants—and clearly did so. He was so successful at it that he held, at the time of the Sakharov letter, an astonishingly high position in addition to his leadership of the Academy of Sciences. For Kotelnikov was chairman of the Russian Supreme Soviet, the highest legislative body of the largest republic of the Soviet Union! For eight years. How could this be?

"I was curious at the beginning," he told an *Izvestia* reporter 30 years later. "How does the system work? Then I got it. It was as simple as can be. Those who took the floor were handpicked by the Central Committee, draft speeches were approved beforehand." He added, "It must have been the easiest job in my life. The most noticeable, though. An irony of fate."[48]

In other words, it was a position with no real power. It was a sinecure, essentially another award for his long service to his country.

Parallels and Ironies

It's clear why a typical person "on the street" today doesn't know what a pixel is. It requires a knowledge of the Sampling Theorem which requires a knowledge of Fourier's frequencies. The public is generally unacquainted with either of these beautiful and elegant ideas. Yet they are the foundational ideas of digital media—actually, of the one universal medium of bits. Digital media dominate the world of today, and the foreseeable future. This and the preceding chapter attempt to impart a lay level of understanding of this new world—an intuitive understanding of the two great ideas. They are easy to summarize:

The real world presents itself to our senses in an apparently continuous way. Fourier's idea teaches us that the real continuous world can be described as a sum of waves of various frequencies and amplitudes—that the visual world can be thought of as music for our eyes.

The Sampling Theorem teaches us how to describe those Fourier waves with discrete samples. Thus remarkably, the analog infinity of the visual world can be accurately encoded into discrete, separated, invisible samples. In the visual world those samples are called pixels. The Sampling Theorem also tells us how to reconstruct a continuous representation of the world from those discrete samples: simply spread each sample with a spreader and add up the results. At the moment of display each discrete pixel contributes a small dollop of analog infinity, in the near vicinity of the pixel, to a reconstructed visual scene. Our eyes make sense of this reconstituted continuity just as they would have made sense of the original scene.

The human drama behind these two essential ideas is as intriguing as the ideas are profound. Fourier knew too much about Napoleon, who consequently banished him from Paris to the provinces for decades. But the effect was that Fourier, shielded from the hurly-burly of the intellectual capital, created his great idea of the world as a sum of waves. And Kotelnikov, protected from incarceration in the Gulag by Valeriya Golubtsova, wife of the murderous Malenkov, continued throughout a long, immensely successful career to develop consequences of his Sampling Theorem. Fourier was forged in the French Revolution; Kotelnikov in Russia's extended revolution—from the 1917 October Revolution, through World War II, and the Cold War. Robespierre and Napoleon were Fourier's tyrants; Stalin, Malenkov, Beria, and Abakumov were Kotelnikov's, indirectly at least. But Kotelnikov's generic tyrant was really state security.

In the biography of the pixel we'll repeatedly find that the received stories aren't necessarily the right ones. And the right ones are often better than the received ones—in addition to being true. Vladimir Kotelnikov, not America's giant Claude Shannon, first brought the Sampling Theorem to the world.

The parallels between the two men are uncanny. Kotelnikov was head of the Institute of Radio Engineering and Electronics of the USSR (today Russian) Academy of Sciences for many years, and it's now named for him. America's immense Institute of Electronic and Electrical Engineers (IEEE) was originally the similarly named Institute of Radio Engineers. It gave its Medal of Honor to Shannon, and it marked the millennium and the Great Digital Convergence by giving its Alexander Graham Bell Medal to Kotelnikov in 2000. The irony is that Alexander Graham Bell was also namesake to Bell Labs—famously Shannon's home.[49]

Although Kotelnikov brought the Sampling Theorem to the world, it's a second irony that it was Shannon who taught it to America. We might invoke the phenomenon of "simultaneous invention" if it weren't for the fact that Shannon never claimed the Sampling Theorem for himself. We'll meet Shannon again in the next chapter, where state security will again be the tyrant—but Western security this time.

On Kotelnikov's ninety-fifth birthday in 2003—on the seventieth anniversary of his proof of the Sampling Theorem—in the Catherine Hall of the Kremlin, President Putin made him a Full Cavalier (alternative translations: Chevalier, Knight) of the Order for Service to the Motherland, only the fourth person to hold the order (figure 2.21).

Figure 2.21

Kotelnikov died on February 11, 2005. He outlived Shannon by only four years, but they both saw the new millennium and the new era that they helped define.[50]

The main purpose of the next chapter is to extend Digital Light from the real world to unreal worlds. Its focus is the third great foundational idea of Digital Light—computation. The pixels I've discussed so far have been derived, taken, from the real world. That includes, for example, those pixels that Kotelnikov took from Venus's polar regions, or, for that matter, any of the myriad pixels that we capture with our cellphone cameras daily. On the other hand, computation lets us create very rich, but completely fictitious worlds. It lets us generate, or make, pixels from scratch. When those pixels are spread and added per the Sampling Theorem and displayed to our eyes, we see a world that doesn't exist. How is this possible?

3 Turing's Computations: Eleventy-Eleven Skydillion

Valentine: There wasn't enough time before. There weren't enough pencils! This took her I don't know how many days and she hasn't scratched the paintwork. Now she'd only have to press a button, the same button over and over. Iteration. A few minutes. And what I've done in a couple of months, with only a pencil the calculations would take me the rest of my life to do again—thousands of pages—tens of thousands! And so boring! . . .

Hannah: Do you mean that was the only problem? Enough time? And paper? And the boredom? Val! Is that what you're saying? . . .

Valentine: Well, the other thing is, you'd have to be insane.

—Tom Stoppard, *Arcadia*[1]

A computer is an existential conundrum masked as an appliance. While appliances aren't transcendent, a computer is doubly so. First, it's the most malleable tool ever invented by humankind. It allows us to do many more things than we can possibly envision. Second, it's the most powerful amplifier that the human mind has ever had. It increases our power to do those things to unimaginable levels. Malleability and Amplification are the twin glories of computation.

The man who first brought us the full-blown idea of computation—his word for it—was Alan Mathison Turing, in a remarkable burst of genius.

St. Turing

He was born in London on June 23, 1912—a century ago—almost exactly halfway between the births of Kotelnikov and Shannon, the heroes of the preceding chapter. Turing was a fellow at King's College of Cambridge by age 22, received an Order of the British Empire by age 34, became a Fellow of Isaac Newton's Royal Society by age 38, and was dead of cyanide poisoning by age 41, on June 7, 1954. So—unlike

Kotelnikov and Shannon—he didn't get to see the new millennium and the Great Digital Convergence.[2]

Turing was a mystery to us first-generation computer science students in the 1960s. We were taught his great idea—the notion of computation—but he himself remained a cipher. Rising out of the mist that otherwise obscured his person was the persistent rumor that he had committed suicide.

Then suddenly, in 1983, Andrew Hodges published the biography *Alan Turing: The Enigma*, which finally brought Turing the man into sharp focus. It explained the mystery: Turing had helped crack Nazi Germany's Enigma code and win the war. But his work at Bletchley Park was top secret and had been impounded for decades by Britain's Official Secrets Act.[3]

Topping that revelation was another. Turing had been openly gay, even recklessly so, when homosexuality was still a crime. When he was arrested for "indecent acts" in 1952, he couldn't use the fact that he had saved England to save himself. The indecent acts trumped the Secrets Act. Given the choice of prison or chemical castration, he chose castration. His marathon runner's body (figure 3.1) grew fatter from the

Figure 3.1
Courtesy of King's College Library, Cambridge.

hormones and developed breasts. It was the humiliation, perhaps, that drove him to eat a (possibly) poisoned apple—in a death scene that could have been lifted straight out of Disney's *Snow White*.[4]

Biographer Hodges, himself a King's College theoretical physicist and a member of Britain's gay liberation movement, finally parted the veil of secrecy. He got the full story and told it carefully, intimately, and well.[5]

In 1950s America, Communists and "sexual perverts" were lumped together as enemies of the state in the "lavender scare" of Senator Joseph McCarthy's reign of terror. England suffered the same delusion, especially after 1951 and the infamous defection to Moscow of Cambridge-educated Guy Burgess, a spy and a homosexual. Turing never had any interest in Communism—he mocked it—and he was so openly and candidly gay that he couldn't have been blackmailed. But McCarthy and MI5 didn't make these distinctions, and Turing had Communist friends.[6]

The Apostles, a prestigious secret society at Cambridge, counted Burgess among its members. Many of them were Marxists or gay or both. It can't have helped Turing's cause that two of his best friends and collaborators, Robin Gandy and David Champernowne, were also Apostles. Gandy, in particular, was a member of the Communist Party during his student days.

Everybody agrees that Turing died of cyanide poisoning, but just how he was poisoned is still controversial. The poison-laced-apple suicide is the most popular theory. But the actual apple was never tested for cyanide, leaving the door open for alternative explanations. His mother believed it was an accident. But another theory is that government security forces assassinated him.[7]

It's a sad irony that the very day after the discovery of Turing's poisoned body, McCarthy's anti-Communist reign of terror was finally brought to heel. On that day, June 9, 1954, Joseph Welch, head counsel for the United States Army, famously rebuked the senator as he attempted to assassinate the character of yet another person with accusations of Communism.

The British government eventually relaxed its hypocritical anti-gay laws in 1967 and apologized publicly in 2009 for its appalling mistake. But both events came way too late to forestall the martyrdom of "St. Turing." The 2012 worldwide celebrations of the centenary of his birth were his vindication—capped off finally by the Queen's posthumous pardon on Christmas Eve, 2013.[8]

Fourier's French Terror and Kotelnikov's Great Terror were vastly and horribly deadly. McCarthy's terror, and the corresponding milieu in England, weren't in the same league, but they ruined thousands of lives nevertheless—and led directly to Turing's death. Turing's tyrant wasn't an emperor or a party chairman, but state security.

He wasn't physically imprisoned, but he was held mentally captive by the Official Secrets Act—in a metaphorical Bletchley Park sharashka.

In Turing's story we again find the ingredients for technological breakthrough: his great idea of computation; the chaos and fear of World War II, which drove the development of computers, the machines that realized his idea; and the tyranny of state secrecy that concentrated the scientists in one place and protected them in a perverse way.

Malleability

The computer is the Proteus of machines. Its essence is its universality, its power to simulate. Because it can take on a thousand forms and can serve a thousand functions, it can appeal to a thousand tastes.

—Seymour Papert, *Mindstorms*, 1980[9]

What a computer does at each step is trivial. A typical step has this form: take some bits from here, twiddle them a little, and put the resulting bits there. A twiddle might be nothing more than a swap of each 0 for a 1 and vice versa, or a move of each 0 or 1 a single position to the right.

Long sequences of these laughingly simple steps strung together are what make the computer powerful. It's not obvious that this should be so—that mindless steps should lead to mindful results. So how does a dumb sequence become meaningful? Where does the magic lie?

A random sequence does nothing interesting. But a meaningful sequence causes a computer to implement a process that's useful or entertaining. Any computer or phone app you know is such a process performed by a sequence of those simple steps. Another sequence results in a Pixar movie.

What computer hardware does is simple—those trivial steps. But to create meaningful sequences of those steps requires considerable mental prowess. That's software design. The creative humans who are endowed with such prowess are programmers. So, the magic lies in their minds.

It's like a concert grand piano. The piano can play countless sequences of tones. That's hardware executing simple steps. Most of the sequences are just noise. But occasionally some software appears that produces glorious music. The sequence of notes induced by programmer Chopin becomes an étude, a waltz, or a mazurka.

A computer, like a piano, can implement countless sequences of its simple basic steps. It can therefore implement countless complex and meaningful processes with

them—its music, so to speak—using only 2 bits rather than 88 piano keys. It's the word "countless" that captures the transcendence of Malleability, a quality so crucial to computers that it deserves its "capital M" status. Our human minds are swamped by the sheer breadth of possible processes that a computer can realize. There's always another meaningful sequence of meaningless steps to produce something we want to use. There's always another app, game, or movie to build. And one tool, the computer, does them all.

In fact, Malleability is fundamentally part of what computation means, as we'll see in this chapter. It's a gift of the concept. But the glory of Malleability comes with a mystery attached—the mystery of unknowability. Although each step that a computer takes is completely predictable, we can't always know how a sequence of those steps will unfold. *Determined in the small doesn't mean predetermined in the large.* A computation must be determined—there must be some answer about what a sequence of completely deterministic steps will do—but we can't always know that answer. The subtle difference between determined and predetermined is the mystery that lurks at the heart of computation. So a computer is simple but profound.

Amplification

The other, very different kind of transcendence is Amplification. It's obvious that a computer can repeat an act—any sequence of its mindless steps. That's simple. What matters is that it can repeat the act an impossible number of times at speeds we can't understand. Not a countless number of times. We can count the repetitions—or at least our computers can. We just can't fathom the numbers involved with our human minds. It's the scale of computer processes that swamps us. Eleventy-eleven skydillion is an invented silly number—Uncle Scrooge meets Bilbo Baggins—but it evokes how silly the numbers in computations are, even when they are actual numbers. We can't imagine them. As Stoppard's Val says in the epigraph, "you'd have to be insane" to deal with them. And insanity probably wouldn't suffice.[10]

Repeating a task that you've already programmed a computer to do is trivial. Simply instruct the computer to repeat the task as many times as you require. There's almost no additional intellectual effort required. But, countering that simplicity is the mental prowess that's required to speed up the computer to reach the unimaginable numbers. That's hardware design. The creative humans with that prowess are engineers.

In electrical engineering *to amplify* means to increase—by a lot. *Exponentially* is how "a lot" is measured—not mere doubling or trebling, for example, but squaring or cubing. The increase is not 2 times or 3 times better but exponent-of-2 or exponent-of-3

times better—not merely $2x$ or $3x$, but x^2 or x^3. If an input signal is, say, 10 volts, then an amplified output is not just 20 or 30 volts, it's 100 or 1,000 volts. Amplification is a gift of technology. The earliest computers were built precisely because they could outstrip human beings—they could amplify human capabilities.

The very first computer amplified human capability by 10,000. By 1965 that factor had jumped to 1,000,000—at least—accomplished by building ever larger machines and by converting the underlying technology from vacuum tubes to transistors. We'll call this the Epoch 1 speedup.

But transcendent Amplification—exponential amplification of amplification itself—came with even more modern technology, the integrated circuit: lots of transistors *and the wires between them* on a single chip. In 1965 the statement now known as *Moore's Law* was the green flag that started the next dramatic speedup—Epoch 2. Human capabilities were not only amplified exponentially by computers, but, dramatically, the rate of that amplification increased exponentially too.

In a nutshell Moore's Law implied that Amplification would go up to the next exponent of 10—the next factor of 10—every five years. So if Amplification of humans was by 10^6 (1 million) in year 1965—as it was—then it would be 10^7 (10 million) in 1970, and 10^8 (100 million) in 1975, and so forth. It would have amazed the creators of the early computers as much as it amazes us today. Another surprise was that the more powerful computers of Epoch 2 got smaller, not larger.

By its very nature we can't understand the implications of Moore's Law. It's an order-of-magnitude thing. We humans can't usually see beyond a factor-of-10 change. We hit a conceptual wall there. So we use the grand expression *order of magnitude* to connote the impasse rather than the bland, simply arithmetical *factor of 10*. The grand expression implies a change so great that only new thought processes—new conceptualizations—can handle it. It's not simply more—it's different. We have to master one order-of-magnitude improvement before we can even start to contemplate what the next order might mean. Yet computers have improved the Amplification of humans by at least 17 orders of magnitude! The first six orders (a millionfold) came before Moore's Law, and 11 more have come since (a hundred-billionfold). All told there's been a hundred-quadrillionfold Amplification—beyond anyone's wildest imaginings, genius or not.

A computer leverages our human intellect past our inherent order-of-magnitude limitations. It Amplifies our puny human-sized actions to extremes unreachable—and unimaginable—by our unaided species. The glory of Amplification comes with the mystery of those order-of-magnitude barriers.

Take or Make, Shoot or Compute

Kotelnikov's Sampling Theorem taught us that a camera can turn the real world into pixels. In other words, we can take pixels from the real visual world with a camera—we can shoot them. Then we can use them to reconstruct what that visual world looked like—even at a much later time or far distant place.

Or we can make pixels *de novo*—we can compute them. If we display pixels that play by the same rules as real-world pixels, then we can see unreal worlds too. The full Digital Light of the new millennium flows from that thought.

We've harnessed Malleability and Amplification to give us full-blown Digital Light— a completely digital feature film, for example, or the hottest videogame, or instantaneous visual access to the international internet experience. Computers create pixels, as well as taking them from the visual world.

This chapter is about the transcendence that is Malleability, the gift of Alan Turing's invention of computation. It's about ideas. The next chapter is about speed. It's about the invention of hardware computers to realize the idea of computation. It's about the transcendence that is Amplification, the gift of technology. And it's also about the dawn of Digital Light which—by a surprising coincidence—occurred simultaneously with that of computers. In mundane terms this chapter and the next are about the heroes of theory and practice—of science and engineering—before the arrival of Moore's Law. In a later chapter, when Moore's Law arrives and drives Amplification supernova in the Epoch 2 speedup, we revisit "the Law" and inspect it more closely.

He's Got Algorithm

> Althoughe a sypher in augrym have no might in signifycacion of itselve, yet he yeveth power in signifycacion to other.
> —Thomas Usk, *The Testament of Love*, ca. 1385[11]

Turing's great breakthrough starts with the idea of a systematic process. Here's an example of what it means to do something carefully or systematically. Suppose a guest in your home, a stranger to your town, wants to know how to get to a grocery store. Your walking directions might be something like this: Go out the front door and turn right at the street. Walk to the first intersection and then go two blocks beyond. Turn left at the street there and walk along it three blocks. Proceed through that intersection, and the store is on the right side, the fourth building in from the intersection.

Intuitively, then, being careful or systematic means that the larger process of getting to the store is broken down into a sequence of smaller steps, where each step or instruction is simple, unambiguous, and obvious to most people. A guest who accurately performs each, in the order given, will surely arrive at the store.

The walking directions above are a simple list of instructions. The guest begins at one end of the list and finishes at the other. The number of instructions to be followed equals the number of steps in the list. Generally, however, there's more structure to a systematic process than that. Consider this one for hammering nails into a board: (1) Fetch a nail. (2) If there isn't one, then you're done, otherwise proceed. (3) Hammer in the nail. (4) If the nail bends, then straighten it out and repeat step 3, otherwise start again at step 1.

This list has the same number of instructions as the walking directions, but it's different in a powerful way. It has loops. You repeat the outer loop (steps 1 through 4) so long as there are nails, and the inner "nested" loop (steps 3 and 4) so long as a nail gets bent when it's inexpertly hammered. You enter at one end of this list and you might never come out—if you bend a nail every time you hammer one, say. The number of steps executed is usually much larger—sometimes vastly larger—than the number of instructions.

There are two branching steps in the nailing directions that take the form "if . . . then . . . otherwise . . ." (steps 2 and 4). These are called *conditional branches*. If some condition is satisfied, then branch off to step so-and-so otherwise branch off to step such-and-such. A conditional branch—signified by an *if*—lets you change the order in which you perform the instructions in a list.

It also lets you escape an *infinite loop*. Consider this one, for example: (1) Say "Hello." (2) Go to step 1. There's no conditional branch with which to escape the loop. So once this systematic process starts, it never halts.

Conditional branches—the *if*s of systematic process—are key to computation. A machine that can execute conditional branches is much more powerful than one that cannot. It can succinctly cause a process of unimaginable length to unfold carefully. It can implement processes that loop on themselves—perhaps eleventy-eleven skydillion times—or even modify themselves as part of the process. Any machine that purports to be a computer must have a conditional branch instruction. A machine can be ten stories tall, fully electronic, and extremely fast, but if it doesn't have a conditional branch instruction, then it's not a computer.

And if it only calculates numbers then it's not a computer. The notion of systematic process is much larger than numbers. Even our first examples of systematic process, the walking and hammering instructions, weren't about numbers. Not surprisingly, Turing understood this notion early and completely.

Not that numbers aren't important. They're one of the things we've been systematic about for millennia. Even in this era of the omnipresent calculator, kids still learn how to add two decimal numbers together. Famously, the way to do it is to add each pair of digits successively, starting at the right, and write one digit of their sum to the answer. If (there it is!) the sum of those digits is 10 or larger, you "carry the 1" to the next step, one position to the left, and add it in there. And so forth. There's another *if* implicit in this process: if you run out of digits or carried 1s to add, then halt. This is a sketch of the process that's often called the addition *algorithm*. We're all happy, I'm sure, that our calculators now "remember" the details of this algorithm for us and know them well enough that they can add two dozen numbers, if we insist, rather than just two.

In the last century the word *algorithm* became synonymous with what we've been calling "systematic process." The word is a corruption of the name of a ninth-century Persian arithmetic expert, al-Khwarizmi. He wrote in ancient Baghdad about systematic processes involving the decimal number system—a new concept just in from India featuring a strange new thing called 0. Later, in the late Middle Ages, that Indian number system itself came to be called *algorism* or *augrym*, two more corruptions honoring his name. So the notion of an algorithm is rooted in numbers and number manipulation— but by no means bound by it.

Geoffrey Chaucer in the fourteenth century used *nombres in Augrym* to describe markings on an astrolabe. But his friend Thomas Usk used the term in a more impressive way. His epigraph is about the power of the 0—the *sypher in augrym*. It essentially says that while a 0 alone is nothing, a 0 appended is a lot. In our terms, each appended 0 is an order-of-magnitude increase—a lot of something indeed. His *augrym* was nowhere near our *algorithm*, but his aphorism appears in hindsight to be a precocious observation about the potential of Amplification.[12]

What happens when the number of steps in an algorithm gets large, the number of loops multiplies, their level of nesting deepens, and the conditional branches ramify vastly? By asking questions about systematic processes at the turn of the twentieth century, mathematicians started to feel their way toward the world of computation, but they didn't know it yet. They hadn't yet glimpsed the twin glories of Malleability and Amplification, or the mysteries associated with each.

The eProblem

David Hilbert, a prince among mathematicians, was at the University of Göttingen, a center of the mathematical universe—until the Nazi purge of Jewish mathematicians destroyed it. Beginning in 1900, Hilbert used his international prestige to focus

attention on specific hard problems, some of which concerned the very foundations of mathematics itself. These famous problems took names such as Hilbert's Second and Hilbert's Tenth. Solving any one of them would immediately establish that you were a world-class mathematician.

In 1928 Hilbert posed another hard problem. This one was about a simple logic system—called *first-order logic*. Mathematicians use first-order logic to formulate precisely worded statements, which may be true or false. Hilbert asked if there was a systematic way, an algorithm, to decide if a statement in this simple logic system is true or not.

Here is such a statement: *all objects are pinecones*. Here's another: *all objects are quinces*. A compound statement that is always allowed in the system is made by combining any two other statements with the word *or*: *all objects are pinecones, or all objects are quinces*. The system has a rule that lets you replace this combined statement with a rearranged one that's equivalent to it: *all objects are pinecones or quinces*. Here the word *equivalent* means that if the former statement is true, then so is the latter, and if the former is false, then so is the latter. The rearrangement of words, then, doesn't change the truth value of the statement. The simple rearrangement collapses the two initial statements that were joined by *or* into one statement with the *or* between *pinecones* and *quinces* instead. This seems obvious, but the point is that each step in this logic system transforms one statement into an equivalent one using a simple, even trivial, operation. The new statement *derives from* the old one.

Derivations are sequences of such steps, with operations as simple as the *or* rule applied at every step. What we've described so far is a systematic way to derive one statement after another in such a way that truth, or falsity, is maintained at each step. If you start with true statements, a derivation will always yield a true statement.

It's the true statements that interest mathematicians. They start with very simple— obviously true—statements and derive more true statements from them using the logic system. The true statements they start with are called *axioms*. For example, it's an axiom that a number is equal to itself. That's obviously always true. The awesome glory of math is that such derivations can lead to totally unexpected results, even though every step is simple and obvious.

But Hilbert asked for a decision algorithm, not a derivation. He did *not* ask that the systematic process actually generate a derivation of the statement from the axioms— only that it accurately decide whether a derivation was possible or not. The distinction might seem unimportant. If you can decide that a statement is true, why is it important to show how it was actually derived from the axioms? It turns out to be fundamentally important.[13]

In the scholarly genealogy of families, it's possible to know that Joseph from the seventeenth century, say, was the direct ancestor of James alive today without formally establishing a father-to-son path, a generation-by-generation descent, between them. If they share the same DNA on the Y (male) chromosome—a straightforward lab test establishes this—then they *must* be related by a male line. A path between them *must* exist. But knowing that a path exists is nothing at all like knowing the actual series of males who passed the particular DNA down the male line—something that's often quite difficult to establish. And knowing that such a path exists might encourage you to expend the research effort to find the actual path—to know you weren't wasting your time in a futile search.

So Hilbert's big question of 1928 asked if simple logic had a trick—like the DNA test—that would decide in a systematic way if a statement was true without actually doing the derivation from the obviously true axioms. This is called Hilbert's Entscheidungsproblem.

It's a forbidding name, but it's simply German for *decision problem*. Is there a systematic way to decide the truth value of statements expressed in simple logic? Putting it in German, however, surely heightens its profundity for English readers. *Decision problem* sounds like a business school topic, but Entscheidungsproblem suggests a Götterdämmerung to shake and renew the world, which is actually what it did. Let's call it the *eProblem* since it led to email—and saying Entscheidungsproblem soon becomes tiring.

In England in 1934, Max Newman presented the eProblem in a lecture at Cambridge University. He talked about a systematic process, but "mechanical process" was the term he actually used. Newman's choice of words was key. He could just as well have said "systematic process," "effective process," "recipe," or "algorithm," among others. There were no precise words for the concept yet. That was exactly the problem.[14]

Student Alan Turing attended that lecture. The exceedingly literal-minded Turing proceeded to formalize Newman's "mechanical process" with a simple paper "machine." Newman was surely surprised that his own student—so young (only 22) and awkward! and stammering!—solved the profound eProblem with a simple machine not long after that fateful lecture. In fact, Newman didn't believe it at first. The machine seemed like a toy—not serious math. Surely such a profound mathematical result couldn't have come from such a simple device. But he quickly became convinced of Turing's result.[15]

Turing used his machine—now called a *Turing machine*, of course—to solve the eProblem. First, he invented computation—it's exactly what Turing machines do. Then he used computation—a precise description of what we mean by systematic, or mechanical, process—to solve the problem. The sequences of simple steps in logical derivations

might remind you of the sequences of trivial steps that computers take. Both cases yield something mindful from mindless individual steps. Turing was the first person to formally connect the two, and it made him a god in mathematics.

He showed that there is no trick DNA test for simple logic. You have to do the full derivation, if you can find one. There can't be an algorithm of the type that Hilbert had asked for. As mathematicians say, Turing found that simple logic is *undecidable*. It was such an unexpected and disturbing result that even the great Hilbert didn't believe it at first. If Turing had done nothing else—like save Britain or invent computation—this would have put him in the scientific pantheon. He had solved one of the hard problems. But it was his machine—not his solution of the eProblem—that made him famous in the larger world outside math. The modern computer is a direct conceptual descendant of Turing's machine.

While Turing was solving the eProblem, so was Alonzo Church at Princeton University in New Jersey. Church, an American mathematician, had done graduate work at the University of Göttingen about the time that Hilbert announced the eProblem. In fact, Church beat Turing to the solution by several months. By the rules of academia Church had won and the glory would have normally been all his. But Turing's solution technique was strikingly different from Church's. In math the method of proof is often as important as the fact of the proof itself. Newman thought that the mathematical world should know about Turing's new method.

Newman urged Church to acknowledge Turing's contribution, and Church did. They both went public with printed papers in 1936. This was a big step because it was Turing's intuitive, industrial, even folksy, machine that inspired the birth of the computer, not Church's abstruse formalization (*lambda definability*). They were equivalent concepts—Turing proved it in his paper—but Turing's choice of words had profoundly different consequences. The hard problem that they both solved isn't important to Digital Light, but Turing's solution technique—his machine—is.[16]

The two approaches presaged a skirmish that still defines computer science—the battle of the ivory tower versus the stinks. "Going out in stinks" was slang at Cambridge for taking a degree in the natural sciences—chemistry bearing the brunt of the insult. Turing conceived his great idea of computation in the scentless, clean ivory tower of Cambridge mathematics, but it was his gritty, real, industrial model that inspired the computer, not Church's pure mathematical concept. Computer science is still split along that line. It's lumped with mathematics at some universities and engineering at others. Malleability is a tower phenomenon, and Amplification is a stinks glory. The players in the mad rush to the first computers would have to straddle the tower–stinks divide.[17]

Turing wasn't the only person to formalize the notion of systematic process. Church did that too, as we've seen, and there were several others. But Turing's method has been so influential that the other approaches pale in comparison. In our ordinary world we still use the concepts that he introduced at Cambridge in his seminal 1936 paper. His word *computable* is the one that stuck. He also gave us the idea of programming, although he didn't call it that. That makes him the first programmer. Also, alas, he was the first to write buggy software.[18]

And he was the first example of another computer tradition. His quirky personality—intense literal-mindedness, honesty to a fault, social awkwardness, and sartorial disregard—qualified him as the first geek. Perhaps we would now say he was "on the spectrum."[19]

Newman was afraid that Turing was fast becoming a "confirmed solitary" and told Church so. Newman thought that mixing with the logical elite at Princeton University—people who could speak the same language—might reverse this tendency. So he asked Church to accept Turing as a graduate student, and Church obliged again. Turing would earn his PhD under Church in America.

Turing sailed to the States on the steamship *Berengaria*, disembarking in Manhattan in September 1936. It's just a coincidence, but Kotelnikov had recently landed there, also on the *Berengaria*, in May. The Russian stayed only 60 days, probably involved in secret code work at the Amtorg Trading Company in downtown Manhattan. He'd already departed for home by the time Turing arrived. Two ships passing in the dark, so to speak—on the same ship.

A real nexus formed shortly after this coincidence. Turing proceeded from Manhattan to nearby Princeton for his studies there. Then his mentor, Newman, came for a six-month visit to Princeton, to the neighboring Institute for Advanced Study—sometimes called the *Princetitute* to distinguish it from the University (and to save the speaker from the IAS mouthful). John von Neumann—another major player in this story—was already at the Princetitute as one of its first permanent scholars.[20]

Not a Toy

To get a handle on Turing's great idea, consider the business card in figure 3.2. It has one corner cut off and a round hole in the center. Both the front (with copyright) and the back are inscribed. You can admire the deceptive simplicity of this card, but don't be fooled—it's amazingly powerful.

Imagine that there's a paper tape running from left to right behind the card. It's divided into squares, and you can see one square through the hole in the card. The tape

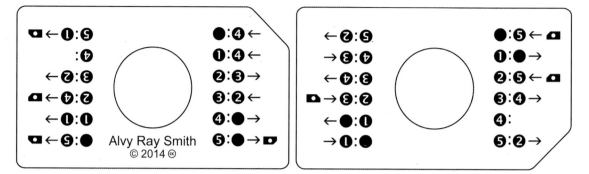

Figure 3.2

is mostly blank, but there are typically one or more squares with symbols on them. I chose the non-blank symbols in this case to be the numerals 1, 2, 3, 4, and 5, but they could just as well be #, !, $, %, and &. The point is that they're distinct marks, without meaning. In particular, they're not numbers. We call them symbols, but they symbolize nothing. Simply replace a 1 with #, a 2 with a !, and so on, everywhere in the description of this business card device, and *nothing changes*—except the shapes of the marks on the squares.

Figure 3.3, step 1 (top row), shows a tape with just four marks on it: 5155. The rest of the tape is blank. The card is shown slightly transparent so that you can see the tape through it. The list of strange markings down the right side of the card—with the circled numbers, colons, arrows, and so on—contains six of the *rules* that govern this device. There is one rule for each possible symbol on the tape. The upside-down list at the left of the card holds six more rules.

The business card device works like this. Find the rule for the symbol in the hole. (Pay no attention to rules written upside down.) For step 1, it's the rule at top right, the one for the blank. There's a colon after the blank, followed by a 5. It says to replace the blank with a 5—write a 5 in the blank. Following the 5 is a left arrow. It says to move the card left by one square. The little glyph at the right of the rule represents the business card itself. It says that you should rotate the card to match the glyph's orientation. In this case, it means to rotate the card one half turn clockwise, putting the cropped corner in the northwest position, resulting in the step 2 configuration.

The rule that applies in step 2 is at the lower right, for the symbol 5 in the hole. It says to change the 5 to a 2—erase the 5 then write a 2—then move right one square. There's no little card glyph this time, so the card remains in the same orientation. The step 3 configuration is the result.

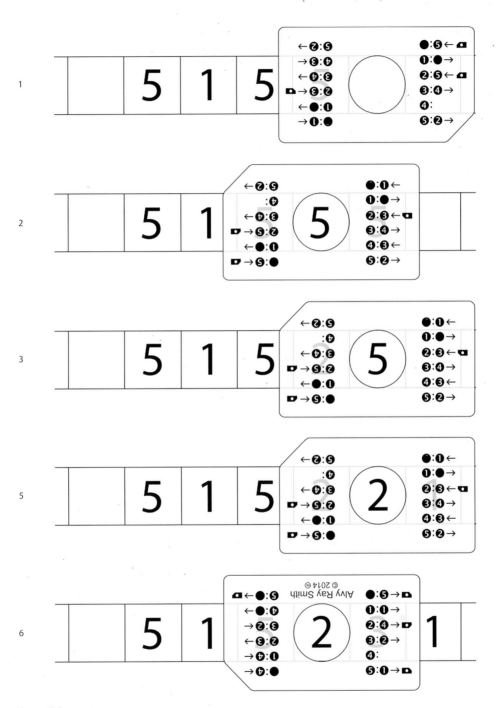

Figure 3.3

Skipping ahead two steps gives the step 5 configuration (step 4 not shown). The card maintains the same orientation (northwest) during these steps. The rule to apply in this case is the third one from the upper right: change the 2 to a 3, move left one square, and rotate the card to the orientation shown. Here it means to turn the card over, putting the cropped corner in the southwest. This reveals the other side of the card (shown in step 6) and two more lists of rules different from the two lists we've seen so far.

And so on and on. If you pursue this tedium further, you'll find that the card will eventually end up in its original orientation, with a 4 in the hole. The rule that applies has nothing right of the colon, which means nothing else happens. The computation halts.

This hasn't been an idle game. The goal, believe it or not, is Digital Light. *The business card device is a Turing machine.* This is one of Turing's toys. It's a hardware implementation of Turing's most famous invention.

In the 1930s a "computer" was a human—usually a woman—who executed the bookkeeping processes of, say, an insurance company or later the codebreaking processes of Bletchley Park. In conversation with his mother Sara, Turing referred to the hundred or so "computers" working for him there as "slaves"—which indicates the punishing nature of systematic (or "mechanical") processes.[21]

Turing captured what "computers" did with pencil and paper when they carefully executed a systematic process—such as adding a list of, say, several dozen numbers—perhaps interrupting the effort with a tea break. A Turing machine was the model he devised that captured the essential simplicity of what they did.

But it didn't capture their tedium. The tedium comes—as you've discovered if you followed the instructions above—from the unceasing repetition of the tiny steps, the constant worry of error, and the effort of keeping track—during a tea break, say. Nor did it capture their boredom. Recall Stoppard's Hannah: "And the boredom? *Val!* Is that what you're saying?" A machine wouldn't suffer tedium or get bored. Those are human problems. Turing created an abstract model of what a "computer" does that matters. He abstracted her tedium out of existence as immaterial. He maintained notions such as different states of mind, multiple steps, writing and erasing symbols, and an endless supply of scratch paper.

There are four possible orientations—or states—the business card may take, and there are six symbols (counting the blank). So, there are six rules for each orientation of the card, one for each symbol that might appear in the hole. The general rule is that at each step the symbol in the hole may change, the hole moves left or right one square, and the card orientation may change. Or it may simply stop. That's all there is to it.[22]

Turing defined each of his machines to have only four things: a one-dimensional tape divided into squares, a finite set of symbols for it, a tape scanner with a finite

number of states, and an "instruction table" that tells you what to do with each combination of scanner state and tape symbol. In our running example, the tape scanner is the business card with a hole in it, the six symbols are the digits 1 through 5 and a blank, and the four states are the four orientations of the card. The four sets of rules form the instruction table. And one other thing. The tape is as long as necessary in either direction. There's always another square if you need it. There's always more scratch paper. Perhaps you can understand now why Newman couldn't believe at first that such a simple device—a toy it seems—led to a profound mathematical result. But from this simple "machine" concept came all of computing.

You might glimpse the modern computer in the business card device. The tape scanner—the card—is the CPU (central processing unit), and the tape is the memory. But a modern computer can execute *any* computation, by simply changing its program, whatever that means. Surely our simple business card device can't execute *any* computation, can it? Here's the surprise. Yes, it can. Pixar could compute *Toy Story* with it! They wouldn't want to, however, because it's so tediously slow that it might take the lifetime of the universe, but speed is a separable issue, addressed in the next chapter. The point is that our device isn't just any ordinary Turing machine. *The business card machine is a* universal *Turing machine.*[23]

Turing's great idea wasn't only that a Turing machine could execute a systematic process—that what we mean by a "systematic process" or "mechanical process" is embodied exactly in a Turing machine. But that was a pretty good idea all by itself. The addition algorithm—how to add two numbers together to get their sum—is such a process. So, there has to be a Turing machine that adds two numbers on its tape together and generates their sum on its tape. And does nothing else.

Another systematic process is one that reverses any string of letters. For example, given *abcdefg*, it swaps the outermost pair of letters, then the next most outermost pair, and so on. It proceeds until there are no more pairs to swap, or until only a single letter remains, yielding *gfedcba* in this case. Therefore, a Turing machine exists that will do this reversal for any string on its tape, and nothing else.

Turing's master stroke, however, was to show how a *single* Turing machine can do what any other Turing machine can do. It can perform *all* systematic processes—including addition of two numbers or reversal of a string of letters. It's one machine that can compute anything that's computable. That's what *universal* means in computation. When we say Turing's great idea was *computation*, we mean it was universal computation. The modern computer is a descendant of this particular kind of Turing machine, the universal Turing machine. But how can a Turing machine be universal?

Don't explain computers to laymen. Simpler to explain sex to a virgin.

—Robert A. Heinlein, *The Moon Is a Harsh Mistress*[24]

Heinlein be damned! Turing's trick for making one of his machines universal is clever. A Turing machine is a simple thing that's defined by its set of rules. The business card machine, for example, is defined by its 24 rules, 6 for each orientation of the card. So Turing reasoned that it must be possible to design a Turing machine that could take a description of *any* Turing machine, plus the input to that machine, and simulate what that machine would do given that tape. The reason he believed it to be possible is that such a simulation is a systematic process, and a Turing machine is meant to capture just what we mean by systematic process. A Turing machine that simulates any other is a universal Turing machine, and Turing showed how you could construct such a machine.

The A in figure 3.4 represents *any* Turing machine, depicted as a scanning head that moves left and right along an infinite tape. The business card machine is an example. Its "scanning head" is the hole in the card. The business card will be our running example of an arbitrary Turing machine A. U is a *universal* Turing machine that can simulate any Turing machine A, given a one-dimensional description of A's rules—its instruction set—and a description of A's tape data.

In our example, A's rules are just the 24 rules that specify the business card machine. They are *encoded* into a form required by U. A's rules as presented on the business card are in the form of two two-dimensional tables of instructions written on two sides of the card, with half of them upside down. U needs a one-dimensional version of these rules on its tape, written in the set of symbols that U uses there. We will show an example encoding of A's rules shortly.

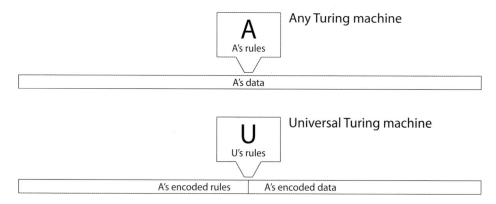

Figure 3.4

By A's data we mean the nonblank symbols that appear initially on its tape—for instance, 5155 was the initial data for the business card machine in the earlier example. It is also encoded into a form required by U. We will show an example of A's data encoding too. In words, the initial data on the tape of the universal Turing machine, U, consists of both A's rules *and* A's data, in one-dimensional form, as shown.

Turing noticed that the set of rules of any Turing machine can be written into one line of symbols. For the business card example, you can list all 24 of its rules in a single line if you use one-symbol abbreviations f, b, F, and B for the four orientations of the card—front, back, rotated front, and rotated back—and divide the rules into those four groups, with six rules per group:

(six f rules) (six b rules) (six F rules) (six B rules)

See the annotation for how this encoding might actually look.

Turing's first trick was to write that one-line machine description onto U's tape, one symbol per tape square. Think of it as written in the left half of the tape.

Turing's second trick was to write a one-line description of A's tape, containing its initial data, to the right of A's description. The encoding here is straightforward. So our business card machine's description and initial data might look like this, using a vertical bar to separate the two and a 0 to encode a blank:

(six f rules) (six b rules) (six F rules) (six B rules) | 000000051550000000

At this point the universal Turing machine U "knows" what the arbitrary Turing machine A is because it has a complete description of that machine's behavior, as expressed by its rules. And the universal machine knows what tape that arbitrary machine is initially looking at. U knows its input data.

The universal machine needs to know only two more things to simulate arbitrary machine A: which symbol it's currently scanning and what state it's currently in. Turing's third trick was to add a symbol on the left part of the tape indicating the current state and another symbol on the right half indicating the currently scanned square. These four pieces of information about arbitrary machine A—its description, initial data, initial state, and initially scanned symbol—form the initial data for the universal machine. Here's a representation of U's input tape for the business card machine in back orientation, on initial data 5155, and initially scanning the blank (0) just to the right:

(six f rules) (six **b** rules) (six F rules) (six B rules) | 00000005155**0**000000

The bold **0** marks the initially scanned symbol, and the bold **b** marks the initial orientation of the card, hence which rules to use. See the annotation for how U's tape might actually look.

The design of a set of rules for U so that it can simulate an arbitrary machine A encoded like this onto U's tape is a tedious process. The point is that U can "see" a complete description of the arbitrary machine and a complete description of the data for that arbitrary machine. It can see the current state of the arbitrary machine and the currently scanned square of that machine's data tape. That's a complete description—at one moment—of the machine to be simulated. The next moment can be similarly simulated, so Turing designed a U in his famous 1936 paper that could systematically convert the representation for one moment into the representation for the next moment. So at some later time in the simulation of the business card machine, U's tape looks like this:

(six f rules) (six b rules) (six F rules) (six **B** rules) | 000000051555000000

Then it would simulate the next step, and then the next step, and so on. The actual construction is painful, but the gist of it isn't hard. If you're willing to lose your Heinleinian virginity, read the annotation for further details of the simulation.

Turing showed how machine U can simulate each step of operation of an arbitrary machine A. It takes lots of U's steps to simulate only one of A's steps, but that's immaterial to the argument—speed doesn't matter for the concept of computation. U is a universal computer because it can compute anything that any other machine can compute. Just change the description part of U's tape to change what gets computed.

Turing had invented programming. In modern terminology, Turing stored the *program* of an arbitrary machine in the memory of the universal machine, and he stored the *data* for it there too—in the left and right halves of the universal machine's tape. To change which machine the universal machine simulates—that is, which computation it performs—you need only change the program, the description part in the left half of the tape.

The universal Turing machine is, in essence, what we now call a *stored-program* computer, since it stores the program and the data in the same way—both in the memory of the machine. And a stored-program computer is what we mean by the single word *computer* today. We call any particular machine A, as represented by its encoded rules, a *computer program*, or just *program*. This also explains why programmers often call themselves *coders*. They encode an arbitrary algorithm—implemented by a particular Turing machine—into the one-dimensional form the computer U needs. Figure 3.5 shows how a universal Turing machine U corresponds metaphorically to a modern computer.

A modern computer nearly always has its program divided into at least two parts. One part is called the *operating system*, or *OS*, such as Windows, MacOS, or AndroidOS. This program part is always running. It's a case where an infinite loop is desirable. The program part that gets changed to meet your individual needs is called an *application*

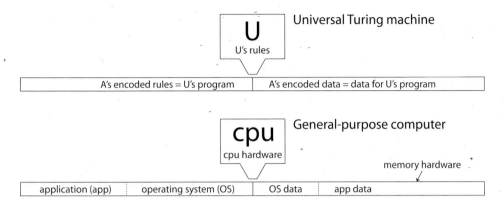

Figure 3.5

(or *app*, popularly). Similarly, the data memory holds data of importance to the operating system separate from the data for the app. The operating system just "takes care of business," like getting an app loaded into memory in the right place and started, taking care of mouse or finger input, and watching for power failure. It's an app that represents an arbitrary Turing machine A in a modern computer. And there's such an A for every algorithm, or systematic process. That's the observation that underlies the world of computation.

It's worth stating again what Turing accomplished. He showed that there's a single machine that can do anything that's systematic. It can't hammer nails or strike piano keys, but it can do anything systematic that can be represented with symbols (and then the symbolic output can be used to drive a machine that hammers nails or strikes keys). To change what the machine does, all you have to do is change its program, or app. He invented the concept of computer—by which we mean stored-program computer. We realize it in hardware only to make it go fast.

How many programs can a computer compute? How many apps can it run? Well, there are so many that you can't ever finish counting them. It's like asking how many pieces of music a piano can play. The computer is the most malleable tool ever invented by humankind. That's the wonder of Malleability. Digital Light is just one of the worlds embraced in its infinite folds.

Johnny von Neumann

The Princetitute—slang for the Institute for Advanced Studies in Princeton—was a magnet for geniuses, particularly those fleeing Nazi Europe. It had already collected a

small but impressive cluster of stars when Turing and Newman arrived in town in the late 1930s, Turing for his graduate studies and Newman for a sabbatical. Most famously, Albert Einstein was already there. But more importantly for our story, so was John von Neumann.

He was born Neumann János Lajos on December 28, 1903, in Budapest. His father was Max Neumann, a banker. In 1913 the Austro-Hungarian government ennobled Max—presumably for his financial assistance—which allowed him to use the *von* surname form. So Max's son was always known as John von Neumann in America. He moved there permanently in 1933 and became one of the earliest members of the Princetitute.

John had been a member of the wealthy elite of Budapest and continued to enjoy an aristocratic lifestyle in his new country. He always drove Cadillacs, for example, but they were often wrecked and replaced, a clue to his personality. And he answered to "Johnny," another clue. This famous photograph of Johnny (figure 3.6, top left) shows him in a business suit and tie—his usual dress—astride a mule that faces away from all the others (ass backward, you might say) in a train headed into the Grand Canyon. He was a bon vivant and gracious host. He loved martinis, ridiculous party hats, and a good salacious limerick.[25]

Von Neumann became famous for his contributions to fields as diverse as quantum physics and game theory, not to mention his membership in the secretive Manhattan Project for the development of nuclear weapons, and subsequent membership in the Atomic Energy Commission. But he also became famous for his contributions to computers, most notably a widely emulated general organization of computer subsystems called the *von Neumann architecture*.

He was a genius's genius, the "cleverest man" with the "fastest mind." He was certainly the resident genius of the Americans in the race to the computer, their counterpart to the British genius, Alan Turing. To put the two in perspective, it's convenient to summarize that the intellectual heritage of Digital Light derives from the stored-program conception of computation, principally due to Turing, and from the architecture implementing that conception, principally due to von Neumann.[26]

Von Neumann was fleetingly involved with one of David Hilbert's famous challenges to the foundations of mathematics. He made a stab at Hilbert's Second Problem several years before Turing tackled Hilbert's Entscheidungsproblem, the eProblem.

Hilbert's Second asked if the axioms of arithmetic—the fundamental, even obvious, truths of arithmetic—are consistent. It was important, Hilbert thought, to show that simple arithmetic—at the very least—is supported by a logic system that could *not* lead to contradictions. That seems reasonable, but in 1931 Kurt Gödel in Vienna proved that

Figure 3.6
Courtesy of Marina von Neumann Whitman.

a system robust enough to support arithmetic *and* be free of contradictions couldn't be complete. This astonishing result, known as Gödel's Incompleteness Theorem, means that there have to be truths about arithmetic in such a logic system that can't be proved true in that system. Here's another way to say it: the price of consistency demands that you be content with not being able to prove everything systematically. Gödel's result said there couldn't be a universal math machine for deriving every mathematical truth—in contrast to Turing's later result (1936) that there *is* a universal computer for everything computable.

Gödel's result is tangentially germane to the story of Digital Light because it establishes von Neumann's credentials. Von Neumann actually heard Gödel present his revolutionary result in 1930, before Gödel published it. As a measure of von Neumann's ability, he almost immediately understood it and proposed a stronger result directly to Gödel himself. He was highly disappointed, we may assume, to learn that Gödel had already proved the stronger result. Another glimpse of von Neumann's personality is that he ceased contributing to formal logic from that moment on. If he couldn't be the top dog in a field, it seems—if he couldn't out-Gödel Gödel—then he moved on to dominate another.

Von Neumann didn't approach computation the way that Turing did, although he was fully prepared to understand Turing's theory when it appeared. Instead he came at it from the engineering angle, by thinking about the realization of actual machines. In his role developing the thermonuclear or H-bomb, he made himself familiar with all the attempts at building calculating machines—immediate predecessors to computing machines—in the United States in the postwar 1940s. He was looking for the best machine to make thermonuclear calculations rapidly. In particular, he found his way to a room-sized machine in Philadelphia, called Eniac, built in 1946. It resembled what we would come to call a computer. Indeed, he used Eniac for H-bomb calculations. The flaws in this "almost-computer" inspired von Neumann and his colleagues to conceive the architecture of a computer—one with a stored program—that would heavily influence the computers of Digital Light. They came at it from necessity in the stinks while Turing did so from theory in the ivory tower.

Like Turing, von Neumann led a brilliant but brief life. Cancer took him at age 53 in 1957, just three years after Turing, so he also missed the Great Digital Convergence of the new millennium. Unlike Turing, however, he was openly celebrated by his government in his lifetime. President Eisenhower presented him with the Presidential Medal of Freedom in 1956. He had worked on both the atomic and hydrogen bombs and the ICBM strategy of the United States—and was such a hawk that nobody ever doubted his loyalty. He was "violently anti-communist" by his own Senate committee testimony.

But ironically his collaborator Klaus Fuchs passed the secret information that the two developed—a method for igniting thermonuclear explosions—to the Soviets.[27]

There was a moment in 1937 when von Neumann, Max Newman, and Turing were all in Princeton—the future leaders of the British and American computer efforts. Hardly missing a beat, von Neumann attempted to recruit Turing to the Princetitute in 1938. Astonishingly, Turing rejected this plum offer. Think of it. It could have been von Neumann *and* Turing out of the starting gates at the Princetitute. And the first computer might have been American.[28]

Turing's and von Neumann's personalities were so diametrically opposed, however, that a team starring the two of them, the geek and the bon vivant, might not have worked. Von Neumann must have sensed he'd be alpha dog to Turing. Probably Turing did too. There's no telling however because Turing, true to character, struck out on his own. He returned to England, where he was almost immediately recruited into Bletchley Park. It was 1939, and England was frightened for its life.

Bletchley Park

Bletchley Park was where Turing famously helped crack the encryption scheme that the Germans used for war communications. They employed a devilishly complex encryption machine called Enigma—its actual trade name—which resembled an old-fashioned black typewriter encased in wood. A clerk would type a text message into Enigma—say from an admiral at German naval headquarters to a U-boat at sea—and the machine would scramble the letters one way, then scramble the scrambled letters a second way, and so forth. The scramblings were several layers deep, and each could be changed. The U-boat would configure its receiving Enigma just like the sending one. The received message would then be descrambled layer by layer, in reverse order, until the original message was revealed and typed out for the U-boat skipper. They used a one-time pad system to reconfigure the machine's scramblings each day. Recall that both Kotelnikov and Shannon had proved such a system was unbreakable—at least if used correctly. But the Germans assumed the system was unbreakable because so many configurations were possible. Indeed, they never figured out that Turing and his colleagues at Bletchley Park had broken it. Bletchley exploited the fact that operators didn't always use the system properly, but mostly they used massive calculations. That's where computation comes in. (Enigma was cracked in Bletchley's Hut 8, shown at photos B and C in figure 3.7. Photo A is the odd manor house.)

The trial and error approach to descrambling Enigma code was very tedious work, done at first by hand—by the hands and minds of hundreds of computers of the

Figure 3.7

human female variety, Turing's "slaves." To help ease the tedium and to increase the speed of decoding, the Bletchley Park people built large machines, called Bombes. They weren't computers yet, as we mean that word now, but they were certainly on the way to them. They weren't programmable, even with hardware toggles and cables, in any general meaning of that term. In a sense a Bombe was a Turing machine, but not a universal Turing machine. It performed a systematic task of many steps—trying out the myriad possible scramblings an Enigma might have used—but that was the only computation it could do. The speed of the hardware Bombes greatly exceeded that of the flesh-and-blood computers. Speed was of the essence, to get messages to American and British merchant ships in the path of a U-boat, say. So the push was on—to make computation *fast*.

Max Newman

Turing needed a partner, not a leader. He was too much the loner. That's where Max Newman—already his mentor and promoter—would figure again. Like Turing, Newman returned to England after his stay in Princeton. Unlike Turing, he had a family—his wife, Lyn, and their young sons, Edward and William—and needed to protect them. Since he was Jewish (as was von Neumann, by the way), he feared for the safety of his family if the Nazis took England. By 1940 he had stashed Lyn and the boys in faraway but familiar Princeton, where they would remain for several years. Meanwhile, he joined Bletchley Park.

Turing had led the first-wave attack against the Enigma encryption machine with the Bombes. Then it was Newman's turn. He led the second-wave attack, against a newer German encryption machine—nicknamed Tunny (British for tuna). This attack employed a giant electronic machine, Colossus, first built in 1943. Actually, ten of these beasts were used. All of these almost-computers—they weren't stored-program computers—were functional before the almost-computer Eniac in America.[29]

And Turing indirectly had a lot to do with Tunny and its Colossi. He came up with a mathematical insight known in Bletchley-speak as *Turingismus* which was key to cracking Tunny. It's surprising that he didn't have a more direct part, considering both his relationship with Newman and his own Bletchley Park machine experience with the Bombes. But he and Newman didn't team up then—and wouldn't for a while longer—because decoding texts no longer excited Turing. His new interest was encoding voices. The British government ignited that interest by sending him back to America on a special mission.[30]

The Vocoder Connection

Turing and Kotelnikov had slipped past each other in Manhattan in 1936 and never met, but a surprising connection nevertheless existed between them. It was the *vocoder*—a contraction of "voice coder"—not computing, sampling, or codebreaking as you might imagine. The vocoder entangled Turing not only with Kotelnikov but also with Shannon and even Solzhenitsyn. They all worked on vocoders. In retrospect the vocoder seems like a trivial distraction compared to the computer. But at the time it appeared to be an equally central piece of technology. In retrospect too, we can see that it held the seeds for future digital advances in light and sound.

Recall from chapter 2 that Kotelnikov, and subsequently Shannon, proved one-time pads to be unbreakable. A vocoder augmented with one-time-pad codes made the

spoken word as secure as the written word. An encrypted vocoder—a voice scrambler—was like an Enigma machine for the voice.

Stalin became increasingly paranoid and demanded a voice scrambler to keep his communications safe from potential spies. That demand would drive Kotelnikov and Solzhenitsyn together in the Marfino sharashka in northern Moscow.

Churchill and Roosevelt (and later, Truman), though less irrationally, also needed a voice scrambler for wartime communications—the X System. And that drove Turing and Shannon together at Bell Labs in 1943. The British government appointed Turing as its expert to validate the security of the X System. That's why he wasn't teaming up with Newman at Bletchley Park. Instead he joined up briefly with Shannon, the expert with the same assignment from the American government. For security reasons the two couldn't mention cryptography, but they could talk all they wanted about computation, computer chess, and the computer as a model for human intelligence.[31]

The fact that so many of the pixel's heroes designed vocoders is remarkable, but the real relevance of the device to our computation story is that Turing made one of his own. He called it Delilah—for "man deceiver," an allusion to the biblical lover and betrayer of Samson—at the suggestion of his close friend, Robin Gandy. Designing Delilah gave him the hands-on engineering experience that he had lacked. Delilah wasn't a computer, but the experience prepared Turing to design one—a real universal Turing machine. It was a preparatory move from the tower to the stinks.[32]

There's a good reason to delve further into the vocoder. It's a good example of the frequency and sampling ideas from the previous two chapters.

First we use Fourier's frequency idea. We break the band of frequencies used by a voice into say ten smaller bands. Suppose the frequencies assumed for the human voice are 0 to 3,000 cycles per second. (Voice communication typically doesn't use the full range of human hearing capability, which can reach as high as 20,000 cycles per second.) Think of this band of frequencies as divided into ten bands of bandwidth 300 cycles per second each. For example, all frequencies in the original voice message less than 300 cycles per second are in band 1, those between 300 and 600 cycles per second are in band 2, and so forth. The rough idea of the voice scrambler is to scramble these ten bands in a known but secret way, transmit the result, and then unscramble at the receiving end.

Now we invoke the Sampling Theorem to represent each of the ten bands with ten sets of samples at the appropriate sampling rate. What actually gets scrambled, and then transmitted, are these ten sets of samples. If a one-time pad system is used for additional security, then its contribution is added to the samples in each channel before the scrambling step. At the receiving end, the unscrambling of the bands

happens, and the one-time pad code is subtracted if used. The ten sets of frequency components are reconstructed per the Sampling Theorem, and these are then all added back together to get the original voice message.

The surprise in all this is the fact that the Sampling Theorem was being used at all. Recall that this was 1943, and Shannon didn't publish his version until 1948. Clearly sampling was completely understood in the West five years before Shannon published. It's no surprise that sampling was used in Russia for their vocoders, because Kotelnikov had published it there in 1933. Furthermore, Turing used sampling in the design of Delilah, his own vocoder, shortly thereafter. He reported that he conceived his version of the vocoder on board the ship he took in 1943 returning home from America the second time.

The vocoder is still with us—but now has a computer built into it. In modern mainstream music, the augmented vocoder is trade-named Auto-Tune. Today it's about voice enhancement, not encryption. Musicians—such as Cher, Laurie Anderson, and T-Pain—who use it are distant conceptual cousins and strange bedfellows of Turing, Kotelnikov, Shannon, and Solzhenitsyn. Auto-Tune is "the Photoshop of the human voice" because it enables many singers—not so good as the three just mentioned—to be pitch perfect. And the Photoshop reference reminds us that pixels and soxels are the same idea—that we can create sound patterns from scratch with computers, as well as light.

Unknowability

Most people think computers are beyond understanding, but in fact they're remarkably simple. You've already experienced one, the business card device, and computed with it. It has only four states and six symbols, and it's made of paper. Yet it can compute anything that's computable. It *is* a computer.

But computers do have to be programmed. As you might suspect, that's the tricky part, and it can be quite tedious and error prone. Even Turing himself made mistakes in his programs. But that's software, not hardware. Hardware is conceptually simple, and it's separable from software.

Knowing the hardware doesn't tell us about the software. We can know the complete wiring diagram of a computer's hardware without understanding what it's computing. For example, you now know how the business card "hardware" works—completely. Yet you've no clue, based on that understanding, what any one of its software programs means. You can know everything about how a Steinway grand works, but you'll not deduce a Chopin étude from it without the score—its musical software. Surely it's also

true that you can know the complete wiring diagram of a human brain without knowing what that brain is thinking.

This is where the hard problem—the eProblem, Hilbert's Entscheidungsproblem—that originally motivated Turing comes into play. To be clear, our main concern here isn't the hard problem—it's the computer, the machine Turing used to solve it. But it's important to remind ourselves that there's something profound at the root of computation. It's worth the reminder because so few people are aware of it and therefore have the wrong intuition about what a computer is.

Many think that a computer is a completely deterministic machine. That's exactly true because each step that a computer takes is completely defined. For instance, each step of the business card machine is determined by its instruction table of 24 rules, the currently scanned symbol, and the current orientation of the card. But the inference that's drawn—that what a computer does is therefore completely predetermined—is false. The fate of the machine *is* completely determined, but you can't always know what that fate is. And if you can't know it in advance, then what does *determined* mean?

To define *determined* in terms of a machine, recall those many-stepped processes again, with all their loops and branches and attendant self-reference. They're a different kind of mathematical animal. That vague sense that computers are difficult has something to it, after all. But it's not because of the hardware. It's something about hardware *and* software and the way one runs the other.

Remember that Turing's solution to the eProblem was that there is no solution: it's undecidable whether a statement in simple first-order logic is true or false. You can certainly decide in some cases, but not in all. There's no algorithm for it. There's a similar consequence in computation—a certain unknowability, or unsolvability—called the *halting problem*: in general, you cannot even know something as simple as whether a computation will halt! There's no systematic test to decide if it will eventually stop or not. There's no algorithm, given a program and its input data, that can discover whether the program will eventually halt or will run forever.[33]

In other words, there's no DNA test for halting. You have to run the program to see what it does. That is, you have to find the path of computer operations from the start to the finish—if there is one. If it halts then you know the answer, but if it doesn't halt, then you don't yet know. What if you let the program run a little longer? You might be on a wild goose chase. It might be in an infinite loop. You can't know in general.

So a computer is completely determined in the small but unknowable in the large. In normal practice this strange behavior isn't really a problem. Programmers usually have a pretty good idea of what their program is going to do—once it's working properly, that is. So in Digital Light the unknowable is mostly a theoretical concern.

Programmers try their best not to write unknowable code. Many programming disciplines have evolved over the decades to help them avoid the pitfalls of the unknown.

One of the pitfalls is a result of the computing aspect that most interested Turing: the ability for a computation to actually change itself while computing. For example: (1) Subtract input number x from input number y. (2) If the result is negative then change the step number in step 3 to 4 otherwise change it to 5. (3) Go to step 4. (4) Write "minus" and halt. (5) Write "plus" and halt.

Let's try this with the number 7 assigned to x and 6 assigned to y: (1) 7 minus 6 equals 1. (2) The result is positive, so: (3) Go to step 5. (5) Write "plus" and halt. Not only can a program be a nasty tangle of branches and loops, but it can be a moving target. Most modern operating systems "protect" the programmer—like self-locking car doors—by prohibiting such self-modifying code. It wreaks havoc too easily. Nevertheless, Turing actually pursued the idea into the world of real computers. His conditional branch instruction, when he got a chance to design one for actual hardware, was realized with self-modifying code.[34]

It's useful to know about that unknowability when you contemplate computation as a model for the human brain or mind—as Turing, von Neumann, and Shannon all did. Computation might not turn out to be a good model, but it can't be dismissed out of hand by claiming that it's deterministic and hence predetermined—that is, it's somehow too rigid and constrained to be worthy of us. You just have to let it run to see what it does.

Programming

> The process of preparing programs for a digital computer is especially attractive because it not only can be economically and scientifically rewarding, it can also be an aesthetic experience much like composing poetry or music.
>
> —Donald E. Knuth, *The Art of Computer Programming*[35]

Programming is the secret to computation, but it took at least a decade for scientists to realize that. Turing exhibited the first programs in his famous 1936 paper, "On Computable Numbers." He wrote them for the conceptual machines—the Turing machines—that introduced computation. So he invented programming and the stored-program concept. He gave us the word *computation* but not the word *programming*. Where did that word come from? Turing used *instruction table preparation* to refer to programming.

Let's look more closely at what Turing actually did. Suppose he wanted a machine that reverses any string of letters on its input tape. He designed the set of rules—the

instruction table—for a particular Turing machine that implemented a systematic reversal of letters. Call it A. Then he would hand A's rules to a universal computer. Recall the picture that shows an arbitrary machine A on its tape and the universal machine U on its tape. "A's encoded rules" in that picture is what we would now call the *program* for A. The clever, intellectually interesting part is designing the instruction table for A—not encoding it into the form required by U. Encoding is straightforward and, well, mechanical. In our example of the business card machine, substitute a 0 for a blank, an f for front orientation, and so on. Pretty dumb stuff. A machine wouldn't get bored doing it, but a human would.

The separation of programming into the creative part and the boring part still holds. In the piano metaphor, the composition of a piece is the creative part, and its encoding as notes and rests on a musical staff is the boring bit. One principal use of modern computers is to do that boring encoding step for computations. It's called *assembly* or *compiling*. A programmer works at a high symbolic level—in an English-like language—to create a program, the fun part. Then a computer encodes the program into those tedious long sequences of almost trivial operations that a computer actually understands—a great example, by the way, of a common nonnumeric use of computers. That's the way it works now anyway.

In the late 1940s, however, those preparing to build the first hardware computers used the term "setting up" to describe how you made a machine compute what you wanted it to compute. In the slightly earlier days of the almost-computers—like Eniac, for example—it meant actually inserting cables and toggling switches, since that was the only way a program could be installed on the hardware. Later—as stored-program computers were contemplated—"setting up" seems to have meant not only creating a program but making sure it was loaded into the memory of the computer in the right place.

At first it was like an afterthought—now that we have a machine, let's make it go. Back then just building a computer that worked took nearly all the creative bandwidth of engineers. But they soon discovered that "setting up" was a complex, error-prone, and burdensome activity. It became the tail that wagged the dog. This seems obvious now, when some programs have millions of steps written by hundreds of programmers.

But back then, they needed a body of techniques to guide and ease the task of "setting up," and they needed a better name for it, too. Documents in the von Neumann archive at the Princetitute capture the very moment when the verb *to program* first appeared. It's both the birth of the word *programming* and the art of programming, a new discipline.[36]

In a memo dated September 5, 1945, every place *programming* would have been a useful term, von Neumann instead used "setting up," surrounding it with placeholding

quotation marks. He said, "I wish to reemphasize that . . . such a flexible and highly automated system of 'setting up' the machine for a problem [is] absolutely necessary for the scientific uses which one should contemplate." Whatever we call it, he said, it's absolutely necessary.[37]

A letter dated November 1 tentatively suggests, within protective quotation marks, an alternative to "set up": "The electronic precision device which we are planning would of course surpass it [Eniac] in speed, and flexibility (all-purpose character) and will be at least as easy to 'set up' or 'program.'" That is, he said, it can't be toggles and cables as it was with Eniac.[38]

Then it happened. Just a couple of weeks later on November 19, "setting up" never appeared. It was *programming* now, and without apologetic quotation marks. The third document is the minutes of a meeting held in the office of a project member, Vladimir Zworykin. "The code outlined in the following table is presented simply to prove that it is possible to do the job. The operations listed are sufficient for complete programming." Not only *programming* but *coding* was prefigured in these minutes.[39]

The von Neumann team apparently meant *programming* to be the creative part and *coding* to be the boring part, a "secretarial task." Programmers today call themselves *coders*, and they write *code*. They mean the creative aspect, whatever the term. They understand that the boring part is now relegated to the machine itself.

So in late 1945 the von Neumann team, probably von Neumann himself, was the first to use the word *programming* more or less the way we mean it today. Turing soon used the term too, in a lecture in 1947, but he used it only a few times in a constrained context.[40]

Whatever the term, it became clear fairly early that programming, the creative aspect, was the difficult part of computing, and that a discipline for it would have to develop. Computer science departments all over the world sprang from that recognition.

Programming is the way to make pixels that represent fictitious worlds. It extends Digital Light from just taking pictures to making them—from just shooting them to computing them.

Myths about Computers

[It] becomes an enchanted loom where millions of flashing shuttles weave a dissolving pattern, always a meaningful pattern though never an abiding one; a shifting harmony of subpatterns.
—Sir Charles Sherrington, *Man on His Nature*[41]

The next chapter is about turning the concept of computation into real practice—the race for the first machine. Before we get there, let's dispel three myths about computers:

they don't have to be electronic, they aren't necessarily made of bits, and they aren't based on numbers—not even 0s and 1s.

First of all, computers don't have to look anything at all like those you commonly know: your cellphone, laptop, desktop, the giant mainframe at your large corporation, or the supercomputer at your high-tech research facility. The business card device is a good counterexample. It's a computer, and to serve my purposes in this book, it's been realized as ink on paper, stiff card stock, and thin metal. It's obviously not electronic.

A popular pedagogical trick is to have a classroom of students become a computer. Let's take the idea up a notch. Suppose we get every person in the United States who's older than 12 to line up in a row. That line is going to be the tape of our computer—its memory. We'll enlist some Canadians and Mexicans if we need more memory. Suppose each person has five hats of different colors. Those five colored hats will be the symbols on our tape. A sixth symbol will be the absence of a hat, and that'll be the default condition of all except a few people. We'll select one person to be the scanner of the tape. Barack Obama was president when I first devised this example, so we'll make him our tape scanner, relieving him from tape-square duty. He has the 24 rules of the business card machine with him—its instruction set—expressed in the five colors rather than the numerals 1 through 5 (and no hat for the blank). The rules are divided up into four sets of rules as usual, and each set of rules is in one of his pockets, two in the front and two in the back. So his pockets are the four states.

Obama starts with a person wearing a red hat and applies one of the pocketed sets of rules—say the rules in his right front pocket. The person addressed will swap hats to one of a different color, or remove his hat entirely, if the rule in Obama's right front pocket for red hats says to. Then Obama moves left or right one person, according to the same rule. He then changes pockets for the next rule if the current rule instructs him to. And so forth. That's a computer made of humans, with pockets for states and hats for symbols. It can compute anything, because it's doing the same thing as the business card machine, a universal computer. It's just a different hardware realization of the same machine. But it's a real computer—and certainly not electronic (or numeric).

The business card computer, or its human equivalent, is also a counterexample to our second debunked belief about computers—that they must be composed of bits. Recall from chapter 2 that a bit has two states, like a light switch that can be either up or down. But the business card machine has four states, or orientations. And each tape square can hold six values, or symbols. Nowhere in the business card machine is there a part with just two values. It's not made of bits. Neither is the human equivalent.

Bits aren't required, but engineers quickly discovered that they are extremely handy in practice. In fact, they used bits in computer design for years before someone got

around to formally converting Turing's great idea to bits. That someone was Claude Shannon. Perhaps it was his 1943 meetings with Turing in Manhattan—their ostensibly vocoder-oriented meetings—that kicked off this interest. Shannon showed that a Turing machine with any number of symbols can be replaced with another that has only two symbols and will compute the same thing. Since the tape of a Turing machine is its memory, a tape square in Shannon's equivalent Turing machine is one bit of memory, with the two symbols as values.[42]

The third myth is more pernicious. It's the belief that the two values of a bit must be 0 and 1. In other words, the third myth is that computers are built of 0s and 1s and that therefore computers are fundamentally about numbers. This myth conflates a *calculator*, which *is* a machine for number crunching, with a computer, a much larger idea. It also conflates the notion of a glyph (a name) with what it might represent (that is, with what is named).

The misconception is a natural one, arising from our usual choice of names for the two states of a bit. We *conveniently* call them 0 and 1. But we could call them night and day, down and up, dot and dash, or ooh and aah. I think you'll agree that those names aren't as convenient, or succinct certainly, as 0 and 1. But, as with the business card machine, they're just names and not numbers.

It's easy to understand why computation has been confused with numbers. Turing's original paper was titled "On Computable Numbers." The "n" in Eniac stands for "numerical." The word *algorithm* pays tribute to early arithmetic. Many of the original computations on the very slow machines of the time were numeric—such as the early H-bomb calculations. Numbers were the easiest first symbols to attack with the new tool of computation. Some of the early practitioners themselves seem never to have understood that the computer was much more than a fast number cruncher—a calculator—but Turing knew how much more computers could do. In fact, it's interesting to note that Turing's Bombes and Newman's Colossi at Bletchley Park didn't calculate or manipulate numbers but instead used symbol substitution to break codes.[43]

Sir Charles Sherrington, the author of this section's epigraph, used his famous "enchanted loom" metaphor to describe the waking cortex of the human brain, but it also fits the workings of a modern computer. It's about changing patterns. It's not about numbers unless the meaning *we attach* to the patterns is number. But that's only one of myriad interpretations we can make of the patterns. To the computer it's just pattern.

If there are no numbers in a computer, then what *is* there? Nearly all the world's computers today are electronic and built of bits. They're built from computer chips, perhaps our greatest technological achievement. If you *could* look inside such a chip in operation, you'd find patterns of high and low electric voltages. Those are the bits.

A familiar place with a similar pattern that you *can* see—well, measure anyway—is an electrical outlet in your home. We know that the AC voltage there varies in a Fourier wave from a maximum voltage crest to a minimum voltage trough 60 cycles per second (US). What comes through your plug and into your computer is actually a constantly varying wave, going from low to high voltage and back again.

But in a chip, voltage doesn't vary smoothly and incessantly the way it does at an AC outlet. It maintains its value—say, high—until it's instructed by a computer rule to change to the other value, low. Each chip location that can assume either a high or low voltage—and change to the other under control—realizes the abstract idea of bit. What we *say* is that a bit is a 1 until instructed to change to a 0. See how convenient those names are! But the physical reality is voltages—like the reality at an AC outlet—not numbers.

If you think about a computer with trillions of bits built into it, often in regular arrays, then you'll see why Sherrington's metaphor works. When it's operating at the tremendous speeds of today's computers, the patterns of trillions of voltages warp and weave in an electronic dance that changes billions of times per second. Sometimes they weave movies out of whole cloth.

The secret of Digital Light isn't that somehow you can turn pictures into numbers, like the old "paint by numbers" coloring books. It's that the visual patterns we see every day, patterns of light and shade and movement, can be represented by the voltage patterns in a machine. We mimic the patterns of the world with the patterns of our computers.

Tying It All Together

To the Bletchley Park group of cryptographers and mathematicians, text was encrypted German war messages. To London's illustrious Bloomsbury Group of writers and thinkers, it was high English literature. It would appear at first blush that Bletchley and Bloomsbury had little in common. But the two circles intertwined with one another in loose but curious ways in the 1940s and 1950s.

This is not unexpected since British intellectuals, whether mathematical or literary, tend to filter through either Cambridge or Oxford. For example, the novelist E. M. Forster, the publisher Leonard Woolf, and the economist John Maynard Keynes were all renowned Bloomsbury members. And they all belonged to Cambridge's secret society, the Apostles, which included Alan Turing's collaborators, Robin Gandy and David Champernowne.

That's coincidence, however. Not far removed from it is the familial connections via the Stracheys. Bloomsbury's Lytton Strachey had a brother, Oliver, who was a cryptographer at Bletchley Park, and a nephew, Christopher, Oliver's son, who was Turing's classmate at Cambridge. Christopher Strachey is notable in the next chapter as author of the first documented videogame.

But a truly meaningful connection tied Bloomsbury's Forster to Turing. Forster's novel *Maurice* dared to convey—in manuscript only—what it was like to be "an unmentionable of the Oscar Wilde sort." Turing took comfort in this book, according to his biographer.[44]

Perhaps the most interesting tie concerns yet another Bloomsbury giant, Virginia Woolf, whose husband, Leonard, was also her publisher. Virginia famously kept extensive diaries so it's not surprising that the name of one of Leonard's story editors, Lyn Irvine, appears in them. The unexpected twist is that Lyn married non-literary Max Newman, Turing's mentor and fellow Bletchley Park contributor.[45]

Fearing for their half-Jewish sons during the war, Lyn took exile with the boys in Princeton, New Jersey. Max knew the area from the time he spent there with Turing before the war. But he remained in England this time, leaving Lyn alone with the children. On a state visit, after spending several hours with President Roosevelt in Washington, John Maynard Keynes searched her out in Princeton. His gesture was a refreshing reminder to her of London and a respite from intellectual isolation.

Lyn and Max's younger son, William, remembered the visit. Keynes accompanied young William to a barbershop for a haircut and seated him next to von Neumann. But something upset the boy, who fled in tears. Keynes pursued and coaxed him, with silvery tongue no doubt, back into the chair for his haircut while von Neumann got a shave.[46]

Lyn's friendship with Turing began later when both were back in England and living in Manchester. Still starved for the London literary scene, she found him a refreshing change from Max's other visitors who talked mostly of math. She saw him as a "very simple, humble, gentle personality." We look to her for a deeper understanding of St. Turing.

Although hardly a geek in her eyes, she did touch on Turing's geeky characteristics in print. She wrote in the foreword to Sara Turing's biography of her son, "He never looked right in his clothes." And, "He had a strange way of not meeting the eye."

Lyn became particularly close to Turing after he was arrested and no longer had anything to hide—other than official secrets. He said to her during those last days, "I just can't believe it's as nice to go to bed with a girl as with a boy."

"I entirely agree with you," Lyn replied. "I also much prefer boys."

There grew between them an intimacy that belied the geek. Now, instead of "a strange way of not meeting the eye," his eyes were "blue to the brightness and richness of stained glass," she wrote. "But once he had looked directly and earnestly at his companion, in the confidence of friendly talk, his eyes could never again be missed. Such candour and comprehension looked from them, something so civilized that one hardly dared to breathe." Like Turing's mother, Lyn never believed he committed suicide.[47]

But Lyn's lasting contribution to Digital Light was her son. William Newman would coauthor the first textbook on computer graphics.

Off to the Races

As we get set to start chapter 4 about the birth of Digital Light—and how it's intertwined with the birth of computers—here's a quick review of chapter 3. I presented computation at an intuitive, conceptual level by stressing its mindless simplicity in the small and comparing its awesome Malleability and theoretical mystery—its unknowability—in the large. I suggested that programming is where the creativity—and difficulty—lies. I established computation as systematic, or algorithmic, processes that manipulate patterns of symbols. The processes are realized with ever-so-simple individual steps—but lots of them. I disabused us of the notion that number is fundamental to computation—there are no 0s and 1s in a computer—and that determinism somehow limits the idea. I showed that speed, bits, and electronics aren't required for computation.

Nevertheless, the next chapter is about speed, bits, and electronics. Speed matters a great deal in the real world, and bits and electronics are key to achieving it. The unexpected gift is awesome Amplification and its order-of-magnitude mystery, where computation goes supernova and emits Digital Light.

Contributions: Two High Technologies

4 Dawn of Digital Light: The Quickening

I'm not really interested in computers, I made one and I thought one out of one was a good score so I didn't make any more.

—Sir Frederic "Freddie" Williams[1]

I asked Professor Kilburn, why is it that whenever I open a computer science textbook I get the American origins of computers but the Brits are nowhere? So Tom [Kilburn] took his pipe out of his mouth and said, "Those who need to know do know."

—Simon Lavington, British computer historian[2]

When I began writing this book, I thought, like most of my colleagues, that the first computer pictures were created in the Sixties, particularly by Ivan Sutherland and his group at Utah. But when I tried to pin down the date, I soon realized that no one knew exactly when the first digital pictures emerged. This chapter is the result of my quest to find them. After many days in obscure archives in Cambridge, Oxford, Manchester, and Boston, I can finally tell the story accurately and fully.

And the answer is a massive surprise: the first pixels were on the first computer. British engineers Freddie Williams (figure 4.1, left) and Tom Kilburn (right) created them both, plus the first effective computer memory system, beating out theoretical heavyweights Turing and von Neumann. The Brit engineers—pithy straight-talkers with a touch of in-your-eye fun—would surely have snorted at such grand characterizations, while they agreed with them privately. Because it was all true. They birthed and mothered that computer—delightfully named Baby—in Manchester, England, in 1948. It was a fully electronic hardware realization of Turing's great idea of 1936—the stored-program universal computer. It was exactly what we mean by a computer today.

The race to the first computer is closely contested. The Brits won it, by the account above, but the Yanks were hot on their heels. Freshly uncovered and exciting records

Figure 4.1

suggest that the race was closer than previously known—a matter of days—and that the Yanks may even have got there first. Let's call it a tie. We'll discuss that development later. But our main mission is Digital Light—those first pixels, about which there is no controversy.

The Yank von Neumann understood the Brit Turing's great idea of computation as well as Turing himself did, and both geniuses made a try for a hardware version of it. But Turing bogged down in bureaucratic infighting, his biggest and only failure—unless you count personal survival. And von Neumann's team failed to get an electronic memory of the Williams and Kilburn variety working in time; they, and about a dozen other early American efforts, adopted the Williams and Kilburn memory.

Without question Williams and Kilburn created the first Digital Light. The bits of Baby's memory were spots of light on the face of a cathode-ray tube (CRT). Each spot could have two sizes, conveniently called 0 and 1. But since these bits were visible on a CRT, and since they were arrayed there in neat rows and columns, they doubled as the first pixels.

Williams gave us the first displayed pixel. Then Kilburn created the first digital picture from an array of those spread pixels in 1947, slightly before Baby's completion—in utero, so to speak. Luckily for us he took a photograph of the big event (figure 4.2).

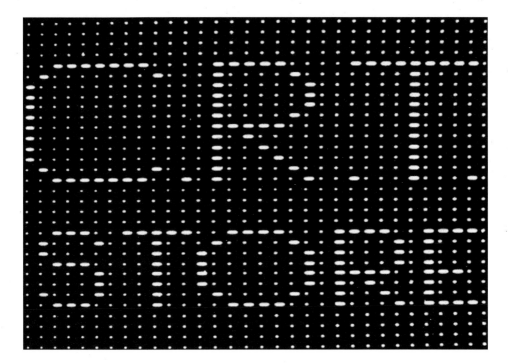

Figure 4.2
Tom Kilburn, First Light, 1947.

I call that display *First Light*. This humble picture was the very beginning, the dawn of Digital Light. It was the beginning of the whole modern world of images—a world unimaginable without pixels. Importantly, it was an *intentional* two-dimensional picture, not an arbitrary incoherent array of dots.

Because making pictures was considered frivolous in those early days of computers, historians have barely mentioned them. Digital Light is a neglected part of the story of early computers, and so First Light has been invisible and unrecognized.

The story begins with Turing's great idea. He brought us Malleability, that first miracle of computation—a way to control and execute an infinity of complex processes. But he didn't give us speed. Computation was tediously slow at first—recall the business-card computer. Turing and von Neumann were aware that to make software go fast, they must convert it to hardware. Realizing Turing's soft idea as hardware, the computer, was the key to making computation fast. Amplification—the second miracle of computation—required it. Computers arrived in two easily marked steps.

I call the first step, the years 1948 to 1965, Epoch 1. This was the era of dinosaur machines of immense size—measured in rooms and even acres—but not all that smart. They were ponderous and limited by small memories. Room-sized Baby at first had only a thousand bits—128 bytes in today's measure. But Baby signified the launch of the age of hardware-assisted computation, the first quickening and the beginnings of Amplification.

Quickening in this chapter's title refers to the conception of Baby and of computers in general. But more importantly it also means speedup. Computers from Baby on made computation *fast*. That was, and is, their purpose.

Epoch 2 began in 1965 and is ongoing. Although computers increased in speed during Epoch 1, it wasn't until 1965 that a particularly potent kind of quickening, the second quickening, took hold. From it comes the current supernova era, when computer power explodes exponentially as physical size shrinks dramatically. Its nature is captured by Moore's Law: *everything good about computers gets better by an order of magnitude every five years*. This astonishing statement is so revolutionary that it's difficult for us to grasp. It tells us that computers improve by a factor of ten in just five years—and do so every five years thereafter. An automobile in 1965, say, capable of 60 mph, would by Moore's Law measure go 600 mph in 1970 and 6,000 mph in 1975—at no increase in price. Unthinkable for cars, but true of computers. A veritable miracle. The hardware miracle of Moore's Law led directly to the productivity miracle of Amplification. And Amplification enabled the Great Digital Convergence and created the modern world.

Predawn: The Yanks versus the Brits

It's an old competition—since the American Revolution at least. Stereotypes maintain it: Yanks overclaim while Brits understate. Or worse: Yanks use bucks where Brits use brains. The British spy novelist John le Carré famously called Americans the Cousins, and he didn't mean the kissing variety. The Cousins were allies in the war against Hitler and then the Cold War, but cooperation was often reluctant. The two teams both competed and cooperated in the race to the first computer. And it was a close race—so close that some historians are still debating it.

In the 1960s my American generation was taught that Eniac, born in Philadelphia in 1945—a machine made by Yanks (us)—was the first electronic computer. But it wasn't—not by today's meaning of computer as an electronic stored-program machine. It wasn't even the first of the almost-computers. The Brits (them) had already won that round, but we Yanks couldn't have known it. There's that Official Secrets Act—Turing's

tyrant—in play again. The Brits had won the first skirmish without the Yanks even being aware of it.

The Brits aren't blameless either, when it comes to making uninformed or inaccurate pronouncements. They've claimed that their machine Colossus at Bletchley Park in early 1944 was the first electronic computer. That's wrong too. Colossus, like Eniac, used hardware programs, not software. Both were big and both were electronic, but they weren't stored-program computers. Reprogramming either beast required toggling switches and replugging cables—a manual rewiring of the machine hardware at pokey human speeds. The beauty of Turing's stored-program computer idea is that a program itself can be stored in the very same memory that holds its data. To change a program and the data it manipulates are the same process. If the computer is electronic, then changing programs happens at electronic speeds that leave humans in the dust. You don't need an external guy—or, more often in fact, gal—to slowly swap out cables and throw switches.[3]

But those room-sized behemoths served the Cousins well. The almost-computers boosted both the Yanks and the Brits militarily. Eniac made H-bomb calculations. Colossus helped to crack a German encryption scheme and ensured a successful D-Day landing in Normandy. The machines were extraordinary electronic training grounds—or inspirations, at least—for the engineers who would proceed to design and build true computers. Those true computers would be driven by software programs stored in the computer just like data, not imposed from the outside by a cable gal.[4]

The Dawning of the Light—and Computers

Freddie Williams moved to the University of Manchester in December 1946. His first goal wasn't to build a computer but rather a fast memory for one. His experience with wartime radar—featuring blips on a screen—inspired his idea that the best solution probably lay with the cathode-ray tube. He had seen a promising radar technique at Bell Labs in New York when he visited in 1946.[5]

Just before his move to Manchester, Williams had succeeded in storing one bit on a CRT. He had devised, in other words, a way to display a small blob (a dot) or a big blob (a dash) at a location on the screen at the flattened end of the tube. He could write a bit. Furthermore, he (well, his electronic circuits) could look at a blob that was already stored on the face of the tube and determine whether it was big or small—he could read a bit stored there. He could also change a large blob to a small one, or vice versa. In convenient modern terminology, he could arbitrarily write a 0 or 1 to a location, and he could read what was stored there. Most importantly, a value he wrote to a location

persisted there until he, or a computer, explicitly changed it. In other words, it was remembered. Voila! In 1946 Williams had created the first visible computer bit.[6]

He was on his way to creating what would be called a Williams tube. It should be called a Williams-Kilburn tube—but hardly ever is—because Tom Kilburn soon joined Williams at Manchester and by March 1947 was already actively involved in the tube design. By the end of the year Kilburn was able to store 1,024 bits on the face of the tube in a rectangular array—and to create and take the photograph of First Light, that first Digital Light display (figure 4.2). Then quickly he advanced to 2,048 bits, created another picture, and took its photograph (figure 4.3). But the word *bit* didn't exist yet, as we know from chapter 3, so he used *digit* instead. He wrote a report, his doctoral thesis, "A Storage System for Use with Binary Digital Computing Machines," issued December 1, 1947. He was 26. That was the moment.

Kilburn's 1947 report publicly announced the dawn of Digital Light with the two photographs. They weren't photos of just any array of spots. They were two *pictures* rendered digitally and stored in an electronic digital memory. Kilburn *intended* them to be two-dimensional pictures.

Kilburn created First Light, the first digital picture, by the "far too laborious" method of lighting each of 1,024 spots by hand. The display was an array of 32 by 32 spread pixels. He used 32 keys "arranged in the form of a typewriter" to toggle in the bits. Kilburn described the display as an array of "picture elements." The short form *pixel* didn't yet exist—not until 1965, as we've seen. And he confused display elements (visible) with picture elements (invisible). We discussed this distinction in the Kotelnikov chapter, but there was no such distinction yet for Kilburn.[7]

Kilburn created the second digital picture in the 2,048-bit memory using the same tedious typewriter-like method. Each spread pixel in these pictures had two states, dash (big blob) and dot (little blob), known conveniently as 1 and 0. A spread pixel here is a rounded splash, or blob, of light of two different sizes. There were no little squares— even in the earliest days.

Kilburn's purpose—clearly stated in his report and in its title—was to design a memory for a computer. He described just such a hypothetical computer in the report. Then he and Williams promptly proceeded to build an actual computer, and within half a year delivered the famous Baby.[8]

The sober, suitably rewarded Kilburn in figure 4.4, a Fellow of the Royal Society, holds an icon of his fame, a Williams tube—a Williams-Kilburn tube to be clumsily exact—while Baby hovers in the background. Williams and Kilburn both received great honors during their lifetime. By the time Freddie Williams died in 1977, he was Sir Frederic and also a Fellow of the Royal Society. Kilburn died in 2001 one year after the

Figure 4.3

Figure 4.4

Computer History Museum in California made him a Fellow, a fitting beginning of the new millennium.

Forbidden Fruit

But there's no evidence that Kilburn ever understood the momentousness of First Light, the first picture on a computer. After he created the first two pictures in 1947, he never made another one, so far as we know. In fact, nobody else made pictures on Baby either. People seem to have felt that picture making just wasn't a serious use of the computer. It was profane. It was forbidden fruit—although not exactly a graven image. The war was just over, computation resources were scarce, and the need for them was intense. David "Dai" Edwards, who worked with Williams and Kilburn on Baby, said that users were "desperate" for the machine then. Another member of the team, Geoff Tootill, said that the team still operated under a wartime ethos then and had no time for relaxing.[9]

Making pictures was a relaxing, good-time activity to them. A picture as a memory test pattern was one thing, but otherwise wasting Baby's rare computing resource for such a frivolous and profane pursuit was something else altogether. Instead, the machine should be computing something "serious."

For perspective, consider the totally different environment decades later, in 1998, when an exact replica of Baby was built for its fiftieth anniversary. A programming contest for the celebration elicited several Baby programs that created pictures, even animated ones, on Baby's monitor. One generated the word BABY.

The Baby rebuild had been spearheaded in Manchester by Chris Burton. He arranged a visit for me to see Baby at Manchester's Museum of Science & Industry on July 4, 2013. Baby welcomed me with PIXAR scrolling across its monitor (figure 4.5)—a computer animation! My host, Brian Mulholland, had written the Baby program for it the previous day. But it could have run on Baby in 1948.[10]

Picture creation is obvious—irresistible even—for modern programmers who are comfortable in peacetime, flush with computational resources, and more familiar with computers as picture producers than as number crunchers. Computers without a visual display, animation, and interaction are almost unheard of now. We call them servers instead.

The Race

It's still not easy to sort out the early history of computers. Even the single story of Baby at Manchester is complicated. A complete history would have too many

Figure 4.5

people, machines, and countries—and too much nuance—to fit comfortably in a book, much less a chapter. I prune away much of this thicket with a careful definition of what we mean by a computer and by focusing only on those pathways that led to Digital Light. This leaves intact a remarkably robust part of early computer history.

Yet that smaller part still has dozens of players. To give structure I continue to divide them into two teams—the Brits and the Yanks—and posit a dramatic race between them. It's an Olympian fiction. The competitors were no more national teams than Olympic teams are—bound only by the flag they wave and the medal count. Nevertheless, the device organizes and tracks the complex Olympic games, and it works for computer history too. And there's a bit of truth behind the competition too.

A "flow chart" (figure 4.6) of the early history of computers gives hardware and software contributors equal credit. This has hardly ever been the case for computers—a reflection of the never-ending tower versus stinks battle. Software here is generalized to include all work that is only mental.

Software contributors who were also famous theoreticians—Turing and von Neumann, notably—often got assigned the glory when it just didn't happen that way. Baby's hardware "mothers," Williams and Kilburn (solid lines), were more important to Baby itself than its early programmers, Turing and Newman (dashed lines).

The flow chart also makes the interconnectedness of the various players obvious. People are represented by circles, computers by rectangles, and concepts by parallelograms. There's no viable straight-line narrative path through the chart. But it *is* rooted. Topmost and center is Turing's 1936 "On Computable Numbers," the concept paper that started it all with its definition of computation and its careful description of a stored-program computer. From it flowed von Neumann's 1945 *Edvac report* and Turing's 1946 *Ace report*, which described two different architectures for actual computers.

Programming is the best-known form of software. The mathematics of computation is another, as in "On Computable Numbers." The third type of mental work is represented by the Edvac and Ace reports. A software contribution in its full sense therefore includes the idea of the stored-program computer, an architecture for one, or programs for it. The dotted lines flowing from the Edvac report in the chart show its conceptual (soft) contribution to almost every computer in the chart aside from Turing's direct line.

Similarly, but in hardware, Williams and Kilburn influenced the design of several early machines on both teams. Their design (hard) contribution is indicated by solid lines from each in the flow chart. They weren't engineers on any of the other non-Manchester computers, but the Williams-Kilburn tube directly influenced the design of those machines.

Architecture versus Design

Between the idea
And the reality
Between the motion
And the act
Falls the Shadow
—T. S. Eliot, "The Hollow Men"[11]

A computer *architecture* is—as it sounds—a plan. It differs markedly from a computer *design*. I'll reserve that otherwise familiar word for the act of making an architecture exist in the real world, with actual electronic devices. Architecture is idea; design is reality. Design is a hardware issue, requiring at least as much creativity as architecture—some would say more. But it's a different kind of creativity. That's because architecture does not dictate or instruct design. One house architecture can be manifested in many designs. A box labeled *Kitchen* inspires—but in no way directs—a myriad combinations of granites, tiles, woods, handles, lights, faucets, paints, casements, and so forth.

The Birth of Digital Light
(and Computers)

Brits

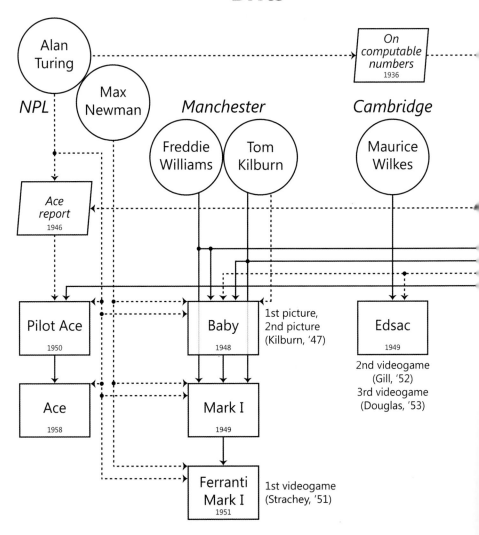

Figure 4.6

soft contribution (concept, architecture, software) ···········▸
hard contribution (hardware design, build) ⟶

Yanks

Figure 4.7

The famous architecture specified in the Edvac report—called the *von Neumann architecture*—influenced at least the six different computer designs shown in the flow chart, and many more. Figure 4.7 shows it in typical plan view. Consider the simple box labeled *Memory*. There's no actual memory technology specified—that's a hardware design concern.

The designers have to take that empty box and figure out how to make a device in the real world that will correctly connect that box to the other empty boxes in the plan. Then they must master the physics of their choices and make the devices all work together with a real memory that holds actual bits, communicates to the world outside itself, and works off the given power grid. The step from an empty box in an architecture to a design is a major creative step. There is no algorithm for it.

Although the Yanks developed the winning architecture, the Brits created the winning design and hence won the race. The design of that one box, Memory, was the crucial factor in the race to the first computer—and digital pictures.

The von Neumann and Turing architectures were equivalent ideas. Both were plans for implementing Turing's stored-program universal computer concept. Turing's architecture had a box for memory too, and control, arithmetic, logic, and input-output boxes. In both architectures the memory and input-output are equivalent to the tape of the universal Turing machine, and the remaining boxes form its scanning head. Turing made the connection explicit in a lecture on Ace in 1947. Similarly, although the Edvac report wasn't explicit, von Neumann told people about Turing's fundamental importance in 1943 and 1944.[12]

A general rule of thumb is that any software process can be made to go faster by implementing it in hardware. In fact, a computer itself is a fast hardware realization of Turing's soft, but painfully slow, idea of a stored-program universal computer. Arithmetic and logic can be software, but von Neumann and Turing went further. They both specified that these very popular operations should be realized in hardware—to go as fast as possible. This is the specification that led to the common misperception that a computer is *only* an arithmetic machine.

Turing's architecture differed from the von Neumann team's in a profound way. Turing specified hardware support for a new concept: the software hierarchy. Programmers (read Turing) quickly learned that it's good software practice to create a program hierarchically. Hierarchy gives meaning and structure to one of those extremely long linear lists of meaningless instructions.

Creating a software hierarchy is like an author breaking a book into a list of chapters. Suppose a program is hundreds of thousands of instructions long—not that unusual in today's world, and mind-boggling. But you could break it up into, say, a hundred parts averaging a few thousand instructions each, and give each part a meaningful name. To the programmer, the program then reduces to only these hundred named, meaningful parts—each called a *subroutine* (not Turing's word). At the highest level of the hierarchy, the program is conceptually only a hundred "instructions" long, where each instruction is a subroutine. It's like a table of contents and its chapters.

The programmer still has to create all the named parts, the subroutines, in all their tedious detail, and the author still has to write each chapter. But the task of writing each part is less mind boggling and more bite-sized. Furthermore, it's a hierarchical idea. A programmer can further subdivide each subroutine into its own sub-subroutines, and they into theirs, and so forth. Bites become nibbles, even easier to program. The subroutine concept tames an overwhelmingly complex task into comprehensibility—like further breaking chapters into headings, headings into paragraphs, and finally into the words themselves. And Turing's architecture specified a hardware boost that makes the hierarchical use of subroutines quick and easy.

Surely Turing's architecture—with its sophisticated subroutine support—should've been the one that got adopted, but it wasn't. The Yanks disseminated von Neumann's Edvac report far and wide in the 1940s, but the Brits didn't publish Turing's Ace report publicly until 1986.[13]

The Brits

Ace, Turing's Only Failure

Sir Charles Darwin, a grandson of the great evolutionary biologist, sought to establish a British national computing resource just after the war. He started well. He hired Turing and brought him to the National Physical Laboratory near London. In late 1945 Turing began the architecture for the NPL computer—to be called Ace—and delivered the plan soon afterwards. His 1946 Ace report referred to von Neumann's slightly earlier Edvac report, which presented the Yanks' competing architecture. But the Ace report went further. It contained a design as well as an architecture—probably the first electronic computer design. Turing dived into the project of building Pilot Ace, the prototype computer that was based on the Ace architecture. Surely Turing's computer—from the man who invented computation—should've been the firstborn, but it wasn't. Pilot Ace had delivery problems.[14]

One problem was Turing himself. First, he kept changing the architecture as brilliant new ideas occurred to him. Second, he was unable to function well as a team player. Or, to spin it positively, he had an unusually strong individuality. But other problems weren't of his making, such as bureaucratic incompetence and an unfortunate physical separation of concept and engineering—of tower and stinks. Keeping hardware and software apart doesn't work for producing computers. Sadly, for Darwin enthusiasts, grandson Darwin was the bureaucrat in charge of that bungle.[15]

Pilot Ace became such a mess that Turing left the project, disillusioned and disheartened, long before it was completed. Darwin wrote, "We are agreed that it would be best that Turing should go off it for a spell." Pilot Ace's exasperatingly overdue first cry finally occurred on May 10, 1950—almost two years after Baby. Pilot Ace barely made it onto the list of the first ten computers. And the full Ace itself, the child of Pilot Ace and Turing's principal goal, wouldn't be complete until a decade after he left.

Before he left the project though, in 1947, Turing gave his notable lecture on Ace—and he used the new word *programming*. In the audience was the engineer Tom Kilburn, who had stopped by briefly on his way to Manchester where he was to join Freddie Williams.[16]

Turing would be on his way there too, in about a year. The happy consequence of his unhappy departure from the Ace project was that he was available for other computer

projects. And Max Newman needed him. Newman was the professor at Cambridge who had originally inspired Turing to make the leap to his idea of computation. And then Newman had urged Turing to study at Princeton. So now Turing's old teacher and mentor made the winning bid for his services in Manchester, to develop software for Williams and Kilburn's Baby.

Baby

Baby was born on June 21, 1948, at the University of Manchester. Williams and Kilburn designed and built it from scratch in a lab in the stinks—the electrical engineering department. They were directly responsible for designing and building it. And Kilburn wrote its first program. They announced Baby's birth—proudly we assume—in the September issue of the prestigious science journal *Nature*.[17]

Newman, who would bring Turing into the project, was in the tower at Manchester—the mathematics department. After his positive experience with the almost-computer Colossus at Bletchley Park, he was intent on having a full-blown computer at Manchester. He seriously considered the Yanks' approach, à la von Neumann, until he discovered that the Manchester home team of Williams and Kilburn was actually ahead. He promptly switched loyalties and began to consult with them about Baby across the tower–stinks divide.

Baby's first program was Kilburn's, not Turing's. The first thing Turing did in preparation for his move to Manchester was to obtain Baby's instruction set. He wrote his first (buggy) Baby program in July 1948, about a month after its birth and still in absentia. He arrived in Manchester about three months later, in October.[18]

Manchester engineering people have taken offense, rightfully, because too much credit goes to Turing and Newman for Baby, especially since Turing wasn't even there until later. Some of this is just the usual sandpaper between tower and stinks, but it speaks to the difficult problem of assigning credit for a complex technical invention of world-changing importance.

But Williams and Kilburn themselves told us that Turing and Newman were intimately part of Baby's creation. In 1975 Williams recalled, "Tom Kilburn and I knew nothing about computers, but a lot about circuits. Professor Newman and Mr. A. M. Turing knew a lot about computers and substantially nothing about electronics. They took us by the hand and explained how numbers could live in houses with addresses and how, if they did, they could be kept track of during a calculation." This might have been Williams's wry sense of humor on display rather than an accurate historical recounting, but he repeated the story several times.[19]

Kilburn's PhD dissertation of 1947 further complicates Baby's history because it listed in its bibliography "unpublished work" by Turing and by von Neumann. Surely Kilburn was referring to Turing's Ace lecture of 1947 and von Neumann's Edvac report of 1945. Although Williams later gave only Turing and Newman credit—the "numbers could live in houses with addresses" quip—he and Kilburn didn't opt for Turing's architecture. Kilburn explicitly said, after he heard Turing's lecture, that he would never design a machine *that* way. Instead they used a von Neumann architecture for Baby. They gave the home team verbal credit but clearly borrowed ideas from the other side, the Yanks.[20]

Baby thrived and begat, so to speak, a second-generation machine. Mark I—short for Manchester Mark I—ran an error-free program on June 18, 1949. Recorded dates are soft for Mark I, but that conservative birth date establishes it as the fourth computer in the world. Turing devised the early software specifications for Mark I.[21]

Mark I soon begat Ferranti Mark I, which debuted on February 12, 1951, as the world's first *commercial* computer. Ferranti—a British firm despite its name—called the computer Madam at first, a title that *The Guardian* embellished to "a 'madam' with unpredictable tendencies." A publicity photo featured Turing hovering over Madam's console. He wrote the computer's programming manual as he had for Ace.[22]

Edsac

Meanwhile in Cambridge, Maurice (pronounced "Morris") Wilkes was building Edsac, destined to be the third computer in the world. Why didn't he invite Turing to join that project? Cambridge was Turing's natural home, after all. He was a fellow of its King's College. Turing must have considered it because he visited Wilkes in May 1948 before he joined Newman in Manchester in October.

Mutual enmity very likely squelched the option. Turing said about his visit with Wilkes, "I couldn't listen to a word he said." He'd earlier criticized a Wilkes proposal as being "much more in the American tradition of solving one's difficulties by means of much equipment rather than by thought." (There's that old stereotype, from Turing no less.)[23]

And Wilkes wrote, "I found Turing very opinionated and considered that his ideas were wildly at variance with what the main stream of computer development was going to be."[24]

Both were right in a way. Wilkes was taking his inspiration directly from the Yanks' von Neumann by this time. And Turing, as usual, was marching to his own drummer—having created an architecture (for Ace) that few others adopted.

Edsac's first cry was on May 6, 1949, almost a year after Baby and just before Mark I. Wilkes chose the twin name to von Neumann's Edvac on purpose, so Edsac came onto the field unabashedly waving the Stars and Stripes.[25]

I attended the "50th anniversary of the computer" at Cambridge in 1999, which celebrated Edsac as the first computer. In the audience was an old acquaintance from Xerox Palo Alto Research Center, William Newman, son of Max Newman. Both of them had lived in Manchester when Baby was created. Young William had even played board games with Alan Turing when the mathematician came to Manchester soon afterwards. William turned to me during a Wilkes claim of Edsac priority and said in his quiet way, "That's not quite the way we remember it."[26]

The Yanks

Edvac Report's Large Progeny

In America, von Neumann (and team) created the Edvac report, and designed a computer based on it. The Edvac computer didn't actually run until much later, but it doesn't matter. The architecture it was based on—von Neumann's—was far-reaching. The influential 1945 Edvac report proliferated it widely. Even today that architecture is widely used. Surprisingly, even the Brits' Baby and Edsac used it. So, it's fair to say that the idea of the stored-program computer and computation comes from Turing but the computer as it actually is—an effective machine in the world—descends from von Neumann . . . with the caveat that Turing and von Neumann knew and understood each other's work and explicitly gave each other credit.[27]

Edvac's large progeny of at least 16 children (6 shown in the flow chart) developed in many places. Importantly it begat Maniac at the Princetitute, with von Neumann as software lead and Julian Bigelow as hardware lead. Maniac begat IBM 701, Big Blue's first commercial computer, which launched that giant corporation's domination of computers.

As if Maniac weren't joke enough, Edvac also begat Johnniac—named for Johnny von Neumann, of course. Such fun gave us Emerac in the film *Desk Set* (1957), the computer that vied with Katherine Hepburn for Spencer Tracy's attention and Hepburn's job. And even Brainiac, the Superman super-villain of DC Comics. Although *ac* usually stood for *automatic computer* in the early acronyms, it meant *and computer* in Maniac and *automatic calculator* in Edsac (and *arithmetic calculator* in Emerac, missing the point).

But the naming fun also brought the tower versus stinks battle into focus at the Princetitute, already the recipient of a slightly undignified moniker to distinguish its official self, the Institute for Advanced Study in Princeton, from Princeton University,

also in Princeton. No one within earshot of the tower purists at the IAS would have heard the name *Maniac*. The purists there called Maniac *the IAS machine*, which remains its formal, and forgettable, name. They would no sooner tolerate the presence of the engineers and their soldering guns than their puerile naming glee. (No doubt *Princetitute* would have made them shudder.) Von Neumann was all that kept the stinks at the Princetitute for as long as they stayed. Immediately after his death in 1957—just three years after Turing's strange death—the stinks were banished and with them the possibility that the Princetitute would become the center of computer science research.[28]

Was Baby First? Eniac+

Von Neumann noticed, as a consequence of the Edvac work, that the almost-computer Eniac could be turned into a true computer with some hardware modifications. The modifications were made, and Herman Goldstine, von Neumann's colleague in charge of the project, recorded that the programmable version of Eniac—dubbed Eniac+ in this book—began full operation on September 16, 1948, at the Aberdeen Proving Ground in Maryland. Goldstine's wife, Adele, helped program it. It could only store a few dozen instructions in its tiny memory, so it was small like Baby, but it was a computer.[29]

Goldstine's date would make Eniac+ the second computer in the world. But new evidence strongly suggests that the race with Baby was much closer. Eniac+ was born sometime between April 6 and July 12, 1948, depending on how many instructions were implemented at any given time: a moving target, in other words—although the date hardens at the end of that interval, when further improvements ceased. Taking the last date as a conservative estimate, and discounting Goldstine's September date, yields an alternative birthdate for Eniac+ of July 12, 1948, less than a month after Baby's birth on June 21.[30]

But in a letter to John von Neumann dated May 12, 1948, Stanislau Ulam said, "I heard from Nick [Metropolis] on the telephone that the miracle of the Eniac really took place and that 25,000 cards were produced. (By now many more?) this is really wonderful, especially as Nick says that they (the cards) seem to make sense." This is impressive evidence. It has one of the creators of the H-bomb stating to another that Eniac+ was successfully computing a difficult H-bomb simulation program on May 12, 1948, more than a month *before* the June 21 birth of Baby. Whichever way you call the race, Eniac+ was a significant achievement that hasn't been generally recognized before.[31]

View from Olympus

To look at the Brits versus Yanks competition the Olympian way—by medal count—the score at the end of 1948 was 1 to 1 (Baby, Eniac+). By the middle of 1949, the count

favored the Brits at 3 to 1 (Edsac, Mark I). But then the Yanks began to score with these notable (but not at all inclusive) hits: Harry Huskey—a free-agent engineer who played on both sides—built Zephyr at the National Bureau of Standards (NBS) in Los Angeles. Yet another child of Edvac, it was operational in August 1950 (and rechristened Swac). Then Jay Forrester's Whirlwind, another child of Edvac, went online in April 1951 at the Massachusetts Institute of Technology (MIT). Arguably, a test version of it came earlier, in August 1949, with Whirlwind– ("Whirlwind minus") its name coined in the spirit of Eniac+ ("Eniac plus"). The Yanks scored again in 1952 with the dedication of Maniac by the von Neumann team at the Princetitute, and in 1953 with IBM 701. The Yanks blasted ahead and never looked back. The rest of the world had joined in the game too. By 1953 there were 150 computer projects in about a dozen countries.[32]

The computer had arrived. It wasn't very speedy yet in the grand scheme of things. It would require the exponential "pace" of Moore's Law to take care of that in Epoch 2. But all the requirements for full Digital Light were finally and effectively in place—Fourier's waves, Kotelnikov's samples, and Turing's computations.

Digital Light

The Brits vied with the Yanks in the race for a fast memory device too. Luckily for Digital Light, both teams looked for *visible* vacuum tube memories. Both would store bits as spots of different sizes displayed on a two-dimensional grid. Hence each location was naturally both a one-bit spread pixel and a one-bit memory. The Brits won this skirmish, and then the battle, with an adaptation of an ordinary cathode-ray tube—the Williams tube. The Yanks immediately adopted that solution too.

Genie in the Bottle

The business card computer, or any universal Turing machine, has an infinite tape for its memory. It can store an infinite number of patterns—of the countable, or digital, type of infinity. That's fine for an ideal machine, but a physical computer has to have a finite memory. But don't let that word *finite* mislead you. Even the first computer could remember an immense number of patterns.

The actual number is so large that it's meaningless. The funny number *googol*—a 1 followed by a hundred 0s—is a gross *under*estimate of the number of states that even little Baby had. (Google, the company, was named for the number, but the founders misspelled it.) The even funnier number *googolplex*—a 1 followed by a googol 0s—is a gross *over*estimate of the number of patterns in even the largest modern computer. But that range, between a googol and a googolplex, might give you a sense of the number of

possible patterns in a computer. Then on the other hand, upon keener reflection, you might see that it's just a ridiculously large number somewhere between two insanely large numbers. The truly important point is that the computer lets us puny humans deal with quantities of such vast size without thinking or even knowing about them—and it has from the very beginning.[33]

The founding engineers on both teams had to choose a practical memory device that could store all those many states. In both cases they settled on some variation of an electronic tube—for the sheer speed of it. The Brits, who won this game, chose to work with a cathode-ray tube, a CRT. Before the Great Digital Convergence, the CRT was a familiar device. We celebrate the Great Digital Convergence with this book, but one consequence of it was the death of analog television. Until then, a CRT was the giant glass bottle in every TV set in every home. The flattened end of the bottle was the television screen. In those olden days, TV was affectionately called "the tube."

Then the engineers had to devise a way to move bits through the tube, a digital use of an analog device. It's common knowledge that electric current is a flow of electrons, and that copper wire forms a good pathway for it. Woven through each of our homes is a network of copper wires guiding electric current to all those wall outlets. But it's not so well known that electric current can also flow through a vacuum—through nothing.

That's exactly what happens in a cathode-ray tube. The electron "gun" is a heated piece of metal that emits electrons and "shoots" them from the thin end of the tube to the far, fat, and flat end. If there was air in the tube, the electrons would collide with its molecules, change direction, and lose energy. To ensure no such traffic jam takes place, all the air is pumped out of the tube, making it . . . a vacuum tube. The high voltage propels the electrons from one end to the other. We call the heated piece of metal a *cathode*, the current of electrons shot from the gun a *cathode ray*, and the whole package a *cathode-ray tube*.

But we can't see electrons. A CRT has to have something else that converts electrons to photons—to visible light. That something is a coating on the flat end of the tube that phosphoresces—emits light—when it's struck by electrons. The coating of so-called *phosphors* absorbs energy from the electrons and emits photons. A phosphor glows when it's shot by an electron gun. The higher the energy of the cathode ray, the more photons are emitted and the brighter the glow. The glow is brightest at the center of the ray and drops down smoothly with distance from the center. It has the necessary shape, that is, to be a decent pixel spreader.

The reason this works as a memory device is that the glow persists for a short time after the cathode ray ceases to send electrons. During that interval (one-fifth of a second, say) the bit represented by the glow is "remembered." It can be used until it

decays. And by methodically repainting, or refreshing, the spot before it decays (five times per second, say), we can automatically make the memory last as long as we wish. We human users see only that a spot gets displayed on the screen and stays there. I will sometimes say that a spot gets *written* to the screen or *painted* on the screen, but both mean the same thing as *displayed* on it.

But a glowing spot only at the center of the screen is boring. What's missing is a way of painting light anywhere on the face of the tube. We need to bend the cathode ray so that its electrons land on the screen anywhere we want a glow, not just the center. For Digital Light we need to be able to paint an array of spread pixels.

Luckily, an important property of a moving electron is that its path will bend as it passes through a magnetic field. Just as a light ray bends when it passes through a glass lens, a cathode ray bends when it passes between the poles of a magnet. Magnets mounted near the electron gun of a cathode-ray tube do the trick. One magnet does the left-right deflection of the ray, and another the up-down. Combinations of the two can bend the cathode ray to any desired position—and do it fast. Electric fields are often used instead of magnetic fields, but it's the same idea.

Calligraphic versus Raster

With the aiming mechanism, whether electric or magnetic, you can scribble the cathode ray over the face of the tube, or you can paint out a nice regular pattern. A cathode-ray tube used in scribble mode—write anywhere you wish, and in any direction—is a *calligraphic* display, from the Greek for *beautiful handwriting*. The cathode ray paints the script *S* (figure 4.8, left) just as you would write it. The intensity of the ray is constantly high. It paints the right *S* (in figure 4.8) calligraphically too, by dropping spots *along* the curve—and specifically *not* on regularly spaced grid points. The spots in this case aren't spread pixels. They're just spots, and they could have various shapes and variable spacings. The Sampling Theorem says nothing about them. And because it doesn't, calligraphic displays—despite their grace—didn't make it into the new millennium.

Another kind of display works like this: the cathode ray methodically paints out a rectangular plot—one left-to-right row after another, top to bottom, like tilling a field. It's called a *raster* display, from Latin for *rake*. In figure 4.9, the ray paints the *S* on the left in raster order, but smoothly along each row. Old analog television—"the tube"—used this method. But again, there were no pixels involved so this method also didn't make it into the new millennium. But a modification of it did: The ray could only paint at regular grid locations along each raster row. The ray paints the *S* on the right in figure 4.9 with spots of specific shape and fixed locations on a grid. They are, in fact, spread pixels, as demanded by the Sampling Theorem.

Figure 4.8

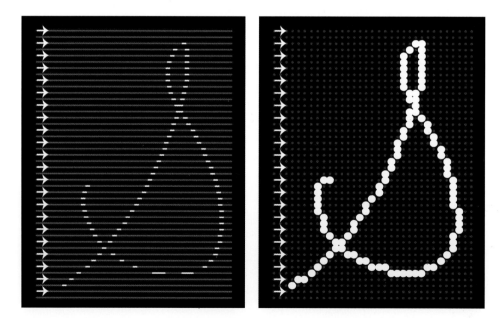

Figure 4.9

The calligraphic versus raster distinction was a big one in early Digital Light. You can see why. The calligraphic displays are seductively graceful. But despite their grace, they didn't use the concept of the pixel, which was key to the future. The Great Digital Convergence of media types into the one medium of bits also forced the convergence of display types into just the one based on pixels—the raster array or grid. It's not at all obvious from the picture (above right) that this should work, but the text you're reading is an example of how well it does. The Sampling Theorem made raster displays with spread pixels as beautiful as calligraphic display with smooth strokes.

It's worth remembering that all modern displays are intrinsically analog. What we see is smooth and continuous, despite being driven by digital and disconnected pixels. The act of display is what makes the separated pixels visible as a continuous field of light and color. As we saw in chapter 2 on sampling, spreading the pixels at the moment of display restores the original visual scene that those pixels represent.

The enabling assumption of the modern digital world is that there'll always be a raster display available to make our pixels visible. We users never need be aware of the nasty details of the actual display devices. The only reason we pay attention to those details here is because the first displays were the first memories.

The Williams Tube Wins

The Brits won the memory race with the Williams, or Williams-Kilburn, tube. But strictly speaking, Williams and Kilburn didn't invent a new kind of tube. They invented a *technique* for using a standard cathode-ray tube. Their computer memory was a CRT that used the Williams-Kilburn technique for bit storage. It stored a bit as a small spot (0) or a larger one (1) that could be seen on the face of the tube, painted there by a cathode ray (and made visible with glowing phosphors). The ray would scan the screen of the tube in raster, or raked, fashion, left to right and top to bottom. The bits were located at regularly spaced locations along each row of the raster—seeds in a tilled field.

The Yanks weren't idle. Unaware of Williams and Kilburn at first, von Neumann's team sponsored a serious attempt at building the first memory tube. They pinned their hopes on Selectron, a tube to be designed and delivered by a division of the Radio Corporation of America. Vladimir Zworykin headed the division, with Jan Rajchman his chief designer and engineer. We met Zworykin in chapter 3. He attended the fateful meeting with von Neumann where *programming* became a word. In fact, the meeting took place in Zworykin's office at RCA, and Rajchman was there too. Zworykin had already played a major role in the 1920s and 1930s in the invention of television.

Zworykin's group designed Selectron to store a bit as a spot (1) or the absence of a spot (0). And the bits could be seen as a raster array of spots (or not spots) through

the clear glass of the tube. But Selectron was much more complex than an ordinary cathode-ray tube. Its development took a long time—fatally long.[34]

It's a pleasing coincidence that early computers on both sides of the Atlantic planned to use memories that were visible. That didn't have to be the case. A bit doesn't have to be visible to work as memory—most modern bits aren't. Notably, Turing's Pilot Ace featured an invisible memory, a mercury delay line in which a 1 was an acoustic pulse, as in a sound wave, that traveled relatively slowly through a pipe filled with mercury. It was "remembered" while it traveled. In the delay line a 0 was no pulse. The sequence of pulses in a delay line recycled through the pipe. What came out of the end of the pipe was reintroduced automatically to its beginning, making the memory of the bits in the pipe last as long as they were needed. The bits in the vast memories of today's computers are also invisible. They're buried deep inside silicon chips. The fact that bits were sometimes visible and arranged in rectangular arrays in the first days of computers gave Digital Light an early launch.

The Williams tube was such an important step that both teams eventually went with it. Within one month of Baby's birth, the Yank Julian Bigelow, Maniac's main hardware engineer, visited Max Newman in Manchester and saw the Williams tube in action. The von Neumann team had held out for Zworykin's Selectron for a long time. But once Bigelow understood how simple it really was to store and read a bit on a cathode-ray tube, they jumped Zworykin's ship and went completely with Williams tubes. They used 40 of them for Maniac's main memory. On the Yanks side, nearly all the first-generation progeny of the Edvac report adopted the Williams tube, including importantly, IBM 701, the first in Big Blue's computer dynasty.

Big Blues: Freddie Williams Outwits IBM

America's IBM (with von Neumann as a consultant) was just getting its feet wet in the computer world as the Williams tube won the memory race. Thomas J. Watson was poised to assume the company's chairmanship. He'd famously created the slogan "THINK" that was now pervasive throughout IBM. Concerned about Baby and its child Mark I, the company invited Williams to its New York headquarters in July 1949. They asked him how it was that a team of "two men and a dog" had managed to build a machine in Manchester more advanced than anything they, the mighty IBM, had done. Williams replied in his no-nonsense manner—one can imagine a twinkle in his eye: "Well, we had an idea for storage and then pressed on regardless and built a computer around that store without stopping to think too much." The assembled IBM personnel gasped, then shrieked with hysterical laughter when they realized that Watson wasn't in the room.

The story Williams told was accurate. Computers *are* rather simple—especially a small computer called Baby. And the simple Williams tube had outraced the complex Selectron. Brit brains *had* beat out Yank brawn in this case.[35]

Baby Monitor

The actual display on a computer that used a Williams tube memory was *not* the Williams tube itself. It could've been—barely. The bits on a Williams tube screen are electric charges from the electron gun made visible with phosphors. But a working Williams tube requires that a "collector plate" cover the screen. The collector plate closes a circuit in the electronics so that the charge—the one that causes the phosphors to glow—can be detected by an electronic circuit and used in the next computation. We say that the circuit *reads* the presence and quantity of the invisible charge. The circuit reads the charge but can't see the phosphors. We humans read the glowing phosphors but can't see the corresponding charge.

The collector plate on Baby's main memory tube was made of gauze, or a fine wire mesh, so you could actually see the bits through it—barely. It doesn't matter because the precious Williams tube was hidden away to protect it from stray electric charges— from a passing motorcycle say—that could corrupt it. The invisible electric charge on the collector plate was more important to the engineers than the glowing phosphors on the screen.[36]

Another cathode-ray tube displayed the bits that were stored on the face of the hidden Williams tube. This was easy. Every time a row of the Williams tube was read (say, five times per second) it was directly copied to the corresponding row of the display tube. The display tube wasn't a memory, just an exact visible copy of the glowing, hidden screen of the memory. Since it was for display only, not computation, it didn't have to be protected from passing motorcycles. We use such a display to observe, or monitor, a memory, and we call it a *monitor*.

Strictly speaking, the first bits were the first spread pixels, but the engineers hid them under electrically protective cover. The spread pixels were there but unseen—the proverbial trees falling unheard in a forest. They really only became visible to humans when they were displayed on the monitor.

Notable Exceptions

Wilkes's Edsac at Cambridge was a notable exception to the broad Williams tube victory. In fact, it didn't use a visible memory at all—not even potentially visible. Like Turing's Pilot Ace, it used mercury delay lines.

But Edsac engineers wanted to see what was in the mercury delay lines, so they also devised a monitor. An electronic circuit converted the train of pulses proceeding through a delay line into a set of spots painted on a cathode-ray tube screen. The electronics took the string of pulses in a delay line and folded them into rows of spots—from one long row (512 bits) to a tilled rectangle of shorter rows (32 bits each). It then simply painted the spots on the monitor screen in the usual cathode-ray tube manner—in a raster array. This monitor made the Brits' Edsac in England's Cambridge another player in the race to Digital Light. Notice that the monitor *could* just as well have been a single long row of lights, not a two-dimensional array. It was a pleasant accident that the technology of monitors led to the raster display.

The Yanks' Whirlwind, at MIT in America's Cambridge, was another notable exception to the Williams tube blitz. Jay Forrester's team there improved on the Williams tube idea to meet the higher speed demands of Whirlwind. They created a competing memory that nevertheless stored bits on a cathode-ray tube, like a Williams tube. It seems, however, that they never intended to use the memory tubes for picture display.[37]

Because it took a long time to perfect this Williams-like "electrostatic memory," Forrester and his team used what they called "test storage" for Whirlwind's memory device. Most of it was toggle switches! Humans "wrote" the toggle switches. Whirlwind could read them but not write them—a read-only memory, in computer jargon. The team devised a special monitor to display the contents of the test storage.[38]

Although shy of being a full computer, and tedious to program, the test configuration of Whirlwind was first used successfully on August 19, 1949. I'll call the test configuration Whirlwind– ("Whirlwind minus"), because it was less than the intended Whirlwind, which was supposed to be a full stored-program computer. It's unusual to break it out separately but important to do so in the history of Digital Light.

At this point in my quest, I discovered a treasure trove—the Whirlwind photographic archives. They weren't located at MIT, where I expected to find them, but at the secretive MITRE Corporation in nearby Bedford. Krista Ferrante, a company archivist, welcomed me on October 11, 2016, to one of the most exciting and rewarding days I spent while researching this book. She'd prepared for me a cart filled with boxes of carefully catalogued photographs. There were lots of them. The early Whirlwind users hadn't apologized at all about making pictures. Krista and I sorted through them delightedly for hours, and I was able to pick out the breakthroughs among them.

Here's an unheralded example (figure 4.10), perhaps the first digital picture from the Whirlwind project. It was created in June 1949, with hand toggling probably, since even Whirlwind–, the almost Whirlwind, wasn't quite ready to program. The initials

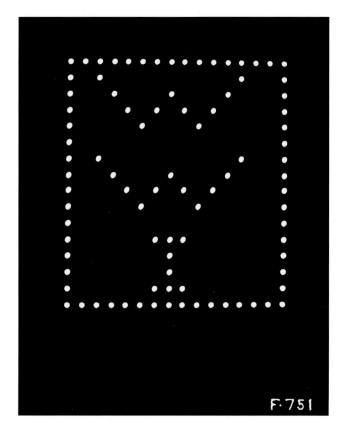

Figure 4.10

stand for Whirlwind I, the full official name of the computer-to-be, which was declared officially complete in April 1951.

To determine which memory location corresponded with a spot on the display, an MIT engineer, Bob Everett, invented a "light gun" that could interact with the display and cause a spot to turn off. It's erasing (figure 4.11) selected spots, or spread pixels, to make a slightly later digital picture, this photo dated April 1952. It was an early Yank interaction with a digital picture, but not as early as the Brits, as we'll see shortly.[39]

The Calligraphic Breach

In September 1949 a "Special Display" was added to Whirlwind–. It was a cathode-ray tube too. This *oscilloscope*, as they called it (borrowing the name from an electronic engineer's tool), could paint a spot at any point on its two-dimensional screen. It wasn't restricted to raster grid locations. The spots were written on the face of a tube,

Figure 4.11

but Whirlwind– couldn't read them. That is, they weren't part of its memory. And they weren't an image of its memory's bits either. The oscilloscope wasn't a monitor like Baby's or Edsac's. It was purely a graphic display device—the first on a computer. *Every image on a graphic display device is an intentional two-dimensional picture.*

This was a significant development in Digital Light. It allowed you to create a picture from an invisible description, or *model*, that was stored in a computer memory. This is what we mean by *computer graphics*.

Whirlwind– programmers, led by Charlie Adams, started to make pictures in late 1949 with programs stored in the test memory of mostly toggle switches. Figure 4.12, of a parabola and a quartic curve with axes, was made on May 18, 1950, and is typical of early pictures on Whirlwind–. The model for each of these pictures was stored in the form of a mathematical equation.[40]

Most of the Whirlwind– pictures were two-dimensional. But figure 4.13 shows two pictures depicting three-dimensional surfaces, probably for the first time, made on

Figure 4.12

Figure 4.13

Figure 4.14
Image courtesy of the Computer History Museum.

March 6, 1950. They give a brief glimpse of pictures to come, but it's worth noting that they aren't in perspective. That fundamental advance was over a decade away, awaiting its Brunelleschi.

The oscilloscope was a calligraphic device. It could paint a spot at *any* point on the screen, coming from any direction and with arbitrary spacing, not just at regularly spaced sampling locations along horizontal lines. That's just another way of saying that these spots were neither bits nor spread pixels. Thus began the calligraphic versus raster split of Digital Light. The main line of computer graphics—a major division of Digital Light—would proceed from this calligraphic branch about a decade later. It would be subsumed by the raster branch at the millennium and the Great Digital Convergence.[41]

Early Contenders

Harry Huskey intended the digital image in figure 4.14 to be a picture. It's from another computer with a Williams tube memory, but this one was a Yanks' machine. Huskey, its engineer, isn't easily pinned down as Yank or Brit because he first worked on Eniac in America, then on Turing's Pilot Ace in England. Then he returned to America and built a machine that he called Zephyr—as advertised here—modeled on von Neumann's Edvac.

I met Dr. Huskey in 2013 when he was installed as a Fellow at the Computer History Museum in Mountain View, California. He was 97 years old. He recalled that it was late 1948 when he manually toggled the bits for this image into a Williams tube memory, using the same technique as Kilburn. This third digital picture was made

Figure 4.15

early in the development of Zephyr. The computer was renamed Swac and dedicated in August 1950.[42]

The Yanks' Selectron effort in 1948 didn't succeed in time to serve as the memory for von Neumann's Maniac. But it's still a player in early Digital Light because an unknown person toggled a picture (figure 4.15) into Selectron by hand. It shows the initials RCA, followed by a line of four dots, for RCA Laboratories, where Zworykin and Rajchman developed Selectron. Rajchman was particularly important in the effort, so he might have created the picture.

J. Presper Eckert, an Eniac and Edvac team member, made another Yank effort toward a visible memory in 1946. He and his team tried to store bits on a cathode-ray tube,

Figure 4.16

and succeeded, but they failed to maintain the bits long enough to constitute a serious memory. The Eckert effort was yet another skirmish in the Yanks versus Brits battle for the first electronic memory, and the Yanks lost again.[43]

Although Eckert failed to build a visible memory of his own design, he got one working as soon as he learned of the Williams and Kilburn result. Herman Lukoff, an engineer in Eckert's group, pushed buttons to enter his initials "H L" into the memory for an endurance test. Lukoff created this picture sometime between December 1948 and March 1949, although we have no photo of it. This memory, however, was never used in a computer.[44]

Calligraphic versus Raster Goes Public

Turing's March 1951 programming manual for the Ferranti Mark I contains the photo shown on the left in figure 4.16. Kilburn presented it at a computer conference held in December 1951. The right half of this photo (with the stairsteps) is perhaps a digital picture created under program control, but it is crude and unconvincing. Its left half is incidental nonsense showing the state of memory bits but has no two-dimensional coherence and is definitely not a digital picture.

Participants at the same conference were also treated to an early calligraphic picture from Whirlwind, as seen in the righthand photo in figure 4.16. This picture was definitely generated from a program. These were the only two digital images in the proceedings of the conference. They publicly announced, in effect, that the calligraphic

Illustrating the type of display which can be shown on the monitor tubes when the Computer has checked a stage of its operations. Other displays are in the form of curves, charts, etc.

Figure 4.17

versus raster split had begun. The Whirlwind picture, at least, qualifies as an example of computer graphics because a stored computer program used an internal model to drive a display (whether calligraphic or raster). The model in this case was the mathematical equation of a seventh-order polynomial—succinct, abstract, invisible. The photo provides further evidence that the Whirlwind team in the early 1950s was starting to make pictures.[45]

Digital Light Gets Serious

This composite of two images (figure 4.17), as well as its caption, comes from a December 1952 marketing brochure for the Ferranti Mark I. As the caption makes clear, the business potential of pictures was finally dawning on this early manufacturer. Pictures

were serious after all. We know that the checkmarks picture was program-generated, because Dai Edwards, part of the original Manchester team, told us so. It was probably programmed by Dietrich Prinz, a Jewish immigrant from Berlin to Manchester in 1938, just in the nick of time.[46]

And Not So Serious: First Videogames

Games have been with us since the beginning of computers. More generally, *interactivity* has been with us that long. It's striking that play has driven innovation in computers since the dawn of Digital Light and that we've insisted on interacting with our most sophisticated machines since we first met them.

Christopher Strachey ("Stray chee"), a fellow student of Turing's at Cambridge, tried to run a checkers program—draughts, in British English—on Pilot Ace. He told Turing that it worked in a letter on May 15, 1951. Then Strachey learned of the much larger memory on Mark I at Manchester, child of Baby. Surely the fact that the memory was visible also impressed him. He had his program recoded for it, and it was running on Ferranti Mark I, the commercial version, by July 9, 1952, at the latest—using Turing's programming manual.[47]

"He had written the manual himself and when I got a copy I could see why it was famed for its incomprehensibility," said Strachey of Turing. "People just weren't used to reading accurate descriptions and this was exacerbated by Alan's slightly irritable assumption that everyone was as intelligent as himself."

The successive states of the checkerboard were displayed on the computer's Williams tube. Figure 4.18 shows six of Strachey's original pictures. They came from a computer under stored-program control.

Strachey's draughts program is a contender—the best so far documented—for the first videogame. But there were several computers built in the period from 1950 to 1952, and any one of them might have been programmed for games (or still pictures or animations). There are certainly anecdotal contenders, as we'll see.

Chess was never a contender, although Turing was a well-known fan of the game. So was Claude Shannon who visited Turing in Manchester in 1950 to talk about it. So was Dietrich Prinz, who joined Ferranti early in Manchester. And so was Strachey. The game was too hard for computers then, but Prinz was able to program a part of it, the endgame (within two moves of a checkmate), in 1951 on Ferranti Mark I. Although he was probably the programmer who generated the checkmarks image (figure 4.17), there's no evidence that his chess program used a visual display.

Two close contenders for the first videogame appeared on Cambridge's Edsac. A November 1952 Cambridge PhD thesis by Stanley Gill described a simple program in

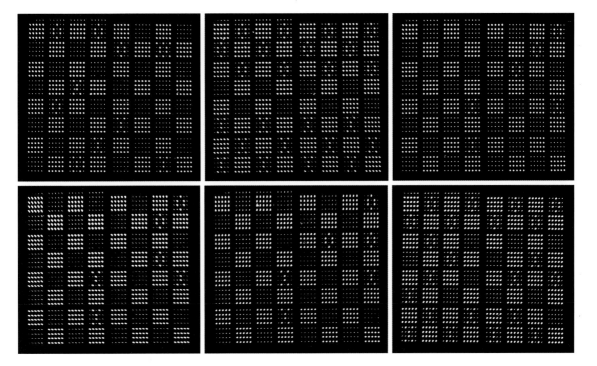

Figure 4.18

which a sheep approaches a pair of gates in a fence. Edsac displayed a vertical line for the fence, we're told, with an upper gap or a lower gap for the gates. A horizontal line was drawn opposite the gate that the program predicted would open. The light beam of Edsac's paper tape reader could be interrupted by a player's hand wave to open the top gate. Otherwise the lower gate opened. The graphics—if not the play—of sheep and gates would have been about as unsophisticated as that of the much later Pong videogame. Alas, nobody took photos.[48]

Alexander Shafto "Sandy" Douglas did take photos (figure 4.19) of his game creation. He programmed tic-tac-toe—noughts and crosses, in British English—into Edsac circa 1952 but before March 1953. These three pictures are originals that he took from the computer's monitor. Using conservative estimates similar to ones I've made in other soft date circumstances, Gill's November 1952 wins over Douglas's March 1953, making them the creators of the second- and third-known videogames. With the same argument, checkers takes priority over sheep and gates (American English), and draughts nudges out noughts (British).[49]

Figure 4.19

At any rate, the parabolas displayed as successive points on the oscilloscope screen represent solutions of the original differential equations for different sets of initial conditions.

Figure 4.20

The Bouncing Ball: Possibly the First Animation

The Brits had the first documented digital pictures and interactive videogames. Surely they had early animations too, because it's clear that Baby could animate. But oddly no evidence of any animations on early Baby has surfaced—not even anecdotes. Both Baby and Edsac did display sequences of digital images, but they were only incidental contents of memory.[50]

There may have been an animated Highland dancer on Edsac, but the only evidence is an anecdotal report. As far as we know, the Yanks had the first documented computer animation in the sense of intentional temporal sequences of two-dimensional pictures. This was on MIT's Whirlwind.[51]

The Whirlwind programming manual, published on June 11, 1951, featured a "bouncing ball display." A sketch (figure 4.20) of the oscilloscope display follows a

F·1415

Figure 4.21

textual listing of the program itself, written by Charlie Adams. The dots were displayed in time succession, according to the caption. This was apparently the first documented computer animation, but it might have been just a still picture rendered slowly—without careful control of time. Each dot, once displayed, simply decayed to give the appearance of a bouncing ball—well, a bouncing dot anyway.

I'll go with, as usual, the conservative publication date June 11, 1951, for the "official" date of this picture, and possibly the first animation. It's supported by an official Whirlwind photograph (figure 4.21) dated December 13, 1951.[52]

I bother with this picture because of its influence. Adams stated that it was "probably the most widely seen demonstration of Whirlwind, before electrostatic storage became operational." Meaning Whirlwind–, in other words. Adams and his colleague Jack Gilmore, who joined him in October 1950, modified the bouncing dot ("ball") into a sort of game (figure 4.22). And they added a "thunk" sound at every bounce, so this version was definitely an animation.[53]

The players would interactively alter the frequency of the bounces with the winner being the first to make the "ball" go through a hole in the floor—a gap along the horizontal axis—with a different sound. The earliest known picture of this "game" is this Whirlwind photograph dated June 1953.[54]

The published code doesn't show that this was a cycling program that awaited the next player's move—in other words, that it was truly interactive. It appears instead to

Figure 4.22

have been a program that was restarted each time with a different set of three initial conditions (the set shown in the hand-drawn figure in 4.21) entered via toggle switches. It's tempting to make the stretch that this constitutes interactivity anyway and call this an early videogame. Some have. It's certainly a form of play. The "game" encouraged MIT students to persist in the tedious process of programming Whirlwind–.[55]

First Definite Computer Animations

The bouncing dot was eventually an animation, if not in June 1951 then by June 1953. But the first two verified *and dated* computer animations did appear on Whirlwind, in 1951. One was raster and the other calligraphic.

Edward R. Murrow's television show *See It Now* on December 16, 1951, featured two Whirlwind animations. The show began with the raster animation shown in figure 4.23. The words HELLO MR. MURROW were rendered in spread pixels. Each column of spots in a word successively brightened and then darkened, presumably under computer control. (The picture at right is a simulation.) The other animation (not illustrated) showed a moving dot that traced out the parabolic trajectory of a missile. The picture was painted calligraphically, one spot at a time along the curve, and left no trail. It was the first bounce of a moving "ball."[56]

Figure 4.23

The mathematician Martin Davis told me a story that establishes another early animation by the Yanks, definitely on a pixel-based display. Davis was briefly debugging code at the University of Illinois in the spring of 1952. The computer he worked on was Ordvac, yet another child of Edvac. It became operational in the spring of 1951. Just like Maniac, it had 40 Williams tubes and a monitor that could be switched to display any one of them. Davis reports, corroborated by his wife Virginia, that someone had written a program that displayed the message HELLO VISITOR! THIS IS THE ORDVAC. The letters were the height of the monitor, so the message was too long to be seen at one time. Instead, it was revealed as the message scrolled across the monitor. This early computer animation was therefore created sometime between spring 1951 and spring 1952. Conservative dating puts it at spring 1952.[57]

In the same anecdotal category is a report from Richard Merwin, who had worked on Eniac, then on Maniac (another descendant of the Edvac report) at Los Alamos, then on IBM 702. Dick and I were members of an IEEE delegation of computer scientists who were invited to spend a month in China in 1978, not long after Richard Nixon's groundbreaking visit there and before China opened its doors to tourism. At a memorable moment, as our bus was passing the Forbidden City, Dick told me about the first computer animation he'd ever seen—a wine bottle pouring its contents into a wine glass—displayed on a Williams tube in the early 1950s. The animation he described could have been on Maniac but was probably on an IBM 701 sometime in 1952 or 1953, or later on the IBM 702, the version he worked on. I call this an anecdote because at the distance of 40 years I suspect my memory of the fine details, and Merwin

is sadly no longer alive to confirm them. Perhaps it's conflated with another version I heard from the graphics pioneer George Michael of the Lawrence Livermore National Laboratory: the IBM 701 computer in the early 1950s used an animation of a beer bottle pouring its contents into a glass as a memory check for its Williams tube memory. And the computer graphics pioneer Robin Forrest reported yet another variation: "It is claimed that one clever programmer managed to write a program which caused an animation of water flowing into a glass to be displayed."[58]

Naive Sampling

You might object that First Light isn't a picture, because it is text: C.R.T. STORE. But text is a picture by any reasonable definition. Each image is exactly—in terms that will become familiar as we proceed—a *rendering* of geometrically defined letters and numerals into pixels, just as a modern animated movie is a rendering of geometrically defined characters into pixels.

The jagged nature of the pictures is unpleasant. Kilburn made them naively, without the Sampling Theorem. It's doubtful he'd ever heard of it. Kotelnikov's first statement of it in 1933 was in Russian, and Shannon's English popularization of it wouldn't appear until 1948. Turing knew the Sampling Theorem as early as 1943—consistent with Shannon's claim that it was generally known in the field—but Turing hadn't yet arrived at Manchester when Kilburn created First Light, the first digital picture. And there's no reason to think that Turing, no matter how smart he was, ever thought about applying the Sampling Theorem to visual fields.

With only one bit, or two values, per pixel, Kilburn's attempt was as good as you could do, naively or not. There simply weren't enough pixels—and not enough bits per pixel—in his Williams tube memory to accurately represent a smoothly defined, sharp-edged object like a letter. In frequencyspeak, the placing of the pixels was nowhere near (twice) the highest spatial frequency in the letters. Not only were these the first pictures, but they first demonstrated the difficult problem of "jaggies" that had to be solved to make Digital Light successful.

All of the first pictures, videogames, and animations—except the calligraphic pictures at MIT—were ad hoc conversions of simple geometrical objects—letters, numerals, lines, curves, and squares—into one-bit pixels. They were naive renderings—with no awareness of the Sampling Theorem. Nobody was yet aware of the ultimate importance of sampling, the idea that would eventually allow the Great Digital Convergence. That's why I don't mind confusing, at this early stage, the calligraphic display used discretely by Whirlwind people with raster displays used by the others. Calligraphic displays were part of our naive childhood.

Figure 4.24

With naivete in mind, the 1760 sampler in figure 4.24 (left) suggests an objection to the early history of Digital Light sketched here. (By the way, *sampler* seems eerily appropriate but comes from an entirely different meaning of the word—a sample of one's work, Elizabeth Laidman's needlework in this case.) Why isn't this a precursor of Digital Light? Why isn't any textile or tapestry that carries a picture? Or any mosaic, such as the one in figure 4.24 (right) that portrays an image built of regularly spaced tiles? Any of these is a picture formed from a naive sampling—without the Sampling Theorem—just like First Light.

Well, they were antecedents to digital pictures and precursors of Digital Light. There's no question about that. They were *remembered*, for one thing, in permanent memories of thread or tile. There were surely thousands of similar precursors spread over centuries, even millennia. But there was no obvious technological path from their discrete samples to today's modern pictures—such as the words you are currently reading. The next section is about a more serious contender for the first pixels.

Figure 4.25

Teletype Pictures

The *teletype*—a machine for typing at a distance—is an old idea, also known as a *teleprinter* or a *teletypewriter*. (Strictly speaking, Teletype is a trade name.) Basically, it works when an electrical signal is transmitted to a typewriter-like machine that turns the signal into a letter by typing its key on a sheet of paper. There is a unique signal for each available letter.

By our definition of a digital picture, an arbitrary typed message isn't a digital picture because there is no intent that it be a coherent two-dimensional picture. But what about the case where the typed letters are arranged in two dimensions with full intention that the result be perceived as a picture? Figure 4.25 shows two examples, one of the Madonna and Child and the other of Dag Hammarskjöld, who became the youngest UN secretary-general in 1953. Note the overprinted characters, which were easy to accomplish with a teletype.[59]

The question is: If the unique signal is digital bits, then can we construe it as a pixel, and then construe the typed letters as a display element for that pixel? This is not a casual question because the signals arguably became digital in 1874 when Émile Baudot (pronounced "boh Doh") designed a "five-unit" system that we would identify

today as a 5-bit coding scheme. Both pictures above were probably specified in Baudot code originally. The gray value of a glyph display element (including those formed by overprinting alphabetic characters) is roughly the relative amount of black to white in the rectangular area occupied by the glyph.[60]

Hundreds, perhaps thousands, of such images were produced over the years—a goodly percentage of them nudes—and passed around among fans, first via telegraph and then via ham radio. Ham operators would drive a teletype with the incoming signals, print the picture, and simultaneously punch a paper tape. The paper tape became the memory from which multiple copies could be struck or sent to friends—for a Christmas greeting, say. So this was a common underground method for making pictures before there were computers—that is, before 1948—and for more than a decade after, when computers were still rare and expensive. Examples are the Madonna and Child from 1947 and the Hammarskjöld from 1962.[61]

The teletype art era straddled the birth of the computer and was quickly and easily adapted to the computer world. New codes were developed for teletypes that supplanted the Baudot code and became the codes with which computers talked to printer terminals—such as teletypes. That overlapping history forces us to contemplate the definition of Digital Light. It raises this definition-stretching question: Before computers existed, were the teletype codes the first pixels?

Not quite. Because of the naive sampling and the crude reconstruction, we can think of them as early predecessors of the pixels of Digital Light. But because the memory system was paper tape, not electronic memory, they don't fit the definition of Digital Light. To be consistent with the other definitions in this book, we insist that electronic computer memory be involved.

First Use of the Sampling Theorem

In the 1950s, 1960s, 1970s, and even the 1980s naive sampling was rampant—and so were calligraphic displays that weren't based on sampling at all. It wasn't until the 1960 to 1970 era of Digital Light that we began to see the first hints of the Sampling Theorem applied to the computation of pixels. These early efforts featured horizontal softening at the edges of geometric shapes, or glyphs, that were used to annotate pictures. In jargon, this was *horizontal antialiasing*.[62]

If sampling is done at less than the rate required by the Sampling Theorem, then the unrepresented higher frequencies appear in the result as a visual noise called *aliasing*. *Antialiasing* is a solution to the aliasing problem, a way of getting rid of the unpleasant jaggies, as aliasing is familiarly called. The correct application of the Sampling Theorem requires computational horsepower, which is why early uses of

Figure 4.26

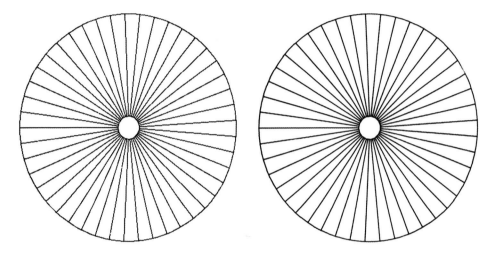

Figure 4.27

it were built into hardware. Implementing it in software awaited further power from Moore's Law.

The first explicit and full antialiasing—in both dimensions—of a geometric model was probably what we see in figure 4.26 by Richard Shoup at Xerox Palo Alto Research Center in 1973 (but see the annotation for a possible 1971 predecessor). The jagged lines are at the top, and the antialiased versions at the bottom.[63]

Shoup (sounds like *shout*) also made in 1973 the tour-de-force wagon wheel pictures shown in figure 4.27 (jagged on left, antialiased on right). He didn't explicitly use the Sampling Theorem for any of these pictures, but the smooth results attest that his method was equivalent. They are composed of 8-bit grayscale pixels and have an old-fashioned video resolution (roughly 500 pixels wide each).[64]

The first explicit use of the Sampling Theorem for spatial antialiasing was at the University of Utah. Thomas Stockham, a digital audio expert there, taught the Sampling Theorem to a generation of early computer graphics pioneers in the 1970s. Utah

student Ed Catmull showed antialiased pictures in his 1974 doctoral dissertation. Another student there, Frank Crow, brought Stockham's teaching to the computer graphics community in his 1976 doctoral dissertation and subsequent publications.[65]

No matter how you parse the history, it's clear that Digital Light was born simultaneously with the birth of computers. First Light was created in utero with Baby. The first pixels were literally bits of the first computer memories. The crucial years were from 1947 to 1952. There may have been a hiatus of one or two years between the first test pictures on Baby's memory tube and the first intentionally program-generated pictures on a stored-program computer. Even so, by 1951 pictures were being made on computers with pixels under stored-program control. These pixels were derived, naively, from geometric models, typically of letters, digits, or other simple shapes. Some of the models were interactive, and some were animated. The true and full use of the Sampling Theorem probably began in the early 1970s.

The pixel unifies the history of all Digital Light, including computer graphics, videogames, image processing, digital photography, apps or operating systems interfaces, digital television, animated movies, virtual reality, and so forth. From this vantage point the several decades-long use of calligraphic displays in computer graphics can be seen as a detour. The large increase in density of display elements on displays and the vast Moore's Law improvements in computation speed permitted raster displays to subsume calligraphic displays and return Digital Light to its raster roots. The collapse of displays into the single raster kind finally enabled the Great Digital Convergence of various visual media. And the Sampling Theorem is the magic that underlies the pixel.

We are now ready to apply and devote the three great ideas—frequencies, samplings, and computations—to two technologies, one old and one new. The old one is the movies. One reason to revisit the history of film movies is to give us the vocabulary that Digital Light would adopt. Creating a digital movie inevitably depended on and derived from the existing technology of film and animation. But the principal reason is to demonstrate how the great idea of sampling works for understanding not only pictures but also moving streams of pictures. It turns out that movie technology depends on the Sampling Theorem too, even though nobody knew it at the time. The Sampling Theorem gives us a better way to think about film. And we'll meet several new heroes and tyrants and revisit mistold stories. The second application of our fundamental ideas will be to Digital Light itself, the new technology of the single new medium.

5 Movies and Animation: Sampling Time

Absolute continuity of motion is not comprehensible to the human mind. Laws of motion of any kind only become comprehensible to man when he examines arbitrarily selected elements of that motion; but at the same time, a large proportion of human error comes from the arbitrary division of continuous motion into discontinuous elements.

—Leo Tolstoy, *War and Peace*[1]

Origins are slippery things, figuratively and literally, and the cinema is possibly the most slippery medium that has ever existed. . . . Origins are shrouded in a mixture of forbidding taboos and driving curiosity, and constitute a troubling concoction of claims to power and ownership (often spurious, always simplified): myths of inevitable progress; national pride; and simple misinformation. Faced with the snake-pit of claims and counterclaims, pure egotism and obfuscation that marks accounts of the origins of cinema one might just throw up one's hands.

—Tom Gunning, introduction to Mannoni's *The Great Art of Light and Shadow*[2]

Movie history is even more contentious than computer history. Many Americans believe that Thomas Edison invented the movies—else it was that unpronounceable Eadweard Muybridge. The French are convinced it was their own Lumière brothers. What's certainly wrong is to simplify so complex a technological achievement. Like movie credits at the end of a film, there are *always* many contributors who are fundamental to a magnificent production. It's never just the director, lead actor, or screenwriter, say. And certainly not the money man or chief marketer. No, the true story of cinema is a briar patch, thornier than that of computers.

There are several metaphorical connections between those two worlds, but the real connection is sampling. Kotelnikov taught us how to sample an audio stream into soxels and a visual field into pixels. But the *flow* of visual fields into our eyes can be sampled too. The familiar name for a sample of visual flow is *frame*. And we call a sequence of frames a *movie*, or a *motion picture*. Visual flow—visual fields that change in

time—is all music too. The great ideas of waves and sampling apply. Then the notion of computation—Turing's great idea—applied to frames (and pixels and soxels) brings us the full glory of Digital Light.

In short, we can accurately represent changing visual fields—what our eyes actually see—with discrete snapshots taken at regular intervals. Each sample is the still picture presented to our eyes at that instant. We can ignore everything that happens between the frames because, upon display, the samples are spread by a movie projector into a continuous flow that accurately represents the original visual flow.

The catch is that none of the men (they were all men) who invented the movies knew this. Nor does the system that they created work in quite this beautiful way. The Sampling Theorem didn't exist—not for another half century. So the inventors created movie technology entirely naively, and it bears the scars to prove it. Flaws from that clumsy youth, locked into the system a century ago, still abide. Digital Light didn't just spring into existence. It inherited its historical past.

In this chapter we take discrete samples of the history of cinema and reconstruct from them a more coherent history—a more honest, less hagiographic one. The tyrants of movie history were businessmen instead of emperors or dictators: Leland Stanford to Edward Muybridge, Thomas Edison to William Kennedy Laurie Dickson, and Walt Disney to Ub Iwerks. In all these cases (and there are more), the dominator was fundamental to the success of the dominated—and vice versa. Both mattered. And we find that many myths—how Muybridge fathered the cinema, Edison invented the movies, and Disney created Mickey Mouse—turn out to be wrong.

Weird Eadweard

He was Teddy Muggeridge at first. Or perhaps Eddy. We don't know his mum's actual endearment, but he certainly wasn't Eadweard Muybridge until much later. That name was the last—and the weirdest—of his many aliases. Officially he was Edward James Muggeridge, born in Kingston upon Thames near London. This table captures the name game that this notable showman worked on the public—with variations of his first name used with variations of his surname:[3]

1830–55	1855–56	1856–62	1862–65	1866–68	1869–1904
Muggeridge	Muggridge	Muygridge	Muybridge	Helios	Muybridge
Edward James Ted Edward	E. J.	E. J. Edward James	E. J.		Edward Eduardo Santiago Eadweard ('82–'04)

He'll always be Edward Muybridge (pronounced simply "My bridge") here because he did his greatest work—the work that matters to Digital Light—under that alias.

He had come to America as E. J. Muggridge—with a *gg*. He had become E. J. Muygridge—with a *yg*—by 1860 when he boarded a Butterfield Overland stagecoach from California bound for the East. He didn't make it. The transcontinental railroad that was so important to his future would've been a far better choice—but it didn't exist yet. As it was, the six Butterfield horses spooked somewhere in Texas along the famous staged line, and he was thrown from the coach. He suffered sufficient bodily—and perhaps mental—damage to sue Butterfield and win a settlement. He was still Muygridge in 1861, now returned to England, when he tried to patent a washing machine. He was first Muybridge—with the *yb*—in 1862 in another English patent application, this one for a printing process. Oddly, he never tried to patent his most important invention—the Zoöpraxiscope—which was yet to come. (The names of movie devices are as much fun as those of computers.)

His most colorful alias was Helios (just the one word). He assumed the name in San Francisco as he set out to be a new kind of artist, a photographic artist, near the time when John Muir first championed California's marvelous Yosemite Valley. Helios—the photographer as sun god—made some of the earliest, and acclaimed, photographs of mighty Yosemite.

It was his murder trial that brought him notoriety—as Mr. Muybridge again, now Edward Muybridge. An all-male jury acquitted him of gunning down his wife's lover—and his child's probable father—near San Francisco. There's no question that he killed the man—point blank to the chest with a pistol that he fully intended for the purpose. Despite the judge's admonition, the jury wasn't about to find a man defending his "honor" (!?) guilty of murder in post–Gold Rush California.[4]

Muybridge affected the weird Eadweard only later in life, at age 52, as he made a name for himself in the art world of Paris. He took it surely from the famous coronation stone (figure 5.1) in his hometown, Kingston upon Thames. Two kings named Edward had been crowned on that stone in the 900s. Embossed in its base twice is *Eadweard*—the Old English spelling. So Muybridge's final first name was just "Ed ward," despite the pucker-provoking transcription.

Between Helios and Eadweard, plain Edward did his memorable work. His patron, Leland Stanford, gained outrageous, robber-baron wealth from construction of the first transcontinental railroad—the iron horses that railroaded the Butterfield stagecoach and its fleshy horses into oblivion (or onto a manicured oval track). The major legacy of his vast fortune was, of course, Stanford University, from which Silicon Valley would spring (in the 1960s) as a hotbed of Moore's Law. But in his own time, Stanford spent heavily on racehorses—his passion—particularly trotters.

Figure 5.1

Figure 5.2

Edward Muybridge, under that name, famously stopped one of Stanford's favorite trotters in mid-trot with a single photograph showing all four hooves off the ground. Received wisdom is that Muybridge proceeded from there to invent movies. It credits him with the first demonstration that a sequence of still photographs of a moving object, such as a horse—or a naked man or woman—taken in quick succession appears to show the object in motion, when projected at similar speed. But this story isn't quite so.[5]

What he actually did was this. He built a 24-camera apparatus on Stanford's farm— The Farm, as Stanford students call the campus today. He used a clever triggering mechanism to open the shutter of each camera in quick succession as a horse raced by. Each camera formed a single photographic image on a glass plate coated with a chemical emulsion. The plates had to be developed immediately on site.[6]

To show the results he took the well-known magic lantern that public speakers used to project still images—the PowerPoint of its time. He added to it a rotating disk larger than an old long-playing (LP) record. He placed small paintings, each derived from successive horse photographs, around the edge of the disk, as shown in figure 5.2 (left, with the shutter at right). As the disk rotated at a more-or-less uniform speed, the projected images appeared to move, recreating the movement of the horse. One complete cycle took about one or two seconds.[7]

Muybridge showed this supposed first movie in Leland Stanford's San Francisco mansion on January 16, 1880. But there are several problems with this claim. For

instance, he didn't project photographic frames. They were paintings derived from photographs. And he modified the paintings with a certain amount of distortion—horizontally elongated legs and bodies—to accommodate a distortion artifact of his projection system. And he didn't have a movie camera, only a sequence of still cameras, each with a slightly different point of view. And, finally, only he could use the system, as it was fixed in place. It's too large a leap to say that a system that didn't have a motion-picture camera, didn't use film, and didn't project photographs was a movie system. Like the almost-computer, his system was at best almost-cinema, and that's a stretch.[8]

And Muybridge wasn't anywhere near the first to show movement from stills, either photographic stills or silhouettes derived from them. The Zoëtrope, popular in the 1860s and 1870s did that (figure 5.3). Imagine a cardboard cylinder about a half foot high and two feet in diameter. If you turned on a light inside the box, and if you were small enough to fit inside, you would see a sequence of pictures around the circumference of the cylinder, their tops aligned. Each picture would be one from a sequence, let's say of a horse taking successive steps during a trot. Of course, you can't fit inside the cylinder, so to allow you to peer in from the outside, slits are cut in the walls between each picture. Through each slit you see one picture positioned on the opposite wall. If you were to walk around outside of the cylinder, you would see that each slit reveals the next picture, the next part of the horse's trot. Now imagine that you view the cylinder from a fixed position outside as it turns. Between the slits, you see darkness. You see a picture only when a slit rotates into position. It's the picture directly opposite, which is the next part of the horse's trot. So, as the cylinder rotates at the proper speed you see a succession of pictures, all apparently in the same location, across the cylinder from your eye. From this succession of samples, you perceive a horse moving in a trot. You probably recognize that this is more-or-less how film movies work, too, with the dark parts of the drum serving as the shutter. Figure 5.3 was drawn by William Kennedy Laurie (W.K.L.) Dickson—a name worth remembering.[9]

The pictures in a Zoëtrope could be photographs or paintings derived from photographs. If you omit the requirement that the images originate as photographs, then the Chinese invented the Zoëtrope almost two millennia ago. And the images in a Zoëtrope weren't restricted to horses.[10]

Nor was Muybridge the first to project sequences of images. Athanasius Kircher was doing that in 1671, or at least writing about it. The proviso about writing is necessary because Kircher placed the lens on the wrong side of the slides (figure 5.4), something he would've noticed had he actually built the projector. Implementation is where the rubber meets the road for ideas.[11]

Figure 5.3

Later in this chapter we'll proceed from live-action films taken in the real world to animated movies made of unreal worlds. Muybridge's original contributions are more pertinent, surprisingly, to animated movies. Animators of the last century derived cartoons from film by tracing in ink, frame by frame, over humans or animals captured in motion on photographic film. This technique, called *rotoscoping*, is what Muybridge did for his supposed first movie.

Animators also famously distort their cartoons—with techniques called squash and stretch, exaggeration and anticipation—to accommodate for the low naive sampling

Figure 5.4

rate of movies. Muybridge stretched the horses in that supposed first movie (or had the work done for him). Look carefully at the images on the Muybridge disc. So he can more properly be remembered as the first to use rotoscoping and stretch, an accomplishment a bit shy of inventing cinema.[12]

If you think about it, Muybridge's most truly memorable legacy are those marvelous static arrays of sequential photographs of moving nudes and animals, still pervasive today as postcards, posters, or albums of his collected works. They are arrayed left to right and top to bottom like the raster of pixels in a digital image.

Animators hold these Muybridge rasters in high regard. In the early 1920s two young pals, Ub Iwerks and Walt Disney, learned from them as they launched their fledgling animation business. And animators still honor them today. Figure 5.5 is a spoof—and high tribute—by Pixar animators. Muybridge famously proved for Stanford that all four feet of a horse leave the ground in one frame, while this "recently rediscovered work" establishes that the one foot of a Luxo desk lamp leaves the ground for four frames.

Some writers have accused robber-baron Stanford of stealing credit from Muybridge, but inspection of the record indicates otherwise. Several decades ago, while browsing

Plate 1292. Child Lamp Hopping *Eadweard Muybridge ca. 1889*

Figure 5.5
© Pixar.

an antique bookstore, I discovered a large plush book from 1882 titled *The Horse in Motion*. I leapt at it believing it to be the original Muybridge study that was famous to anyone interested in animation.

But it wasn't—not exactly anyway. For starters, the author wasn't Muybridge. It was J. D. B. Stillman, whom I'd never heard of. Opening to the title page, I found that Leland Stanford had indeed funded the publication, as expected. Where was Muybridge? I soon found him, as "Mr. Muybridge," prominently displayed in the very first paragraph. An appendix "furnished by Mr. E. J. Muybridge" described his technique. And "Mr. Muybridge" appeared in the very last paragraph too, thus embracing the entire book.[13]

It's clear from the main text that Stanford and Stillman simply didn't care about photography. The movement of horses was the important thing to them. Muybridge's photographs served less as works of art than they did as works for hire—call them a

Figure 5.6

means to an end. Stillman does mention the artistic import of the work, but he meant only the accurate rendition of horses by artists. The horses were the thing. So why did Muybridge sue Stanford over this book?

By the time of its publication he had gone to Paris and crowned himself the noble Eadweard (figure 5.6, right). He announced to the artistic community there that he had invented a new artform and was a buddy of tycoon Stanford (figure 5.6, left). He wowed them with horses and men in motion. He was a leonine marketer of projected movement, and he was lionized. He also had convinced Isaac Newton's Royal Society in England to accept his paper *On the Attitudes of Animals in Motion* and schedule it for publication. But then Stillman's book appeared with the mere work-for-hire mention and Stanford's claim that it was his own idea to film a horse in motion. Importantly, Muybridge's name wasn't on the title page. The Royal Society reneged on the offer to publish the paper, suspecting plagiarism. Muybridge was humiliated. Some of his new fans thought he was a fraud.[14]

And he lost the suit. It all seems so misguided now. Stanford was all about the horses. Muybridge was all about the photographic technique. It *was* Stanford's idea in 1872 to film the horse in motion—an idea re-inspired by an 1874 *Popular Science* article

about the work of Étienne-Jules Marey in France. But it was Muybridge's invention that made it possible. It's a tower versus stinks battle in a different guise—the idea versus the engineering. Stanford gave full credit for the photographs—to the man he had hired for the task. In fact, he signed away the intellectual property rights for the technique to Muybridge—for a dollar. He completely missed the potential import of the technique, both artistically and financially.[15]

Nevertheless, the wealthy Stanford made it possible—with name recognition, money, equipment, and space—for Muybridge the inventor to show the world that rapidly shot sequential photographs projected in the same quick sequence give the illusion of motion. Stanford paid for it—paid a lot—without ever understanding exactly what it was that he had funded. It wasn't about the horses. And flamboyant Muybridge successfully marketed the idea far and wide—perhaps his most important contribution to cinema. "The father of cinema" seems way off the mark for him, but "the Johnny Appleseed of cinema" fits nicely. In particular, his show inspired Thomas Alva Edison's interest in motion pictures in America and influenced Marey in France. And that's the first glimmer of the Yanks versus Franks contest to come.[16]

Defining a Movie

A careful definition of *computer* helped us prune the thicket of historical claims in the story of computers. It cleared the path to Digital Light. We can employ the same technique for cinema history.

Let's also use another approach that worked for computers: separate hardware from software. For cinema, the movies themselves are the software. In fact, the software alone is what we usually mean by "the cinema." We can see *Citizen Kane* on film, television, or cellphone. As usual, the magic lies in the software—the Chopin étude in a piano. But a fundamental notion of this book rests on an appreciation of our modern media culture that itself depends on an intuitive understanding of its technological underpinnings—on seeing marvels and beauties in both realms. Since there are a host of books on movie software—the cinema—we concentrate on the underappreciated hardware.

But before heading too hastily toward hardware, let's notice a curious thing about cinema software. Although a movie projector moves along film in one direction only, software stored on the film can make viewers perceive events that jump backward in time (flashbacks, *The Irishman*) or forward (say ten years later, or millennia even, *2001: A Space Odyssey*), or in infinite loops (*Groundhog Day*), or as repetition with change (*Rashomon*). It's as if movie software computes on our brains what it can't compute on movie hardware.

There's no single word for that hardware, the hardware of cinema. Classic cinema has three separable pieces: camera, film, and projector. By saying *movie machine*, we mean all three—as if they were in one black box—and that's our definition. A movie machine is for cinema what a computer is for computation. Anything less is, at best, an *almost movie machine*—like the *almost-computer* of the last chapter. Since hardware is implicit here, I often drop the word *machine* and use the terms *motion picture* and *cinema* interchangeably with *movie*.[17]

So, when we ask who made the first movie, we don't mean the first content. We mean who had the first movie machine—the first camera, film, and projector working together as one system. That's what we meant by a movie, hardware-wise, most of last century, and it still means that today. In Digital Light, we have digital cameras, store digital frames, and project them with digital projectors.

Why Do Movies Work?

It's not obvious that movies should work. Movies are not smooth like the visual flow into our eyes. The camera records only 24 snapshots of each second of visual flow, and discards everything that happens between frames—but we perceive flow anyway. We see stills, but we perceive motion. How can we explain this?

An Ideal Movie

What could a movie system be like if we invented it today, as part of Digital Light, starting with the Sampling Theorem? The answer seems straightforward: sample a visual flow into frames at twice the highest temporal frequency in the visual flow, then use a good spreader during projection to spread the frames back into a smooth visual flow— just as we turned pixels into a single still picture.

Let's take that description apart. First, what are the frequencies in a visual flow? What are the waves that Fourier would use to represent it? We have to understand that before we can apply the Sampling Theorem—the sample-at-twice-the-highest-frequency business. We also need to decide what "the highest frequency" in a visual flow means. Then we have to figure out what "a good spreader" is for projected frames. What does spreading a frame mean?

For audio the waves are sound waves. For a still visual scene the waves are the undulating corrugations of light intensity shown in the Fourier chapter. Recall the intuitive analysis of my succulent garden in Berkeley. It took some practice to start "seeing" the rhythmic spatial waves that make up that visual scene. It takes practice to "see" the waves in a visual flow too.

Here are some exercises to help you see them. Watch a man walk by. Or a woman jog by. His motion is cyclic, and so is hers. That's the first evidence of a wave in the Fourier version of the flow that's streaming into your eyes. Suppose the man is placing a foot once every second, or one complete step every two seconds. Then there must be a wave with frequency one cycle per two seconds (equivalently, one-half cycle per second) in the wave version of the flow. Suppose that the woman is jogging twice as fast as the man walks. Then there must be a wave of frequency one cycle per second in the wave version of that flow into your eyes.

Other examples are: A stream of cars moving down a street. Spinning wheels on the cars. Pumping bicycle pedals. Lips in a Bronx cheer. Waving goodbye. The hands of the conductor of a symphony orchestra. A bouncing ball.

It's a giant leap from these to Fourier's magical idea, but let's take it: everything you see in the visual flow into your eyes is the sum of, and only of, visual waves, and the stuff of a visual wave is light intensities that wiggle rhythmically in both space and time.

In the Fourier chapter we visualized the waves that make up a visual scene—a still picture—as corrugations, each with a wave cross section. That is, a cross section of a corrugation looks like the wave traced out by a clock's second hand. Luckily, we don't have to actually see waves of a visual flow—of a moving picture—in order to use them. That's good, because a Fourier wave of visual flow is a four-dimensional thing, quite difficult to picture. Nevertheless, let's try. Figure 5.7—showing half of one temporal cycle and four full spatial cycles—is an attempt to show one such wave, but it requires some imagination.

Consider the topmost corrugation in the figure. It has a frequency and an amplitude as usual. A small arrow indicates its amplitude. Notice that a copy of that arrow has been pushed out to the far right, then rotated ninety degrees. I'll return to that rotated arrow soon.

The amplitude of the corrugation changes with time, which advances down the page. Furthermore, the amplitude changes smoothly with the rhythm of a clock's second-hand wave. But I can't draw that. Instead, I call for your imagination.

Imagine that you're looking at a single corrugation, but as you watch, the height of its wave varies, with the rhythm of a wave. Another way to say it is that, as you watch, all the troughs get simultaneously deeper, then simultaneously shallower, then simultaneously deeper, and so on, and the rhythm of that pulsing is the rhythm of a wave. Drawing a single picture of that animation in your mind's eye is the task. Frankly, for the purposes of this book, the animation in your mind's eye is good enough. It is *one* Fourier wave of the variety needed to represent visual flow.

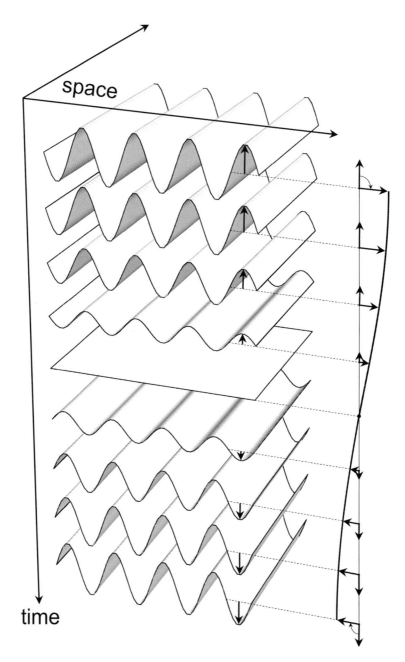

Figure 5.7

Nevertheless figure 5.7 tries to capture that animation. It represents the pulsing corrugation in your mind's eye with nine corrugations—nine frames of the animation, if you will—at equally spaced moments in time. I call on your imagination (again) to place a corrugation at every moment between each pair depicted. The problem is that an analog infinity of them is required.

A small arrow shows the amplitude of the corrugation at a particular moment. Copies of these small arrows are pushed to the far right and rotated as described earlier. The curve that connects the tips of the rotated arrows is a wave. When you imagine inserting a corrugation between any pair depicted, use as its amplitude the corresponding point on the wave at the right.

In summary, a single Fourier wave for visual flow varies as a wave (or corrugation) in space, and it varies as a wave in time too. Each point on this pulsing corrugation is a light intensity. It's wiggling spacetime Jell-O with the rhythm of a wave in all three dimensions.

So that's one wave. Now imagine a whole family of them, each rippling through space with a particular frequency and amplitude, and each pulsing through time with another frequency and amplitude. That's asking a lot. You can understand why practitioners simply use the math that succinctly says the same thing. By Fourier's great idea, a complete visual flow is a sum of such perfect waves, of many frequencies and amplitudes (and directions and phases). A visual flow is spacetime music.

The Sampling Theorem—Kotelnikov's great idea—says that we need to take a sample, or frame, at twice the highest temporal frequency in the visual flow in order to represent the flow accurately. What could that highest frequency be? The full naivete of the early creators of cinema becomes obvious at this point. They just guessed. They had no notion of highest frequency. The cost of film concerned them most, not the accuracy of representation. The higher the frame rate, the more film they had to use. So it was economically smart to use as low a temporal sampling rate as they could get away with. The nascent film industry rather rapidly settled (by the 1920s) on 24 frames per second, where it's been for about a century.[18]

But in an ideal world, what's the highest frequency in visual flow that we should care about? Recall the rule of thumb, in frequencyspeak, that a very sharp edge in a visual scene has very high frequencies. We remove any too-high frequencies by a slight blurring of the scene before sampling it into pixels. Otherwise sampling fails, and we get annoying artifacts—like the stairstepped edges called jaggies.

The same is true of visual flow—visual scenes changing with time—and the same trick works. A sharp "edge" in visual flow is a sudden change in direction of movement. Think of that man walking by again. Suppose he is swinging his arms. The moment

that his arm swings all the way back, then reverses direction to begin the swing forward, is a moment of visual flow edge. Or consider a bouncing ball. The moment of bounce is a sharp edge in visual flow. Those edges should be "rounded off" before the sampling of visual flow into a movie of frames can work accurately. In other words, temporal frequencies that are too high must be removed. Failure to do so creates annoying artifacts—like wheels that appear to spin backward. We'll spend time on that problem shortly.

Ideal Movie Reconstruction

How would an ideal movie projector reconstruct a visual flow from discrete frames? As already suggested, it could be done using the Sampling Theorem in direct analogy with how a display device reconstructs a visual scene from discrete pixels. A display spreads each pixel with a pixel spreader—through space—and adds up the results. An ideal projector would spread each frame with a frame spreader—through time—and add up the results. So, what's a frame spreader?

Figure 5.8 (top) reminds us of what the ideal spreader of the Sampling Theorem looks like. In the case of soxels (audio samples, or sonic elements), this *is* the spreader—in time. In the case of pixels, this is a cross section—in space—of the ideal pixel spreader. In the case of movie frames, it's a cross section—in time—of the ideal frame spreader.

This ideal spreader cannot be realized in practice because it's infinite in extent. Those wiggles go on forever in either direction. The approximation in figure 5.8 (middle) is the one we used in the Kotelnikov chapter for good reconstruction of a visual scene from pixels.

But even this approximate spreader doesn't work for the old-fashioned, analog movie world because of those two negative lobes—the two dips below the horizontal line. We don't know how to make projector light go negative (less than black) so we can't realize the frame spreader above. We could, however, use the approximation in figure 5.8 (bottom).

Since spreading a frame is a new idea to most, let's step through what this spreader shape means. Time advances to the right in the next figure, figure 5.9, and the dot at the center of the horizontal line represents the current frame time—the moment of maximum illumination of that frame by the projector. The dot left of center represents the preceding frame time—when it reached its maximum illumination. The dot right of center represents the next frame time—when it will reach its maximum illumination. And so forth. In detail, the projector light comes up gradually during preceding frame times (represented by the dots to the left of center). It reaches full intensity at the instant of the current frame time (the dot at the center). Then it dies off gradually

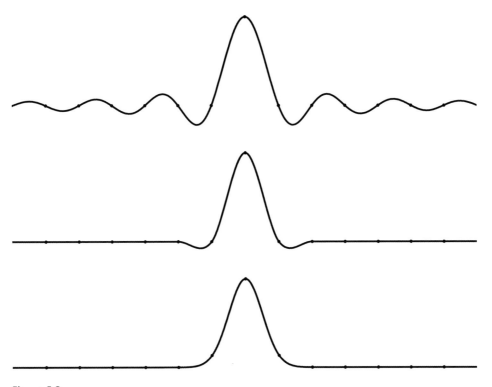

Figure 5.8

during subsequent frame times (dots to the right of center). That's what it means to spread a frame in time.

As you might recall, reconstruction from samples is done by applying the spreader to all samples and adding up the results. This is the tricky part because now we're spreading in time instead of space. This means that while viewing the current frame, we're still seeing the previous two frames and are starting to see the next two frames. Because good spreaders overlap, the ideal projector illuminates several frames simultaneously. It adds the contributions together at the projection lens and hence onto the screen. The moment chosen (the vertical line in figure 5.9) occurs just before maximum illumination of the current frame. At that moment, illumination of the preceding frame has dropped to about one-third full intensity, and of the frame before that to nearly zero illumination. At the same time, the illumination of the frame following the current one is just starting to come up. The frame after that isn't lit at all yet. So four frames contribute to the projected image at the chosen instant—the current frame, of course, but also additions from the two before and the one after.

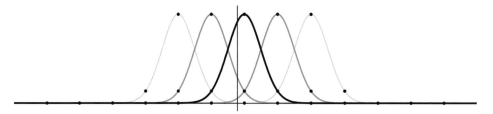

Figure 5.9

Here's the surprise: No such film projector has ever actually existed. Sampling theory informs us that there could have been a beautiful perfect movie system. Such a projector could have reconstructed a smooth visual flow. Our eyes evolved to perceive the world presented just that way. It's not what we had, but the exercise tells us what we could have had and what we should be asking of cinema in the digital age. There's no reason such a system should not exist.[19]

Real-world cinema was actually a crude approximation of that ideal system—and it was close enough to do pretty well. Let's see how it worked, warts and all.

How Movies Were Really Done

What did the inventors of cinema do (or not) to make the system they gave us so non-ideal? First, they didn't give us instantaneous samples as required by sampling. Film frames are fat. They have duration. The camera shutter is open for a short exposure time. A moving object moves during that short interval, and so smears slightly across the frame during the film exposure time. It's like what happens when you try to take a long-exposure still photo of your child throwing a ball and his arm is just a blur. This turns out to be a saving grace of cinema as it was actually practiced.

Second, they made it so each frame is projected twice (at least) by the projector. Ouch! That's not sampling at all. Why did the inventors do that? Simple economics demanded it: 24 frames per second costs half as much film as 48 frames per second. But the eye needs to be refreshed about 50 times per second, or the retinal image fades between frames. Actually, 48 is close enough to 50 to work in a dark theater. How do you get 48 from 24? You show each frame twice! If you show just 24 frames per second, the screen appears to flicker. Hence the "flicks" from the early days of cinema before higher frame rates were adopted.

The third thing the original inventors did was to shut off the light between projected frames. This meant that 48 times per second, nothing (blackness) was projected into the eye—inside the pupil, onto the retina. It's convenient for movie machines—both

the camera and projector parts—to "shutter" to blackness like this between frames. It allows time for the mechanical advancement of the next film frame into position. In a camera, it keeps the film from recording the real world during the physical advancement of the film. In a projector, it keeps the moving film out of eyesight as it's physically advanced.

When you ask how a movie projector works, some people say something like this: There's a top reel of film which is the source of film, and a bottom take-up reel. The film moves from reel to reel and passes between the light source of the projector and its lens, which magnifies the frame-size image up to screen size. In other words, the film moves continuously past the light source. But that doesn't work. The eye sees exactly what's there, and with this scheme the eye would see one frame sliding away as the next frame slides in from the opposite side. It would see the sliding. And that won't work.

What a projector actually does is exactly this: It brings each frame into fixed position with the light source blocked. That's the function of the shutter. Then the shutter opens and the illuminated frame projects onto the screen. Then the shutter closes. Then it opens again, and the illuminated frame is projected a second time onto the screen. Then the shutter closes and the next frame slides into position, and so forth.

We've just described the discrete, or intermittent, movement of film through a projector, as opposed to unworkable continuous movement. The same idea holds for a camera. The physical device that implements this action is called, in fact, an *intermittent movement*. This is the key notion in cinema history that is comparable to the conditional branch instruction in computer history. The mad rush to the movie machine turned on who first got a projector to work correctly, and that hinged on who got an intermittent movement working properly. It's a defining notion.[20]

To recap: An actual film-based movie projector doesn't reconstruct a continuous visual flow from the frame samples and present this to the eye. Instead, it sends "fat samples"—thick with time duration and smeared motion—directly to the eye's retina. It sends each frame twice, and it sends blackness between. It's up to the brain to reconstruct motion from these inputs. How does that work?

Somehow the eye-brain system "reconstructs the visual flow" that's represented by the fat visual samples it receives. Of course, it really does no such thing. Light intensities come in through the pupil as input. But the output from the eye to the brain, through the optic nerve, is an electrochemical pulse train. Neuronal pulse trains aren't visual flows. It could be that the retina actually does reconstruct a visual flow and then converts it to pulse trains for brain consumption. The responses of some of the neurons in the eye certainly suggest the spreader function, complete with a high positive hump and negative lobes. But brain activity is beyond the scope of this book. Let's

concentrate instead on the customary explanations of the perception of motion from sequences of still snapshots.

Perception of Motion

The classic explanation is hoary old *persistence of vision*. It's a real characteristic of human vision: once an image stimulus to the retina ceases, we continue to perceive the image there for a short while. But persistence of vision explains only why you don't see the blackness between frames in the case of film-based movies. If an actor or an animated character moves to a new position between frames then—by persistence of vision—you should see him in both positions: two Humphrey Bogarts, two Buzz Lightyears. In fact, your retinas do see both, one fading out as the other comes in—each frame is projected long enough to ensure this. That's persistence of vision. But it doesn't explain why you perceive one moving object, not two objects at different positions. What your brain does with the information from the retinas determines whether you perceive two Bogarts in two different positions or one Bogart moving between them.

Psychophysicists have performed experiments to determine the characteristics of another real brain phenomenon, called *apparent motion*. The experiments don't explain how the brain perceives motion, but they do describe the limitations of the phenomenon. A small white dot on a black background is presented to a subject's retina. Then that dot is removed, and another dot is presented in a different position. The experimenters can vary two things, the spatial separation of the two dots and the time delay between position change. The brain perceives one dot here and another dot there, but only if the distance and delays are long enough. If the distance and delays are short, the brain perceives that the dot moves from one position to the other. It's *apparent* motion because no actual motion is presented to the eye. The brain perceives what it doesn't see.

Motion Blur

Persistence of vision is such that we still perceive the first image when the second one arrives. That sounds a lot like frame spreading. A frame of short duration spreads out in time and adds to the next frame also spread out in time. It's as if the retina does the image spreading and the adding of successive spread frames. Something like this must be going on because we perceive a continuous visual field although the film projector doesn't present one. You can think of the shape of the persistence function of the eye as the shape of the frame spreader that's built into us human perceivers. Another reason we can assume that the eye-brain system must be doing a reconstruction, one that implicitly uses the Sampling Theorem, is because we perceive exactly the errors

we would expect if that were the actual mechanism—such as wagon wheels spinning backward.[21]

Classic cel animation—of the old ink-on-celluloid variety—relies on the apparent-motion phenomenon. The old animators knew intuitively how to keep the successive frames of a movement inside its "not too far, not too slow" boundaries. If they needed to exceed those limits, they had tricks to help us perceive the motion. They drew actual speed lines, which showed the brain the direction of motion and implied that it was fast, like a blur. Or they provided a *POOF* of dust to mark the rapid descent of Wile E. Coyote as he stepped unexpectedly off a mesa in hot pursuit of that truly wily Road Runner. They provided a visual language that the brain could interpret.

Exceed the apparent motion limits—without those animators' tricks—and the results are ugly. You may have seen old school stop-motion animations—such as Ray Harryhausen's classic sword-fighting skeletons in *Jason and the Argonauts* (1963)—that are plagued by an unpleasant jerking motion of the characters. You're seeing double, at least—several edges of a skeleton at the same time—and correctly interpret it as motion, but painfully so. The edges stutter, or "judder," or "strobe" across the screen. Those words reflect the pain inflicted by staccato motion.

Live-action movies are sequences of discrete frames just like animations. Why don't these movies stutter? (Imagine directing Uma Thurman to stay within "not too far, not too slow" limits.) There's a general explanation that works. It's called *motion blur*, and it's simple and pretty. A frame that's recorded by a real movie camera is fat with duration. It's not a sample at a single instant like a Road Runner or a Harryhausen frame. Motion blur is what you see in a still photograph when the subject moves and the shutter isn't fast enough to stop the motion. In still photographs, it's often an unintended result, but it turns out to be a feature in movies. Without the blur all movies would look as jerky as Harryhausen's skeletons—unless Uma miraculously stayed within limits. The motion blur of moving objects in a fat frame gives clues to the brain about what is moving and what is not. The direction of a blur gives the direction of motion, and its length indicates the speed. Somehow, mysteriously, the brain converts that spatial information—the blurs—into temporal information and then perceives motion with the help of the apparent motion phenomenon.

Why Do Wheels Spin Backward?

Those of us who grew up on old Western film movies saw backward-moving wheels clearly then. Stagecoach wheels occupied large patches of screen real estate—and long snatches of screen time—because there were lots of chases. Bandana-ed banditos were

forever in pursuit of the stage carrying a month's payroll in gold. Disconcertingly, the wheels clearly rotated at the wrong speed, and often even backward.

Television is a sampled medium too, so we continued to see the wheels spin backward when television came along, featuring Westerns as a big part of early afternoon programming. Even today many car commercials exhibit wheels spinning at the wrong speed or even backward, but surprisingly few people see them anymore. Modern directors are clever about hiding them behind clouds of dust or conveniently placed plants and rocks. Or they drop into full slow motion as the wheels enter the center of the screen so they appear to rotate correctly. Or they do nothing. We've all seen the artifact so often that we simply don't "see" it now.

But why do the wheels spin backward? The Sampling Theorem is very clear. We must sample at twice the highest frequency contained in the motion being filmed. Working backward, what's the fastest motion that can be represented at 24 frames per second, the traditional sampling rate of movies? Something that changes no faster than 12 times per second.

Consider the front wheel of a stagecoach—like the runaway Butterfield stage that dumped Muygridge in Texas once upon a time. For convenience, let's say that it's 12 feet around and has 12 spokes. Each time the wagon moves forward by 1 foot, the wheel makes one-twelfth of a complete revolution and the next spoke revolves into the exact same place as the previous one. So, the wheel looks exactly the same after that partial revolution.

If a horse moved the stage at a speed of 12 feet per second, the wave in a Fourier wave version of the visual flow would vary at 12 cycles per second. This means that a movie, with 24 samples (frames) per second, can just barely represent a stagecoach moving at 12 feet per second. But that's only about 8 miles per hour. Any faster and the weirdness begins. Since a galloping horse can hit 25 to 30 miles per hour, those banditos will surely make the stagecoach wheels exceed this sampling speed limit. So even an ideal movie, working at 24 frames per second, can't accurately represent wheels moving faster than those in slow street traffic.

But we know that film movies work inside the brain somehow. That phenomenon of apparent motion our brains use to deduce motion from two still images can also perceive direction of motion. In the case of revolving objects, the brain takes two positions of the spokes and perceives the motion between them, especially if aided by motion blur. It decides the direction of motion from the relative positions of the two samples. It takes the shortest path as its assumption.

If a spoke in position 2 is clockwise from a spoke in position 1 and near it—only a small angular separation—the brain assumes the wheel is spinning clockwise. If near

it but counterclockwise, the brain assumes the wheel is spinning counterclockwise. Hence the brain can confuse forward and backward motion because it sees only samples, not the smooth visual flow between them.[22]

Since sampling is involved in both ideal and film movies, there must be artifacts at higher speeds. There's a price to pay if we fail to sample at (more than) twice the highest frequency in a visual flow. In frequencyspeak, the motion *aliases* into the wrong motion—such as spinning backward or spinning forward too slowly. It takes on a visual representation that's false—an alias.

A Flow Chart of Early Cinema Systems

No! Emphatically No! There is not, there never was, an inventor of the Living Picture.
—Henry Hopwood, *Living Pictures*, 1899[23]

As with computers, it takes a complicated flow chart to even begin to represent the early history of movie hardware. It too allows us to see the complicated relationships of people, concepts, and machines. It too is a simplification of the actual story. Many names, devices, and countries are omitted to reduce the confusion level, while enough detail remains to signal the actual complexity of the development of an important technology. As with computers, many of the other players and machines appear in the annotations.

The simplified flow chart of computer history in the previous chapter retained only those people and developments that mattered eventually to Digital Light. The equivalent simplification here (figure 5.10) is to follow only those systems that resemble the dominant movie system of the pre-millennial period—almost exactly the twentieth century (1895–2000). We relegate to "pre-cinema" those systems that were filmless or frameless—anything like the Zoëtrope or Zoöpraxiscope based on simple rotation.

A major simplification is the complete omission of photo-chemical film itself from this chart. Every system mentioned depended on it. Mastery of celluloid film was crucial to early movie systems. It was a difficult medium. It was brittle, scratched easily, rolled at the edges, and was chemically active. Inventors had to create film stocks with short exposure times and high resolution. Developing and printing them had to be rapid and reliable. It was a nightmare for the early inventors, but it matters not a whit for Digital Light, which substitutes bits for film.[24]

And again, as with computers, we invoke an Olympic metaphor to track the many players. The principal teams this time are the Yanks and the Franks. The players selected for this flow chart contributed to the rise of five powerhouse studios, Edison, Biograph,

The Birth of Cinema (Simplified)

Yanks

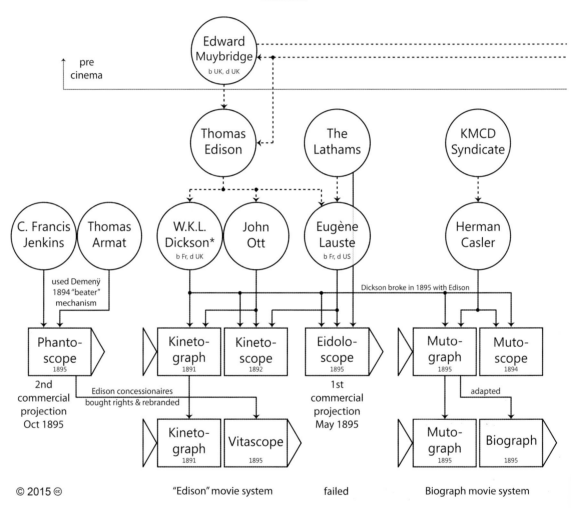

© 2015 ⓒⓒ

Figure 5.10

Franks

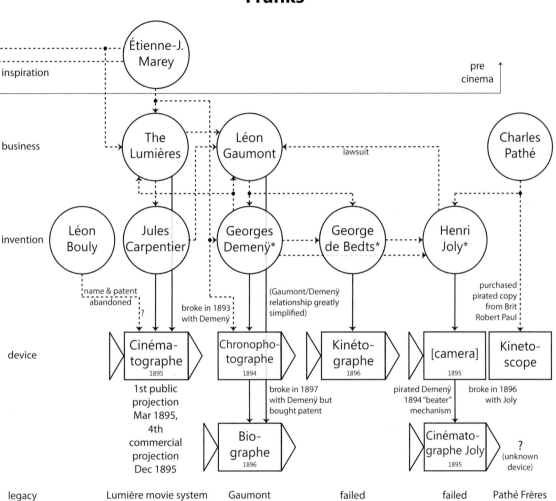

Lumière, Gaumont, and Pathé. A detailed chart that really showed all contributions to early cinema would necessarily show a host of other early inventors and devices, and it would feature at least two other countries, a Brits team and a German team.[25]

Perhaps the most intriguing omission is Louis Le Prince of France, England, and the United States. He made short movies in Leeds, Yorkshire, in 1888. They can still be found on the internet as digital reconstructions. In 1890 he boarded a train in France, apparently headed for Paris and ultimately New York to demonstrate his invention. But he never made it—not even to Paris. He simply disappeared. His family believed that Edison saw him as a serious competitor and had him removed—an unlikely event but indicative of Edison's tyrannical reputation. According to an affidavit, Le Prince had the first complete system of camera, film, and projector by 1889. But it doesn't matter because it apparently had no further effect on the development of cinema.[26]

The text that follows serves as an extended caption for the flow chart of cinema—first for the Yanks side and then for the Franks. But its overriding message is clear: the history it represents is complex, with overwhelming details. The corollary message is that we should immediately run up a red flag if we hear one name claimed as father of, or inventor of, cinema. The second principal message is that 1895 was The Year for movies, the way that 1948 was The Year for computers. And 1895 was The Year for the projector, and of the first realizations of full movie machines using strips of celluloid film.

The Yanks

> Edison's name and involvement guaranteed extensive media attention. . . . Not only did the machine [Vitascope] receive his complete approval, but the "Wizard of Menlo Park" stood ready to play the role of inventor assigned to him [even though he wasn't].
> —Charles Musser, *The Emergence of Cinema*[27]

Thomas Edison, the Steve Jobs of His Time

I was raised on the American hero story of Thomas Edison, so I was surprised to learn that it doesn't pass historical muster. The opening salvo came in 1961 from cinema historian Gordon Hendricks in a book whose title says it all, *The Edison Motion Picture Myth*. In the opening paragraph Hendricks stated his first goal: to begin "the task of cleaning up the morass of well-embroidered legend with which the beginning of the American film is permeated." His second goal was "to afford some measure of belated credit to the work done by W.K.L. Dickson." Subsequent historians of American film, building on Hendricks's careful research, have softened his attack on Edison somewhat,

while maintaining his emphasis on Dickson. And fairly recently, Paul Spehr, a cinema expert for many years at the Library of Congress, finally wrote the first scholarly biography devoted to William Kennedy Laurie Dickson. Although Spehr mentions "the issue of Edison's ruthless, even villainous side," he justifies Edison's business practices as consistent with the times. Nevertheless, what remains of Edison falls far short of the heroic figure I thought him to be when I was a child.[28]

Edison loved to be called the Wizard of Menlo Park, and the American public gladly went along with it. He established a wonderful environment for invention and business. Menlo Park, New Jersey, was the location of one of Edison's fabled labs. Eager young inventors flocked to work with him. He was a superb marketer of his labs and of himself, and he was happy to be the personification of all the inventors there who actually did the work. And he made a lot of money. When his inventors weren't up to the task, his business partners bought the patents of others, replaced their names with Edison's, and smashed competition in the patent courts. Some of his initially naive inventors—notably Dickson—finally noticed their continued omission from the credits and parted ways with their patron, sometimes not amicably.

The sentence-by-sentence parallels with Steve Jobs, the cofounder of Apple, are enlightening. A morass of well-embroidered legend is fast forming around him too. After being ousted from Apple, he cofounded his second company, Next, in Redwood City adjacent to Menlo Park, California. His sale of Next to Apple gained him readmission to Apple, which he famously turned around by superbly marketing the inventions and designs of its eager young creators—which he claimed as his own. The claims weren't necessarily direct, but just like Edison, he never denied the credit when an adoring public or his own marketing department assigned it to him. He pounded his competitors with patents and made a lot of money. We could easily call Jobs the Wizard of Menlo Park West for establishing a rich, supportive environment for bright inventors and taking credit himself for their inventions.

As a case in point, Jonathan Ive—now Sir Jonathan Ive—designed the iMac, iPod, and iPhone. It wasn't Jobs. But Jobs did interact closely with Ive and strongly supported him. Those devices came about from the efforts of both, and many others. Of course, Jobs was a genius at marketing the Apple products—the company's Johnny Appleseed. But, like Edison, one of the main products he marketed was the myth of himself. As this book makes clear, it's always wrong to give just one person all the credit for a complex technological achievement.[29]

Muybridge was another great marketer—in *his* Johnny Appleseed role. With great showmanship, he sold the notion of projected moving pictures worldwide, although he himself didn't have a system that was sufficiently advanced to exploit the excitement

he produced. His sales pitch struck Edison with particular strength. It set Edison to thinking about a better way to make movies.

The two men met a couple of times in 1888 on one of Muybridge's many speaking tours. The idea was to marry Muybridge's improved magic lantern, the Zoöpraxiscope, to Edison's popular phonograph product—and get talking pictures. As subsequent work by Dickson showed, this wasn't a well-thought-out idea. In fact, successful talking pictures wouldn't appear for decades. But it was a good idea.[30]

Edison quickly deduced that Muybridge's approach—even ignoring the audio component—wasn't viable. Muybridge didn't have a reasonable movie machine. For one thing, it was clear to Edison that a movie of only a couple seconds duration wasn't going to work once the initial thrill wore off. So he immediately set out to sketch a better idea. Literally. He submitted a crude sketch—officially part of what was then called a *caveat*—to the US Patent Office, as a kind of placeholder, an intention to file a patent application later. Although this was a highly flawed idea—for instance, where's the shutter?—it was still the spark that set off the invention.[31]

The sketch showed a different way to marry moving pictures to phonographs. An Edison phonograph at that time recorded sound along a spiral track around the curved surface of a clay cylinder—like thread wound on a spool. For movies Edison proposed recording a succession of tiny pictures along the track instead. As the cylinder spun, one could see a succession of these changing images through a magnifying glass aimed at the cylinder's surface. With this device one could say the Edison hatched the idea of the peep show. And sound was out of the picture—at least for a couple of decades.

Edison (in his "Napoleon of Invention" pose, figure 5.11, left) assigned the job of realizing this sketch to Dickson (in his "giving off airs" pose, figure 5.11, right) and went off on a grand tour of Europe. So Dickson, working at Edison's lab, was the one principally responsible for creating a movie system of sorts, bearing almost no resemblance to the original sketch. It had a camera, the Kinetograph, and it used film in long strips—not tiny pictures threaded onto a cylinder. But it lacked a projector. In its stead was the peep show, or nickelodeon—a one-person viewing device called the Kinetoscope. The "Edison" Kinetograph-Kinetoscope system was an almost-movie system—but closer to modern cinema than Muybridge's device. And it had a tremendous effect on the world.

Dickson had to separate from Edison to create a full movie system, complete with a projector. The split wasn't amicable. To say the least, the Dickson and Edison relationship was conflicted. But it hadn't always been so—even on the threshold of 1895, the year movies really began.[32]

Figure 5.11

I believe that, in coming years, by my own work and that of Dickson, Muybridge, Marey, and others who will doubtless enter the field, that grand opera can be given at the Metropolitan Opera House at New York without any material change from the original, and with artists and musicians long since dead.
—Thomas Edison, ca. 1894[33]

The biography of Thomas Alva Edison is in response to the demand which the deep-seated public interest, called forth by the brilliant Edison inventions, has created for a knowledge of the person and life of this greatest of living inventors.
—W.K.L. and [sister] Antonia Dickson, *The Life and Inventions of Thomas Alva Edison*, 1894[34]

William Kennedy Laurie Dickson, the Man Who Really Made Movies

He often used only his initials W.K.L., but his family called him Laurie. He certainly was never William, Will, Bill, or Billy. In fact, he had a certain formality about him that was off-putting to native-born Americans. Four names! Why, that's downright uppity. It certainly bothered Edison, who needled him by pointedly misspelling his surname

as Dixon. One of his colleagues called him—and not out of respect—the "Right Honorable" William Kennedy Laurie Dickson.[35]

Historians—even those who praise Dickson's accomplishments—have thought that he put on airs, that he was self-aggrandizing and stretched the truth. Even his original celebrant, Hendricks, listed 50 known lies Dickson told. Dickson fueled the dismay and distrust with autobiographies such as the following, which sounded unlikely to Americans—or colleagues in Menlo Park:[36]

> William Kennedy-Laurie Dickson was born in France and educated in England. His father, James Dickson, was a distinguished English painter and lithographer; many artists are numbered in his ancestral roll, among others the great Hogarth. His mother was Miss Elizabeth Kennedy-Laurie, of Woodhall, Kirkcudbright, Scotland, a brilliant scholar, musician, and renowned for her beauty. She was a descendant of the Lauries of Maxwellton, immortalized in the celebrated ballad, "Annie Laurie," and the Robertsons, of Strowan, connected with the Earl of Cassilis, the Duke of Athol, and the Royal Stuarts.[37]

But, in fact, most of this is true—even the Royal Stuarts part. The centuries-old lineages of many of his ancestral families are recorded in the classic aristocratic registers of the United Kingdom, Burke's *Landed Gentry* and Burke's *Peerage*. His four names carried much of his lineage. He had two direct ancestors named William Dickson on his father's side, and two others named William Baillie Kennedy Laurie and William Kennedy Laurie on his mother's. So all four names were important to him.

What he consistently omitted from his autobiography, however, is revealing. Like his distant relative Elizabeth Barrett Browning, Dickson descended from Caribbean slaveholder families who made sugarcane fortunes on the backs of thousands of slaves. So it's not surprising that when Dickson immigrated with his mother to America in 1879, at age 18, they first resided near Richmond, Virginia, in America's South, where he soon married a daughter of an old Confederate family. He kept quiet the rest of his life about the extensive slavery in his family's past.[38]

Dickson, being an aristocratic, probably arrogant French-born Englishman of Southern leanings and a slaveholding past, was not the stuff of a proper American legend. Edison, however, seemed to step from the pages of a Horatio Alger novel as the kid who sold newspapers to make a living, then went on to invent the electric light bulb and the phonograph, only to become the American genius behind movies. That was the myth created for Edison, and he happily played the role. But the facts don't support it.

Dickson was the man, not Edison, who designed and built the first successful movie camera, the Kinetograph, known as the Edison (of course) Kinetograph. Others helped him in this task, notably John Ott. The depth of Dickson's overall contribution isn't conveyed by the flow chart. For example, he also designed and built the first movie

Figure 5.12

studio. It was known as the Black Maria—after the paddy wagon—located on the Edison company grounds in Orange, New Jersey, near Menlo Park. And that he made many of the earliest films—over 300 of them from 1890 to 1903. His movies were necessarily short, a minute or so, silent, and black-and-white. They were documentaries—of a male athlete, boxers, a ship coming into harbor, a battle, a pope, a king, a barbershop. He was a software as well as a hardware man, though not of earthshattering cinematic accomplishment. The great narrative art of cinema was yet to come.[39]

Another Edison caveat sketch that Dickson and Ott brought into existence became the "Edison" Kinetoscope. Despite the *scope* suffix, this was not a projector. It was a device for displaying a movie to a single person—the peep show. Edison's business partners took his device into the peep show business quite successfully. The illustration of the New York City showplace (figure 5.12) says it all—down to the bronzed bust of Edison that greeted patrons and the two incandescent wall-mounted dragons.[40]

In fact, the peep shows delayed Edison's entry into the world of cinema. When Dickson recommended that they build a projector for public showings, Edison rejected the idea. He didn't want to cannibalize his peep-show success. His reluctance had two major consequences. First, his company came late to the full movie system. Several other groups had projectors by 1895—the Year of the Projector—and one of them, the Lumière brothers in France, would become very serious competitors. Second, he lost Dickson to a company that *was* interested in projectors. While at Edison, Dickson had

helped two other teams design projectors and go into business. He left to join one of them. That group, which became the Biograph company, would be Edison's most serious American competitor in the movie business.

Edison's business partners quickly realized that they needed a projector to complement the Kinetograph. With Dickson out of the Edison picture, they needed to look elsewhere for a projector. Charles Francis Jenkins and Thomas Armat had developed the Phantascope projector in 1895, so Edison's business concessionaires (Norman Raff and Frank Gammon) bought the rights to it, changed its name to Vitascope, and suppressed the inventors' names by business contract. Finally, there was a full "Edison" movie system consisting of the Kinetograph camera, developed principally by Dickson and Ott, and the Vitascope projector, developed principally by Jenkins and Armat. The Edison system bore the name of the Wizard of Menlo Park, but it wasn't the Wizard's doing—other than his original unworkable caveat sketches for the camera part and some minor modifications of the Jenkins-Armat machine. So much for Edison's inventing the movies. Of the four people who actually developed the "Edison" system, Dickson would rise to even higher prominence, but not fame—in his lifetime anyway.[41]

Importantly, and missing from the flow chart, Dickson was almost singlehandedly responsible for the film part of the Edison (brand) movie system. He was the one who developed the film system that resembles that of the very recent past—doubly perforated film of about 35 mm width, with four rectangular perforations per frame. This was a tremendously difficult and fundamental development in the history of cinema that fades to unimportance in filmless Digital Light. Dickson was a major player in the conquest of reel-to-reel celluloid film and the creation of the projector.[42]

There's an informative way to cut through the Gordian knot represented by the flow chart: the lines of connection show that Dickson had a hand in every Yanks development except the Armat-Jenkins Vitascope. Although it's not as obvious, he also was indirectly part of many of the Franks developments: The Lumières built their system in direct response to the "Edison" Kinetoscope. The 35 mm perforated film format that Dickson perfected was adopted by Gaumont and Pathé. And Britain's Robert Paul built and sold a copy of the Kinetoscope to Pathé. We'll revisit the Lumières, Gaumont, Pathé, and Paul in the Franks section.

Dickson consulted with two non-Edison groups about projectors. He did this on the side while still officially working at Edison. Historians have been unable to establish whether these were ethical pursuits. Dickson apparently believed that he had acted honorably, but Edison considered his actions a betrayal. Dickson, age 65, wrote to Edison in 1926, "Truth will out—which reminds me that that old rumour of my disloyalty to you crops up on occasion, & will ever hamper progress unless denied by you."

Edison wrote a note on the letter, "He was disloyal. I think we better not answer," and filed it.[43]

The first extracurricular group for Dickson was the Lathams, a father and two sons, and a former Edison employee, Eugène Lauste. Lauste had made contributions to the Kinetoscope at Edison's lab. Dickson's role with the Lathams was probably only advisory. He never took public credit anyway. Lauste helped create the Eidoloscope projector, or so some think. It's one of the contested points in cinema history. Regardless, it had its first public showing in April 1895 (under its original name, Panoptikon). Its first commercial appearances began in May, making it the second projector in the world to go public—shortly after the Lumières' Cinématographe in March—and the first to go commercially public.[44]

That year, 1895, was indeed the miracle year in the history of cinema. Not only did the Lathams show the Eidoloscope commercially in May, but Jenkins and Armat demonstrated the Phantascope in October, as the second commercial projection ever. Raff and Gammon, Edison's principal concessionaires, would rebrand the Phantascope as the "Edison" Vitagraph. The Lumières in France soon followed up with the fourth commercial projection, of their Cinématographe, in December. (Max Skladanowsky of the German team captured the third commercial projection, with his Bioskop, in November.) So, 1895 was indeed the breakthrough year—the year that full cinema as we know it began. The race was on.[45]

And so was Dickson's break with Edison. Forever after, Dickson was hurt that Edison denied him credit. At age 71 Dickson could finally write, "I see in many papers & journals I am, since Edison's & Eastman's deaths, given credit for my pioneer work at Edison in producing the 1st film & present day cinema."[46]

Dickson formally parted company with Edison in 1895 to join the KMCD Syndicate, the other extracurricular group. K was Elias Koopman, and M was Harry Marvin, the head businessmen of the group. C was Herman Casler, who became the chief designer and builder with Dickson—who was the D. The group had got to know one another in annual visits to an upstate New York spa and then together created and sold a gimmick camera—a detective camera that fit in what looked like a pocket watch. The friends bonded into a company with a profound effect on the cinema industry—but no memorable influence on espionage.[47]

Casler, with Dickson's advice surely, designed the group's camera, the Mutograph. The two then adapted the Mutograph to be a projector. They called it the Biograph, and the company became known popularly as the Biograph company. Dickson knew how to get around the Edison company patents, so Biograph became Edison's most serious American competitor.[48]

The Franks

The right side of the flow chart of cinema history is devoted to the other team—the Franks. A glance at it reveals a dense web of interconnectedness among the main players. Their story is as complicated, robust, and fraught as the Yanks story. We start at the top with Étienne-Jules Marey. He occupies the inspirational, pre-cinema position for the Franks held by Edward Muybridge for the Yanks. And in fact, Marey and Muybridge influenced one another in the years leading up to 1895, the Year of the Projector.

Marey—Scientist, Artist, and Photographer of Time

Marey knew that all four hooves of a horse can simultaneously leave the earth. He knew it *before* he knew about Muybridge's famous photograph of Leland Stanford's racehorse, and before he himself became, like Muybridge, a photographer of time, or a *chronophotographer*. Chronophotography as practiced by Marey and Muybridge was pre-cinematography—before complete movie systems existed.

Marey knew about the hooves from non-photographic measurements. He made real physiological measurements with devices mounted on real hooves of live horses about 1873. He wrote about it in a *Popular Science* article published the following year. Marey always thought of himself as a scientist, not a photographer. This matters in his story, especially as regards a young assistant, George Demenÿ—a disciple really—whom he would bring into his physiology lab in Paris.[49]

Muybridge, Marey, and Stanford were aware of one another in the early days. Muybridge made the first four-hooves-off-the-ground photograph in California in about 1872 or 1873, but it disappeared. It probably wasn't very good because Stanford hired him to do it again—and presumably right this time—after reading Marey's *Popular Science* article. In 1878 Marey directly urged Muybridge to "animate" his still images of the horse. And Marey hosted a reception for Muybridge in his grand visit to Paris in 1881.[50]

There was a major difference in approach though. Muybridge captured in frames, but Marey captured in strips. Figure 5.13 is a beautiful example of Marey's art—which he thought of as science. His device recorded a multiple exposure on what was essentially a single, very wide frame of film. (I've touched up the background at the top.)

One of the myths of cinema is that, after Edison saw Marey's use of strips, he graduated from frames threaded onto a cylinder to frames recorded on a strip. But Edison was already aware of strip film before he left for France in 1889. In fact, Dickson may have already demonstrated an experimental Kinetograph with a film strip to him before he left on the trip. Nevertheless, it was after his return from the triumphal tour that Edison drew another crude sketch, for another Patent Office caveat, depicting strip film with

Figure 5.13

perforations along two edges. It was Dickson, again, who would painstakingly create from this mere idea the film format of twentieth-century cinema.[51]

In 1890 Marey took a patent for a chronophotographic film camera. It was a camera that recorded intermittently on unperforated celluloid film. He showed a film from the device later that year at the Académie des sciences—of a trotting horse, of course! Presumably his devoted assistant Demenÿ was part of this development. We now meet the team of French inventors and discover who this Demenÿ was.

French Connections—Their Inventions and Intrigues

> The cinematographic industry, as Demenÿ, the Lathams, and Armat and Jenkins were already aware, did not come into being without a number of acts of betrayal, dubious compromises, and knives in the back.
>
> —Laurent Mannoni, *The Great Art of Light and Shadow*[52]

The Lumières get all the credit, much of it deserved. But there were other French inventors and businessmen, and many worked together and "borrowed" from each other at various stages of their careers. Étienne-Jules Marey mentored Georges Demenÿ. Demenÿ partnered with Leon Gaumont. Henri Joly borrowed ideas from Demenÿ and then sued Gaumont. Joly partnered with Charles Pathé who later dumped him. Here are their stories.

The Lumières, Makers of Light in Any Language

There is great confusion over the conception of the Cinématographe Lumière. The two brothers told so many different versions in later life—mixing different accounts at different times, each promoting his own claim to attribute the merit to himself—that the truth became completely obscured. . . . To add to the difficulty, the Lumière archives have disappeared; there will never be an opportunity like the one Gordon Hendricks had in combing the archives of West Orange to re-establish the truth of the invention of the Edison Kinetoscope.

—Laurent Mannoni, *The Great Art of Light and Shadow*[53]

How pretty it is that their name is French for *light*—and how ironic given the historian Laurent Mannoni's take on their trustworthiness. The Lumières were a father and two sons, like the Yank Lathams. Antoine Lumière, the father, had older son Auguste and younger son Louis. The received story is clean and elegant: The two brothers admired and supported one another in all things. They devised a single, elegant instrument, the Cinématographe, that served both as camera and projector. They gave the first public showing of the cinema, and it launched the movie revolution. No wonder the French are so proud of them. But as with so many stories in this book, the received story is almost certainly a manicured creation myth.

Mannoni's epigraph puts the lie to the mutual brotherly support part of the story. But it's perfectly true that the brothers did exhibit a single, elegant device that was both a camera and a projector. It was *reversible* in the sense that one device could both read and write film, both shoot it and project it. Additionally, their Cinématographe was also a film printer. It really *was* a complete movie machine in a single box. The brothers, particularly Louis, slowly perfected it in tight collaboration with engineer Jules Carpentier.

The Cinématographe appears to be a simple device at first glance, but the elegance of that simplicity becomes clear when you read the many letters exchanged between Louis and Carpentier. Day after day, Louis described tiny problems and improvements, and Carpentier found solutions and suggested others. The perfectionism is stunning. The Lumières didn't want to go before a paying audience with their device until it was absolutely perfect. They waited until they had 200 copies of the machine in production before they formally introduced it on December 28, 1895, in Paris—the fourth commercial projection in the world and the second in Europe.

When we look at the dates of the contenders, the push to claim first seems almost unseemly. More important than the quibbled dates was the fervor generated in 1895, when new projectors were being announced and demonstrated every month on both sides of the Atlantic. We can change the order simply by using or not using the adjective "commercial." The first and second commercial projections—that is, to a paying

public—occurred in the United States, the Lathams first in May, Armat and Jenkins second in October. The third and fourth successes were in Europe: Skladanowsky of Germany third in November, and the Lumières of France fourth in December.

But drop that word "commercial" and the Lumières become the first to project a movie publicly. They exhibited a not-quite-perfect machine in Paris on March 22, 1895, to several hundred people. With this public-but-noncommercial measure, the Lathams become second, unveiling their Eidoloscope to the press only a month later, on April 21. And the Lumières become third as well with another showing in Paris in July, for 150 people. To put this in perspective, when they formally went public in December—with a paying audience—it was to only 33 people.[54]

There's no doubt that the Lumières conceived of one box as a complete movie system. But so had Léon-Guillaume Bouly, a bit earlier. He had patented a combined camera-projector system in 1893, also called a Cinématographe. But he let the patent lapse by not paying—or not being able to pay—the annual fee. This allowed the Lumières to use the name freely and perhaps also the basic design. It's unclear what role, if any, the mysterious Bouly played in the development of the Lumière Cinématographe. He's not part of the received story.[55]

Unfortunately, the Lumières's elegant movie in a box idea wasn't adopted by the emerging industry anyway. Nor was their film format. Their own countrymen, Léon Gaumont and the Pathé brothers, Charles and Émile, helped seal their doom by adopting Dickson's 35 mm film system, the unpatented "Edison" system. Nevertheless, the Lumières competed fiercely in the early American market. They figured large then—and still do in the French popular imagination.[56]

Demenÿ, the Dickson of France?

The name Georges Demenÿ pops up in several crucial places in the flow chart of cinema history. Yet, like W.K.L. Dickson, few people have heard of him. But there he is, connected in some way with nearly every Franks player—Marey, the Lumières, Gaumont, George de Bedts, and Henri Joly. What the American historian Paul Spehr has done for Dickson, the French historian Laurent Mannoni has done for Demenÿ. Mannoni, curator of cinema technology at the prestigious Cinémathèque française in Paris, has brought Demenÿ back into historical consciousness. The Demenÿ story is full of disappointment, defeat, and sordid treatment.[57]

The Marey-Demenÿ Relationship

Étienne-Jules Marey was master, mentor, and father-figure to Demenÿ in a decade-long association. The relationship between the two began in about 1880. It was so strong by

1882 that Marey left management of his physiology laboratory to his trusted disciple when he vacationed in Italy that year.[58]

But over time Demeny's commercial urge to make a business of chronophotography collided with Marey's scientific drive to further physiology—an echo of the stinks versus tower rift in computers. Marey started warning Demeny of his displeasure with this direction in 1889. But Demeny persisted, and the relationship was in tatters by 1893. He referred to Marey's "senile and incoherent management" in a letter. And soon after Marey demanded his resignation. Demeny was essentially fired—"struck down by a thunderbolt of Jupiter" was his own phrasing. This was Demeny's first major defeat, and further disappointment in his relationship with Marey would follow.

As mentioned earlier, Demeny had presumably helped Marey develop the chronophotographic film camera that Marey patented in 1890. But this device was crude. It had to be—without perforations to ensure a constant frame rate. Demeny used this experience to build his own Chronophotographe. But his device was more than just a borrowing from the Marey lab. In particular, Demeny's device had a "beater" mechanism, his own crucial design. He patented the beater mechanism in 1893 in England, 1894 in France, and 1895 in the United States. It was a kind of cam that solved the tricky problem of matching the continuous motion of film to the intermittent use of it. Film leaves a projector's source reel smoothly, on the way to the projection lens and illumination. Then the take-up reel collects the film smoothly after projection. But the film is held stationary at the moment of projection by an intermittent movement. If nothing were done, the intermittent movement would be constantly jerking the film from the source reel, or the take-up reel would be yanking film from the intermittent movement. The beater guarded against these stresses by taking up slack in a controlled rhythmic way.[59]

In later years Marey accused Demeny of stealing his credit for the (Demeny) Chronophotographe. This accusation seems a bit of a stretch. Marey himself admitted that the pre-beater design was public, a part of science. Demeny's transgression was that he failed to honor standard practices of scientific credit. It was certainly a psychological mistake not to invite Marey to be part of a business built partially on joint developments—despite Marey's posturing as a pure scientist. And Demeny doubled down by his response to Marey's accusation: Marey was, he said, "a sick old man, unthinking and full of rancor."[60]

The Demeny-Gaumont Relationship, a Sordid Affair

In 1895 Demeny signed with Léon Gaumont to exploit his newly improved Chronophotographe camera (without projector). Gaumont's first act was to change the machine's name to Biographe. Their deal was modified in 1896 to accommodate

Demenÿ's planned improvement of the Chronophotographe/Biographe to make it reversible—both a camera and a projector, a full-fledged movie machine. Demenÿ finally accomplished this in 1896. Then he converted the film format in 1897 to perforated 35 mm, the "Edison" format, to make the machine fully competitive. But by then Demenÿ had suffered his second major defeat, at the hands of Gaumont.[61]

It came as a result of "the Joly affair." Charles Pathé purchased a copy of the "Edison" Kinetoscope and needed films for it. He obtained the copy from the Englishman Robert Paul, who had pirated the design. Paul could do this freely because Edison had failed to patent the Kinetoscope in Europe. But Pathé couldn't very well approach the Edison company to purchase films for an essentially pirated machine. So Pathé made a deal in 1895 with the Franks inventor Henri Joly to build a camera for the pirated Kinetoscope. Joly was a good choice because he knew Marey and Demenÿ and their work. For this task Joly built his Cinématographe—the Cinématographe Joly—and made it reversible into a projector. And he gave it a beater mechanism that he took directly from Demenÿ, which makes what happened next especially unsavory.

Joly had the gall to sue Demenÿ's partner, Gaumont. His lawyer explicitly admitted that Joly had improved on Demenÿ's mechanism. Then he proceeded to order Gaumont to cease production of the Demenÿ machine. The screwy argument seems to be that Demenÿ's mechanism was part of Joly's patented improvement, so the Joly patent covered the Gaumont machine too. It's absurd, but Gaumont's response to the legal hassle was to dump Demenÿ! Not surprisingly, Demenÿ was forever bitter that he wasn't properly credited or rewarded, and he died that way—discredited. It was no consolation to him that Joly was similarly dumped by the Pathés.[62]

The Joly-Pathé Relationship, a Related Sordid Affair

Joly noticed that Charles Pathé was using the Cinématographe Joly only as a camera. Pathé was stuck in the peep-show mentality with Edison and wasn't exploiting the projection capabilities of the device. So, Joly started sniffing around for someone who would understand the business that projection offered. He discussed possibilities, for instance, with George de Bedts—who had been one of Demenÿ's many associates. Pathé got understandably nervous, but his next act was precipitous. He simply kicked Joly and his wife out of the facilities that he had provided them, while hiding Joly's camera from him as they were moved out. This was in 1896, just as the cinema business exploded, using projection. Pathé belatedly realized, as had Edison, that the peep show was a dead end. He quickly found a reversible projector and went into business, ultimately one of the most successful in the cinema world. We don't know what machine Pathé actually used. Perhaps it was Joly's. Regardless, Pathé ousted Joly just as the projection business

that Joly had urged became profitable—without compensation and without the proto-type machine. Joly tried to start a business with another partner, but it failed.[63]

The Demenÿ-Lumière Relationship

Demenÿ's third defeat was delivered by the Lumières who vehemently denied his claim that he had influenced their Cinématographe design. Here's where the lovely Lumière story starts to crumble a bit. Demenÿ sketches discovered in recent decades show an intermittent movement mechanism that uses a pair of claws moved by an eccentric cam—a description of the Cinématographe of 1895. Louis Lumière had seen these drawings, although admittedly ones showing a much cruder mechanism, when he visited Demenÿ in December 1894.[64]

The Demenÿ-Yanks Relationships

Demenÿ also appears on the Yanks side of the flow chart, and some historians think he should be given even more credit there. Jenkins and Armat employed a beater in 1895 in what became the "Edison" Vitascope projector. The US Patent Office declared that it was borrowed from Demenÿ. The Dickson team might also have borrowed it for the Biograph projector, but the historical jury is still out on that. Popular photographic literature of the time described the Demenÿ beater patent, so it was no secret.[65]

There is enough softness and uncertainty in this account of Demenÿ to suggest that he probably was no match to the genius Dickson. Nevertheless, he shouldn't be forgotten. He took part in too much, knew too many of the players, and was responsible for some of the fundamental improvements to the movie machine—perhaps more than we know.

The Edison Trust and the Creation of Hollywood

By 1907 the Edison company owned one of the major US patents on movie cameras and exercised it with incessant litigation. Finally exhausted, Edison's competitors approached the company for relief. The solution was the birth in 1908 of the Motion Picture Patents Company, sometimes called the Edison Trust. About 10 companies pooled their patents together and as a group went after competition. Included in the group was the American branch of the French company, Pathé, and the Eastman Kodak company, the largest supplier of film stock at the time. Even Dickson's Biograph, Edison's greatest competitor, joined. The Biograph projector patents—which Edison couldn't combat—were what made the Trust so effective. If this sounds like monopolistic collusion, that's because it was.[66]

A claim that the Edison Trust led to the creation of Hollywood is too strong. It seems plausible because California was a long way from the New Jersey–based Edison company. Surely the Trust found it difficult to track and exercise patents at that remove. But the more important West Coast benefits were plentiful sunshine, and cheap labor and real estate. Many independent film producers moved there. Examples were Universal Studios, which moved soon after forming in 1912 to Hollywood, and Paramount Pictures, founded there in 1912, both still in Hollywood today. These two Yanks' studios plus Gaumont and Pathé for the Franks are four of the five oldest surviving movie studios in the world. (The fifth is Denmark's Nordisk Film.)

The remote Hollywood location didn't protect Universal Studios. The Edison Trust came after it anyway. But in 1917 the US Supreme Court found against the Trust—citing misused patents. And finally, in 1918, the Edison Trust was terminated as an illegal restraint of trade under the Sherman Antitrust Act.[67]

This completes the extended caption for the birth of cinema flow chart. Now we concentrate on that special branch of cinema—the animated film—that leads, in our telling, to the Great Digital Convergence. There are many paths through Digital Light, but the one I know best is via character animation.

◻ ◻ ◻ ◻

We have distinguished the *taking* pixels half of Digital Light from the *making* pixels half. Taking pixels from the real world to represent the real world has occupied us mostly so far. Making pixels to represent unreal worlds now becomes our focus.

Once we understand how a geometrical model inside a computer becomes a frame of pixels in a stream of frames that create an unreal world, then we'll know enough to intuit how games work, and also virtual reality (VR), augmented reality (AR), and, mundanely, all user interfaces with all apps and with the internet. The same basic principles that we use in three-dimensional digital character animation explain them all. In particular, they all share the notion of an invisible model inside a computer that is being made manifest. Between taking and making, we gain a handle on full Digital Light.

Now we begin our runup to the making pixels part of Digital Light—digital movies in particular. Let's start with a brief history of classic two-dimensional character animation in the film world and how it worked. This provides the language we need for character animation. Then we apply the computer's awesome power of Amplification in later chapters to reach all of Digital Light.

Animated Movies: Unhinged from Time

> The animated cartoon shows us in movement something that is naturally inert and it is essentially the satisfaction of magic that we get out of it.
> —Donald Crafton, *Before Mickey*[68]

> Thus the camera, that George Washington of mechanism, at last is proved a liar.
> —Ashton Stephens, a reviewer upon seeing Winsor McCay's *Gertie the Dinosaur* (1914)[69]

Animated movies have existed as long as cinema itself, at least since that fervor of invention in 1895. But what are they?

Defining them is tricky. Classic cinema takes its frames from the real world. The sets and costumes may be fictitious, the lighting artificial, and the characters impersonated by actors, but all of them are parts of the real world. It's not obvious, but a hand-drawn animated movie takes its frames from the real world too. In cartoon animations, such as Disney's *Snow White and the Seven Dwarfs* (1937), each frame is a photograph of a drawing or a painting of unreal worlds. Those drawings or paintings are objects in the real world. So it's not unreal versus real that distinguishes animated movies.

It's not making versus taking that distinguishes them. Only the small category known as documentary films purports to take pictures of the real world itself. Most of cinema is fictitious. Each frame of most movies, animated or not, is crafted—made—before recording with a camera.

And it's not two versus three dimensions either, as cartoons might suggest. Some so-called *stop-motion* animated movies take each frame from the real three-dimensional world. Take the dancing skeletons of Ray Harryhausen's classic *Jason and the Argonauts* (1963), for example. Or any of the modern *Shaun the Sheep* (2007–present) episodes that I love to watch with my grandkids. Some of the earliest animated movies were stop-motion or, at least, interrupted motion—such as Georges Méliès's *The Haunted Castle* (1896) or James Stuart Blackton's *The Haunted Hotel* (1907). And some of the earliest non-animated movies were films showing an artist in the act of drawing a two-dimensional cartoon—such as Émile Cohl's *Fantasmagorie* (1908) and Winsor McCay's *Little Nemo* (1911). These so-called *lightning sketches* weren't animated movies—so long as the artist's body could be seen—despite the two-dimensional content.

These films illustrate that animated snippets, or *shots*, were often mixed together in various ways with non-animated ones. And that animated movies and their animators were part of the extended Yanks versus Franks cinema Olympics.[70]

So, it's not cartoons versus photographic realism that distinguishes animated movies. This has become particularly obvious in the new world of Digital Light. Computer-animated frames now can be as rich in photorealistic detail as photos taken of the real world.

If none of these things sets animated apart from non-animated movies, then what does? It's the use of time. Unreal time, not unreal space, defines animated movies. Animated movies are unhinged from real time. We call all others *live-action movies* because they are, at base, as enslaved to time as live beings are. John Wayne striding across a Western set in his jangling cowboy outfit occupies a fictitious crafted space but his movements are recorded in real time.

This might not seem right. Famously, a movie is a sequence of shots that a director or editor freely orders, or reorders, in time. Surely being free to reorder time is the opposite of being enslaved by it. But remember that each shot *is* a clocklike sampling of a continuous visual flow. It's live, or real-time, action.

Early cinema was mere spectacle—hey, look at this, now look at this—a sneeze, a boxing match, a seductive dancer, the pope. Dickson's many films circa 1900 were all of this variety. The discovery of the power of the *edit*, soon after those beginnings of cinema, changed all that. The edit disrupts time. We can edit together snippets of film—each with its own inexorably advancing internal time—in arbitrary temporal order. Each snippet, or shot, is a slave to real time, but the ordering of the shots isn't. With this freedom an editor causes *perceived* time to speed up or slow down. Centuries can pass in an instant.

So can millennia, as in *2001: A Space Odyssey* (1968), which famously jumps from a bone cudgel to a spacecraft (figure 5.14). An ape hurls the bone upward. It tumbles slowly as the camera follows it up and up and . . . it becomes an Earth satellite of roughly the same shape in the vicinity of Space Station V, a majestically rotating way-station for humans bound for the Moon. Director Stanley Kubrick's "match cut" spans the entire history of mankind in an instant.

From the power of the edit comes narrative and emotion. And the resulting software is the artform we call "the cinema." An infinity of possible programs compute, metaphorically, on our brains.

Animated movies take the edit to the limit—one every frame. Time is no longer a restriction. There is no visual flow to sample. It's common for the next frame to be what an animator intends to be the current frame taken one twenty-fourth of a second into the future, as if it were recorded in real time from a visual flow. But it doesn't have to be. It occurs at a fictitious time created by the animator, that might bear little or no

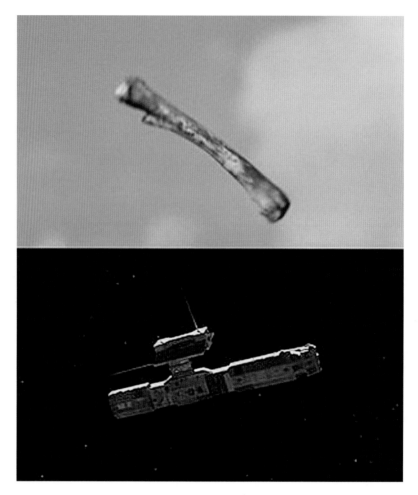

Figure 5.14

relationship to real time—or alternatively be a dead-on accurate simulation of sampled real time.

Hence the world of the animated movie is up for grabs. It can be as abstract as the artist wishes to make it. Any form in any order is permitted. Taken to the limit, abstract animation—the creation of emotion as purely from arbitrary visuals as music is from arbitrary sounds—is one of the great artforms awaiting its Mozart, Chopin, and Stravinsky, but there have been a few practitioners all along. Notable examples are Walter Ruttman's *Lichtspiel: Opus I* (1927) and Oskar Fischinger's *Motion Paint No. 1* (1947)—sheer visual music.[71]

Trickfilms and Lightning Sketchers: Cohl versus McCay

> Cohl was no dilettante; on the contrary, he was on his way to becoming a monomaniac and would dedicate the rest of his life to the promotion of animation as an art and industry. He was the one most responsible for transforming the efforts of his trickfilm predecessors into a unique twentieth-century art.
>
> —Donald Crafton, *Before Mickey*[72]

Like the spectacle era of live-action movies, animated movies went through an early evolutionary phase. At first there were *trickfilms*, like a beheading or a magic trick. Directors used the ability to interrupt time between frames to convince us that a human had lost his head, or that teapots danced. Georges Méliès in France was perhaps the most famous early trickfilmster—*A Trip to the Moon* (1902), for example. Editing was used, within a normal shot, to convince us of something impossible happening in real time. It's the fooling with time in a shot that make trickfilms part of animation.

Succeeding the trickfilms were the *lightning sketches* that featured a presenter, a human who was the director himself. He would proceed to draw on a board, apparently in real time, and then the character drawn would "come to life." It was as if directors were unwilling to commit to full animation or couldn't believe that it would actually work—that an audience would get it. Or they were unwilling to take themselves out of the limelight. The lightning sketcher would show the audience what he was doing, or how to understand what was happening. *Gertie the Dinosaur* (1914) is a famous early example. Winsor McCay appears onscreen and points to a landscape on a large pad of paper. He calls Gertie forth from her cave there. When she appears, she becomes a life on her own—a new center of consciousness, like a new baby. So *Gertie* is a live-action movie intercut with an animated one.[73]

Émile Cohl is to the Franks what Winsor McCay is to the Yanks, so far as being one of the earliest animators. But the two were very different. Animation historian Donald Crafton describes Cohl as cerebral and introverted, and McCay as a gregarious host and a flamboyant showman. So it's not surprising that hardly anybody knows Cohl, even though he produced hundreds of films compared to McCay's handful. Furthermore. Cohl was an Incoherent, a group of artists who concentrated on insanity as an aesthetic issue—not exactly a popular cause. Nevertheless, his *Fantasmagorie* (1908), distributed by Gaumont, was arguably the first animated cartoon, and Crafton calls him the first animator. But he reserves the most important title for McCay: the first character animator.[74]

The Soul of Animation

> In minutes McCay convinces the audience that he has resurrected a lovable and tangible animal—a triumphant moment for animator as life giver.
> —Donald Crafton, *Before Mickey*[75]

The magical soul of animated movies resides in what we call *character animation*, a phenomenon essential to the most common and popular animated movies, from Disney's *Snow White* (1937) to Pixar's *Toy Story 4* (2019). A hand-drawn character—like the Wicked Witch in *Snow White*—appears to move when projected at speed. That shouldn't be a surprise by this time. It's just what the Sampling Theorem guarantees, if the samples are well made. Much more importantly—and magically—the skill of an animator causes the moving character to come alive! It has a conscience, makes decisions, and feels pain—or gives pain—or convinces us that it does anyway. That crafty Road Runner outsmarts, yet again, that unwily Coyote. This magic doesn't come from the Sampling Theorem. It's art, and we can't explain it yet. *To animate* means more than *to move*. It means *to inspirit*. *Anima* is Latin for wind, air, breath, the vital principle, soul. It's the magic of the naturally inert becoming not so—not inert, but more importantly, not dead.

A momentous moment in the history of the animated movie was the projection of the first true character animation—inspirited, not merely moving. It's safe to say it occurred sometime in the early years of the cinema. Crafton suggests in the epigraph that it happened in 1914 with McCay and his dinosaur Gertie. At that moment characters were weaned from an onscreen creator. Audiences could be trusted to get it—to realize that animated characters are lives on their own. No clumsy explanations were necessary. You could omit the explicit human pedagogue.

It wasn't obvious, though, that audiences would get it—that inspirited animation should work. We don't even know what *it* is. Neither do we have any idea how animators do it. Nor do they. Similarly, we don't know how actors persuade us that they are somebody other than who they are. In fact, the two observations are linked. The skill of an animator is the same as that of an actor. An actor convinces us that his or her body and mind are those of some other completely different person. An animator convinces us that an inanimate stack of drawings—or millions of polygons in the case of Digital Light—is alive and conscious. Pixar hires animators by how well they act.

Technologies of Character Animation

As a child in the 1950s, I thrilled as Walt Disney himself explained the animation process on his weekly *Disneyland* television show. He described the technology called

cel animation, detailed in the following section. *Cel* is short for *celluloid*, and it's really spelled with only one "l." When I learned animation on my own in the early 1970s, it was cel animation. When I learned animation from professionals in the mid-1970s, it was cel animation that they taught. When I and my colleagues began to implement animation digitally in the late 1970s, the approach we took was the digital equivalent of cel animation. And when we first implemented two-dimensional animation for the Disney company in the late 1980s, it was cel animation again. So it's no surprise that I thought cel animation was the only animation technology that there was. But I was wrong.[76]

In the early days at the turn of the twentieth century, Émile Cohl placed jointed paper cutouts of his cartoon characters over a background in a technique called *decoupage*. An opaque cutout was positioned over a drawn background. For example, Cohl might have raised the foot of a character in preparation for a step. A frame was photographed, then the cutout was repositioned—so that, say, the knee descended slightly, and the toes were aimed more directly at the floor as the step proceeded. This was essentially two-dimensional animation based on stop-motion photography.[77]

In another technique of the early days, called *slash and tear*, the animator would cut a hole in a background drawing to reveal the topmost of a stack of drawings underneath. Then after photographing one frame, he or she tore off the top drawing to reveal the next position of the character, as seen through the hole in the background. The French Canadian animator Raoul Barré used this technique. It was the only serious competitor to the cel animation technique.[78]

A strong reason for a competing technology was the vigorous defense of patents on cel animation. The man responsible for putting animation on a firm businesslike foundation—ready to sustain the insatiable demand for product of a real movie industry—was John Randolph Bray. He understood the power of a patent and proceeded to develop most of what we now call cel animation and patent it in 1913. But he failed to include the crucial idea of transparent celluloid—cels. Paper was his main material.[79]

Into that patent void leapt Earl Hurd who filed the patent in 1914 that nailed down the cel animation process as we know it. But rather than fight out their differences in the courts, Bray and Hurd reached an agreement to pursue their ideas together, as the Bray-Hurd Process. Bray always took credit for the process, but it's clear that Hurd's patent was the real clincher. They then went after those in the animation business who didn't buy a license from them. So in a smaller way, Bray and Hurd were to animation what the Edison Trust was to live-action movies.[80]

Cel Animation: Ink and Paint

Dip the apple in the brew
Let the Sleeping Death seep through
—Wicked Witch, *Snow White* (1937)

Since cel animation led to Digital Light, we'll discuss it in some detail. With cel anima-
tion technology Ub Iwerks and Walt Disney started the chain of companies that would
bring character animation into the big time. It was the technology used to make Dis-
ney's *Snow White* (1937), the first successful feature-length animated movie—the film
that might have suggested death with a poisoned apple to Alan Turing.[81]

The cel animation technology seems obvious once you hear its details. That's why,
I suspect, so many of us knew of nothing else. Cel animation uses photography to
capture a sequence of images. A cameraman lays down, on a special "camera stand,"
a background scene that's been painted by a background artist on opaque material as
the first, or bottommost, layer. Then he layers above that a transparent celluloid with
a character painted on it—a completed cel. The two layers are held in strict registration
by metal pegs that are part of the camera stand. Holes punched along the top of each
layer receive those pegs. Then he lays down another cel, with another painted char-
acter on it, above the first. And so on. With all the foreground characters in register
above the background, and held tightly against it, he takes a photo of the stack. The
camera sees the composite image formed by the stack. That's one frame of the movie.
The cameraman repeats this laborious process—from the bottom up—for each frame of
a movie because each character usually moves a little between frames. He does this as
many as 130,000 times for a feature-length film.

To create each individual cel in the first place, an animator draws the character
assigned to him, in position, using pencil on paper. In each subsequent drawing his
character moves slightly. Each sheet of paper is of regulation size and punched with
regulation holes across its top for the registration pegs. Then a clear sheet of celluloid,
of the same size and punched the same way, is registered above the animator's drawing
using the pegs to hold position firmly. An *inker* carefully traces the pencil drawings,
visible through the clear celluloid, with black ink onto the cel.

The inker passes each inked cel to an *opaquer*, whose job is to fill the areas sur-
rounded by inked lines with painted color—like a child with crayons and a coloring
book, being very careful not to go outside the lines. The opaquer turns the inked cel
over and paints on its back side so that the paint lies under the inked lines as viewed
normally through the cel. This preserves the quality of the inked lines—their varying

widths, for example—as seen by the camera. *Opaquing* is the term used because the paint has to be applied thickly enough to stop the passage of light through the cel. The background layer can't be seen through the painted, opaque parts of a cel—through a character—or any cel through another, except in the unpainted places.

As a practical matter, there's a limit of four or five cels per frame. No cel is perfectly transparent. Each additional cel layer causes a slight bit of light lost through even the transparent parts. In fact, opaquers have to alter their paint colors slightly on each layer to accommodate the slow buildup of opacity through a stack of supposedly transparent cels.

It's not hard to see that cel animation, with 130,000 frames, is a logistical nightmare. Suppose there are four layers per frame plus the background. That means that a 90-minute feature-length movie might have 650,000 objects to track. And every single one of them has to be checked carefully for completion, without error, and in correct order both framewise and layerwise. Animation houses of the last century used elaborate handwritten accounting processes to keep track of these logistics—the ugly plumbing of seductively charming character animation.

For perspective, Digital Light eases both problems, the buildup of opacity in a stack of cels and the ugly logistics task. In digital animation, transparency is perfect. There's no limit to the number of cels. Opacity buildup is not an intrinsic problem in animation, only in cel-based analog animation. But logistics *are* intrinsic. Fortunately, computers are perfect for that thankless, but fundamental, task.

Squash and Stretch

Animators must create and assemble 24 frames for each second of film projection, but early animators actually often "shot on 2s." That is, they created only 12 frames per second, but photographed each frame twice to get the necessary 24. They would depart from this practice only for sequences of fast movement. "Shooting on 2s" reduced the logistics and halved the production effort but made for choppier animation.

Early animators developed a bag of tricks to compensate for the resulting low temporal sampling rate and for the fact that each frame is actually static. It's instructive—and fun—to inspect these remarkable tricks. The principal ones are *squash and stretch*, and *anticipation and exaggeration*. They were created by animators who were completely naive of the Sampling Theorem but deeply understood human perception and storytelling.

Consider the lowly bouncing ball, often a beginner's first animation. As a real ball bounces, the parabolic curves it follows decrease in height. At the moment of impact, a real ball deforms slightly. The softer the ball, the greater the deformation. In figure

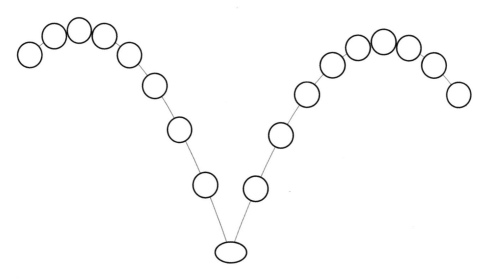

Figure 5.15

5.15, a ball at each frame time shows what a sample at that instant would look like. Note that the bounce happens at the moment of sampling, exactly at that frame time. Because animators get to choose their sample times—they're unhinged from time— they always choose that exact moment as a frame.

Remember that each frame of any movie gets projected twice to avoid flickering. This means that even in the best case—shooting on 1s, not 2s—each position of the bouncing ball gets projected on the retina twice. But when animators are shooting on 2s, each frame is repeated twice. That means that each frame shot on 2s gets projected on the retina four times! Consider the frame at the moment of impact. The retina sees that frame four separate times. And yet the brain manages to perceive a single moment of impact. How could this possibly work? There's nothing in the Sampling Theorem to handle this situation.

Furthermore, the moment of bounce is a sharp "edge" in visual flow. In frequency-speak, that edge has very high frequencies and needs to be sampled at a much higher rate than 24 times per second—and certainly much higher than 12 frames per second implicit in shooting on 2s. The right thing to do, according to the Sampling Theorem, is to get rid of the high frequencies by rounding off that sharp change in direction. But that's not what animators do. They want that sharp edge, so instead they *exaggerate* the moment—the instant of highest frequency change. Again, how can this possibly work? It should be clear now that animators are unhinged from physics too, but somehow guided by their experience of it.

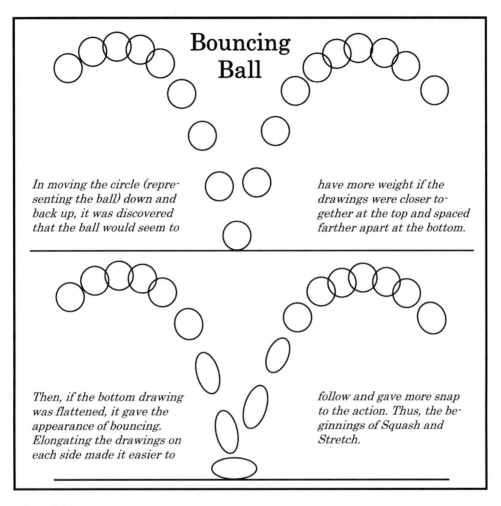

Bouncing
Ball

*In moving the circle (repre-
senting the ball) down and
back up, it was discovered
that the ball would seem to*

*have more weight if the
drawings were closer to-
gether at the top and spaced
farther apart at the bottom.*

*Then, if the bottom drawing
was flattened, it gave the
appearance of bouncing.
Elongating the drawings on
each side made it easier to*

*follow and gave more snap
to the action. Thus, the be-
ginnings of Squash and
Stretch.*

Figure 5.16

Figure 5.16 is (a mockup of) a lesson on the bouncing ball by two masters, Frank Thomas and Ollie Johnston, two of Disney's extremely talented Nine Old Men—the secret of the company's animated movie success. My computer renderings poorly represent their charming pencil sketches, particularly at the moment of impact.

Frank and Ollie—as they were known to everyone—state in their caption that the closer spacing at the top was a result of experiment. Actually, it's exactly what the physics of the situation demands if the path is sampled at equal time intervals, as shown in the preceding, precisely executed illustration (figure 5.15).

They distorted reality to "give the appearance of bouncing." Notice in the bottom half of figure 5.16 how the ball elongates (stretches) toward the point of contact, flattens (squashes) at the moment of contact, and slowly relaxes its stretch in the frames after contact. This illustrates squash and stretch, but also anticipation of an event (stretching toward the bounce before it happens), and exaggeration of the bounce and of the follow-through. In Frank and Ollie's words, these tricks "gave more snap to the action." The tricks improved the viewer's subjective, perceived "reality."[82]

In fact, Frank and Ollie improved it at every step. Compare the top drawing in figure 5.16—of the bounce without squash and stretch—to figure 5.15. Both pictures are meant to exhibit the same thing, a bouncing ball as it actually occurs. But Frank and Ollie, free of the physical bonds of the real world, free of gravity and its parabolas—and free of the Sampling Theorem—drew a bounce that is already somehow richer and fuller than the physically correct one. Then they improved on the improvement with squash and stretch. Notice that their samples aren't exactly at the right locations, and the ball doesn't quite follow true parabolas. And the deformation at the moment of impact (even more outlandish in their actual drawing) has little to do with real deformation. It's more like an elastic bag full of water than a rubber ball.

Frank and Ollie discovered with raw intuition, they claimed, how to overcome the flaws in the sampling of a bouncing ball. Why should these remarkable tricks work so well? One suspects it must have something to do with the sampling process. Since we don't really know how the brain reconstructs an animation from samples presented to the retina—especially quadrupled samples—we have to guess why they work. It appears that animators pack their samples, their frames, with rich hints for the human brain. The elongated balls, before and after the bounce, elongate in the direction of motion. That's a big hint to the brain, like motion blur in a standard film frame.

And that exaggerated deformation of the ball at the moment of impact must flood the brain with dramatic information. The animators maintain the perceived volume of the ball—preserving some notion of a physics at work. But they exaggeratedly squash the ball vertically and stretch it horizontally—sometimes almost into a pancake. When such a sequence plays back at speed, the bouncing ball is liquid, fun, and floppy—with snap to the action. The ball has weight and deformability you can feel. The animators control our emotions by how much they exaggerate the squash and stretch. The phenomenon of apparent motion doesn't quite capture what happens. Apparent deformation is more like it.

My Baptism in Squash and Stretch

My most memorable encounter with anticipation, exaggeration, squash, and stretch happened just as I was mastering three-dimensional animation with computers. This

was on Long Island in the mid-1970s when computers were still very crude. I modeled my left hand as a simplified skeleton composed of little cylinders for bones and little spheres for joints. I even had 8 carpals (as in carpal tunnel syndrome) for the wrist— 8 little spheres. It worked surprisingly well if you didn't look too closely.

I made a copy of the left hand and mirrored it, giving me a right hand. Copying and mirroring are very easy for a computer. With two hands, now what should I do? What animation could I make? I observed my two hands closely as I clapped them. Do this yourself, and you'll notice that the distance separating your palms is only a couple of inches or so. The fingers of one hand curve slightly around the index finger or little finger of the other hand as the palms come together. The thumb of one hand curves slightly around the thumb or the palm of the other hand. The motion is rigid—palms apart, palms together. It was an easy animation to implement, even with the crude tools of the day.

But it was boring! It was sterile. It occurred to me that this was exactly what squash and stretch, anticipation and exaggeration, were designed to alleviate. They were meant to improve perceived "reality." And they should work for this new three-dimensional animation just like they did for old two-dimensional cel animation. In both cases, the results are two-dimensional frames viewed by humans.

So I bent the hands back at the wrist—impossibly far back, as shown in figure 5.17. I exaggerated that motion. I anticipated the motion of the hands going together by sepa-rating them first—going backward to emphasize going forward. That's anticipation. Then I slung the hands together. I exaggerated the speed. When the palms slammed together and stopped suddenly, the fingers did not. They stretched out beyond the palm they had just passed—impossibly far, exaggeratedly far. And then they retracted to a natural position. They also swelled at the tips as they stretched, and then they col-lapsed to their natural shape just as they retracted to their natural position. I did this for both sets of fingers and both thumbs. Lots of stretch, but not much squash.

When I played this animation back at speed, the result was delicious! A big, fat, sloppy pair of clapping hands that seemed alive and made me feel good. And filled me with appreciation for the masters.

Rotoscoping

Drawing every frame of an animated film by hand is high drudgery. Why not film live actors and then outline them to get animated cartoons? This short-cut notion—called *rotoscoping*—was reinvented several times. Edward Muybridge had an artist replicate each frame of that famous trotting horse as an inked tracing, painting, or silhouette. Hence our suggestion that we should consider him the father of rotoscoping, rather than of (live action) movies.

Figure 5.17

Laurent Mannoni, of the Cinémathèque française, showed me two short film loops from the beginnings of cinema. One consisted of photographic frames apparently of Georges Méliès performing a trick. The other loop, from Germany in 1897, used hand-painted frames derived from the first loop, each a colorful painted cartoon of the corresponding photographic frame.[83]

But the US patent for the process went to Max Fleischer in 1917. He began using the process to animate his famous Ko-Ko the Clown in the *Out of the Inkwell* series in 1915. His brother Dave performed the choreographed movements of Ko-Ko for the camera. Then Max used his rotoscope stand to derive a cartoon from each frame. A projector enlarged each live-action frame of Dave onto a transparent easel, from behind. Max mounted a cel on the easel, over the projected image. Then he traced a cartoon outline of Dave onto the cel to make a frame of the animated film. Both Max and Dave claimed to have originated the idea, but their claims conflict. As we've seen, it probably doesn't matter, as they surely weren't the first with the idea anyway. But they did exploit it effectively. Dave had worked at Pathé, but it was Bray who finally released *Out of the*

Inkwell in 1919, undoubtedly delighted to have the rotoscoping process under patent control—like cel animation.[84]

Dave Fleischer played a role in Digital Light, but he never knew it. Dave and Max formed Fleischer Studios, famous for many animated films, including the *Popeye* films. A young animator, John Gentilella, worked on *Spinach Packin' Popeye* (1944), produced by Dave long after Max died. Then, under the alias Johnny Gent, he headed up the animation for *Tubby the Tuba* (1975), produced with old-fashioned cel animation on the campus of the New York Institute of Technology, owned by Alexander Schure.[85]

Schure hired Ed Catmull and me (and others) to incorporate a digital computer into Johnny's animation process. Ed worked on foreground outline animation and I on color fills of the animated outlines and on painting the backgrounds. We didn't advance fast enough to help with *Tubby*, but we and the rest of the Computer Graphics Lab at NYIT did develop the original ideas that later became—after many years and much refinement—the digital cel animation system CAPS (Computer Animation Production System) at Disney.

Ed and I (and others) joined Lucasfilm in about 1980. While there, Disney approached us to digitize their cel animation process. I negotiated the CAPS contract for over a year with Disney. When Ed and I shortly thereafter cofounded Pixar, in 1986, we took CAPS with us, where it was completed to the mutual satisfaction and admiration of both companies. CAPS was used until the Walt Disney Company bought Pixar in 2006. It was Johnny Gent and his team at NYIT who had taught us the intricacies of full-scale cel animation in the 1970s that formed the basis of our relationship with Disney, culminating about 30 years later in the purchase of Pixar by Disney.

Ub Iwerks and Walt Disney

> You'll notice as Ub and Walt feel their way through the animation business, they can only survive by being supremely naïve about the prospects of getting distribution and finding money. They are consistently being fleeced, consistently being bamboozled, and nothing stops them.
> —Russell Merritt, quoted in *The Hand behind the Mouse*[86]

> Walt Disney was maturing into a charismatic leader and visionary whose powers of persuasion were not lost on Ubbe.
> —Leslie Iwerks and John Kenworthy, *The Hand behind the Mouse*[87]

It's time to tell the story of the very influential Disney company—even the unpretty parts. Walt Disney was born Walter Elias Disney on December 5, 1901, in Chicago, and after his stint as a soldier, he moved to Kansas City, Missouri. Ub Iwerks was born as

Ubbe Eert Iwwerks on March 24, 1901, in Kansas City, and in 1924 he adapted the spelling of his name to Ub Iwerks. I use that alias for him, as I've done similarly for others, because it's the one he used when he did his greatest work. The two men were hired by the same commercial art company in Kansas City and soon became fast friends.[88]

After about a year both were fired, so they formed a company, Iwwerks-Disney Commercial Artists. They thought about calling it Disney-Iwwerks but agreed that it sounded like an eyeglass company. It didn't matter because the company soon failed, entering bankruptcy in 1920. The two friends then hired on with Kansas City Film Ad Company. This was when they discovered the world of animation—and fell madly in love with it.

They devoured Muybridge's famous raster arrays of stop-motion humans and animals and made flipbooks from the individual frames. And they learned the animation craft from the influential book *Animated Cartoons* (1920) by Edwin G. Lutz. They learned slash and tear, and ink and paint. They learned rotoscoping. They studied Hurd, McCay, and the Fleischers. And, of course, they had to try their own hand at an animated movie. Ub's natural mechanical bent helped them implement the systems of the pioneers and do it well. They weren't hounded by patent issues because they were out of the limelight, in far off Kansas City.[89]

Walt quickly distinguished himself as the talker, marketer, and organizer of the duo. For example, he talked their boss at Kansas City Film Ad into loaning them a stop-motion camera for extracurricular use. Walt set it up in his family's garage. He, brother Roy, and friend Ub then set to work after hours to make short animated movies.

The idea of lightning sketches inspired one of their early works. They photographed Walt's hand, then moved that hand rapidly above a drawing. The hand appeared to do the drawing. They soon assembled a demonstration—or demo—reel from such pieces. Its purpose was to support Walt's marketing efforts to sell a series of short films. The manager of the Frank Newman Theatre chain in Kansas City bought the series idea, so they called the shorts Newman Laugh-O-grams. One of them sold ladies' stockings, a film remembered mainly for a beautiful model they used named Lucille Fay LeSueur, alias Billie Cassin, alias—much later in her career—Joan Crawford. Another poked fun at potholes in local streets.

As these pieces suggest—and the name Newman Laugh-O-grams strongly implies—Walt, Ub, and Roy were headed for entertainment, not ads. But their boss at Kansas City Film Ad wouldn't support an expansion in that direction. If you want to entertain, then start your own company, he told them. Walt did exactly that.

He was so convinced of the idea that he left Kansas City Film Ad in 1922 and started Laugh-O-gram Films. Ub stayed behind. He required a steady income that would support

his mother. Walt quickly solved that problem by swinging a distribution deal for the new company. It seemed to provide Ub with the security he needed, so he made the leap and rejoined Walt. But he'd made a mistake. The second company went bankrupt too. Ub rejoined Kansas City Film Ad. Walt moved to California where brother Roy now lived.[90]

There Walt and Roy started a company called Disney Brothers Cartoon Studio, Walt's third. Before Laugh-O-gram Films collapsed, he and Ub had managed to make the film *Alice's Wonderland*. Walt used it to make pitches—and succeeded in landing another distribution deal. But after delivery of seven shorts in the *Alice* series, the distributor Charles Mintz sent Walt a blistering letter with a clear message. They had to improve the quality immediately. So Walt wrote Ub in 1924 pleading with him to join them in California. And Ub did. The quality of the *Alice* films improved markedly. Walt ceased animating. Producing would be his forte forever after. Ub became the highest paid animator at the studio, and in 1924 officially took the alias Ub Iwerks. And Disney Brothers studio went on to make dozens of *Alice* films.

Disney Brothers based their next series on Oswald the Rabbit, as usual created and animated by Ub. But then something nasty happened. Their distributor Mintz underhandedly hired away all the Disney Brothers animation staff—except loyal Ub Iwerks—and also took away the rights to Oswald the Rabbit.

It was in this dire moment that Mickey Mouse was born. Walt asked Ub for a new main character to replace Oswald, and Ub designed the character that would come to symbolize Disney throughout the world.[91]

They worked in secret on what would become *Plane Crazy* (1928), the first film to star Mickey Mouse, with Ub as codirector (with Walt) and animator. Then they created *Steamboat Willie* (1928), their first sound film, with Ub as both director and animator (figure 5.18 is a mockup of the text of the title card). Both films were successes and went on to become classics. Next was *The Skeleton Dance* (1929), with Ub as animator and Walt as director. It was the first of the company's 75 *Silly Symphonies*. Ub directed four of the first seven of this series, and Walt the other three. Walt was, as head of the studio, the producer of all these films.[92]

All seemed well, but it wasn't.

Walt began to fiddle with Ub's animation timings—his choice of the sampling moments—the secret to the feel of animation. Walt would change them without asking. Walt began riding Ub hard, while taking credit away from him. It became clear that the Disney company had become all about Walt Disney—and that would, in fact, eventually become its name.

Perhaps the proverbial straw that broke Ub's back was this incident: A boy at a party asked Walt to draw and autograph "his" famous Mickey Mouse. Walt turned to Ub

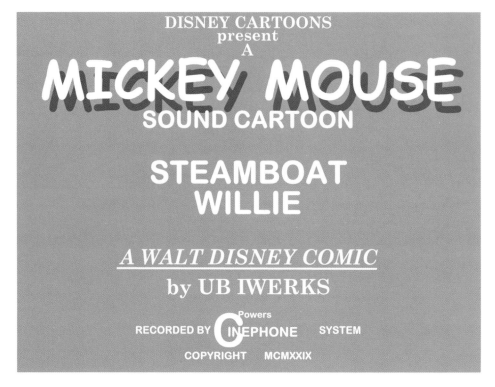

Figure 5.18

and said, "Why don't you draw Mickey and I'll sign it." Ub snapped back, "Draw your own—Mickey!" It was 1929. They had been together, as friends they'd thought, for most of 10 years. Ub decided that he had to go. Walt had moved from friend to tyrant. Marketing had become more important than invention.[93]

The best time to start afresh might not have been after the crash of 1929, but late that year Ub was approached to do so. A businessman named Pat Powers, a Disney competitor, financed him in a new company. Powers informed Walt of Ub's decision, suggesting to the shocked Walt that he hadn't lost Ub—if he would do a deal with Powers. "I wouldn't want him," responded Walt bitterly. "If he feels that way, I could never work with him."

In February 1930 Ub formed Ub Iwerks Studio. For the next decade, it was Ub's life. A series of films based on his newest character, Flip the Frog, was the new studio's entrée. But the Iwerks studio never thrived, despite producing dozens of films. By 1936 it had to close its doors. There were sputters and starts after that, but by 1940

Figure 5.19
(Left) © Sharon Green/Ultimate Sailing. (Right) © Doug Gifford.

Ub was sick of production and wanted to contribute to the artform instead. There was only one studio where he could do that. He rejoined Walt—but on completely different terms.[94]

Sadly, the Walt Disney Company's story of itself no longer includes Ub's foundational role. He's been written out, apparently the price of Walt and Roy's belief that their friend Ub had abandoned them during the years when they made animation history with *Snow White*. But once he was back at Disney, Ub strongly reestablished himself, especially on technical matters if not in the hearts of Walt and Roy.[95]

By the time Ed Catmull and I started making our annual surreptitious pilgrimages to Disney in the mid-1970s, looking for funding of computer animation, both Walt and Ub had died (in 1966 and 1971). But Ub's sterling reputation was still intact. And his son, Don Iwerks, was there to carry on his father's tradition. People at the technical level there assured us that "Ub would have" backed the idea that we proposed—digitizing the Disney cel animation process. Walt's nephew (and lookalike) Roy Edward Disney (figure 5.19), son of Walt's brother Roy Oliver Disney, and skipper of the *Pyewacket*, would finally make that happen about a decade later, as champion of the CAPS project. And another two decades after that, he would help clear the way for the purchase of Pixar by Disney.[96]

Felix the Cat

> I gave Felix a personality, using many facial expressions. . . . He would be a pet. . . . He would
> influence young children. . . . He would fulfill many wishes. . . . Looking back, we see a door
> opening slightly on a road that led to a new field of visual arts.
> —Otto Messmer, foreword to Donald Crafton's *Before Mickey*[97]

> To me a mouse is a repulsive thing.
> —Otto Messmer, epigraph in *Before Mickey*[98]

There's an echo of Walt and Ub in Pat Sullivan and Otto Messmer. Their product was
Felix the Cat, a character and series still beloved of animation aficionados. Messmer did
the animation (figure 5.20). Sullivan was the mover and shaker, became rich, and took
the credit.

Figure 5.20

Felix occupies a special territory between abstract animation and cartoon character animation—surrealism with a large dose of realism, say. His tail could become a question mark or an exclamation point at appropriate times. His ears would click together like scissors. Felix could solve problems in the most absurd ways. For example, to get to an elevated place with no ladder, he would detach his own tail, deform it into a stair-stepped line, and climb up the "stairs."

Donald Crafton celebrates Felix on the cover of his definitive animation history, *Before Mickey*, and devotes the entire last chapter to him: "It was the quintessential cartoon of the 1920s." It was black-and-white and soundless, but it worked and keeps on working.[99]

By 1926—before Mickey—Felix was almost as popular a screen star as Charlie Chaplin. Felix dolls sold very well—an early exercise in merchandising the movies. But the lack of sound eventually doomed the Sullivan enterprise. He refused to use it for years, until the resounding success of audio in Disney and Iwerks's *Steamboat Willie* (1928) forced him to change his mind. But then he chose an inferior audio system, and the studio was essentially dead by 1930.

Nevertheless, Felix made Sullivan a millionaire—in the 1920s. He and his wife Marjorie were incredibly wealthy in the fabulous New York City of the jazz age. They drank hard and partied hard while Messmer ran their money-making studio. But in 1932 Marjorie fell to her death from the fifth-story window of their apartment, and Pat never regained full emotional stability.

Sullivan's name was the one attached to the *Felix the Cat* series, not Messmer's. But Walt certainly knew who was doing the work. He visited Messmer at the Sullivan studio several times in 1928 while in New York City following the success of *Steamboat Willie*. Walt was starting to think big—a feature-length film—and he needed talent. "He begged and pleaded," said Messmer, who wasn't interested in leaving New York City. "And besides, it looked like Felix could go on forever. He was at the height of his success." Sullivan soon failed, however, and Walt had the whole field to himself, but he never signed Messmer.

Tower versus Stinks Revisited

I haven't really explained how films work—especially animated films. As with our ignorance of how actors and animators do what they do, it's because the brain is almost certainly involved. That terra incognita is the limit on film technology in both the general case and the special case of animation. Once the technology passes through the pupil, we have to throw up our hands—or make educated guesses. In other words, to

rely on the psychophysical phenomena of persistence of vision and apparent motion is just another way of saying, "The brain does it."

A major theme of this book is that the Sampling Theorem, Kotelnikov's great idea, is key to understanding Digital Light. Since films appear to sample visual flow at 24 frames per second, surely the Sampling Theorem should explain why films work. But we discovered instead that they don't work exactly that way. The lovely ideal movie system that follows from sampling theory was not the one that was actually used.

The actual system was definitely a sampling process of some sort, but it projected each frame twice, and the frames were fat and filled with clues such as motion blur for the brain to feast on. In an ideal system the frames are thin—instantaneous. They therefore cannot contain motion blur clues. But they can represent any motion that doesn't exceed the twice-the-highest-frequency restriction. The Sampling Theorem guarantees it. As we approach Digital Light, we'll look for adherence to the ideal system. Does the modern real world spread and add the samples outside the pupil? Or continue to rely on "the brain does it" handwave?

Animated films fall even farther outside the bounds of the Sampling Theorem—especially those shot on 2s. In that case, every frame is projected onto the retina four times! Consider the bouncing ball. The moment of its contact with the ground happens again and again and again and again. Yet our brain figures it out. It doesn't see the quadruple whammy, but rather perceives one long delicious impact—aided undoubtedly by the tricks of the animation masters, like squash and stretch, anticipation and exaggeration.

Ideal versus actual is suggestive of tower versus stinks, another theme of this book. They both fundamentally matter. Indeed, it's exactly the tower versus the stinks, and why it's wrong to rate the creativity of one over that of the other. Actual movie machines were created in the stinks. We can come along later in the ivory tower and propose a beautiful mathematical idea to "explain" why movie machines work. But it's clear that the movie inventors didn't start from theory. The Sampling Theorem doesn't work as an explanation of their machines. But it does show us which way to go next. This interplay of doing and thinking is closer to the way the world works than either theoreticians or engineers commonly like to admit.

The story of film and animation also vividly reminds us of another part of the secret of movie technology, one we understand even less. The key to both the Sullivan and Disney businesses was the fact that they hired people with the rare artistic talent to make pictures come alive. That's the method that works in the digital world too. The best hire of my life was the Disney-trained animator John Lasseter, whose inexplicable talent was the unquestioned key to Pixar's unmatched early success.

The Moore's Law factor is now (2020) 100 billion X and rapidly approaching 1 trillion X. Despite all the claims about artificial intelligence and deep learning inspired by that awesome, supernova surge in computational power, we are hardly any closer now to understanding how an animator or actor creates a personality than we were in the 1920s and 1930s. According to television commercials, all automobiles are now intelligent, but none of them can inspirit a character.

I am not saying that there exists a hard limit to technology—that machines *cannot* be creative. My personal faith is that we will someday understand how creators create and perhaps even machines. But that's faith, not science. I could, with as much justification, elect to believe just the opposite—and many humans do. It's "faith-based science" to claim or imply that we are almost there, any day now. Meanwhile, into the foreseeable future, we continue to hire the best human artistic talent we can to animate and act—they're the only known solution. We still seek out the few Ubs, Ottos, and Lasseters of the world.

The Rise and Shine of Digital Light

6 Shapes of Things to Come

The Spline Shape

> Spline approximation contains the delicious paradox of Prokofieff's [*sic*] Classical Symphony: it seems as though it might have been written several centuries ago, but of course it could not have been.
>
> —Philip J. Davis, mathematician, 1964[1]

A pleasure of the San Francisco area is easy access to fine music. Even so, I was astounded when Ravi Shankar, the great Indian sitar player, walked into the computer graphics lab at Lucasfilm in the wee hours of a night in 1982. I was working alone on the paint program written by one of our resident geniuses, Tom Porter. I had devoted that evening to learning about Tom's latest feature—splines. Ravi's host was Clark Higgins, the video wizard for both the Grateful Dead rock band and us.[2]

"You know Ravi Shankar, don't you, Alvy?"

I melted. "Of course I do." I had seen him first in *Monterey Pop* (1968), a defining movie of the Sixties. I knew he'd performed at Woodstock in 1969, another defining event of the era. I didn't know him, but I certainly knew him.

Ravi was a beautiful man, small, smiling, and impeccably dressed in (mostly) white Indian apparel. Best of all, he wore a subtle and surprising fragrance that surrounded him—a sensual aura that both enhanced his presence and engulfed me as he stood peering over my shoulder.

By happenstance there was a flower displayed on the computer screen, near the top. A visiting artist the previous day had painted a small blossom there of red and blue petals and a white-dotted center. It brightened the room when Ravi joined me, like a cutting of a real flower.

"A spline," I explained, "is a graceful curve through a few points. Our computer can register only a few points along this path." With a grand gesture, I stroked a stylus across a large tablet. I said little else that night. I simply showed Ravi how it worked.

The gesture was an arbitrary one, starting low and moving upward. With a wrist flick, I swept briefly downward in midstroke, then upward again, ending high.

Then Tom's paint program instantly took over. First, it created a spline through the sparse points from the tablet. We couldn't see the spline, mind you. It was pure geometry, with zero width, stored inside the computer somewhere. But then, after a hint of a pause, the program rendered it into what looked like a stroke of paint on the color display before us. The invisible spline became the backbone of a visible paint stroke. The lag between my gesture and the program's stroke was so brief that it seemed—with a pinch of imagination—that I, not the computer, had painted it directly on the screen. The color had been a random choice—a brown, as luck would have it.

The program simulated a brushstroke with soft edges and varying width. The stroke began with no width near the bottom of the display, then widened gradually as it swept upward and into the curves, and finally narrowed to nothing again as it ended upward . . . just at the flower! A perfect stem for it. As if I had planned it that way. But I hadn't. All three of us knew I hadn't. It took our breaths away. In that extended moment Ravi Shankar, my musical hero, swimming with me in his own heavenly scent and as startled as I, touched my shoulder and whispered, "Allllllllvyyyyy!"

A Plump of Ducks, a Pod of Whales

A "plump" of ducks rose at the same time and took the route to the north in the wake of their noisier cousins.

–Henry David Thoreau, *Walden*, 1864[3]

The spline of the Ravi Shankar demo is a piece of geometry that derives from a draftsman's tool of the same name. My father taught me mechanical drawing as a child, long before the personal computer. The tools were a precision German compass for drawing circles, a T-square for right angles and straight lines, and India ink pens and nibs. He had another rather mysterious tool called a French curve (figure 6.1) that resembled Santa's sleigh if you turn the picture upside down. Its purpose was to steady our shaky hands as we tried to draw a smooth curve of unusual shape. In the illustration a draftsman has placed a French curve in three successive positions to help him draw a curve piecewise. The pieces are curve parts A, B, and C, each found in various places along the French curve's many edges. This draftsman was lucky. He found all needed curve

Figure 6.1

Figure 6.2

parts near one another along the runner of Santa's sleigh. But sometimes you can't find the curve you seek.

Serious draftsmen need something more trustworthy. Designers of luxury yachts won't put up with a French curve that might lack the curve parts needed. To draft curves for a racing hull, say, they use a thin flexible strip held in place with heavy weights, as shown in figure 6.2 (right). The strip passes through points fixed by the weights and relaxes into a smooth curve through them so the edge of the strip can be traced into the boat plans. That drafting tool—the strip and the weights—is called a *spline*.[4]

The geometrical spline in the Ravi Shankar demo was directly inspired by the boat designer's physical one. The weights in the physical version are known as *ducks* (or *whales*), for obvious reasons. You can even buy a plump of ducks painted as mallards, mergansers, harlequins, and so forth, as shown. The hook tips protruding from physical ducks are the points that the physical spline must pass through. A geometrical spline has only virtual ducks, without bodies or hooks. The ducks in this case are simply the

points that the spline must pass through. In the Ravi Shankar demo, the ducks were the separated points obtained from the tablet as I made my gesture.

Interpolation versus Sampling

> Point of view is worth 80 IQ points.
> —Alan Kay, Xerox PARC, ca. 1980[5]

A spline provides an answer to what joins separated points—such as those from a tablet in the Ravi Shankar demonstration. It's a smooth, gracefully undulating geometric curve that passes through the points. It's a guess at what lies between them, with the proviso that the something there should be interesting, even pretty. Connecting the dots is trivial otherwise: just join each to the next with a straight line segment. The zigzag result doesn't please most eyes.

To understand splines we invoke, believe it or not, the Sampling Theorem yet again. But we have to take a slightly different point of view.

We met Sir Edmund Taylor Whittaker so briefly in the chapter on the Sampling Theorem that his name might not ring a bell. He was England's candidate for Sampling Theorem discoverer in 1915, 18 years before Vladimir Kotelnikov. He was one of England's great mathematicians. He studied at Trinity College, Cambridge, Isaac Newton's college, and became a Fellow there in 1896. He was elected a Fellow of the Royal Society in 1905. To cap his illustrious career, Whittaker headed the mathematics department at the University of Edinburgh.

Yet I gave the crown for the Sampling Theorem to Kotelnikov. Why not Whittaker? There are two reasons. First, he didn't prove the theorem from the point of view we use in Digital Light for the display of pixels. Second, even if you accept his point of view, he didn't completely prove the theorem as it's currently used.

Whittaker's expertise was *interpolation*. His point of view is captured in a book he coauthored:

> The Theory of Interpolation . . . in its most elementary aspect may be described as the science of "reading between the lines of a mathematical table."[6]

Data tables aren't things of beauty to most people, but they are handy. Suppose we've taken the temperature at every hour on the hour at a particular location on the University of California at Berkeley campus. Then what's our best guess at the temperature there at 15 minutes after any given hour, let's say 3 p.m., on the same day? Whittaker's theory of interpolation yields a good estimate, a useful number.

To interpolate means *to put something between*. It's implicit in the definition that the something between is *created* to be there. If we're lucky, the created data might actually represent the real world—the temperature at 3:15 p.m. on the Berkeley campus, say. It's meant to make sense as if it were measured, but it wasn't. Whittaker was a master of interpolation, or the creation of data between.

Kotelnikov's contrasting point of view never encompassed the *creation* of smooth curves. His point of view was the *reconstruction*, not the construction, of smoothness. He started with smooth curves—of brightnesses or loudnesses, say. He found a way to throw away most of that data to get a set of discrete samples—pixels or soxels, for example—from which he could later reconstruct the original smoothness. His Sampling Theorem teaches us exactly how to do that.

Whittaker's point of view was the opposite. Discrete data points were what he started with. He sought to find a smooth thing that connected them, and that's why he didn't prove the more powerful version of the Sampling Theorem that Kotelnikov proved (and Claude Shannon re-proved).[7]

Kotelnikov's Sampling Theorem in its simplest form has two parts, as we've described. The first part tells us how to sample a smooth something that can be described as a sum of Fourier waves—which turns out to be most smooth things in the natural world. In particular, it tells us to sample at (more than) twice the highest frequency of a wave in that sum. The second part tells us to use the ideal spreader to spread the samples and add them up to reconstruct the original smooth something. In other words, the second part tells us how to interpolate the samples to get a smooth curve, the original curve, through them. Kotelnikov starts with smoothness, takes discrete samples, then reconstructs the original smoothness: smooth to discrete to smooth.

Whittaker's Interpolation Theorem tells us to spread each given data point with the spreader—the same ideal spreader as Kotelnikov specified. Then add up the results to get a smooth interpolation, a smooth curve, between the data points. That curve is a sum of Fourier waves up to a highest frequency consistent with the spreader used. Recall that the ideal spreader wiggles as often as does the wave of highest frequency. Whittaker starts with discrete data, interpolates a smoothness between them, then discovers the desired data along the new curve between the original data points: discrete to smooth to discrete.

Despite the two points of view, the results are mathematically equivalent. One is just the other in reverse. So why not give Whittaker credit for the Sampling Theorem? The reason to hold back is that he didn't prove the more complex form of Kotelnikov's Sampling Theorem, the so-called *bandpass* variation that's used so often in the modern world. We used it in the chapter about Turing, for his vocoder work, where he broke

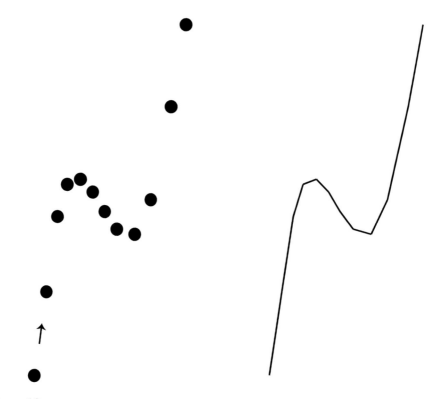

Figure 6.3

an audio signal containing 0 to 3,000 cycles per second into 10 bands each with band-width 300 cycles per second (0 to 300, 300 to 600, . . .).

Nevertheless, it's fitting that we crown Whittaker the king of interpolation in this chapter. It's a beautiful balance to feature Whittaker's interpolation point of view in the creation of smooth objects for computer graphics and Kotelnikov's sampling point of view in the discrete display of them. It's not at all obvious that one basic idea, from two different points of view, figures in both Digital Light domains—Whittaker in making, Kotelnikov in taking.

A Spline for Ravi Shankar: Sampling in Reverse

Figure 6.3 (left) is a picture of the points from the tablet in the Ravi Shankar demonstration. The tiny arrow shows the direction of my gesture. The tablet recorded the gesture in equal time steps, so you can see that I drew fast at first, slowed down for the turns, and finished rapidly. The picture at the right is what we do *not* want, with straight

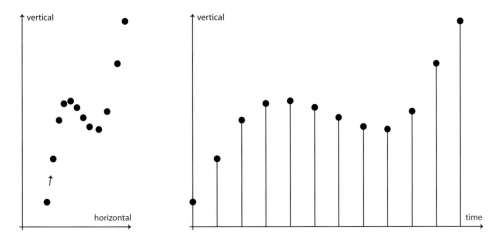

Figure 6.4

lines between the points. It's an interpolation of the same data, but not a pleasing one. It's a stiff zigzag "curve." Back in the bad old days people thought that this was all that a computer could do. They imagined that computers were rigid and angular—mechanical, in a word—before Moore's Law proved them wrong. In computer graphics, linear interpolation—straight lines between points—is hardly ever desirable.[8]

We can do much better. The location of each point can be measured vertically from the lower edge of the tablet. Figure 6.4 (right) is a plot of the vertical positions of each point. It's just the points at the left spread out horizontally in equal time steps.

We've made the vertical positions look like samples as depicted in an earlier chapter. They aren't samples of a known reality, but there's no reason we can't act like they are. Let's construct that fictitious "reality" with the Sampling Theorem. Notice that we say *construct* rather than *reconstruct*. It's that point-of-view thing again. We know how to do this construction: spread each sample with a good spreader, and add up the results. Figure 6.5 is what you get. The smooth curve passes through—interpolates—the "sampled" vertical positions, located at the spreader peaks in the picture. The points on this curve are the desired vertical positions as they change smoothly in time.

Next we repeat the same trick for the horizontal positions. The result is a smooth curve that passes through—interpolates—the "sampled" horizontal positions. The points on that curve are the desired horizontal positions as they change smoothly in time. (See the actual construction in the online annotation for this paragraph.)

With these two curves we can plot the desired two-dimensional spatial curve, the spline, at any particular instant: we take its vertical position at that very instant from

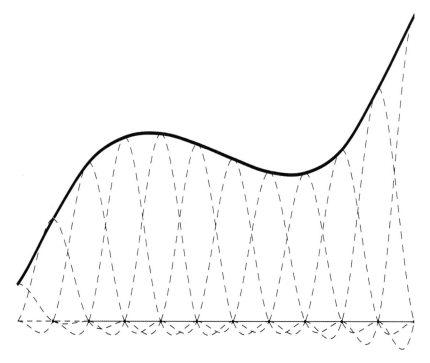

Figure 6.5

the first curve and its horizontal position at that same instant from the second curve. If we do this methodically as time increases, then we trace out the desired curve in the same direction and order as the original gesture of the stylus over the tablet. That is, we've constructed a pair of smooth curves, for vertical and horizontal positions, that pass through, or interpolate, the tablet points of the Ravi Shankar demonstration. Which is a complicated way to say that we've created a smooth curve through the points.

Let's go through that again. We *assume* there is a smooth curve through the given tablet points and that it's the path of the original gesture. If you think about it, to make that possible, the vertical changes along the path must vary smoothly, and so must the horizontal changes. So we use the Sampling Theorem's reconstruction technique to construct a smoothly varying curve of vertical positions, and another of smoothly varying horizontal positions. Both *have* to pass through the vertical and horizontal positions of the sample points in two-dimensional space. At any other time during the stroke, we can simply read off the vertical and horizontal positions—from the two constructed curves—of the point that must lie on that path at that time. Figure 6.6 (right)

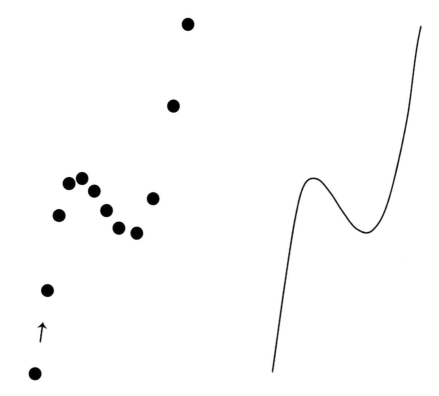

Figure 6.6

shows what the resulting spline looks like, compared to the points (ducks, left) that determined it. The human input via the tablet is on the left and the computer's output on the right. It's smooth, not zigzag. It's a spline, one of the loveliest ideas in Digital Light. And *spline* is such a nice word.

Splines in Practice

Look again at a picture (figure 6.7, top) of the spreader specified by both Kotelnikov and Whittaker. It's the theoretically correct spreader.

But we can't use that ideal spreader for our spline constructions because it's infinite. Those ripples diminish, but they go on forever. We previously used instead the practical, finite spreader in figure 6.7 (bottom) and claimed that it was a "good approximation" to the ideal spreader. But that was in the context of reconstruction—Kotelnikov's domain. Here, where the context is construction, not reconstruction, we don't need to use the ideal, and infinite, spreader. We're perfectly happy using the simpler, and finite,

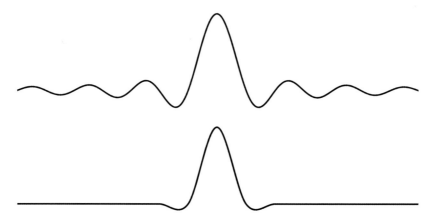

Figure 6.7

spreader. And the notion of approximation is irrelevant. We exactly construct a new curve, not approximately reconstruct a known one.

The spline that you get using this simpler spreader has been rediscovered several times. In computer graphics, it's called the Catmull-Rom spline in honor of two computer graphics students who rediscovered it: Ed Catmull, who cofounded Pixar with me, and Raphael Rom.[9]

Since both Catmull and Rom came to their spline from the Whittaker point of view of interpolation to construct smooth curves, it wouldn't have occurred to them to think of it as a reconstruction from Kotelnikov samples, nor that their spreader was an approximation to the ideal spreader. And they wouldn't have thought of the Fourier frequency content of the splines they generated.

The two different uses—in creation and display—come from different points of view, and that's why I give construction credit to Whittaker and reconstruction credit to Kotelnikov. The practical consequence is that the one spreader can be used in both contexts. One computer program suffices for both. That the same idea is useful in both Creative Space and Display Space is a surprising and beautiful connection.

Computer Graphics Defined

The Ravi Shankar spline demonstration is an example of *computer graphics*, a major branch of Digital Light—a synthetic branch, making pictures not taking them. Computer graphics always requires two steps: We create objects by modeling them with invisible geometry in Creative Space, a process I'll describe at length in this chapter and

the next. Then we view them by rendering the geometry-based models into the spread pixels of a Display Space, such as a printed page, a cellphone display, or virtual reality (VR) goggles. That's our definition of computer graphics.

On that night with Ravi Shankar, Tom Porter's program created an invisible spline as the backbone of a paint stroke. That was the geometry underlying the stroke. Although geometry is fundamental to the definition of computer graphics, a model isn't only geometry. The stroke model also had color, soft semi-transparent edges, and a width that varied in time. The program rendered the model of the stroke into pixels which were then spread into visibility by the full-color display in the Lucasfilm graphics lab. It was an example of two-dimensional computer graphics, because the model was based on two-dimensional geometry.

The picture in this chapter of that same spline is a much simpler rendering. Its model has exactly the same geometrical path as the paint stroke I showed to Ravi Shankar. But the other components of the model are different. It's a black line of constant width on a white background. Both pictures are examples of computer graphics. A single geometric object in Creative Space can be rendered a great many ways in Display Space, depending on those non-geometrical model components.[10]

On the other hand, if there's no geometry, then it's not computer graphics. Adobe Illustrator renders two-dimensional geometric models into pixels. It's a computer graphics program. Adobe Photoshop creates pixels from scratch or modifies pixels taken from the real world. It's not a computer graphics program. It's an *image processing* program, from another major branch of Digital Light. Similarly, early Apple offered MacDraw, a computer graphics program, and MacPaint, a pixel-packing, or image processing, program. (See the annotation for discussion of a generalized notion of "geometry.")

Computer graphics is geometry in, pixels out. Image processing is pixels in, pixels out. Both are used for creating pictures. In the early days of very expensive memory, image processing was about taking pictures only, but Moore's Law has made it possible now, in the new millennium, to make pictures directly from pixels.

The Adobe and Apple product pairs reflect the old division of Digital Light caused by the calligraphic "detour" I mentioned in chapter 4. In the early days, geometry-based programs were designed for calligraphic displays, and pixel-based programs for raster displays. What makes the distinction tricky now is that, since the Great Digital Convergence, both varieties display in pixels. What separates computer graphics from image processing is the contents of its distinctive geometry-based Creative Space. But both branches now share the same Display Space.

There are many examples of two-dimensional computer graphics. Even the interface to Microsoft Windows that I'm using right now is computer graphics. The windows on

the screen in Display Space are rectangular models of a stack of papers on a desktop in the program's Creative Space. And the interface to Microsoft Word is similar. Its model is a sequence of rectangles representing the document pages, and each letter on the pages is defined ultimately by a geometric model. Webpage design and the browsers that use the resulting pages are further examples. Geometry in, pixels out.

A major goal of this book is to show how a Pixar-like movie emerges from a computer. Each frame of such a movie is modeled with three-dimensional geometry internal to the computer, then rendered into two-dimensional spread pixels for full-color display. That's what we mean by three-dimensional computer graphics, the main focus of this book. Videogames are created the same way. And VR too—with two displays of each frame, one for each eye, to produce a stereo effect.

A spline is a curve, not a surface, and we want to focus attention now on modeling surfaces. The next shapes we consider serve that purpose. The first of them is simple and familiar.

The Triangle Shape

What exactly is a triangle? I consulted the carefully preserved plane geometry textbook from my Clovis, New Mexico, high school, a book that shaped my entire future. The book begins on page 7 with points and straight lines. The two ideas can't really be defined—we just "know" what they are—but we can start to "understand" them by what they lack, or what they are not: A point has no width, no height, and no thickness. It's pure location. A straight line has no width, no thickness, and goes to infinity in both directions of its one dimension. It can be specified by naming any two points on it. A line segment is a finite piece of a straight line defined by two points on the line, the line segment's endpoints. A broken line is composed of line segments, each connected nose-to-tail with one other, except the last one. So a broken line has two dangling endpoints.[11]

To my surprise, the textbook doesn't arrive at the lowly triangle until page 57. A polygon is a closed broken line, it says. The last endpoint of the last line segment is connected to the first endpoint of the first line segment—no dangling endpoints. Finally, a triangle is a polygon with just three sides. None of these is visible, but the textbook does say that a point is represented by a dot in a picture. Figure 6.8 shows that geometry lesson in one figure. These are visualizations of the five invisible geometrical objects I just mentioned. They are concrete renderings of the simple abstract geometric models.

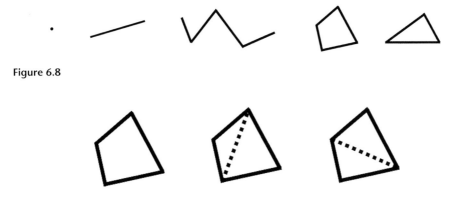

Figure 6.8

Figure 6.9

The textbook's longwinded approach to the triangle does have the advantage that it introduces an important term. It's *polygon*, a much beloved word in computer graphics. A general approach in computer graphics is to describe a fictitious world with polygons.

But we'll immediately rid ourselves of the need for the word *polygon* with this key fact: Any polygon can be subdivided into triangles: choose any corner, or vertex, of a polygon and connect it to all the other corners (vertices) with line segments. So, we only ever have to talk about triangles. Figure 6.9 shows two different ways to convert a four-sided polygon into two triangles with one additional line segment (dotted). It would take two additional lines for a five-sided polygon, and so forth. (See the annotation for caveats.)[12]

Because of this trick, we only need to concentrate on models made of triangles. Not every model can be made with triangles, though. The geometric model for the Ravi Shankar curve is just a spline, not a polygon. The text in the first digital picture, First Light, and the game boards of the early videogames in the Dawn of Digital Light chapter also had simple models that didn't reduce to triangles. The models were, with few exceptions, just straight line segments.

But consider Pixar's animated films from *Toy Story* to *Incredibles 2*, Illumination's *Despicable Me*, and all other animated films with three-dimensional characters—"Pixar-like" movies. Their characters are composed of surfaces, and surfaces can be modeled just with triangles.

If we learn how to deal with a single triangle, then we can let Amplification—that great glory of computers—take care of all the rest, often many millions of them. The central idea of this chapter (and the next) is that if you can understand how one triangle gets from computer memory to display screen, then by invoking Amplification

Figure 6.10

you can intuit how a full picture gets to the screen. It's the computer tirelessly comput-
ing the same thing over and over, millions even billions of times, very fast, that makes
computer graphics possible. It's hard to do—impossible for an unaided human—but
easy to understand.

The Classic Teapot
For decades computer graphicists showed off their latest advances by making pictures
of a single object . . . a teapot. In fact, it's *this* actual teapot—figure 6.10 is a photograph
of it, not a computer rendering—that holds a place of honor in the Computer His-
tory Museum. The teapot belonged to Martin Newell, an Englishman naturally, who
was a computer graphics professor at the University of Utah in the 1970s. It's less well
known that Newell modeled an entire tea set with teacups and saucers, teaspoons, and
a creamer to accompany the teapot.[13]

Figure 6.11 shows how you can use geometry to model a complex object, a teapot, in
a computer. The same idea is used to model the shape of each character in a Pixar-like

Figure 6.11

movie. These are two different representations of Newell's teapot—called *wireframe* representations for obvious reasons. The model on the left is a mesh of triangles. The one on the right is a mesh of four-sided polygons. Diagonals drawn on each of the four-sided polygons would convert it to a mesh of triangles too. Triangles are flat, but we represent curved surfaces with so many small triangles that the collective surface appears curved at an appropriate viewing distance. Soon, we'll describe how to create such meshes, but just assume they exist for now.

To be clear, these pictures are *not* what's inside the computer. There are no pictures inside a computer, even ones that look like geometry. The pictures are renderings into spread pixels of the geometric models inside the computer that are then presented on a display—namely the printed page you are reading now.

What is a "geometric model inside a computer"? Let's recall that there are only patterns of information inside a computer. Although bits aren't required for computation, nowadays patterns of information are always stored that way. So the model is a pattern of high and low voltages in an integrated circuit chip located somewhere in the bowels of a computer.

I also noted in earlier chapters that bits don't necessarily represent numbers, but they often do, and they do in geometric models for computer graphics. Each line segment forming a triangle—that is, each of its sides—is represented by numbers that identify the positions of its two endpoints. In other words, a computer memory holds the coordinates of each vertex (the point where the sides meet), its horizontal, vertical, and depth locations. So, a model made of triangles inside a computer is simply patterns of bits representing numbers that are the locations of triangle vertices in three-dimensional space. The model is essentially a list of numbers—generally a very long list. The teapot list would use about 26,000 numbers—just for a teapot. Buzz Lightyear

would require millions. Amplification is the only way we can possibly deal with such numbers.

Another kind of information is usually stored in a geometric model. You can think of it as the model's structure: this point is connected to that one, this triangle shares an edge with that one, this teapot handle is connected here to the teapot body, or the hip bone is connected to the thigh bone of a character. These pieces of information are numbers too. They are computer memory addresses. For example, the three coordinates of a point might be followed with a fourth number. It tells the program where to go in memory to find another point that is connected to this one.

The computer doesn't in any way know what any of this data means. The computer itself has no notion that those patterns of high and low voltages are a geometric model. It takes a program to make sense of the patterns. It's a program that "knows" that the bits represent numbers and that the stored numbers represent triangles. Or that a number is an address where a connected component can be found. A long list of meaningless steps, a program, gives meaning to a model stored inside a computer that is to become a picture on the computer's display. In fact, it's the human who wrote the program who knows the meaning of the program and the data it manipulates.

You don't have to see a model as it's created. In the early days nobody saw the models they made. Martin Newell couldn't see the model of his teapot as he built it in a computer. But a modern computer graphics program does let us see a model while we design it. That moment when we first *could* see a model *while* we built it is a highly honored one in computer graphics, as we will soon discover.

How does a list of numbers become a teapot or Buzz Lightyear? If you know how one triangle makes the journey from bits to spread pixels, then it's the Amplification glory of computers that does the rest—the heavy lifting, the part that no human being, no matter how skilled, smart, or computer savvy, could do. It's the dumb thing that computers do so well. So, our goal boils down to getting one triangle onto a screen. If you understand that, you understand it all.

How to Draw a Triangle

A model made of triangles is three-dimensional, but a picture of it—that is, the geometry model rendered into the spread pixels of a Display Space—has only two dimensions. The two wireframe teapots depicted in figure 6.11 appear three-dimensional because they were rendered in perspective, which squashed the triangles. But they're still triangles. It's those two-dimensional triangles we learn how to draw here.

It's easy on an old-fashioned calligraphic display. A program simply instructs the display to sweep out a line segment—one side of a triangle—from one of its endpoints

to the other. And then the program repeats the instruction for the other two sides. That's it. A picture of one triangle is now visible. A short list of numbers stored as bits in a memory is now a picture of a triangle on a display. Using the miracle of Amplification, we then have our computer repeat this simple process tens of thousands of times very rapidly to view the geometric model of a full teapot as a wireframe picture on a calligraphic display.

Although displaying triangles in this way is conceptually simple, computer graphicists spent years making the process efficient. It's a waste of precious time, for instance, to draw a triangle side more than once if it's shared by another triangle. We've glossed over several other matters important to computer graphicists, but they are the plumbing (see the annotation). You needn't know about them to understand intuitively how ultimately simple it is to convert a triangle stored as numeric values in computer memory locations into a picture of the triangle on a display screen. Or of a mesh of triangles into a picture of a teapot.[14]

It's easy to draw a line segment, hence a triangle, on a calligraphic display. But modern displays aren't calligraphic. They're raster displays of spread pixels. How do you represent a straight line segment at any angle on a display that is arranged in strict rows and columns? Another way to ask the question is this: How do you render a line segment to a raster display?

The first rendering algorithm in computer graphics to bear a person's name was *Bresenham's algorithm*. It was one of the earliest known procedures for approximating a straight line segment with pixels. Jack Bresenham in 1962 had to use pixels that were either on or off to (crudely) represent line segments. That's all he had then.[15]

Here's a line segment (figure 6.12, the diagonal) rendered with Bresenham's algorithm as black spread pixels on an otherwise white background. The pinpoint dots are pixel locations. Spread pixels (the big dots) are placed at the locations nearest or on the

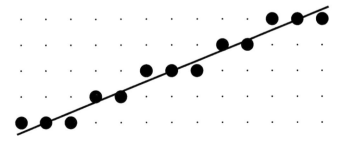

Figure 6.12

given line segment. Bresenham's algorithm is the most efficient one possible for use on simple raster displays that can display only black or white.

Of course, the diagonal line segment that you see here is actually a rendering into the spread pixels of a modern display (or printed page) of the otherwise invisible line segment. And the "spread pixels" (the large dots) of Bresenham's approximation of the line segment aren't actual pixels drawn large. Pixels are no more perfect little disks than they are perfect little squares.

Bresenham's algorithm and others like it gave us the "jaggies" of early computer graphics. You can see the telltale stairsteps if you squint your eyes at figure 6.12 (and ignore the diagonal line segment). It's an ugly look that many people thought at the time was what computer pictures *had* to look like—that misperception again that computers had to be rigid and "mechanical." As we saw in the Dawn of Digital Light chapter, it took 10 more years before Dick Shoup showed us that jaggies weren't intrinsic to computers. In 1973 he demonstrated straight lines that were rendered beautifully with spread pixels (figure 4.26). But those pixels had far more than two values—two orders of magnitude more.

What first attracted me to Bresenham's algorithm wasn't its efficiency. It was that name Bresenham. It's spelled exactly the way Dick Bresenham, a high-school classmate from Clovis, New Mexico, spelled it. Surely Jack Bresenham of the algorithm couldn't have come from Clovis too. I checked and found that in fact he worked for IBM in England, which settled the matter. Or so I thought. But when the first edition of an important computer graphics textbook was published, Mrs. Bresenham in Clovis called Mrs. Smith in Clovis and said, "My son has a chapter, and so does yours." She exaggerated our importance, as moms do, but the point was made: Jack was Dick's brother, and he did come from my hometown. When I finally met Jack, I learned that he'd left Clovis just before I was old enough to know him.[16]

Flow Chart of Early Computer Graphics (Cont.)

Let's now turn to placing these developments in historical context. I use a flow chart here, like those I used in the preceding two chapters, to guide us through a complex history involving many players. The flow chart of the history of computers I presented in the Dawn of Digital Light chapter covered the late 1940s and the early 1950s. We can think of that period as the first stage of the period before Moore's Law—that is, the first stage of Epoch 1. Figure 6.13 is the continuation of that chart (figure 4.6) into the late 1950s and through much of the 1960s, the second stage of Epoch 1. The box labeled "Whirlwind" is repeated here to show where the two charts join.

The item "Moore's Law 1965" appears in the lower middle of the flow chart, indicating the fateful event that kicked off Epoch 2. We'll save exploration of Epoch 2 for the next chapter, except for one carefully labeled event included here for convenience. (That an event occurred after 1965 doesn't imply that it utilized Moore's Law.) Individuals are enclosed in circles, and a group in an ellipse. Computers and a special-purpose hardware device are in rectangles. Programs, books, and concepts—all soft ideas—are in parallelograms.

Everything I said about flow charts in earlier chapters continues to hold for this one too: It's not an exhaustive presentation of the field. Many players and events that are omitted here are supplied elsewhere in the text or in the annotations—but certainly not all of them. And the chapter's prose can be thought of as a lengthy caption for the chart. As before, the chart's complexity demonstrates that the story of a high technology is seldom, if ever, a simple narrative of a single leader.[17]

An Important Distinction: Objects versus Pictures

Computer graphics by definition is the creation of visible pictures from invisible geometric models held in computer memory. There are two major ways to use those models, and that distinction leads to a major partitioning of computer graphics.

In one case, the models represent objects intended to exist in the real world. A *computer-aided design* (CAD) practitioner uses computer graphics to design objects. Ultimately, objects matter in CAD—not pictures of them. CAD is object-oriented computer graphics.

The opposite case is *picture-oriented computer graphics*. A digital movie is an excellent example of how only pictures matter—not the objects pictured.

A major proviso separates CAD from picture-oriented computer graphics. In a word, it's accuracy. The computer models of objects in CAD are accurate representations of objects intended to exist in the real world, such as cars, buildings, and machine parts. In the early days, CAD produced objects, not pictures. For example, a computer model might be used to drive a milling machine that cut the corresponding object from blocks of metal, or foam, or wood.

Since computer-aided design objects must sustain real-world wear and tear, they are often subjected to serious testing while still in computer model form. So a bridge made of steel trusses might first be tested, in a computer simulation of stresses, before the actual trusses are forged and assembled. The accurate computer model of the bridge serves as input to the simulation of expected loading of the bridge by traffic or wind. Or two parts of a spacecraft intended to attach rigidly are checked, while still in computer

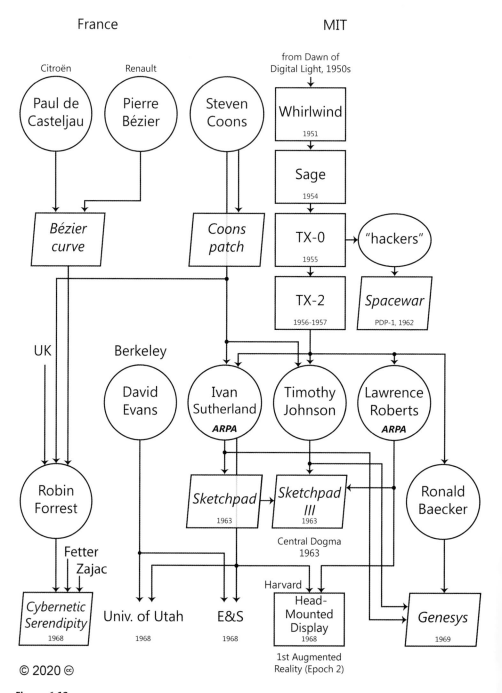

Figure 6.13

Early Computer Graphics
Second Stage of Epoch 1, 1950s–60s

***ARPA**=Director of ARPA's Information Processing Techniques Office (IPTO)*

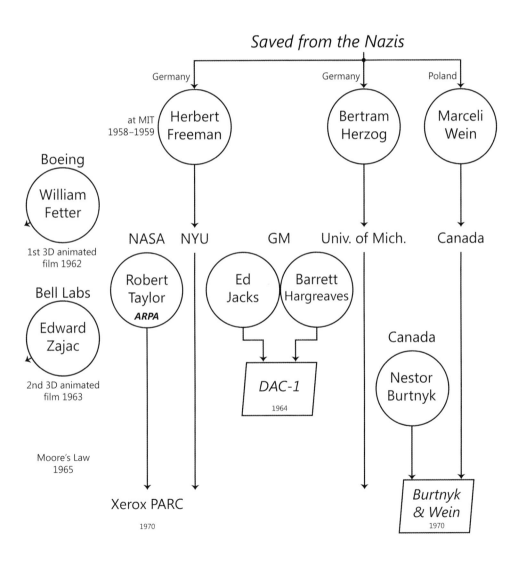

Saved from the Nazis

Germany — Herbert Freeman (at MIT 1958–1959)

Germany — Bertram Herzog

Poland — Marceli Wein

Boeing — William Fetter — 1st 3D animated film 1962

Bell Labs — Edward Zajac — 2nd 3D animated film 1963

Moore's Law 1965

NASA — Robert Taylor **ARPA**

NYU

GM — Ed Jacks

Univ. of Mich. — Barrett Hargreaves

Canada

DAC-1 1964

Canada — Nestor Burtnyk

Xerox PARC 1970

Burtnyk & Wein 1970

model form, to ensure that they will reliably fit together when actually realized in metals.

But in the rest of computer graphics, pictures-as-output are everything—hence picture-oriented computer graphics. Accurate measurements and testing are irrelevant. The pictures only have to *look* convincing. Pixar might send Woody's *Toy Story* model to someone who turns it into an accurate, buildable CAD model and makes a toy, but the principal purpose of the original model was *Toy Story* the movie.

Hollywood is famous for its false fronts. Think of the main street in a cowboy shoot-'em-up. Computer-generated movies are all false fronts. There's nothing inside Woody's surfaces. He's only skin deep. There's nothing to test or stress inside. Who cares if he's buildable? Characters only have to look right.

Consider the texts C.R.T. STORE of First Light and HELLO MR. MURROW of the early animation presented in the Dawn of Digital Light chapter. No objects in the real world corresponded to those displays. Or recall the two early games from that same chapter, checkers and tic-tac-toe. Again, no actual game board or pieces corresponding to these ever existed in the real world. And the mathematical curves displayed on Whirlwind weren't objects in the real world. There was never any form to these early examples other than spread pixels on a computer display and (simple) nonvisible models of them. Thus all the pictures from the Dawn of Digital Light were instances of picture-oriented computer graphics, not computer-aided design. Yet we'll find that the earliest leaders of computer graphics generally came from CAD.

Computer-aided design and picture-oriented computer graphics are closely related and have intertwined histories. It's no surprise that they are often conflated. From here on in this book, *computer graphics* will usually mean "pictures are king" and abbreviate picture-oriented computer graphics. I carefully designate the "objects are king" mode as *computer-aided design*. That bears repeating: although CAD is part of computer graphics, I'll usually mean by computer graphics in this book the non-CAD part.

I constrained the charts in previous chapters to map the pathways leading to Digital Light. This chart (figure 6.13) concentrates further only on those that led to the computer graphics part of Digital Light. It emphasizes those parts of computer graphics that are especially important for making digital movies, the focus of the next chapter. Fortunately, it nevertheless captures many major events of early computer graphics.

The Milieu

Computer graphics emerged in a particular milieu. It shares it with the inventions of the personal computer and the internet. It's quite a story—of a national technological blossoming.

Money Pours into R&D

The US government responded to the threat of Nazi Germany by pouring massive amounts of money into a few centers of research and development, not something that's normally done in a capitalist society. War was imminent. Speed was essential. There was no market competition for these funds—no Request For Proposal documents outlining the details, no bidding. They were just handed out. The Massachusetts Institute of Technology was a major beneficiary of the largesse, a gift that solidified MIT's position as a top technological university in the world.

MIT was heavily funded in 1940 and set up two labs. The Radiation Lab concentrated on radar, a technology that promised to turn the tide of war against the Germans. Research on it was of the highest importance. The other lab, the Servomechanisms Lab, concentrated on control of complex systems. (A servomechanism, or servo, is typically a motor that uses feedback for fine control.) These labs changed names several times, which makes keeping track difficult. It simplifies more-or-less into the two lines of descent in this table (indentations identify subgroups not renamings):

Rad Lab Descent	Servo Lab Descent
Radiation Lab '40	Servomechanism Lab '40
Research Lab for Electronics '46	Digital Computer Lab '51
Project Lincoln '51	Electronic Systems Lab '59
Lincoln Lab '52	CAD Project MIT '59

The Whirlwind computer began in the Servo Lab, went into the Digital Computer Lab in 1951, and was subsumed into Project Lincoln (in the Rad Lab column) also in 1951. So computer graphics descends primarily from the Rad Lab, but not completely. The Computer-Aided Design (CAD) Project began at MIT in 1959 as part of the Electronic System Lab. So it's tempting to say that computer-aided design descends from the Servo Lab. But the computer graphics and computer-aided design stories at MIT were more intertwined than that, as we soon see.

Bush's Memex—Imagining the PC in 1945

Just after the war, Vannevar Bush, a professor and administrator at MIT, published a significant and influential paper: "As We May Think" appeared in *The Atlantic Monthly* and was republished in *Life* magazine. Bush was astonishingly prescient, considering that he wrote before computers even, and well before the internet:

Consider a future device for individual use, which is a sort of mechanized private file and library. It needs a name, and, to coin one at random, "memex" will do. A memex is a device in which an individual stores all his books, records, and communications, and which is mechanized so that it may be consulted with exceeding speed and flexibility. It is an enlarged intimate supplement to his memory.[18]

He got a lot wrong in this famous "memex memo." In the paragraph just before the one quoted above, he tells us that the memex is desk sized. And the name "memex" didn't stick. But some of his other comments are dead-on accurate visions of the future 75 years hence—that is, now: "Wholly new forms of encyclopedias will appear, ready made with a mesh of associative trails running through them." And: "There is a new profession of trail blazers, those who find delight in the task of establishing useful trails through the enormous mass of the common record." In a way that's what I'm doing with this book.[19]

Bush (no relation to the US presidents) was instrumental in setting up the Manhattan Project and the National Science Foundation. He was the first person to be the science adviser to a president (Franklin D. Roosevelt). Perhaps his most notable student at MIT was Claude Shannon. But another was Frederick Terman who would later, at Stanford University, lease university lands to high-tech firms to create what is now known as Silicon Valley.

Founding ARPA and NASA

The atomic test conducted at the Trinity Site in New Mexico in 1945—followed shortly by the Hiroshima and Nagasaki bombings—signaled the war's end. And the Cold War with Russia followed right on its heels. Pouring fuel on the fire was the American physicist Klaus Fuchs, who was present at the Trinity Site test and passed nuclear secrets to the Soviets. And, ironically, while working with super-patriot John von Neumann on America's H-bomb, Fuchs also informed the Soviets about its crucial secrets. The Soviets exploded Joe One, their first A-bomb, in 1949 and Joe Four, their first H-bomb, in 1953. (These were American monikers for the bombs—named for Joseph Stalin, of course.)

Then came the second shocker. In 1957 complacent Americans were stunned by the Soviet launch of space satellite Sputnik. This was in spite of the fact that Vladimir Kotelnikov of the Sampling Theorem had clearly warned us about it, as we saw in an earlier chapter. The US response was to form the Advanced Research Projects Agency (ARPA) in the Defense Department in 1957 and the National Aeronautics and Space Administration (NASA) in 1958. ARPA would fund much of what became mainstream computer graphics. People influential to the future of computer graphics would serve as administrators at both ARPA and NASA. The first of these was J.C.R. "Lick" Licklider.

Licklider's Symbiosis—Imagining the Internet

In 1960 "Lick" Licklider published a paper, "Man-Machine Symbiosis," in the *IEEE Transactions on Human Factors in Electronics*. This paper was as significant and influential as Bush's memex memo of 1945. Lick saw that the new beasts among us, the computers, were not to be our slaves but rather would work together symbiotically with us:

> It seems reasonable to envision, for a time 10 or 15 years hence, a "thinking center" that will incorporate the functions of present-day libraries together with anticipated advances in information storage and retrieval and the symbiotic functions suggested earlier in this paper. The picture readily enlarges itself into a network of such centers, connected to one another by wide-band communication lines and to individual users by leased-wire services. In such a system, the speed of the computers would be balanced, and the cost of the gigantic memories and the sophisticated programs would be divided by the number of users.[20]

Lick didn't get it exactly right in those days before Moore's Law and the internet. Some leaders in those early days thought that time-shared computers were the thing. Instead of one user at a time getting access to a big computer, several users would get access apparently at the same time. It was only "apparently at the same time" because the computer was fast enough to make it seem that way. Ten users would each get the big computer's resources for a tenth of a second say. They would "time share" the big machine.[21]

Neither Licklider nor any other visionary could yet see that Moore's Law would make it possible for all computers to time-share multiple apps run by single users. That is, single users would perceive that all their apps were running simultaneously (and with multiple CPUs per computer it would actually be so). Nor could these visionaries see that computers would become so small that sharing one big one would no longer be necessary. Nor that individual users all over the world would be interconnected, not just computer centers. But then Moore's Law didn't exist until 1965.

Engelbart's Augmentation—The First Graphical User Interface

Doug Engelbart published the third paper that, with Bush's memex memo and Licklider's symbiosis paper, formed the intellectual backbone of the intertwined stories we're telling. *Augmenting Human Intellect: A Conceptual Framework* was published by Stanford Research Institute in 1962. Engelbart too tried, before Moore's Law and Epoch 2, to grasp how we humans might deal with the new dinosaurs among us:

> This is an initial summary report of a project taking a new and systematic approach to improving the intellectual effectiveness of the individual human being. A detailed conceptual framework explores the nature of the system composed of the individual and the tools, concepts, and methods that match his basic capabilities to his problems. One of the tools that shows

the greatest immediate promise is the computer, when it can be harnessed for direct online assistance, integrated with new concepts and methods.[22]

Engelbart rather pedantically steps his way through what a human interacting intelligently with a machine might be like. More important than his text, however, was what he *showed* us. In 1968 and funded by ARPA, he staged the famous "mother of all demos" at a computer conference in the San Francisco Bay Area where he interacted in real time with a computer at a distant location via a graphical user interface using a new pointing device he had invented—which he called a mouse. This was the beginning of the personal computer interface familiar to us all today, using the prototype of the very device, the mouse, that we still use today to control it.

Next we step back to the beginning and concentrate on the parts of this milieu that particularly affected computer graphics.

The Age of Digital Dinosaurs

Psychedelic my ass: Children of A-Bomb.
—Bob Lenox[23]

Digital Light dawned between the American A-bomb of 1945 and the Soviet H-bomb of 1949—between World War II and the Cold War. Recall from the Dawn of Digital Light chapter that making pictures on the few precious computers in the 1940s was considered frivolous. They "should" be computing A-bomb or H-bomb statistics. Nevertheless, the first digital picture, First Light, appeared in 1947 on Manchester's Baby. Two of the first documented interactive videogames were created in 1951 and 1952 at Manchester and Cambridge Universities. And the first documented computer animations appeared on Whirlwind at MIT in 1951, funded by the Air Force. In all these early cases, geometric models were rendered to a display screen as spread pixels, and some of them could change pictures interactively. Whirlwind is at the top of this chapter's flow chart because it connects that early history to this Soviet-fueled, defense-funded next stage—one nevertheless not devoid of occasional frivolous picture making.

The Cold War spawned the most cold-blooded beasts of the 1950s, or rather beasts with the most cold-blooded mission—defense against nuclear attack. The biggest and scariest at the time was the Sage computer, the immediate successor to Whirlwind. The Air Force worked with MIT and IBM to implement Sage, a project comparable in size and cost to the Manhattan or Apollo Projects. Starting in 1958 more than 20 centers were built, each four stories tall, windowless, and housing two Sage computers. Each computer cost $238 million (about $2 billion in today's dollars), occupied half an acre

Figure 6.14

of floor space, and weighed over 100 tons. And each featured an often-yellow graphical display with a "light gun" for interaction.

Among the remaining artifacts of Sage today are those graphics stations. The military user in figure 6.14 (right), staring into the gaping maw of the beast, appears ready to shoot it—or solder it anyway. To get a proper sense of this effort, picture a room filled with dozens of servicemen and their guns at display stations arranged in rank and file.

The normal business end of Sage (figure 6.15) depicts aircraft and missile locations against crude borderlines. A dotted line at display right—an "unidentified flying object"—approaches the United States. But the *Atlantic Monthly* told an alternative story in an article titled "The Never-Before-Told-Story of the World's First Computer Art (It's a Sexy Dame)." Someone, anonymous of course, used the $238 million machine to display "forbidden fruit"—a girlie pinup traced from *Esquire*, the men's magazine. The article claims that she was the first depiction of a person on a computer display, sometime in the late 1950s. This might even be true, but remember that anecdote of a Highland dancer on Edsac, probably in the early 1950s, mentioned in chapter 4. In any case these graphics were the calligraphic, or vector, variety that have come and gone extinct, losers in the long run to raster displays of pixels, the modern form. Despite the size of the Sage dinosaur, its graphics were simple—but they were interactive.[24]

Spacewar and the First Hackers

> Ready or not, computers are coming to the people. That's good news, maybe the best since psychedelics. . . . The trend owes its health to an odd array of influences: The youthful fervor and firm dis-Establishmentarianism of the freaks who design computer science; an astonishingly

Figure 6.15

enlightened research program from the very top of the Defense Department; . . . and an irrepressible midnight phenomenon known as Spacewar.
—Stewart Brand, *Rolling Stone*, 1972[25]

A new breed of countercultural cat appeared in the late 1950s and early 1960s, brought on by, and unique to, the computer revolution. They called themselves hackers. It was a term of deep respect then, without a trace of the opprobrium it now has in a world of election manipulation, identity theft, and ransomware. The hackers of MIT fell totally in love with TX-0, grandson of Whirlwind. They called it "Tixo." It was the first computer that was completely theirs if they were willing to figure it out themselves (they were) and if they were willing to court it at the most obscure times of day (they were). Tixo was a baby dinosaur that filled a room, but they could romp with it. And it had a graphics display and a light pen.[26]

Those original hackers are legendary now. The cult quickly spread to the West Coast. Stewart Brand was the first to celebrate them above ground. In the late 1960s he was the noted publisher of the *Whole Earth Catalog*, the hippie generation's product bible. His next stunt was a 1972 article in *Rolling Stone* magazine that put the public spotlight on hackers and raised a few eyebrows at a place called Xerox Palo Alto Research Center (PARC). Its title set the tone: "Spacewar: Fanatic Life and Symbolic Death Among the Computer Bums."[27]

At least one original MIT hacker had moved to PARC by then, near San Francisco, the capital of hippiedom. The three-piece button-down suit executives of corporate Xerox in upstate New York were embarrassed by the rock'n'roll coverage of their research center. Computer bums yet! People who looked and acted like that—like me, as I was there then—couldn't possibly have serious business ideas. This uncrossable cultural divide might have been why Xerox failed to capitalize on the personal computer. It had been invented at PARC in the early 1970s just as we now know it—mouse, windows-based interface, laser printer, network, and all. By those bums.[28]

In 1984 journalist Steven Levy published *Hackers*, cementing their fame. His book told the full and marvelous story of this gang of talented and influential mischief makers. I mention them in this book because they made pictures on computers slightly before another contingent at MIT did something pictorially remarkable on TX-2, son of TX-0 (there was no TX-1).[29]

In the Dawn of Digital Light chapter, we learned that Tom Stockham, a digital audio expert, taught a generation of computer graphicists at the University of Utah how to antialias their sampled pictures—how to take the "jaggies" out. Stockham had been inspired to his audio calling while a professor at MIT by the hackers there making music on TX-0.[30]

But the most memorable hacker achievement was a two-dimensional interactive game called *Spacewar*. They had created several "graphics hacks" on Tixo, using its CRT graphics display. But the newest computer in the building soon became the hackers' darling: the PDP-1. They created *Spacewar* on it in 1962. Figure 6.16 shows an opening maneuver. The PDP-1, a $120,000 computer (that's just shy of $1 million today), had been given to MIT by the Digital Equipment Corporation in an attempt to break giant IBM's lock on the marketplace. It was essentially a son of Tixo and was better in every way.[31]

For our purposes we only need to know that *Spacewar* was interactive computer graphics. Users interacted with the game via joysticks and buttons. It featured a slowly rotating star field, two cartoon rocket ships that shot torpedoes (dots) from their nosecones, and a central star. There was gravity and a jump-to-hyperspace button. *Spacewar* was an important event in the history of games, and in real-time computer graphics. But in this book, we focus on the part of Digital Light that is computer graphics with no time constraints.

What Do We Mean by Real Time—or by Interactive?

The term "real time" has several meanings, all related to the human perception of the passage of time. One popular meaning is clocked real time, as in videogames. Another

Figure 6.16

is real time on demand, as in the "interactive" design of computer models. These are handy terms that help us subdivide the vastness of Digital Light.

In videogames, an imaginary clock ticks, and a new picture must be rendered and ready for display at each tick. The natural "clock" for video is the frame rate of 30 frames per second, a rate chosen because it approximates the human sense of time passing smoothly and at the same pace as time in the real world. In videogames, then, a new picture must be displayed every thirtieth of a second.

Videogames are the overwhelming example of real-time graphics of the clocked variety in the modern world. But in the early days, flight simulators—costing millions of dollars each—were the principal expression. Fighter pilots would train on flight simulators, and astronauts on spacecraft simulators. They still do today. Virtual reality (VR) is the newest member of the clocked real-time class, rendering to dual displays inside special goggles for a stereo, or so-called 3D, effect.

A principal example of unclocked, or on-demand, real-time graphics is interactive design of internal computer models. That's just another way of saying "pictures that change fast enough to convince users that it's happening 'instantaneously' *while* they interact with the computer."

Another example is almost every interface to every app. I just clicked on the Save icon in Word. The icon "instantly" lit up as I hovered the mouse cursor over it, then a "time-is-elapsing" rotating icon appeared "instantly" as I clicked the mouse and saved the file.

In either the clocked or unclocked case, the trade-off for real time is either low image quality or high product price. In the clocked case, videogames still (as of 2020) show

the visual artifacts of insufficient time to compute a fully rendered picture while maintaining a low consumer price.

In the unclocked case, the picture quality used in interactive design of models is still typically lower than the final rendering of the objects or scenes so designed. Designers might watch a line-drawing display of an object or character that they are creating—say a wire mesh view of a teapot rather than a fully shaded, colored, and textured teapot.

The Received History of Computer Graphics

Computer graphics is my profession, but I only had a shaky hold on its history. The version I received was roughly this: Ivan Sutherland wrote Sketchpad, the first interactive computer graphics program, it was said, at MIT in 1962. Then he went to the University of Utah in Salt Lake City in 1968 and fathered a dynasty of computer graphics pioneers. In fact, there's a lot of truth in that summary. For example, Ed Catmull was one of Sutherland's students, and many of our colleagues over the years at the New York Institute of Technology, Lucasfilm, and Pixar were Utah educated. And the early graphics hardware we used was manufactured by Evans & Sutherland, a company David Evans and Ivan Sutherland cofounded in Salt Lake, also in 1968.

But the Sutherland narrative doesn't fit what we've discovered in the Dawn of Digital Light chapter: The first digital pictures, interactive games, and animations were on the earliest computers in the late 1940s and early 1950s. Whirlwind had a light gun that let you interact with its display. As we've seen in this chapter, the fellow who was shooting, or soldering, Sage is interacting with its graphics in the late 1950s. And *Spacewar* was interactive at MIT slightly before Sketchpad. Obviously, there's a discrepancy in the story that needs explanation.

Like many histories of technology, the received version omits great swaths, and overly emphasizes a single person. And it leaves out two well-known founding fathers of the field, Steven Coons and Pierre Bézier, who predated Sutherland by a generation. The field is quite aware of these founders, however. For decades, the highest award in computer graphics has been the Coons Award. And Bézier curves have been featured in the popular apps Adobe Illustrator and Adobe Photoshop for decades as well. But there's been no smooth weaving together of the historical web.

I Meet the Pioneers

The easy narrative actually doesn't match the history I personally know, either. The first computer graphics pioneer I met and worked with was Herbert Freeman, who was not of the Utah school. He was born Herbert Friedmann in Germany and managed to escape

the Nazi scourge with the help of Albert Einstein. When Herb's parents tried to obtain permits for the family to enter the United States, he alone was disallowed, accused of having tuberculosis. It wasn't true, but it took years and three letters from Einstein himself to get the child over the bureaucratic hurdles and safely into America in 1938, just in time. In 1949 Herb met and thanked Einstein personally for this tremendous favor.[32]

About a year before he met the great scientist, Herb got a master's degree in electrical engineering from Columbia. At a summer class at MIT in 1952 he met Whirlwind and became excited by digital computers—so much so that by the next year, he had designed his own computer, called Speedac, at the Sperry Corporation. A doctorate from Columbia led to jobs at MIT with the Servomechanism Lab in 1958 and Lincoln Lab the following year. In 1960 he joined New York University. His specialty was computer graphics, and in 1972 he cofounded one of the earliest scholarly journals of Digital Light, as reflected in its title: *Computer Graphics and Image Processing*. Making *and* taking. Geometry *and* pixels.[33]

Herb hired me straight out of Stanford graduate school in 1969 into his department at NYU. During my four years with him, he introduced me to Ron Baecker and Marceli Wein from Canada, two of the earliest computer animators, and to Robin Forrest from England.

Robin Forrest

Robin, my favorite Scot, came up to London from Norwich, while I was researching and writing this book, to guide me through the early history of my own field. Which he proceeded to do as we laughed and reminisced all day in the tearoom of a Bloomsbury hotel.[34]

"I first met you in November 1971," he opened as we shook hands.

"And you're the devil who roped me into those patent cases in the 1990s," I teased.

"Indeed I was."

(Computer graphics colleagues and I had tried our best in British court to save a British software company from a British hardware company. We failed to make our case, and the software company was forced out of business. But then the same hardware company tried the same legal maneuver against an American company in an American court. This time we successfully helped protect Adobe, and its flagship Photoshop product, from a crippling royalty. The court mercifully found all five patents invalid and removed a scourge from the field.)

"And I," Robin added, "first introduced you to Jack Bresenham."

Jack Bresenham was the other computer graphicist from Clovis, New Mexico. Robin and I were off and running.[35]

I couldn't have asked for a better guide through the early history—certainly not a wittier one. Robin has been with the University of East Anglia for over 40 years, now professor emeritus. Robin experienced much of the early history himself. He worked at various times with Coons, Bézier, and Sutherland, and had been at the early MIT, Cambridge, and Utah university centers. But he also told me about lesser known places such as Citroën, Renault, and General Motors.[36]

Robin's tales soon elucidated the fundamental historical and definitional problem. Computer graphics is about both internal models of objects *and* pictures of them. Does the history of computer graphics begin with models of objects or with pictures of them? There are different versions of the history depending on the emphasis. The histories of computer graphics and computer-aided design are typically, and understandably, tangled together.

Coons and Bézier

The problem with calling Coons and Bézier the founding fathers of computer graphics is that neither made pictures, not at first, anyway. Coons created his foundational work in the aircraft industry at the old Chance Vought company. Bézier did his at Renault, the French automobile manufacturer. They both used geometric models of three-dimensional surfaces inside a computer, but neither had a display device to see pictures. Coons created actual airframe surfaces, and Bézier actual auto body surfaces.

They didn't care about pictures per se. They cared about actual objects in real three-dimensional space made of real materials—automobile and airplane bodies, or maquettes for them. It's the Creative Space versus Display Space distinction again. Coons and Bézier had Creative Space but no Display Space. Or to put it another way, their displays were the objects themselves, not pictures of them. They had computer-controlled machines that carved or cut actual objects from real materials. In other words, they were doing computer-aided design aimed at objects, not computer graphics aimed at pictures. We'll spend time later in this chapter disentangling these fields. But there's no question that Coons and Bézier are claimed by both. They are a good place to start.

Steven Coons

Coons turned me on, he turned Ivan Sutherland on, . . . he was worth several full professors.
—Timothy Johnson, creator at MIT of Sketchpad III[37]

Figure 6.17
Photo of Steven Coons, by his MIT student, Abbott Weiss, 1964.

Steven Anson Coons (figure 6.17) was not only an intellectual leader. He was an entertaining lecturer—and his students loved him. He was fun.[38]

The story goes that around 1936, while or after Coons was a mathematics student at MIT, he took a job "pushing a broom" at Chance Vought Aircraft. While he was sweeping the floors, he happened to notice that a boss was bogged down in the mathematics of an aircraft surface representation. So he secretly worked out a solution, which famously became known as the *Coons patch*, a name that stuck. From that humble beginning as an intuitive mathematician formalizing aircraft design, he became a father of both computer-aided design and computer graphics.[39]

Coons's career had bumps. As a young man, he had to leave his mathematical studies at MIT after only a year "under adverse conditions," and never obtained a formal degree. The adverse condition was probably simple poverty. Nevertheless, because of his accomplishments in the aircraft industry, he was hired as an assistant professor at MIT in 1948. Eventually, he advanced to associate professor. But to the puzzlement of his colleagues and despite his profound influence on other pioneers at MIT—in particular, on Ivan Sutherland and Tim Johnson (see the flow chart)—he was passed over for further advancement. Perhaps his lack of a PhD was the reason. Nevertheless, he subsequently held positions at the universities of Syracuse, Utah, Michigan, and Colorado.[40]

The Patch Shape: Coons Patch

Robin Forrest's career has straddled both computer-aided design and computer graphics. That day in Bloomsbury he told me an establishing story of computer-aided design, from the era just before computers. It concerned the famous Spitfire fighter aircraft that featured so prominently in the crucial 1940 Battle of Britain against the German air force, the Luftwaffe. The Spitfire's master design was a set of cross-sections scored into aluminum sheets and stored on large tables somewhere in Hampshire, England. Although drawings could be reproduced from the master, it certainly wasn't secured safely inside a computer memory, because none existed yet. One Luftwaffe strike at that Hampshire location would have destroyed the specifications for this important fighter.[41]

But Robin's question was this: What was the Spitfire wing shape between those cross-sections? Well, it wasn't defined, and that was a problem. A smooth surface that interpolated successive cross-sections was required, but it didn't yet exist.

These words remind us of the spline in the Ravi Shankar story. Aircraft designers needed to generalize the spline to a surface. They needed a smooth surface that interpolated between successive curves—such as the Spitfire cross-sections. The solution is called a *patch*, a piece of surface that smoothly passes between two curves—two splines, say. The two curves form opposite edges of a patch, and the surface between varies continuously, even gracefully, from the curve at one edge to the curve at the opposite edge. The Spitfire engineers needed a well-defined patch between the cross-sections scored on those metal sheets to completely define the plane's wing. But the concept didn't exist yet in 1940.

The man who introduced patches to aircraft design was Steven Coons. *Patch* was his word. He didn't work on the Spitfire, but he did work in the aviation industry and sought to solve this looming problem. The Coons patch he defined is the patch described above but with two pairs of opposite edges. The Coons patch example shown

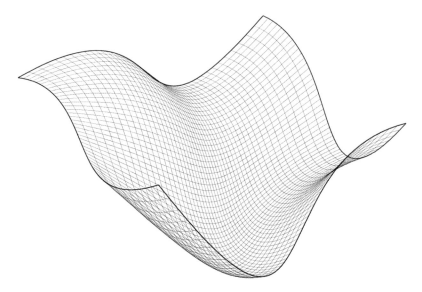

Figure 6.18

in figure 6.18 resembles a rumpled, but not creased, piece of tissue paper. Each edge bends smoothly in two different directions. And a smoothly undulating surface joins, or interpolates, opposite edge curves in both directions.

In the generality of Coons's definition, a patch could have edges of *any* shape, not just simple curves as shown in the figure. For example, the curve on one edge might be your first name in handwriting, and the opposite edge your surname. So long as you provide a method for blending one name into its opposite, it's still a Coons patch. But that blending function can be tricky business.[42]

Sculpting a Model: Patches to Triangles

To make a complex surface in computer graphics, like a teapot, a character, or an airplane, we design a set of patches that join one another smoothly along their edges and cover the desired surface—like a quilt—including its nooks and crannies. Then we subdivide each patch into four-sided "patchlets" by stepping along each edge in increments, as shown in the preceding figure. Subdivision proceeds like this until the patchlets become small enough to be considered flat polygons. For our purpose each of these flat patchlets is then divided into two triangles with a diagonal, as before. So, we're back to having to understand only one triangle again.

Displaying a triangle is easy, and so is displaying a model made of thousands of them using Amplification. But there's no way to minimize the difficulty of building

a model in the first place. Modeling is a form of sculpting, and there's no easy way to teach sculpting. That's the task of professional modelers.

The Coons Award and Siggraph

The most prestigious award in computer graphics honors the inventor of the Coons patch. The Steven Anson Coons Award is presented by Siggraph, the largest and most important annual computer graphics conference. Its name is short for the Special Interest Group on Computer Graphics and Interactive Techniques, a part of the large professional computer science organization quaintly called The Association for Computing Machinery (ACM). Siggraph is the not-to-miss conference for tens of thousands of enthusiasts every year, as it has been for decades.

We owe both the award and the conference, in part, to another early computer graphics pioneer who was saved from the Nazis, Bertram Herzog (1929–2008). Herzog was rescued by the Kindertransport program for Jewish children. It got him safely to a foster home in England. From there he emigrated to the United States in 1946 and earned his PhD in 1961 at the University of Michigan. A couple of years later he met Coons, who befriended him and converted him to computer graphics. Bert was instrumental in founding Siggraph in 1969. And he helped name Siggraph's highest prize the Coons Award for his friend.[43]

Pierre Bézier

He's described as jovial with a libertine's spirit, a reasoned nonconformist. In his milieu he's simply "a genius."

—about Pierre Bézier

Since then I was inevitably seen as a dangerous lunatic who had been allowed to go free for too long.

—Pierre Bézier, about himself[44]

Pierre Étienne Bézier, by all accounts a wickedly witty man, was a Franks father of picture-oriented computer graphics and computer-aided design, but a practitioner of the CAD half only. Like Coons, Bézier worked out a mathematics of surfaces before there were pictures of them. He came up with a similar patch idea for auto body design. The portrait of him in figure 6.19 is made with Bézier curves, named for him.[45]

Bézier was a car man, through and through. Educated as an engineer, he entered Renault at age 23 and spent his entire career there. Like Coons, he started small, as a tool setter in 1933. Then he worked his way up to a tool designer in 1934. This led to

Figure 6.19
Bézier with Béziers. © Antony Hare, 2010.

his becoming Head of the Tool Design Office in 1945. By 1948 he was Director of Production Engineering and then Director of the Machine Tool Division in 1957.

This all sounds like a smoothly unwinding career, but I encountered a puzzling lacuna. An online Renault history states, "Pierre Bézier, a Renault engineer who, while a prisoner of war in Germany, improved upon the automatic machine principle introduced before the war by GM." I'd been unable to learn anything more about this mysterious period until shortly before this book's deadline. A last-minute posting to a French Facebook page resulted in a contact who resolved the mystery: Bézier was held prisoner in a German Offizierslӓger (prisoner of war camp for officers), probably Oflag XI-A at Osterode am Harz, for about a year starting in 1940.[46]

Bézier was responsible for producing most of the mechanical parts for the famous 4CV automobile, the first European car to sell over a million units (figure 6.20, left).

Figure 6.20

But that happened before there was computer-aided design. He started his research in CAD in 1960, focusing on interactive curve and surface design, and three-dimensional milling of clay models and masters. By 1968 he had perfected his system, called Unisurf, and launched it into production at Renault. The Renault 10 in the center photo probably used this CAD system. He did have drawing machines for pictures, but his clear goal was the manufacture of automobiles. They were his ultimate displays. The rightmost picture of a Renault "master" is an example.[47]

Robin Forrest visited Bézier in 1969. "He had a system that could cut full-size car panels, and we were very impressed by that." Forrest tells how Bézier got his engineers to embrace computer-aided design:

> Bézier was vice-president of production engineering at Renault, and was in a position to say to his staff: "You can stop using clay models and now you will use my method." But he told us he didn't do this. . . . Bézier built this machine with which you could build car panels, but he just left it. He got one or two star designers who were interested but wondered what the thing was. He told them how to use it. Some of them were convinced and played around with it. He said "one morning I came in, and this beautiful wooden sculpture was outside my door [cf. figure 6.21], and *that's* when I realized I had won the battle. Because this can do art." And this is the way to introduce these technologies. You don't force it. You let people find it for themselves and do amazing things, and then they do things and you are left thinking, "how the heck did they do that with my system? I don't know!" That's the nice thing about this kind of work.[48]

Bézier became seriously academic late in life. A couple of years after he retired in 1975, he got his doctorate in mathematics at the University of Paris. He died in 1999, just missing the new millennium, and outliving Coons by 20 years.

Siggraph—the annual computer graphics conference—awarded him the second ever Coons Award in 1985, the first having gone to one of Coons's direct intellectual heirs, Ivan Sutherland, in 1983. There's no Bézier prize in picture-oriented computer graphics, but there's a Bézier Award in computer-aided design (awarded by the Solid Modeling Association).

Figure 6.21
Photo by Tina Merandon.

Paul de Casteljau: Unsung Hero

> Therefore the idea began to stir in my mind to go through the car body forms mathematically . . . It was either absolute thoughtlessness, in order not to call it madness, or else a phenomenal trick. . . . It is only too true that there is rosserie in the French word carrosserie, standing for car body (rosserie meaning nastiness)!
> —Paul de Casteljau, about himself[49]

Paul de Faget de Casteljau was another Franks father of the field (figure 6.22). Like Bézier he was also in the auto industry and also had a self-deprecating sense of humor. He developed mathematical systems for car design at Citroën in 1958 that were quite

Figure 6.22

similar to Bézier's slightly later work at Renault. Unlike Bézier, he is often overlooked, although Bézier himself gave him priority. Unfortunately for de Casteljau, Citroën wouldn't allow him to publicize his findings until 1974. By then the curves that both men had originated were called Bézier curves, and so they've remained—Stigler's Law in action once more. Ironically, de Casteljau was the 2012 Bézier Award winner in the computer-aided design field.[50]

More Shapes: Bézier (or de Casteljau) Curves

Both Bézier and de Casteljau saw the computer as a way to increase the efficiency of automobile manufacture. They developed, independently it seems, the mathematics of another way to represent surfaces, the *Bézier patch*. These were not Coons patches but similar to them in the sense that they also could be attached smoothly at the edges—quilted, so to speak—to form complex surfaces. Bézier patches are another way to model surfaces that can then be subdivided into polygons and triangles for subsequent rendering to a display.

Figure 6.23

Bézier's (or de Casteljau's) mathematics isn't important here, but an intuition about it is. Recall the Ravi Shankar demonstration, and how the horizontal and vertical coordinates of the tablet points were spread with a spreader that has two negative "lobes" to get a spline through the tablet points. It was called a Catmull-Rom spreader (figure 6.7, bottom). If we use the spreader in figure 6.23 instead, with no negative lobes, then we get a slightly smoother spline. Computer graphicists call it—rather clunkily for such a pretty curve—a *B-spline*, where the B stands for "basis" but is otherwise uninformative. Figure 6.23 is the B-spline spreader.

The two splines are shown side by side in figure 6.24. Both are derived from exactly the same points, the ones from the tablet in the Ravi Shankar demo. Although you probably have to strain to see it, the new curve (on the right) is more graceful than the older one. It accomplishes this by passing only near the tablet points, not through them. It's therefore an approximating spline, not an interpolating one.

Bézier (or de Casteljau) gave us a curve that's a little bit of both, although he (they) didn't think of it that way. The next picture (figure 6.25) shows two Bézier curves—one that connects the leftmost point to the middle one, and another that connects the middle point to the rightmost one. Adobe Illustrator and Photoshop have a special tool (the pen tool) for creating smooth curves from Bézier segments like these. A designer begins at say the leftmost point and draws out a line, shown dashed here, that gives the desired curve's slant at that point. We call it a tangent line. Designers control the slant's angle by rotating the (dashed) tangent line, using the given point as a pivot. They control the curve's tightness by lengthening or shortening the tangent line—by moving the off-curve point in or out.

The left curve in figure 6.25 was created by pivoting and scaling the lengths of two tangent lines, one for the leftmost point and one for the middle point. The right curve was similarly created by pivoting and scaling the two other tangent lines shown.

In all cases, the slant of a dashed tangent line matches the slant of the curve as it passes through a given point. Bézier curves are typically joined together as follows for full gracefulness: the tangent line for the first point of the second curve is just an

Figure 6.24

Figure 6.25

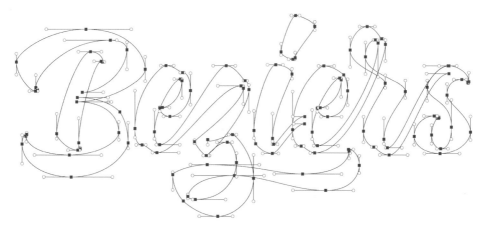

Figure 6.26
By Dave Coleman.

extension of the tangent line for the last point of the first curve. It's exactly the same length and slanted at the same angle, but in the opposite direction.

Bézier would have described this process as interpolating the leftmost, middle, and rightmost points, using the four tangent lines for control. But mathematically this is equivalent to specifying the seven points in the figure. The four off-curve points define the length and angle of the four tangent lines. The curve that's formed by smoothly joining two Bézier curves is usually just described as a sequence of Bézier curves. But it could be called a Bézier spline, and I suggest that it should be. Then we could say that the Bézier spline in the figure interpolates three of the seven points and approximates the other four—a little of both.

Chances are good that the text letters you are reading now were designed with Bézier curves. And figure 6.26 shows an amusing use of the curves, "Beziers" designed with Bézier curves. Short straight lines show the slants where the curves join (all horizontal or vertical, incidentally).

The Patch Shape: Bézier Patch

A Bézier patch is a patch with each edge defined by a Bézier (or de Casteljau) curve. It's yet another tool for modeling complex surfaces. In figure 6.27 Martin Newell's teacup and saucer—not so famous as his teapot—are modeled with 26 Bézier patches. From left to right, the patches are subdivided into smaller and smaller "patchlets" to show how the appearance of curvature is approached in computer graphics. The web of dots that are not located on the teacup or saucer surfaces are the points approximated

Figure 6.27
By Michele Bosi.

by the patches. Unlike Coons patches, which interpolate, Bézier patches (partially) approximate.

Robin Forrest translated one of Bézier's books and received from him a copy of the French version dedicated: "For Robin Forrest to whom I owe more than he perhaps thinks." Robin says, "I've not unraveled that enigma." It pertains perhaps to Robin's having showed Bézier and the world that the mathematics originally used by Bézier was actually related to the sophisticated mathematics introduced by Sergei Natanovich Bernstein—yet another great Russian. Bernstein was an expert in several fields, but the pertinent one here is approximation theory. He was to approximation theory what Sir Edmund Whittaker was to interpolation theory.[51]

The Forgotten History of Computer Graphics: The Triumvirate

A lesson from the Dawn chapter is that Digital Light began in 1947 and flourished in the early 1950s—including computer graphics, the branch of the Digital Light that renders internal geometric models into visible pictures. That early decade of computer graphics, like the earlier CAD work of Coons and Bézier, is hardly ever mentioned. The usual history of the field starts, instead, with Sketchpad. Part of our job is to articulate what made Sketchpad so important.

Ivan Edward Sutherland famously demonstrated Sketchpad in 1962 at MIT and completed it and published it in January 1963 as his PhD thesis. It was a two-dimensional geometrical design program that featured user interaction. It was highly touted then and still is—and should be. But the glory of computer graphics is three-dimensional scenes and objects, viewed in two-dimensional perspective.[52]

It was Sutherland's fellow graduate student Timothy Edward "Tim" Johnson who put Sketchpad into three dimensions and perspective. He called his program Sketchpad III and published his master's thesis on it in May 1963. The "III" was for three

dimensions, not third version. (There was no Sketchpad II.) Why isn't Sketchpad III remembered with equal force? One can argue that converting from two dimensions to three wasn't that big a change, indeed a rather obvious one. But perspective was huge, nontrivial, and nonobvious. Sketchpad III incorporated the solution for perspective that Johnson learned from yet another fellow graduate student, Lawrence Gilman "Larry" Roberts. Roberts completed his PhD thesis in June 1963. So 1963 was the year of the Triumvirate of computer graphics, all at MIT's Lincoln Lab: Ivan Sutherland, Tim Johnson, and Larry Roberts. And two, Sutherland and Johnson, were students of Steven Coons.

Figure 6.28 shows icons representing the three respective achievements, the square for Sutherland's Sketchpad, the cube for Johnson's Sketchpad III, and the cube in perspective for Roberts's contribution to Sketchpad III.

And figure 6.29 displays photos of the Triumvirate of MIT classmates in the same order: Sutherland, Johnson, Roberts.[53]

Figure 6.28

Figure 6.29

TX-2's Calligraphic Display on a Grid

The Triumvirate did their work on TX-2, son of Tixo and great-grandson of Whirlwind. The early computers of the late 1940s and 1950s had mostly raster displays. Then calligraphic displays came into use for several decades and distracted computer graphicists—the calligraphic detour that I mentioned in chapter 4. The millennium's Great Digital Convergence reintroduced the raster display, which is now the world standard.

The TX-2 display was a crossover kind of display. It was calligraphic but could only display dots in a fixed array. Ivan Sutherland's Sketchpad thesis of 1963 describes it as a 1024 by 1024 array of dots, which suggests a raster display. But the dots could be turned on in random order, not row-by-row order. The dots would turn off if they weren't refreshed, simply by the natural decay of the phosphors on the cathode-ray-tube screen.

In the Dawn of Digital Light chapter are pictures of two types of calligraphic display. The most obviously "calligraphic," as in handwriting, is the one that draws strokes of light in the direction of motion. The other type lays down spots, not continuous strokes, along such a path. Figure 6.30 (left, repeated from the Dawn chapter) is calligraphic. It's dotted, but the spots aren't restricted to exact grid locations.

Figure 6.30

Figure 6.30 (right) looks like a raster display—but with a big difference: the spots are displayed in calligraphic order instead of raster order. So this display differs from any of the preceding ones. Its spots aren't spread pixels. They are approximations on a fixed grid of a calligraphic stroke. The TX-2 display was this calligraphic variety. Here's what actually happened in TX-2: A sequence of line segments was drawn in order. Each one was converted into spot positions by a Bresenham-like rendering algorithm, and the spots in those positions were sequentially turned on by the display circuitry.

It must have been unpleasant sometimes because Sutherland goes to pains to describe methods to keep the screen from flickering. A few line segments could be drawn without flickering, but as the number of them increased the display could no longer keep up and would start to flicker. He introduced the trick of displaying only every eighth point and then going back later to display the other seven between them in a similarly spaced out way, but this caused lines to "be composed of crawling dots." It was a form of interlaced display, but for a calligraphic, not a raster, display. He also introduced random display of the dots which made the screen "twinkle" instead of crawl.[54]

Not surprisingly, when Sutherland later cofounded, with David Evans, the company Evans & Sutherland, one of its first products was a true calligraphic display—with strokes not spots, and definitely not spots constrained to a grid. It was called LDS-1, for Line Drawing System—not Latter-Day Saints as some thought, given that cofounder Evans was a devout Mormon and E&S was located in Salt Lake City. LDS-1 first shipped in 1969. The company's next version was the popular Picture System. The Computer Graphics Lab at the New York Institute of Technology—containing the group that would later become Pixar—began in 1974 with machines from E&S, the first one a calligraphic Picture System.[55]

The Central Dogma of Computer Graphics

Here's how to think about computer graphics today, regardless of where it's used—in movies, games, VR, or so forth: A fictitious world is modeled inside a computer memory. It's a model, not a picture. It's standard three-dimensional geometry á la Euclid and other early Greeks. It's not visible. A picture of this world is two-dimensional. So to make a picture, a fictitious camera is placed in the fictitious world. The camera is virtual. Its body, lenses, tripod, and so forth are not modeled. All we care about is where the virtual camera is located in the scene, what direction it's pointed, and which way is up. Like a real camera, this virtual one has a viewfinder that captures a rectangular view of the fictitious world it's looking at. We call the viewfinder a *perspective viewport*

in computer graphics—just *viewport*, for short. Tim Johnson first implemented a (perspective) viewport in Sketchpad III.[56]

The portion of the unreal world that the virtual camera captures in its viewport is flattened into two dimensions—just like a real camera flattens the real world into a two-dimensional image in its viewfinder. And one further, very important, thing: the viewport sees the unreal world *in perspective*—just like a real camera's viewfinder does. It's the same perspective through which we humans perceive the visual world. Johnson used Larry Roberts's perspective solution in the viewport of Sketchpad III.

I call this the Central Dogma of computer graphics because it doesn't have to be that way. After all, a computer is the most malleable instrument ever invented by humankind. The geometry doesn't have to be Euclidean, but it is in the Central Dogma. It could be Lobachevskian—with no parallel lines—as trumpeted by Kotelnikov's grandfather (see chapter 2). Most importantly the perspective doesn't have to be Renaissance perspective, but the Central Dogma has it so. In short, the Central Dogma represents an unreal world exactly as we humans perceive the real world. It's the virtual camera's perspectival view of the unreal world, all inside the computer, that is finally rendered into pixels so that we can actually see it.

The art of M. C. Escher shows just how screwy perspective can get. In figure 6.31, inspired by Escher and done without a computer, the straight beams have to bend, apparently, to let a grid of them vanish in perspective toward two points at infinity. The two vanishing points are on lines perpendicular to one another in three-dimensional space, but they appear along a single line in one plane. That's not unusual in perspective drawings. But the picture's intent is to have spreading lines that emanate from the lower vanishing point become apparently constantly spaced as seen looking toward the upper vanishing point. The demand is so severe that straight lines coming toward the viewer from the lower vanishing point have to bend upward to accommodate it. And those coming from the upper vanishing point have to bend downward. That's a nonhuman perspective. We don't see straight lines bend, and the Central Dogma doesn't allow it. (This picture, from outside the Central Dogma, was used for 38 years as the cover for the annual *Foundations of Computer Science* proceedings.)

The early origins of computer graphics in computer-aided design, in the work of Coons, Bézier, and de Casteljau, for instance, contributed to the Central Dogma. It's a necessity in CAD where the objects designed must exist in the real world. But although the Central Dogma is the discipline that's nearly always practiced in computer graphics, it's certainly not required. Computer artists have violated it since the beginning. In a sense, that's their role as artists—to exercise the medium of Digital Light without artificial limits and show the rest of us what they find. But there's

Figure 6.31
Synapse, © Alvy Ray Smith, 1973.

been a lot of creativity even within the Central Dogma discipline. Take any movie by Pixar, DreamWorks, Blue Sky, and others creating animated feature films. There's so much Creative Space within the discipline that many artists never consider venturing outside it.

Here's the punch line. Johnson and Roberts at MIT in 1963 were the ones who introduced us to the Central Dogma *as it's now used* (although they didn't call it that). They deserve more credit than they tend to get. In particular, they get less credit than Sutherland. But all three were in on it at some level. That's why I call them the Triumvirate. Before expanding on these three leaders, let's briefly review a history of perspective in computer graphics, because Johnson and Roberts weren't the first with perspective. Nor were they first with the Central Dogma.

First Perspective, Central Dogma, Movie, and Computer Graphics

> Animation is a natural for computer graphics and could be greatly expanded because of it. . . . The capabilities of "the art machine"—computer graphics is the official nomenclature—could best be described as the relating of any number of points in space from any desired viewing position.
> —William Fetter, "The Art Machine," February 1962[57]

Over a year before the influential Triumvirate contributions of 1963, William Fetter (1928–2002) at the Boeing aircraft company in Wichita, Kansas, filed for a patent on perspective as executed on a computer. He filed in November 1961 with coworker Walter Bernhart, who did the mathematics. The patent contained the drawing of an airplane, figure 6.32, probably the first computer model rendered in perspective ever published.[58]

As evident from the epigraph above, Fetter had formulated the Central Dogma of computer graphics by February 1962. In his words, "computer graphics . . . is the relating of any number of points in space [a model] from any desired viewing position." He assumed perspective, so this fits our Central Dogma definition. In all fairness then, Fetter and Bernhart at Boeing practiced it first. But nobody inherited the Central Dogma from them. It was inherited instead in the form Tim Johnson and Larry Roberts presented in 1963, as I explain in detail in the online annotation.[59]

The mention of "computer graphics" in the epigraph is one of the earliest uses of that important term. In that same article Fetter said, "*Computer graphics* [his italics] was born at the Wichita Branch of the Military Aircraft Systems Division of The Boeing Company." He clarified later in life that the term was first used by his supervisor

Figure 6.32

at Boeing, Verne L. Hudson (1915–2001). We can comfortably and conservatively give Hudson credit for the term by early 1962. Fetter certainly worked to popularize it and was using it frequently in 1962.[60]

An interesting claim by Fetter, particularly for this book, is that he made the first computer-animated movie in 1960: "[I] produced the first perspective motion picture animation (Naval cockpit visibility) '60." But in a separately obtained list of his films, the earliest is dated "Est. Year" 1962. *A4B–F4B, Carrier Landing*, and the earliest that roughly matches his own description is dated 1964, *AMSA Cockpit Visibility*. Conservative dating gives Fetter credit for the first three-dimensional animated movie, presumably in perspective, probably in 1962.

We learned in the Dawn of Digital Light chapter that the first known digital animations were on Whirlwind in 1951. They were broadcast on television, but not recorded to movie film. The Whirlwind animations actually moved on television, which means Whirlwind could animate in real time. The big distinction is that Fetter's animation was from a three-dimensional model viewed in perspective, but Whirlwind's models were only two-dimensional. Even 10 years after Whirlwind, in 1962, the only way to see a three-dimensional model move in real time was to record frames to film, and then project the film in real time.

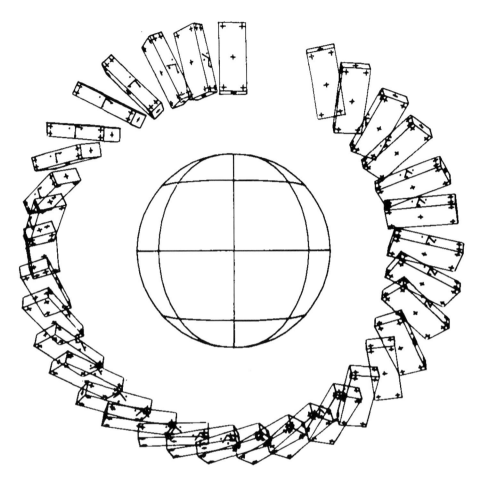

Figure 6.33

Another Perspective and Another Movie

At the famed Bell Labs, Edward E. Zajac derived another perspective solution. He submitted it for publication in October 1963, and it was published the following March. According to a footnote in his paper, he had made a 16 mm movie of a three-dimensional object moving in perspective by that time. He is therefore sometimes credited with the first computer-animated film, dated 1963. But since Fetter's 1962 film (probably) already existed, we credit Zajac with the second animated film.[61]

The Zajac movie frames weren't seen on a computer display at all. They were written directly (and slowly) to film, frame by frame. Figure 6.33 shows all the frames of the moving object written atop one another in one picture.

Zajac said, "The basic transformation needed to make a perspective drawing is mathematically trivial to state." It is, and his solution is mathematically equivalent to the one Tim Johnson and Larry Roberts used, also in 1963. But Zajac's solution, like Bernhart-Fetter's, is not the one that was passed down to modern computer graphics. Details relating the Zajac, Bernhart-Fetter, and Roberts perspective solutions appear in the annotation.[62]

What Exactly Did Ivan Do?

If you've ever encountered Ivan in a meeting, you'll know that every meeting with Ivan is an encounter.
—Steven A. Coons[63]

I built TX-2 for you, Ivan.
—Wesley A. Clark[64]

Like Steven Coons, the name Ivan Sutherland shows up again and again in computer graphics. My colleague Ed Catmull studied under Sutherland and told me about him over the years. I had even been in the same room as Sutherland a couple of times, but I'd never really gotten to know the man. So, on May 9, 2017, I Skyped him in Portland, Oregon, from my flat in Cambridge, England—at 5 a.m. his time per his request, the usual time he starts his days.

We spent an hour and a half together, chuckling much more often than I had anticipated. Sutherland was not the stern man I expected from reports. Yes, his initial demeanor suggested a saturnine personality, but I soon detected a slight smile, almost hidden. And there was the occasional witty remark—with a funny bite to it. His opening salvo to me was a reminder that Sketchpad's development occurred in the era of hulking dinosaur computers, this one filling a room with towers of electronics. He had to walk, he told me, *through* TX-2 to work on Sketchpad.

TX-2 at MIT was probably the world's most powerful single-user computer at the time. Its home was Lincoln Lab, a secret facility with high security (once more, a military tyrant offers cover). But as a Lincoln Lab employee and MIT student, Sutherland had access to the beast. And he got to use it by himself as if it were his own. The whole roomful of electronics responded only to him. TX-2 was his own personal T Rex, with a graphics display and a light pen. Sutherland could manipulate points on that display with the pen.

He stored models of line segments in the memory of TX-2 and he wrote a program that rendered these invisible two-dimensional models into visible two-dimensional

pictures on TX-2's raster-calligraphic crossbreed display. If he let the light pen hover in the vicinity of a point on the display—say the end of a line segment—then he could grab the endpoint and move it to a new location. The endpoint coordinates stored in the internal model in memory would change. And the display would show an updated picture of the changed model.

Sutherland also showed *rubberbanding* for the first time. He would grab one end of a line segment and drag it to a new location. The old line segment disappeared as a new line segment was drawn instantaneously to the new location. So the line segment was redrawn *as* he moved the light pen. It would lengthen or shorten as the new endpoint required and in whatever direction the user indicated. The technique and its effects amazed viewers. It seems so obvious now, but nobody then had seen it before.

Sutherland's two-dimensional Sketchpad emphasized the power of constraints on geometry and the ability to do stress analysis and other physical tests on his models. This put Sutherland directly in the main line of computer-aided design development.

Tim Johnson, another member of the MIT Triumvirate, put Sutherland into perspective, so to speak, for me. I've left the engineering (computer-aided design) talk intact in the following story, which also reminds us of Coons's influence:

> Steve Coons showed up one night . . . to see Ivan's graphical constraints in action for the first time. Coons was taken back by the "constant length" constraint, which fixed a line length. He [Coons] casually noted . . . that he could draw a truss and show the strain just by adding a text display for each constrained line that showed the amount of stretch/compression the line was undergoing. Ivan had never anticipated such a use. He added the text for the next demo and Steve went to work drawing classic structures to test it. That moment marked the immense power of Ivan's work.[65]

Constraints aside, the level of graphic display in Sketchpad seems almost trivial by today's standards, but nobody had seen anything like it in 1962. Or had they? As usual the history of a technology isn't as simple as the received version. There was another interactive computer graphics and computer-aided design program in development at the same time. Design Augmented by Computers (DAC-1) was created, with IBM's help, for exclusive use by designers and engineers internal to General Motors in Detroit. The contract for it was let (legalese for *awarded*) in 1960 and development occurred at IBM in Kingston, New York, until IBM delivered the system to GM in April 1963. It was always a three-dimensional system. GM was aware of Sketchpad but considered two-dimensional line segments insufficient for its design purposes. They needed three-dimensional curves.[66]

At first there was no push to make the system public. That is, not until Sketchpad and Sketchpad III published in 1963. GM quickly got DAC-1 published in 1964 to share

in the glory. But few remember it or its authors, Edwin Jacks, Barrett Hargreaves, and many others.[67]

Here's what Barrett Hargreaves himself told me as I prepared this chapter:

> Yes, you could use the light pen to enter line segments. The designer could enter two locations and request a straight line between them. Or there were a number of computer graphic dialog routines that allowed him to develop curved lines. He could for instance, enter an existing 3-D surface and match a line or surface to that surface or a given distance from the original surface. The end result could be a tape that drove a numerically controlled machine tool.
>
> The DAC-1 system was a very early development that employed engineers and designers working along with GM Research computer specialists and mathematicians. The engineers told us what they needed and we programmed responses to their requests. The engineers did use DAC-1 to work on the design of vehicle parts, mostly body parts like hoods and fenders.
>
> Probably the most important contribution of DAC-1 to GM was that, in the very early 1960s, it demonstrated to GM engineers and GM engineering management that *computer graphics* could effectively be used in design and engineering. There were numerous cases where computers were used for fuel economy calculations, vehicle handling calculations, cam stress analysis, etc. but DAC-1 proved that body parts and other graphic oriented engineering could be greatly assisted using the computer.[68]

According to Hargreaves, GM worked with MIT on software for DAC-1 and the light pen. The MIT and GM groups would have known about one another. There are intriguing historical hints here involving DAC-1 that deserve further sleuthing. One thing lacking in DAC-1 accounts is exact dates. For example, did it have three-dimensional curves when Sketchpad had only two-dimensional line drawings? Did it have three-dimensional interactive graphics before Johnson's Sketchpad III? That DAC-1's delivery in April 1963 predates Sketchpad III's publication in May 1963 suggests that it did, but these are both external dates and not necessarily indicative of internal developments. We do know that DAC-1 did not display in perspective.[69]

Hargreaves also delivered the following surprise—evidence of an early computer animation at GM shown to Walt Disney himself, but not on DAC-1:

> Walt Disney visited the GM Research Laboratories Computer Technology Department sometime in the early 1960 time frame. A fellow computer graphics programmer named Hugh Brouse had developed an automated movie of Mickey Mouse for Mr. Disney. Mr. Disney was fascinated. We all stood agape as he walked around our little computer department.[70]

Again, the dates are soft and details lacking. And Hugh Brouse has died. So, without hard evidence that proves otherwise, and using our conservative dating scheme for establishing priority, let's assume henceforth in the Sketchpad versus DAC-1 contest that Sutherland was first. It's certainly true that his Sketchpad was publicized far and wide, and DAC-1 was not. But it's also clear that DAC-1 was an interactive computer-aided design program at about the same time.[71]

But what exactly had Sutherland done first, if we give him that? It wasn't interactive computer graphics. That had already been done a decade earlier—by Christopher Strachey and his draughts (checkers) videogame and by Sandy Douglas and his noughts and crosses (tic-tac-toe) videogame. Both programs from the early 1950s enabled a user to interactively change, say, a board square from an empty one to one holding an X or an O. The internal board model was updated, and the display was redrawn to show the new board configuration with jaggedly rendered Xs and Os.

This was really Sutherland's innovation: Sketchpad rendered interactively, with emphasis on *rendered*. The program updated an internal geometric model interactively, *as* you moved your hand. But Strachey's and Douglas's games did that too. The important new thing was that Sketchpad rendered the updated model to the display *while* you moved your hand. It didn't just change the model. It re-rendered it too. Sketchpad had no notion of where the next line might be drawn, nor how long it would be, nor at what angle it would lie. And it had to render it as fast as the user's hand moved the endpoint locations. Thus the user had a sense of full agency in changing the geometric model interactively.

Strachey's draughts program, running on the ancient Mark I computer at Manchester, displayed pre-rendered geometrical elements—the board, Xs, and Os. The Mark I wasn't fast enough to render even an X at interactive speeds. Douglas's noughts and crosses running on the ancient Edsac at Cambridge was similarly disadvantaged. But 10 or so years later TX-2 at MIT *was* fast enough to render several dozen line segments instantaneously, as perceived by a human anyway.

Sutherland had giant TX-2 to himself and was the first to exploit its speed graphically. We've already discussed rubberbanding. He also caused Sketchpad to do things such as hold one endpoint of a line segment fixed while rotating the other endpoint about it. The effect was to rotate the line segment—as you watched—while the user (Sutherland) moved the light pen on the display's surface. Or he could rotate an entire object, consisting of several line segments, in real time while twirling a knob. The key difference between this and interactive games in the early 1950s was that the rendering of line segments happened instantaneously, or apparently so. The Sketchpad program had no idea of where new line segments might be located, so couldn't have pre-rendered them.

What Sutherland accomplished with Sketchpad was the first *interactively rendered* computer graphics. It doesn't roll off the tongue as nicely as "first interactive computer graphics"—with which Sutherland and Sketchpad are often credited—but it has the advantage of being accurate. The notion is that a geometric model rendered to a display is instantaneously replaced with another rendering of the model, which incorporates changes that depend on a user's input and hence can't be predicted by the program.

TX-2 was the first single-user computer with a display that was fast enough, and Sutherland leapt to use it that way.

But there was *something* new about Sketchpad: something that interactive rendering made possible but doesn't explain; something that hasn't yet been captured in this discussion of interactive rendering. Curious? The something new was this: the user himself felt as if he (not yet she, generally) were changing the model by "touching" a picture of it on the display. We call this the *picture-as-interface* notion. The early interactive board games changed the internal model interactively by typing, not by touching the picture itself. And the early Edsac game called "sheep and gates" worked by interrupting the light beam of Edsac's paper tape reader with a hand wave. *But as a user of Sketchpad, the new experience was for you yourself to change the picture by touching it.* If you were a designer you could, for the first time, see your model while it was being created. DAC-1 allowed the same thing at about the same time.

I'm using "touch" here quite loosely, to include bringing a light pen or light gun into close proximity to a computer display screen. Since cursoring with a mouse feels to us like touching something with the cursor, I also include that mode as touch. Similarly, I include cursoring by moving a trackball, joystick, your finger on a touchpad, or waving a wand in virtual reality.

Actually touching a screen with a finger or fingers, as we do on cellphones and touchpads today, would appear to be a fairly recent development of the last decade or so. But that's not true. The Plato project masterminded by Dan Alpert, Don Bitzer, and others at the University of Illinois let users directly touch its plasma panel displays, starting in 1972. The display elements of these binary raster displays famously glowed orange. A recently published history of this project, *The Friendly Orange Glow* by Brian Dear, should reestablish the Plato development in modern computing history.[72]

In the early days before I could show people a live demo, I would describe how moving a mouse on a desktop made a change on the display. I would spend about 15 minutes in every talk explaining that this really worked. People were surprised that if you were moving in one place and causing a cursor in another place to move in rigid mimicry, it would feel as if you were moving up there on the display, not down on the desktop. The advent of personal computers in the early 1980s banished that question. Suddenly everyone just knew, from personal experience, how a mouse connected to a cursor.

Whether you cause something to happen on a screen by moving a mouse or by actually touching the screen, you perceive that your hand is the agent that changes the picture. It feels that way, but that's not what actually happens. What actually happens is this: The "touching" device causes commands to be issued to a running program—Sketchpad say. The program causes the geometric model in computer memory to

change, and then that causes a re-display of the changed model—a re-rendering of it—to the display that has just been "touched."

From today's vantage point, working with two-dimensional geometry—such as a square, a triangle, or a circle—doesn't sound like much, but Sutherland was there first and had to solve myriad problems. He had to create a data structure that represented the topology of the objects in his model: this line segment is connected to that one—and stays connected during movements.

He had to cause a display device to display a picture of the objects while the TX-2 was doing Sketchpad work. That is, he had to think about a display process running separately from the main computation process. This is how modern displays work, but Sutherland had to confront it head on.

He had to create an algorithm for rendering a line segment to the display as a set of points. This was about the same time as Bresenham's famous algorithm in 1962 for doing the same thing, but Sutherland solved it independently and without regard for efficiency because the TX-2 was so fast.

He had to figure out how to track a light pen on a display. People after him, like Tim Johnson, could just start with many of these problems already solved. Two-dimensional geometry alone doesn't sound like much of a contribution, but Sutherland also created the plumbing of interactively rendered computer graphics for the first time (probably, remember DAC-1).

And for computer-aided design, he contributed the important notions of constraints, topology preservation, accuracy, and testing of his objects that we won't further pursue here.[73]

But most importantly, Sutherland showed us the power of feeling in control of a computer by "touching" its display and seeing something change instantaneously. Sutherland might not have entirely been first, but hardly anybody saw, or was even aware of, earlier instances. Sage, for example, was top secret. And DAC-1 was internal to GM. But MIT was smart about marketing. Film demos of Sketchpad were distributed far and wide. You can still watch Alan Kay on YouTube narrate (well after the fact) a 1962 film demo of Sketchpad and sense the original excitement. The rubberbanding alone was enough to astonish the world, and it was certainly new at the time.[74]

This use of interactivity in Sketchpad appears to have been the dramatic origin of what we now call the *graphical user interface*. I asked Sutherland about this in our Skype call. He wasn't ready to go that far. His program allowed a user to control the picture of an object through "touch" via a light pen.

The final metaphor that gave us the full graphical user interface was the notion that a user could control *anything* through touching a display, not just pictures of geometrical

objects. The internal model that changes under user touch could be, for example, the file or folder system of the user's computer. An icon of a folder is the displayed version of an actual folder in the computer memory. It is not a picture of it, because there is nothing there to make a picture of. Moving the folder's icon actually moves the folder somewhere new in the memory.

Tim Johnson in Perspective

Tim Johnson had the misfortune of looking a lot like Ivan Sutherland in the early 1960s. He had a bigger, readier smile than Sutherland but the same hair, glasses, and narrow face. Many online photos today, captioned as Sutherland at the controls of Sketchpad, are actually Johnson at the controls of Sketchpad III. When I contacted Johnson in late March 2017, he good-naturedly accepted the situation. He's now resigned to it, he said. What else could he do? I promised him I would do my bit to turn it around.

Johnson's Sketchpad III was in the main line of computer-aided design development. With it he introduced, as we've mentioned, the four-pane window layout popular with computer-aided design modelers: three showing top, front, and side views of an object without perspective, and the fourth, the viewport, showing the object from any angle and in perspective using the Roberts perspective solution.

Consider that viewport for a moment. Assume that it fills the entire display. That's the view you see in every frame of every Pixar-like movie. Those other three panes, with the top, front, and side views, are used during the design phase only, for the convenience of modelers.

In figure 6.34, upper left, Johnson (not Sutherland!) is at the controls of Sketchpad III. The closeups of each display show all four panes, with the viewport in the upper right of each. Tim started with three faces of a simple cube (in the upper right figure). He then added, using a light pen, a triangle at the top of the front face F (lower left), which shows in the other panes as he adds it. He then added (lower right) a skewed rectangle to the side face S and perhaps is adding another to front face F.[75]

The viewport was Johnson's innovation: "Ivan [Sutherland] got the homogeneous thing going by pointing me in Larry Roberts's direction. I quickly appreciated how clean (and brilliant) his [Roberts's] approach was. . . . The perspective view port was my notion." And that (perspective) viewport notion is key to computer graphics.[76]

I asked Johnson if he had implemented Coons patches in Sketchpad III, given that Coons was his master's thesis adviser. "I did Steve's patches as a quick and dirty standalone TX-2 program, it was not part of Sketchpad III."[77]

Figure 6.34

And what had he done with himself since those early days? Johnson pursued a career in architecture after Sketchpad III. In MIT's Department of Architecture, he applied Sutherland's constraint ideas to architectural plans, leading to a professorship there. Then he built a demonstration solar building on the MIT campus. He ended his professional career by starting a successful business that did stylized "photorealistic" renderings of architecture. That is, Johnson started his professional career in the computer-aided design branch of Digital Light and ended it in the computer graphics branch. But he's never been honored with an award by either.[78]

Larry Roberts, Renaissance Man

Larry Roberts didn't look like his MIT classmates Ivan Sutherland and Tim Johnson. He had darker hair and didn't wear glasses. And he didn't write a version of Sketchpad. In fact, he didn't start in computer graphics. Roberts initially worked in the image processing branch of Digital Light. He studied a *Playboy* magazine photograph, in

digital form as a raster of pixels, to understand how many bits per pixel he could omit and still maintain image quality.

But his far more impressive work involved the recognition of three-dimensional shapes in digitized photographs—not of *Playboy* Bunnies but of simple objects like cubes and prisms photographed in perspective. He extracted line drawings of these objects by detecting their straight-line edges and corners, taking the perspective into account. Then he deduced their three-dimensional structure and displayed it on the TX-2 display, crossing back over into the computer graphics branch of Digital Light for this part of his work. He had to master perspective to accomplish this, and the way he did so became his fundamental contribution to computer graphics.[79]

His perspective solution is used universally in computer graphics today. It's from an esoteric math called *projective geometry*, and it utilizes the oddly named *homogeneous* coordinate. It wasn't an obvious or intuitive step.

The technique asks us to append a fourth coordinate to each point in our geometry. The plane geometry of my high-school textbook uses points with two coordinates, the first for horizontal location x and the second for vertical location y. That's the geometry of Sutherland's Sketchpad, both internally and in display.

Students like me learned a smidgen of solid, or three-dimensional, geometry in high school too. It appends a third coordinate to each point, its depth location z in three-dimensional space. Solid geometry is what's internal to Johnson's Sketchpad III. For display, Johnson needed only two-dimensional points, but in his most interesting twist, he had Sketchpad III also display the internal model in perspective. This is where the perspective solution of his classmate Roberts came in.

The Roberts technique appended that strange fourth, "homogeneous," coordinate to every point in an internal model. Let's call it h. An abbreviated point in Roberts's world—in projective geometry—becomes (x, y, z, h). The first three coordinates are just the usual location of a point in space. But what *is* that fourth coordinate? We've talked about spacetime where a point has a fourth coordinate, which is its location in time. But the homogeneous coordinate isn't time. What it *means* is this: given a point normally located at (x, y, z) in an internal geometric model, use the point $(x / h, y / h)$ to locate that point *in perspective* on the model's display. In other words, the way to get a point into perspective is to divide its first two coordinates by its fourth coordinate h (and simply ignore the third coordinate). That's not obvious, is it? The Renaissance artists and architects certainly didn't know this algorithm.

But Roberts went even further, and Johnson incorporated these other ideas into Sketchpad III as well. Roberts introduced the spatial transformation machinery that's used universally in computer graphics today. By spatial transformation we mean

moving, rotating, or resizing an object. I won't explain it further other than to say that it uses four-dimensional multiplication on the four-dimensional points that Roberts introduced with his perspective solution—where the fourth coordinate is the homogeneous one. To explain further would take us into the mathematical weeds of "matrix" algebra. The important point to remember about Roberts is that he combined both perspective and spatial transformations together in matrix form, as we do universally today. He didn't create either homogeneous coordinates or matrix algebra. But combining the two was profound. Here is Roberts's discovery in his own words:

> It turned out there was no technology in the US or in the world at that point in time integrating both matrices and perspective geometry. Somehow the two had been totally separated in time and space throughout the world. So I went back to the German textbooks and found out how perspective geometry was done and that had no knowledge of matrices. I went to other textbooks and found out about matrices, of course, and put the two together and created the four dimensional homogeneous coordinate transform, which is widely used today for perspective transformations. This paper probably is even best known of all of the work that was in this original thesis because it provides, with a single four dimensional transform any perspective display of an object.[80]

Why isn't there a Roberts Award? And what happened to Larry Roberts? You might be surprised. He became a major force behind the invention of the internet! But that's a story that needs a context.

IPTO Facto: ARPA Funds Computer Graphics

J.C.R. Licklider, you may recall, imagined the internet in his "Man-Machine Symbiosis" paper of 1960. So it's not surprising that two years later ARPA snapped up "Lick" and made him the first director of the new Information Processing Techniques Office. IPTO would become, under a succession of strong leaders, a major force in our story. In particular, it would spur development of the internet, personal computers, and computer graphics.

Immediately, Lick started funding projects that might realize his vision of man and machine working in harmony. He had a remarkably free hand at this and attained true visionary status with it. One of the first things he funded was Doug Engelbart's "augmented" man-machine communications project at the Stanford Research Institute near Stanford University. This project led to the first full implementation of a graphical user interface. As noted earlier, Engelbart showed it off in the famous "mother of all demos"—which he drove with a new device, called a mouse.

Similarly intrigued by Engelbart, Robert Taylor at NASA also pitched in funds. A nexus of visionaries formed—Licklider at ARPA, Taylor at NASA, and Engelbart at

SRI—who would affect all the intertwined stories of this technically explosive decade and the next.

Licklider, Engelbart, and Taylor were quite aware of the Triumvirate's Sketchpad and Sketchpad III developments at MIT from 1962 to 1964. They cited them as evidence of their collective man-machine vision. Not surprisingly then, the second director of ARPA's IPTO was Ivan Sutherland in 1963. The third director was Bob Taylor in 1965. And the fourth director was Larry Roberts in 1966. ARPA's funding helped these men influence not only Digital Light, but also the complexion of our entire modern world.

While Ivan Sutherland was at IPTO he inherited and continued to fund David Evans in Berkeley. When Evans subsequently founded the graphics department at Utah, he urged Sutherland to join him. Sutherland finally did so in 1968, and at the same time the two cofounded the computer graphics hardware company Evans & Sutherland in Salt Lake City. The company and especially the department would have a tremendous influence on the subsequent history of computer graphics.

In 1970 Bob Taylor, after his stint handing out ARPA funds at IPTO, founded the famous lab at Xerox PARC (Palo Alto Research Center). I would work for him there a few years later. This is the lab where personal computing as we now understand it was created, integrating the personal computer, a windows-based graphical user interface, mouse, laser printer, raster graphics, and Ethernet.

Larry Roberts used his IPTO leadership position at ARPA to cause the creation of the ARPAnet, which became the internet. The internet is now implemented using the Ethernet components that were invented at Taylor's lab at Xerox PARC. Two of the four earliest nodes on the ARPAnet were Stanford Research Institute and the University of Utah.

As I wrote an early draft of this chapter (April 2017), Roberts was inducted as a Fellow of the Computer History Museum in California. His official induction made no mention of his founding role in computer graphics and its Central Dogma. He's celebrated entirely for his role in founding the internet—quite enough accomplishment for any one man. He received from the IEEE alone the Harry M. Goode Memorial Award in 1976, the W. Wallace McDowell Award in 1990, and the Internet Award in 2000. He was a member of the National Academy of Engineering, which in 2001 awarded him the Charles Stark Draper Prize. But he was never similarly honored for his fundamental computer graphics contributions.[81]

Shapes in Motion: Computer Animation

Animation is a continuing theme of this book. Even though Sutherland is primarily known for computer-aided design, he hinted at animation in his 1963 Sketchpad

Figure 6.35

thesis. Figure 6.35, which was part of the thesis, is a simple drawing of a girl and three positions of her eye. The notion is that if you substitute in the three eye positions in succession, she'll wink. It's worth quoting Sutherland to see how far we've come:

> One way of cartooning is by substitution. For example, the girl "Nefertite [*sic*]" shown . . . [above] can be made to wink by changing which of the three types of eyes is placed in position on her otherwise eyeless face. Doing this on the computer display has amused many visitors.
>
> A second method of cartooning is by motion. A stick figure could be made to pedal a bicycle by appropriate application of constraints. Similarly, Nefertite's hair could be made to swing. This is the more usual form of cartooning seen in movies.[82]

Sutherland was wrong that this second form, by constrained motion, was usual in the movies. Cel animation used substitution of inbetween shapes, and it was the usual form until the millennium. And it's still the usual form even today if substitution is taken to mean the interpolation of inbetween shapes in three dimensions.

After his MIT thesis, Sutherland proceeded to join ARPA and fund, as we've seen, David Evans. Then he resigned from ARPA, went to Harvard for a few years and, in 1968, joined the University of Utah department of computer graphics that Evans had founded. Many researchers in modern computer graphics graduated from that department, each telling the story of Sutherland's primacy. Although Sutherland didn't directly pursue animation, Utah graduates were fundamental to the computer animation industry treated in the next chapters.

Cybernetic Serendipity: Artists Discover Nascent Computer Animation

No visitor to the exhibition, unless he reads all the notes relating to all the works, will know whether he is looking at something made by an artist, engineer, mathematician, or architect.
—Jasia Reichardt, *Cybernetic Serendipity* curator, 1968[83]

Bell Labs was home as we've seen to Edward Zajac's computer animated film in 1963. It was also home to an early computer animation production system. In 1964 the Bell Labs researcher Ken Knowlton devised a computer language for slowly generating movies—in raster mode—one frame at a time to film. It came to be known as Beflix. It was not interactive. It assumed a frame was divided, in "high-resolution" mode, into 252 by 184 little squares. Tiny characters "in typewriter mode" could be written to each square. The camera was defocused so that the characters were blobs of different intensities. That is, they were crude spread pixels, on a grid and without overlap. A primitive movie made this way by Knowlton in 1964 can be seen online. One made by Zajac and a student in 1964 and 1965, using Knowlton's language, can also be seen online.[84]

And here a gong sounds. Artists began to work with the technologists at Bell Labs and other places. These were artists trained as artists, not computer scientists, who sniffed something new in the air. They were a new breed who perceived computation as a fresh substance to explore in sculpture, music, poetry, and pictorial art. One, whom we meet again in the next chapter, was Stan Vanderbeek, an experimental filmmaker, who made movies at Bell Labs in the 1960s, working with Ken Knowlton.

This was the famous Sixties, and definitions were being questioned. Some computer scientists saw themselves as artists, causing dismay in the artistic community. Arguments rage to this day, and I won't settle them here. Ken Knowlton, whether you call him an artist or not, began a lifetime of experimentation with various display elements. He created dozens of digital pictures using anything—dominoes, dice, toy cars, and seashells, say—to spread his pixels. In the 1990s, 34 years after his first movie

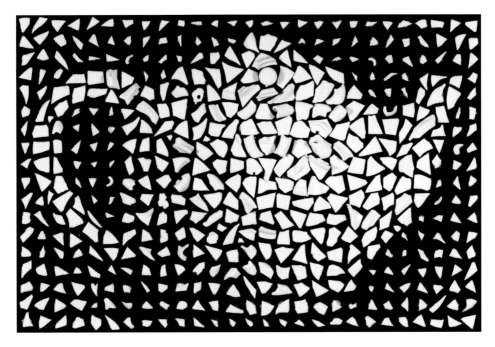

Figure 6.36
This Is Not Not a Teapot, © Ken Knowlton, 1998. Collection Laurie M. Young.

with spread pixels, Knowlton was still working in the medium—with teapot shards as display elements (figure 6.36).[85]

Although many people in the late 1960s didn't consider the computer an artistic tool, one woman did, and her 1968 exhibition has gone down in history. Jasia Reichardt's seminal exhibition *Cybernetic Serendipity* opened in London that year. The catalog cover (left), and poster for it (right), in figure 6.37 are collector's items now. Even then she carefully avoided calling the creators of the works "artists." Fifty years later this is still a minefield in certain circles, with actual lawsuits pending.[86]

But Robin Forrest has no problem eschewing the term, despite his having contributed the contorted wireframe patch on the right side of the figure 6.37 poster. "I never considered my image to be art, but she [Reichardt] did. So, it must be art! But why that image?"[87]

In 2005 Reichardt took an indirect route to describing the creators, by repeating another author's words:

He also pointed out that most of the pictures in existence in 1967 were produced mainly as a hobby and he discussed the work of Michael Noll, Charles Csuri, Jack Citron, Frieder Nake,

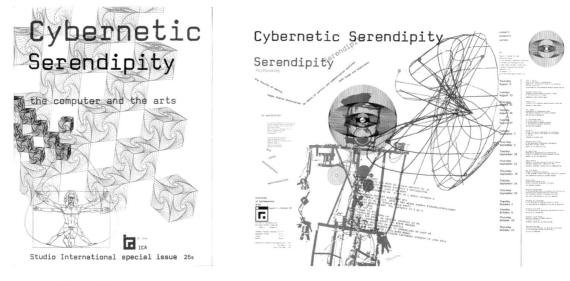

Figure 6.37
© Cybernetic Serendipity, 1968, design by Franciszka Themerson.

Georg Nees, and H. P. Paterson. All these names are familiar to us today as the pioneers of computer art history. . . . The possibility of computer poetry and art was first mentioned in 1949. By the beginning of the 1950s it was a topic of conversation at universities and scientific establishments, and by the time computer graphics arrived on the scene, the artists were scientists, engineers, architects.[88]

People in this chapter, in addition to Robin Forrest, who also appeared as creators in *Cybernetic Serendipity* were William Fetter, Ken Knowlton, Stan Vanderbeek, and Edward Zajac.[89]

TX-2 and Computer Animation

As crocodilesses began to cavort across the TX-2 screen, picture-driven animation became a practical reality.
—Ron Baecker, PhD thesis, MIT, 1969[90]

Ronald Michael Baecker is the fourth major beneficiary of the TX-2 computer at MIT in my telling. He was directly influenced by two of the first three, Ivan Sutherland and Tim Johnson. I remember the colorful Baecker from the Sixties as a dashiki-clad Canadian, with a cool new program.[91]

In late 1966 Baecker began a stick-figure animation program on TX-2—an Epoch 1 machine. He then began working with Eric Martin, a charming and talented animator from Harvard's Carpenter Center of the Visual Arts, on mastering the control of animation dynamics. This work was inspired by suggestions from Sutherland and Johnson to use "waveforms" to control movements. The result was Genesys, for Generalized-cel animation System.[92]

Baecker generalized the waveform notion to what he called "p-curves." These curves define paths of changing positions through spacetime, as opposed to curves that define a character's shape. If he wanted a dog to hop, he drew a curve on the display showing the motion in time—he actually drew the hops through time. Then a drawing of a dog would follow that path. If the path was a hop, then the dog hopped. If he substituted a drawing of a lady crocodile for the dog, then the "crocodiless" hopped. Baecker completed Genesys in 1969, making it the earliest interactive computer animation program.[93]

But Genesys "was kind of confusing for most art persons at that time," according to my long-time friend and colleague Ephraim Cohen, a New Jersey sketch artist. Ephraim was so skilled at sketching that he could sometimes get a free meal by drawing a waitress's portrait while she served his table. He would effortlessly capture her personality.

In a recent email, Ephraim told me, "I was introduced to Ron by a mutual friend, Lynn Smith, then an animator at the Carpenter Center at Harvard. Lynn and I were friends in high school. Ron was looking for people to use his animation system." Ephraim, a mathematician and programmer as well as an artist, wasn't confused by the p-curves. He explained, "I was a natural fit, so we were introduced. It was all done on the TX-2 in Lincoln Labs. Also, I killed an afternoon there playing *Spacewar*. The animation I did was not much. I think it was all done in two days."

He helped Baecker with one of the first Genesys animated productions, although the system's drawing capabilities (see the studies in figure 6.38) fell far short of doing justice to Ephraim's sketching skills. We'll reencounter Ron Baecker, Eric Martin, and Ephraim Cohen (respectively, the programmer, the animator, and the artist) in the next chapters.[94]

Baecker's waveform or p-curve type of animation wasn't the usual one, which is what made it confusing. Genesys didn't interpolate as was traditionally done in cel animation between keyframes, or "critical frames" as Baecker called them:

> Interpolation occurs when the key animator asks his assistants to fill in the pictures intermediate to a pair of critical frames. It has been suggested that part of this process could be mechanized. We do not consider further that problem in this paper.[95]

We *do* consider interpolation further here, however. That's next.

 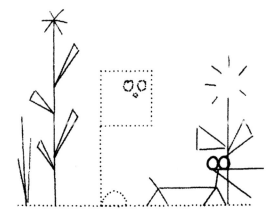

Figure 6.38

Schindler's List and the First Digital Inbetweener

On June 12, 2016, Marceli Wein and Susan, his wife, picked me up at my in-laws' farm in southern Ontario and drove to Gananoque, where we boarded a motorboat for the short ride to their home on one of the Thousand Islands in the St. Lawrence River. It was a chilly day, so we sat around a fireplace and caught up on our separate lives after 40 years of going different directions. This gentle man told me a most amazing story:

Remember Steven Spielberg's movie *Schindler's List* (1993), which told us how a greedy German businessman, Oskar Schindler, saved more than a thousand Jews from the Nazi horror at Auschwitz? Well, Marceli's father, Wolf Wein, was a master tailor who became number 5 on that list. But before those events unfolded, Wolf Wein had saved his 8-year-old son, Marceli. In Marceli's own words:

> In the spring 1943 I was sent to a hospital in Krakow ghetto with scarlet fever. . . . My father heard that the hospital was being shut down and everyone in it would be killed. He visited me that night, wrapped me in a blanket, and smuggled me out. . . . I remember walking out with my father and a group of Jewish workers, as they went from the ghetto to a slave labour factory. On the way, he handed me to a woman who was waiting along the route. The person to whom I was handed over was a fine lady, Zofia Jezierska, whom I then called my aunt. I went with her to a flat in Krakow. After a few days I moved with her to Warsaw. I was now a "hidden child."[96]

Zofia raised Marceli as a Roman Catholic with the nom de guerre Marek Czach. Meanwhile his older brother was shot and killed, and his mother died in a concentration camp. But thanks to Schindler, his father Wolf survived. He and Marceli eventually reunited and settled in Montreal in 1952.

Marceli studied at McGill University there and was exposed to the potential of computer imaging during his PhD studies. Excited by the possibilities he joined Nestor Burtnyk in 1966 at Canada's National Research Council doing early computer graphics research. "We were interested in how non-technical people could interact with computers."[97]

Burtnyk heard a Disney animator talk at a computer graphics conference in 1969. The animator explained the cel animation process that we discussed previously in the chapter on movies: A head animator draws keyframes in pencil outline. Then inbetween frames, between the keyframes, are created by inbetweeners. Inkers trace the penciled lines in India ink onto cels (celluloid sheets), and opaquers fill the outlines with color. Burtnyk and Wein decided to create a cel animation assistant using a computer.

Burtnyk wrote the two-dimensional interpolation program that would take a line in a keyframe and the corresponding line in the next keyframe and interpolate one to the other with lines in appropriate positions in the inbetween frames. That is, the computer would become the inbetweener in a system called *keyframe animation*. Thus they created in 1970 the third documented two-dimensional computer animation system, after Knowlton's and Baecker's—all systems that were actually used in productions.[98]

Knowlton's Beflix system, the first, was completely pixel oriented, with no geometry to interpolate. Baecker's Genesys moved fixed geometrical objects along curves but didn't interpolate them. Burtnyk and Wein's system was the first interpolating, or inbetweening, computer animation system.

Burtnyk and Wein were honored in 1996 as the Fathers of Computer Animation Technology in Canada. And they received a technical Academy Award in the United States in 1997 for their contribution.

The Moore's Law Speedup: Amplification Goes Supernova

Moore's Law arrived in 1965. Its announcement ushered in Epoch 2 of computation speedup. It brought Digital Light as we now know it to fruition.

The "Law"—because it isn't really a law—was named for Gordon Moore, cofounder of Intel, the most successful computer chip company in the world. Intel, a cornerstone company of California's Silicon Valley, traces its intellectual origins directly to the transistor. The transistor led to the integrated circuit—lots of transistors on a single chip—and to Moore's Law. Before Moore's Law, computers got bigger as they got more powerful. After it, they got smaller. That is, they got denser.

Moore formulated his "Law" this way: The number of components on an integrated circuit chip doubles every 18 months. Actually, he first said 12, then later 24, but the

average stuck. It's a "Law," and not a law, after all. It was simply an observation in 1965—based on just four meager data points.[99]

He also predicted—it's only humorous in hindsight—that "there is no reason to believe it will not remain nearly constant for at least 10 years." But it's held constant now for 55 years. It's become the Law, despite the fact that there's no reason grounded in physics to believe it really is one.[100]

I stated a handy reformulation of Moore's Law earlier: Everything good about computers gets an order of magnitude better every five years: "10X in 5" is an easy way to remember it (pronounced "ten ex in five"). Figure 6.39 is a picture of Epoch 2, with its Year One, 1965, on the left.

The down-to-earth business world calls the Moore's Law curve a "hockey stick." It's a profits chart to die for. Extend the curve at the last angle shown—approaching vertical—to see the hockey stick. This is a picture of exponential increase. Exponential *means* explosive. Moore's Law describes and predicts an exponential increase in

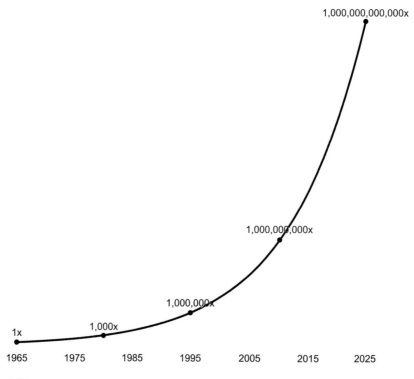

Figure 6.39

computational speed or memory density, or an exponential decrease in cost and size—everything good about computers gets exponentially better.

Moore's Law is the Archimedean lever that has moved the world. Amplification of human capabilities reached a millionfold in Epoch 1. Then Moore's Law in Epoch 2 has leveraged the factor another hundred-billionfold—a trillionfold by 2025. Amplification of human capabilities since the invention of the computer, all told, will have been a *quintillion*fold by then—18 orders of magnitude! That's as unimaginable—and as silly—as skydillionfold, but it's real.

No history of any modern aspect of computing—of Digital Light in particular—can ignore the spectacular role of Moore's Law. It's the explosive background against which all specific discoveries and advances of the last five decades have taken place—most of them infeasible without it. As we proceed through the biography of the pixel in the next chapters, the role Moore's Law plays will be increasingly evident. The genealogy of concepts in this case is *not* divorced from historical time—from the heavy ticking of the Moore's Law clock.

Nor can we disregard that ticking clock in the present. The "Law" is still going supernova. In fact, it's going beyond. A supernova can shine 10 billion times brighter than its originating star, but computers will soon be a trillion times more powerful—in Epoch 2 alone—than the original machines. Getting a handle, however slight, on the superlatives of Moore's Law is at the heart of understanding computation and computers—and Digital Light.

We've seen what Moore's Law is exactly—but why is it? A partial answer is that there's no imminent physical barrier to the realization of a bit. It's merely the presence or absence of something—say a voltage. It has no size. It's just a distinction and nothing more. It's pure information. The rest of the answer must reflect the maximum rate at which humans can innovate. The exponential improvement of a given technology—Moore's Law in the case of computer chip technology—measures the ultimate speed at which a large group of creative humans can proceed to improve a technology, under competition, when there is no ultimate physical barrier to its improvement and when the technology must pay its own way.

On the face of it, Moore's Law is a puzzler. If we believe it, then why should we bother with the intervening steps? If we know that computers will improve by a factor of four in three years, why bother building the factor of two improvement first? If we know that computers will improve by a factor of 100 in 10 years, then why bother with the factor of only 10 version in 5 years? Why not go directly to the higher factor?

An extreme form of this question makes its absurdity obvious. If we knew in 1965 that computers would be a hundred billion times better in 2020—as they are—why did

we bother to build the computers that were 10 times better in 1970, 100 times better in 1975, 1,000 times better in 1980, and so forth? Why didn't we just proceed to build the 2020 machines, skipping all the years—and pokey machines—between? The question in this form shows the flaw. In 1965, assuming that we had faith in the new "Law," we were simply unable to imagine the computer of 2020—much less how to build it. Engineers have to arrive at each level before they can even begin to imagine a way to reach the next one, and then create it. We can't skip the intervening steps.

No, we have to follow the Moore's Law path of incremental improvement of chip technology to even imagine what the next improvement could be. It's like the evolution of living things. Tiny changes aggregate into eventually massive changes—with the viability of the living thing intact at every step. There couldn't have been a direct one-step leap from a bacterium to a baby. Just as in Darwinian evolution, Moore's Law changes improve the fit—toward cheaper, smaller, denser, and faster in the case of computers. And we can't see where the accumulated changes are heading in either case because there is no teleology. But, when it comes to technology, we implement each step to see if it actually works, then gain the courage, the insight, and the engineering mastery to proceed to the next step. It's also how we can assess the financial gamble that's necessary to proceed to the next step. We need to know that it's within feasible bounds.

Moore's Law describes the hardware phenomenon that expresses itself to us as Amplification. What was once unfathomable becomes feasible, then ordinary.

Sutherland Again: The Birth of Virtual Reality

Yet it was not, in reality, Diaspar he was examining. He was moving through the memory cells, looking at the dream image of the city. . . . To the computers, the memory circuits, and all the multitudinous mechanisms that created the image at which Alvin was looking, it was merely a simple problem of perspective. They "knew" the form of the city; therefore they could show it as it would appear from the outside.

—Arthur C. Clarke, *The City and the Stars*, 1956, as excerpted in Jim Blinn's PhD dissertation, 1978[101]

The ultimate display would, of course, be a room within which the computer can control the existence of matter. A chair displayed in such a room would be good enough to sit in. Handcuffs displayed in such a room would be confining, and a bullet displayed in such a room would be fatal. With appropriate programming such a display could literally be the Wonderland into which Alice walked.

—Ivan Sutherland, *The Ultimate Display*, 1965[102]

The Annotated Alice in Wonderland, written in 1960 by Martin Gardner, was de rigueur reading for a generation fascinated with their own mind trips and magic mushrooms. So it's no surprise that Ivan Sutherland's description of the ultimate display in 1965 reads like a psychedelic dream—and invokes Alice. In an act that cemented his fame as the dominant leader of computer graphics in the Sixties, Sutherland implemented a first pass of that dream at Harvard in 1968. He called it a *head-mounted display*. A user who wore it was treated to a simple three-dimensional computer-generated scene, a "virtual reality," mixed with the real world in the user's surround. Virtual reality (VR) is the oxymoronic modern coinage for the computer-generated part. The mixture of a VR with the real world is called augmented reality (AR)—that is, reality "increased" or "improved" by the VR. Both these terms are odd takes on "reality" but have stuck.

Some consider Sutherland's head-mounted display the first realization of VR or AR. There had been earlier head-mounted displays, but this was the first that tracked head position and adjusted the virtual scene, in close to real time, to accommodate the user's always changing perspective. Figure 6.40 shows its optics system (the man is *not* Sutherland).[103]

Sutherland's head-mounted display was far short of controlling "the existence of matter," but it did present a stereo view of a three-dimensional world created from straight line segments in perspective. And the perspective was Larry Roberts's perspective, the one that combined homogeneous coordinates and matrix manipulations. Sutherland's Sketchpad of 1963 didn't embrace the Central Dogma of computer graphics, but his head-mounted display of 1968 did.[104]

Moore's Law enabled VR. The head-mounted display development occurred early in Epoch 2—after Gordon Moore formulated the "Law" in 1965. Indeed, Sutherland used integrated circuit chips in his head-mounted display design.[105]

Sutherland then famously claimed, according to rumor, that all the problems in computer graphics had been solved! That's a surprise to generations of contributors who have continued to solve computer graphics problems year after year, and still do— the Siggraph conference is full of their papers. During my conversation with Sutherland he told me he would never have made that statement. And truly belying the claim that he did is a 1966 paper Sutherland wrote called "Ten Unsolved Problems in Computer Graphics." But the rumored claim is consistent with advice he gave James Kajiya, another outstanding Utah graduate:

> The best way to do research is to pick a problem that everyone thinks is really hard. Find a fresh way of looking at it that makes 90% of it easy. Solve the easy 90%. Then everyone else will work on the hard 10% and reference you.[106]

Figure 6.40

Sutherland himself moved on to a very hard problem in a completely different sphere. He paired up with Carver Mead (who coined the term *Moore's Law*) to solve the seemingly intractable problems of designing integrated circuit chips of higher and higher density. That is, Sutherland turned his attention to keeping Moore's Law alive and well. He's still working on a difficult aspect of the problem today from his office in Portland, Oregon.[107]

Digital Light: From Shapes to Shades

I started this chapter by describing a demonstration I presented to Ravi Shankar in the early 1970s. My purpose was to drive home the notion of a model based on geometry by using a two-dimensional case and to round out the importance of the Sampling Theorem by showing it in reverse in the concept of spline. Finally, the spline as an interpolation or approximation of points led to the patch as an interpolation or

approximation of curves (of splines, in fact). That introduced the three-dimensional world of computer graphics.

I then returned to the end of the Whirlwind era and spent the rest of the chapter taking us through the 1950s and 1960s in a milieu spawned by the Nazi and Soviet threats and the massive American technological responses to them. The US government and especially ARPA and NASA provided the protected and controlled world that let the computer innovators thrive. They were given their heads in protected environments with generous support and without the usual burdens of profitability and industrial competition.

Because the Ravi Shankar demonstration with its colored brushstrokes was from the 1970s, you might have been lulled into thinking that the rest of the chapter, about the 1950s and 1960s, had color graphics. But it didn't. We are only now, at the end of the 1960s, at the point where color is about to flower, and the Moore's Law dynamo is poised to drive it.

From shapes and grayscale pictures in this chapter, we graduate in the next chapters to color, shades, transparency, texture, light, shadow, and so forth, generically classed as shaded images. We learn how to render a single colored, shaded triangle-shaped area and then Amplify it to full computer graphics glory.

I further restrict our focus there to just the part of computer graphics that is computer animation, and we'll finally learn how a movie springs from the guts of a machine.

7 Shades of Meaning

Figure 7.1
First color pixels, 1967, used to render the Lunar Module in NASA-2, the Apollo Moon Project simulator.

Epoch 1 was gray. Epoch 2 is color. Color dawned in Digital Light soon after Gordon Moore stated his famous "Law" in 1965, the event that kicked off Epoch 2. It was no coincidence. Every color pixel display (and there are very many) is a flag flying in celebration—not only of that event but also of computer history's Epoch 2 and the explosive Amplification it brought us. Pixels acquired color in the psychedelic Sixties—in the very year, 1967, of the Summer of Love and the Human Be-In. But that *was* just coincidence. Digital color wasn't a countercultural achievement. It resulted from the mainstream rush to the Moon—or away from Earth, depending on how you look at it. I didn't discover the full story until I wrote this chapter.[1]

In this and the next chapter I'll briefly explain where color came from, then trace the path from those first colored pixels to the first digital movies and explain how to compute them. The shocker is that it all happened in about 35 years. But that's what Moore's Law and the resulting Amplification means: a factor of 10 every 5 years. During those years the dynamo that drove Digital Light ripped through a seven-order-of-magnitude power surge—a supernova with a glow that suffuses every screen today and every page of this chapter and the next. The creators of the first digital movies surfed this new kind of wave as it crashed on the shores of our civilization. Yet those movies were only tiny colorful indicators of a much larger force at work in the world.

This biography of the pixel begins with the invention of sampling and ends, in the next chapter, with the Great Digital Convergence. Between those endpoints I intend to cover all Digital Light, but the very nature of Moore's Law suggests that this book has vanishingly small space for such an explosively large field, with its ever-increasing number of subfields. The Moore's Law supernova would force more and (exponentially) more technology into each successive page if chapters were to properly represent the whole.

My solution is to let picture-oriented computer graphics be the final exemplar of the whole vast field. And within picture-oriented computer graphics, digital movies will stand for all the rest. As picture-oriented computer graphics here represents the much larger field of Digital Light, so digital movies represent all the many other kinds of computer graphics that emerged from the Great Digital Convergence—including electronic games, computer-aided design, flight simulators, app interfaces, and virtual reality.

Here's how we'll proceed. Starting in 1965, we begin to mount the Moore's Law wave in mind-stretching order-of-magnitude steps, toward the Great Digital Convergence at the millennium. We take five large steps to get there—to the digital movie epitome. These steps are cast as five subchapters of a two-chapter biography of the color pixel. These two chapters unwind at exponential speed. The subchapters are labeled by the

Moore's Law factor at work during the corresponding time: 1X, 10X, 100X, 1,000X, and 10,000X—that is, in five-year increments. Thus each subchapter step reminds us of the essential contribution of the Moore's Law engineering marvel which empowered it all.

Moore's Law 1X (1965–1970)

What's a Color Pixel?

We know from the Dawn of Digital Light chapter that a pixel is a sample of a visual field. Furthermore—and this is crucial—it's a sample that has been digitized into bits. In this chapter we use pixels to sample *colorful* visual fields. Naturally, we call them *color pixels*.

We also know that we can't see a color pixel. It has no shape. It's a sample of a visual field at a single point. It has a location on a mathematical grid of locations and a single color associated with it. To see an invisible pixel, it must be spread by a display element on a display device and added to the other spread pixels there. The spreading and adding reintroduces the infinity of colors that the original visual field had before it was sampled. That's just a restatement of the magic of the all-important Sampling Theorem.

But how is a color "associated" with a pixel? Each display element is a piece of matter in the real world that glows with colored light, and it must emit light of millions of different colors to be useful in the modern world. So there must be an input control to tell a display element which of its many colors to emit.

The point is that a pixel doesn't hold a color. It holds color *controls*. Color display elements vary from manufacturer to manufacturer, so let's consider a typical one. It's composed of three tiny light-emitting parts in proximity, each contributing one of the three primary color components—red, green, or blue (for emitted light). At normal viewing distances our eyes fuse these tiny separate glowing parts together into a single glowing color. Such a color display element needs three input controls, voltages say, to vary the three small glowing parts. The higher the voltage, the brighter that primary component glows.

Our definition of a color pixel requires that it must be displayed under digital control. The bits in a color pixel drive the three digital controls of a color display element. It's so *convenient* to say that a pixel stores a color that we sometimes use that terminology. But pixels don't actually store colors—just as bits don't actually hold 0s and 1s. In the next section, I'm careful to say that a pixel controls, rather than stores, a color.

How to Count Colors

Let's review how to count digitally—colors in particular. We've used the lowly light switch before as a metaphor for a bit. A switch can be on or off, analogous to a bit representing 1 or 0 (if we insist on numbers as names). So a 1-bit pixel can control the display of only two different colors. Typically, the two colors are black and white, but they could be any two fixed colors—say, mauve and chartreuse.

Two light switches can be in four different positions: both on, both off, or one on and the other off in two different ways. So a 2-bit pixel can drive a display element into one of four possible colors. As the number of bits in a pixel increases by one, the number of possible colors it can control doubles. Three light switches can be in eight positions, all four possibilities for two light switches with the new third switch on, plus all four possibilities for two light switches with the new switch off. So a 3-bit pixel can drive or control eight possible colors. And so forth. For convenience, I will often put the equivalent number of possible colors controlled in parentheses after mentioning the size of a pixel in bits.

Color pixels became serious when the number of bits reached six and above. The obvious place to store pixel color controls is in those bits. Such direct storage is, in fact, the method most often used today—and that's why the notion of a pixel storing a color seems so natural.

But during the early days of very expensive memory, an indirect way of storing the color controls was popular. It used what was called a *colormap*, or a *color lookup table*. The bits in a pixel were interpreted as a row number in a table of color controls stored somewhere else in computer memory. That row of memory bits (not the pixel's bits) controlled the color. The idea was to keep the bits per pixel small—since there were so many pixels—while making the number of possible color choices per pixel large.

Consider the 1-bit pixel already mentioned. One bit can directly turn on or off a display element. That's all. So the only possible colors that a 1-bit pixel can control directly are black for off (0) and white for on (1). But indirectly that one bit can point to one of two rows—row 0 or row 1—of a colormap elsewhere in memory. Suppose each colormap row has 24 bits. That's enough bits to control over 16 million different color display possibilities. There are only two rows, so only two possible colors are available at any one time, but they could be as subtle as mauve and chartreuse. Since the one level of indirection happens at electronic speeds, it occurs instantaneously so far as pokey humans are concerned. With the colormap trick, a pixel doesn't control a display element. It selects the row of a colormap table that controls a display element.

An 8-bit pixel is a more typical example. An 8-bit pixel can point at one of 256 rows in a colormap table. Again, let's assume each colormap row has 24 bits. Thus, instead

of 256 possible colors (8 bits' worth) available directly, the colormap trick makes over 16 million colors (24 bits' worth) possible indirectly. The number of colors that can be controlled remains the same (256) in both cases, but the number of choices for those colors is immensely increased in the indirect case.

In this chapter we encounter 6-bit pixels (64 colors) and 8-bit pixels (256 colors), then we leap to 24-bit pixels (over 16 million colors). A human can discern up to about 16 million colors, so there is little reason in ordinary circumstances to use pixels with more than 24 bits. A pixel bit count of 24 became common at the millennium—thus enabling the Great Digital Convergence. So 24-bit pixels (with exactly 16 *megacolors* we say) are the norm today—in a digital movie or a cellphone.

Searching for the First Digital Color

One way to be free of past conditioning is to simulate alternative futures through the fail-safe power of the digital computer. This is "art" at the highest level ever known to man, quite literally the creation of a new world imperceptibly gaining on reality. . . . The possibilities for purely aesthetic exploration are revolutionary and have yet to be attempted. *City-Scape* is the first step toward that future time.

—Gene Youngblood, *Expanded Cinema*, 1970[2]

Gene Youngblood was a film critic and columnist for Los Angeles newspapers in the 1960s. In 1970, three decades before the Great Digital Convergence, he pondered the coming changes and published his thoughts in *Expanded Cinema*. It was a definitive book in media arts, a new field that promoted experimental film, video—and even nascent computer graphics—as emerging artforms. It was a summation and celebration of the vibrant Sixties in many ways—a clear achievement of the countercultural revolution. Surprisingly, the book turns out to tell us a lot about the history of Digital Light.

We learned back in chapter 2 that the word *pixel* was first used in 1965. Youngblood mentioned "PIXELS" in *Expanded Cinema* only once—just like that, all uppercase. It was still a strange word to him only five years later. Moore's Law existed, also since 1965, but hadn't yet caught the public's attention, as evidenced by Youngblood's observation:

The bit requirements necessary for computer generation of real-time realistic images in motion are as yet far beyond the present state of the art.[3]

Youngblood didn't know it, but he had taken a precious snapshot of the moment when digital color arrived. He didn't define pixels, but his examples focus us on a definition. And hints in his book guided me to the first colored ones.

If *Expanded Cinema* was right, the space race promised to be the color-pixel incuba-
tor. The military organization ARPA funded pre-color computer graphics, as we learned
in chapter 6. Its sister institution NASA, founded about the same time, pushed com-
puter graphics into color.

In a chapter titled "Cybernetic Cinema and Computer Films," Youngblood discussed
NASA's involvement with the Jet Propulsion Laboratory (JPL) at Caltech in Pasadena,
California, on the Mariner spacecraft program. From 1962 to 1973, NASA teamed up
with JPL for seven successful unmanned missions to Mars, Venus, and Mercury. JPL
built an imaging system for the project. Youngblood had this to say about it:

> This fantastic system transforms the real-time TV signal into digital picture elements that are
> stored on special data-discs. The picture itself is not stored; only its digital translation.[4]

That is, it stored discrete pixels, not continuous analog television signals.

The epigraph for this section comes from Youngblood's discussion of *City-Scape*, a
color film of a simplified urban vista by Peter Kamnitzer. Youngblood also observed in
1970 that the film had been made on a simulator that General Electric built for NASA:

> It has been used for more than ten years to simulate conditions of lunar landings.[5]

Could NASA contractors GE and JPL have been displaying color pixels as early as
1960 or 1962? Keep in mind that the Triumvirate and the Central Dogma of computer
graphics—that three-dimensional Euclidean geometry shall be viewed in two dimen-
sions using Renaissance perspective—debuted, as currently used, at MIT in 1963. It
would be quite a surprise if color preceded that black-and-white landmark. Let's explore
what color meant to NASA.

The Space Race to Colorspace

Youngblood described the JPL system for portraying digital color images at 6 bits per
pixel (64 colors). Ultimately the system worked like this: Pictures were sent to Earth
and stored on a magnetic spinning disk, then reassembled into 512 rows of 480 pixels
each for color television display. But JPL's very first image (figure 7.2) wasn't quite so
sophisticated: it had only 200 by 200 pixels stored in memory, and its display was
hand-drawn on paper!

There's a special word for a digital memory that's used to store pixels. It's called
a *framebuffer* because it can buffer (or store) one frame (or digital picture). It's just
ordinary memory—except that you can see what's in it. A framebuffer is intimately
associated with a display device, which sweeps through the framebuffer memory
every thirtieth of a second and uses the pixels there to control the colors on, say, a
television display. For its first space picture, JPL used a mechanical framebuffer—that

Figure 7.2

magnetic spinning disk—composed from 6-bit pixels, representing 200 rows of 200 pixels each.[6]

Mariner 4 sent its first image data back from Mars on a July 1965 flyby. The spacecraft relayed 21 photographs to Earth, taken through alternating red and green filters. Since the photos were taken from a moving spacecraft, successive images weren't in register. But where they did overlap, a crude color reconstruction was possible—with just the red and green components, but no blue. The engineers were eager to see Mars, and they didn't want to wait for the computer to process and display the data. Instead they bought colored pastel sticks from an art supplies store and hand-painted the display elements onto a numerical printout of the raw pixel values. This wasn't an electronic display "device," so this wasn't the first digital color image by our definition.[7]

Close inspection reveals that these were not colors from Mars. The official report states clearly, "Although the data obtained are roughly equivalent to a two-color photograph, it was not intended that the two pictures should be combined to form a color picture, and many factors combine to prevent the direct interpretation of the digital data as indicative of any specific color." What the excited engineers did was assign colors to the 6-bit pixels, with lighter colors assigned to brighter pixels and darker colors to dimmer ones. That the resulting colors suggest the colors of Mars was an accident of their choice of pastel sticks. Those engineers didn't yet know the actual colors of Mars.[8]

The Mariner engineers used a technique that resembles the colormap way of storing a color indirectly in a pixel. They set up a color key, or legend, that assigned brown to pixel values from 45 to 50 and yellow to values from 20 to 25, and so forth. They used only six different colors, rather than the 64 that the technique permitted (because 6 bits can store that many). Another way to put it is that their color table coded all 64 pixel values into just six colors. For instance, rows 45 through 50 of the table, corresponding to pixel values from 45 to 50, all stored the same color, a brown.[9]

A colormapped image is sometimes called a *pseudocolor*, or false-color, image. The colors are arbitrarily assigned to the pixel values, in no particular order—not unlike what the Mariner engineers did. There's no requirement that colors in a colormap represent reality. Early computer artists used pseudocolor so often—with spectral colors in rainbow order—that it quickly became as trite as tie-dyed T-shirts.

Although this was a momentous achievement in the space program—a color picture from Mars!—two things keep me from calling it the first colored Digital Light. First, mechanical disks are a blemish on the "firstness" of the event, as we saw in early computer and movie histories; we're really looking for the first completely electronic implementation of color pixels—using a fully electronic framebuffer. And second, the hand implementation of the display elements puts it outside Digital Light. But the Mariner system was a spectacular "almost first" in Digital Light.

The First Color Samples Weren't Pixels

If JPL didn't have the first color pixels, what about General Electric, the other suggestion garnered from Youngblood's *Expanded Cinema*?

An August 1964 GE "Final Report" described what I thought might be the earliest use of computed color. A GE flight simulator built for NASA's Manned Spacecraft Center in Houston featured a model consisting only of an infinite ground plane that was covered, or *textured*, with repeating tiles of color. Figure 7.3 is an early color picture from that simulator, often called NASA-1. It represents rather crudely the Moon's surface as seen by a pilot through the spacecraft window—the red area is the landing zone and the different textures represent, say, craters.[10]

You can think of each tile as being a small raster-ordered array of smaller tiles, or subtiles. So a tile is a square consisting of 64 square subtiles in an 8 by 8 array. These are not pixels! They are actually small geometric squares. NASA-1 computed a perspective view of the tiled plane, one display element at a time across each scanline of a color television display. It did this very fast, in real time. That's why it cost millions of dollars in 1964. For each display element on each scanline, NASA-1 computed which tile a pilot would see at that point looking out into the textured plane, and which subtile.

Figure 7.3

That's a geometrical calculation, using perspective geometry. Then it simply looked up the color of that subtile and sent it to the color display.[11]

That sounds very much like sampling a continuous visual scene and then reconstructing the scene at display time from the samples. But these samples were analog. In this simulator, a color was not stored digitally. Each color was set by rotating a potentiometer, something like the volume knob on an old-fashioned radio or the revolving dimmer switch on your ceiling lights. So NASA-1 took color samples but didn't convert them to color pixels. They weren't the earliest color pixels.

Another "almost first" of this NASA-1 coloring technique was the use of a technique called *texture mapping* in computer graphics. Colors that are stored in an array give fine structure to an otherwise featureless expanse. I don't call this the first use of texture mapping, however, because it wasn't fully digital. That first would await the arrival of a young man, named Ed Catmull, who first described it in a remarkable PhD thesis at the University of Utah in 1974. We'll hear more about him and that thesis later in this chapter.

Robert Schumacker ("Shoo mahk er") was an engineer on NASA-1 at GE in upstate New York in the early 1960s. In an email sent from his home in Salt Lake City, he shared a photo of himself at work then, with a flattop haircut and a pipe. And he explained in detail how the simulator image I just described was generated despite the very limited memory of those early computers. Most importantly, he revealed that subtle distinction between sample and pixel.[12]

But then he told me about the most truly bizarre aspect of the project. The roll—as in yaw, pitch, and roll—of a simulated spacecraft had to be displayed to a pilot. Scan-lines in normal television are always horizontal. But in NASA-1 they rotated the entire television display using the electromagnetic deflectors of the cathode ray tube—in real time. Schumacker himself had implemented this unique analog technique. It was a jaw-droppingly difficult engineering feat. But it was still cheaper in pre–Moore's Law 1964 than computing the roll, even with a million-dollar budget.[13]

Digital Light Clarifies the Whitney Dynasty Contributions

Youngblood dropped another hint about first color pixels in his book's historical snap-shot. He described the beautiful collective work of the impressive Whitney family—an artistic dynasty in California—brothers John and James, and John's three sons, John Jr., Michael, and Mark. Did the Whitneys have the first color pixels?[14]

John Whitney Sr.'s stunning early "computer art" isn't part of Digital Light because it was made with analog devices. His early cinematic works are truly beautiful, and inspired me personally, but they aren't digital. There were no pixels at all, and no digital computer. But that changed in 1968 when John Sr. created a film called *Permutations*. It used a digital computer, but its graphics were calligraphic, not pixels. And the color in *Permutations* was added after the fact, using color filters. It wasn't computational. *Permutations* is lovely, but not what we're looking for.[15]

His brother James Whitney also created beautiful work but without pixels. So we turn to the younger generation. Two of them, John Jr. and Michael, did make digital computer art films. Michael was the first Whitney who utilized pixels, with his *Binary Bit Patterns* (1969). But he too added the color optically—still no color pixels. Later, Moore's Law would move John Jr., in particular, toward color pixels, as we'll see.[16]

City-Scape

We've already seen that Gene Youngblood wrote (if not raved) in his book about Peter Kamnitzer's *City-Scape*. Kamnitzer, an architecture professor at the University of California at Los Angeles, wanted a graphics system for city planning, not art. Making pictures for art's sake would surely have been perceived as a frivolous use of the rare

systems of the day, reminding us of a similar perception in the early days of Baby's First Light.

Whatever Kamnitzer's argument was, he successfully gained access to a $2 million simulator ($15 million today) that General Electric built for NASA's Manned Spacecraft Center in Houston. In 1968 he used it to create *City-Scape*, a real-time drive-through of a simplified urban landscape. The simulation was in color, but the color was so primitive that Youngblood didn't bother to use it in *Expanded Cinema*. In fact, figure 7.4 is from Youngblood's book.

Figure 7.4

Youngblood marveled instead, referring to *City-Scape*, that "no representational imagery existed before it was produced by the computer." In other words, the NASA system made pixels from scratch. Youngblood's astonishment at that amazes us today.[17]

But what interested me was that those pixels were color pixels. In 1968. Youngblood called the system NASA-2. But what was it exactly, and when did it first make color? The *City-Scape* discussion was the clue that finally flushed my historical quarry.

The First Color Pixels and the First Color Rendering

> Our child has learned a new trick, has taken another step forward in maturing to full adult-hood as a tool for the advancement of mankind. When talking movies first appeared, people said the world would never be the same. Half-tone [shaded] graphics has arrived and the computer world has been changed forever.
> —W. Jack Bouknight, 1969[18]

NASA-2 was son of NASA-1. It too was built at GE for NASA spacecraft simulation—for the Apollo Moon Project. The same engineers created both systems. Here are some important NASA-2 firsts, all of which occurred at General Electric in upstate New York. It displayed:

The first grayscale rendering of a three-dimensional model—a tetrahedron—on June 28, 1966.[19]

The first color pixels on March 31, 1967. They were 6-bit pixels (64 colors). (But see the next section.)

The first color rendering of a three-dimensional model—the Apollo Lunar Module—that same day.[20]

As I began to understand that NASA-2 had the first color pixels, I discovered that two of its key engineers, Rodney Rougelot ("Roozsh low") and Robert Schumacker, who we met in the discussion of NASA-1, had both retired to Salt Lake City.

In 2018 I proposed a trip to meet the two of them. Rougelot graciously invited me to his home near the University of Utah for the event. He and Schumacker are still best friends after decades of working together. So they both were there, and we chatted for seven delicious hours.

Rod Rougelot was a joking, articulate *large* presence. I didn't notice that he was the shorter of the two, until he pointed it out—with a grin. Then he told me about an especially meaningful encounter:

In 1951 Rougelot arrived at Cornell University in upstate New York four days before classes began. He was early to attend a freshmen orientation held in a Boy Scout camp,

where he shared a tent with another entering freshman, Donald Greenberg—who would become another computer graphics pioneer. Their lives would remain intertwined, as we will see.[21]

Rougelot graduated from Cornell in 1956 with a bachelor's degree in electrical engineering. In July 1960 he started work at GE's facility in Ithaca, also Cornell's hometown.

That same year Bob Schumacker, the taller of the two friends, graduated from MIT with a master's in electrical engineering and joined GE Ithaca too. When I met him in Rougelot's home in Salt Lake City, he had dropped the flattop and pipe of his youth. He's now a master pilot and a folk dancer. He looks directly at you when he speaks, and it's no nonsense stuff. When I asked for technical details, I got them, carefully calibrated for my skill level.

The two of them—with an often-mentioned team of others—created the NASA-1 and NASA-2 simulators for the Apollo Project. They built NASA-1 at GE Ithaca and NASA-2 at GE Syracuse, about 50 miles north of Ithaca. For NASA-2 the team used integrated circuits, which were just becoming available. By early 1967, this simulator had displayed the first color pixels and—using those pixels—the first three-dimensional rendered objects. They were among the first fruits of Moore's Law and, so far as this book is concerned, marked the true start of Epoch 2.[22]

In 1972 Rougelot and Schumacker joined Evans & Sutherland in Salt Lake City and created there an impressive series of flight simulators of increasing sophistication. Ivan Sutherland told me, in a Skype conversation, that these former GE engineers were most important to the subsequent success of E&S. Rougelot eventually became CEO of the company.[23]

Earlier Color Pixels—Solid Red Ones

I was nearing completion of this book when the graphics pioneer Bob Sproull asked me how Rougelot and Schumacker prototyped the NASA-2 project. His meaning was clear. The first color might have happened earlier than March 31, 1967. Sproull's intuition was correct.

Schumacker remembered that to convince NASA that rendering three-dimensional objects was feasible, they presented a demo of "one real-time triangle." I pursued that lead and hit pay dirt. Rougelot and Schumacker then remembered the demo in more detail. It was presented after NASA-1 was delivered "in 1965 (maybe very early 1966)." It displayed a solid red triangle, rendered in real time, that rotated and translated convincingly in three dimensions. They used the programmable part of NASA-1 as the computer that controlled the motions, and they built a special-purpose device from discrete components (not yet integrated circuits) to do the rendering.[24]

Schumacker recalled, "The triangle demonstration convinced us that implementing any useful systems of even just a few polygons would be prohibitively big and expensive. Fortunately the first practical real integrated circuits came out about the time we bid the contract. . . . Motorola was still getting the bugs out of the fabrication process while we were designing!"[25]

This almost forgotten demonstration from the bleeding edge of the Epoch 2 explosion deserves special mention. Conservative dating suggests that the first color pixels were displayed in very early 1966, but the date is soft. The 1967 date captures the first *shaded* color pixel rendering.

How to Render a Color Triangle

Rougelot and Schumacker made colored renderings of the three-dimensional Apollo Lunar Module on GE's NASA-2 (go back to figure 7.1). How did they do it?

I've noted before that a complex three-dimensional geometric model can nearly always be replaced with a model that's just triangles. Emulating chapter 6, I show how to render only one triangle, with the understanding that millions of triangles are similarly rendered using the glory of computer Amplification.

A triangle here is considered to be a flat surface bounded by three line segments. In plane geometry, a triangle is the line segments, but here it's the flat triangular surface between them that matters.

Let's look first at the case, as in the 1967 Lunar Module, where a single triangle is large with respect to pixel spacing. Later we discuss the case where triangles are small relative to pixel spacing, the usual case in the postmillennial world. Figure 7.5 shows both cases (look carefully for the small triangle). The dots represent pixel locations—that is, where samples are to be taken. For our purposes, imagine that these triangles are pure geometry. But they aren't, of course, they are renderings into the display mechanism of this page. Let's just pretend that they are perfect triangles.

The worst way to render these triangles into pixels is as follows: if a pixel location falls inside a triangle then its pixel is the triangle's color (blue), otherwise it's the background color (white). Figure 7.6 shows the result, with little blue disks representing blue pixels. Notice that the little triangle was missed completely, and the big one is ragged with "jaggies."

But this isn't a display of the blue triangle digital picture, and the little disks aren't pixels. (Ironically, the illustration *is* a digital picture.) Little disks are no more pixels than little squares. I could have used little stars. Each *represents* a pixel—that is, a point location and its attached color. The black dots (going back to figure 7.5) are sampling point locations; the disks are colored samples taken at those locations. Notice that all

Figure 7.5

Figure 7.6

the other disks in figure 7.6 are white, so you can't see them here. All of these must be spread by a display device (screen or printer) to turn them into a digital picture that we can see.

Although this is the worst way to render, it's the way it was done in the early days. It's what the GE engineers had to do in 1967 to render the Lunar Module with the first color pixels. Notice the jaggies along the edges of the LM in figure 7.1. That was naive rendering, with little or no explicit use of the Sampling Theorem.

Next we render the same two perfect triangles ideally, making maximum use of the Sampling Theorem. Then we discuss various methods that have been devised over the years to approximate the ideal rendering method. These were especially important in the days of insufficient memory and low computational power. To feel the depth of that insufficiency, compare the 1X to 10X Moore's Law factor in this section with today's (2020) factor, about 100,000,000,000X. It was 11 orders-of-magnitude worse in those days! Unimaginable—unless you were there.

Figure 7.7

The Sampling Theorem is very clear. Take samples at (slightly greater than) twice the highest frequency. But a geometric triangle has sharp edges. Recall our rule of thumb in frequencyspeak that sharp edges have high frequencies—and very sharp edges have very high frequencies. In fact, we can't sample perfect triangles often enough. Their edges contain frequencies that are too high—infinitely high. The pixels and display elements would have to be too closely spaced to be physically or economically feasible.

In computer graphics we typically work in the other direction. The pixel spacing is a given—as it is in our example—and we must fit the Sampling Theorem to it. This means that we must rid a perfect triangle of its high frequencies—its sharp edges. We must ensure that the edges are rounded off enough so that the rise of the edge from the background doesn't happen faster than the pixel spacing. Figure 7.7 shows the two perfect triangles after they've been blurred enough to be properly sampled by the pixels. The small triangle has been blurred almost out of existence. The triangles look exceptionally blurry. But imagine that the actual spacing is say 1/100th that spacing, more like the spacing of display elements on your cellphone. In that case, the blurring wouldn't be noticeable. I've exaggerated it here.

Figure 7.8 shows the pixels that result from sampling the blurred triangles. Again, we can't see the pixels, and they have no shape, so a little disk only *represents* a pixel— its location and the color attached. The little triangle isn't missed this time.

Recall what the Sampling Theorem tells us: when the pixels thus represented are spread and displayed by the display elements of a display device, we see the two blurred triangles. Not the perfect geometric blue triangles in our model. There is no way that such sharp-edged perfection can be represented accurately with pixels. That's just another way of stating the Sampling Theorem. The trick is that, at sufficiently high resolution, we humans are comfortable with slightly blurred triangles—because they don't look blurry to our eyes at normal viewing distances.

Figure 7.8

But there's a problem with the ideal rendering I just outlined. What does it *mean* to remove the too-high frequencies from a piece of hard-edged geometry? What replaces the triangle in the model? A triangle should be replaced with a computer description of a triangle with rounded edges. Or if two triangles abut, then the junction must be rounded off and described somehow in the model. These aren't geometrical concepts. Nobody actually replaces a geometrical model in computer graphics with a rounded version—with too-high frequencies removed. So what do they do? They develop more and more sophisticated approximations to the ideal scenario. In fact, the history of computer graphics can be thought of as the push for better approximations that trick the eye. I discuss one of these tricks next.

Subsampling

What if we just sampled at more closely spaced pixel locations? Say, twice as often? Imagine that the pixels are twice as dense. Figure 7.9 shows the old pixel locations at the left, the suggested new denser ones in the middle, and superposition of the two at the right. The denser sampling would, in fact, double the frequency (both horizontally and vertically) at which unpleasant aliasing artifacts, such as jaggies, would start to appear. But the problem is that we can't afford a framebuffer with four times as many pixels. What can we do?

The idea is to sample the model at four locations surrounding each actual pixel location (large dots), as shown on the right. The four samples obtained for each actual pixel location in this way are called its *subsamples*, or *subpixels*. The four subsample colors are averaged together to form the color of the one actual pixel—the one that is stored and sent to a display element. You can see the 2 by 2 array of subsample locations surrounding each actual pixel location on the right of the figure.

Figure 7.9

Figure 7.10

I've used a 2 by 2 array of subsamples here for ease of illustration, but higher densities also work. Pixar uses a 4 by 4 array of subsample locations. Figure 7.10 shows closeups of the two cases. The large dot is the actual pixel location, and the surrounding small dots are its subsample locations. In the 4 by 4 case, the 16 subsample colors are averaged together to form the one color stored in the actual pixel—the color eventually sent to a display element for spreading and display.

The subsampling trick effectively increases the resolution of the final image, but it doesn't completely avoid the artifacts due to sampling very high frequencies—edges of triangles, say—at too low a frequency to satisfy the Sampling Theorem. Subsampling with a 2 by 2 array doubles the highest frequency that can be adequately handled with discrete samples, and the 4 by 4 case quadruples the highest frequency. But there remain even higher frequencies in sharp edges that both cases miss. A surprisingly

effective trick alleviates this remaining problem. We'll return to it when Moore's Law delivers three more orders of magnitude of computational power.

Reality—the Central Dogma Extended

> Reality is just a convenient measure of complexity.
> —Alvy Ray Smith[26]

"Is your goal to simulate reality?" was a persistent question at talks I gave in the early days of computer graphics. "No!" I would reply, annoyed by the question because we wanted to create art, not simulate reality. I finally crafted the rejoinder in the epigraph above, which seemed to satisfy both the questioners and me—at the time. The point I was trying to make was that if the world of an animation was rich enough—say, approaching reality—then audiences would be comfortable with it and pay attention instead to the characters. Reality wasn't what we were about. It was the characters and their fictitious worlds—or it was all those pictures "out there" not bound at all to characters or the world as we know it.

Simulating reality, though, has always been dear to the hearts of computer graphicists. The NASA engineers who led the way wanted to show the reality of the Moon and the Lunar Module to the Apollo astronauts. And the computer-aided design branch of Digital Light aims to display objects for the real world as they would actually appear.

But reality seems to be a blatant contradiction to the fantastical content of the first digital movies—and before them the early visual effects in movies. It's resolved by extending the Central Dogma beyond just Euclidean geometry and Renaissance perspective. We henceforth include Newtonian physics in the Central Dogma—especially the physics of optics, motion, and gravity. Computers certainly aren't bound by the Central Dogma, extended or not, nor is Digital Light.

Think of the Central Dogma as a "symphonic" form for computer graphics. Though bound by the form, creativity is unbounded. The fanciful worlds crafted within the Central Dogmatic form honor real-world physics, geometry, and perspective. *Toy Story*'s Woody and Buzz Lightyear walk in Earth's gravity, with lights and colors that work the way they do in the real world. Or at least they appear to.

Oddly, nobody has ever articulated the Central Dogma before. That's probably because it's just so *obvious*. It certainly is for CAD people, and we've seen that picture-oriented computer graphics and CAD share common origins. Furthermore, modern visual effects work requires adherence to the Central Dogma to seamlessly integrate computer graphics with live-action footage. This reminds us that Larry Roberts, the

Triumvirate originator of Central Dogma perspective, came to his solution in an effort to seamlessly integrate three-dimensional computer graphics lines with photographs of real-world prisms.

Animators squash and stretch the form, but the world they work in is the "normal" of the tacitly assumed Central Dogma. Computer graphicists everywhere devoted themselves—and still do—to simulating reality, one technique at a time.

Simulating Reality

> But they were all just hacks. Actually simulating the physics of soap, bubbles, air, water, etc., was ludicrously expensive and would never be achieved in his lifetime. . . . Far from being a source of frustration, this comforted him, and made him happy—perhaps even a little smug—that he lived in a universe whose complexity defied algorithmic simulation.
> —Neal Stephenson, *Fall; or, Dodge in Hell*, 2019[27]

Reality is unreachable by serial digital computers creating pictures for displays with finite resolutions. *Simulating* reality is all we can aspire to. Reality is analog—at least at the resolutions that interest us, orders of magnitude coarser than the fine granularity of the real world at the level of quarks and quanta. Reality operates in parallel. Rays from the sun and other light sources impinge on our real world everywhere at the same time. And despite the glibness of my epigraph—*Reality is just a convenient measure of complexity*—the resolution of the real world is extremely high.

This book isn't a computer graphics textbook, so I won't describe every technique computer graphicists have devised for simulating reality. Rather I'll sketch several of the early breakthroughs and how to think beyond them. This is a good place to mention that these techniques apply broadly to several other aspects of Digital Light—such as videogames, CAD, flight simulators, and virtual and augmented reality. They aren't confined to just the one branch, digital movies, that forms the armature for my presentation of all Digital Light.

My goal in this chapter and the next, in support of that larger vision, concerns the first digital movie—The Movie—representing the Great Digital Convergence. I emphasize the techniques that were used to make that first movie. But that wasn't the only possible path. When we first conceived The Movie at NYIT, we would have been happy to make it in two dimensions with an interpolating inbetweening program—outside the Central Dogma. After all, the world was satisfied with the likes of *Cinderella* and *Snow White* from Disney for years. Story and character carried the day—a message that was not lost on us.

But like everything driven by Moore's Law, the final three-dimensional Central Dogma form of The Movie emerged piecemeal as the computer graphics community mastered the additional capabilities enabled by each hardware advance. This probably explains why it took Disney so long to wholeheartedly adopt the new form. Disney waited until the form was demanded by the box office, not just desired by the filmmakers.

Shading

I've already discussed rendering, so now let's turn to *shading*, the other technology suggested by the chapter title. Shading has the general meaning of choosing the final color of each rendered pixel. The shading of the triangles in the examples above is trivial: every pixel is blue (or white). Shading is a word that takes on grander meaning as the chapter unfolds and Moore's Law provides more horsepower. (Too bad that "Moorespower" doesn't trip lightly off the tongue.) In the early days of color pixels, shading a surface had a traditional Central Dogma meaning—the straightforward increase or decrease of color brightness across a surface, while holding its hue constant. In this context, to lighten means to increase brightness, and to darken means to decrease it.

The Apollo Lunar Module rendering in figure 7.1 illustrates such a simple shading. A single light source is placed in a convenient location, such as above right and behind the viewer of that figure. As a triangle more fully faces the light source, it lightens. And it darkens as it increasingly turns away. This is called *flat* shading and is as simple as early Moore's Law could accommodate: each triangle is rendered in exactly one color.

For flat shading, think of a flagpole raised at the center of each triangle, as shown in figure 7.11 (left). The top of the flagpole points up, the direction perpendicular to the triangle. The angle between "up" and the light source is crucial to the calculation. If the triangle faces the light source—that is, the angle is zero degrees—then its color shade is as bright as possible. As the angle increases, the shade darkens (middle). When the triangle faces at a right angle to the light source, the surface shade is as dark as possible. Beyond that the triangle faces away from the light source and is unilluminated (right). Since this shading calculation uses trigonometry (Greek for triangle measurement), I won't present the details. Suffice it to say that the trigonometric computations of flat shading are as precise and well-defined as those of geometry. Computers can be told how to do them once, and then Amplification repeats them millions or billions of times with no further human effort.

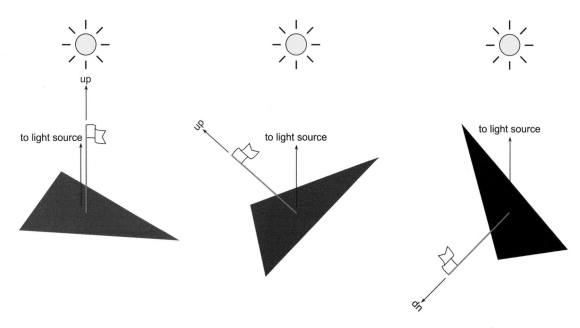

Figure 7.11

The Flows toward Digital Movies

In this chapter I begin to weave together several threads, or flows, from previous chapters to deliver the next stage of Digital Light—the part devoted to computer-animated movies. The flow chart in figure 7.12 is meant to capture these threads and tie them into new strands.

The caveats for this chart are familiar: There is no simple narrative, and there is no single one person. To keep the flood of names manageable, many persons are omitted—especially painful in this chapter and the next—but they are often described in the annotations. This is only a sketch, not a complete scholarly history, of even the restricted subset of computer graphics devoted to digital movies. Finally, the prose of this chapter and the next is an extended caption to this figure.

I add the new strand originating with NASA and General Electric that led to the first color pixels. It also led to Evans & Sutherland, the company in Salt Lake City, a different pathway to E&S than the ARPA-oriented approach of the preceding chapter. Then three of the strands—University of Utah, E&S, and Xerox PARC—braid together and flow into the New York Institute of Technology, from which Lucasfilm then Pixar derive. Another tributary flows in from the new (to this chapter) GE strand to Cornell University, and from there into Lucasfilm, then Pixar.

To help with still too many names, I introduce a new device in this flow chart: A rectangle that encloses a group of people unites them into a "bloc" by some single feature. For example, the largest rectangle encloses eight persons who were contributed, so to speak, by the University of Utah to NYIT. If an arrow touches the enclosing rectangle then it applies to all persons inside it. If it touches only one person enclosed, then it applies to that person only. For example, all eight in the Utah bloc were at NYIT, but only Jim Blinn was a student of Bertram Herzog, the pioneer mentioned in chapter 6. All five people in the lower-left bloc were extremely important early members of Lucasfilm computer graphics (and not NYIT), but only Rob Cook was Don Greenberg's student at Cornell. And so forth.

The first two threads, or flows, rejoining from the preceding chapter are those descending from Bob Taylor and Herb Freeman. Then I pick up the Ivan Sutherland and Dave Evans thread from the preceding chapter and the new Rod Rougelot and Bob Schumacker thread from this chapter, and also the new Don Greenberg thread. I braid all these together to lead to NYIT, and then in the following chapter, to Lucasfilm, and then Pixar.

Similar strands combine for DreamWorks Animation and Blue Sky Studios. There were many more companies in the history of digital movies, but these three are representative. They were the first three to produce feature-length movies completely on computers at the millennium: Pixar's *Toy Story* (1995), DreamWorks's *Antz* (1998), and Blue Sky's *Ice Age* (2002). For space reasons, and my personal expertise, I concentrate mostly on the Pixar threads.

Now, in the next subchapter, let's take another giant Moore's Law order-of-magnitude step toward those accomplishments.

Moore's Law 10X (1970–1975)

The First Shaded Computer Animations

Rod Rougelot and Bob Schumacker developed NASA-1 at the General Electric facility in Ithaca, also hometown to Cornell University. They developed NASA-2—with the first color pixels and first real-time color three-dimensional renderings—at GE in Syracuse, about 50 miles north. Their last accomplishment at GE Syracuse was a non-real-time (abbreviated "non-RT") system in 1968, designed to further develop three-dimensional computer graphics, unrestricted by the real-time limitation.[28]

During those years, Don Greenberg had proceeded along a separate path to a PhD in architecture at Cornell in 1968, the same year that Rougelot and Schumacker brought

Figure 7.12

Germany

Robert Taylor

Herbert Freeman

Bertram Herzog

from previous flow chart

Xerox PARC
1970

NYU EECS
1969

Triple-I
1962

Richard Shoup

Digital Movies
Epoch 2: 1965–2000

Alvy Ray Smith

Gary Demos

contributors:

technical

David DiFrancesco

Richard Chuang

John Whitney Jr.

Ampex AVA
1978

artistic

financial

C = from Canada

Glenn Entis

MAGI
1972

Ivan Sutherland

Carl Rosendahl

Pacific Data Images
1980

Digital Productions
1982

Carl Ludwig

Jeffrey Katzenberg

Dream-Works
1994

Eric Darnell

Blue Sky
1985

Chris Wedge

Antz
1998

Ice Age
2002

© 2019 ©

the non-RT system online in Syracuse. For context, Sutherland's head-mounted display was under development at Harvard at about the same time.

In one of those crucial "who you know" moments, Rougelot gave Greenberg—his old Cornell buddy from the freshman Boy Scout tent days—access to the new GE system, the non-RT system. There was a catch, however. Greenberg could use it only at night, from 5 p.m. to 8 a.m. nominally, three nights per week. And it was in Syracuse, about an hour away from Ithaca.

For months, on every available day, Greenberg would drive a crew of his students from Ithaca to Syracuse for the overnight shift. From this slog came the "Cornell movie" of 1972, a 15-minute computer-animated trip through the Cornell campus showing how a proposed new building would fit in. Color images from the movie were published in Greenberg's article about computer graphics in the *Scientific American* of May 1974, and on its cover.[29]

Don Greenberg, the man with the readiest, warmest grin in computer graphics, was characteristically as concerned about his students as himself. He coached his young team to computer graphics success. Perhaps it's no surprise that he's an athlete—and still a tennis champ in his 80s. Starting with that first movie, he built Cornell's renowned computer graphics department, which became as influential as the University of Utah's.

Rougelot and Schumacker already had real-time three-dimensional rendered graphics in 1967. But their system depended on NASA's bottomless resources and used special-purpose hardware. I draw a distinction between real-time animation and film animations where the computation of each frame takes as long as necessary. The Cornell movie fell within the boundaries of what single individuals at universities could accomplish on general-purpose computers. Was it the first three-dimensional rendered computer animation?

Known contenders for the honor are a one-second animation of a face becoming a bat in 1971 reported by Ed Catmull, then a graduate student at the University of Utah. Or an animated face by Ed's classmate Fred Parke also in 1971. Or the animated hand Ed reportedly computed in January 1972 and demonstrated in August 1972 (figure 7.13, left). Or an animated human face by Ed's classmate, Fred Parke, in 1972 (figure 7.13, middle). Or the Cornell movie that Marc Levoy, Don Greenberg's student, says was completed in mid-autumn 1972 (figure 7.13, right). Of these, only the Cornell movie was in color. Ed's face-to-bat shaded graphics animation, completed in late 1971 or perhaps early January 1972, and Fred's animated face made apparently at the same time, for the same class, are the winners of this particular contest. Let's call it a tie. But

Figure 7.13

once again there was a remarkable technological convergence in a single year, 1972, like 1895 for movies.[30]

More Than One Triangle

Most interesting models contain a multitude of triangles—often millions of them. Consider the wireframe teapots in chapter 6, with hundreds of triangles. Or the buildings on the Cornell campus in the Cornell movie. These triangles often overlap one another as seen from a chosen viewpoint. And if they are full of solid color then they tend to hide one another. Perhaps the most studied computer graphics problem in the early days was called the *visible-surface problem*, or the *hidden-surface problem*, which amounts to the same thing: Of all the triangles in a scene, which ones are visible to the virtual camera of the Central Dogma?

The very notion of geometry is that we know exactly where every point of a triangle is located—anywhere on its surface—in the sense that we can calculate it. We know exactly where the viewpoint of the virtual camera is located and which way it's looking.

In particular, the distance from the viewpoint to any point on a triangle can be calculated. Let's call that distance the point's *depth*. Thus a point farther away from the viewer's eye—from the virtual camera—is deeper into the scene. We can calculate the depths of points on a triangle at pixel locations. That's what the math of geometry is all about. I'm not asking that you understand how to do such calculations. I ask only that you understand that when a computer has been instructed to do such a calculation once, it can do it again and again *ad infinitum* with no further need of humans.

Consider just two triangles, a blue one and a red one, as shown in figure 7.14. An easy way to render one in front of the other, even if they intersect, follows:

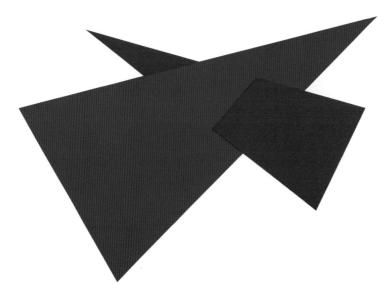

Figure 7.14

1. Render the blue triangle first, as we did earlier, but with one difference: each time the triangle is sampled at a pixel location, calculate the depth of the triangle at that point and save that also in memory. This requires as many memory locations as there are pixel locations. It can be thought of as a second framebuffer that, instead of storing colors of pixels, stores their depths. Not surprisingly, such a piece of memory is sometimes called a *depthbuffer*.

2. Now render the red triangle. But before storing one of its pixels in the framebuffer, first compare its depth at that location to the depth already stored there in the depthbuffer. If no depth was previously stored, meaning that no blue pixel has been rendered there, then simply store the red pixel in the framebuffer and its depth in the depthbuffer. If its depth is less than the depth already stored in the depthbuffer, then store a red in the framebuffer, replacing a blue already there. In that case, replace the (blue) depth in the depthbuffer with the (red) depth. If there are more triangles to render, just repeat step 2 for each one.

Depthbuffering, by the way, was a major contribution of Ed Catmull's famous 1974 PhD thesis. Ed was actually second with depthbuffering, barely scooped by Wolfgang Strasser in *his* 1974 PhD thesis. But Strasser's thesis was in German, so they didn't know about each other.[31]

Depthbuffering is easy to describe, but it has a problem: you have to render all the triangles, even those that are completely hidden. Some approaches to visible-surface

Figure 7.15

solutions suggest ordering the triangles in depth order and then rendering only those that are visible or partially visible. This can often save much rendering time.

But intersecting triangles can't be put in depth order. Part of one triangle is deeper than the other triangle, while its other part is shallower. But you can always subdivide intersecting triangles into smaller triangles that don't intersect, as shown in figure 7.15.

Whether you use depthbuffering for visible-surface solution or a depth-ordered sort of (non-intersecting) triangles, it's the magic of Amplification that repeats the computation for millions of triangles. Vast numbers of computations shouldn't be confused with difficulty, especially when each one of them is as easy to understand as depthbuffering.

Shadows

The Central Dogma dictates that digital objects cast shadows just as real-world objects do. A computer graphics model initially contained only object descriptions and the location of the virtual camera. But the notion of a model quickly expanded to include light sources, such as lamps. In the early days, a light source was very simple. It had a location at a single point and emitted white light in all directions. It was a point light source. As Moore's Law power grew, the light sources got fancier and more carefully simulated real-world light sources. They had extent—that is, they occupied an area, not just a point—and had color, and other properties of real lamps, lights, and the sun.

Figure 7.16

Determining shadows is essentially the same problem as the hidden-surface problem. This is particularly obvious if you consider only a single simple point light source. Imagine that the virtual camera views the scene from the location of the light source. Any surface that cannot be seen from this viewpoint must be in shadow.

Calculating shadows therefore is a well-defined, if tedious, computation. Suffice it to say we know the geometry of all the objects, and the geometrical location of the light source. So it's straightforward to calculate which surfaces are in shadow. Then we can use that fact later to determine what color should finally be rendered to the display when we see it from the desired viewpoint, which will be different from the light source itself. Improvements in Moore's Law would later allow multiple light sources, with extent and color. And, as usual, Amplification means that a programmer had to devise only one algorithm. Our computers would faithfully re-execute it millions and billions of times.[32]

Texture Mapping

The triangles we've seen rendered so far had a simple solid color—the simplest of shading models—perhaps darkened if they were in shadow or aimed away from the light source. Early computer graphicists quickly learned how to render in fancier ways as Moore's Law gave them more power. For example, the color could be shaded as distance (depth) from the virtual camera increased, or as nearness to a known light source decreased (figure 7.16, left). And triangles could be partially transparent (second from left). A triangle could be textured with pixels from another picture, of say grass or denim (third). This is essentially the texture mapping technique I explained briefly in the earlier discussion of the NASA-1 simulator. Or combinations of the techniques could be used (figure 7.16, right). These are just a few examples from an infinite variety.

Texture mapping is based on a fundamentally powerful idea. And it's a prime example of pixel-based Digital Light married to geometry-based Digital Light. The powerful idea is that one digital image can control what another looks like. Texture mapping was the first of several techniques that were based on this idea.

Figure 7.17

We've already seen that Rod Rougelot and Bob Schumacker had the analog version of the idea in the NASA-1 simulator for the Apollo Project. As a scanline through a geometric triangle was being rendered into color on a television display, the color was obtained from a geometric computation that accessed a raster array of colored geometric subtiles. Once the appropriate subtile had been computed, then its (analog) color was sent to the display.

The digital equivalent, introduced by Ed Catmull in that 1974 PhD thesis, replaces the raster array of geometric subtiles with a raster array of pixels—that is, it replaces geometry with digitized samples.

In figure 7.17, a triangle is represented at top left. There is no color for the triangle stored in the computer's internal model. Instead its colors are stored indirectly in the texture map represented at the right—from a digital photograph of a yellow rose.

The triangle isn't actually visible. It's stored mathematically in a computer model as a geometrically perfect Euclidean triangle. You can't see it. The triangle you do see is a rendering of the abstract triangle into the display of this page.

Similarly, a texture map is an array of pixels, and you can't see them. The rose is a display of the texture map, not the texture map itself. This is a reminder of one of the principal points of this book: The display of pixels is separate from the pixels themselves. To see pixels, they must be spread by the display elements of the chosen display medium—the printed page in this case. The explanation that follows asks that you not conflate spiky pixels with their smooth display.

So the rose is a sampled picture that's used to control the colors of another. You can think of texture mapping as applying a decal to a triangle. Or think of the triangle as a cookie cutter and the texture map as the dough. Apply the decal, or cut out a cookie, at any angle you wish—such as the $10°$ used here. But decals and cookie dough are smooth continuous things. To make sense of these metaphors you must remember that a texture map can always be reconstructed into a smooth continuous picture by spreading and adding the pixels as taught by the Sampling Theorem.

The idea is to render the triangle, scanline by scanline, into pixels for a display device. In the figure, the middle triangle shows the process midstream. The upper scanlines have already been rendered. The dots indicate (crudely) the pixel locations along the current scanline to be rendered next. The pixel colors there are to be taken from the rose texture map. The dots on the rose show the locations to be sampled for colors. A straightforward geometric calculation computes the point in the texture that corresponds to a pixel location to be displayed. The line of dots so calculated on the rose is tilted $10°$ to take rotation of the decal or cookie cutter into account.

But there's a problem. A texture map is pixels. It's a spiky bed of nails so far as the computer is concerned. The point that you sample in the texture map, based on the geometry, almost certainly doesn't correspond to one of the texture map's pixels. In general, the straightforward geometric calculation results in a point that lies *between* the pixel locations of the texture map. In the early days, practitioners used the color of the pixel in the texture map nearest to the calculated point to render a pixel to the display. That's a poor approximation, but there wasn't enough power then for fancier computations. The next idea was to find the four nearest pixels to the calculated point and average their colors for the final display color.

But there is a right way to do texture mapping that is a direct consequence of the Sampling Theorem: Spread and add the pixels in the texture map to get a continuous smooth surface—the decal or cookie dough—exactly the magic of something from nothing introduced in the Kotelnikov chapter. Then the calculated point must fall somewhere on this reconstructed smooth surface. The color at that exact point on the reconstructed surface is the color to send to the display device. Many years' worth of tricks have been devised to avoid doing this full computation, but it was

always there for the taking. All that was missing was a sufficiently high Moore's Law factor.

Texture mapping's larger idea bears repeating: one image can be used to control another. Texture mapping uses the control image to determine the color of the other image. Texture mapping is a popular form of shading in the general sense that shading supplies the color of a rendered pixel. But there's another meaning too, where the shading of a color depends on simulation of physical, Newtonian optics.

Shading Gets More Realistic

Computer graphicists quickly discovered, with increased Moore's Law power, how to subvert the geometrical truth to get more pleasing shading. The Frenchman Henri Gouraud, at the University of Utah in 1971, had the clever idea of putting a different "up" at each corner of a triangle. Instead of one flagpole at the center of the triangle, he placed flagpoles at each corner—and then tilted them in different directions. He computed the color at each corner, shaded according to the "up" at that corner as explained earlier. Then the shade at each point on the triangle was interpolated between these corner shades. The kind of interpolation Gouraud used is so-called linear interpolation: if the shade at one corner is A and at another corner is B, then a point halfway between the two corners has the shade halfway between A and B. Figure 7.18 (right) shows that careful choice of the ups at the corners yields a shaded image that's superior to simple flat shading.[33]

Figure 7.18

Flat **Gouraud** **Phong**

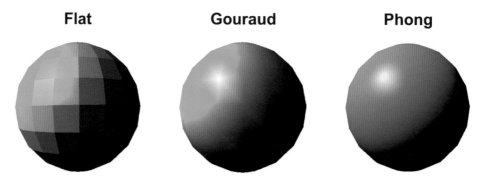

Figure 7.19

But something wasn't quite right about *Gouraud shading*. There was no proper highlight as we often see on actual objects in the real world, at least not a convincing one. A Vietnamese student, Bui Tuong Phong, stepped forward at Utah in 1973 to take care of that problem. He noted that Gouraud shading assumes an unnatural light source, one whose intensity varies linearly, or proportionally, as up veers away from it. No light source actually works that way. None are linear. Phong added a realistic nonlinearity to his light source model (figure 7.19, right). That means as up approaches the light source, the color shade of its triangle brightens dramatically fast. You get a more realistic highlight in that vicinity.[34]

Phong also used a more sophisticated way to calculate the shading, which required more horsepower but gave better results. Like Gouraud, he placed flagpoles at each corner and then tilted them in different directions. A smooth surface of ups was interpolated between them, thus defining "up" at any point on the triangle. The kind of interpolation Phong used was also linear interpolation: if the up at one corner is tilted at angle A and the up at another corner is tilted at angle B, then a point halfway between the two corners has an up angle halfway between A and B. In general, it's almost always not the one-flagpole-at-the-center direction.

Recall from the discussion of splines and patches in chapter 6 that interpolation is just sampling "upside down." So *Phong shading* is essentially another marriage of the math of sampling with the math of geometry. Think of it as a surface that defines its optical shape without actually changing the geometrical shape of the model. It's a surface of ups, so to speak, floating above the underlying geometric model—a neat trick that gets rid of flat facets without really getting rid of them, as the result shown in figure 7.19 (right, ignoring the silhouette). It's another false-front technique for a new kind of Hollywood.

And the trick generalizes. Phong used simple proportional, or linear, interpolation between the ups at the corners. By using more ups distributed over a surface, you could interpolate bicubically to create a smooth undulating surface of ups from, say, Bézier patches. I'll show how to take that idea to an extreme at the next order of magnitude.

Phong added the notion of a lighting model to computer graphics modeling. To put it another way, shading took on the added meaning of lighting as well. The shading notion began to generalize to more sophisticated simulations of physical optics.

Meanwhile another branch of Digital Light was advancing in California, near Stanford University, in an area soon to be known as Silicon Valley. It was also about color pixels, but it was outside the Central Dogma.

Dick Shoup

Richard "Dick" Shoup was born in Pittsburgh in 1943 and grew up red-haired and freckled-faced a few miles north in Gibsonia. He was a farm kid with 50 acres of elbow room, who would become an accomplished jazz trombonist and electronics whiz. In the late 1950s, Dick's uncle gave him some pamphlets on radio and electronics written by Hugo Gernsback, creator of *Amazing Stories*, the science fiction magazine, and they inspired his future career.[35]

Dick got his PhD in 1970 from Carnegie Mellon University under Gordon Bell, who would become chief architect at Digital Equipment Corporation. Bell helped design the PDP-1 there, the computer that *Spacewar* made famous. Dick's dissertation was about programmable computer logic, a scheme that employs many copies of a logic "cell" that can be programmed for function and connectivity to neighboring cells. We became fast friends because my 1969 PhD dissertation had been about cellular automata. My topic was roughly the mathematical equivalent of his hardware research.

The day after he finished that dissertation, Dick went west to California to join the Berkeley Computer Corporation intent on building a massive timesharing machine. But the timing was wrong. The bottom fell out of the timesharing market just then, leaving him and his high-powered colleagues worried about a paycheck by November 1970. Fortunately, Bob Taylor had just joined Xerox Palo Alto Research Center (PARC) across San Francisco Bay from Berkeley. He quickly scooped up several of the key folks at the failing company, including Dick Shoup.

Dick's main contribution to PARC was his Color Video System. He designed and built its hardware and wrote its first software, including *SuperPaint*. The system had 8 bits per pixel (256 colors) and a completely digital framebuffer. Dick wasn't the first with color pixels—the NASA-2 picture from six years earlier proves that—but his system made serious and full use of them. His pixels were available to anyone,

like me, who could program or paint. They were general-purpose color pixels, so to speak.

A Broken Leg Leads to PARC

Albert Einstein wrote letters to save the child Herb Freeman from the Nazis in 1938, as we learned in chapter 6. Three decades later, by then a computer graphics pioneer, Freeman hired me fresh out of Stanford graduate school as a new assistant professor at New York University, where he was department chair. I was a computer scientist who painted as a hobby, with oils and acrylics, so I must have seemed like a natural fit for computer graphics. He soon urged me to make the leap from tower to stinks—to forsake my PhD work, the theorem-proving part of computer science, for the picture-making part. But my response was, "When you get color, Herb, then I'll do it." In fact, I had to be jerked off my feet and stopped cold to make the change.

The wake-up call came while I was schussing an icy New Hampshire ski slope in late 1972. My stocking cap slipped and blinded me. Another skier, completely out of control, was barreling toward me on a collision course. I ripped through him at full speed. I might have impaled or debrained him, but the stumblebum skied away unharmed. I didn't. A nasty spiral fracture of my right femur put me down for three months in a full body cast, nipples to toes—a helpless, immobile invalid completely dependent on others.

But I wasn't miserable in that plaster crib. Far from it. It was a vast mental playground. It seems that when you relieve your brain from the chore of moving your body around, it becomes free for everything else. To while away those hours, I thought and thought and thought. And finally realized with harsh clarity that my life was as off course as that stumblebum.

Something was wrong. Academically I was well under way, but I wasn't doing anything about my art. Inexorably, I reached a decision. When I emerged from the cast, I would resign my professorship and return to California where "something good would happen." As I look back now, it was a breathtakingly content-free plan. But I executed it anyway—and the something good did happen. There I reconnected with my cellular logic friend, Dick Shoup. At his urging, I joined him in 1974 at Xerox PARC—in its heyday—and found color pixels and a paint program. Art *and* computers.[36]

SuperPaint and Framebuffers

Dick was clear that he wasn't the first with color pixels, but he didn't know who was. In fact, we've seen that Rougelot and Schumacker and their team had the first color pixels six years earlier than Dick, in 1967. Their 6-bit pixels (64 colors) were implemented in

the NASA-2 spacecraft simulator. I list in the annotation several systems with 2 and 3 bits per pixel in 1968 and 1969, including the first paint program, with 3-bit pixels (8 colors), by Joan Miller at Bell Labs. All these developments, except Miller's, used mechanical disks for memory, and her system used analog color control, so it wasn't fully digital.[37]

Dick was also reluctant to make the claim that he was first with 8-bit pixels (256 colors). Who knew, he'd ask, what those secret government agencies had been up to in the 1960s and 1970s? I've heard anecdotes, but found no documentary evidence, of 8-bit pixels (256 colors) predating Dick's at PARC in 1973.[38]

Nevertheless, there were several ways in which SuperPaint excelled: It had a color-map that mapped each of the 256 pixel values to one of 16 million colors—that is, 8 bits in, 24 bits out. It was video complete to the American NTSC standard, with a video camera in, NTSC-compatible video out, and an NTSC encoder for it to display on a standard television studio monitor. Most importantly, every pixel was under computer program control with a general-purpose computer. And it might have been the first completely digital 8-bit framebuffer system—the jury's still out on that.[39]

Figure 7.20 shows SuperPaint's menu display at PARC in 1974. The HSB color selector sliders at the top—for hue, saturation, and brightness—represent my first algorithmic contribution to Digital Light. They replaced the RGB sliders—for red, green, and blue—that Shoup originally programmed there. I had tried to mix pink with the RGB sliders and couldn't do it. I asked Dick to add an artist-friendly mechanism. Pink is easy to mix, I explained, if you can choose a hue from the color circle—red in this case—then add white to lighten it. Or choose an orange hue and add black to darken it to a brown. "Nobody's ever done that," he said. So I did, implementing this low-hanging fruit concept overnight. With the new sliders, adding white reduced saturation. Adding black decreased value, or brightness. The hue chosen in this figure is a fully saturated and fully bright magenta.[40]

SuperPaint wasn't computer graphics, although it took me years to understand enough to make that statement. The Central Dogma was not in effect. In the preceding chapter I defined computer graphics to be the rendering of geometric models into pixels. But Dick Shoup's pixels weren't in the service of geometry. SuperPaint had (almost) no geometry in it.

Dick certainly knew how to render geometry into pixels. The straight lines and wagon wheels he rendered without jaggies in 1973—at PARC, but not in SuperPaint—are witness to that, as we discussed in the Dawn chapter. And there were a couple of geometry-based tools available on the menu of SuperPaint. For instance, a click on the fourth icon from the left in the top row of icons (figure 7.20) invoked a line-drawing

Figure 7.20

tool. SuperPaint would then render a jagged line segment between any two points the user selected. And it could render a rectangle. That was about it geometrically.

Moving a cursor on a display with a handheld device—a stylus on a tablet in this case—was a new concept then. Dick had to explain the interaction technique of clicking and dragging "down there" on the tablet, while following a cursor "up here" on the display to each new user. Menus, icons, cursors, and sliders—in color—began their climb to the commonplace starting with SuperPaint in 1973.

So, what was SuperPaint? It was a picture creation tool, but not computer graphics. It was pixel-based, but not an image processing system. It was interactive but not a videogame. It was definitely Digital Light, however, because it was mediated via pixels.

Some of the terms I've used previously become especially valuable for describing SuperPaint, or paint programs in general. The crucial distinction is between Creative Space and Display Space. Creativity in computer graphics occurs in a Creative Space that's invisible. It resides in a geometric model held in computer memory. It becomes

visible when it's rendered into Display Space via pixels. Creativity in a paint program occurs directly in Display Space. Paint programs are image creation systems that do not distinguish Creative Space from Display Space. The pixels (usually) aren't renderings of geometry, nor do they simulate reality. They are created from scratch by the user-artist. They don't honor the Sampling Theorem because they don't sample a continuum. They just are. Which is a long-winded way of saying they don't honor the Central Dogma. The typical computer graphics program is like photography. You arrange three-dimensional objects in the perfect way, and then take a picture of them from a particular viewpoint. Paint programs are like, well, painting. They let you make whatever image you want from scratch.

But paint programs are definitely part of synthetic computer graphics and not analytic image processing. There is no Creative Space in image processing. The modern world has conflated painting and image processing, so the original distinctions are blurred. Adobe Photoshop was designed originally to process photographic images, but the modern version includes painting in a variety of styles and the incorporation of geometrically defined elements.

There *is* a model of sorts behind a paint program. But it's just a metaphor, not geometry and not physics. It's the act of painting with a brush on a canvas. A paint program like SuperPaint simulates this metaphor with a computer program. The brush is simply a cluster of pixels. In figure 7.20 the currently selected brush (indicated by a red arrow) is a medium-sized disk. The "handle" of the brush is the physical stylus used with SuperPaint on its tablet. It could have been a mouse, already in use elsewhere at PARC, but Shoup found the mouse clumsy—"like painting with a bar of soap."

In SuperPaint, as a user slides (without pressure) a stylus across a tablet, a cursor on the display tracks the movement. So the cursor always shows the current location. The moment the user applies pressure on the stylus, closing a tiny switch in its tip, a copy of the current brush is written into the framebuffer at that location, and it's instantly displayed in the current color. So long as you keep pressure on the stylus, copies are written into the framebuffer—and hence displayed—as fast as the stylus location can be read from the tablet. This is an obvious way to interact with a computer today, but it wasn't then.

What exactly gets copied, or painted, into the framebuffer? It's a set of pixels with the shape of the current brush, in the current color, and centered on the current location. A paint stroke is defined by the path the user takes with the stylus, a sequence of separated points that are indicated by the user's movements. If the points are close enough then the copies of the brush that are consecutively painted into the framebuffer overlap and appear to form a continuous stroke. But the stroke isn't actually continuous. In those

bad old days, it was easy to stroke the tablet so fast that the computer couldn't keep up, leaving a "stroke" of separated brush copies.

Eventually, as Moore's Law made computers faster, paint programs were written that *could* render a continuous brush stroke along a geometrically defined path. But that took many years to develop. Rendering a continuous stroke was awkwardly slow at first. We have already encountered the notion in these pages. The spline demo for Ravi Shankar in chapter 6 was a geometrically defined paint stroke. It was the slow rendering—the pause between my gesture on the tablet and the rendering of the stroke into the framebuffer—that evoked the surprise and amazement in that demo.

Adobe Photoshop is the dominant outgrowth of this line of picture-creation tools, although it was originally designed as an image processing program for interactively massaging pixels that were taken with a camera, not made with a brush. The painting metaphor is a powerful one. A computer program like SuperPaint or later Photoshop reinterprets it to mean interactively creating or modifying a picture with local operations that are defined by a brush that the user controls.

Animation at PARC

After my first encounters with SuperPaint and the Color Video System, I wrote a letter to PARC with this observation (confusing, as many do, the system with its principal program): "One of my first intuitions on seeing the machine was that it would be a fine instrument for making animated films." In preparation for officially joining them, I taught myself the basics of character animation from a famous how-to book by Preston Blair, the great animator who made Hyacinth Hippo dance in Disney's *Fantasia* (1940). Figure 7.21 shows the cover and the pages for bounces and walks.[41]

When I arrived at PARC in 1974, Ron Baecker, the dashiki-clad creator of the early Genesys animation program, was visiting there for an extended stay. And so was Harvard animator Eric Martin. They were as attracted to Dick Shoup's SuperPaint system as I was. And, naturally, Eric soon painted and recorded a lovely bouncing ball animation, *The Ever-Popular Bouncing Ball* (1974), which is available online.[42]

Among my first animations there was a walk cycle right out of Blair's book. Then I proceeded to walk a pirate's head, a pickle, a hammer, and a tomato—and a digital scan of David DiFrancesco's head. Although we didn't know it, we were taking some of the first steps on the road that would lead eventually to Pixar and the first digital movie.

David DiFrancesco

When I met the artist David DiFrancesco, he'd already been on a worldwide quest for ways to meld computers and art. A National Endowment for the Arts grant allowed

Figure 7.21

him to work with Lee Harrison III of Computer Image Corporation in the early 1970s. David had gone to Tokyo for access to one of Harrison's creations, called Scanimate, an analog animation machine, and had just returned in 1974 when he saw Dick Shoup give a SuperPaint demo in San Francisco. From the audience David asked Dick what SuperPaint had in common with Harrison's Scanimate. It was a well-placed question because Dick and Lee Harrison were good friends, and Dick knew Scanimate well. He encouraged David to call PARC.[43]

But when his many calls started to come, Dick asked me to handle them. David's nonstop entreaties, enlivened with his unusual humor, worked their magic on me. I finally relented and suggested that we share an evening "jamming" on SuperPaint. That meant time-sequential jamming—there was only one stylus—where one artist would paint for a while, then the other would add to the painting, then the first artist would modify the work of the second, and so forth.

David loved machines as much as he loved art. He loved any kind of machine—cameras, cars, planes, and especially motorcycles. He was a motorcycle maniac—with refined taste. His collection featured a 1938 vintage Brough Superior and a 1951 Vincent Black Shadow. Because he liked all machines, he put up with the inherent torture of working with the early digital ones. He could drive right through the pain for the results. It was all part of the adventure!

This indifference to hardship was characteristic of early computer artists. Another David, David Miller, would jam with us at PARC and proceed—as David Em—to join

future colleague Jim Blinn at Pasadena's Jet Propulsion Lab. Em would suffer for years in the fluorescent lights, roaring and freezing air conditioners, and institutional green walls at JPL to create his sunset-beautiful digital paintings and strangely tiled three-dimensional landscapes. You had to love the machines in their childhood and envision their growth. You had to crave the process of discovery and believe that the technology would become less harsh "in a couple of years." We hadn't yet learned to invoke Moore's Law, but that's what we were doing.

David DiFrancesco, familiar with "art biz" as he called it, soon suggested that we ask the NEA for a grant to exploit the new artistic medium that was offered by SuperPaint—color raster graphics. He needed the money since he was only at PARC unofficially, and I wanted to make art and call it that. I'd gotten several National Science Foundation grants as an NYU professor. NSF grant proposals were 40 pages thick and submitted in 20-plicate, so I listened in relieved surprise as David told me how the NEA worked. You only had to submit a single page! He knew because he was currently living on his second NEA grant. The artists' work that accompanied the single page was the principal consideration. We made a video using Dick Shoup's system and submitted it with a one-page grant proposal, cementing our relationship and casting our lots together.[44]

PARC Dismisses Color

And it was not a moment too soon. I was fired soon afterward, on January 16, 1975. When I asked why I was being let go, Jerry Elkind, Bob Taylor's boss, told me that Xerox had decided not to do color.[45]

"But," I argued in disbelief, "color is the future, and you own it completely."

"That may be true, but it's a corporate decision to go black and white."

I shouldn't have been surprised. Bob Taylor had fired a warning shot earlier. He had approached me one day and asked, "Don't you think Shoup's system is difficult to use? Isn't Newman's approach better?" He meant William Newman, who was working in a corner of the same room as SuperPaint. William was the very fellow we met in the computation chapter who was the son of Alan Turing's mentor Max Newman and had played a form of Monopoly with Turing himself. William was designing black-and-white graphics with 1-bit pixels on PARC's Alto computer. "No!" I had screamed inside, while disagreeing quietly on the outside. Taylor obviously didn't get it.

So Xerox blew off color graphics, just as they missed the personal computer about a year later.[46]

Whatever the reasons for our departure from PARC, David DiFrancesco and I needed to find "the next framebuffer" to satisfy the NEA grant we hoped to land. With inexorable Moore's Law improvements, a framebuffer would shrink from the size of a

large microwave oven at PARC to a single graphics card a few years later, and then to a vanishingly small part of a graphics chip now. But at the time a framebuffer was a rare and expensive beast.

We heard that Evans & Sutherland in Salt Lake City was building the next one, so that was our first destination. By sheer coincidence, as we pulled into the parking lot at E&S, a yellow and black Lotus zipped in beside us. Out hopped Jim Kajiya, with hair down to his waist, even longer than mine. Kajiya, a brilliant engineer and theoretician—and later a professor at Caltech—was building the next framebuffer at E&S. He would be an important colleague for decades.[47]

Our hopes that we would get access to this nascent framebuffer were quickly dashed. Although we never mentioned the word "art," it was clear that art was our purpose. This didn't mesh politically with Utah's defense-related funding sources— the US military tyrant for computer graphics. We were about to depart disappointed when someone mentioned that a "crazy rich man" named Dr. Alexander Schure from Long Island had passed through recently and "bought one of everything in sight." "Did he buy a framebuffer?" I asked hurriedly. Yes! And he wanted to make animated movies! Martin Newell, of teapot fame, was departing the next day to consult at the rich man's school, the New York Institute of Technology. He promised to call me with a report.

Newell's advice soon came, "If I were you, I'd jump on the next plane." David and I did just that.

"Who should we ask for?" I had quizzed another Utah acquaintance.

"Ed Catmull. But be careful, he's a devout Mormon."

"That's not a problem."

Moore's Law 100X (1975–1980)

Money Comes to Raster Graphics: Uncle Alex

> Our vision will speed up time, eventually deleting it.
> —Alexander Schure, president and cofounder, NYIT[48]

Alexander Schure, the rich man (figure 7.22) on Long Island, was our "Uncle Alex" because of a pure but astonishing coincidence. My California housemates near PARC were Richard and Sandra Gilbert. Richard told me that his uncle in New York was doing what I was doing at PARC, but I dismissed him. How could I not know about such a person in the small world of computer graphics? Surely Richard, an economist,

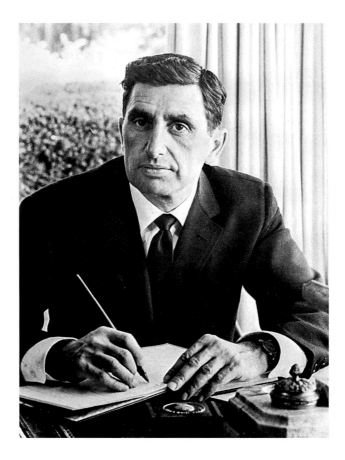

Figure 7.22

must be mistaken. But when I returned from my first trip to the New York Institute of Technology, tremendously excited about the man I'd met there, Richard exclaimed, "Alvy! He's the uncle I've been trying to tell you about."[49]

Uncle Alex saw himself as the next Walt Disney. You can almost see how the delusion formed. A family friend, Alexander Nikolaievich Prokofiev de Seversky (figure 7.23), "Sasha" to Uncle Alex, and a trustee of the New York Institute of Technology, had featured in a Disney film.

De Seversky was an ace naval pilot for Russia in World War I. He was an aristocrat unwelcome in Russia after the 1917 Revolution, so he escaped from Russia by taking the Trans-Siberian Railway to Vladivostok and then a Japanese steamship that arrived in San Francisco on April 21, 1918.[50]

Figure 7.23

De Severksy settled in New York, where he started an aircraft company, Seversky Aircraft, later renamed Republic Aviation. Shortly after Pearl Harbor he published an influential book, *Victory Through Air Power*, which argued for the creation of an independent US air force. In 1943 the Disney company turned the book into an animated propaganda movie of the same name, a project that Walt supported enthusiastically. De Seversky himself appears in the film for about 10 minutes. The Disney family stayed with him on Long Island for several days when *Victory* opened in New York.[51]

In 1964 de Seversky helped NYIT purchase the most impressive building on campus (figure 7.24), built originally for the Alfred I. du Pont family. It would eventually play roles in a couple of movies, *Three Days of the Condor* (1975) and *Arthur* (1981). Schure renamed the building the de Seversky mansion for his friend and benefactor. It would become the future home of the NYIT video studio in the 1970s, with a direct link to the computer graphics lab "next door" through the woods. The de Seversky mansion would also be the dramatic setting for the first meeting David DiFrancesco and I had with Uncle Alex, ushered into his presence by Ed Catmull and Malcolm Blanchard.[52]

Before Schure ever heard of computer graphics, he had established a 100-person animation studio on the campus to work on a feature-length animated film, *Tubby the Tuba*. It used the same old-fashioned cel animation technology I described in the chapter about movies and animation, the technology Disney used to produce *Victory Through Air Power*.

But then a traveling salesman sold Alex Schure on computer graphics. Pete Ferentinos was the East Coast sales representative of Evans & Sutherland. Ferentinos

Figure 7.24

made a cold call on NYIT and soon had Schure enthused about the cost savings that computer graphics equipment could make for *Tubby the Tuba*. As part of his sales pitch, Ferentinos arranged for Schure to visit E&S in Salt Lake City and meet Dave Evans and Ivan Sutherland.[53]

This strong offensive pushed Schure over the edge. He bought several E&S products for NYIT. Then Evans asked him who would run the devices, adding, "You just missed the right man." He meant recent graduate Ed Catmull. This was 1974, about the same time that I was being ushered out of PARC.

Ed Catmull

When Ed graduated from the University of Utah with his PhD in 1974, one of his advisers, Ivan Sutherland, was in the process of creating a company that would use computers in Hollywood. Ed hoped that this company would be his ticket into moviemaking, animation in particular. I asked Sutherland about the company in a May 2017 Skype conversation.

"We were 10 years too early," Sutherland said of his 1974 foray, which he and cofounder Glen Fleck planned to call The Picture/Design Group. Sutherland and Fleck

did several design jobs at the time but could never get enough of them to support a company. It never got off the ground.[54]

Ed could wait no longer. He had a wife and a young child to support. So he took a job at a computer-aided design company, Applicon, in Boston. That's where he was when the 1974 call came from Alex Schure at the New York Institute of Technology. Although Ed had been at Applicon for only a month or so, he leapt at the opportunity Schure offered—something about running E&S equipment at NYIT and making an animated movie. Ed's future lay in picture-oriented computer graphics, not CAD.

Pixels Meet Geometry at NYIT

Malcolm Blanchard, another graduate of the Utah computer science department and Ed's officemate at Applicon, came with him to NYIT in late 1974.[55]

The second two members of "the Lab" joined just a few months later, in early 1975, before all the new machines had been delivered. They were David DiFrancesco and me, from Xerox PARC, the laboratory Bob Taylor had founded. So two ARPA threads, Sutherland's and Taylor's, entwined at NYIT.

The geometry-based computer graphics at Utah married the pixel-based graphics at PARC in 1975 to seed the group to be known eventually as Pixar. It was a potent mixing of art and technology. Another way to put it is that inside the Central Dogma (Utah) and outside the Central Dogma (PARC) joined forces. The four original Lab members at NYIT—Ed, Malcolm, David, and I—would stay together through the later manifestations of the group as Lucasfilm in 1980 and Pixar in 1986.

Raster Graphics Gets Its First Public Art Funding

Ed and Malcolm were married men, and Ed soon had a second child. They essentially kept a 9-to-5 schedule on weekdays and didn't work weekends. But David and I were still single and worked around the clock, on weekends too, making art—particularly after the framebuffer arrived. We slept only when we had to.

David was living off his NEA grant, but it was running out. We hadn't heard yet about the fate of the grant we'd proposed together. David checked and discovered to his anger and my dismay that the NEA had lost our art submission, the crucial part. To make amends they agreed to a site visit. But that's exactly what we wanted! It was hard to explain what we were doing, but easy to show.

The NEA sent out the artist Stan Vanderbeek and an official named Nancy Rains. Vanderbeek was famous, featured in both *Cybernetic Serendipity* (mentioned in chapter 6) and *Expanded Cinema* (in this one). In fact, Vanderbeek had coined the term "expanded cinema."[56]

David and I picked up the team at the Manhasset, Long Island, train station at 4
p.m., the last possible hour of the last possible day for site visits. They were doing their
NEA duty, but just barely. "We need to catch the 5 o'clock train," Rains ordered. That
meant we would have only thirty minutes for the visit. "OK, but we don't think you'll
want to."

And they didn't. From our days at PARC, David and I were accustomed to mouths
agape at first sight of color pixels and raster graphics. The NEA pair were no different.
We talked and looked at pictures—and made pictures—for hours. Finally, about 4 a.m.,
they suggested that it was time they returned to the renowned Algonquin Hotel in
Manhattan. We drove them in, all four of us high with happiness and camaraderie. At
the hotel, Vanderbeek thrust his hand through the car window for a final shake and
said, "Well, you boys got your grant!"

Christine Barton Connects the Framebuffers

There was an unusual real-time computer graphics machine on the North Shore of
Long Island about 10 miles west of NYIT. It simulated a massive oil tanker negotiating
New York City's harbor. It's hard to believe now, but there was a plan afoot to allow
giant tankers in that important harbor—before the *Exxon Valdez* oil-spill disaster in
Alaska, that is. Since a large tanker needs a mile turning radius to make a right or
left turn, and since the New York harbor is a tight space by that measure, a skipper
had to practice on a simulator first. The idea was crazy and never happened, but
the simulator was real. And it was used later to recreate and study the *Exxon Valdez*
mishap when that nightmare did finally happen in 1989—in vast Prince William
Sound.[57]

Evans & Sutherland in Salt Lake City created the harbor simulator, with the ungainly
name Computer Aided Operations Research Facility, or CAORF (pronounced "Kay orf").
It was installed in July 1975 at the US Merchant Marine Academy in Kings Point, Long
Island. You entered a brick building—with a prow!—through portholed doors to "the
bridge." The toilet was a "head." Inside you found yourself on a ship's bridge, complete
with pilot wheel, sweeping radar, speed control lever, and foghorn control. All of these
were real, not computer simulations.

The view out the (glassless) windows was the surprise. It was completely computer
generated and filled your visual space. The real devices on the bridge were the human
interface to the unreal computer simulation. The pilot saw a 240-degree display of a
simplified New York Harbor with the Statue of Liberty, the Verrazano-Narrows Bridge,
the Empire State Building, and the rest of the New York City skyline. The "tanker"
moved through this computer-generated harbor as you piloted with the wheel.[58]

CAORF was engineered by Rod Rougelot and Bob Schumacker—of NASA-2 and the first color pixels. They had left GE and joined E&S in October 1972. Rougelot became the project engineer for CAORF, with Schumacker on his team, naturally. "We bet the company on it," Rougelot told me. And it worked. The airline industry understood from the tanker simulator that piloting airplanes could be simulated too. Airline flight simulators made E&S successful.[59]

Software for the tanker simulator was managed by John Warnock. He was later at PARC and even later cofounded Adobe. But meanwhile his E&S shop was in California. A young woman, Christine Barton, worked there on CAORF's software and came to Long Island for its installation in the prowed building.

Schumacker had attended Ed Catmull's thesis defense at the University of Utah in 1974. So at the CAORF installation, he invited Ed over for a visit from nearby NYIT. That may have been how Christine met Ed. Her version is that she learned NYIT was nearby and had recently bought E&S equipment, so she called Ed and visited him there. In any event, after Ed described what he was doing, Christine asked him for a job, and he hired her. She was the first woman computer scientist with the NYIT group and its fifth member, in 1975. She was one of the few women anywhere in male-heavy early computer graphics.[60]

Christine had network expertise. She had worked with the early ARPAnet precursor to the internet. She would connect our many computers together at NYIT into a local area network before LAN was a common term. Her network server also allocated framebuffers to competing users, a problem nobody else in the world had at the time. Most places were lucky to have one framebuffer capable of holding one 8-bit video image (256 colors) at 512 by 512 pixel resolution. NYIT, at its height, had *18* of these framebuffers. They could be configured in various ways using Christine's system. For example, three of them could be ganged together for a 24-bit full-color video image (16 million colors).[61]

And Christine made art. She created animations on the nascent system at NYIT, as we all did. She lived in Holloway House, yet another mansion associated with NYIT, this one a mile or so distant from the campus.

"Christie," as we called her then, endeared herself to David DiFrancesco and me by taking us to visit the new CAORF simulator. She had an acquaintance, an on-site employee, who let us into the facility at night. That's when the fun began. We joyrode the tanker, taking the simulator to its limits. We turned the sky red. We flew the tanker at 200 miles per hour, 40 feet below the water level and 40 feet above. We flew it through the Statue of Liberty at full speed to see what would happen, and through the Empire State Building. Nothing happened, of course—it was

Figure 7.25
By Ephraim Cohen, 1977.

just a simulation. The E&S programmers hadn't put any information inside those structures, because no one was supposed to be there. The polygons that were used to simulate them simply went away when they were struck—sharp edges receding offscreen—revealing black nothingness, like shattering a stained-glass window into the dark.

The Lab Starts to Grow
Figure 7.25 is a drawing that shows the Lab personnel in 1977: (from the left) Ephraim, Garland Stern and Lance Williams, Tom Duff and Christine Barton, with Duane Palyka and Ed Catmull distant between them, and me and David DiFrancesco with our vehicles.

Two people who would influence our graphics and moviemaking future arrived at NYIT in 1975. Lance Williams and Garland Stern, from the University of Utah, spent that first summer with us. Lance and Garland were a technological duo, approximately the same height, both with long blonde hair—Garland's in a ponytail. They talked the same talk and hatched plans together. They both came again the next summer and then joined us permanently.[62]

Multifaceted Lance Williams was particularly important to me personally. He and I argued all the time, but it was the kind of intellectual tussling that benefitted us both—me anyway. He introduced me to William Burroughs's *Naked Lunch*, a particularly fascinating book for those of us just exiting the Sixties, and to Bruce Springsteen.

More importantly, Lance taught me how to antialias raster images. He'd learned it from Tom Stockham, the audio expert I mentioned in chapter 6 who taught a generation of Utah students about sampling. And Lance also introduced me to the Monkey King, a popular Asian literary character who would figure in our cinema future.[63]

Garland Stern, once he joined NYIT permanently, wrote the two-dimensional animation program that would inform Pixar's future relationship with Disney.

Scan-and-Paint Animation Bests Keyframe Inbetweening

Moore's Law hadn't yet delivered enough horsepower for three-dimensional animation, so learning how the computer could best help two-dimensional animators was the issue of the day. The answer wasn't obvious at first.

Ed Catmull wrote what we all thought would be the computer approach to cel animation . . . but there was a problem. His animation program, called *Tween*, was an excellent two-dimensional inbetweening program. It used interpolation much like the keyframe animation program described in chapter 6 that Nestor Burtnyk and Marceli Wein had created in Canada in 1970. The animator Peter Foldes created the landmark film *Hunger (Le Faim)* (1974) on the Burtnyk-Wein inbetweening system. And NYIT animators eventually produced a 22-minute television short called *Measure for Measure* (1980) partly on Tween. But they had difficulties with it.

Ed addressed every issue they raised, but the intrinsic flaw he couldn't address was the unintuitive fact that two-dimensional computer animation is more difficult than three-dimensional. Consider a man walking to the left in profile, swinging his arms. We know, with our human intelligence, that the far (or right) arm appears in back of, disappears behind, and then reappears in front of the man as he walks. Then it changes directions while in front of the man, disappears behind, and then reappears in back of the man. But the computer doesn't know this. How does it interpolate from one position to the other? What does "behind" mean? What makes the six positions just described the motion of a single thing? In three dimensions, the arm is one object moving smoothly through space. The standard hidden-surface solutions of computer graphics take care of the arm's disappearing behind the body as it swings.

The classically trained NYIT animation staff found Tween formidable. It wasn't natural to people who were used to pencil and paper. Figure 7.26, a character "model sheet" for a Roman soldier in *Measure for Measure*, suggests why they were dismayed. Each numbered curve in a keyframe based on this model sheet corresponds to a similar curve in the next keyframe, which has the soldier in a slightly altered position—head turned a little and right arm raised, say. Each curve was interpolated by Tween to its corresponding curve via instructions that the animators had to provide. If the keyframe

Figure 7.26

Figure 7.27

was frame number 10, say, and the next keyframe was frame number 14, then Tween would create three inbetween frames composed of those interpolated curves.

Figure 7.27 shows the difficulties of moving only the soldier's right arm. Look for curve number 39 on the leftmost edge. Figure 7.27 (left) shows curve 39 moving from its position in keyframe 10 into its position in keyframe 14 along a straight-line path (dotted line) in equal time steps. It's just a dumb interpolation. The computer has no idea that this is an arm and needs to move in a unit like an arm. Notice that the curves shorten toward the middle of the motion then lengthen again. So this arm would change size and apparent volume as it moved. And the inbetweens move the same distances between frames. Animators hardly ever want a movement that rigid and ungraceful.

To achieve a pleasing movement, the NYIT animators had to tell Tween what path to follow and how to space the inbetweens in time. In figure 7.27 (right), the arm edge moves along a curved arc (dotted) and preserves length. And it moves different distances in the (necessarily) equal time steps. It moves slowly then fast then slowly again. In the worst case, the animators would similarly have to tell every line how to move—for over a hundred lines in this Roman alone.

Not only was Tween interpolation a completely new way of working for the classic animators, but we computer graphics people found it inherently difficult too. It was an important lesson for us. Since the definition of The Movie required that it be completely digital—nothing hand-drawn allowed—it would almost certainly require three-dimensional character models. The third dimension, with its notions of connectedness, objects, and depth, would make all the difference.

Meanwhile Garland Stern created a two-dimensional animation program that the NYIT animators *did* intuitively understand—one that allowed hand drawing. They used it (in addition to Tween) to produce *Measure for Measure*. It allowed them to work in

pencil and paper, just as they always had. They—not the computer—did the keyframe interpolation, just like they always had. They created all the inbetween frames by hand. But everything else was done on the computer—inking, opaquing, frame composition, and filming. The original drawings were analog, but everything else was digital.[64]

Garland's program, called *SoftCel*, was a "scan-and-paint" system. The animators drew each frame with pencil and paper on standard cel animation paper just as they always had. Separate characters in each frame were drawn on separate pieces of paper and inbetweened, by hand, separately. With a scanner, Garland digitized each drawing the animators produced. That is, he made a digital version of each drawing by sampling it and storing the grayscale pixels so obtained in digital files in the computer. The pixels were taken, not made. The curves didn't have jaggies because they weren't renderings from hard-edged, high-frequency geometry. The smoothness of the actual pencil drawings was preserved by the scanner.[65]

Each frame was brought into a framebuffer so that it could be seen on a computer display. Typically it was noisy, with spurious dots created by dust, say, on the paper or on the scanner's glass during scanning. A SoftCel user would rid the scanned image of noise and perform other image processing chores on it—such as brightening and contrast enhancement. An important chore was to close all open curves. An animator might have thought he'd drawn a closed oval when, in fact, he'd left a small gap in it. It was crucial to the next step—filling an area with solid color—that such gaps be closed. You can think of all the processes in this paragraph as the digital version of inking on a transparent cel with India ink in traditional cel animation.

The pixel creation stage then took over—the paint part of scan-and-paint. During my first months at NYIT, I wrote a program called *TintFill* to accomplish the digital equivalent of the opaquing step in traditional cel animation. As I described in the movies and animation chapter, classic opaquers painted the areas inside lines drawn on a cel in India ink. Like with a child's coloring book, the point was to keep the solid color painted inside the lines, not crossing them.[66]

Similarly, TintFill filled closed areas—such as the Roman's right arm and fingers—with a single solid color. A user would select a color then click on an area to be filled with it. TintFill did the rest. If TintFill found a gap in an enclosing curve, then the color leaked out and flooded the entire drawing, hence the need for closing all gaps in area-defining curves.

All areas of a character were sequentially filled this way. The result was saved to a digital file on the computer. At this point, several files existed for each frame of the final piece. If there were three animated characters in a scene, then there were three separate digital files, one for each character, for every frame in that scene.

Meanwhile, an artist painted background scenes into a framebuffer using a digital paint program and saved each into digital files. Since I knew how to write paint programs from my time with Dick Shoup's SuperPaint at Xerox PARC, my other major program in the early days at NYIT was *Paint*, an 8-bit paint program with 256 colors. There were several other 8-bit paint programs in existence, including one that Garland Stern had written at Utah and brought with him. I wrote my own since I wanted a different user interface, and then I worked with a professional cel-animation background artist, Paul Xander, to make this an efficient tool for his use.[67]

The final step was to combine, or "composite," all the digital files for one frame into a final frame and send it to a film printer or a videotape recorder. First a background scene for the frame would be restored to a framebuffer from a digital file. Then each of the character layers would be restored in proper order above the background. The transparent parts of the character layers would let the images behind show through, the background in particular. The alpha channel made such compositing possible.

Alpha Channel

Everything we touched at NYIT was a first. We tried to make a list of firsts once, but it soon became ridiculously long. But the one that had the longest life and the most ramifications happened almost casually. Ed Catmull and I invented the *alpha channel*.

Early in the Lab's history and late one evening, our patron Uncle Alex Schure visited and quizzed me: "We have the best computer graphics in the world, right?" I assured him that we did. "How do we stay out in front?" We had only one framebuffer at the time, 512 by 512 pixels, 8 bits per pixel (256 colors). It had cost Schure $80,000. I told him that if he bought us two more 8-bit framebuffers then we could gang them together and have one 24-bit framebuffer (over 16 million colors). I explained the difference between just 256 colors and 16 megacolors, and that nobody in the world had that capability.

I wasn't convinced that Schure understood me, but a few weeks later he announced that he'd bought *five* more of those 8-bit thingees, so we would have *two* of those 24-bit thingees! The five new 8-bit framebuffers cost $60,000 each. So the first RGB, or full-color, 24-bit framebuffer cost him $200,000—$80K for the initial 8-bit purchase plus $120K for two new 8-bit ones—but the second one only cost $180,000. Not only did we have the first full-color framebuffers in the world, but we had two of them. And he had spent the equivalent in today's money of over $1,700,000 on us, just on my say so. This largesse impresses me even more in retrospect than it did then. At the time we were, simply, thrilled.

He would soon buy us 12 more 8-bit framebuffers at about $40,000 each—Moore's Law at work. That totals to an additional $480,000, or about $1,900,000 today. We easily had more full-color pixels than anybody else on the planet in about 1978. We were the envy of the computer graphics community. For calibration, your cellphone today has more pixel memory capacity than all 18 of the Lab's framebuffers combined. And, as a reminder of the incessant driving force behind all this, Moore's Law has cranked through eight orders of magnitude since then.[68]

We went crazy with full 24-bit RGB. I generalized Paint with 8-bit pixels to *Paint3* with 24-bit pixels in 1977. I called it Paint3 because it used three framebuffers. It was the first "full-color," or 24-bit, paint program in the world. It featured 16 megacolors—so many that an artist could paint with soft-edged brushes that didn't create jaggies. The colors melded together as they would with real paints. "It's like painting with an ice-cream cone," someone said memorably.[69]

I soon generalized all pixel-oriented programs to the 24-bit version. And with so much memory lying around, it was easy for Ed and me to leap one day to the addition of a fourth channel for every digital picture. We called it the alpha channel. We created it to solve one particular problem, not realizing how important alpha would become. The modern digital imaging world depends on it.

The problem Ed was trying to solve was the perennial one, the hidden-surface problem that I've previously discussed—what surfaces of a scene are visible to a virtual camera from its point of view? Hidden surfaces don't have to be rendered, saving much computation time. There were already several algorithms available that made stabs at this problem.

Ed was developing a new one that assumed the virtual camera saw a two-dimensional world divided into an array of little squares, as through a window screen. (More about that later.) Note that the little squares were geometrically defined areas of the model— *not* pixels.

Ed's algorithm calculated the intersection of each geometric object in his model with each of the little square areas. If several objects intersected a square, then it further determined how much area of each object was visible to the virtual camera. In other words, he solved the hidden-surface problem in each little square area and represented the result with one pixel. Each pixel represented a square geometric area around its location. The problem was to determine the one color that would best represent all the complexity inside a single square area.

The final foreground pixel color for that square area was an average of the colors of the contributing objects, each weighted by the area of the square it occupied. Its opacity was the area of the square obscured by the objects. If they completely obscured the square,

then the foreground pixel there was completely opaque. If they completely missed the square, then the pixel was completely transparent. Otherwise it was partially opaque.

Ed wanted to render three-dimensional foreground objects against *any* two-dimensional background. To test the algorithm, he started with a preset background picture so that he would know the ultimate color behind every little square, in case it wasn't obscured by the foreground objects. But he didn't want to always have a "hard-wired" background.

He said to me, "I wish there was some easy way to check my algorithm against different backgrounds." We chatted for a few minutes and quickly saw the solution. At some point in his computation of each final pixel, his algorithm calculated, as described above, the resulting foreground color, and its partial opacity. Combining this with the background color was a separable problem. So we separated it out.

I had written the programs used at NYIT to save and restore digital images to and from computer files, typically stored on a digital disk. These were the first full-color, 24-bit save and restore programs, because we were the first to have 24-bit pixels. I knew immediately how to solve Ed's problem. I would simply add a fourth channel to each pixel in these programs. It would hold the pixel's opacity.

If a pixel was opaque, its 8-bit alpha channel had value 255 (all 1s). If it was transparent, its alpha value was 0 (all 0s). There were 254 possible partial opacities available in between. So each image pixel now had 32 bits, 8 each for red, green, blue, and alpha. We called them RGBA pixels. Christine Barton's framebuffer allocation system let us configure a 32-bit framebuffer from four 8-bit ones on the network.

Ed would change his algorithm so that it computed only the foreground color and its opacity at each pixel and saved the results to a computer file, one that honored the new fourth channel. In other words, he would just ignore the background color until a later step. I would rewrite the restore program so that it would recognize the new alpha channel and use it to correctly combine Ed's computed foreground color with an arbitrary background that was already displayed in a framebuffer.

Why did we call it *alpha*? Because that's the term we used in the formula for combining a foreground image with a background image. For short I'll call them f and b. Alpha was the Greek letter α, but we pronounced the formula this way: "alpha f plus one minus alpha b." The idea was that alpha was like a control knob that varied smoothly from 0 to 1 as you turned it. By "alpha f" we meant alpha times f. So turning the control knob caused this contribution to the result to vary smoothly from no foreground image to full foreground image. And "one minus alpha b" meant the quantity "one minus alpha" times b. Turning the knob caused this contribution to vary from full background image to no background image.

Figure 7.28

Figure 7.29

The idea is that only one control knob is turned, and the two contributions are added together. So the knob at one extreme (alpha is 0) results in no foreground image plus full background image—only background. At the other knob extreme (alpha is 1), the result is full foreground image plus no background image—only foreground. Alpha's value directly reflects the opacity of the foreground image.

The knob at its halfway position (alpha is .5) results in an image that is half foreground and half background. At its one-quarter position (alpha is .25), the resulting image is one-fourth foreground image added to three-fourths background image. If you smoothly turn the knob from one extreme to the other, you get a full movie cross-dissolve from background image to foreground image. One image smoothly replaces the other. Figure 7.28 shows a cross-dissolve from a white cross on a blue square to a red circle on a white square, as alpha varies from 0 to 1 by steps of .25.

I've been talking as if there was a single value of alpha (opacity) for an entire image. In fact, that's what figure 7.28 shows. But by introducing an alpha channel into each pixel, we allow a different opacity at each pixel. The same formula works on a pixel-by-pixel basis. Some foreground pixels can be transparent, some opaque, and others partially opaque, meaning that a background pixel can show through partially at those locations. An RGBA pixel thus holds its color in the RGB channels and states how seriously that color matters with the A, or alpha, channel. Thus 32-bit pixels became our norm.

Alpha used in the pixel-by-pixel way is shown in figure 7.29. The foreground object is just the round red disk, with no background. All pixels outside it are transparent

(or partially transparent along the disk edge). The rightmost image is the red disk composited over the leftmost square image. That's done with the alpha channel of the red disk on a pixel-by-pixel basis. The sequence of images is otherwise just like the one above: a global alpha is used to cross-dissolve one image over the other—in this case a shaped image over a rectangular one.

Alpha was a trivial development—or so we thought at the time. We got there first because we were the first to have a wealth of pixel memory. It was so easy an idea that I'd implemented it completely by the next morning, complete with pages for our programming manual that described the new kind of pixels as RGBA for red, green, blue, and alpha, thus establishing the name for the new channel that's still in use today. And Ed had done his part quickly too, changing his hidden-surface program to store a fourth value with each foreground pixel, its opacity, in the new RGBA format.

To run his tests, Ed had only to perform these steps: (1) Use my "old" 24-bit restore program to fetch *any* RGB background image *b* into a framebuffer. It was assumed to be opaque everywhere. (2) Use my new 32-bit restore program to fetch an RGBA foreground image *f* into the same framebuffer, an image that his program had saved in the new format. The restore program executed the "alpha *f* plus one minus alpha *b*" formula at each pixel, where A at each pixel in the foreground image held the alpha value (opacity) that Ed had computed there. And the background image showed through in places where the alpha "control knob" changed the foreground image from opaque to transparent.

The new alpha channel made it easy to place foreground characters over a background image. The parts of a character that had been filled with solid color were opaque. The scanned curves delineating colored areas had soft edges, meaning that they were partially transparent. This let them combine gracefully with whatever was behind. All other parts of a digital cel were transparent, with alpha 0.

It was straightforward to create an alpha channel for a pencil drawing in scan-and-paint. The drawing itself was its own alpha channel—well, actually the negative of the drawing was. A drawing was made in black pencil on a white background, so its negative would be a white drawing on a black background. Suppose the scanned drawing lies in an 8-bit framebuffer, with 255 (all bits 1) representing a white pixel and 0 (all bits 0) representing a black one. The grays in the scanned drawing would lie between 255 and 0. Let's choose one of them for an example—say gray value 100. To get the alpha channel for the drawing, subtract each pixel from white (255). That's what it means to take the negative. So a white pixel would have an alpha value of 255–255, or 0. It would be transparent. A black pixel would have alpha 255–0, or 255. It would be opaque. And a gray value, say 100, would have an alpha of 255–100, or 155, and would be partially

opaque (155/255 or about 61 percent opaque). Any areas opaqued with color would be fully opaque, of course, with alpha 255.

Alpha may have seemed trivial, but it was profound. It took me many years to perceive its full profundity. The next step in the evolution of the idea would come some years later from our colleagues at Lucasfilm, Tom Porter and Tom Duff, who added an "algebra" to the new channel—a non-trivial extension of the elemental idea. And they observed that if you stored the colors "pre-multiplied" by alpha in a pixel instead of the raw color, you could save a lot of multiplications every time the picture was restored. This was back when multiplications were slow and expensive. The four of us got a technical Academy Award for our combined contribution to digital filmmaking—the universal method for combining digital images.

Many popular programs today would not be what they are without alpha. Adobe Photoshop and Microsoft PowerPoint spring to mind. But even operating systems such as Windows and MacOS use alpha to do floating icons, rounded corners, and partially transparent windows.

The company I would start years later, after Pixar, called Altamira Software, would be built on an idea that sprang logically and profoundly from the enhanced alpha channel: *a digital image does not have to be rectangular*. Pre-multiplied alpha finally allows us to overthrow the tyranny of the rectangle. Consider the red disk above. Its shape is defined by the non-zero parts of its alpha channel. The pixels with alpha 0 don't exist for all practical purposes. The disk is a round image object. It's a *sprite* (or shaped image) made of pixels, not geometry. My colleagues and I wrote an image compositing program, Altamira *Composer*, based on this notion and sold it (and the company) to Microsoft in 1995.

There is nothing about alpha that requires submission to the Central Dogma, although alpha is certainly often used in its service. Paint programs and their relatives, such as Photoshop, aren't subject to the Central Dogma, and neither was Composer.

Three-Dimensional Graphics Makes Inroads

With so many university-trained members, it's no surprise that the NYIT Lab resembled an academic department. The place was consensual and collegial. Publications and academic kudos were more important than pay or title. Just as at a university, nobody wanted to be department chairman, so Ed Catmull took on that thankless duty. People weren't assigned tasks, although Ed might suggest one occasionally. Typically, each person just figured out what needed to be done and volunteered to do it. But everyone was aware that NYIT was a godsend, a well-funded research paradise, and we all worked as hard as we possibly could. There were new discoveries every day in this Garden

of Eden! We got to name all the new plants and animals—and gather all the low-hanging fruit.

Ed's low-key management style was right for the original small group of headstrong individuals. But over the years, little by little, we started to feel him at work as an actual manager. He added hardware design to the Lab and a small digital audio group, neither of which would have happened if Ed hadn't been the manager. And he exploited his University of Utah connections by making occasional personnel additions—or summer visitations, at least—to the Lab. Lance Williams and Garland Stern were the first of these summer visitors in 1975 and 1976. Many of them "stuck," like Lance and Garland, and became permanent employees.

One who didn't stick was Jim Blinn, who joined us from Utah for that same 1976 summer. He was, and still is, a tall and gangly long-haired man, frequently outfitted in a sweater of a particular green knitted by his mother. He's a brilliant technical star who affects a saturnine sternness, but it's a disguise for generosity and a wry humorous streak.[70]

Before that visit was over, Blinn had animated a texture-mapped three-dimensional tea creamer (from Martin Newell's famous tea service) and a three-dimensional "man" who ran in a circle, with realistic shading of his surfaces relative to a fixed light source. Shuttling between the University of Utah and NYIT, he also experimented with a new shading technique called *bump mapping*. It's worth discussing further because, like texture mapping, it's another definition-shaking marriage of samples and geometry in Digital Light. In both cases, pixels become part of the Creative Space model of a geometric object. That is, in both cases pixels make the leap from Display Space into Creative Space.

As in texture mapping, one image controls the appearance of another. That is, one array of samples controls the look of a geometric surface as it's rendered into another array. In this case the controlling image affects the *apparent* shape of a surface. Figure 7.30 shows how bump mapping can make an orange sphere *appear* to be an orange. It's only apparent because the geometry doesn't change at all. Look at the edge of the "orange" and note the smooth, bumpless silhouette. It's another Hollywood false-front trick that works wonderfully so long as the apparent bumps are small relative the overall geometry. Would you have noticed the bumpless silhouette if I hadn't pointed it out?

Bump mapping advances the earlier shading techniques by two orders of Moore's Law magnitude. It takes the notion of multiple ups (remember those little flagpoles?) to the limit. The control image pixels (shown in figure 7.30, center) change the direction of up *at each pixel* in the final rendering of the sphere. In the simplest case of flat shading,

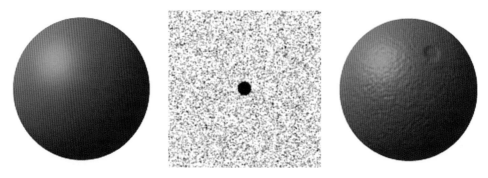

Figure 7.30

up is just the flagpole at the center of each triangle. Then Gouraud introduced the notion of ups at the corners of each triangle—tilted flagpoles. They defined a "surface of ups" that you can imagine floating above the triangle. As each final pixel is rendered into a display, the up used for shading it properly is taken from the corresponding place in that floating surface of ups.

Bump mapping increases the number of ups at a handful of points on a triangle, such as its corners, to an up at every point. Each pixel in a bump map can have a different up. Using classic Sampling Theorem reconstruction—spread each sample and add—a surface of ups is generated from the ups in the bump map to create a surface floating above the triangles as complex as you want. You can't see this floating surface, but you can see the shading perturbations—the bumps—it induces.

Without getting into the trigonometric weeds, suffice it to say that fooling with the ups point by point on a surface can be used to make us see bumps on a surface that aren't really there—in the sense that they aren't in the geometric model.

Blinn first worked on the idea in 1976 at Utah and during a Christmas visit to NYIT but didn't perfect it until 1978 when he turned it into a paper presented at Siggraph, the annual computer graphics conference. And it was part of his PhD dissertation at Utah in the meantime. Figure 7.31 shows his first animatable bump-mapped sphere (with bumpless silhouettes), in raster-scan order, from 1977.[71]

Blinn wound up joining the Jet Propulsion Laboratory in Pasadena. He flowered there and made a name for himself with the production of Voyager spacecraft flyby movies. Each movie simulated the passage of Voyager by one of the planets, like Jupiter. For texture maps, he used the latest photos of the planets that had actually been sent back to JPL by Voyager itself. This kept him busy for years, and placed JPL on the map of important places in computer graphics.

Figure 7.31

Ed brought two more Utah colleagues out to Long Island in 1977. Neither Ephraim Cohen nor Duane Palyka ("Pal kah") was a formal student at Utah, but they'd made themselves useful, so Ed hired them at NYIT. Both were artists *and* programmers.

Ephraim was the artist in the preceding chapter who worked with Ron Baecker's Genesys animation program on the TX-2 at MIT. As an artist, he delighted us with revealing caricatures, such as the one of the Lab personnel circa 1977 (figure 7.25). He contributed many pixel manipulation programs to the Lab, including another paint program. Years later, post-NYIT, his most visible Digital Light contribution—a Digital Light temple really—would be the Times Square multistory façade for NASDAQ in Manhattan, which he helped design and implement.

Duane Palyka was included in the classic 1968 show *Cybernetic Serendipity* and was featured on the cover of a book called *Artist and Computer*, painting a picture of himself—with a computer paint program and a mirror. He contributed one of the few programs at NYIT that rendered three-dimensional objects. It was painfully slow

and served mostly to remind us of how much we needed Moore's Law to manifest its promise.[72]

Canadians and Unix

Our Lab at NYIT had the beginnings of two-dimensional digital production under way—with Tween, TintFill, and Paint3—but our software development environment was stuck in the Dark Ages. We would never get to The Movie at this slow pace. I'm not talking about low Moore's Law power, but inefficient software tools. We knew we could do better at the present Moore's Law level than we were. What we needed was a "good" programming language.

Ed Catmull and I both knew what a bad one was like. We had both taught the Fortran programming language—foisted, as we put it, on the public by IBM—and both detested it. We decided early on that we wouldn't use it at NYIT. Instead we would program in tedious assembly language (see the Turing chapter) and wait for a good programming language to come along.

Then one day our restraint paid off. We learned about an elegant programming language called C (yes, the one letter, we were told). It came as part of a new operating system, called Unix. Both were lovely and logical, and we adopted them immediately at the university price of about $100. Ron Baecker had told Ed about Unix, yet another contribution by that man.

As I explained in the Turing chapter, an operating system is a program that's always running—like Windows, MacOS, or Android OS (OS for operating system). It's in an infinite loop on purpose. It takes care of business: Which apps are running? How much memory do they need? What input or output devices are required? Is there an electrical emergency that demands instant attention? And it handles a myriad other "plumbing" concerns. It's a deep kind of program that takes a special kind of mind. Systems programmers are those people.

Ken Thompson and Dennis Ritchie at Bell Labs had created Unix, with Ritchie designing the C language, and they were awarded the Turing Award in 1983 for this accomplishment. Unix is now one of the fundamental operating systems in the world—MacOS is an adaptation—with C its very popular programming language. Ken Thompson himself hand-delivered an early copy of Unix C to NYIT. He arrived in a yellow Corvette Stingray directly from Bell Labs in New Jersey.[73]

None of us at the Lab then cared much for systems programming, and none of us were competent with Unix. We needed a Unix expert. Ron Baecker again made a valuable suggestion: We should consider a student he supervised at the University of Toronto. So that's how we met Tom Duff. He interviewed for the job at NYIT in 1976.

He was fresh and different, not being from Utah, E&S, or PARC. The only other Canadian at the Lab was Uncle Alex himself.[74]

But Tom was surprisingly shy. He barely spoke up during his interview trip. Consequently, his talks with various Lab members were quite short. We soon found ourselves collectively twiddling our thumbs, wondering what to do with our silent visitor for the remaining hours before his scheduled departure.

Someone proposed that Tom try his hand at a Unix game that Garland Stern had created—a multiple-choice text game. A correct answer took you to another level of Unix difficulty. The goal of the game was to teach the rest of us how Unix worked. None of us could solve it. Unix details were too obscure—even for Garland, who knew barely more than the rest of us.

When Tom heard about the game, he grabbed a keyboard and ripped his way through it in about five minutes. It was child's play for him. He was obviously our Unix expert! We snapped him up—and he was at Pixar until very recently (2021), a hacker guru and grand old man. And his genius extends far beyond just Unix to computer graphics.

NYIT–Lucasfilm–Pixar

Despite the many parts of Digital Light, I choose to focus only on pathways to the digital movies. That is, I concentrate on their part in the Great Digital Convergence at the millennium. So, I ignore here all image processing, all real-time simulators and games, all app interfaces, and all computer graphics not intended for feature-length character animation. For practical reasons—the space limitations of one chapter and my wish not to swamp the lay reader with interminable lists of names—I stick to the pathways leading to three companies, Pixar, DreamWorks, and Blue Sky. This means, with few exceptions, that I barely mention the many other companies and researchers involved in the computer graphics part of the Digital Light revolution. It also means that I treat DreamWorks and Blue Sky lightly.

Since my personal experience is the NYIT–Lucasfilm–Pixar axis, I will say far more about that path than the others. But this treatment is nowhere near a detailed history of even that remarkable track. Rather I follow just those software strands of the story that led to digital movies. And this chapter is certainly not anywhere near a detailed history of the two other paths—of Pacific Data Images–DreamWorks and of MAGI–Blue Sky. I'm more interested in showing how the strands interacted and influenced each other than in presenting all the people and technologies of the other two main paths to digital movies at the millennium.

I leave it to others to write the detailed histories. Those for DreamWorks and Blue Sky are yet to be written. For the NYIT–Lucasfilm years I can hardly top Michael

Rubin's 2006 book, *Droidmaker*. Rubin based it on interviews with those of us who were there, and it's accurate in nearly all details. Similarly, I recommend *The Pixar Touch*, the excellent 2008 history of the slightly later Lucasfilm and early Pixar days by the historian David Price, who wrote from archival materials rather than journalistic hearsay. Here I recount only the high points of the NYIT and Lucasfilm years as regards those members who went on to form the movie-making group that took the name Pixar.[75]

In particular, Tom Duff, Ed Catmull, David DiFrancesco, and I would proceed to Lucasfilm and then to Pixar. Two others from NYIT would follow the same path. Malcolm Blanchard, one of the original four horsemen, left NYIT long before the rest of us, but he would rejoin us at Lucasfilm. A newcomer to NYIT late in the game was Ralph Guggenheim, who would play a key role in the subsequent move to Lucasfilm. Ed and I would cofound Pixar, and David, Malcolm, and Ralph would all become founding employees.[76]

But we weren't the only ones working toward the Great Digital Convergence. Like minds were exploring the edges of technology at Cornell and MAGI.

The Cornell and MAGI Connections

The Computer Graphics Lab at NYIT was located on Long Island, a few miles east of New York City. Just north of the city, in Westchester County, was another early computer graphics center, the Mathematical Applications Group Inc. (MAGI). It had added computer graphics to its other mathematical offerings in 1972. So NYIT and MAGI were the downstate graphics loci.

The upstate contemporaneous locus was Don Greenberg's group at Cornell University. It featured Marc Levoy and other Greenberg students who had created the Cornell movie in 1972.

We at NYIT took a field trip or two to MAGI over the years, but the group we bonded more closely with was Cornell—an academic group like ourselves. Greenberg made sure that either we visited his facility in Ithaca, or he and his students visited NYIT once or twice a year.

We had a rich patron, Uncle Alex Schure, so we were always ahead of Cornell in top-of-the-line equipment, but Cornell was never far behind. We had the first 24-bit framebuffer in the world at NYIT. A year or so later Cornell had one. We worked with animators at NYIT. Soon Marc Levoy at Cornell was working with the Hanna-Barbera animated film company, of *Flintstones* fame. I finally wrote up the HSB (aka HSV) color transform algorithm I had implemented in 1974 at Xerox PARC as a paper in 1978. In the same journal was a similar color algorithm by George Joblove from Cornell.[77]

An early relationship with MAGI also formed. It began with NYIT's David DiFrancesco and his search for a film recorder of movie quality for the Lab. His focus soon narrowed to two companies, Celco and Dicomed. For the same reason—computer animation—MAGI was also interested in a film recorder and was considering Celco. Conveniently, Carl Ludwig, a Celco consultant, set up a meeting at MAGI. Thus, in about 1975 or 1976, we had our first major contact with MAGI. David eventually elected to go with a Dicomed. But he had established a lifelong friendship with Carl Ludwig, and we'd seen inside MAGI for the first time. And Carl would become a cofounder of Blue Sky Studios over a decade later.[78]

Sunstone

I'd made an art video using color raster graphics at Xerox PARC in 1974. I called it *Vidbits*. When I returned from California to the video art scene in New York City, it became my calling card. They'd never seen anything like it.[79]

So when the well-known video artist Ed Emshwiller visited NYIT wanting to make a movie, I leapt at the chance. "Emsh" had begun his artistic career painting abstract oils in Paris. In the 1950s he made a name for himself painting covers for *Galaxy* and *The Magazine of Fantasy & Science Fiction*. Then he discovered 16 mm filmmaking and became an artistic leader in that medium. And then a leader in video art. Then video disk art.

We had discovered Emsh from a PBS television special about him. To our surprise, we learned that he lived on Long Island, in nearby Levittown! Someone said, "Let's invite him over." I said, "I don't think we need to. He's going to find us."[80]

And that's what happened. Obviously Emshwiller was tracking the high-technology edge of new media. One day he showed up at the Lab, as predicted, and announced that he had a Guggenheim Fellowship to make a three-hour movie. He wanted to use it with us, and he had six months. We burst into laughter. We had to explain to him, upset and puzzled, that these were the early days. He'd be lucky to get three *minutes* done in six months.

But we committed to it, and thus began the second important artistic collaboration of my life, after David DiFrancesco. I was a technically oriented person with artistic leanings. I loved art. Emsh was an artistically oriented person with technical leanings. He loved technology. We hit it off, much as David and I had earlier.

Our working style went like this: Emsh would present an artistic concept. For example, the first one he proposed was a human face pushing its way through a block of stone. I responded from my technical know-how and a sense of Moore's Law: "We'll be able to do that someday, Emsh, but not yet. But if you modify your concept this way,

Figure 7.32
(Right) One frame from *Sunstone*, 1979, by Ed Emshwiller.

then I can do it." I explained that I could make a two-dimensional representation of a face pushing through stone, if seen face-on only. Then he said, "Well, if you can do that, then what about . . ." and so forth, back and forth, until we had decided mutually on an artistic idea that I could actually implement in that day of painfully slow computation. It was another form of "jamming." Figure 7.32 (left) shows the two of us at work (Emsh on my right) on *Sunstone*. The sun image floats eerily in space off the color display, the result of the camera's being jostled slightly in the middle of a double exposure—room lights on to capture us, then off to capture the screen. This "error" captured, we agreed, our creative mindset perfectly.

Two NYIT colleagues, Lance Williams and Garland Stern, also participated. Lance contributed a "tongue" that floated around the screen, and Garland accomplished a two-dimensional real-time digitization of an analog video recording that portrayed Emsh's son, Stoney (for whom the piece was named). Garland used the same machine for digitizing these video frames that he used for digitizing animators' drawings in his scan-and-paint system. He took these pixels from the real world, from a monochrome videotape, rather than making them with a computer. But, instead of gray pixels, he ran them through an 8-bit colormap for a rainbow pseudocolor effect. Thus *Sunstone* was a mixture of image processing Digital Light and computer graphics Digital Light.

Sunstone would become the first color raster graphics in the collection of New York's Museum of Modern Art. It wasn't digital video—which didn't exist yet—but every frame was a raster of pixels and hence Digital Light. Only the delivery medium wasn't yet digital. That wouldn't happen until the Great Digital Convergence—when HDTV was standardized in 1998.

We used three different Digital Light technologies for *Sunstone*: two-dimensional interactively painted pixels, digitized real-time video, and three-dimensional completely non-real-time computer graphics.

The painted pixels were created with Paint3. The video pixels were digitized in real-time using the digitizing system that Garland Stern had built for NYIT's scan-and-paint system. But in 1979 there simply wasn't enough Moore's Law power to render full three-dimensional scenes of several objects in a prolonged animation—with jaggies removed. That would come, of course, but it didn't fully exist yet. So I wrote a program called *Texas* (for Texture-Applying System). It simplified the world to two-dimensional planes embedded in a three-dimensional world. I called each plane a "flat" as in a stage production, and together the flats were a "stage set." There was a picture texture-mapped onto each flat. By changing the texture at each frame, a flat could display a two-dimensional animation as it moved through three-dimensional space. That is, the flats could be positioned in any way on a three-dimensional "stage." The Central Dogma was in effect in this stylized world: a virtual camera observed the stage and its view was rendered in Renaissance perspective into final frames for display.

As a measure of the pain involved at this time—even with the restriction to flats—an exploding cube sequence in *Sunstone* that was only 18 seconds long took 56 hours to compute. But it was three-dimensional fully antialiased texture-mapped raster graphics. Three of the cube faces carried two-dimensional animations as they whirled off into space—one face held a hand-painted animation by Emsh, another the real-time video grabbed by Garland Stern, and the third an animated sun that I did.

Emsh departed the Lab in late 1979 to become provost at CalArts, the very school that Walt Disney founded to train animators for his studio. My first visits to CalArts were to see Emsh, and finally in 1990 to celebrate his life and mourn his death with hundreds of others. CalArts would figure prominently in our future. And the working style Emsh and I developed presaged the coupling of the artistically creative and the technically creative that would work so well eventually at Pixar.

Jim Clark Stirs the Hornet's Nest

A cautionary event unfolded during the last couple of years at NYIT. Ed Catmull hired Jim Clark, with a PhD from Utah, to join the Lab and build a head-mounted display—like Ivan Sutherland's. Jim helped reveal that our patron Uncle Alex was a minor tyrant too, though not in the league of Napoleon, Stalin, or Uncle Sam.

Jim was a surprise to me. He came from Texas and talked like me. We quickly hit it off as homeboys. He grew up in Plainview, Texas, about 80 miles straight east of my hometown of Clovis, New Mexico. But the similarity ended there. Jim had been kicked

out of Plainview High School for fighting. He joined the Navy and discovered from an intelligence test that he was a very smart person. So he took night classes and managed to get admitted to various colleges, ultimately resulting in a PhD in computer graphics at the University of Utah.[81]

But at NYIT, he and Alex Schure clashed almost immediately. Looking back, I can see why. Unlike the rest of us at the Lab, Jim had a strong entrepreneurial streak. Schure saw him as a competitor, not a contributor. Jim quickly detected the problem, realized it wasn't going to work with Schure, and started writing letters in search of another job. He wrote them at the Lab with a word processor, which was just becoming common.

One morning Schure confronted Jim with a printout of these letters and accused him of preparing to steal our secrets and take them elsewhere. Schure fired him on the spot. None of this made any sense to us. Jim hadn't hidden the fact that he was looking for somewhere else to go. And he was too smart to need to steal our technology. Our "secret" was that we had the best hardware available at the time. The ideas that were implemented on that hardware were public knowledge. In short, we didn't believe Schure's accusations.[82]

Nor did we understand where the printouts came from. Schure was incapable of digital snooping. That could only mean that we had a mole in the Lab! We knew who it probably was but were never sure. It didn't matter because Jim left, having revealed an angry, vindictive Schure. He'd treated our friend unfairly, so our caution flags went up.

As for Jim Clark, the entrepreneur, he would go on to cofound Silicon Graphics, a hardware company that was important to computer graphics, and later Netscape, the pioneering internet browser company.

Secret Trips to Disney

Our doubts about Schure and his ability to produce a movie were growing. Ed and I had been making a pilgrimage to Disney almost every year and continued doing so. It should've been Disney funding us, not Schure, we thought. They were the animation company that both of us had loved as children, and they had the money. We were sure that Walt himself wouldn't have hesitated. But every year it was the same old story at Disney. First it was, "Can you boys make bubbles?" Well, no we couldn't that year, but the next year it was something else they found we couldn't yet do—such as steam, or smoke.

In our January 1977 trip to Disney, Ed and I were accompanied by Dick Shoup. We met with Don Duckwall (yes!), head of animation, and presented a seminar. From my notes:

> We were surprised and pleased that Don Duckwall showed up and expressed positive (but not overwhelmingly so) reactions: "I believe you can now do bubbles." He suggested that he might

be interested in us for special effects. A large group of about thirty people showed up for the seminar—most were young eager guys who *loved* what they saw—especially the 3-D stuff.[83]

But the big treat of the visit was meeting the grand old animators, Frank Thomas and Ollie Johnston. We showed them our stuff too.

> They seemed to like what they saw—asked lots of questions—but didn't know what to do with the info.[84]

Frank and Ollie would remain our enthusiastic friends until their deaths, when they were in their 90s.

The technical people at Disney, however, knew exactly what we could do. One of them, Dave Snyder, warned us not to expect anything to happen with his higher management. They wouldn't support us. On the other hand, "Ub would have," he said. Iwerks was a cofounder, in a sense, of Disney with Walt, and Snyder openly admired him.[85]

The most awkward of these trips occurred near the end of our NYIT sojourn. Alex Schure visited Disney about a week after we did. "Oh, Ed and Alvy were just here," someone at Disney told him—and worriedly informed us later in a phone call. Schure never mentioned it, and we didn't either. Obviously nothing came of either visit, but we were nervous, having witnessed Schure's treatment of Jim Clark.

Tubby Tanks

The computer graphics group at NYIT managed not to get involved in any way with *Tubby the Tuba* (1975) (figure 7.33). David DiFrancesco and I worked on titling concepts. Luckily, they never got any traction. One day we all gathered at MGM's screening room in Manhattan to see the first showing of *Tubby*. It was bad. Everything that could go wrong with a cel-animated film had—dust on the frames, for example, and shadows under the drawn lines.

But *Tubby* did serve the purpose of inspiring us with the vision that would drive us for years. Not *Tubby* itself but the production of it. The sheer tedium of *Tubby*'s production, as we came to learn its details, made it clear to us that computers could greatly assist in moviemaking, if for no other reason than to ease the workload, keep track of the massive logistics, and increase the quality. And from that we leapt to the thought that someday, somehow, we could be the first group to make a completely computer-generated movie. Lance Williams soon proposed a movie called *The Works*, starring a robot named Ipso Facto, as the first vehicle. But Ed and I did back-of-the-envelope Moore's Law calculations and realized that *The Works* was infeasible at the time. None of us knew it would take another 20 years to realize the vision of the first digital movie.

Figure 7.33

Why did it take so long? Mostly it was not enough Moore's Law, so to speak. But we knew that was just a matter of time. Technically, we had to solve several key problems. The most important was the motion-blur problem. Artistically, we had to figure out how to interface artists to our machines gracefully. The Tween example had shown us that a difficult interface wouldn't work. We had to master a new way of animating three-dimensional objects. And we had to find artists who could work comfortably with our hardware and software.

8 The Millennium and The Movie

Moore's Law 1,000X (1980–1985)

Lucasfilm's Secret Trip to NYIT

Then suddenly the earth moved—more than usual. On one morning in early 1979 Ralph Guggenheim at NYIT was contacted by George Lucas of Lucasfilm. Well, not the man himself, but a representative, Bob Gindy.

We had imagined that one day we'd get a call from Disney, but this one was a surprise. All we knew for sure was that Lucasfilm's *Star Wars* (1977) had astounded everyone—especially us—with its visual effects. And rumor was that Lucas had used computers to make the movie, although we were unsure exactly what that meant. We definitely noticed that he had included a computer-generated sequence of black-and-white calligraphics by our friend Larry Cuba—for planning the attack on the Death Star. Lucas was a successful filmmaker where Schure was not. Perhaps this was our big break?

According to Ralph, Gindy called him in January or February 1979, stating that he was head of development for Lucasfilm and that George Lucas was looking to modernize the film industry with computer technology.

"George has four projects he wants to pursue."

"OK, what are they?" Ralph replied.

Gindy mentioned computerized editing, computerized sound design and mixing, and computerized special effects.

"And the fourth?" asked Ralph.

"Computerized accounting for the company's books."

He stated this as if it was just as challenging as the other three. And he kept punctuating the conversation with tidbits about how wonderful life in California's Marin County was and how great the real estate values there were.

At that Ralph asked, "I'm sorry, what did you say your title was?"

"Well," Gindy admitted, "I'm head of real estate development for George."

He went on, "No one at our company knows anything about computers, so I called the head of the computer department at Stanford. When I described what George wanted, he said, 'We don't really do that kind of work here, but you should contact Raj Reddy at CMU. He's into that graphics stuff.'"[1]

Ralph Guggenheim was a recent Carnegie Mellon University graduate known to Reddy, and that led Gindy finally to call Ralph at NYIT. Ed and I were meeting in a room of Gerry House, the NYIT mansion which housed the Lab, when Ralph burst in saying that Lucas had called—meaning Gindy. Because of Schure's treatment of Jim Clark, we immediately shushed Ralph and told him to shut the door before he said anything else.

We would only discover later that Lucas had no intention of using our graphics pictorial skills in his movies. He just wanted digital expertise to modernize the machines used by Hollywood and to help with the logistics of moviemaking. But we leapt to the conclusion that Lucas wanted us to make content for his movies, as Larry Cuba had done. After all, "computerized special effects" was on Gindy's list as well as accounting.

The next step was to make formal contact and express interest. Because of the mole, Ed and I didn't trust the computers at NYIT. We drove off campus to a typewriter rental company in nearby Glen Cove and rented one of those giant black old-fashioned typewriters made of cast iron—reminiscent of the German Enigma machine. Then we proceeded to Ed's home to compose a letter to Lucasfilm.

This would be the most important letter of our lives. For hours, Ed and I carefully wordsmithed it, and I typed it. One of my sorrows is that we didn't preserve a copy of that letter. But I do remember some highlights. One was particularly unusual. We had the most comfortable lab in the world, and we didn't want to go downhill. So it was important, we urged, that someone from Lucasfilm visit NYIT to see how well—even luxuriously—we were treated. And we made it clear that the visit should be anonymous.

Lucasfilm did make the visit, but it was hardly anonymous. Bob Gindy, the real estate manager, came. He was quiet enough, but he was accompanied by Richard Edlund, Lucasfilm's Academy Award–winning head of special visual effects. Edlund sported a giant belt buckle with *Star Wars* emblazoned in large letters. Ed and I gulped but proceeded with the demonstrations. Comments were made about the belt buckle, but nobody deduced its significance.[2]

I asked Edlund what he was doing the remainder of that important day. Had he ever been to Manhattan? No, he hadn't. I was going in for the evening, I told him, and he

was welcome to join me. "I don't have any particular plan. I just go in and see what happens." He was happy to do the same. We spent most of that night roaming around Manhattan. It was a warm night with many people on the streets. Three-card-monte sharps were out, and Edlund snapped photos of them at work. We found our way into the Village and into an avant-garde music concert. We talked and talked. Finally, about 4 a.m. we wound up the night in a coffee house sipping affogatos. I was convinced that the friendship we established that evening would result in a warm welcome at Lucasfilm. It never occurred to me that Edlund wasn't looking to us for content, but for our hardware and software expertise.

Ed and I were soon invited to visit Lucasfilm headquarters, The Egg Factory, in Los Angeles. We made the trip, and met the president of Lucasfilm, Charles Webber. We didn't meet George Lucas, but progress was made. Subsequently, Ed was invited for a second visit, this time to meet George Lucas in Marin County, near San Francisco, which would soon become the new Lucasfilm headquarters.

Lucasfilm hired Ed as the result of this second meeting. By Ed's telling, Lucas was impressed that Ed was willing to name our competitors as alternative hires, whereas the reverse was not true. Ed left NYIT in mid-1979 to implement Lucas's vision in hardware and software—and we continued to believe Lucas meant to include our digital imagery in his movies.[3]

Our plan was this: Get Ed hired. Done. Then when he could, he would bring me in and also David DiFrancesco. We couldn't raid NYIT or take any of its technology with us.

As part of the plan, and to stay clear of the litigious Schure, David and I "laundered" ourselves, as we put it, by leaving NYIT in October 1979 and joining our old friend Jim Blinn at the Jet Propulsion Laboratory in Pasadena, California. We worked with him on Carl Sagan's *Cosmos* television series. This was a clean break with NYIT and intended to be taken that way. We were very clear with Bob Holzman, Jim's boss at JPL, that we were going to leave as soon as Ed beckoned us to Lucasfilm in Northern California. He said, "Perhaps I can change your mind." "We don't think so," we both responded. Lucasfilm had tremendous appeal. It was a real movie company.

During his months alone at Lucasfilm, Ed determined that he needed to start three hardware projects—Computer Graphics, Digital Audio, and Video Editing—to satisfy Lucas's hardware and software vision. (Lucas would ask him a year or so later to add a fourth project, Games.) We should've noticed then that there was nothing said explicitly about digital content. Again, we just assumed it was intended.

Since I would direct the computer graphics portion, Ed began sending me résumés of people while I was still at JPL. The word was leaking out about something happening

at Lucasfilm. And Ed started holding deeper conversations with David about building a film reader-writer that we would need at Lucasfilm. Film was still the medium of movies, and we would have to interface our digital technology to it.

Ed finally gave me the long-awaited call in early 1980, and I joined him at Lucasfilm. Then a couple of weeks later, David got the call. We all three shared an office with Marcia Lucas, George's wife, above a small antique store in San Anselmo, Marin County, across the Golden Gate Bridge from San Francisco. Ed officially appointed me Director of the Computer Graphics Project, part of the Computer Division, which was the overall organization that he managed. David's film recorder project was part of the Computer Graphics Project.

Ed and I proceeded to flesh out our part of the Lucasfilm world with hires. It wasn't hard to do. Everyone wanted to be in the movies. For example, when we first approached Andy Moorer at Stanford about heading the Digital Audio Project, he leapt from his chair as we entered, before we had said a word, and announced to the room, "If you're here for the reason I think you are, the answer is yes!"

The Computer Graphics Project
The principal designated task of the Computer Graphics Project was to replace the optical film printer with a digital equivalent. In 1980 an optical printer was perhaps the least understood instrument in Hollywood. But it was fundamentally important for special effects. It was the analog way of compositing images in the first *Star Wars* movie. An optical printer combines images on separate strips of film into a single strip of film. A speeding spacecraft, for example, was shot by moving a physical model in front of a blue screen. Then in an optical printer the blue parts of the shot could be replaced with a star field shot separately. Or several separate spacecrafts could be composited, say with an asteroid belt, over a star field. We would, no surprise, use an alpha channel to composite them digitally. David's laser scanner-printer was to be the input-output device for the digital optical printer we would build.

David DiFrancesco set his sights on a laser-based film scanner that could both read and write film. But nobody had ever built a laser reader-writer for 35 mm motion-picture color film before. David approached it cautiously by building two such devices with competing laser technologies, beginning his magical transformation from artist and motorcycle enthusiast to a laser scanner-printer and digital photoscience expert.[4]

We needed framebuffers at Lucasfilm, of course. I soon contracted with Nick England and Mary Whitton—a husband-wife power pair—at Ikonas Graphics Systems in North Carolina to build us a framebuffer with four channels—the first commercial

framebuffer with an alpha channel as standard equipment. This was the hardware basis of Tom Porter's RGBA paint program—the one with splines that astonished Ravi Shankar in chapter 6.[5]

RGBA Paint

Alex Schure had dismayed me by selling an NYIT paint program to Ampex, the company south of San Francisco that invented videotape. Not my sophisticated 24-bit program, Paint3, but the much simpler 8-bit version, Paint. A young Stanford-trained coder there, Tom Porter, had worked at adapting it to the Ampex Video Art (AVA) product. So I hired Tom, my first direct computer graphics hire, to write the Lucasfilm paint program.

A paint program creates color pixels directly, as opposed to the Central Dogma method of rendering them from a three-dimensional computer model seen in perspective. Paint3 could paint in vastly more colors than Paint. But more importantly, because it could access so many colors, it could meld a paint stroke with soft edges into whatever colors were already in a framebuffer. As a result, there wasn't a hard, jagged edge between the paint stroke and the background image, a condition that afflicted Paint with its 8-bit framebuffer and only 256 colors available.

At Lucasfilm, Tom went beyond 8-bit Paint and 24-bit Paint3 to write the first RGBA paint program in the world. What this RGBA paint program could do was paint an alpha channel too. As you paint a 24-bit paint stroke with soft edges into the color (RGB, or red, green, blue) channels of the framebuffer, you simultaneously paint the opacity of each pixel into the alpha (A) channel. Once Paint3 painted a stroke, it became part of the image permanently. But an RGBA paint stroke could be reused on other backgrounds. That's how the spline-shaped strokes for the Ravi Shankar demo were laid down over arbitrary backgrounds and could be reused. To have full control of a digital image, we had to be able to have full control over its alpha channel too. RGBA paint, with 32-bit pixels, was one such important tool—incorporating the new alpha channel everywhere.

Amplifying RGBA

In designing our digital optical printer at Lucasfilm in the early 1980s, we observed that we could build a special-purpose computer that would go four times faster than a general-purpose computer. This was because our data was RGBA pixels, meaning that we could compute the same thing on all four channels of a pixel simultaneously. It would be a special-purpose computer only in that it assumed its data was pixels. Otherwise it would be a general-purpose computer that could compute anything on the

channels. Another way to say it was that our computer would be a general-purpose computer *for pixels*. And that's what we built.

A factor of four is not an order of magnitude, but it's still a substantial speedup. This machine, which came to be called the Pixar Image Computer, was a stopgap to get additional computational power while we waited for Moore's Law to give it to us normally. I won't dwell on it here because Moore's Law did supplant it rather rapidly. It did, for a short time, however, give us more horsepower than any other computer graphics facility had. But where did that name come from?

I proposed to four people in the graphics group at a hamburger lunch one day that we take *laser* as inspiration and name our machine with a noun that looked like a Spanish verb. Using my New Mexican heritage, I explained that a Spanish verb ends in *-ir*, *-er*, or *-ar*. I proposed *pixer*, *to picture* or *to make pictures*, pronounced in Spanish "peeks Air." Loren Carpenter, one of the four, said, "You know, Alvy, the word *radar* has a really high-tech sound to it." And I jumped, "Well, *pixar* is a valid Spanish form too." I pronounced it "peeks Ahr." And that was it. The machine had a name, a noun that looked like a (fake) Spanish verb meaning *to make pictures*. We quickly dropped the Spanish pronunciation, to "Pix ahr." This word, originally the name of a Lucasfilm machine, would figure highly in our future, as would Loren.

Fractals

Loren Carpenter had sent the most impressive résumé I reviewed during the interlude at JPL. What he sent wasn't really a résumé. It was several 8 by 10 color photographs of computer renderings of a mountain resembling Seattle's Mount Rainier, near Boeing where he worked. It was obvious that Loren had mastered *fractals*, a new way of modeling natural scenes—like a snow-covered mountain—with convincingly natural detail. Loren's a very smart guy. He knew that all he had to do was show us the pictures, and we would know what he could do. Indeed, we had to have him!

I immediately got in touch, but Loren refused to discuss anything further until I had seen a computer-animated movie he was making for the upcoming Siggraph, the big annual computer graphics conference, to be held in late summer that year (1980), in Seattle. Ed and I were sitting in the front row at that Siggraph film show when Loren finally showed his short movie *Vol Libre*. It featured fractal mountains—with a teapot buried in the vast "natural" landscape—and brought the house down. I rushed the stage after his landmark presentation and said, "Now?" He said, "Now." We hired him immediately for Lucasfilm.

Fractals are a nifty way of using Amplification to turn one triangle in a computer graphics model into millions. The simple idea is illustrated in figure 8.1. The only

Figure 8.1
Images courtesy of Pixar Animation Studios.

explicit step we take as puny human beings is shown in the top row: We take the midpoint of one side of a triangle and displace it, in three dimensions, by a small amount. For instance, we might raise the midpoint above the plane of the original triangle by a distance that is small compared to the length of the side. Similarly, we displace the midpoints of the other two sides. The actual displacement in each case is taken in a random direction and a random height, and the newly located midpoints are connected to one another with straight lines. In other words, the original triangle is replaced with four smaller triangles as shown, and they exist in three-dimensional space instead of two. That's step 1.

Our human work is done. The computer takes over with its awesome Amplification capability and applies the same trick to each of the four triangles that step 1 just created. The result is the first picture on the left in the bottom row. Four triangles become sixteen. That's step 2. Then the computer repeats the trick on every triangle created in step 2 to get the second picture in the bottom row. And so forth, until our original triangle starts to look a lot like a mountain. Amplification has replaced one triangle in our model with 1,024 triangles in just five steps. Each step gets increasingly difficult for a human but is nothing to a computer. In ten steps this fractal mountain technique takes our one puny triangle into over a million triangles. And fifteen steps would yield over a billion tiny triangles. There's hardly a clearer example of awesome Amplification at work. It's also a testimony to how easily we are fooled with complexity.

What Loren had sent me was photographs of a fractal mountain created this way. He had rendered each triangle into an appropriate color to look like a snow-capped mountain of earthy browns and wooded greens. It was obvious that he had mastered fractal technology.

Beyond Plastic

We now knew how to make mountains, but another problem was that computer graphics surfaces always appeared to be made of plastic. Look at the Phong shading example at the 10X step, circa 1973 (figure 7.19). The ball is shiny blue with a white, sharply defined highlight. It appears to be a blue plastic ball.

People had preconceptions back then about what computed pictures *had* to look like. They assumed that anything created on a computer had to look rigid or jagged or faceted—in a word, "computery." As each of these problem characteristics was solved, the notion of "computery" evolved, and *plastic* became the new standard for defining the look of computer pictures. It didn't help people's early perception of computers that *plastic* had taken on the social meaning of *shallow* or *artificial*.

But Rob Cook, one of Don Greenberg's graduate students at Cornell, had figured out how to leave plastic behind. His new technique yielded rendered surfaces that appeared to be made of, say, copper, wood, or aluminum rather than plastic. He had incorporated more physics into computer graphics, namely the interaction of light with materials. The color of the highlight, and its shape, were clues to us humans of what material was simulated. Whether it was matte or glossy mattered too. These all constituted *appearance factors* for a computer model. With this notion, shading took on yet a larger meaning.

We must have this guy too! So I called Rob and offered him a job. He wanted to know if he could stay at Cornell a little longer and complete his master's degree in science. "The offer is for now," I said. And he accepted it. I learned later that Don Greenberg had intended to start a company featuring Rob's tremendous talent. Disappointed as he was, Don told me that it would have been unfair to stop Rob from joining the exciting group at Lucasfilm. And Rob did eventually complete his degree with Don.

Shading Language—A Conceptual Leap

At Lucasfilm Rob Cook's genius flowered again. He took shading to the limit with a novel concept called a *shading language*. That is, he created a grammar for talking about shading. The leap to a language is always a significant advance in computer science. And just slightly behind Cook was Ken Perlin at New York University with much the same idea.[6]

A computation, as described in the Turing chapter, is a list of carefully defined steps doing meaningless things like exchanging each 1 for a 0, and vice versa, or shifting all bits one position to the right. Turing himself made the first leap toward the notion of a language by introducing the subroutine: a short list of the meaningless steps that is

used again and again is given a name; then a programmer can think of a computation as a list of the subroutine names, instead of the underlying tedious instructions.

I compared the subroutine notion to breaking up a book into chapters, the chapters into paragraphs, and the paragraphs into words. Using hierarchy like this lets mere humans keep track of immense numbers of tiny meaningless steps—or words in the case of writing a book. A programmer at this level generally knows both the meaningless steps and the subroutines, as an author knows both the words and their organization into units.

The next leap toward a language divorces us humans from knowing about the underlying meaningless steps altogether. We can think in terms that are meaningful to a specific field, such as shaded, or rendered, computer graphics. The "terms" are implemented as subroutines with fixed names. But users of the language made of these names don't have to know how the terms are actually implemented. They just have to know that somebody has done so correctly.

Consider the popular word-processing program Microsoft Word, which I'm using to compose these very pages. As a user, you can think of the characters on the keyboard or icons in the menus as terms in the Word language. You don't have to know the long sequences of meaningless steps in your computer that each term invokes. Very few people know them. Consider typing the letter "A." In effect, doing so kicks off a long sequence of steps that places an "A" in the current font, at the current size, in the current color, in the current location, on the current page, and cause a rendering of the letter to appear on a screen display of the current page. And if you've inserted the letter amid an already displayed sentence, then the underlying instructions must move the letters in the model of the page around to give space for the new one. Typing an "A" causes a great many things to happen that you, the user, never have to care about. All you must know is that typing an "A" at the current location results in an "A" appearing where you want it. Similarly, *Cut*, *Copy*, and *Paste* are terms in the Word language that cause amazing things to happen underneath, unseen by you. So do terms like *Insert Picture* and *Insert Hyperlink*, and so forth.

Cook's and Perlin's notion of a shading language followed a pathway that has become familiar in computer science as Moore's Law brings more and more realms into the province of computation. The idea is that a field is crystalized by the creation of a computer language that formally captures it. In the mid-1980s Cook and Perlin took the language idea into vast uncharted territory: the generalization of shading by introduction of a shading language.

We have considered a handful of shading techniques so far: texture mapping, bump mapping, Gouraud shading, Phong shading, transparency, and material appearance

factors. We could continue to explain one such technique after another. But Cook and Perlin's really big idea is that *any* computation can be used to affect the "shading" of a rendered surface.

Suppose I wanted to texture map and bump map a triangle. Or suppose I wanted it to be brass with bumps. Or combinations of all the above. Shading language generalized the notion of shading. There's a digital infinity of shading programs that can be written in a shading language. That's the essence of what it means to compute—the miracle of Malleability.

How to Render a Three-Dimensional Scene

It's time to understand how a virtual scene described with three-dimensional geometry— and carefully specified shading—is rendered in color into a two-dimensional picture, say one frame of a digital movie. We've already seen how to render the triangles that make up the scene, but these renderings were not in color. And only the outlines of the triangles were rendered.

And then we saw rendered colored triangles that were large with respect to pixel spacing. Here we take on the more practical modern case of hundreds of triangles small enough to fall in the cracks between pixel locations.

Let's pursue the same strategy as before: I'll show you how simple the basic idea is at each pixel. Then I'll allow the magic of Epoch 2 Amplification to take care of the immense number of computations that are actually required to implement it for an entire frame, or eventually, an entire movie. That part is inhuman, but not hard to understand once you understand the essential computations.

So, think of yourself as the camera. Look out at the world with your eyes held in fixed position. You see the world in two dimensions and in perspective. (To be unambiguous, let's assume you have one eye closed, so only one eye is the camera.) The virtual camera in computer graphics does the same thing. The "world" it sees is invisible geometry. But it's carefully defined, and the math that projects it onto a two-dimensional frame in perspective is well understood.

In other words, we know enough to calculate which triangle is in front of another triangle in the model of the scene we want to render. Using the simplification that all models are collections of (perhaps millions of) triangles, this means that we can calculate what order to render the triangles in.

I'm not going to oversimplify. The ordering of triangles takes a lot of computational work, but the brunt of it is handled by our faithful computers. All we really need to understand is that it's rather straightforward to determine which of two triangles is the one in front, as seen from the virtual camera. Which triangles can the camera see?

We've discussed two approaches (of many possible) to finding the visible surfaces: depthbuffering and geometric sorting.

The basic problem is to render the virtual camera's view of the world to a frame of color pixels that can be seen when they're displayed. Here's an easy way to understand the problem: Imagine that a window screen separates your eye from the visible world. The wires of the window screen divide the two-dimensional visible word into little squares. Caution, yet again: these are *not* pixels! As a first approximation to the problem, let's assume that each one of these tiny window-screen views of the world does result in one pixel in the final image. This approximation was commonly used in the bad old days and was a large contributor to the false notion that a pixel is a little square—even among practitioners.

So the problem of rendering a view of a scene has been reduced to the problem of rendering one pixel for each window-screen cell. What *one* color represents all the triangles, or parts of triangles, that fall in that tiny square as seen by the virtual camera?

I write this from the tidy kitchen of a wonderful apartment in Gamla Stan, the old island at the heart of Stockholm. I look out at the world and see the blue-and-white dishes on the blue shelves, the spices on another, water glasses on another, black skillets and utensils above the little gas stove, dried flowers, a rack of hanging stainless steel knives, a dish drainer next to the sink, and so forth. There's a large window at the left of my visual field. A white geranium in bloom and other plants fill the wide sill. Outside I see a chestnut tree partially obscuring the yellowish buildings of old Stockholm, and beyond that the blue sky with cumulus clouds.

Next I imagine a window screen separating me from the scene I just described. My job is to choose just one color to represent the visual scene as seen through each cell of the window-screen grid. You can imagine a four-sided pyramid, with its apex at my eye, that passes through the window-screen at exactly one wire grid and broadens as it proceeds to infinity beyond. One color (!) has to represent everything that falls in that little pyramid, as seen from my eye.

In some cases, this is very simple. For example, some of the cells see only the far blue sky. That's the color for their pixels. Some see only the pastel blue wall of this kitchen. The fact that the pyramid there intersects the buildings next door doesn't matter. The wall is opaque so the kitchen wall color hides all those building wall colors. Those are all hidden surfaces. The kitchen wall color is the color for these pixels.

The cells that peer through stacks of dishes are more difficult but straightforward. I'm looking at a stack of nested blue-and-white soup bowls. The little pyramid from my eye intersects several bowls at a time, but they are opaque so only the surfaces directly visible through the window-screen cell contribute to the color. The color I need here

would be a weighted combination of blue and white depending on the proportions of each intersected by the little pyramid for one window-screen cell. The other bowls don't matter, the blue shelf wall beyond the bowls doesn't matter, the old buildings in Stockholm beyond the wall don't matter, the sky beyond doesn't matter. Although they're inside the little pyramid, they're all hidden from my view.

The shelf holding glasses is more difficult. Some of my window-screen cells can see through five layers of glasses to the pastel blue shelf wall beyond, which means that the blue of the shelf wall is modified by 10 partially transparent glass walls that separate it from me.

The really difficult cases are the cells that look out the window. Some of these can see the geranium plant, the partially open window casing beyond, the chestnut tree beyond the window, and either Stockholm buildings or clouds in the sky beyond the tree, or both. But the problem remains the same: determine for each cell what surfaces are visible and what color each contributes proportionally by visible area. Then the final *one* color chosen for the corresponding pixel is the average of those colors. The little pyramids in this case intersect dozens, perhaps hundreds, of surfaces, each of which might contribute a tiny bit of color to the final average.

Computer graphics doesn't happen in a pretty Stockholm kitchen. It happens inside a computer. There are no geraniums or dishes, but there might be a geometric model of a tree, of a stack of soup bowls, of a shelf full of glasses, and so forth. It's the same problem otherwise. What does a virtual camera see at each window-screen location, and what's the average color there?

Ray Tracing and Hyper-photorealism: The Central Dogma on Steroids

> It was a self-portrait depicting the artist reflected in a mirrored sphere supported in his left hand. Escher's face was in the middle, but a geometrically distorted rendering of his office could be seen around it. In the background of that was a window. This, of course, was gathering in light from at least ninety-three million miles away. The point being that in order to make a faithful 3-D computer graphics rendering of an object as simple as a shiny ball, you would, in theory, have to take into account every object in the universe.
> —Neal Stephenson, *Fall; or, Dodge in Hell*, 2019[7]

If the goal is to simulate real-world optics, then there's something missing from the description in the preceding section. Imagine sending out one ray from your eye through a cell in the window screen to the world beyond. Eyes don't emit rays, but let's act like they do for this exercise. Such a fake "eye ray" is the reverse of a real light ray reflected, say, off some surface into our eye. In the preceding, each eye ray proceeds

Figure 8.2

in a straight line out into the world until it encounters an opaque surface, then stops. (Think of the sky and clouds as an opaque painted flat at infinity.) If the eye ray passes through a window or through a water glass, it passes directly through it to whatever surface is beyond.

But real light rays are affected by the materials they pass through. An eyeglass lens is an obvious example. Its whole purpose is to bend light rays to the better service of our eyes. Generally, a light ray changes direction—it *refracts*—when it passes through a transparent material.

Consider a mirror in the scene. A light ray *reflects* off a mirror surface at the same angle at which it first encounters the mirror. This is usually stated this way: the angle of reflection equals the angle of incidence.

Generally, a light ray is both partially refracted and partially reflected by a real-world material. That is, a light ray splits into two light rays as it passes through a surface in the world.

I've barely hinted here at the complex optical properties of materials. In full Central Dogma realism, a scene supposedly made of real-world materials must simulate these actual optical properties—rays coming into the eye from all sorts of directions, not just straight ahead. A renderer that closely honors these properties is called a *ray tracer*.

Ray tracing had been around since the late 1960s in some form, but it burst into full computer graphics flower in 1979 in a paper by Turner Whitted of the fabled Bell Labs in New Jersey. His paper wasn't about ray tracing per se but about what he called "global illumination"—taking the full optical physics of reality into account. Ray tracing was his method for getting fully serious about the Central Dogma—and Moore's Law supported him in this huge advance toward "physically based rendering." At the 1979 Siggraph conference, Turner showed the picture that rocked the computer graphics community (figure 8.3). In fact, this is a frame from an animation he made of the waffled sphere orbiting the glass sphere, with appropriate shadows and warpings. Turner received the 2013 Coons Award from Siggraph.[8]

Central Dogma renderings, with or without ray tracing, are often described as *photorealistic*. Ray tracing obviously contributes to heightened photorealism, but it also encourages what we might call *hyper-photorealism*—a celebration of optical effects for the sheer joy of it, as opposed to serving some narrative purpose. Figure 8.4 is an excellent example by "French 3D artist" Gilles Tran.[9]

Doing It Like Monkeys Do

One of the most important techniques ever devised in computer graphics rendering turns out to be one used by monkeys—and human beings. It's called *random sampling* (or *distributed ray tracing*), but we must be careful about what random means. Figure 8.5 is a picture of how a Rhesus monkey eye samples the real world. It's from a 1983 issue of *Science*. The white dots are the locations of photoreceptors in a monkey retina.[10]

This suggests that Mother Nature doesn't use an evenly sampled grid for viewing the real world, but rather a noisy one. It's as if pixel locations are offset slightly and randomly from fixed grid locations. (The important message here—not to be overlooked as we concentrate on the details—is that Mother Nature uses sampling!)

Figure 8.3
By Turner Whitted, 1979.

A good approximation results if we mix the randomly "jittered" grid idea with the subsampling idea. Figure 8.6 shows the 4 by 4 array of subsamples associated with a single pixel (big dot), without jittering by random distances on the left, and with such jittering on the right. The pattern on the left was presented previously in the subsampling discussion (figure 7.10). Compare the sampling pattern at the right to the monkey retina just presented. The math used for the subsample offsets ensures a restricted kind of randomness with no clumping of the samples, or large areas unvisited by some subsample.

Figure 8.4
Gilles Tran, *Glasses*, 2006.

The math shows that this "monkey" solution replaces objectionable aliasing—such as jaggies—with unobjectionable noise. We just don't see low amplitude noise. There is no perceivable pattern. This jittering notion has many applications, and not just in computer graphics. The general idea is called the Monte Carlo method (named for the famous casino in Monaco), and it was exactly the Monte Carlo method applied to simulations of H-bomb explosions that Eniac+ (which tied for first computer with Baby, in our telling anyway) executed as its first program.[11]

Consider the audaciousness of the computer graphics solution: only one color will ultimately represent the immense complexity that might exist in a visual scene inside one window-screen cell. To see what that means, figure 8.7 shows a famous hairy character, James P. "Sulley" Sullivan, from Pixar's *Monsters, Inc.* (2001). (We depart momentarily from strict Moore's Law timeline here to make this important point—see the annotation for more about fur.) Next to his picture is a closeup of one window-screen

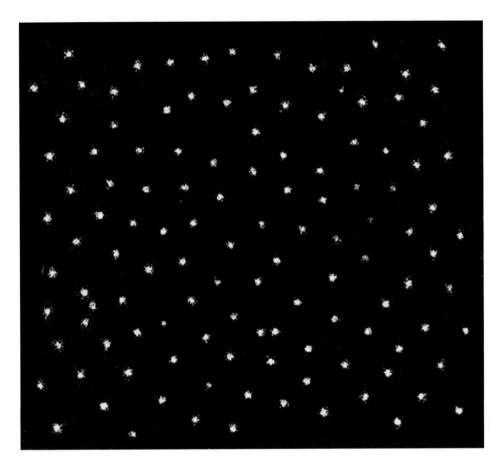

Figure 8.5
With permission from AAAS.

cell's view of Sulley's fur. (And full disclosure here: *Monsters* was not computed at this very high resolution! This is simply a demonstration of what the underlying fur model offered *if* it was computed at that resolution.) The computer graphics solution we seek is *one* color (of the pixel located at the large white dot) to represent all the complexity of that furry cell, at the resolution actually used—the one shown of Sulley at the left. The idea is to use jittered subsampling because computing the actual average color would be too difficult. We don't have to know the colors as depicted at every point in this square cell. We need know only the colors at the 16 randomly selected points.[12]

Figure 8.6

Figure 8.7
Concept and pictures courtesy of Thomas Porter. © Pixar.

About Approximation

Let's revisit that little-square approximation before moving on. I say that the final color of a pixel is an average of the colors visible in each window-screen cell. In other words, assume that a box filter will be used as a spreader to reconstruct the color continuum from the discrete pixels. A box filter gives each subsample equal weight. But we know from the Kotelnikov chapter that the box filter is the worst spreader that can be used in sampling theory.

A box filter is nowhere near the ideal filter or the several well-known approximations to the ideal, like the Catmull-Rom spreader or the B-spline spreader, with their middle humps and rounded shoulders. These would not weight the subsamples equally, and they would consider contributions from areas around neighboring pixels. Nevertheless, computer graphics has used the box filter as a crude approximation for decades, mostly because Moore's Law has only recently begun to deliver enough computational horsepower to use better sampling and reconstruction. Better approximations to the correct sampling of a geometrically defined world, with better spreaders, are only now being explored as Moore's Law continues to deliver. Improved image quality is always the goal.[13]

Motion Blur

I omitted one very important step in the discussion above about rendering a movie. In the movies and animation chapter we discussed how motion blur in a movie film frame is a major clue to our brains about how to perceive motion from 24 still frames projected per second. We early understood that animation without motion blur would fail—the classic failure being Ray Harryhausen's juddering skeletons in *Jason and the Argonauts* (1963), also discussed in that chapter.

Ed Catmull, in particular, kept the need for motion blur visible to the rest of us at NYIT, and he began working on a solution to provide it in computer animation back then, in the mid-1970s. Later at Lucasfilm he emphasized the problem by starting a competition. Surely he thought he would win the competition because he'd been working on the problem for years. The surprise was that he didn't win, but his leadership did. Rob Cook, Loren Carpenter, and Tom Porter—a genius triple threat at Lucasfilm and later Pixar—solved the problem.

Rob and Loren came up with the jittered subsampling method of antialiasing in space. Then Tom realized that the same idea might work in time as well. It did. One technique solved both problems. The idea is to subdivide the time that a virtual camera's shutter is open into "subframes." For example, each square area that is to be subsampled with a 4 by 4 array of jittered subsamples in space is assumed to be subsampled

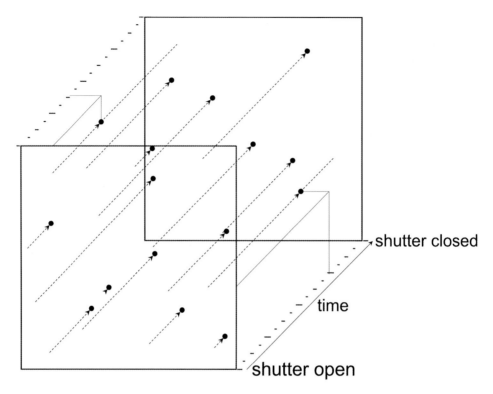

Figure 8.8
Concept courtesy of Thomas Porter, Pixar.

in time into 16 subframes, 16 slabs of time between shutter open and shutter closed (figure 8.8). Then each (spatial) subsample is taken in a separate (temporal) subframe and randomly jittered within the time slice occupied by the subframe. The results are averaged in space and time to make the one color to represent the motion-blurred cell. The 4 by 4 jittered spatial subsamples of the previous image pushed into the time domain, one to each of 16 subframes, and further randomly jittered within the time slice occupied by its subframe. Each dashed line begins in the "shutter open" subframe. The space and time coordinates for two subsamples are shown in detail, for the seventh and twelfth subframes. For clarity, only their two dashed lines are shown extended to the "shutter closed" subframe.

Tom Porter, in a tour de force, created a breathtaking picture (figure 8.9) for that breakthrough moment of the Central Dogma. He titled it *1984*, naturally, and premiered it at Siggraph that year. It demonstrated not only the use of jittered subsampling

Figure 8.9
Thomas Porter, *1984*, 1984, and a closeup. © Pixar.

to solve motion blur, but also the solution of several other problems, such as soft shadows. The amazing team of Cook, Carpenter, and Porter—I called them The Proletariat—had mastered a host of problems with one beautiful idea. Tom's iconic image graced the cover of *Science84* magazine in 1984, with the title "This Picture is a Fake."[14]

It's the Central Dogma in full glory, save for one thing. The reflections in the pool balls aren't the result of optically accurate ray tracing of three-dimensional objects in the geometric model. There is no window, pool player, or palm tree in the geometric model, nor are there beer signs. Rather, our artist-animator John Lasseter painted them with Tom's paint program. And Tom texture-mapped them to featureless poolroom walls that *were* in the set. Thus a light ray that impacted a pool ball after bouncing off one of those walls picked up color from the texture map on it.

Porter's *1984* was ray-traced using the random sampling technique. The picture rides the line between pleasing photorealism and hyper-photorealism, those hand-painted poolroom texture maps being the one departure from the full Dogma. The techniques would serve us well in making The Movie, where photorealism would not be the goal.

Unix Experts Become Graphics Wizards

We've been pursuing the rendering path at Lucasfilm. But meanwhile, the modeling and animation paths had to develop in parallel. Oddly, several important contributors to them came first as Unix system programmers and then as computer graphicists. The

Unix-to-graphics highway had already brought us Tom Duff while he was still at NYIT, as I mentioned previously. Tom had proved himself there to be a graphics guru as well as a system expert. He had programmed, for example, a three-dimensional program for rendering ellipsoid-shaped objects. He called it *Soid* and had made several animations with it at NYIT. I used Soid to make the clapping hands (figure 5.17).

After Ed Catmull, David DiFrancesco, and I departed NYIT for Lucasfilm, Tom was the only person still at NYIT who figured out what he had to do to be included too. Because of Alex Schure's tyrannical tendencies, Ed was very careful not to poach but quick to move when Tom announced that he'd left NYIT. Lucasfilm would be a Unix shop too and needed Unix experts. But more importantly, Tom would create the crucial three-dimensional modeling program at Lucasfilm. He became part of the Computer Graphics Project.[15]

In a surprisingly parallel way, Bill Reeves, another Unix expert cum computer graphics expert—and, like Tom Duff, a Canadian from Ron Baecker's group at the University of Toronto—would write the crucial animation program for Lucasfilm. Ed hired him for his Unix expertise, but Bill soon found his way into the computer graphics group where he would play a major role. Siggraph 2018 honored Bill for his total impact on the field, by making him the first recipient of its new Practitioner Award.

And yet another outstanding programmer (though not a Canadian), Eben Ostby, later joined Lucasfilm and advanced along the Unix-to-graphics pathway. Eben had served a stint at the fabled Bell Labs before Bill hired him into our systems group. And Eben soon proved himself adept too at modeling, animation, and rendering software.

Bill and Eben would be among the 40 founding employees of Pixar. Oddly, Tom Duff would not. He exited Lucasfilm before Pixar began, only to rejoin us after the founding, having spent the intervening years at . . . where else, but Bell Labs.

Particle Systems

Some things just don't lend themselves conveniently to modeling with geometry. One of Bill Reeves's major contributions to Digital Light was something he called *particle systems*. Consider clouds, fire, and water. Or fireworks, stars, and smoke. They are fuzzy objects. In 1982 at Lucasfilm, Bill came up with the notion of modeling a fuzzy object using a collection of many tiny particles. Think of each particle as a dot with small but nonzero size. A *particle system* changes in time, with particles in the system being born into the system, moving or changing within it, and then dying out of the system. Each particle is programmed with a lifetime during which it follows a trajectory. It might have some feature such as color, transparency, or size that could change during its lifetime. A particle moves or changes randomly according to the needs of

the fuzzy object modeled. At each time instant, the living particles are rendered into an image.[16]

One of Bill's first applications of his new technique was fire. Each particle had a color, usually red, but some were randomly green. Each had a randomized location on a flat surface and shot up from there in a randomized direction. A particle's trajectory was determined by an imagined gravitational field, so it arced back to the ground. Each had a randomized initial size and transparency. And each particle was motion blurred. That is, in each frame the start and stop locations of a particle along its trajectory were calculated, typically a small distance. The particle would be smeared at rendering time along that path.

The rendering of this particle system model at each step was accomplished simply by rendering an antialiased straight line between the start and stop positions of each particle in a single frame. Recall that Malcolm Blanchard had introduced antialiased (no jaggies) line segments at NYIT in about 1976 and Dick Shoup had rendered them before that at Xerox PARC in 1973. So a soft-edged, typically red short line segment would implement the smear of a particle along its path of motion. The colors of the line segments were just added together in a framebuffer. Because of the few randomly assigned greens, these additions resulted in a hot yellow-orange glow at the heart of a fire as it exploded from the surface. Then as the particles died off, they would tend toward mostly red and appear to be cooling.

The Genesis Demo

Tom Duff, Bill Reeves, Rob Cook, Loren Carpenter, Tom Porter. We were assembling a world-class team of computer graphics stars at Lucasfilm. And Jim Blinn joined us from JPL, but just as he had earlier at NYIT, Jim became uncomfortable outside his own peculiar programming world and returned to JPL. And we added Pat Cole, from Jim's team at JPL, another pioneering early woman, to the group.[17]

We assumed that George Lucas would knock on our door any day with a request for computer graphics content for one of his movies. But he never came. Finally, it dawned on me. George Lucas didn't know what he had! He had made the classic mistake of assuming we were only a bunch of "technoids" doing hardware and software, while he and his team were the "creatives" making movie content. I thought we'd made it clear that we were content creators as well, but the message hadn't taken.

It took Paramount Pictures to enlighten Lucas about our capabilities. For our next lucky break, Paramount approached Industrial Light & Magic (ILM), Lucasfilm's special-effects division, for work on *Star Trek II: The Wrath of Khan* (1982). The Paramount people wanted some computer graphics in *Star Trek II*, but ILM didn't do

computer graphics. The new guys "next door" did, ILM told them. That's when they called me in.

I listened to the Paramount people describe what they wanted in the film. It was to be something that explained a key narrative device called "the Genesis effect," which converted death to life instantaneously. The idea they pitched was a rock floating in an aquarium that would, somehow, become covered with green moss. I looked at them puzzled and said, "Do you have any idea what we can and can't do with computer graphics at this time?" They admitted that they didn't. So I suggested that I depart for a day and return with a shot proposal that would satisfy their narrative needs and be something that we could actually compute cost-effectively in the early 1980s. They agreed. But then I remembered a crucial problem. "We can't do movie resolution yet. We can only do video resolution." "That's not a problem! This is *supposed* to be a video demo to Admiral Kirk."

I walked out of that room about ten feet off the ground. This was it! We had just been given the big break! Finally, a chance at the big screen! We had just been asked to create a complete shot—on our own!—in a major motion picture that was surely destined to be successful.

I was up all night designing the shot. It would use—it *had* to use—all the talents of our assembled team of computer graphics wunderkinder and it had to explain the Genesis effect. I sketched a storyboard of what became known as the Genesis Demo. It consisted of just six crude panels drawn on the green engineering pad papers that I used extensively at the time. Just before I presented it to ILM and Paramount, I thought it would be a good idea to dress up the storyboards a bit by using standard ILM story-board format. Figure 8.10 shows two cleaned-up storyboard panels from the final version I drew for the proposed shot.

Jim Blinn's Voyager spacecraft planetary flybys at JPL were the prime inspiration. The (unseen) spacecraft in my storyboard circled a dead Moon-like planet covered with craters. Loren Carpenter would design the star field and spacecraft trajectory. Tom Duff would make the craters with bump maps. Pat Cole would model the projectile fired from the spacecraft toward the dead planet. The impact of the projectile starts a conflagration. Bill Reeves would implement the fires, using his new particle systems. A wall of fire dramatically engulfs the planet and melts its surface. From the molten surface arise fractal mountains, which Loren would make using the fractal technique described earlier. Seas would form and the mountains would cool and turn green. As the spacecraft speeds away, the dead planet would be newly revealed as living and Earth-like. Tom Porter would oversee this last part with his paint program and texture mapping. The Genesis Effect wouldn't be instantaneous, as desired, but it would take only a minute to explain.[18]

Figure 8.10
Images courtesy of Pixar Animation Studios.

Despite the crude storyboards, we got the job. Gathering the team into a room, I announced, "We just got our big break," and told them that we were going to do a first-rate job—satisfying Paramount's narrative needs and pleasing the *Star Trek* audience. Then my main message: "But what this shot really is, is a 60-second commercial to George Lucas so that he'll know what he's got."

I knew a secret about George and planned to exploit it: When he watches a movie, he's constantly aware of the camera and the cameraman's decisions. He doesn't get sucked in by the emotion. If you think about it, a director who can't pull you into the emotion of his or her film has failed. Nevertheless, George Lucas could avoid the emotion and track the camera, or perhaps do both. I explained this to the group. "So we're going to put a camera move in this shot that no real camera could possibly make. It won't be gratuitous. It'll make perfect narrative sense. But it will blow George's socks off."

And that's what we proceeded to do. Loren Carpenter masterminded a complex multidimensional spline through dozens of ducks to describe the camera's move. This was another use of the spline concept introduced in the Shapes chapter. Here the spline interpolated the camera position and orientation in four-dimensional spacetime (three of space, one of time). The camera looks at the approaching dead planet, rotates to track the action on the planet surface, staying just ahead of a traveling wall of fire, gazes down at the growing mountains speeding by below, and then looks back at the now living green planet, with an atmosphere, as our spacecraft speeds away, completing its planetary flyby. Figure 8.11 is a composite of several Genesis Demo elements.

Figure 8.11
Image courtesy of Pixar Animation Studios.

The day after the premiere of *Star Trek II: The Wrath of Khan* (1982), George Lucas, a rather shy man it seemed to me, stepped one foot into my office. "Great camera move!" he said. Then he was gone. He'd got it! In his next movie, *Return of the Jedi* (1983), he included a short sequence created by Tom Duff and Bill Reeves of our group. And, importantly, he must have told his good friend Steven Spielberg about us. Spielberg would include Lucasfilm computer graphics in his *Young Sherlock Holmes* (1985). And the word began to spread that there was a new way to make captivating film content. By *Terminator 2: Judgment Day* (1991) computer-generated raster imagery had entered the Hollywood technological firmament. And we'd made a major step toward our goal—the first team effort by the group who would become Pixar.

Tron: 15 Minutes of Digital Light Fame

But the 1982 Genesis Demo wasn't The Movie. The Movie still needed the millennium's Great Digital Convergence, but work was underway. *Star Trek II* was an early workout for the group that eventually became Pixar and created *Toy Story* (1995). We were proud of the Genesis Demo, but it was just special effects. In that domain, we were

far from alone. *Tron*, a cult favorite that followed *Trek* by only a month in 1982, best illustrates this. *Tron* served the same function for the group that evolved into Blue Sky and made *Ice Age* (2002).

The Moore's Law 1,000X step from 1980 to 1985 saw the birth of many companies ready to supply digital special effects for hire. Disney used four of them to produce *Tron*: Robert Abel and Associates and Triple-I (Information International Inc.) in California, and Digital Effects and MAGI (Mathematical Applications Group Inc.) in New York. Two of these are of continued interest here: Triple-I, near Hollywood, was home to John Whitney Jr. and Gary Demos, and of great concern to us at Lucasfilm as a serious competitor in the race to The Movie. And it was MAGI from which, as I just mentioned, the Blue Sky group would later emerge. The annotation lists many other firms from this formative era.

The director Steven Lisberger brought the concept of *Tron* to Disney, on the advice of Alan Kay, formerly of Xerox PARC—he who equated point of view with 80 points of IQ. Lisberger came from a classic character animation background, but with Kay's insistence he promoted computer animation to Disney. But not computer *character* animation. All the characters in *Tron* would be live human actors made up with what appeared to be red or blue neon piping. This made them look like glowing cartoon characters, but it was really the result of an analog post-production process. The project was unusual for Disney, a company that didn't normally go outside itself for help. To his credit Ron Miller, Walt Disney's son-in-law, was the Disney executive who gave *Tron* the go-ahead.[19]

The digital production of its computer effects animation was a logistical nightmare. It required integrating work from four companies, on the East and West Coasts, with four different looks and four different hardware and software bases. Together they managed to produce a reported 15 minutes or so of computer graphics that was incorporated into the final movie. This claim of substantial screen time is difficult to assess because it surely included all the appearances of the Bit, contributed by Digital Effects. The Bit was a tiny polyhedral "character" that could exist in only two alternating colors, blue and yellow, and occupied little screen space.[20]

The most memorable *Tron* computer graphics was the "light cycle" sequence produced by MAGI in Westchester County, New York (figure 8.12). The whole scene is about three minutes long, including about one minute at least of intercut live-action footage. Importantly, the light-cycle sequence impressed a young animator, John Lasseter, working at Disney then: "It absolutely blew me away! A little door in my mind opened up. I looked at it and said, 'This is it! This is the future!'" Later, after he had joined Pixar, he was to say, "Without *Tron*, there would be no *Toy Story*."[21]

Figure 8.12

MAGI Gets a Character Animator

Mathematical Applications Group Inc. was founded in 1966 to evaluate nuclear radiation using Monte Carlo ray tracing. The company soon realized that they could simulate light rays with their technique, not just nuclear radiation. In 1972 they created a computer graphics division called MAGI/SynthaVision to exploit this notion and make early television commercials. So MAGI had always used ray-tracing as its rendering technology, which set it apart from other firms. Judging by the light cycles in the figure above, they hadn't yet exploited ray tracing's hyper-photorealism by 1981 when Disney hired them for *Tron* effects. MAGI hired Chris Wedge as an animator for the *Tron* (1982) sequences, a decision that was very important for the future of digital movies.[22]

The historical flows braided again in 1983 when Disney contracted with MAGI to make a test film based on Maurice Sendak's popular children's book, *Where the Wild Things Are*. The notion for the Wild Things test was that the characters Max and his dog would be created traditionally with two-dimensional cel animation, but over a three-dimensional computer graphics background. Chris Wedge and others at MAGI produced three-dimensional wireframe backgrounds. Disney animators John Lasseter and Glen Keane hand animated to those backgrounds. Thus Chris Wedge and John Lasseter, two animators so important to the future of digital movies, made their first contact with each other and with digital Hollywood.[23]

Pacific Data Images Joins the Flow

As the flow chart for this chapter shows, there were three loci that that led directly to the three studios who produced the first digital movies at the millennium. MAGI entered the business in 1972 with its SynthaVision division. NYIT started its computer animation laboratory, the Lab, in 1974. The third locus was Pacific Data Images (PDI) in California.

Carl Rosendahl borrowed $25,000 from his father and started PDI in 1980 to commercialize computer graphics. For perspective on the risk he took, Ed Catmull, David DiFrancesco, and I had just set up shop at Lucasfilm in Marcia Lucas's office in 1980. We were a research group and not self-supporting at all. It hadn't even occurred to us that we could support ourselves doing computer graphics.

Rosendahl was joined by Richard Chuang in March 1982 and Glenn Entis a month later to become the three cofounders of PDI, the animation company. The latter two wrote PDI's animation software, and the three of them received a technical Academy Award for the PDI animation system in 1994.

Chuang learned computer graphics from videos of a class taught by Ed Catmull and others of us from Lucasfilm. Entis, as a computer science student in Brooklyn and a programmer in Manhattan, had learned computer graphics at nearby NYIT—in a class Ed and others of us from NYIT taught in the late 1970s. And Entis took over from Tom Porter on Ampex's AVA project when I hired Tom into Lucasfilm.[24]

We tracked PDI's commercial progress more closely than other computer graphics houses because it was "doing graphics right" as colleague Loren Carpenter put it. For starters, they were a Unix house and wrote in the C language. But PDI didn't—yet—appear to us to be a competitor for The Movie. Nor did MAGI—yet. There was only one company on that list, Digital Productions.

Digital Productions Buys a Supercomputer

John Whitney Jr. and Gary Demos were at Triple-I when Disney contracted with it for *Tron* special effects, one of four such companies. But the pair soon disagreed with management over the amount of computing power needed for the project. They departed Triple-I in 1981 and started Digital Productions in 1982—with an investment by Ivan Sutherland.[25]

Back in 1974 Sutherland had unsuccessfully sought to start The Picture/Design Group with Glen Fleck and enter the Hollywood market. Ed Catmull had waited for the company to form until demands of his young family forced him to seek employment elsewhere. Another young man, Gary Demos, also intended to be part of Sutherland's company, and possibly also John Whitney Jr. from the talented Whitney family. John

(Jr.) and Gary seemed to be fixtures in our part of the computer graphics universe that was aware of the movies.

Ed and I tracked them carefully. They were unusual in that they computed with very powerful computers and filmed at very high resolutions. They were located near Hollywood and tied into the movers and shakers of the movie business. In 1981 at a luncheon in Los Angeles on Francis Coppola's stage set for *One from the Heart* (1982), I sat across a large table from John and the actress Teri Garr. My heart sank as I realized they'd grown up together and were clearly old friends. Coming from outside, did we even have a chance? Would John and Gary beat us to The Movie?

We thought they might, with good reason. They had already been involved in several feature films. At Triple-I John contributed digital image processing scenes to MGM's *Westworld* (1973), a financial success. Then he and Gary rendered the actor Peter Fonda's head in three-dimensional shaded graphics in *Futureworld* (1976), a not so successful sequel to *Westworld*. We were especially familiar with *Futureworld* because it included two other pieces of three-dimensional shaded raster graphics—Ed Catmull's hand and Fred Parke's face (figure 7.13), grayscale animations they had created at the University of Utah in the early 1970s.[26]

John and Gary then worked on *Looker* (1981) at Triple-I, a film that featured a three-dimensional rendering of a full body scan of the actress Susan Dey. In a remarkable coincidence, the *Looker* story concerns a plastic surgeon, Dr. Larry Roberts, who performs minor alterations on supermodels seeking bodily perfection. Michael Crichton, who wrote the screenplay, was probably unaware of the seminal role of another Dr. Larry Roberts—he of the Triumvirate at MIT in 1963—in perfecting the display of (computer) models in perspective. But *Looker* contained only a little computer graphics. And it too was a financial failure.[27]

But the day finally came when Ed and I thought the game was up. News flashed through the small world of computer graphics: John and Gary had purchased a Cray supercomputer! Our Cray salesman, Bence Gerber, had been trying for a couple of years to sell us a multimillion-dollar Cray at Lucasfilm, but we couldn't make sense of such a purchase nor justify its cost. The Cray supercomputer just wasn't a good match to what we intended to do. Or so we thought, until we heard about the Digital Productions purchase. Ed and I whipped out the proverbial envelope and made our calculations again. Had we gone wrong somewhere? The answer, again, was no. The purchase just didn't make economic sense.

Richard Chuang, the cofounder of PDI, remembered the situation almost the same way:

I will never forget the day Digital Productions announced they had got a Cray. Initially it was shocking. Wow, there goes the industry—they can afford a Cray—no one will be able to compete. But later that day—I will never forget—me, Carl, and Glenn sat on the floor, discussing that we could never afford a Cray to compete, but an hour later I did the maths and I came back and said, Wait a minute—these guys will never last, they can't afford it—if you have any business sense you know the cost/value proposition—and you can calculate that. The return on investment on a Cray doesn't justify the business we were in.[28]

John and Gary had taken a tremendous gamble—betting that studios in Hollywood would use the Cray, if readily available to them, thus spreading the cost across several moneyed users. But that didn't happen. The Cray was a mistake, and it doomed the only competitors who truly frightened us at the time. Digital Productions made a noble effort with *The Last Starfighter* (1984), using the Cray, but their 12-minute three-dimensional contribution was far short of a complete movie. Digital Productions ceased existence for all practical purposes in 1986, the year Pixar began, purchased by another production house in a hostile takeover.[29]

We didn't know until later that Lucasfilm had considered going with John and Gary but had chosen us instead. In 1978 while still at Triple-I, they had submitted a film test to Lucasfilm of a beautiful X-wing fighter à la *Star Wars* (1977), modeled in three dimensions and rendered at very high resolution. But they didn't antialias the sharp edges of the X-wing. They supposed that the high resolution would make the jaggies at these edges too small to see. But that wasn't the case. Richard Edlund, the same Lucasfilm special effects master who had visited us at NYIT with his big *Star Wars* belt buckle, spotted the jaggies immediately and wouldn't tolerate them.

Although we rendered at much lower resolution—because that's all we could justifiably afford—we took great pains to antialias all edges. From the beginning, "No Jaggies" was our Lucasfilm motto. It was the crucial difference. In fact, our care to rid digital movies of sampling artifacts, in both space and time, would be one of our "secrets" of success. The photo in figure 8.13 (left) shows Ed and me (left to right) at Lucasfilm in the early days with one of the earliest Lucasfilm computer graphics geniuses, Loren Carpenter, our fractal expert. I'm wearing the "No Jaggies" T-shirt that each of us had, its logo shown more clearly in figure 8.13 (right).

Were we wrong to think of Digital Productions as our competitor? John and Gary never stated that they intended to make a digital movie. Their work was nearly always special-effects work for other movies. But there was one area where they competed directly with us, or so we thought. When we proposed the Computer Animation Production System (CAPS) to Disney—as I described in the movies and animation chapter—Disney personnel told us that Digital Productions was being considered too.

Figure 8.13
(Left) Image courtesy of Pixar Animation Studios. (Right) Concept by Craig Reynolds.

That hinted strongly of an interest in character animation. Rightly or wrongly, John and Gary gained our respect. They were smart, and ready to make the big play. Years later, in the late 1990s, when Gary asked for my help in Washington, DC, to fight for changes to the HDTV digital television standard, I was happy to join him.

André & Wally B.

The work by Digital Productions in *The Last Starfighter* was impressive, but it had no digital characters. We wanted to do character animation. But we were missing something essential—a character animator—someone with that indescribable ability to inspirit sketched lines or rendered triangles.

A great animator had actually visited Lucasfilm. Brad Bird had looked us up in 1980 while we were still above the antique store in San Anselmo sharing an office with Marcia Lucas. He wanted to make an animated movie with us. He was the funniest man I'd ever met (and still is). As we walked the streets of San Anselmo chatting, he had me in constant stitches. But I knew he was too artistically sensitive to put up with the harsh environment of computers at that time. They were noisy, required frigid air-conditioning, and failed often. And they were infuriatingly slow.

But just a few years later, we got a second chance. We had enough tools now, and finally had enough Moore's Law–empowered computation, but we were lacking an animator. Then Ed Catmull and I met just the person we needed to make The Movie: John Lasseter. We met him during one of our annual pilgrimages to Disney, which continued

after we joined Lucasfilm. John wasn't the least bit frightened of us, unlike most of the animators at NYIT. John was excited. He had already worked with MAGI on a short test for *Where the Wild Things Are*. He had seen *Tron*. He already had a sense of what it was like to work with computers.

According to Ed's and my records, we had actually met John earlier, first at Lucasfilm on February 16, 1983, and again on May 11, but he didn't make a strong impression on us then. It was the third encounter with him at Disney where his name registered unforgettably with us. He took us down into the Disney archives and asked what we wanted to see. The first thing out of my mouth was, "Preston Blair's dancing hippo in *Fantasia*." He proceeded to show us Blair's original drawings! He fluttered the edges of Blair's sheets with his thumb the way animators do . . . and Hyacinth the Hippo danced! This was a potent, magical moment for me. Next I asked to see the pink-elephant scene from *Dumbo*, which John proceeded to oblige. I felt us bonding then and there.[30]

But Ed and I couldn't touch John. He was working for Disney. Nevertheless, he had impressed us highly. Although very young he'd won the "student Academy Award" for best animation, twice, at Disney's CalArts in its character animation school, the school that Walt had founded.

On the plane back from the 1983 Siggraph, Ed and I decided that at the *next* Siggraph, in 1984, we would announce to the world that we did character animation. That would be our differentiator. While still on the plane, on green engineering pad paper again, I sketched the storyboard for what I initially called *My Breakfast with André*, in homage to a film several of us particularly admired, *My Dinner with André* (1981), starring André Gregory (playing André) and Wallace Shawn (playing Wally).

So in our animation, an android named André would awake, arise, and stretch mightily. The sun would rise revealing a rich and beautiful natural landscape. Character animation had arrived! It wasn't a good story, but I couldn't see that yet.

Luckily, a couple of months later, Ed was attending a convention on the old *Queen Mary*, permanently docked in Long Beach as a meeting venue. We were on the phone, having our daily business update call, when Ed surprised me with, "I just saw John Lasseter. He's no longer at Disney." "Get off the phone RIGHT NOW," I cried, "and go hire him!" Ed knew it was an excellent idea, of course, and did exactly that.[31]

There was only one catch. George Lucas had told Ed that the computer graphics team could not do character animation. Only Disney could do that, he insisted. So we hired John in late 1983 as a "user interface designer," not "animator," to keep him off George's radar. We wouldn't know for years that Disney had fired John for wanting to pursue computer animation.

John's response to my *Breakfast with André* storyboards was, "Can I make a few suggestions?" "Of course, that's why you're here!" And he proceeded to save the project. First, he softened the android into a rounder, cuter André. Ed designed a more malleable body, a teardrop shape, for him. It was far more flexible than a collection of spheres. Then John suggested adding another character, a bumblebee. Ed's teardrops became its legs. To complete the tribute to *My Dinner with André*, the bee had to be named Wally in honor of Wallace Shawn. In fact, he became Wally B. We changed the title to *The Adventures of André & Wally B.* This would be John's first outing with the group now known as Pixar, and my second shot as a director.

Until John arrived, I truly thought I would be the animator of the piece. I had made those delicious clapping hands, after all. I didn't yet understand the awesome talent that a true character animator has to have, and which I definitely did not. I could make triangles move, but I couldn't make them emote. I couldn't inspirit them. I could make hands clap, but I couldn't convince you they belonged to a conscious being. John *could* do all that, and he did it easily and naturally.

The team didn't quite finish *André & Wally B.* by the 1984 Siggraph in Minneapolis, but Siggraph officials allowed us to show it anyway. There's nothing sweeter than to have thousands of your peers, who understand exactly what you've accomplished, shouting and stomping and cheering your work. Now we were in the character animation business, loud and clear, all flags flying.

André & Wally B. was obviously an artistic breakthrough, and it was received that way. It wasn't just human-shaped objects that moved. It was two *characters* who emoted. They connived! And there was a story. It was simple and a bit mean—a giant bee threatens little boy André, who tries to divert the bee's attention; there's a chase; the giant bee stings the bejesus out of the little boy—but it was a story. There was a professional character animator at the tiller.

It was also a technological breakthrough. It demonstrated that we had modeling, animation, rendering, and film recording programs sophisticated enough to bring the dream of three-dimensional characters to the cinema screen. And it featured two specific technological advances.

Bill Reeves modified his particle system idea that had generated the planet-melting fires of the Genesis Demo. Turn a fire particle green and leave a rendered path behind as it follows a trajectory and you get . . . grass. He also devised a tree-generation version of his system that created clouds of particles, as leaves, attached to trunks and branches—yellows and oranges for deciduous trees and dark greens for evergreens. As with fractals, a few simple computations repeated millions of times Amplified a simple database into a satisfyingly complex "natural" forest. A first.

Figure 8.14
© Pixar.

Most important of all, *André & Wally B.* demonstrated to the Siggraph world of 1984 that we had solved motion blur. Wally B.'s wings were blurred. André's swift departure smeared him across a frame. The Cray company lent us time on one of their super-computers in order to complete the film for Siggraph (and perhaps finally attract us as a customer). Figure 8.14 shows four successive frames. The number of computa-tions in the third frame was so high that it "brought the Cray to its knees," accord-ing to Loren Carpenter who was overseeing the computation at Cray. He decided that nobody would notice that the smear wasn't complete and accepted the incomplete frame. Nobody noticed.

George Lucas attended that first screening of *André & Wally B.*, much to our surprise and delight. He was really in town to see Linda Ronstadt perform, but he took in our Siggraph premiere too. Lucas was finally going to see what we could do! And in front of a large and almost certainly enthusiastic audience. It was years later when I learned from Michael Rubin, researching his book *Droidmaker* about the Lucasfilm days, that Lucas hated the piece. Luckily, he didn't say so. It would have broken our hearts.

The piece wasn't complete for one thing, despite the time on a Cray supercomputer. One scene still had wireframe foreground characters, although hardly anyone who saw it at Siggraph recalls them. For another, it wasn't nearly as polished as later Lasseter animations became. This was his first shot at a completely computer-generated piece with three-dimensional animated models. Almost everybody else, thousands of them, in the Siggraph audience appreciated the immense advance that had been made and could see the future. But Lucas apparently could see only what was directly before him at the time. So here's another case where a man with a different vision from our own inadvertently helped us realize ours. And we helped him realize his clear and important vision of digitizing film production. Furthermore, a few years later he did make the change. Lucas began to use computer-generated imagery more densely than any other moviemaker in his second series of *Star Wars* movies.

John Lasseter and Bill Reeves first formed their tight duo during the production of *André & Wally B.* John was the artistically creative member of the collaboration, and Bill the technically creative one. One couldn't succeed without the other.

I'm very proud that the environment that we created at Lucasfilm, and carried later into Pixar, disallowed the pernicious technoid versus creatives error. We engendered a mutual admiration society between technically creative and artistically creative people, equal in prestige, salary, promotion, benefits, and most importantly, dignity and respect.

Monkey Business

A little-known "almost" occurred in our last years at Lucasfilm. Despite George Lucas's resistance to making a computer-animated movie, we almost made the first one, The Movie, with a Japanese firm.[32]

People representing the heir apparent of Shogakukan ("Show gah khan"), a major Japanese printing company, approached us in 1984 with a large idea: make the first digital movie, and base it on the mischievous Monkey King, beloved of Japanese children—indeed, most children in Asia. I thought this was a magical concept since Monkey had been part of our world for years. Lance Williams had introduced us to him at NYIT. We believed we were the right people for the job. All the signs said so. John Lasseter immediately got to work on character studies for the hero (figure 8.15).

But how much should we charge for production? Nobody had ever costed a feature-length digital movie before, so I proceeded to do so from scratch. I ran the numbers, factoring in everything I knew about the logistics of animation, the pixel resolution

Figure 8.15
Images courtesy of Pixar Animation Studios.

we must work at, the cost and speed of computers then, the storage space needed, the filming costs, the personnel and equipment expenses—everything but marketing and distribution costs. The results weren't good. It would cost about $50 million in 1985 (about $120 million today). It was two to three times too much, especially for such a risky undertaking—the first digital movie with three-dimensional characters and sets. But worse: it would take us three years to compute it. Laurin Herr, our translator and business interface with the Japanese, knew immediately that the three years was the deal breaker. So we backed out of the deal as gracefully as possible, with thanks all around.

And we had learned a valuable lesson: We were still too short of computational power to cost-effectively generate a digital movie. We needed another order-of-magnitude improvement. We knew in 1985 with detailed clarity informed by Moore's Law that it would take five more years to attain The Movie.

Was There Sufficient Software Technology in 1985 for The Movie?

After our experience declining the Monkey King project, we started to consider if our software technology, as it stood in 1985, would be sufficient to make The Movie when Moore's Law finally delivered that order of magnitude in hardware performance. Was it just a matter of waiting for Moore's Law? This was a valid question and difficult to answer precisely.

When we first conceived of The Movie, in the 1970s at NYIT, we thought we had enough technology, with Ed Catmull's Tween program and my TintFill program for foregrounds, my Paint3 program for backgrounds, David DiFrancesco's filming expertise, and the alpha channel for compositing. For hardware we had 18 framebuffers, the first frame-accurate computer-controlled broadcast quality video recorder for tests, and several computers. We also had digital audio, and the beginnings of a movie logistics system that we learned from the classic cel animation studio also on the NYIT campus. And, in a sense, we had access to character animators, like Johnny Gent, associated with Uncle Alex Schure's *Tubby the Tuba* studio. We were surrounded with people who actually had made feature-length films—and were making another one. It wasn't an unlikely possibility to us.

But several things were wrong with this scenario. Most importantly, we quickly learned that two-dimensional computer animation was too hard for real animators— that is, the classically trained cel animators at NYIT. And we learned that Alex Schure's studio really wasn't up to the task as the producer.

Furthermore, our concept of The Movie at that point didn't adhere to the Central Dogma of computer graphics. That might seem surprising because Pixar became

famous for creating the first feature-length digital film inside the Central Dogma "symphonic" form—character animation based on three-dimensional Euclidean geometric models, operating in a world of Newtonian physics, viewed in Renaissance perspective by a virtual camera, and rendered into pixels for display.

The symphonic form wasn't a foreign concept back then, but a digital movie honoring it was unreachable. Lance Williams had early proposed *The Works* as a movie in Central Dogma form, in the late 1970s. He and Dick Lundin and others slaved at NYIT producing a few seconds of spectacular footage. But Ed and I ran the Moore's Law numbers on *The Works* and realized it would cost hundreds of millions to produce. In other words, it wasn't feasible at the time.

But what if Moore's Law had not been a factor? Suppose there had always been enough computational power at a reasonable cost to make a feature-length digital movie. Further suppose that character animators had always been available. When would we have had enough technological expertise to make The Movie?

The surprising answer is that we were always ready to make The Movie—except for one technological leap. Fundamentally, there always needed to be modeling, animation, and rendering programs, but the sophistication of these would and did ride the Moore's Law wave. The genius of artistically creative animators is that they can turn the current level of technology into a compelling story at any time. After all, Disney animators turned pencil on paper and paint on cels into *Snow White* in 1937.

The one necessary technological leap for Central Dogmatic digital movies was motion blur. We understood this—without knowing how to solve it—after suffering as spectators from the unpleasant judder of Ray Harryhausen's famous stop-motion battling skeletons in *Jason and the Argonauts* (1963). The only technological barrier keeping, say, *The Works*, from being made—given enough Moore's Law power, of course—was the lack of a feasible motion blur solution. But back to reality, motion blur wasn't effectively solved until the Cook, Carpenter, and Porter Proletariat trio did so for *André & Wally B.* (1984)—as displayed dramatically in Porter's spectacular picture *1984* (figure 8.9). But in 1985, we *did* have a good motion-blur solution.

I've presented several technological techniques in these pages. A sampler includes fractals, particle systems, and patches in modeling. And texture mapping, bump mapping, Phong shading, and ray tracing in rendering. But the claim is that none of these—save motion blur—was *required* for The Movie. It's as hard to think backward along the Moore's Law curve as it is to think forward—unless you were there. It's almost impossible for us now to imagine the world without these techniques and the concomitant level of Moore's Law computational power.

I argue this by noticing that with every five-year turn of the Moore's Law crank many more techniques become possible. And they are often used to make adherence to the Central Dogma increasingly dramatic. Although it's not a law, one can think of a "conservation of production" being maintained. As Moore's Law exponentially contracts movie computation time, the computational demands of improved modeling, animation, and rendering techniques expand to keep the total production time constant, on the order of, say, a year or so. This "constancy" is sometimes known as Blinn's Law, credited to Jim Blinn.

In practice this means that the computer graphics community unceasingly invents new algorithms and improves older ones. And they refine the production process in ever more efficient ways. On the quest for The Movie, it meant that we kept technological advance on a high burner while we waited for Moore's Law to deliver.

Moore's Law 10,000X–10,000,000X (1985–2000)

Lucasfilm Begets Pixar

George and Marcia Lucas divorced in 1983. Since California is a community-property state, George effectively lost half his fortune overnight. Over the next couple of years this resulted in the Computer Division's being split into distinct units that could be sold off. First to go was the Digital Audio Group and its product, SoundDroid, and the Video Editing Project and its product, EditDroid. They were made part of a spinoff called The Droid Works. The only part that George wanted to keep within Lucasfilm was the Games Project. It would become LucasArts. This left only the Computer Graphics Project to deal with.

I walked into Ed Catmull's office near mine and announced, "We're going to be fired, Ed. George has never really understood who we are, and he can no longer afford us." Then I used a religious word meaningful to both of us, "It would be a sin to let this world-class group disperse. Let's start a company to give them a home." This was two computer nerds talking to one another. Neither of us had more than a middle manager's sense of budgets and resources, nor any detailed notion about raising money.

Ed immediately agreed and we proceeded to A Clean Well-Lighted Place for Books, a popular bookstore in nearby Larkspur Landing, next door to San Rafael, where the ferries to San Francisco embark. We bought two books each on how to start companies. I bought the two slim ones in figure 8.16. This correctly calibrates our level of business expertise at the time.[33]

"What will the company do?" Ed asked reasonably, given that we both knew the Computer Graphics Project couldn't become a separate company that depended on

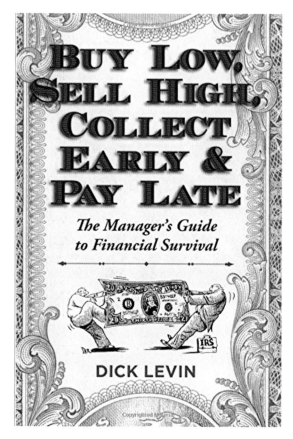

Figure 8.16

movies, not yet. Or more importantly that it would be difficult to capitalize our company on the prospect. The Monkey King project had convinced us that we needed another crank of Moore's Law, another five years and its order-of-magnitude improvement, to produce a movie cost-effectively. We'd have to do something else in the meantime to hold the team together. Calculations convinced us that neither a software company nor a digital effects and commercials house would produce revenues enough to support our group of forty people. It had to be hardware.[34]

And, we had a prototype special-purpose computer, the Pixar Image Computer, which the group had built for George Lucas, as part of a system for digitizing the optical printer. Let's follow standard Silicon Valley practice, we argued, by raising capital on the prototype and taking it into production. We didn't have any other ideas. This had to be it. Hardware might be able to pay for our group and keep it together for five

years while we waited for Moore's Law. A moment's reflection should have reminded us that we didn't know much about marketing, sales, hardware engineering, manufacturing, finance, human resources, and so forth—not outside of a research department level anyway. Those four little business books were going to teach us all that, presumably. We were desperate to keep the group together, get to that first Movie, and get paid while we waited.[35]

So Ed and I wrote up a business plan to build and sell Pixar Image Computers, "supercomputers for pixels," and to keep a small team of computer animation experts—centered on John Lasseter and Bill Reeves, assuming they would go along with the plan—alive for the next five years ready to make The Movie once the call came. Now we had to capitalize the company.

But first, we had to sell the idea of it to the 38 other members of the Lucasfilm computer graphics group. Ed and I took each of them out, usually one at a time, to a favorite Thai restaurant in downtown San Rafael. We described the plan, emphasizing that each employee would own a piece of the new company. Collegial to the end, we meant *everybody*, regardless of job description.

And we needed a name for the entity. We were egalitarian there too. Everybody had a try at creating a name and trying to convince the others. We had failed once before on this front. We had tried repeatedly to name the Lucasfilm computer division something cool like Industrial Light & Magic. Even George Lucas had tried. But no two people could agree, so it remained Computer Division. Here we were again. We used a placeholder for a name in the early documents. GFX (pronounced "graphics") lasted a while, but it was unsatisfactory, and a name search found that it was already claimed anyway.

Finally, it came time to submit the incorporation papers to California's secretary of state. A name was required for this formal step. In desperation I appealed to the group, "You know, everybody associates us with the word 'Pixar' now because it's become the short name for our computer. Why don't we just use Pixar as our company name?" There was a general groan of disappointment and disapproval, but we were out of time and nobody had a better suggestion. That's how Pixar got its name. I've already explained how we named the computer based on a fake (or let's say "coined") Spanish verb, *pixar*, meaning "to make pictures." So Pixar is a company that makes pictures. Come to think of it, it makes fake pictures—as in not based on, or taken from, reality. But rather than saying "fake" pictures, let's instead call then unreal pictures.

Birth Pangs
Ed Catmull and I began the grind of finding funds for our new company in mid-1985. George Lucas's business managers were keen on helping us since part of any deal would

rebound to Lucasfilm. But we didn't know how long we had before they would simply pull the plug on us.

The first idea was to approach the VCs, the venture capitalists, who famously funded startup companies in Silicon Valley. With the clout of Lucasfilm and the help of Lucasfilm business managers, we approached 36 VC or investment banking firms. But we didn't fit their idea of a seed capital startup—and they all turned us down.[36]

Then we turned our minds to making a "strategic partnership" with a large corporation instead. Of the 10 we talked to seriously, 8 turned us down. But we almost closed a joint deal with two vast corporations, General Motors and Philips—GM was the largest in the world at the time.[37]

We dealt with the GM division that had formerly been a separate company, Electronic Data Systems, headed by H. Ross Perot. He was the same man who would run for US president several years later. GM saw our technology as a way to replace their expensive clay modeling technique for new car designs.

Then Philips decided to partner with GM to share the financing load. We had a new rendering technology that yielded three-dimensional internal views of human beings from CAT scans—without surgery—a potentially revolutionary medical imaging advance.[38]

It came down finally to a crucial meeting in midtown Manhattan, in a boardroom at the Philips building high above Grand Central Station. We signed a letter of intent with GM, Philips, and Lucasfilm, dated November 7, 1985.[39]

But the deal never happened. Unknown to us and perhaps to everybody in that boardroom, H. Ross Perot had three days earlier berated the GM board of directors about their purchase of Hughes Tools for over $5 billion. No board member had ever objected at a GM board meeting before—not since the Depression! That wasn't supposed to happen. It took a year before Perot actually left GM, with $700 million to encourage him to do so. But it was immediately clear, when the news broke in the *Wall Street Journal*, that anything at GM that involved Perot was dead. Our deal fell right in that crack.[40]

This is a good place to remember that the larger idea of this book is Digital Light and not just digital movies. Notice that neither auto-body simulation for GM nor medical imaging for Philips had anything to do with digital movies. But both were parts of Digital Light. Auto-body simulation is part of computer-aided design (CAD), although in our case GM was more interested in pictures of autos we would render from internal computer models than with the objects themselves. And medical imaging is part of image processing—taking pictures (of the human body) rather than making them. We had explored several other parts of Digital Light as well, such as geological imaging

for oil wells, intelligence satellite imagery, heat stress testing of mechanical parts, gas dynamics. We were ready to exploit any of these avenues to obtain funding to keep us alive for the ultimate goal of The Movie.

GM-Philips had been our last hope, our forty-sixth attempt at such funding. Ed and I were frantic now. Lucasfilm had finally run out of patience. In the airport limo on our return trip to California, we came up with a Hail Mary—go back to Steve Jobs.

Three months earlier, on August 4, 1985, Steve had invited Ed, me, and Ajit Gill, our financial manager, to his mansion at Woodside, not far from Palo Alto. Steve had just been ousted from Apple. He proposed that he buy us from Lucasfilm and run us as his next company. We said no, we wanted to run the company ourselves, but we would accept his money. And he agreed.

But when Steve presented his proposal to Lucasfilm, they paid him no heed. His number was $7 to $14 million. GM and Philips were talking $20 to $36 million. And that deal was proceeding nicely.

But now that the GM-Philips deal had fallen through, Ed and I decided to call Steve and ask him to make exactly the same offer again, the one with a valuation less than half of the deal that just went sour. We believed Lucasfilm, at the end of its tether, might go for the reduced amount. Steve did that very thing, Lucasfilm did go for it, and that's how Steve Jobs became the venture capitalist who financed Pixar. Note that he did not *buy* Pixar as very often misreported. He financed a spinout corporation that was partially owned by the employees.

The deal was much as we had discussed back in August. Ed and I would run the company as president and executive vice president. Steve would be majority shareholder, and the three of us would be the board. And all our employees would get a share of the company. Steve took 70 percent and the employees 30 percent. Ed and I took 4 percent each and all 38 other founding employees took smaller pieces on a graduated scale. Steve capitalized the company with $10 million. We took the first check from him at the signing for $5 million, and Ed immediately endorsed it over to Lucasfilm to purchase rights to the technology we had developed at Lucasfilm, including the Pixar Image Computer. It was an exclusive right except that Lucasfilm got to use the technology as it existed when we departed.[41]

Pixar was born February 3, 1986, in San Rafael, north of San Francisco. We had managed to keep the team together, including our nugget of an animation unit. And, as all startup entrepreneurs have to believe, we thought we had an exciting product in the Pixar Image Computer. Meanwhile Steve was running NeXT, yet another hardware company, about an hour and a half away, south of San Francisco. That physical separation turned out to be a godsend.

Five Years of Hell and Six Sparkling Jewels

We kept the possibility of The Movie alive during the next five years with a series of short films, created by Lasseter and Reeves and their team. This honed their skills, let us further develop our modeling, animation, and rendering algorithms, and elevated our spirits. Among these short pieces was *Luxo Jr.* (1986), the first computer-animated film since *Le Faim (Hunger)* (1974) to be nominated for an Academy Award. It was certainly the first Central-Dogmatic three-dimensional animated film to be so honored. Then *Tin Toy* (1988) won the 1989 Academy Award for Best Animated Short Film, not because it was computer-animated but because it was an excellent short film. Lasseter and Reeves shared the Oscar for this achievement—the first Oscar for Pixar of many to come. The other Pixar shorts from this period were *Red's Dream* (1987) and *Knick Knack* (1989). These were four of the sparkling jewels that sustained us during these otherwise tough years.

Each one of these pieces represented continued improvements in the underlying in-house technologies. For example, *Luxo Jr.* incorporated the first articulated objects that self-shadowed themselves, from multiple light sources. Two of the light sources, the two lamps, were in the scene itself, another first.

Artistically, *Luxo Jr.* was John Lasseter's attempt to convince his animation colleagues elsewhere that the computer was not a hard, rigid, linear, arithmetic machine somehow antagonistic to their artform. In that he was spectacularly successful. Everyone, especially other animators, responded to the personalities of the two lamps. The looming question was not are they alive, but what is their gender? Father and son? Mother and daughter? Viewers could care less about the underlying geometry and self-shadowing. And John purposely didn't specify the genders. They were whatever you chose them to be.

As another example, the second jewel, *Red's Dream*, was designed to show off our hardware product, the Pixar Image Computer. The principal background for the piece, a bicycle shop, was the most complex computer graphics scene ever rendered at the time.

The fifth jewel was CAPS, the Computer Animation Production System we created for Disney. It kept Pixar and Disney close in a mutually admiring relationship and was a major source of income for the fledgling Pixar. Every Disney cel animation for years was executed on the system, using Pixar Image Computers running software written by Pixar people (and logistic software written by Disney people). Disney first used CAPS for one scene in *The Little Mermaid* (1989). The first complete movie using the system was *The Rescuers Down Under* (1990). CAPS was eventually used for a total of 18 Disney feature films. And Disney was a principal customer of Pixar Image Computers. That was part of the CAPS deal.[42]

But Pixar was a lousy hardware company. The hardware wasn't lousy, but the company was. And even the famous hardware manufacturer Steve Jobs, holding a majority of the company and sitting on the board, wasn't enough to make it a successful one. We failed several times over these five years. That's failure measured the usual way: we ran out of money and couldn't pay our bills or our employees. If we'd had any other investor than Steve, we would've been dead in the water. But at every failure—presumably because Steve couldn't sustain the embarrassment that his next enterprise after the Apple ouster would be a failure—he'd berate those of us in management . . . then write another check. And effectively devalue employee equity. After several such "refinancings," he had poured about half his $100 million Apple fortune into Pixar. In today's money, he'd put about $115 million into Pixar. On March 6, 1991, in Pixar's fifth year, he finally *did* buy the company, but from the employees, not from Lucasfilm in 1986 as later portrayed. Now he owned it completely. We employees no longer owned even a single share.[43]

And the company was still in serious financial trouble. We tried all sorts of small things, like a television commercial business based on John Lasseter and Bill Reeves's small team. But none of these ideas had enough income-producing capacity to even hope to pay for our company. Jobs explored a notion of folding us into NeXT, but his cofounders there wanted nothing to do with it. There was really only one way out. Moore's Law had to save us by making The Movie finally economically feasible. Only movies had enough potential reward to save us.

RenderMan

> It was a wild ride. . . . My involvement with Pixar was glorious and brief, but I consider it to be one of the most fruitful and enjoyable periods of my career.
> —Jim Lawson, co-developer of Pixar's RenderMan[44]

Pixar's sixth and crowning jewel during the pre-Movie years was *RenderMan*. Its name was a pun on the Sony Walkman.[45]

The path to RenderMan began with individual shading techniques, such as Gouraud shading or Phong shading from the 1970s at the University of Utah. Then, as we saw, Rob Cook generalized the notion into a shading language at Lucasfilm in the early 1980s. He wrote his system as a front end to Lucasfilm's internal rendering solution, which was the Reyes renderer written initially by Loren Carpenter and then improved substantially by Rob. The name *Reyes* (pronounced "Rays") was Loren's clever acronym for Renders Everything You Ever Saw, or Renders Everything You'll Ever See. Reyes

honored the local Point Reyes National Seashore and was developed to run on Lucas-film's specific hardware.[46]

The next big leap was to free the shading language from the specificity of Lucasfilm's hardware. This was the leap from a specific language to a *standard* language—from one company's hardware to any company's. This was the leap that created a unified computer graphics industry—hence the importance of RenderMan.

Recall the business card universal Turing machine from the computation chapter. This machine understood a language with instructions like: "$3:4 \leftarrow$ [glyph]," meaning, "if you see a 3 on the tape square in the hole, then replace it with a 4, move one square left, and rotate the card so it looks like the glyph." Each computer has a similarly torturous machine language that is unique to that particular computer.

A breakthrough in computation was the development of standard high-level programming languages, such as C from Bell Labs, that ran on any computer. A user writes a program in an English-like language. This program is passed through a special program that the programmer doesn't have to understand, called a compiler, which converts the standard programming language into the machine language of a specific computer. When someone purchases the Unix system, for example, it comes complete with the high-level C language and a compiler for C into the low-level machine language for the machine that the purchaser owns. In a sense, there are different Cs for different machines.

Similarly, RenderMan frees a picture maker from having to know the specifics of any one company's rendering hardware. When you buy RenderMan, you get its shading language, a compiler of that language, and a complete rendering system for any specific hardware that supports the language. A moviemaker, say, has only to know RenderMan's shading language, and the RenderMan system takes care of the rest—the generation of the pixels—behind the scenes, so to speak.

The person who led the charge to the RenderMan standard was Pat Hanrahan, one of Pixar's first hires after the founding of the company. Pat is a gentle man with a ready smile who came from a world of worms to the world of computer graphics.

As graduate work at the University of Wisconsin, he specialized in the neural structure of *Ascaris lumbricoides*, the most widespread parasitic worm in the world, infecting probably a billion people. This large roundworm can reach a foot in length, with colonies of them living in the intestines, lungs, and bloodstream. It's a puzzle as to what led Pat from disgusting worms to beautiful pixels, but that's what happened. He set out in his new direction by joining the Lab at NYIT, after the Lucasfilm contingent had departed. Then he found his way from New York to California to become yet another of Pixar's resident geniuses.

The tradition of seducing personnel from other parts of the group into computer graphics continued. Jim Lawson, of the epigraph, was formerly part of the digital audio project at Lucasfilm. Like Pat Hanrahan, he also joined Pixar shortly after its founding. Jim and Pat worked together to toughen up Rob Cook's internal shading language into the RenderMan shading language that was intended for the outside world. Lawson would write the "behind the scenes" pixel generator for RenderMan.[47]

This is not the place to give RenderMan details, but a short list of some of the official terms in its now-standard shading language surely won't surprise you: *bump*, *depth*, *phong*, *refract*, and *texture*. The language lets you define light sources, shadows, and pixel spreaders. And much more.

RenderMan decoupled the artist from the tool. It was difficult for anyone outside of Lucasfilm and Pixar to use Carpenter and Cook's renderer Reyes. RenderMan made the technology available to a new group of people—both artists and technicians—outside of Pixar. With it, modeling program A could talk to RenderMan renderer X, and modeling program B could talk to RenderMan renderer Y. It all worked, even though all the pieces (A, B, X, and Y) were developed completely independently. In a sense, there are different RenderMen [*sic*] for different computers. In other words, people can use the language to write different RenderMan renderers that work with various modeling programs and run on various computers. Moving from fixed shading techniques to a shading language (Cook) was huge, and the leap from a specific language to a standard language (Hanrahan) was huge again.

Creating a good standard is hard—it must be very well designed in order to work universally and to hold up over time. There had been many previous graphics standards, but Hanrahan's was the first to incorporate programmable shading. And the flexibility that it provided is why RenderMan has endured for 30 years.

RenderMan, published in 1990, has become a Hollywood staple for visual effects and animation based on the Central Dogma of computer graphics. Instead of creating one algorithm at a time for shading triangles, each incompatible with all the others, RenderMan established a common basis for all such algorithms. It's a productivity enhancer for the process of rendering.[48]

And the industry has rewarded its developers richly. Rob Cook, Loren Carpenter, and Ed Catmull received an Academy Award for rendering contributions in 2001, the first Oscar ever awarded for computer science. Pat Hanrahan has won three technical Academy Awards, one shared with Loren, Rob, Ed, and others for RenderMan. Rob, Ed, and Pat have all been honored with Siggraph's Coons Award, its highest award. And, as I complete this manuscript in March 2020, I've just been told that Ed Catmull and Pat Hanrahan have been presented the Turing Award.[49]

The Movie Comes into Focus

Moore's Law finally ticked over another order of magnitude—to the 100,000X step. Disney stepped forward in 1991—five years after the creation of Pixar—and said, "Let's make that movie you've always wanted." They financed it, and saved Steve Jobs's face (and investment) and Pixar the company. The Movie was not Steve Jobs's idea, as sometimes misreported. Jobs was running NeXT. He never talked about movies. It was Disney's idea and our dream and goal since the 1970s.

This was The Movie, exactly what we'd been waiting for, for five painful years. But there was a problem. Our lead animator, John Lasseter, refused to work with Disney. They had fired him after all. And he was convinced that Jeffrey Katzenberg, then head of animation at Disney, was a tyrant he couldn't work with. So, Ed and I were frantic yet again.

Katzenberg understood the problem and stepped into the lurch. In 1991 he called a meeting at Disney's Burbank headquarters designed to convince John that he *could* work with Disney and with himself. Ed and I attended this crucial meeting. So did John Lasseter and Bill Reeves, our tight animator-programmer duo. And Steve Jobs came along presumably to size up fellow tyrant Katzenberg.

Katzenberg ran the meeting. He started by surprising us. "I tried to hire John away from you, but he's loyal and won't leave." We didn't know that. John hadn't told us. "So in order to get at his talent, Disney will work with Pixar to make this movie." I paraphrase Katzenberg: "John, I know you think I'm a tyrant, so what we're going to do today is this. I'll leave the room, and Steve will too. Then the rest of you can mingle with one another for hours if you wish and ask the hardest questions you can about what it's really like around here, what I'm really like." And that's what happened. John, in particular, talked deeply with animators and directors at Disney the rest of the afternoon.

At the end of the day, John and I were walking together a small distance in front of everybody else returning to our rental car for the drive to Burbank's airport. "What do you think?" I asked nervously. "I can do it," John said. I knew right then that the deal was on for all practical purposes. It still had to be negotiated and contracted, but there was nothing substantive in the way.

But I had to leave. I had to get Steve Jobs out of my life. About a year earlier he had attacked me in full bullying, tyrannical mode in what is infamously known as "the whiteboard incident." It's described summarily in Walter Isaacson's book *Steve Jobs*.[50]

Now, knowing that the 15-year-old vision of The Movie was about to be realized, I could leave Pixar. So I negotiated my departure from Pixar to start a new company, Altamira Software (for the cave, and with another Spanish name). It was based on a

pixel-editing product heavily based on the alpha channel. The product hit the market in 1994, and Microsoft bought the company a couple of months later.

Ed Catmull closed the movie deal with Disney in July 1991. We celebrated it with champagne at Pixar where I maintained an office until September 1991.[51]

Toy Story, The Movie

Then it happened! During the next four years, Pixar completed The Movie with Disney's help and it premiered in 1995. It had been 20 years since the group first got together at NYIT, and 15 years since they expanded at Lucasfilm. It was approaching 10 years since Pixar's founding. *Toy Story* had brought together a powerful outpouring of technical and artistic creativity from the geniuses we've met in this chapter, who had in turn built atop the decades of talent and achievement presented in previous chapters. The movie was a fitting exemplar of the arrival of the Great Digital Convergence. Although concentrated in the digital-movies part of Digital Light, its technologies would soon influence other parts, like videogames and virtual reality. Within a few years, three-dimensional animated features would replace two-dimensional cel animation. Digital Light had more than arrived; it had taken over.

And *Toy Story* was wildly successful almost as soon as the movie was "in the can." Pixar and Disney took it to New York City for a first glimpse by critics, and their enthusiasm was electric.

Jobs saw this and made a brilliant move that salvaged his business reputation and made him a billionaire. He decided to take Pixar public on nothing more than the promise of *Toy Story*. Pixar had little cash except what it had from selling off bits and pieces of the failing hardware part of the company, from its percentage of the sale of my company Altamira to Microsoft, and from motion-blur patent license fees paid by Microsoft and Silicon Graphics, Jim Clark's first company. The public offering of Pixar occurred on November 29, 1995, and went very well, the biggest of the year, outstripping even that of Jim Clark's second company, Netscape.[52]

So much has been written about Pixar's successes starting with *Toy Story* (1995) that I will say only a little more here. By the millennium or thereabouts, Pixar had produced three other successful digital movies: *A Bug's Life* (1998), *Toy Story 2* (1999), and *Monsters, Inc.* (2001). As of this writing (2020), Pixar has produced 23 digital movies. Disney bought the company—finally!—in 2006 for over $7 billion. This is astounding considering they could have had us for free in the 1970s when we approached them on bended knee, for $10 million in the mid-1980s when Jobs was our last-chance, Hail Mary investor, and $50 million in the late 1980s when he would have sold us to anyone to make himself whole and unembarrassed.

PDI Begets DreamWorks and *Antz*

Pacific Data Images ran a smart company. They weren't the first computer graphics company, but they outlasted all the others founded about the same time in the late 1970s and early 1980s. They used off-the-shelf computers and never made the mistake of buying or leasing supercomputers. They bootstrapped themselves into longevity by producing hundreds of broadcast television graphics, such as flying logos. In 1985 they proposed a digital movie but were unable to fund it. This is not surprising considering that we were concluding about the same time that the Monkey movie was not feasible. But this also means that Pixar should have probably been considering them as a competitor for The Movie.

PDI created several short films in the late 1980s, much as Pixar had with its "jewels" at about the same time. Some PDI jewels were *Opéra Industriel* (1986), *Burning Love* (1988), and *Locomotion* (1989).[53]

Not giving up on the movie idea, PDI formed a Character Animation Group in 1991 to gain the skills and artists it needed for digital movies. Eric Darnell joined then, an animator just graduated from CalArts, the same Disney-founded school that trained John Lasseter and Brad Bird (though Darnell graduated in experimental animation rather than character animation). He soon created a jewel of his own, *Gas Planet* (1992).[54]

In 1994 Jeffrey Katzenberg departed Disney in a power struggle with its president, Michael Eisner, and with Walt's nephew, Roy E. Disney. Then Steven Spielberg, Katzenberg, and David Geffen cofounded DreamWorks SKG (for the three cofounders) in late 1994 using a major funding contribution from Microsoft cofounder, Paul Allen.

DreamWorks SKG bought a large but minority part of Pacific Data Images in 1995. The new outfit was renamed PDI/DreamWorks, and later DreamWorks Animation when the minority interest in PDI was converted to a majority. I'll use DreamWorks as the name here. It released its first digital movie, *Antz*, on October 2, 1998, co-directed by Eric Darnell.[55]

After *Antz*, Eric worked as a story artist on *Shrek* (2001), DreamWorks's second digital movie. A new Oscar category was created in 2001 for Best Animated Feature Film. *Shrek* was the first digital movie to win it, beating out Pixar's *Monsters, Inc.* (2001).

DreamWorks has of this writing (2020) created many digital movies, including the four in the *Madagascar* franchise, five in the *Shrek* franchise, six in the *Kung Fu Panda* franchise, and three in the *How to Train Your Dragon* franchise.

PDI and DreamWorks deserve much more attention than I have room for in this chapter. I've only told their story in relation to the flows that created Pixar. The many technological advances made by this group deserve full treatment by someone, and the

individual players should each be developed. The same should be said for MAGI and Blue Sky, summarized next.

MAGI Begets Blue Sky and *Ice Age*

> They were projecting their imaginations into it and inflating it, so it seemed almost as if the characters were reaching off the screen. The space between the seats and the screen was filled with this very palpable energy of engagement and the fluctuation of that—or the intensity of it—became the only measure of creative integrity that I've ever cared about from that moment forward.
>
> —Chris Wedge, director of *Ice Age* (2002), about the audience at its first screening[56]

MAGI and NYIT were both downstate New York computer graphics studios in the late 1970s, located about 20 miles apart as the crow flies—but only as the crow flies. New York City lay between.

Carl Ludwig was the Celco consultant at MAGI who worked with NYIT's David DiFrancesco in the late 1970s when David was considering the purchase of a Celco film recorder. MAGI used a Celco recorder for its part of Disney's *Tron* (1982), and subsequently hired Ludwig, who proceeded to improve MAGI's ray-tracing software.

Chris Wedge was the principal MAGI animator on *Tron*. Then he and Disney's John Lasseter worked together on the Wild Things test there in 1983, Lasseter on the two-dimensional foregrounds and Wedge on the three-dimensional backgrounds.

In February 1987 Wedge, Ludwig, and four others from MAGI cofounded Blue Sky Studios on the East Coast after MAGI shut down. This was almost exactly a year after Ed and I cofounded Pixar on the West Coast in February 1986. Blue Sky stayed afloat for the first few years with television commercials and feature-film effects.

And they had their jewels too. Two early ones were created by Chris Wedge. The first was a series of computer-animated shots of cockroaches in the mostly live-action movie *Joe's Apartment* (1996). And 20th Century Fox was impressed enough by Wedge's contribution to acquire Blue Sky in 1997.

Meanwhile, Wedge was also working on his second jewel, a short computer animation called *Bunny* (1998). It won an Oscar for Best Animated Short Film in 1998. Blue Sky was ready for the big time.[57]

Ice Age (2002), with Wedge directing, was the company's maiden voyage in digital movies, the first of many successes. *Ice Age* was nominated for an Oscar in 2002 for Best Animated Feature Film. As of this writing (2020) the company has produced 13 digital movies, including 5 in the *Ice Age* franchise alone.

As I've said before, this is far short of the full treatment that MAGI and Blue Sky should receive. But here is not the place. What is right and true is that Pixar, Dream-Works, and Blue Sky in short order celebrated the Great Digital Convergence with feature-length digital movies at the millennium.

In the final chapter, I reopen the discussion to all Digital Light. Lest the dazzle of The Movie and its siblings blind us, we need to reestablish the truly gigantic sweep of Digital Light, of which the digital movie branch is a mere example.

Taking Stock

This concludes our quick trip through the first 30-odd years of Epoch 2 computer graphics, from the first color pixels of 1967 to the first digital movies at the millennium. Moore's Law was the unrelenting player throughout those years. From a factor of 1 in 1965, it exploded to a factor of 10,000,000 at the millennium—seven orders of magnitude! The first color pixels required it, and the first digital movies even more so. There would be no story here without Moore's Law and the creative engineering triumphs it represents.

We've stopped at the millennium, just before the big computer animation studios made their many billions of dollars. I've barely touched on the almost two decades since then, during which the Moore's Law factor has reached 100,000,000,000X—four more orders of magnitude! It's the raw fuel of the ongoing revolution and the studio successes. It's made VR practical at last.

The digital movies are only a drop in the vast ocean that is Digital Light. Yet many lessons from the movies can be used to understand the rest of Digital Light. For example, the narrative form of VR is essentially two digital movies computed in real time, one for each eye for the stereo effect. Add interactivity to the mix to get the game form of VR. Everything you know about modeling, rendering, pixels, displays, antialiasing, animation, and the Central Dogma transfers directly from one realm to the other.

The theme of many chapters of this book has been the schema of (1) an idea, (2) chaos that drives it, and (3) a tyrant—or less pejoratively, a patron—to provide, often unwittingly, enough space or protection to realize the idea. In this chapter, the driving idea was that a computer could make feature-length animated movies. The chaos that drove their creation was the disruption of the universe caused by the awesome Moore's Law explosion. The only way to understand the disruption of seven orders of magnitude is simply to live it and ride the wave, as it reveals itself one order of magnitude at a time.

As for tyrants and patrons, Pixar's original patron was Alexander Schure, who first provided us a beautiful place and the right equipment—the best in the world at the time—for early development. Uncle Alex was the strangest of the wealthy patrons of the group now known as Pixar. He was the first—so the bravest, or the craziest—of them all, and the only one who lost everything. Next were George Lucas and Steve Jobs, who both became billionaires, with Jobs's first billion coming directly from his Pixar investment. Informally, there was a fourth and unsung patron, Roy Disney, Walt's nephew, discussed in the movies and animation chapter. He stepped forward at two crucial times with his influence. As a result, the Disney company eventually purchased Pixar, owns it now, and has made billions from it.

But our dominant patron, Steve Jobs, was also our dominant tyrant. He provided, presumably to salvage his ego, the money and the time that made it possible for us to ride through the last several years of hell to implement the great idea of The Movie.

Steve had nothing creatively to do with *Toy Story*. Ralph Guggenheim, who made first contact with Lucasfilm at NYIT and became Pixar's coproducer for *Toy Story*, stated in a recent book, "I would say between '86 and '95 when *Toy Story* came out Steve probably—I'm not exaggerating—I don't think he was in our building more than nine times in nine years." Steve did like to have John Lasseter visit him and show him partial movie results so he could talk the talk. But just as Ed and I never let Steve in Pixar's buildings if we could avoid it, Lasseter never let Jobs into a Pixar story meeting. It hardly mattered. Steve was running NeXT at the time, an hour and a half away, and its serious financial problems kept him busy.[58]

But Jobs leapt at the critical response to the completed *Toy Story* and—brilliantly— took Pixar public. Part of Jobs's marketing story for the public offering was his new myth that he had cofounded Pixar and run it as CEO from inception. Neither claim was true, as is well documented. And he made sure *he* was standing before the cameras at the release of *Toy Story*, not Ed Catmull.[59]

About Explanation

I don't expect you to be able to render a movie after reading these chapters, but I do hope that the mystery of extracting a movie from a computer has been greatly reduced. The process is essentially this: compute what average color properly represents each pixel location. This can be, and often is, a complicated computation. But it's a computation—a well-defined process of many steps. That's what a computer does. It repeats this computation at each pixel, millions of times for a frame of a movie. Then it repeats the computations again, millions of times per frame, for over a hundred thousand

frames. It's the glory of Amplification that makes this astonishingly large number of computational steps happen in a reasonable amount of time—say several months to a year for a feature-length movie.

But I cannot explain the overriding mystery that resides in the several human contributions: Artists create stories with emotion-provoking characters. Animators inspirit those characters constructed from geometry. Programmers organize millions of meaningless computer steps into meaningful computations to render the stories and characters into movie frames. Engineers improve the underlying chip technology to reach ever more awesome Moore's Law speeds. All those are pure inexplicable human creativity.

In the next, closing chapter, I revisit the idea–chaos–tyrant theme as it's been instructed or modified by each technology studied. And I also review several other consistent lessons derived from the various chapters: the insufficiency of simple narrative, the genealogy of technology, the surprising flows that define each, the actual simplicity of technological ideas—and their beauty—and the existence of true magic, at least as we (don't) understand it today, provided by human beings.

A *canon* is defined as "a collection or list of sacred books accepted as genuine." I hope to establish with this book the beginnings of a canon for Digital Light, based on sacred facts not myths. It's not too late to begin this task. We're only two decades into the new millennium, and Digital Light extends indefinitely into the future.[60]

Finale: The Great Digital Convergence

In the introduction I promised to explain how pictures became separated from their media—how a wild boar trotted off the cave wall in Altamira after dozens of millennia, or how Jacques-Louis David's heroically hagiographic Napoleon rode his mighty steed off the royal walls of Europe and into the opening pages of this book.

That explanation required me to develop an underappreciated key idea—the pixel. And *that* led directly to Digital Light, the vast pictorial domain mediated by pixels which dominates the modern visual world. It's so vast, in fact, that I selectively pruned the Digital Light parts to fit inside the book while faithfully representing the topic as a whole. The unexpectedly sophisticated pixel binds it all together and makes it possible to generalize the specifics of the chosen parts to the entire domain.

In this final chapter I zoom out far enough for us to see all Digital Light again. I discuss what's happened in the two decades since my chosen end point for the story, at the millennium. That was four orders of magnitude ago, by Moore's Law, and computers have become 10,000X more powerful in the interim—compliant with the "Law."

The revolution proceeds, so I also attempt to do what the phrase "orders of magnitude" suggests is impossible: predict what might happen next as the Moore's Law Amplification factor races for 1 *trillion* X in 2025, and then . . . it's not quite infinity and beyond, but the numbers are nevertheless mindbogglingly big. What might that future hold?

But first, let's review and comment on the key fundamental technological points.

The Separation of Picture from Display

Digital Light is *any* picture composed of pixels. It's a *very* broad class. It includes almost all the pictures in the world today. In fact, because of the digital explosion, Digital Light includes nearly all the pictures that have ever existed. But that became true only

recently, beginning around the year 2000, the millennium—in an unheralded event I call the Great Digital Convergence. The change crept upon us quietly and unremarked—and quickly—seemingly overnight. All media types converged into one—the universal digital medium, bits. The separation of pictures from their display became complete. But how could a convergence be a separation?

The answer lies exactly in the difference between a *pixel*—short for *picture element*—and a *display element.* The conflation of these distinct kinds remains one of the most prevalent technical confusions in the world today. Both are often called "pixels," but that just cannot be. A *pixel* is a digitized sample of a visual scene at a point. We can't see a point, hence we can't see a pixel. The little glowing area on a display that we can see is an analog reconstruction from an underlying, unseen pixel. We call such a tiny glowing spot a *display element.*

A display element takes a digital pixel as input and outputs an analog blob of colored light. We say that a pixel must be *spread* by a display element to be seen. Those blobs of color—which, by the way, are hardly ever little squares—overlap to form a smooth continuous picture.

Pixels are discrete, spiky, separated, digital, and invisible. Display elements—spread pixels—emit smooth, continuous, overlapping, analog, and of course visible glows.

Pixels are universally valid, but display elements are far from universal. Display elements differ from device to device and manufacturer to manufacturer.

Pixels succinctly represent a picture. Display elements, driven by those pixels, display it. That's exactly the separation of a picture from its display that has changed the modern picture world . . . and called for my efforts in this book to clarify the pixel/display confusion.

When all pictures could be represented by pixels, the need for other media types disappeared. This was the moment of the Great Digital Convergence. Thus, the separation of digital pixels from analog display elements enabled the convergence of many analog media types into the one digital, or universal, medium.

The fact that pixels are universal is why the Great Digital Convergence works. I can take any of the pixels in my cellphone and send them to the display of my laptop, my desktop, my inkjet printer, my television set, the television set in an arbitrary hotel room, to my wife's phone, or her laptop, to a PowerPoint projector in an arbitrary lecture hall, etc. Or over the internet to you and your devices. The display elements of these devices vary considerably, but in all cases, the pixels are the same.

My cellphone contains thousands of pictures, each with millions of pixels. I suspect yours is much the same. Clearly, the pictures are "in there" somewhere but you

can't see them. If I ask to see one of the pictures, then *at that moment*—seemingly instantaneously—the spreading of the pixels occurs, and the picture display is reconstructed from its pixel representation.

That this scheme works is a gift of the great Sampling Theorem—a mathematical triumph. The fact that it happens so fast and at such high resolution is a gift of the great Moore's Law—an engineering miracle.

The quiet but revolutionary changeover to this scheme happened coincidentally at the millennium. It became standard then—not very long ago—to assume we could see our pixels whenever and wherever we wanted. There would always be a display device, one that understood the universal medium, available to us for our viewing pleasure. That's the meaning of the Great Digital Convergence.

The Pixel as Fundamental Particle of Digital Pictures

But what exactly is a pixel? And how could a discrete grid of them—a spiky bed of nails—represent a smooth visual field accurately? The fundamental theorem (fancy for "truth") of Digital Light answers all this. It's the Sampling Theorem, brought to us in full modern form by Vladimir Kotelnikov in 1933. His surprising mathematical result is the backbone of all modern visual media (and audio too). The theorem says that to accurately represent a visual field, take samples of it on a regularly spaced grid of points—hence the bed of nails—where the spacing must meet a certain criterion: the frequency of spacing of the samples must exceed twice the highest Fourier frequency in the scene.

That's abstract and unintuitive enough to explain why most of us don't yet know what a pixel is. Let me state the definition succinctly, putting slight adjustments in parentheses for accuracy: A pixel is a (digitized) sample of a visual field taken at (greater than) twice the highest Fourier frequency in it. So long as you recall the parenthetical bits, you're free to omit them in stating the definition in a memorable way: *A pixel is a sample of a visual field taken at twice its highest frequency.*

That curious word *frequency* dominates the definition, as it does the Sampling Theorem. So I devote the first chapter of this book to explaining what a (Fourier) frequency is. Joseph Fourier's great idea is this: A visual field can be represented as a sum of waves of different frequencies and amplitudes. It's music. Most people understand that music is a sum of sound waves of different frequencies (pitches) and different amplitudes (loudnesses). Fourier teaches us that the same is true of a visual scene. It's a sum of color brightness waves of different frequencies and amplitudes.

I'm writing this final chapter in a castle in Scotland. A potato chip product (figure 9.1), for sale in a nearby shop, will help you visualize the relationship of furrows to corrugations in my explanation below.

A brightness wave can be pictured as an extensive piece of corrugated sheet metal or furrowed potato chip. Its frequency is how fast it wiggles up and down spatially (say four wiggles per inch for the chip), and its amplitude is the maximum height (brightness) of its wiggles. The surprise is that adding together corrugations or furrows of different wiggle rates and brightness heights gives you a picture of, say, your child or pet, or the Grand Canyon, or the Milky Way. Brightness waves are spatial, and loudness waves are temporal, but the math doesn't distinguish between the two. Whatever works for one also works for the other. That's what Fourier taught us.

I hope you'll start to see the musical structure of the visual world—its frequencies. They're everywhere and can quickly become a new way of seeing.

Fourier's idea is an alternative *analog* way to represent an analog visual scene. Kotelnikov's idea is a *digital* way to represent an analog visual scene. His Sampling Theorem starts with the Fourier representation and tells us how to take pixels from it, and then how to view the original scene from them when we so desire. It's the Sampling Theorem that makes the second half of the pixel definition—the twice the highest Fourier frequency bit—so important. The second chapter explains how this magic works, which justifies devoting the first chapter to Fourier's waves.

Another purpose of the second chapter is to show that digital is not somehow less than analog. Taking samples seems to imply that the infinite amount of information between samples is lost—that digital is only an approximation—but it's not so. The Sampling Theorem, if correctly applied, proves that digital discards nothing. Instead, it's an extremely clever repackaging of infinity.

Computation as a Principal Source of Digital Light

Half of Digital Light—the make part (as opposed to the take part)—originates in computers. So in the third chapter I explain the third great foundational idea of Digital Light: computation, and the machines called computers that make computations go fast . . . and computer-animated movies possible.

The central idea is easy to understand: a computation is a careful process accomplished by breaking it into a sequence of smaller, simpler steps. But that innocuous sentence is not nearly as pedestrian as it might seem. It contains multitudes.

The young Cambridge student Alan Turing in 1936 was the first to fully grasp it, name it, and discover the surprises in it. There were predecessors who glimpsed the

Figure 9.1

promise of computation—Leibniz, Babbage, Lovelace—but it was Turing who finally and completely captured it, in a stroke of amazing genius. He solved a difficult mathematical problem—called the eProblem here—with a simple machine. His solution—using what we now call "a Turing machine"—revolutionized the world. It was a paper machine of such astonishing simplicity that his mentor Max Newman at first thought it only a toy.

I designed a Turing machine out of a business card and some paper tape to demonstrate in chapter 3 just how simple they are. It can be "operated" in one of four orientations, and it uses an alphabet of six symbols. That's it. But this machine can compute anything that is computable in the world. It's an example of Turing's most profound result: there is *one* machine that can compute what *any* other such machine can compute. We call it a *universal Turing machine*. That's the idea from which the modern computer directly springs, and which sets Turing apart from his intellectual forebearers.

But the details of his discovery matter. He showed that the computation of any one specific Turing machine could be encoded into a string of symbols. We call this a *program* today, and we often call programmers *coders*. Turing showed that if a program is stored as if it were data in the universal machine, then that machine can simulate the specific machine encoded in the program. In other words, it can compute the same thing that the specific machine does. So, by simply changing the program, the universal machine can compute anything. Not only had Turing thoroughly described computation for the first time, but he had invented the *stored-program computer*. All modern computers are universal stored-program computers. They are Turing's idea made to go fast.

But before exploring what that means, let me stress the marvels of computation, one of the most profound ideas of all time, yet now so ordinary. Turing's idea was and is so large that it encompasses all known ways of executing careful process. Another way to put it is this: The computer is the most malleable tool that humankind has ever made. The number of possible computations is beyond understanding. Nobody has ever discovered a careful process that cannot be accomplished with a stored-program computer. So, after about 80 years of experience, we now believe that the two ideas, careful process and computation, are equivalent.

A computer is sometimes thought to be a hard-edged, rigid, deterministic, very complex, number-crunching machine. Such a machine certainly could have nothing to do, some think, with subtlety, mystery, art, grace, or intelligence. Assumptions about what kinds of pictures people can produce with computers are all too often colored by such misperceptions. That's why, in chapter 3, I bust open five myths to reveal the true beauty of computation.

First, computations are about much more than number crunching. They're about pattern manipulation. To be sure, one of the popular patterns we often manipulate are numbers, but to think computers are bound by numbers is wrong and hampers our imaginations. Part of this particular misunderstanding can be traced to the notion that computers are basically 0s and 1s and therefore intrinsically based on numbers. But there are no little 0s and 1s in a computer. Both 0 and 1 are simply names for two states, usually two voltages in a modern computer. We could just as well, but not so conveniently, call them Mutt and Jeff. Computers are about changing patterns of states, not doing arithmetic.

Second, the belief that computers must be made of bits (with two states named 0 and 1, of course) is wrong. The business-card machine we "operate" is made of four states, not two. It's 4-ary, not binary. And those states are orientations of the business card, not numbers. But, as I explain in the fourth chapter, all modern computers *are* made of bits. That choice turned out to be our path to awesome speed—to the second miracle of computation called Amplification—but it's not required.

Third, computers don't have to be electronic. Again, however, because of our unquenchable thirst for speed, all computers *are* electronic. Like the choice of using bits, electronics turned out to be our path to astonishing Amplification. But it's also not required.

Fourth, computers are deterministic, but that doesn't mean what it might seem to. Determinism is perhaps the most misunderstood aspect of computation. I state what Alan Turing discovered this way: *determined in the small does not imply predetermined in the large*. It's true that each step a computer takes is simple and completely deterministic. And it's true that the ultimate outcome of any sequence of such steps must be completely determined. But it doesn't follow that we can predict, or predetermine, what that outcome will be. A computation, in general, may not be predictable despite the fact that every step is determined. *In general, the only way to know for sure what a computation will do is to perform it.*

This doesn't normally affect Digital Light—we usually know what our computations are going to do—but it's offered to calibrate our notions of computation. Assuming computers are rigid and deterministic doesn't do computation justice. Some have thought that computers couldn't possibly be a model for the human brain because of that rigidity and determinism. But scientists are hard at work on artificial intelligence (AI), another idea first pursued by Alan Turing. Compare the following sentence to the similar one about computation in the preceding paragraph. *The only way to know for sure what human beings will do, in general, is to stand back and watch them live their lives.*

The fifth and final myth is that computers are complex, when what we really mean is that they do lots of simple things very fast. Each step a computer takes is simple and meaningless, an operation like "shift the bits left (or perhaps right) by one position." There is a mystery of complexity here, but it's not complexity of the computer. It's our inability to explain how a person creates a list of thousands, even millions, of dumb steps that does something meaningful, like compute a movie. It's the complexity—mystery even—of human creativity.

In the early days of Digital Light these misconceptions led people to think that a computer could only produce limited kinds of pictures. For example, it was originally assumed that computers could make only blocky pictures, or that animated movement had to be along graceless straight lines. But no such limits actually existed. Convincing avatars of human beings in subtle motion, and complex emotion, have been computed and projected on the big screen.

The foundational ideas give us enough machinery to present a taxonomy of Digital Light, to help us talk about roads taken and not taken in this book.

Varieties of Digital Light Experience

Distinction 1: Take versus Make, Shoot versus Compute

> Construction: Draw a distinction.
> Content: Call it the first distinction.
> —G. Spencer Brown, *Laws of Form*[1]

The first distinction in the world of Digital Light turns on the origin of a pixel. If it's a sample of the real world, then we say it is *taken*. We *take* such pixels from the real world by sampling the real world and digitizing the results. A common way to obtain such pixels is with a digital camera—the one in your cellphone, for example. We say we *shoot* such pixels. This is true whether we're taking snapshots, or still photographs, or a video sequence (which samples time as well as space).

If a pixel is created from scratch, then we say it is *made*. The usual way to *make* a pixel is by performing a computation with a digital computer and filling the pixel with the results of that computation. There is no necessary connection between a pixel we *compute* and the real world. In fact, these pixels are often associated with fantastical worlds.

The take versus make distinction is the same as the difference between *analytic* and *synthetic*. So is the shoot versus compute distinction.

This first distinction divides the vast world of Digital Light into its two major sub-fields. The analytic half goes by various names, which we clump together and generically call *image processing*. Similarly, the synthetic half is generically called *computer graphics*. Indeed, an early academic journal of the field was called *Computer Graphics and Image Processing*. To be tenable, this book is devoted mostly to just the computer graphics "half." Except for the occasional mention, it omits image processing. To understand how massive a lacuna that creates in the body of Digital Light, consider the following examples from the omitted half: *all* photos made with your cellphone, *any* video you make of your child or pet, *all* space station and Mars rover videos, *all* hurricane and severe weather videos, *all* modern movies of live actors shot in the real world, *all* cable television news shows (excluding the highly synthetic commercials and logos), *all* spy satellite imagery, *all* rearview mirror displays in modern cars when in reverse, and so forth on and on, are examples of analytic Digital Light.

But the pixels of this analytic (or take) half of Digital Light obey the same rules as those of the synthetic (or make) half. Fourier's frequency idea applies. Kotelnikov's Sampling Theorem applies. The distinction between pixels and display elements is the same. The image file formats are the same. The display devices are the same. Pixels are pixels. Digital Light is *one* thing. Only the methods used to fill the pixels with meaningful bits differ. If you understand how pixels work, then you have a handle on *ALL* Digital Light.

Distinction 2: Object versus Picture

Because of the finite amount of space in an actual book, I have further subdivided synthetic computer graphics. The distinction is based on intent. If the main purpose is to generate an object in the real world—a car, house, or toaster, say—we'll call it *computer-aided design* (CAD). If the intent is a picture, not an object, then we enter the world of *picture-oriented computer graphics* (often shortened to *computer graphics* when it's clear that only pictures are intended.)

The histories of the two subfields—CAD and picture-oriented computer graphics—are highly intertwined and share originators, as I explain in the sixth chapter. After considering this overlapping early history, I don't further treat CAD in this book and leave that task to others. But, again, everything we say about pixels in this book applies to CAD pixels too.

Distinction 3: Real-Time versus Not, Interactive versus Not

A visual scene that changes through time is called a visual flow. It's a smooth analog flow and therefore subject to both Fourier and Kotelnikov techniques. Thus we can

sample it in both time and space. We're all familiar with regular time samples: in movies and television we call them *frames*.

The main path through the entirety of Digital Light in this book is via the non-real-time branch of picture-oriented computer graphics. So, defining "real time" is important, if only to confine its presentation. There are two notions that convey real time to us, so we must distinguish them.

The first notion is that the next frame in a time-varying visual flow is computed during a single frame time—the time between temporal samples. The computation is fast enough to render the next frame at the next tick of the clock—for example, every one sixtieth of a second for real-time digital video. This is *clocked real time*. The most common use of clocked real-time computer graphics is videogames, or electronic games as they are also known. I'll say more about them in a moment.

The second notion of real time is that it's fast enough to seem instantaneous to a person interacting with the changing images. This is *interactive real time*. An easy example is cursoring. A user drags a mouse across a desktop, or a finger across a touchpad, while watching a cursor move on a screen. As fast as the person moves, the screen is updated by removing the cursor from its previous position and placing it at its current position. Real time is fast enough to convince us that the cursor is rigidly tied to our mouse or finger. It's unclocked and controlled entirely by the user's movements. If the user doesn't move, then no picturing computations are performed. A common use of interactive real-time computer graphics is in the user interface to almost any app on any cellphone, tablet, laptop, or desktop computer. And to the operating system itself—say Windows or MacOS. All of these interfaces are, of course, parts of synthetic Digital Light.

A digital movie is the principal exemplar in this book. That's the part of non-real-time computer graphics in which the machine can compute as long as necessary to create a picture. To compute a movie in real time would require that each frame be computed in a twenty-fourth of a second. And the entire movie in 90 minutes or so. To show how unrealistic that is today in the movie industry, Pixar movies take months to compute and have taken as long as 30 hours for a single frame. A year has about a half million minutes. To reduce a year's computation to a 90-minute real-time movie would take a speedup by four orders of magnitude—10,000X. Assuming that Moore's Law continues to hold—and that's a very big assumption—we could expect a real-time movie in about 2040.

On the other hand, computers are now so fast that they can generate real-time pictures. That's what many modern videogames do. Furthermore, they change what they compute depending on input from the game player while gaming. So they utilize both

types of real time, clocked and interactive. The images aren't as photoreal and complex as a movie's, but the only real technical difference between the digital movies pursued in this book and videogames is how much horsepower is available. The point is that what this book covers applies to games too, although I don't concentrate on them or their particular history and heroes.

The Idea–Chaos–Tyrant Triad

One particular motif in this book—call it a thematic chord sounding throughout—involves an idea–chaos–tyrant triad that haunts technological breakthroughs. We first learn how the motif plays out in the three "foundational great idea" chapters of part I, where each triad is also tied to a single person. Then comes a second motif, when we discover that received histories of technologies are often riddled with error. In later sections, we pursue both motifs into other technologies as they are tied to groups of people.

Fourier's Waves

The story begins with a French revolutionary, Joseph Fourier. In this case, the *idea* was Fourier's great notion that all nature is music. The *chaos* that drove his world was the French Revolution and his subsequent battles with emperor and king. Napoleon was the *tyrant* who exiled Fourier to a remote department centered at Grenoble and thus unknowingly provided him space to develop his revolutionary idea.

Kotelnikov's Samples

In the second chapter of fundamental ideas we meet a Russian unknown to most Americans, Vladimir Kotelnikov. He took Fourier's great idea and erected his own atop it: the great Sampling Theorem is the subtle and beautiful idea that made Digital Light possible.

The *idea* here, in the idea–chaos–tyrant triad, is Kotelnikov's highly nonobvious sampling notion that discrete, spiky samples can *accurately* represent a smooth, analog continuum. His *chaos* was the sequence of wars that so affected the course of world history, especially in Russia—the Russian Revolution, the civil wars that followed, both World Wars, and the Cold War. His *tyrants* were Stalin's successor Malenkov, the KGB's Beria, and the Soviet secrecy apparatus with its Gulag of prison camps. In Kotelnikov's case, his protectress, Valeriya Golubtsova, Malenkov's wife, knowingly and repeatedly protected him from the chaos and gave him a home in her university.

And the Sampling Theorem *was* Kotelnikov's idea. Americans are taught—I was taught—that it was Claude Shannon's or Harry Nyquist's, but Shannon never claimed

it and Nyquist never stated it. Thus we see how stories handed down about technology are often erroneous but nevertheless part of our received knowledge. In this case, the corrupting error is almost certainly nationalism, or politics more generally. In Cold-War America, how could such an important idea be credited to a Soviet Communist?! Told with as much accuracy as possible, a proper history of each technology not only examines but also suggests why "alternative" versions exist.

Turing's Computations

The third great foundational *idea* of Digital Light comes from the digital world's famous gay martyr, Alan Turing. He singlehandedly created the concepts of the stored-program computer, computation, and programming as we now know them. His *chaos* was World War II, and his *tyrant* was the Official Secrets Act of Great Britain, which for one thing wouldn't allow him to explain his role in saving the country when he was jailed for homosexuality. (But wrongs are sometimes partially righted. The new £50 note of Great Britain will feature Turing and enter distribution in 2021.)

Turing's story unfolds in counterpoint to that of John von Neumann. Johnny's awesome intellectual powers made him one of the mere handful of geniuses in the world who understood and appreciated what Turing had accomplished—the invention of the stored-program computer. And he made it his duty to get hardware computers built in the world—to make Turing's idea go fast—with a simple architecture that has dominated computer engineering for decades.

Turing invented the concept of programming, and von Neumann participated in naming it. They both noticed that programming, or software, more than hardware, was the challenge for computation.

Two High Technologies and the Received-History-Is-Wrong Motif

Two technologies—computers and movies—contributed to the evolution of Digital Light. In the second part of this book we look at two technologies subsumed within them: Digital Light itself in computers, and animation in movies. Computers are obviously crucial to Digital Light, and we find them linked intimately with Digital Light at its birth. But movies have contributed crucial structure and terminology to Digital Light too, especially digital movies. More importantly, movies depend on the same fundamental great idea of sampling as does Digital Light. Movies extend sampling from space into time and bolster our argument that sampling is a key technological contribution to the modern world. One theory helps explain it all.

These two high technologies independently demonstrate the received-history-is-wrong motif of the book, especially as presented by their strangely flawed histories and outlined by the idea–chaos–tyrant triad for each technology, which extends to groups of people.

Computers and Digital Light

There was one major drawback to Turing's invention of the computer: it was insufferably slow. His machine could have computed Pixar's *Toy Story*, but it might have taken the lifetime of the universe to do so. So Turing launched a project to build an electronic version of his universal stored-program computer to make it go fast. He invoked what is by now a familiar rule of thumb: to make software go fast, implement it in hardware. In other words, hardware and software are fundamentally equivalent if speed is ignored. I emphasize this because modern historians are still assigning credit for the stored-program computer to hardware engineers in the late 1940s, whereas Turing had already described and used the concept in his famous paper of 1936. It was key to his proof of universality, as I show in a sketch of his proof in chapter 3.

What we mean by the word *computer* today is exactly this: an electronic stored-program computer. Turing stepped out of mathematics and joined a project in the 1940s, called Pilot Ace, to build the first such computer. He failed, for reasons I explain in the fourth chapter, but others picked up on the idea. In fact, the race was on. Several teams rushed to create the first machines, especially in the United States and United Kingdom.

What becomes clear is that many claimants for first computer don't qualify. Once again, the received stories are wrong. It certainly wasn't America's Eniac, which wasn't a stored-program computer, or England's earlier Colossus, also not stored-program. By following a careful definition of computer, it's possible to actually list the first 10 or so computers. According to that definition of an electronic, stored-program computer, Baby at Manchester in England was the first computer. It won because it had the first successful electronic memory. The memory and Baby were created by English engineers Freddie Williams and Tom Kilburn with a solution usually called a Williams tube. Turing soon found his way to Baby although he did not design or build the machine.

Meanwhile genius John von Neumann was intent on building a computer in America. His team contracted with Vladimir Zworykin (already famous for television) and his group at RCA Labs to build an electronic memory. The short version of this history is that the Zworykin team failed to get their memory working in time. The von

Neumann team got word of Baby's memory solution, the Williams tube, and immediately adopted it.

Von Neumann analyzed every computer or computer-like machine he could find. He noticed that Eniac could be converted into a computer by adding some simple hardware to make it a stored-program computer. I call the resulting new improved Eniac by the name Eniac+. There's scholarly argument, as I write, about whether Eniac+ did indeed win the "first computer" title. The two machines were born within a few weeks of one another by almost any definition of "complete," while recorded dates differ and keep the historians arguing.

I emphasize Baby in this book because it displayed the first pixels. The Williams tube stored bits on the surface of a cathode-ray tube (CRT), a dash for 1 and a dot for 0. Those were Baby's display elements (or spread pixels). They were arranged in an array. Kilburn made the picture I've called First Light in 1947, just slightly before Baby was completed in 1948.

Because of this first-computer / first-light coincidence, chapter 4 is not only a history of computers but also of early Digital Light. In that chapter I begin to elaborate another theme of the book, that a high technology hardly ever reduces to a narrative about a single creative genius. Even an explanation of the early handful of computers requires the introduction of what I call a flow chart, or genealogy, of the "family" of people involved in the creation of these important machines.

But this particular history—of computers—is the only one in the book that almost does fit the single-creative-genius mold. At the very top of the chart is Alan Turing. There is no single direct path from Turing to Baby, the first computer. Von Neumann is also near the top of the chart, as are a few others. The chart shows who influenced whom, more-or-less in correct time order. It shows how the ideas proliferated and affected the early computers. The summary is that Turing invented the concept of computer—meaning stored-program computer—while von Neumann helped to create the architecture that allowed engineers to implement Turing's idea in hardware. Baby, in fact, despite being built in England, used a von Neumann architecture. And von Neumann's American team adopted the British memory solution, the Williams tube, to make its breakthrough with Edvac and Edvac's numerous progeny.

Introducing Moore's Law in this chapter brings into play a formulation that is easy to apply throughout the remainder of the book: *everything good about computers gets better by an order of magnitude every five years*. This makes the revolutionary implications of Moore's Law, as the awesome supernova powerhouse of the Digital Revolution, more obvious than does the usual formulation in terms of integrated-circuit component density. I suggest that this mysterious "Law" measures the ultimate speed at which a large

group, say thousands, of creative people can proceed to improve a technology, under competition, when there is no ultimate physical barrier to its improvement and when the technology must pay its own way.

Meanwhile the flow chart mechanism makes it easy to visualize the international interactions, and competitions, in early computer history. The same chart lets us visualize the earliest developments in Digital Light because all the first breakthroughs occurred on the first computers. Of particular importance to this book, one of the branches of this first flow chart leads naturally to the flow chart in chapter 6. That's the branch that eventually leads to modern computer graphics, via the Whirlwind computer at MIT, a source of many of the earliest pictures in Digital Light—including probably the first animations. Then we follow that line into chapter 7 and its flow chart.

But first I interrupt the flowing story of Digital Light to introduce another high technology that influenced digital movies. Chapter 5, missing so far from this short summary, is about the old technology of traditional analog movies.

Movies and Animation

As I prepared to write this book, I noticed with dismay that I myself, with over 50 years of experience in making computer movies, couldn't tell you who built the first computer or who invented the movies. I assumed that nobody else could either. There was a systemic flaw in the telling of technological history, which I set out to understand. My solution for both technological histories is the same: First, define terms carefully. And second, use a genealogical approach rather than simple narrative.

I've just discussed the results of this approach to the history of the first computers. Much of the problem there disappeared with a good definition of the word *computer*. The rest of the problem vanished when nationalistic claims were discounted in favor of interacting families of creators. The result is an easy-to-follow history which includes the principal players and locales. It also makes it straightforward to assign breakthroughs in Digital Light to appropriate centers of early computer creation. I cannot claim infallibility, of course, but I do claim that this approach gives an easily correctible structure to the history. So, in chapter 5, I apply the same approach to movies.

Like almost everybody I've quizzed, I assumed that movies were created by Thomas Edison, Eadweard Muybridge, or the Lumière brothers. But I couldn't tell you which. In fact, the definition and flow-chart analysis techniques show that movies weren't created by any of them. Stated correctly, all of them influenced the proper story, but some of the main innovators have simply disappeared from popular histories or have never been included. This is particularly true for William Kennedy Laurie Dickson in America

and Georges Demenÿ in France. But they weren't single heroes acting alone either. It takes the flow chart to indicate who worked with whom, who stole from whom, who backstabbed whom, and so forth. It also makes it possible to see the various players in perspective. Edison, under these lights, comes across as a tyrant who stole credit from the inventors he supported. Muybridge is revealed as an excellent salesman of an idea that he didn't implement. And the legendary sainthood of the Lumière brothers suffers from revelation of the details of what they actually did. It's a much more complex story than I would've ever guessed.

As with computers, a careful definition—of a *movie machine* as camera, film, *and* projector—served as the clarifying concept. Invention of only one part of this trio is insufficient as a claim to the invention of movies. A look at the flow chart for this chapter shows that there can be no simple narrative that captures movie machine history. There is little that could be meaningfully simplified.

Technologically, the movie and animation chapter allows us to exercise the Sampling Theorem in a third dimension, time, where the *frame* is what we call the sample of visual flow. I began the chapter believing I could explain why movies move using the Sampling Theorem. But I discovered that the Sampling Theorem explanation is not precisely the right one. We *could* make an ideal movie using the theorem, but apparently that solution hasn't been implemented. I call it an "outside the pupil" explanation, where spreading the samples (frames) occurs before light enters the human eye.

Instead movies, even digital movies, use the technique of presenting successive "frames" to a human eye. This seems to work by exercising the perceptual mechanisms of the human brain "inside the pupil." That is, separated frames are supplied directly to the retina and brain, which does the reconstruction into smooth motion. I don't attempt to explain the brain's mechanism but point out that it seems, from the evidence, to be doing something akin to Sampling Theorem reconstruction from samples.

The movie chapter also covers animation—particularly character animation—as well as technology and people. Walt Disney and the often overlooked Ub Iwerks feature in this section. The suggestion is that the classic animators' tricks of squash and stretch, anticipation and exaggeration are intuitive solutions to sampling problems. What a personal surprise it was, again because I've been in the field for more than 50 years, to learn of alternative two-dimensional animation systems that were considered in the early days. Only the well-known cel animation system made it into the modern world. So cel animation was the animation technology that the "group now known as Pixar" implemented for Disney's Computer Animation Production System (CAPS) in the mid-1980s. It was the only technology we knew.

Idea–Chaos–Tyrant Triads in Two Contributing High Technologies

Computers

The great *idea* here was that Turing's 1936 idea of stored-program computer could be made to go fast if implemented in hardware. And the race was on, starting in the early 1940s. The *chaos* driving production of the first computers was the rise of Hitler and Nazi Germany and the tremendous fear that they would reach the production of an atomic bomb before the United Kingdom or United States did. In fact, the first computer, Baby, was completed in 1948 after the destruction of Hitler and the Nazis. But the chaos continued because Soviet Russia quickly replaced the German role as existential enemy, and the hydrogen bomb replaced the atomic bomb as the most feared weapon. Early computers were used in weapon calculations and simulations of bomb explosions.

The *tyrannies* that directly affected Turing and von Neumann were the respective state security systems of the United Kingdom and United States. In particular, the UK's Official Secrets Act was responsible in effect for the hounding of Alan Turing, perhaps even to his death.

Movies

The great *idea* for this high technology was that replicating a visual flow in time before a paying audience was good business. The idea inherently hinged on a sequence of photographs as the method of presenting visual flow. Thus it built on the relatively new field of still photography from the middle of the nineteenth century and bore first fruit just at the end of it, in 1895.

There was no obvious external source of chaos driving the development of movies. The *chaos*, if we wish to promote something to that level, was the pure capitalistic competitive rush to what was presumed to be a lucrative new market.

But there was a clear *tyrant*, at least on the American side. Thomas Edison fills the role nicely. He famously set up a well-furnished laboratory to which he invited enthusiastic young inventors. He gave them a home and encouragement. The trouble was that Edison then claimed all their inventions as his own, and he pocketed all the money and fame. The clearest example in this book is the case of William Kennedy Laurie Dickson. Dickson is hardly known today although he was the one who built the camera for Edison and the projector for Biograph, as well as perfecting the 35 mm perforated film format that became the standard of the movie world.

On the French side, there was no such obvious tyrant. But the false myth that the Lumière brothers not only loved each other but also invented movies together has a

tyrannical hold on the French imagination. The truth is that the brothers stabbed each other's backs, took ideas from others such as Georges Demenÿ, and lost the film format battle to Dickson.

The subfield of movies called animated films are those divorced, or unhinged, from real-world time. The original *idea* was that hand-drawn frames could form visual flow for entertainment. Its *chaos* was the same as that for movies in general, if we are again willing to elevate competitive capitalism to chaos. And the role of *tyrant* is filled by Walt Disney himself, who went from eager entrepreneur to claiming he was the sole inventor of the company and of Mickey Mouse, or at least letting that perception gain uncorrected ground in the public mind.

The Rise and Shine of Digital Light

The third part of this book is devoted to Digital Light proper. I tell its story using picture-oriented computer graphics as an armature in three chapters (6, 7, and 8) that cover developments preceding Moore's Law (Epoch 1) and after (Epoch 2). For just a moment, though let's go back to chapter 4 and the dawning moments of Digital Light, to recall what we discovered there.

Revisiting the Dawn

The first pixels were displayed in late 1947, 70-plus years ago, on a CRT destined to be the first display device. I call that first digital picture First Light. We find its pixels, the first pixels, on the first computer, Baby. The Dawn chapter (4) covers the origins of both pixels and computers. I've already summarized the part about computers, so now I move on to the pixels and pictures part.

Several digital pictures appeared in the late 1940s, and the early 1950s saw the earliest interactive games and animations. During this early stage, making pictures with the precious computers was generally considered frivolous, not serious like nuclear bomb calculations. But it was impossible to stop the push toward pictures on machines. Given a display device, people just have to make pictures. Even if it cost millions of dollars.

The first concerted departure from the pictures-are-frivolous era occurred on Whirlwind at MIT in the early 1950s. Many early pictures appeared on versions of this computer, including perhaps the first digital animations and early interactive games, and the first three-dimensional pictures (but without perspective). The flow chart for chapter 4 carries us directly into the chart for chapter 6 and the rise of Digital Light.

The Rise—Shapes of Things to Come

We begin chapter 6 with one of the loveliest shapes in computer graphics—the spline. It's a graceful shape that belies the early mistaken belief that computers could draw only rigid, blocky, angular, linear things. The spline, it turns out, can be explained by the Sampling Theorem! Actually, the reverse of the Sampling Theorem. This lets us introduce another claimant to the invention of the Sampling Theorem, the Englishman Sir Edmund Taylor Whittaker, whose work preceded Kotelnikov's by 18 years. He almost had (the reverse of) the Sampling Theorem, but that "almost" keeps him from primacy. Because he used a different point of view from that of Kotelnikov, he missed one of the important points of the full theorem (what engineers call the "bandpass" version). Kotelnikov's point of view was this: given a smooth, continuous signal, sample it into discrete samples, then later reconstruct the samples—spread them, we say—back into the original continuous entity. Whittaker's point of view was the reverse: given a set of discrete data points, find a smooth continuous curve through them that accurately predicts what points might rationally fall between the given points. Whittaker's technique for interpolating values between his given data points is indistinguishable from what we call spreading the samples and adding them. But whereas Kotelnikov was reconstructing a given curve, Whittaker was constructing, or inventing, one. And points on the constructed curve were important to him, not the curve itself—data not shapes.

Much of the rest of chapter 6 is about modeling three-dimensional shapes with triangles. I recount the stories of some of the earliest researchers in what would become computer graphics. The earliest players, such as Steven Coons and Pierre Bézier—and the almost forgotten Paul de Casteljau—weren't particularly interested in pictures. They used computers to carve wood or foam, or otherwise compute an actual object—such as an automobile body or airplane wing. So they were, strictly speaking, pioneers of computer-aided design, or CAD. But object-oriented CAD and picture-oriented computer graphics were one and the same at this early stage. The starting point for both was a geometric model inside a computer's memory.

The story of computer graphics technology has usually been told in the narrative way by featuring one man, Ivan Sutherland, while at the same time honoring other founding fathers incoherently—by naming the highest award in the field after Steven Coons, or by naming a particular curve after Pierre Bézier. So once again, the received stories are inadequate if not in error. I attempt a more convincing and integrative history here using yet another genealogical flow chart that connects, as I mentioned, to the flow chart of chapter 4 (Dawn).

With this technique I replace the simple narrative, that computer graphics began with Sketchpad written by Sutherland in 1962, with a more robust network featuring

Coons, Bézier, and the forgotten de Casteljau from the automobile and aircraft indus-
tries, and three often overlooked players who all escaped the Nazi horror to contribute:
Herb Freeman, who was saved by Albert Einstein; Bertram Herzog, saved by the Kinder-
transport program; and Marceli Wein whose father was on Schindler's list.

Ivan Sutherland continues to be a major player but shares the founding role with
a Triumvirate of MIT classmates consisting of himself, Tim Johnson, and Larry Rob-
erts. Indeed, Sutherland gave us the first *interactively rendered* two-dimensional graphics
system, called Sketchpad. At about the same time Sutherland's classmate (and looka-
like) Tim Johnson gave us the first interactively rendered three-dimensional system,
called Sketchpad III—the III for three dimensions, not version number. This was appar-
ently the first interactive three-dimensional system of any sort, although the three-
dimensional DAC-1 system from General Motors was available at approximately the
same time. Sketchpad III definitely exceeded DAC-1 in its use of perspective, employing
a method devised by the third classmate in the Triumvirate, Larry Roberts, a method
that's still used today.

Sutherland and Roberts, along with Robert Taylor from the new agency NASA,
became successive funders at another new agency ARPA (now known as DARPA). Much
of the early funding of the industry came from NASA and ARPA. Sutherland then joined
David Evans to found Evans & Sutherland computer graphics equipment supplier and
also the famed computer graphics department at the University of Utah, where many
future leaders of the field got their training. Taylor then founded the famous computer
laboratory Xerox Palo Alto Research Center (PARC). Roberts went on to help kickstart
the internet.

The *idea* of this chapter is that internal models of fictional worlds made of fictional
objects can be rendered into two-dimensional pictures. The disruptive *chaos* of the
period was the Soviet nuclear threat and the space race. The *tyranny* was the national
security system. The glory of the period was the complete abeyance of capitalistic prin-
ciples in the United States to more quickly prepare it for possible nuclear attack. Vast
amounts of money were handed out quickly, without competitive bidding, by vision-
ary young geniuses—especially from the two newly created agencies, ARPA and NASA.
It was a big gamble, but it paid off handsomely. One way it did so was to acceler-
ate development of Digital Light, to which both agencies contributed—ARPA in this
Shapes chapter, NASA in the next chapter (Shades).

Another kind of force entirely, namely the art world, begins to figure in the Digital
Light story here. This chapter emphasizes the close connections between Digital Light
contributors and seminal art-world events, like the famous *Cybernetic Serendipity* book
and exhibit. Both the art world and the tech world took careful note of one another

starting here, both aware of something new in the pictorial arts. Their connection continues to this day.

The Shine—Shades of Meaning

The black-and-white line drawings in chapter 6 advance in chapter 7 to colored surface renderings—from shapes to shades. Indeed, Moore's Law, and the explosive growth in computer Amplification enabled by Epoch 2 computers and circuitry made all this color possible: from the first color pixels in 1967 to the first articulation of the vision of The Movie—the first completely digital movie—in the late 1970s. As before, the flow chart of this chapter is a continuation of the previous chapter's chart. The complexity of the chapter spurred me to break it into three steps, or sections, named by the corresponding Moore's-Law power factor, from 1X to 10X to 100X.

Step 1 (Moore's Law 1X) is about the creation of the first color pixels. Where and when did they appear? The media-arts classic written by Gene Youngblood in 1970, *Expanded Cinema*, serves as an unexpected lead to the solution of this mystery. The breeding ground turns out to be the Apollo Moon shot. We establish that General Electric engineers Rod Rougelot and Bob Schumacker displayed the first rendered color while designing a NASA Apollo simulator. This was 1967, and they used the first fruits of Moore's Law to do so. We learn what it means to render geometry into color pixels and how to do it.

Step 2 (Moore's Law 10X) covers early Digital Light at Xerox PARC, the University of Utah, and Cornell University. PARC descended from both ARPA and NASA. University of Utah computer graphics descended from ARPA. And Cornell's descended from Rougelot and Schumacker at GE via a chance encounter in a tent with Don Greenberg. PARC had the first general-purpose color pixels available in the world and the first fully antialiased pixel renderings. But Xerox decided not to pursue color. Students from Utah and Cornell were responsible for the first three-dimensional rendered computer animations—Cornell's in color. In this section I introduce elemental rendering techniques: texture mapping, shading models, and partial transparency, among others.

Step 3 (Moore's Law 100X) introduces the New York Institute of Technology (NYIT) headed by the idiosyncratic Alexander Schure on Long Island. He fancied himself heir to Walt Disney and was the first financier to invest heavily in the digital movie. He lost everything, but not before Xerox PARC "graduates" and University of Utah graduates came together there and formed the group later to become Pixar. Here is where the vision of The Movie—the first completely computer-generated feature film—first forms. I explain in this section that two-dimensional animation is harder than three-dimensional and introduce the all-important alpha channel.

The Millennium and The Movie

The continued explosion of Moore's Law drives us on into chapter 8 to The Movie itself at the millennium—and to the Great Digital Convergence that The Movie symbolizes. Computer graphics now gives way to just digital movies. As I cover Moore's Law improvements from 1,000X to 10,000,000X, I again subdivide them into Moore's Law order-of-magnitude steps.

Step 4 (Moore's Law 1,000X) is about Lucasfilm, founded by George Lucas in Marin County, California. The group at NYIT watched Schure fail with *Tubby the Tuba* (1975). Lucas, on the other hand, was a successful producer of the breakthrough special-effects movie *Star Wars* (1977). So some of the group happily leapt to California in 1980 to work with him when he beckoned. Here the group got its first big-screen exposure, worked on contract with the Disney company to digitize classic cel animation, and hired its first great animator. The group was approached by a Japanese company to make the first movie, but the Monkey project, as it was known, failed to materialize because of insufficient Moore's Law power. Then George and Marcia Lucas divorced, making the group too expensive for Lucas to support and leading to the spin-out company Pixar. A principal technological advance was the leap from a grab bag of rendering techniques to a language for expressing an infinity of them—a shading language. Another was a breakthrough method for efficiently handling motion blur, crucial to the advancement of three-dimensional animation. In fact, the first three-dimensional character animations appeared. Almost in parallel with the Lucasfilm group, Pacific Data Images (PDI) and Mathematical Applications Group Inc. (MAGI) arrived at character animation.

Step 5 (Moore's Law 10,000X–10,000,000X) is about the creation of the first digital movies. The first was *Toy Story* (1995) by Pixar, the company spun out of Lucasfilm in 1986. The second was by DreamWorks Animation, out of PDI, called *Antz* (1998). Blue Sky, the third of the first digital movie companies, out of MAGI, soon produced *Ice Age* (2002). These three movies served as colorful markers of the millennium and a sign that the Great Digital Convergence had finally happened. The corresponding flow chart shows how these early digital studios shared many common flows.

The final idea–chaos–tyrant triad of the book starts with the great *idea* being to create the first digital movies. The *chaos* driving it was the tremendous disruption created by Moore's Law. There were several *tyrants*, the most obvious being Steve Jobs for Pixar. His money enabled the company to exist, but true to form, he subsequently claimed Pixar and The Movie were his ideas and took most of the money, never mind the credit. For all the wrong egocentric reasons, he continued to support Pixar through its most difficult days, but the effect was the same as if he had shared our vision. True to

tyrannical form, he unintentionally created a financially protected space in which we could survive to realize our vision.

The Central Dogma

Without comment or notice, the 1960s computer graphics community adopted the Central Dogma as implicitly practiced by the Triumvirate—Tim Johnson and Larry Roberts using it in 1963 in Sketchpad III, joined by Ivan Sutherland in 1968 with his head-mounted display. As the original Central Dogma dictated: pictures shall be based on models built from Euclidean geometry in three dimensions and viewed in two dimensions with Renaissance perspective. It's a dogma because there is nothing about computers or computation that forces these choices. The entire world of picture making, from abstract geometric patterns to expressionist splatters, is possible for computers. Nevertheless, the computer graphics mainline honors the dogma.

In the late 1960s when color computer graphics became possible, the Central Dogma was silently extended to include Newtonian physics, also not required by computers. This full "symphonic form" is the one honored today in digital movies, VR (virtual reality), videogames, flight simulators, and so forth. Here it is in succinct summary:

Central Dogma = Euclidean models, Renaissance perspective, Newtonian physics.

Although highly structured, this form admits of astonishing fantastical creativity as is clear from any list of the digital movies made at and since the millennium. But the awesomely large subspaces of Digital Light outside the Central Dogmatic form beg to be explored. Paint programs are the most obvious Digital Light creative tools from the early days that were not subject to the Central Dogma.

Notice that in the analytic, image processing half of Digital Light, the Central Dogma isn't dogma. It just is. It's how the real world actually works. At least it represents our best models for the normal real world at human scale.

Notice also that CAD is subject to the Central Dogma by definition. Its objects must exist in the real world and withstand physical testing for use in that Newtonian world. It's the shared historical roots of computer graphics with CAD that has made the Central Dogma seem so natural—and unspoken—for picture-oriented computer graphics too.

Computer vision people like to state that what they do is the inverse of computer graphics. What they mean is that the brain generates, from two-dimensional retinal input, three-dimensional internal models of what we perceive. What they actually mean is that brains do the inverse of that part of computer graphics subject to the Central Dogma.

And Beyond

What I've written so far in this finale summarizes the book and the development of Digital Light up to the millennium. But two decades have now passed during which the always-exploding Moore's Law has fueled ever more awesome advances in Digital Light. I sketch in the following sections only some of those developments.

Postmillennial Uses of the Central Dogma

In modern virtual reality (VR), a stereo pair of images—one for each eye—is generated in real time and according to user input, such as head position. The user wears a special pair of goggles or glasses. Performing massive computations in real time is not easy and requires much special effort. But recall the rule of thumb: if you want a computation to go faster, use special-purpose hardware. The algorithms are the same but sped up by the hardware. In other words, the same techniques used to make movies are being used, with hardware help, to create VR. Understanding movie pixels explains VR pixels to a large degree. And the hardware assist is sometimes nothing more than what your cellphone provides. (For context, the iPhone was introduced in 2007 and the Android system in 2008, just yesterday in the grand scheme of things.)

The flow chart from the Shades chapter extends naturally into this discussion of VR. Eric Darnell, animator at DreamWorks Animation, cofounded with Maureen Fan (as CEO) a VR company, Baobab Studios, in Silicon Valley. Some in the company, such as Larry Cutler (as CTO), are graduates of DreamWorks and Pixar. Glenn Entis from DreamWorks, Glen Keane from Disney, and I from Pixar are advisers to the startup. Baobab has already created and produced several prize-winning character animations in VR. Similarly, many people from visual effects studios and game companies are now creating VR content.

Of current interest in Digital Light is augmented reality (AR), where a synthesized picture is combined with the real world in real time. In general, this is a combination of take and make Digital Light. The real world is digitized in real time. The AR device synthesizes a fictitious world in real time and combines its pixels with the real-world pixels to create a new kind of visual experience. In the simplest cases, this is just a simple superposition, using an alpha channel, of the synthetic scene over the real scene. The real world is simply a two-dimensional background to the synthetic foreground. In fact, sometimes the real world is not digitized at all. It's simply passed through and combined optically with the synthetic images inside the goggles or glasses.

The artist Darcy Gerbarg has recently been exploring the edges of Digital Light using AR. Her work illustrates the categories of this book. Her principal tools are Google's Tilt

Brush, a VR app, and Adobe's Photoshop, the classic two-dimensional pixel app. Tilt Brush allows a painter to paint in three dimensions with strokes of paint that honor the Central Dogma. They are modeled in Euclidean geometry, are bumpmapped to look like paint strokes, cast shadows according to Newtonian physics, and are viewed in Renaissance perspective. But then she combines the VR paint strokes with images from the real world using a special program in her cellphone. In other words, she sees her three-dimensional VR paint strokes, from selected viewpoints as she moves, super-imposed over two-dimensional cellphone images of, say, her studio. Then she brings selections of these AR scenes into Photoshop and creatively changes the content of pixels at her artistic will. Her work pulls you into two-dimensional space in a new and powerful way, not subject to the Central Dogma but using it (figure 9.2).[2]

At the current extreme of Digital Light is a more complex case—often called mixed reality (MR) to emphasize how it differs from simple AR: a computer derives three-dimensional structure from the real world so that the synthetic world appears to interact meaningfully with it—a synthetic animal walks convincingly on a real-world tabletop, say. This resembles what our brains must be doing—the inverse of computer graphics, subject to the Central Dogma of course. In AR only the Display Spaces of the

Figure 9.2
Vibrant band-TL2-205552D2eC2, © Darcy Gerbarg, 2018.

real and synthetic worlds combine. In MR the Creative Spaces combine—the internal models of the two worlds intertwine.

As I write (in 2020), there are several technological approaches toward MR: Microsoft is pursuing its HoloLens device and Magic Leap a direct-to-retina approach. We await the maturity of these extraordinary devices and others. Note that they appear to represent, respectively, outside-the-pupil and inside-the-pupil solutions, utilizing the terminology from the movie and animation chapter of this book. The pupil represents the hard boundary between what happens external to and internal to our brains.[3]

Technical questions about MR abound while we wait. Will real-world objects hide computed objects? And cast shadows on them? Will computed objects show through transparent real-world objects? Will real-world light sources change the shading of the computed objects? Experts I quizzed at Siggraph 2019 assured me that some of these questions have already been answered but are still trade secrets. True mixture of the two worlds seems a daunting problem. It's a full integration of take and make, of shoot and compute, a synthesis of computer graphics and inverse computer graphics both subject to the Central Dogma. Surely it's a big enough problem to fuel a generation of computer graphicists (if not neuroscientists and science-fiction authors)—and artists.

And a new term has just evolved to house the many possible directions this might go. It's called XR for extended reality, for any mixture of real and virtual environments.

Varieties of Creativity

Pixar people won a technical Academy Award in 1996, one of many over the years. The technical awards are handed out at a ceremony that's just as glamorous as the televised Academy Awards—the same tuxedos and gowns, limousines and movie stars, fancy banquet, and time-limited acceptance speeches. But no broadcast television crews and no red-carpet interviews. The Academy of Motion Picture Arts and Sciences senses, justifiably, that the general public might not be interested in ground-hugging fog machines or spider-web generators, two technical awards I've personally witnessed over the years.

The event is always hosted by a movie star. In 1996 it was Richard Dreyfuss, famous to us for many roles, but especially as Curt in George Lucas's *American Graffiti* (1973). Ed Catmull and I were seated at a table with the Pixarians to be awarded. *Toy Story* had had its smashing debut just a few months earlier.[4]

Dreyfuss began with the de rigueur speech about how actors and technologists depend on one another and how important this other, non-televised Academy Award ceremony is to actors such as himself. "We actors and technologists are marching together into the future," he said. But then he added a twist. He looked at our table

and said, "Notice, Pixar people, that I said *together!*" A nervous titter slid through the audience. The actors there had obviously been listening to overly glib statements from colleagues in my industry that "any day now, we'll replace actors with simulations."

In 2000 I was invited to write an article for *Scientific American* magazine about that very subject—the possibility of replacing actors. What I wrote then emphasized the something special about people that we can't yet explain—not even a little.[5]

I'll call it *creativity* here, but that's an imprecise term. What I have in mind is what Turing and Kotelnikov and Fourier did, what programmers and engineers and modelers do, and what animators and actors do.

It's what Turing did when he invented computation and the stored-program computer, seemingly out of nothing. It was an astonishing leap of creativity, one of the greatest ever. That's technical creativity of the theoretical variety—from the ivory tower. Kotelnikov did it too with the Sampling Theorem, another of the great creative leaps. And, of course, Fourier's great idea was the one Kotelnikov leapt from to build his.

It's what programmers do, or what enables them to do it, when they build from a very long list of meaningless computer instructions a program that does something meaningful—like compute *Toy Story*. That's technical creativity, of the engineering variety—from the stinks as I've called it here. The constant creation of awesomely faster computers, as described by Moore's Law, is another example of this variety. And another is building elaborate internal models, of characters say, using geometry and a shading language.

And it's what animators do when they convince us that a stack of triangles is conscious and feels pain—the inspiriting of crafted characters. That's artistic creativity. Actors have it too, convincing us that their bodies house minds belonging to people completely distinct from themselves. In fact, actors and animators believe it's the same skill. As previously stated, Pixar hires animators by how well they act.

What I wrote in 2000 still holds today two decades later: we don't have a clue about how to replace actors. But we can replace the *appearance* of an actor. A screen appearance that represents an actor is called an *avatar*. We can replace an actor onscreen with a convincing avatar—even in emotional closeup. I know this because it's been done. There are shots of Brad Pitt in *The Curious Case of Benjamin Button* (2008) where Brad Pitt is not Brad Pitt but an avatar of him—a digital representation of his appearance. The point is that the avatar is "driven by" a great actor, namely Brad Pitt himself. He and his skill were not replaced. Only his screen appearance was. The convincing nuance was his, not some computer program's.[6]

That was my prediction in 2000—that we would be able to make a "cameraless" live-action movie so long as the avatars of the human actors were controlled by those

special people called actors. I made the prediction eight years before the existence proof of *Benjamin Button* by extrapolating from the continued advancement of computer animation.

Animators have a skill that's essentially indistinguishable from that of actors except by the medium used for expression—the human body for actors or triangles for animators. They both convince us of an inner life that is, in fact, not that of the actor or animator practicing his or her art. As we saw in chapter 8, by the millennium at least three computer-animated movies had shown us that animated triangles had inner lives when they were manipulated by the creators called animators. The leap I made that year was that the realism of the characters would inexorably increase, by the Moore's Law miracle, to a point where they would convincingly represent the appearance of human beings. Cartoon avatars would evolve toward realistic avatars. It would remain the unique job of animators and actors "driving them" to convince us of their inner life.

I waved my hands in 2000 and suggested that since it took us 20 years to get from the idea of a computer-animated movie in 1975 to a real movie in 1995, perhaps it would take 20 more to arrive at the first cameraless—but not actorless—movie. So 2020 is actually here as I make final edits to this chapter, which makes it clear that my handwave was only that. There's no evidence in sight of an emotionally effective cameraless movie, with only human avatars and without visible humans. And certainly no evidence of actors, or animators, being replaced by computer simulations. Richard Dreyfuss can relax for the foreseeable future.

But . . . 2020 has advances that hint at something different. Consider a recent movie, *The Irishman* (2019). Each of the great septuagenarians Robert De Niro, Joe Pesci, and Al Pacino acts in it as his younger self. This "de-aging" lies somewhere between taking a movie with a digital camera and making one with computer graphics. And it's far from cameraless. Instead an elaborate camera (actually three cameras) is used to record the actors' performances as in classical filmmaking. They are unencumbered by dots or other special markers used in earlier attempts at rendering an actor's avatar. Then digital artists, using sophisticated, state-of-the-art software, take over to carefully convert each actor's actual face into a convincing representation of his younger self. The avatar of De Niro is a younger De Niro. It's driven by De Niro himself. Digital artists refer to the slow process of rendering a complex avatar as "baking." So, to bake a movie is to both take and make one—an amalgam of analytic and synthetic Digital Light.[7]

A word of caution, though: These wonderfully deceptive artistic advances can be used against us by the unscrupulous. Such misrepresentations of people are called *deepfakes* and are already being deployed.[8]

A Summation . . .

The pixel, a seemingly simple but subtle device, unites all digital picture making and taking into one realm, Digital Light, which comprises nearly all of modern pictures. Digital Light can be easily understood by the intuitive presentation of just three great foundational ideas: Fourier waves, Kotelnikov samples, and Turing computations.

Two foundational high technologies are relevant to Digital Light—computers and movies—both treated at an intuitive level. Computers are obviously foundational to anything "digital." Movies are too because they exercise the Sampling Theorem, and from them Digital Light inherited terminology and concepts. In this book I set the record straight on the histories of these two technologies. The better way to show such history is as a genealogical flow chart of many people. This is very different from the seductive narrative, featuring one heroic person, that is so popular but so often corrupts the facts. The soul of the book is in the "family" stories represented by these charts, with all the usual celebrations and quarrels, collaborations and competitions, high-mindedness and deviltry of human relationships. The flow-charting techniques are then applied to the history of Digital Light technology itself, particularly the path through it that yielded the first digital movies.

A repeating motif resounding in all these histories of foundational ideas and high technologies is an idea–chaos–tyrant triad: a great idea, a chaos or disruption demanding or driving its implementation, and a tyrant or other form of tyranny that protects, often for the wrong reasons, the creators as they struggle to realize the idea.

A drumbeat becomes louder and louder as the book proceeds and then booms as it reaches the last chapter where it becomes deafening and definitive. It's the regular order-of-magnitude burst of additional power every five years, described by Moore's Law. I pay close attention to this exploding supernova, a revolutionary development that we barely comprehend. It stretches our order-of-magnitude limitations as human beings. It Amplifies us. Digital Light is but one of its shining achievements.

. . . and Beyond Beyond

> Any system simple enough to be understandable will not be complicated enough to behave intelligently, while any system complicated enough to behave intelligently will be too complicated to understand.
>
> —George Dyson, third law of AI, *Analogia*[9]

John Bronskill, an old pixel-packing colleague, approached me a couple of years ago during my wife's sabbatical at King's College, Cambridge—where Alan Turing did his

seminal work. Bronskill startled me: "Alvy, we don't have to program anymore!" He had made a name for himself writing extensions for Adobe Photoshop, perhaps the most popular pixel app in the professional world.

"What do you mean?"

"Read this," he said as he thrust a scientific paper into my hands. It was from the Artificial Intelligence Research Laboratory of the University of California at Berkeley. The paper described a neural net of a certain variety that was trained with 1,000 unlabeled and arbitrary photographs of horses and 1,000 unlabeled and arbitrary photographs of zebras. The horse photographs contained any number of horses of various colors in arbitrary arrangements. The zebra photographs were similar although the zebra colors didn't vary, of course. All these photographs were digital, comprising pixels. After suitable training (which I won't describe), the net could do the following astonishing feat: presented with an arbitrary photograph of zebras, the trained net would return the same photograph but with every zebra replaced with a horse (figure 9.3, upper pair). (Actually, with a horse-colored version of each zebra or vice versa, each horse replaced by a zebra-striped version of itself.)

"How does it work?" I asked, adding, "I don't think that problem is even well-defined." What's a horse to a computer? What's a zebra? How do you map one to the other?

John just brushed past these observations: "I don't know. Nobody does. It just does it! It's too hard to reverse engineer."

The same neural net did other amazing things. Trained on landscape photographs and on paintings by Vincent van Gogh, it would take in an arbitrary landscape photo and output a painting in the style of Vincent. Or vice versa. Or in the style of Monet. Or it would convert summer landscapes to winter landscapes. Or vice versa.

I mention this in the spirit of "what comes next in Digital Light?" I confess that I don't understand what's going on here, or whether it's even important in the long run. But let's think about it a little.

Turing allowed his stored-program, or universal, Turing machine to compute on its program as if it were data. That's exactly what his invention of the stored-program computer allowed. Is the horse-to-zebra computation an example of computing on the program? Turing was particularly fascinated by this possibility, and by artificial intelligence. For context, the operating systems of modern computers typically disallow computing on the program because it can easily create havoc.

The neural net is simulated on a normal computer, so the program doing the simulation is not being computed on. But suppose the neural net was an actual neural net, not just a simulation. Could it be construed as computing on its own program? I

Figure 9.3

believe so. Our own brain is clearly a neural net, and there's no program store separate from a data store in it, so far as we know. And it's probably not doing anything beyond a Turing computation. We've not found any careful process that does so after 80 years of experience with the concept.

In 1965 I began graduate studies at Stanford because it was one of two universities (that I knew of) offering the fascinating new subject called artificial intelligence—often abbreviated these days to AI. MIT was the other. I learned from John McCarthy, a founding AI father at Stanford. And I had several influential discussions with MIT's Marvin Minsky, another founding father.

After a couple years I dropped out of AI, having decided that it wasn't going to happen in my lifetime. That might have been a premature conclusion given that I probably have two decades to go but, in the meantime, I helped make the first digital movie. Having accomplished that, I now have time to return to musing about AI. In fact, I've never stopped doing so.

It was John Bronskill's remark that brought me up short. I had always assumed that when AI was finally explained, I would be able to understand the explanation. Yet here was an example of machine learning—perhaps not quite advanced enough yet to be called AI—that I couldn't understand. Is it because the net computes on its own program? We know that, in general, we can't even tell such a simple thing as whether a program will halt, so perhaps it's no surprise we can't figure out what this zebra-horse program does.

For what it's worth, the horse-to-zebra process isn't perfect. One example presented in the paper Bronskill showed me has as input the famous photograph of Vladimir Putin riding shirtless on horseback. The output is both Putin and his horse melded into a two-headed, zebra-striped centaur (figure 9.4).[10]

The very nature of the current revolution is that we cannot predict it beyond one order of magnitude. We just have to ride the wave and see to what exciting, even mysterious, place it takes us next.

Figure 9.4

Parting Shot: A Magic Carpet

What have we done here? We've replaced a picture with an abstract mathematical object, and with it opened a vast new realm of imagination. The object is disconcertingly repetitive and discrete, with each of its loci awaiting application of its own little blob of infinity. But from it comes all the pictures of the world, or worlds. I close with a passage from Italo Calvino's novel *Invisible Cities*, in which the author imagines the young explorer Marco Polo describe to Kublai Khan, the aging Mongol emperor, his discovery of a magic carpet in the city of Eudoxia. It's a conversation at the boundary between real and represented:

> In Eudoxia, which spreads both upward and down, with winding alleys, steps, dead ends, hovels, a carpet is preserved in which you can observe the city's true form. At first sight nothing seems to resemble Eudoxia less than the design of that carpet, laid out in symmetrical motives whose patterns are repeated along straight and circular lines, interwoven with brilliantly colored spires, in a repetition that can be followed throughout the whole woof. But if you pause and examine it carefully, you become convinced that each place in the carpet corresponds to a place in the city and all the things contained in the city are included in the design, arranged according to their true relationship, which escapes your eye distracted by the bustle, the throngs, the shoving. All of Eudoxia's confusion, the mules' braying, the lampblack stains, the fish smell is what is evident in the incomplete perspective you grasp; but the carpet proves that there is a point from which the city shows its true proportions, the geometrical scheme implicit in its every, tiniest detail. . . . An oracle was questioned about the mysterious bond between two objects so dissimilar as the carpet and the city. One of the two objects—the oracle replied—has the form the gods gave the starry sky and the orbits in which the worlds revolve; the other is an approximate reflection, like every human creation.
>
> —Italo Calvino, *Invisible Cities*[11]

Acknowledgments

Extraordinary Thanks

My deepest thanks to Alison Gopnik, my wife, companion, and helpmeet. She encouraged me from the start, a decade ago, to write this book, and then proceeded to teach me how to do it. I eagerly listened to her, since she'd written several bestsellers. "Unpack those sentences," was an early instruction, observing that my academic sentences housed about five normal ones. Another piece of her guiding wisdom was: "It'll take at least fifty edits before the words even start to take on that appearance that they flowed naturally and smoothly from your unconscious." Instead of an apology to a spouse for being "away" for ten years, I get to thank mine profusely for letting me share the world of writing—its joys and tribulations—with her.

And I give a different kind of profound thanks to Barbara Robertson. Barbara is famous in the computer graphics world for decades of prize-winning reporting. She's worked as first editor with me on this book throughout its multiyear gestation. She's one of the few people in the world, other than Alison, who can criticize my writing freely and know I'll take her comments goodnaturedly—if perhaps grumpily—and act on them. Barbara's usual devious trick was to "suggest" a simple rearrangement of my sentences. In nearly every case, her rearrangement worked better than my original. The words were still mine but better. The flow was smoother, the logic cleaner, and the rhythm snappier. Barbara has been a friend for much of my computer graphics career, and our friendship has survived working together this way. Indeed, I believe it's better than ever before.

Special Thanks

Here I single out several people who provided special, sometimes crucial, assistance on various topics covered in the book:

General: Sean Cubitt invited me to give a talk at a conference called Digital Light in Melbourne a decade ago, and that was the origin of this book. Eric Chinski encouraged the triad theme and first used "biography" to describe what I was doing. Robert Charles Anderson, Neelon Crawford, David DiFrancesco, Laurin Herr, and Bob Kadlec gave me unstinting friendship and reader support throughout.

Art: Darcy Gerbarg and Jasia Reichardt offered artistic insights woven throughout.

Sampling: Fyodor Urnov provided breakthrough encouragement and contacts for my Russian approach to the Sampling Theorem. Chris Bissell provided me with the technical details.

Computation: Martin Davis, friend and world-class mathematician, helped me immensely with the theories of logic and computation, particularly the famous unsolvability results. Sir John Dermot Turing shared insights about his famous uncle.

Computers: Chris Burton paved my way to early computers. In particular, he arranged my visit to see Baby in Manchester. George Dyson provided evidence from the John von Neumann archive. Marina von Neumann Whitman corrected my understanding of her father John's personality and athletic ability. Martin Campbell-Kelly, Simon Lavington, and Brian Randell guided me through the intricacies of early computer history.

Dawn of Digital Light: Krista Ferrante hosted me at an important and rich visit of discovery to the Whirlwind photo archives at MITRE Corporation. Dag Spicer encouraged me to turn the Dawn chapter into a journal paper. Jack Copeland asked hard questions that helped me refine my digital definitions.

Movies and animation: I thank the late Paul Spehr for William Kennedy Laurie Dickson expertise, Laurent Mannoni for French cinema expertise, Donald Crafton for animation history expertise, and Leslie Iwerks for Ub Iwerks (her grandfather) expertise.

Shapes: Robin Forrest put the early days and players in perspective. Ivan Sutherland, Tim Johnson, and the late Larry Roberts shared details of the beginnings of interactively rendered computer graphics at MIT. Barrett Hargreaves provided rare General Motors DAC-1 information. Jaron Lanier fleshed out my understanding of early virtual reality. Christian Boyer introduced me to surprising aspects and details of Pierre Bézier's career.

Shades: Gene Youngblood helped me solve the mystery of the first color pixels. Rob Rougelot and Bob Schumacker happily filled in the missing details. Colleagues Christine Barton, Jim Blinn, Ed Catmull, Rob Cook, Tom Duff, Don Greenberg, Pat Hanrahan, Jim Lawson, Marc Levoy, Jim Kajiya, Alan Kay, Eben Ostby, Tom Porter,

Bill Reeves, Bob Sproull, Steve Upstill, and Turner Whitted—among many others—reminded me of the details in many shared developments.

The future: To John Bronskill for machine learning; Eric Darnell, Maureen Fan, and Pam Kerwin for virtual, augmented, and mixed reality; and Barbara Robertson for de-aging and deepfakes.

MIT Press: Mary Bagg, the copy editor and a joy to work with, took my prose for a final outing, making it crisper and clearer, and gently proving that there's always more good editing to be done. Sean Cubitt closed the loop begun 10 years ago. Doug Sery led the charge and talked motorcycles with me. Noah Springer guided me through the picture permissions phase. Judith Feldmann calmed my fears about typeface choices among her more formidable duties. And Leonard Rosenbaum indexed.

In Memoriam to Those Who Helped Me but Didn't Survive to See the Book

Michael Caroe, Malcolm Eisenberg, Harry Huskey, William Newman, Larry Roberts, Dick Shoup, my parents Alvy and Edith Smith, Paul Spehr, Bob Taylor, and Lance Williams.

Content Providers, Historians, Readers, Advisers, and Other Help and Hosting (not Already Listed)

Sam Annis-Brown, Michael Arbib, Bobby Aucutt, Lynn Aucutt,

Ron Baecker, Don Bitzer, Ned Block, Lenore Blum, Manuel Blum, John Bohannon, Kellogg Booth, Adrian Gopnik Bondy, Thomas Bondy, Stewart Brand, Jack Bresenham, Buzz Bruggeman, Mark Burstein,

Kathy Cain, Daniel Cardoso [y] Llach, Susan Carey, Shelley Caroe, Arthur Champernowne, Richard Chuang, Elaine Cohen, Ephraim Cohen, Susan Crawford,

Lem Davis, Virginia Davis, Brian Dear, Tom DeFanti, Llisa Demetrios, Gary Demos, Nicholas de Monchaux, Daniela (Prinz) Derbyshire, David Derbyshire, Susan Dickey, Pete Doenges, Vicki Doenges, Jon Doyle,

Dai Edwards, Judy Eekhof, Sara Eisenberg, Nick England, Glenn Entis,

Sarah Favret, Paulo Ferreira, David E. Fisher, Marshall Jon Fisher, Eugene Fiume, Jim Foley, Rosemary Forrest, Susanna Forrest, Christine Freeman, Herb Freeman, Henry Fuchs,

Richard Gilbert, Sandra Gilbert, Mashhuda Glencross, Ken Goerres, Noah Goodman, Olga Goodman, Adam Gopnik, Blake Gopnik, Irwin Gopnik, Morgan Gopnik,

Myrna Gopnik, Oona Luna Gopnik-McManus, Trisha Gorman, Fiona Greenfield, Tom Griffiths,

Francois Haas, Sheila Sperber Haas, Sarah Harrison, Rowland Higgins, Jane Hirshfield, Toby Howard, John (Spike) Hughes, Doug Huskey,

George Joblove, Steven Johnson,

Scott Kim, Youngmoo Kim, Mark Kimball, Don Knuth, Pat Kuhl,

David Link, Tania Lombrozo, Judson Lovingood,

Alan Macfarlane, Charles Mann, Terrence Masson, Jim Mayer, Charles McAleese, Jerry McCarthy, Tom McMahon, Géraldine Marquès, Andrew Meltzoff, Gene Miller, Don P. Mitchell, James A. (Andy) Moorer, Daniel Moroz, Brian Mulholland, Walter Murch, Charles Musser, Michael Muthukrishna,

Eva Navarro-Lopéz, Nicholas Negroponte, Ted Nelson, Andrew Neureuther, Martin Newell, Peter Norvig,

Robin Oppenheimer,

Carl Pabo, Don Panetta, Laure Parchomenko, Flip Phillips, Daniel Pillis, Bruce Pollack, Joyce Pottash, Paul Pottash, David Price,

Rich Riesenfeld, Peter Robinson, Dave Rogers, Rhonda Rougelot, Michael Rubin, Ginny Ruffner, Donna Ruth,

The San Francisco Philosophy Club, Piero Scaruffi, Dana Scott, Irena Scott, Evan I. Schwartz, Laurens Schwartz, Lillian Schwartz, Tom Sito, Jesse Smith, Sam Smith, Lee Smolin, John Steiner, Neal Stephenson, Jack Stifle, Clifford Stoll, B. V. Suresh,

Philip Thomsett, Pascale Torracinta, Bob Tripodi,

Dmitry Urnov,

John Warnock, Ben Watson, Marceli Wein, Susan Wein, Mary Whitton, Stephen Wolfram, Jim Woodward, Julie Woodward, Katie Woodward,

Jane Youngblood.

Archives and Archivists

Bodleian Library. Oxford University, Oxford, UK. Christopher Strachey archives. Particularly folders CSAC 71.1.80/C.20–C.33.

Chester Fritz Library, Grand Forks, ND. Elwyn B. Robinson Department of Special Collections, University of North Dakota. Curt Hanson, Head.

La Cinémathèque française Library, Paris. Laurent Mannoni, Director.

Computer History Museum, Mountain View, CA. Dag Spicer, Curator.

Cradle of Aviation Museum. Judy Lauria Blum, Curatorial Department.

Defense Technical Information Center (DTIC), National Technical Reports Library (NTRL). Jennifer Kuca, reference librarian.

Google *Books* and *Search*.

Hofstra University. Geri E. Solomon, Assistant Dean of Special Collections and University Archivist.

Hoover Institution. Stanford University, Palo Alto, CA. Paul H. Thomas, Librarian, and Molly Molloy.

Internet Archive.

Martin Campbell-Kelly's personal OXO archives.

MITRE Corporation, Whirlwind Photographic Archives, Bedford, MA. Krista Ferrante, Archivist, Patsy Yates, Public Affairs Lead, and Susan Carpenito, Information Release Officer.

Museum of Science & Industry (MOSI), Manchester, UK. Ferranti Ltd. Archives. Brian Mulholland, Jan (Hargreaves) Hicks, Senior Archivist, John Turner, and Ruth Láynez.

Online original genealogical records: Ancestry.com, newspapers.com, www.Family Search.org.

Online video records: www.YouTube.com.

Pixar Archives, Emeryville, CA. Christine Freeman and Liz Borges-Herzog, Archivists.

Shelby White and Leon Levy Archives Center, Institute for Advanced Study, Princeton, NJ.

Software

Adobe: Acrobat, Illustrator, and Photoshop.

Microsoft: PhotoDraw, PowerPoint, and Word.

Wolfram Research: Mathematica.

Prior Appearances of Selected Text and Figures

The business-card universal Turing machine and explanation, based on part of chapter 3 (Turing), was given to all entering University of California at Berkeley Freshman in 2013 as part of the *On the Same Page* event designed to welcome them. A card-stock realization of the business-card Turing machine was presented to each Freshman—about 8,000 of them—accompanied by a

copy of George Dyson, *Turing's Cathedral: The Origins of the Digital Universe* (New York: Pantheon Books, 2012).

Smith, Alvy Ray. "A Taxonomy and Genealogy of Digital Light-Based Technologies," chapter 1 in Sean Cubitt, Daniel Palmer, and Nathaniel Tkacz eds., *Digital Light* (London: Open Humanities Press, 2015). This paper, presented in Melbourne in Mar. 2011, was the origin of this book.

Smith, Alvy Ray. "His Just Deserts: A Review of Four Turing Books," *Notices of the American Mathematical Society* 61, no. 8 (2014): 891–895. Based on part of chapter 3 (Turing).

Smith, Alvy Ray. "The Dawn of Digital Light," *IEEE Annals of the History of Computing* 38, no. 4 (2016): 74–91. A scholarly presentation of chapter 4 (Dawn).

Smith, Alvy Ray. "Why Do Movies Move?" in John Brockman ed., *This Explains Everything: Deep, Beautiful, and Elegant Theories of How the World Works* (New York: Harper Perennial, 2013), 269–272. Based on part of chapter 5 (Movies).

Smith, Alvy Ray. "How Pixar Used Moore's Law to Predict the Future," *Wired Online*, Apr. 17, 2013, https://www.wired.com/2013/04/how-pixar-used-moores-law-to-predict-the-future/, accessed Apr. 13, 2020. Based on part of chapter 6 (Shapes).

Notes

Emails are addressed to the author unless otherwise indicated.

Abbreviations used in citations:

ACM Association for Computing Machinery

AFIPS American Federation of Information Processing Societies

IEEE Institute of Electrical and Electronics Engineers

JPL Jet Propulsion Laboratory, California Institute of Technology

NYIT New York Institute of Technology, Old Westbury, Long Island, NY

PARC Xerox Palo Alto Research Center, Palo Alto, CA

Siggraph Special Interest Group on Computer Graphics and Interactive Techniques of the ACM

Beginnings

1. Henri Breuil and Hugo Obermaier, *The Cave of Altamira at Santillana del Mar, Spain* (Madrid: The Junta de las Cuevas de Altamira, The Hispanic Society of America, and The Academia de las Historia, 1935), Plate XLV.

2. *Appletons' Cyclopaedia of American Biography*, 6 vols., edited by James Grant Wilson and John Fiske (New York: D. Appleton and Company, 1887), 1:311–312.

3. This book is fully annotated online at http://alvyray.com/DigitalLight/. The annotations are organized by page number and then keyed to the first three words of each paragraph for which I provide additional information, source material, or mathematical documentation.

Chapter 1

1. Victor Hugo, *Les Misérables* (Boston: Little, Brown, 1887), 192.

2. Charles Percy Snow, "The Two Cultures," in *The Two Cultures and the Scientific Revolution: The Rede Lecture, 1959* (New York: Cambridge University Press, 1961), 1–21.

3. Ronald N. Bracewell, *The Fourier Transform and Its Applications* (New York: McGraw-Hill, 1965); Jacques-Joseph Champollion-Figeac, *Fourier et Napoleon, l'Egypte et les Cent Jours* (Paris: 1844); Victor Cousin, *Notes Biographiques pour Faire Suite a l'Éloge de M. Fourier* (Paris: 1831); Jean Dhombres and Jean-Bernard Robert, *Joseph Fourier, 1768–1830: Créateur de la Physique-Mathematique* (Paris: Belin, 1998); Enrique A. González-Velasco, *Fourier Analysis and Boundary Value Problems* (San Diego: Academic Press, 1995); Ivor Grattan-Guiness (with J. R. Ravetz), *Joseph Fourier, 1768–1830* (Cambridge, MA: MIT Press, 1972); John Herivel, *Joseph Fourier: The Man and the Physicist* (Oxford: Oxford University Press, 1975).

4. William Wordsworth, *The Prelude, or Growth of a Poet's Mind (text of 1805)*, edited by Ernest de Selincourt and Stephen Gill, X:692 (Oxford: Oxford University Press, 1970).

5. Joseph Fourier, letter to Villetard, June/July 1795, in John Herivel, *Joseph Fourier: The Man and the Physicist* (Oxford: Oxford University Press, 1975), 280.

6. Joseph Fourier, letter to Villetard, June/July 1795, in Herivel, *Joseph Fourier*, 284.

7. Wordsworth, *The Prelude*, X:335.

8. Robert B. Asprey, *The Rise of Napoleon Bonaparte* (New York: Basic Books, 2000); Robert B. Asprey, *The Reign of Napoleon Bonaparte* (New York: Basic Books, 2001). Asprey uses the birthname spelling "Nabolione" instead of the more common "Napoleone."

9. Andrew Robinson, *Cracking the Egyptian Code: The Revolutionary Life of Jean-Francois Champollion* (Oxford: Oxford University Press, 1975).

10. Grattan-Guiness, *Joseph Fourier*.

11. *Oeuvres de Fourier*, edited by M. Gaston Darboux, 2 vols., 2:97–125 (Paris: Gauthier-Villars et Fils, 1888–1890); Steve Jones, *Revolutionary Science: Transformation and Turmoil in the Age of the Guillotine* (New York: Pegasus Books, 2017), 338.

12. Grattan-Guiness, *Joseph Fourier*, 188–193.

13. Herivel, *Joseph Fourier*, 189, citing J. J. Champollion-Figeac, *Fourier et Napoleon, l'Egypte et les cent jours* (Paris, 1844), 187.

14. Herivel, *Joseph Fourier*, 135–136.

15. Louis L. Bucciarelli and Nancy Dworsky, *Sophie Germain: An Essay in the History of the Theory of Elasticity* (Boston: D. Reidel, 1980), chapters 7–8.

16. *The Eiffel Tower: The Eiffel Tower Laboratory*, "The 72 Savants," https://www.toureiffel.paris/en/the-monument/eiffel-tower-and-science, accessed Feb. 18, 2020.

17. Bucciarelli and Dworsky, *Sophie Germain*, 137.

18. Grattan-Guiness, *Joseph Fourier*, ix.

19. González-Velasco, *Fourier Analysis*, 23–25, 36–44; Grattan-Guiness, *Joseph Fourier*, 188–193.

20. Bracewell, *The Fourier Transform*, 1–5; Grattan-Guiness, *Joseph Fourier*, 193.

Chapter 2

1. Aleksandr I. Solzhenitsyn, *The Gulag Archipelago: 1918–1956: An Experiment in Literary Investigation* (New York: HarperCollins, 2001), 1:590.

2. Vladimir Aleksandrovich Kotelnikov, "O Propusknoi Sposobnosti 'Efira' i Provoloki v Elektrosvyazi [On the Transmission Capacity of the 'Ether' and Wire in Electrical Communications]," in *Vsesoyuznyi Energeticheskii Komitet. Materialy k I Vsesoyuznomu S'ezdu po Voprosam Tekhnicheskoi Rekonstruktsii Dela Svyazi i Razvitiya Slabotochnoi Promyshlennosti. Po Radiosektsii* [The All-Union Energy Committee. Materials for the 1st All-Union Congress on the Technical Reconstruction of Communication Facilities and Progress in the Low-Currents Industry. At Radio Section] (Moscow: Upravlenie Svyazi RKKA, 1933), 4.

3. David R. Brillinger, "John W. Tukey: His Life and Professional Contributions," *The Annals of Statistics* 30 (2002): 1569–1570; Jon Gertner, *The Idea Factory: Bell Labs and the Great Age of American Innovation* (New York: Penguin Press, 2012), 135; Fred R. Shapiro, "Origin of the Term Software: Evidence from the JSTOR Electronic Journal Archive," *IEEE Annals of the History of Computing* 22 (2000): 69–71; John Wilder Tukey, "The Teaching of Concrete Mathematics," *American Mathematical Monthly* 65 (Jan. 1958): 1–9.

4. W. R. Bennett, "Time Division Multiplex Systems," *Bell Systems Technical Journal* 20 (1941): 199–221; Denis Gabor, "Theory of Communication," *Journal of the Institute of Electrical Engineering* (London) 93 (1946): 429–457; Karl Küpfmüller, "Über Einschwingvorgänge in Wellenfiltern [Transient Phenomena in Wave Filters]," *Elektrische Nachrichten-Technik* 1 (1924): 141–152; Harry Nyquist, "Certain Topics in Telegraph Transmission Theory," *Transactions of the AIEE* (proceedings of the Winter Conference of the AIEE, Feb. 13–17, 1928, New York, NY), 617–644; Herbert Raabe, "Untersuchungen an der Wechsilzeitigen Mehrfachübertragung (Multiplexübertragung)," *Elektrische Nachrichtentechnik* 16 (1939): 213–228; Claude E. Shannon, "A Mathematical Theory of Communication," *Bell Systems Technical Journal* 27 (July, Oct. 1948): 379–423, 623–656; Stephen Mack Stigler, "Stigler's Law of Eponymy," *Transactions of the New York Academy of Sciences* 39 (1980): 147–158; Edward Taylor Whittaker, "On the Functions which are Represented by the Expansions of the Interpolation-Theory," in *Proceedings of the Royal Society of Edinburgh* 35 (1915): 181–194; John MacNaughton Whittaker, *Interpolatory Function Theory* (Cambridge: Cambridge University Press, 1935).

5. Christopher C. Bissell, "Vladimir Aleksandrovich Kotelnikov: Pioneer of the Sampling Theorem, Cryptography, Optimal Detection, Planetary Mapping . . . ," *IEEE Communications Magazine* 47 (2009): 32; Mikhail K. Tchobanou and Nikolay N. Udalov, "Vladimir Kotelnikov and Moscow Power Engineering Institute—Sampling Theorem, Radar Systems . . . a Fascinating and Extraordinary Life," *Proceedings of the 2006 International TICSP Workshop on Spectral Methods and Multirate Signal Processing*, Florence, Italy, Sept. 2–3, 2006, 177.

6. John Herivel, *Joseph Fourier: The Man and the Physicist* (Oxford: Oxford University Press, 1975), 154, 172; Natalia Vladimirovna Kotelnikova, "Vladimir Aleksandrovich Kotel'nikov: The Life's Journey of a Scientist," in Yu V. Gulyaev et al., "Scientific Session of the Division of Physical

Sciences of the Russian Academy of Sciences in Commemoration of Academician Vladimir Aleksandrovich Kotelnikov," *Physics-Uspekhi* [English version] 49 (2006): 727.

7. Kotelnikova, "Vladimir Aleksandrovich Kotel'nikov," 728–729.

8. Kotelnikova, "Vladimir Aleksandrovich Kotel'nikov," 728–729.

9. Mikhail Bulgakov, *White Guard* (New Haven: Yale University Press, 2008); Kotelnikova, "Vladimir Aleksandrovich Kotel'nikov," 728–729.

10. Bissell, "Vladimir Aleksandrovich Kotelnikov," 24; Kotelnikova, "Vladimir Aleksandrovich Kotel'nikov," 729; Tchobanou and Udalov, "Vladimir Kotelnikov," 172.

11. Kotelnikova, "Vladimir Aleksandrovich Kotel'nikov," 730; Tchobanou and Udalov, "Vladimir Kotelnikov," 172–173.

12. Kotelnikova, "Vladimir Aleksandrovich Kotel'nikov," 731; Tchobanou and Udalov, "Vladimir Kotelnikov," 173.

13. Richard F. Lyon, "A Brief History of 'Pixel,'" an invited paper presented at the IS&T/SPIE Symposium on Electronic Imaging, Jan. 15–19, 2006, San Jose, CA.

14. Shannon, "A Mathematical Theory of Communication"; Claude E. Shannon, "Communication in the Presence of Noise," *Proceedings of the IRE* 37, no. 1 (Jan. 1949): 10–21.

15. Fredrich L. Bauer, *Decrypted Secrets: Methods and Maxims of Cryptology* (Berlin: Springer-Verlag, 1997), 6; David Stafford, *Roosevelt and Churchill: Men of Secrets* (New York: Overlook Press, 1999), 22.

16. Shannon, "Communication in the Presence of Noise."

17. Bissell, "Vladimir Aleksandrovich Kotelnikov"; Kotelnikova, "Vladimir Aleksandrovich Kotel'nikov."

18. Solzhenitsyn, *The Gulag Archipelago*, 1:408.

19. Robert Conquest, *The Great Terror: A Reassessment* (New York: Oxford University Press, 2008), 13–14.

20. Kotelnikova, "Vladimir Aleksandrovich Kotel'nikov," 731–732; John G. Wright, "Stalin's Pre-War Purge," *Fourth International* 2, no. 10 (1941): 311–313.

21. Kotelnikova, "Vladimir Aleksandrovich Kotel'nikov," 730.

22. "Death of G. M. Krzhizhansovsky," *Current Digest of the Soviet Press* 11 (1959): 31; Mary Hamilton-Dann, *Vladimir and Nadya: The Lenin Story* (New York: International Publishers, 1998), 16, 19, 22–25, 30–32, 36–38, 40, 47, 53, 65–66, 94, 295; Vladimir Petrovich Kartsev, *Krzhizhanovsky* (Mir, 1985), 61–62, 171; Frederik Nebeker, *Dawn of the Electronic Age: Electrical Technologies in the Shaping of the Modern World, 1914 to 1945* (Hoboken, NJ: John Wiley & Sons, 2009), 84; Helena M. Nicolaysen, *Looking Backward: A Prosopography of the Russian Social Democratic Elite, 1883–1907* (Palo Alto: Stanford University Press, 1990), 34, 62, 65, 206, 339; Stefan Thomas

Possony, *Lenin: The Compulsive Revolutionary* (Chicago: Henry Regnery Company, 1964), 38; Rochelle Goldberg Ruthchild, *Equality and Revolution: Women's Rights in the Russian Empire, 1905–1917* (Pittsburgh: University of Pittsburgh Press, 2010), 183; John G. Wright, "How Stalin Cleared Road for Hitler," *Fourth International* 2, no. 9 (1941): 270–272.

23. Boris Evseevich Chertok, *Rakety I lyudi: Fili Podlipki Tyuratam* [Rockets and people, Vol. 2: Creating a rocket industry], 4 vols. (Moscow: Mashinostroyeniye, 1996), 2:96–108.

24. Aleksandr I. Solzhenitsyn, *In the First Circle*, the restored text, translated from the Russian by Harry T. Willetts (New York: HarperCollins, 2009), 92.

25. Bissell, "Vladimir Aleksandrovich Kotelnikov," 29; Kotelnikova, "Vladimir Aleksandrovich Kotel'nikov," 731; Tchobanou and Udalov, "Vladimir Kotelnikov," 173.

26. "The Amtorg Trading Company Case," in *Recollections of Work on Russian*, document 3421019, http://www.gwu.edu/~nsarchiv/NSAEBB/NSAEBB278/06.PDF, accessed Feb. 28, 2020, 1–2; *Arthur Fielding: The Perseus Legend*, blog, Sept. 5, 2010, http://arthurfielding.blogspot.com/, accessed Feb. 28, 2020; Vladimir Chikov and Gary Kern, *Comment Staline a vole la Bomb Atomique Aux Americains: Dossier KGB 13676* [How Stalin stole the atomic bomb from the Americans] (Paris: R. Laffont, 1996); Herbert Romerstein and Eric Breindel, *The Venona Secrets: Exposing Soviet Espionage and America's Traitors* (Washington, DC: Regnery, 2000), 206; Henry L. Zelchenko, "Stealing America's Know-How: The Story of Amtorg," *The American Mercury*, Feb. 1952, 75–84.

27. David Kahn, *The Codebreakers: The Comprehensive History of Secret Communication from Ancient Times to the Internet* (New York: Scribner, 1967, revised and updated 1996); S. N. Molotkov, "Quantum Cryptography and V. A. Kotel'nikov's One-Time Key and Sampling Theorems," in Gulyaev et al., "Scientific Session of the Division of Physical Sciences" [English version], 750–761; Claude E. Shannon, "Communication Theory of Secrecy Systems," *Bell Systems Technical Journal* 28 (1949): 656–715, n. 1; Tchobanou and Udalov, "Vladimir Kotelnikov," 173–174.

28. Kotelnikova, "Vladimir Aleksandrovich Kotel'nikov," 732; Tchobanou and Udalov, "Vladimir Kotelnikov," 174.

29. Kotelnikova, "Vladimir Aleksandrovich Kotel'nikov," 732; Tchobanou and Udalov, "Vladimir Kotelnikov," 173–174.

30. Kotelnikova, "Vladimir Aleksandrovich Kotel'nikov," 732, 734.

31. Simon Ings, *Stalin and the Scientists: A History of Triumph and Tragedy 1905–1953* (New York: Atlantic Monthly Press, 2016), 312–314.

32. Keith Dexter and Ivan Rodionov, *The Factories, Research and Design Establishments of the Soviet Defence Industry: A Guide*, Version 13, University of Warwick, Dept. of Economics, Jan. 2012; Kotelnikova, "Vladimir Aleksandrovich Kotel'nikov," 733–734; Solzhenitsyn, *In the First Circle*; Marshall Winokur, "Review of *Architecture of Russia from Old to Modern*, Vol. 1: *Churches and Monasteries*. Japan: Russian Orthodox Youth Committee, 1973," *Slavic and East European Journal* 26 (1982): 113.

33. Solzhenitsyn, *In the First Circle*, 217–218.

34. Homer W. Dudley, "The Vocoder," *Bell Systems Technical Journal* 17 (1939): 122–126; Kotelnikova, "Vladimir Aleksandrovich Kotel'nikov," 731; Dave Tompkins, *How to Wreck a Nice Beach: The Vocoder from World War II to Hip-Hop: The Machine Speaks* (Brooklyn: Melville House Publishing, 2011), 70, 122–130.

35. Solzhenitsyn, *In the First Circle*, 92.

36. Kotelnikova, "Vladimir Aleksandrovich Kotel'nikov," 734.

37. Chertok, *Rakety I lyudi*, 2:106–108; Boris Evseevich Chertok, "V. A. Kotel'nikov and His Role in the Development of Space Radio Electronics in Our Country," in Gulyaev et al., "Scientific Session of the Division of Physical Sciences" [English version], 761–762; Dexter and Rodionov, *The Factories, Research and Design Establishments of the Soviet Defence Industry*.

38. Kotelnikova, "Vladimir Aleksandrovich Kotel'nikov," 734–735.

39. *Digital Imaging and Communications in Medicine (DICOM), Part 14: Grayscale Standard Display Function* (Rosslyn, VA: National Electrical Manufacturers Association, 2004).

40. E. Brad Meyer and David R. Moran, "Audibility of a CD-Standard A/D/A Loop Inserted into High-Resolution Audio Playback," *Journal of the Audio Engineering Society* 55 (2007): 778; Joshua D. Reiss, "A Meta-Analysis of High Resolution Audio Perceptual Evaluation," *Journal of the Audio Engineering Society* 64, no. 6 (June 2016): 364–379; *The Super Audio CD Reference*, "Thread Debunking Meyer and Moran," http://www.sa-cd.net/showthread/42987, accessed Feb. 28, 2020.

41. Vladimir Aleksandrovich Kotelnikov, "The Age of Radio," in *Life in the Twenty-First Century*, edited by Mikhail Vassiliev and Sergei Gouschev, translated by H. E. Crowcroft and R. J. Wason (London: Penguin, 1961), 129.

42. Paul Dickson, *Sputnik: The Shock of the Century* (New York: Walker Publishing, 2001), 98–99, 130; NASA's *National Space Science Data Center* (Sputnik), https://nssdc.gsfc.nasa.gov/nmc/spacecraft/display.action?id=1957-001B, accessed Feb. 28, 2020.

43. Ben Evans, *At Home in Space: The Late Seventies into the Eighties* (New York: Springer-Praxis, 2012), 37; Edward Clinton Ezell and Linda Newman Ezell, *The Partnership: A NASA History of the Apollo-Soyuz Test Project* (Mineola, NY: Dover, 2010), 182–188.

44. Lutz D. Schmadel, *Dictionary of Minor Planet Names*, 5th ed., vol. 1 (Berlin: Springer-Verlag, 2003), 231; Tchobanou and Udalov, "Vladimir Kotelnikov," 176–177.

45. *The KGB File of Andrei Sakharov*, edited by Joshua Rubenstein and Alesander Gribanov (New Haven: Yale University, 2005), 193–196.

46. Vitaly Lazarevich Ginzburg, "The Sakharov Phenomenon," in *Andrei Sakharov: Facets of a Life* (Gif-sur-Yvette, France: Editions Frontières and P. N. Lebedev Physics Institute, 1991).

47. Chertok, *Rakety I lyudi*, 2:108; *Time Magazine*, July 22, 1957, "Russia: The Quick & the Dead."

48. Bissell, "Vladimir Aleksandrovich Kotelnikov," 32.

49. Bissell, "Vladimir Aleksandrovich Kotelnikov"; Mark Bykhovskiy, "The Life Filled with Cognition and Action (dedicated to the 100th Anniversary of Academician V. A. Kotelnikov)," *IEEE Information Theory Society Newsletter* 59 (2009): 13–15; Kotelnikov, "O Propusknoi Sposobnosti 'Efira' i Provoloki v Elektrosvyazi," the introduction; Tchobanou and Udalov, "Vladimir Kotelnikov."

50. Chertok, "V. A. Kotel'nikov," 765; Ings, *Stalin and the Scientists*, 173; Heinrich Lantsberg, "IEEE Life Fellow Honored by Russia's President Putin," *IEEE Region 8 News* 7 (2004): 1; Ethan Pollock, "Stalin as the Coryphaeus of Science: Ideology and Knowledge in the Post-War Years," in *Stalin: A New History*, edited by Sarah Davies and James Harris (Cambridge: Cambridge University Press, 2005), 271–288; Tchobanou and Udalov, "Vladimir Kotelnikov," 177.

Chapter 3

1. Tom Stoppard, *Arcadia* (London: Faber and Faber, 1993), 51–52 (excerpt from act 1, scene 4).

2. Alan Turing obit., *Biographical Memoirs of Fellows of the Royal Society*, Nov. 1, 1955, https://doi.org/10.1098/rsbm.1955.0019, accessed Feb. 29, 2020; Sara Turing, *Alan M. Turing* (Cambridge: Cambridge University Press, 1959; repr. Centenary Edition, 2012).

3. Sir Harry Hinsley, "The Influence of Ultra in the Second World War," http://www.cix.co.uk/~klockstone/hinsley.htm, accessed Feb. 28, 2020; Andrew Hodges, *Alan Turing: The Enigma* (New York: Simon and Schuster, 1983).

4. B. Jack Copeland, *Turing: Pioneer of the Information Age* (Oxford: Clarendon Press, 2012), 285, n. 6; Hodges, *Alan Turing*, 149; Sara Turing, *Alan M. Turing*, 117.

5. Copeland, *Turing: Pioneer*, 223–234; Hodges, *Alan Turing*, 487–492; Sir John Dermot Turing, *Prof: Alan Turing Decoded* (Cheltenham, Gloucestershire: The History Press, 2015); Sara Turing, *Alan M. Turing*, 114–121.

6. Hodges, *Alan Turing*, 71, 73.

7. Copeland, *Turing: Pioneer*, 223–234.

8. David Leavitt, *The Man Who Knew Too Much: Alan Turing and the Invention of the Computer* (New York: Atlas Books, W. W. Norton, 2006), 18.

9. Seymour Papert, *Mindstorms: Children, Computers, and Powerful Ideas* (New York: Basic Books Inc., 1980), viii.

10. Re Scrooge meets Baggins see *Walt Disney's Uncle Scrooge* (New York: Dell Publishing Company Inc., Mar.–May 1954), no. 5, 11; J.R.R. Tolkien, *The Lord of the Rings* (Boston: Houghton Mifflin Harcourt, 2004), book 1, chapter 1, paragraph 1.

11. Thomas Usk, *The Testament of Love* [ca. 1375], edited by Gary W. Shawver (Toronto: University of Toronto Press, 2002), II.7.71–73.

12. Geoffrey Chaucer, *A Treatise on the Astrolabe; addressed to his Sowns*, 1391, edited by Walter W. Skeat (London: The Chaucer Society, 1872, repr. 1880), I.9.3.

13. David Hilbert and Wilhelm Ackerman, *Principles of Mathematical Logic* (New York: Chelsea Publishing, 1950), 112–124.

14. David Anderson, "Historical Reflections: Max Newman: Forgotten Man of Early British Computing," *Communications of the ACM* 56, no. 5 (May 2013): 30.

15. Copeland, *Turing: Pioneer*, 1–2; Brian Randell, email Aug. 8, 2014; Sara Turing, *Alan M. Turing*, 63.

16. Michael A. Arbib, *Theories of Abstract Automata* (Englewood Cliffs, NJ: Prentice-Hall, 1969), chapters 5–6; Stephen Cole Kleene, "General Recursive Functions of Natural Numbers," *Mathematische Annalen* 112 (1936): 727–742; Emil Leon Post, "Finite Combinatory Processes—Formulation I," *Journal of Symbolic Logic* 1 (1936): 103–105; Alan Mathison Turing, "On Computable Numbers, with an Application to the *Entsheidungsproblem*," *Proceedings of the London Mathematical Society, Series 2* 42 (1936): 230–265; Alan Mathison Turing, "Computability and λ-Definability," *Journal of Symbolic Logic* 2, no. 1 (1937), 153–163.

17. John S. Farmer and W. E. Henley, eds., *Slang and Its Analogues: Past and Present*, multiple vols. printed for subscribers only, 1903, 6:368.

18. Donald Watts Davies, "Corrections to Turing's Universal Computing Machine," in *The Essential Turing: The Ideas That Gave Birth to the Computer Age*, ed. B. Jack Copeland (Oxford: Clarendon Press, 2004), 103–124; Martin Davis ed., *The Undecidable: Basic Papers on Undecidable Propositions, Unsolvable Problems and Computable Functions* (Mineola, NY: Dover, 2004), 115, 118; Hodges, *Alan Turing*, 392; Emil Leon Post, "Recursive Unsolvability of a Problem of Thue," *Journal of Symbolic Logic* 12 (1947): 7.

19. Leavitt, *The Man Who Knew Too Much*, 186–187, 196.

20. George Dyson, *Turing's Cathedral: The Origins of the Digital Universe* (New York: Pantheon Books, 2012), 52–53, 88–89.

21. Davis, *The Undecidable*, 135–140; Sara Turing, *Alan M. Turing*, 70.

22. Martin Davis, "What Is a Computation?" in *Mathematics Today: Twelve Informal Essays*, ed. Lynn Arthur Steen (New York: Springer-Verlag, 1978), 246.

23. Yurii Rogozhin, "Small Universal Turing Machines," *Theoretical Computer Science* 168 (1996): 231–233.

24. Robert A. Heinlein, *The Moon Is a Harsh Mistress* (New York: Orb Books, 1997).

25. Dyson, *Turing's Cathedral*, 54; Marina von Neumann Whitman, *The Martian's Daughter: A Memoir* (Ann Arbor: University of Michigan Press, 2013), 1–2, 7, 16–17, 50, 52, 54, 60.

26. Jacob Bronowski, *The Ascent of Man* (London: BBC Books, 2011), 323–327; Dyson, *Turing's Cathedral*, 45, 326; Herman H. Goldstine, *The Computer: from Pascal to von Neumann* (Princeton, NJ: Princeton University Press, 1972, paperback 1980, fifth printing 1983), 167, 171.

27. Jeremy Bernstein, "John von Neumann and Klaus Fuchs, an Unlikely Collaboration," *Physics in Perspective* 12, no. 1 (Mar. 2010): 36–50.

28. Hodges, *Alan Turing*, 95, 117–132, 144–145.

29. B. Jack Copeland ed., *Colossus: The Secrets of Bletchley Park's Codebreaking Computers* (Oxford: Oxford University Press, 2006), 157–158.

30. Copeland, *Colossus*, 380–381.

31. Homer W. Dudley, "Thirty Years of Vocoder Research," *Journal of the Acoustical Society of America* 36 (1964): 1021; Dave Tompkins, *How to Wreck a Nice Beach: The Vocoder from World War II to Hip-Hop: The Machine Speaks* (Brooklyn: Melville House Publishing, 2011), 48, 81, chapters 2–3.

32. David Anderson, "Was the Manchester Baby Conceived at Bletchley Park?" British Computer Society, Nov. 2007, draft dated 2004, https://www.researchgate.net/publication/228667497_Was _the_Manchester_Baby_conceived_at_Bletchley_Park.pdf, accessed May 15, 2020; Hodges, *Alan Turing*, 245–246; Tompkins, *How to Wreck a Nice Beach,* 42.

33. Copeland, *Turing: Pioneer*, 241, n. 14; Martin Davis, *Computability & Unsolvability* (New York: McGraw-Hill, 1958), 70; Martin Davis, *The Universal Computer: The Road from Leibniz to Turing* (New York: W. W. Norton, 2000), 159–160.

34. Simon Lavington, ed., *Alan Turing and His Contemporaries: Building the World's First Computers* (London: British Informatics Society, 2012), 82.

35. Donald E. Knuth, *The Art of Computer Programming*, Vol. 1: *Fundamental Algorithms* (Menlo Park, CA: Addison-Wesley, 1968), preface.

36. Dyson, *Turing's Cathedral*.

37. Copeland, *The Essential Turing*, 383; George Dyson, private communication, Mar. 2013, excerpts from three dated letters from the Comptroller's Office, John von Neumann file, Shelby White and Leon Levy Archives Center, Institute for Advanced Study, Princeton, NJ.

38. George Dyson, private communication, Mar. 2013.

39. George Dyson, private communication, Mar. 2013.

40. Copeland, *The Essential Turing*, 388, 390, 391; David Alan Grier, "The ENIAC, the verb 'to program' and the emergence of digital computers," *IEEE Annals of the History of Computing* 18, no. 1 (1996): 51–53; John Mauchly, "The Use of High Speed Vacuum Tube Devices for Calculating," Aug. 1942, in Brian Randell ed., *The Origins of Digital Computers: Selected Papers* (New York: Springer-Verlag, 1973), 330–331.

41. Charles Scott Sherrington, *Man on His Nature* (Cambridge: Cambridge University Press, 1942), 178.

42. Turlough Neary and Damien Woods, "Four Small Universal Turing Machines," *Fundamenta Informaticae* 91 (2009): 120–123; Claude E. Shannon, "A Universal Turing Machine with Two

Internal States," in Claude E. Shannon and John McCarthy eds., *Automata Studies* (Princeton, NJ: Princeton University Press, 1956), 157–165.

43. Dyson, *Turing's Cathedral*, 225–242.

44. Hodges, *Alan Turing*, 78.

45. Virginia Woolf, *Virginia Woolf: The Complete Collection*, includes *The Diary* (5 vols., 1977–1984), Amazon.com Kindle edition, AtoZ Classics, 2018.

46. William Newman, "Married to a Mathematician: Lyn Newman's Life in Letters," *The Eagle* (St. John's College, Cambridge, 2002), 47–56, http://www.mdnpress.com/wmn/pdfs/Married ToaMathematician.pdf, accessed Feb. 29, 2020, 1–3.

47. Sara Turing, *Alan M. Turing*, xxi.

Chapter 4

1. *Manchester Baby*, https://www.youtube.com/watch?v=cozcXiSSkwE, accessed Feb. 22, 2020.

2. *Manchester Baby*.

3. B. Jack Copeland ed., *Colossus: The Secrets of Bletchley Park's Codebreaking Computers* (Oxford: Oxford University Press, 2006), 301; B. Jack Copeland, *Turing: Pioneer of the Information Age* (Oxford: Clarendon Press, 2012), 104, 107.

4. Copeland, *Turing: Pioneer*, 64, 113–116.

5. B. Jack Copeland, "The Manchester Computer: A Revised History. Part 1: The Memory," *IEEE Annals of the History of Computing* 33 (2011): 4–21; Tom Kilburn, "From Cathode-Ray Tube to Ferranti Mark I," *Resurrection: The Bulletin of the Computer Conservation Society* 1, no. 2 (1990): 16–20; *Frederic Calland Williams (1911–1977)*, http://curation.cs.manchester.ac.uk/computer50/www .computer50.org/mark1/williams.html, accessed Feb. 29, 2020; Frederic C. Williams and Tom Kilburn, "A Storage System for Use with Binary-Digital Computing Machines," *Proceedings of the IEE* 96, part III, no. 40 (Mar. 1949): 100.

6. Copeland, "The Manchester Computer: Part 1."

7. Tom Kilburn, "A Storage System for Use with Binary Digital Computing Machines," Dec. 1, 1947, a report to the Telecommunications Research Establishment, Great Malvern, England, section 2; Williams and Kilburn, "A Storage System," 82.

8. Dai Edwards, email July 16, 2013; Kilburn, *A Storage System*, sections 1.4, 1.5, 4.2, 6; Thomas Lean, interviewer, "David Beverley George (Dai) Edwards Interview," *An Oral History of British Science*, reference no. C1379/11 (London: The British Library Board, 2010), 68–69; Frederic C. Williams, "Early Computers at Manchester University," *The Radio and Electronic Engineer* 45 (1975): 327–328; Williams and Kilburn, "A Storage System."

9. Chris Burton, email June 24, 2013; Dai Edwards, email July 16, 2013; Lean, "Dai Edwards Interview," 87.

10. Chris Burton, emails June 24, Sept. 13, 2013.

11. T. S. Eliot, *Poems: 1909–1925* (New York: Harcourt, Brace, 1925).

12. B. Jack Copeland, ed., *The Essential Turing: The Ideas That Gave Birth to the Computer Age* (Oxford: Clarendon Press, 2004), 378–379, 383; B. Jack Copeland, ed., *Alan Turing's Electronic Brain: The Struggle to Build the ACE, the World's Fastest Computer* (Oxford: Clarendon Press, 2005; paperback, 2012), 455–456; George Dyson, *Turing's Cathedral: The Origins of the Digital Universe* (New York: Pantheon Books, 2012), 136ff; Brian Randell, "On Alan Turing and the Origins of Digital Computers," *Machine Intelligence* 7 (1972): 3–20; *Dai Edwards: The First Stored Program Computer*, https://www.youtube.com/watch?v=T8JEexHSh1U, accessed Feb. 22, 2020.

13. B. E. Carpenter, "Turing and ACE: Lessons from a 1946 Computer Design." *15th CERN School of Computing.* L'Aquila, Italy, Aug. 30–Sept. 12, 1992, 230–234 (Geneva: CERN, 1993), 231.

14. Copeland, *Alan Turing's Electronic Brain*, chapter 20, 369; Andrew Hodges, *Alan Turing: The Enigma* (New York: Simon and Schuster, 1983), 305–307; Simon Lavington, email Sept. 2013; *AlanTuring.net: The Turing Archive for the History of Computing*, http://www.alanturing.net/index.htm, accessed Feb. 29, 2020.

15. Copeland, *Alan Turing's Electronic Brain*, 114; Hodges, *Alan Turing*, chapter "Mercury Delayed"; Simon Lavington, ed., *Alan Turing and His Contemporaries: Building the World's First Computers* (London: British Informatics Society, 2012), 13, 80.

16. Copeland, *The Essential Turing*, 368–369, 388.

17. Frederic C. Williams and Tom Kilburn, "Electronic Digital Computers," *Nature* 162 (1948): 487; B. Jack Copeland, "The Manchester Computer: A Revised History. Part 2: The Baby Computer," *IEEE Annals of the History of Computing* 33 (2011): 22–37.

18. Chris Burton, email Sept. 9, 2013; Simon Lavington, *A History of Manchester Computers* (Swindon, Wiltshire: The British Computer Society, 1998), 17.

19. David Anderson, "Was the Manchester Baby Conceived at Bletchley Park?" British Computer Society, Nov. 2007, draft dated 2004, https://www.researchgate.net/publication/228667497_Was_the_Manchester_Baby_conceived_at_Bletchley_Park.pdf, accessed May 15, 2020, 39; Tom Kilburn, "The University of Manchester Universal High-Speed Digital Computing Machine," *Nature* 164 (1949): 684; Lean, "Dai Edwards Interview," 58, 60; Williams, "Early Computers at Manchester," 328.

20. Chris Burton, email Sept. 2013; Copeland, *Alan Turing's Electronic Brain*, chapter 20; Kilburn, *A Storage System*, bibliography; Lavington, *Alan Turing and His Contemporaries*, 96; Brian Randell, email Aug. 8, 2014; Williams and Tom Kilburn, "Electronic Digital Computers."

21. Lavington, *A History of Manchester Computers,* 17–18.

22. *Guardian*, Manchester, July 9, 1951; Lavington, *Alan Turing and His Contemporaries*, 38; *Alan M. Turing (1912–1954)*, http://curation.cs.manchester.ac.uk/computer50/www.computer50.org/mark1/turing.html, accessed Feb. 29, 2020.

23. Copeland, *Turing: Pioneer*, 132.

24. Hodges, *Alan Turing*, 352–353; Lavington, *Alan Turing and His Contemporaries*, 25, 81–82; Alan Macfarlane, *Film Interviews with Leading Thinkers*, Collections, Streaming Media Service, University of Cambridge, interview with David Hartley, May 2, 2017.

25. Edsac 99, University of Cambridge Computer Laboratory website for the 50th anniversary of Edsac, https://www.cl.cam.ac.uk/events/EDSAC99/, accessed Feb. 29, 2020; Lavington, *Alan Turing and His Contemporaries*, 28.

26. Lean, "Dai Edwards Interview," 90; Whirlwind Bi-Weekly Reports, Dec. 15, 1947–Dec. 21, 1951, Servomechanisms Lab, MIT, Cambridge, MA; Maurice V. Wilkes, David J. Wheeler, and Stanley Gill, *The Preparation of Programs for an Electronic Digital Computer: With Special Reference to the EDSAC and the Use of a Library of Subroutines* (Cambridge, MA: Addison-Wesley, 1951).

27. Copeland, *Alan Turing's Electronic Brain*, 115.

28. George Dyson, email Apr. 22, 2013; Marina von Neumann Whitman, *The Martian's Daughter: A Memoir* (Ann Arbor: University of Michigan Press, 2013), 50.

29. Herman H. Goldstine, *The Computer: from Pascal to von Neumann* (Princeton, NJ: Princeton University Press, 1972, paperback 1980, fifth printing 1983), 233; Hans Neukom, "The Second Life of ENIAC," *IEEE Annals of the History of Computing* 28, no. 3 (Apr.–June 2006): 4–16.

30. Bertram Vivian Bowden, ed., *Faster than Thought: A Symposium on Digital Computing Machines* (London: Sir Isaac Pitman & Sons, 1953), 174; Thomas Haigh, Mark Priestley, and Crispin Rope, "Engineering 'the Miracle of the ENIAC': Implementing the Modern Code Paradigm," *IEEE Annals of the History of Computing* 36, no. 2 (2014): 41–59; Thomas Haigh, Mark Priestley, and Crispin Rope, *ENIAC in Action: Making and Remaking the Modern Computer* (Cambridge, MA: MIT Press, 2016).

31. George Dyson, emails Aug. 16, and Oct. 25, 2017.

32. Bowden, *Faster than Thought*, ix; Copeland, *The Essential Turing*; Martin Davis, *The Universal Computer: The Road from Leibniz to Turing* (New York: W. W. Norton, 2000), 177–183; Dyson, *Turing's Cathedral*; Goldstine, *The Computer: from Pascal to von Neumann*, 324, 349–362; Lavington, *Alan Turing and His Contemporaries*, 8–9; Whirlwind Bi-Weekly Reports, no. 185, Dec. 15, 1947, to no. 1361, Dec. 21, 1951.

33. Rachael Hanley, "From Googol to Google," *Stanford Daily*, Feb. 12, 2003, http://web.archive.org/web/20100327141327/http://www.stanforddaily.com/2003/02/12/from-googol-to-google, accessed Feb. 29, 2020.

34. Dyson, *Turing's Cathedral*, 68–69, 103, 148.

35. Lavington, *A History of Manchester Computers*, 22.

36. Chris Burton, emails July 2014; *Computer 50: The University of Manchester Celebrates the Birth of the Modern Computer*, http://curation.cs.manchester.ac.uk/computer50/www.computer50.org/index.html, accessed Feb. 29, 2020.

37. B. Jack Copeland and A. A. Haeff, "Andrew V. Haeff: Enigma of the Tube Era and Forgotten Computing Pioneer," *IEEE Annals of the History of Computing* 37, no. 1 (2015): 67–74.

38. Charles W. Adams, "A Batch-Processing Operating System for the Whirlwind I Computer," *Proceedings of the National Computer Conference* (1987): 787–788.

39. John (Jack) T Gilmore Jr., "Retrospectives II: The Early Years in Computer Graphics at MIT, Lincoln Lab and Harvard," *Siggraph '89 Panel Proceedings* (Siggraph '89, Boston, July 31–Aug. 4, 1989), slide 3, p. 40; Edward R. Murrow, "Jay W. Forrester and the Whirlwind Computer," *See It Now*, Dec. 16, 1951, https://criticalcommons.org/view?m=DTVj10Hz5, accessed Mar. 1, 2020; Norman H. Taylor, "Retrospectives I: The Early Years in Computer Graphics at MIT, Lincoln Lab and Harvard," *Siggraph '89 Panel Proceedings* (Siggraph '89, Boston, July 31–Aug. 4, 1989), slide 3, p. 20.

40. Whirlwind Bi-Weekly Reports, no. 899, Sept. 16, 1949, 1.

41. Adams, "A Batch-Processing Operating System for the Whirlwind," 787–788; Fred Gruenberger, ed., *Computer Graphics: Utility/Production/Art* (Washington, DC: Thompson Book Company, 1967), 106.

42. Doug Huskey [son], email Aug. 25, 2013.

43. J. Presper Eckert Jr., H. Lukoff, and G. Smoliar, "A Dynamically Regenerated Electrostatic Memory System," *Proceedings of the IRE* (1950): 498–510.

44. Jack Copeland, email Aug. 3, 2014; Eckert et al., "A Dynamically Regenerated Electrostatic Memory System"; Herman Lukoff, *From Dits to Bits: A Personal History of the Electronic Computer* (Portland, OR: Robotics Press, 1979), 88.

45. Chris Burton, email Sept. 13, 2013; Krista Ferrante, email Oct. 20, 2016; *Proceedings of the 1951 AIEE–IEE Conference*, "Review of Electronic Digital Computers," Dec. 10–12, 1951, 59, 71; Whirlwind Bi-Weekly Reports, no. 1326, Oct. 26, 1951, 19.

46. Dai Edwards, email July 16, 2013; *The Manchester Electronic Computer* (Hollinwood, UK: Ferranti, 1952), 13.

47. Copeland, *The Essential Turing*, 356–357; Hodges, *Alan Turing*, 446–447, 477; David Link, "Programming ENTER: Christopher Strachey's Draughts Program," *Resurrection: The Bulletin of the Computer Conservation Society* 60 (Winter 2012): 23–24; Christopher Strachey, Bodleian Library, Oxford University, Oxford, UK, Christopher Strachey archives, folders CSAC 71.1.80/C.20–C.33 for his draughts program, 1950–1952, folders C20–C33.

48. Martin Campbell-Kelly, email July 28, 2013; Alexander Shafto Douglas, "Noughts and Crosses: An Early Computer Version," draft Apr. 9, 1992, intended for Martin Campbell-Kelly, ed., *IEEE Annals of the History of Computing* 14, no. 4 (Oct.–Dec. 1992), special issue on Edsac; Joyce M. Wheeler, "Applications of the Edsac," *IEEE Annals of the History of Computing* 14, no. 4 (Oct.–Dec. 1992), 28.

49. Martin Campbell-Kelly, "Past into Present: The Edsac Simulator," in *The First Computers: History and Architectures*, ed. Raúl Rojas and Ulf Hashagen (Cambridge, MA: MIT Press, 2000), 409; Martin Campbell-Kelly, emails July 9–10, 2013.

50. Jack Copeland, emails July–Sept. 2014.

51. Martin Campbell-Kelly, email July 9, 2013.

52. Taylor, "Retrospectives I," slide 6.

53. Fred Brooks, personal conversation Aug. 13, 2018; J. Martin Graetz, "The Origin of Spacewar," *Creative Computing* 7, no. 8 (Aug. 1981): 60.

54. Adams, "A Batch-Processing Operating System for the Whirlwind," 787–788; Gilmore, "Retrospectives II," slide 3, p. 40; Gruenberger, *Computer Graphics*, 106; Hrand Saxenian, *Programming for Whirlwind 1*, Report R-196, June 11, 1951, Digital Computer Laboratory, MIT, 55; Taylor, "Retrospectives I," slide 7.

55. David E. Weisberg, *The Engineering Design Revolution: The People, Companies and Computer Systems That Changed Forever the Practice of Engineering*. 2008, http://cadhistory.net/, accessed Mar. 1, 2020, chapter 3, p. 5.

56. https://criticalcommons.org/Members/ccManager/clips/mits-whirlwind-computer-debuts-on-see-it-now-with/view, accessed Feb. 22, 2020.

57. Martin Davis, email Oct. 18, 2013.

58. A. Robin Forrest, *War and Peace and Computer Graphics: From Cold War to Star Wars*, Microsoft *PowerPoint* presentation, Nov. 2013; Robin Forrest, interview, London, Sept. 5, 2016; *Merwin Biography*, https://www.computer.org/volunteering/awards/merwin/about-merwin, accessed Feb. 29, 2020.

59. Nick England, email Aug. 11, 2019.

60. *Wikipedia*, Baudot code, accessed Aug. 12, 2019.

61. *ASCII Artwork: The RTTY Collection*, http://artscene.textfiles.com/rtty/, accessed Feb. 22, 2020; *John Sheetz*, https://www.youtube.com/watch?v=c1Beg5qb4is, accessed Feb. 22, 2020.

62. James Kajiya, email Apr. 29, 2017; Robert Schumacker, email Mar. 6, 2018; Dick Shoup, email Jan. 2014; K. W. Uncapher, *The Rand Video Graphic System—An Approach to a General User-Computer Graphic Communication System*, R-753-ARPA, Apr. 1971, 4, 11–12.

63. Stewart Brand, *The Media Lab: Inventing the Future at MIT* (New York: Viking Penguin, 1987), 171; Robert Schumacker emails Mar. 4–5, 2018; Richard G. Shoup, "Some Quantization Effects in Digitally-Generated Pictures," *Society for Information Display International Symposium, Digest of Technical Papers* 4 (1973): 58–59; *The SuperPaint System (1973–1979)*, http://web.archive.org/web/20020110013554/http://www.rgshoup.com:80/prof/SuperPaint/, accessed Feb. 22, 2020; Nicholas Negroponte, "Raster Scan Approaches to Computer Graphics," *Computers & Graphics* 2, no. 3 (1977): 191–192.

64. Bob Schumacker, email Mar. 4, 2018; Shoup, "Some Quantization Effects."

65. Malcolm Blanchard, email Jan. 29, 2014; Edwin Catmull, "A Subdivision Algorithm for Computer Display of Curved Surfaces," PhD thesis, University of Utah, Dec. 1974; Franklin C. Crow, "The Aliasing Problem in Computer-Generated Shaded Images," *Communications of the ACM* 20 (1977): 799–805.

Chapter 5

1. Leo Tolstoy, *War and Peace*, translated by Louise and Aylmer Maude (New York: Alfred A. Knopf, 1992), first lines, book 3, part 3, chapter 1.

2. Laurent Mannoni, *The Great Art of Light and Shadow: Archaeology of the Cinema* (Exeter: University of Exeter Press, 2000), xix.

3. Edward Ball, *The Inventor and the Tycoon* (New York: Doubleday, 2013); Henry V. Hopwood, *Living Pictures: Their History, Photo-production and Practical Working, with a Digest of British Patents and Annotated Bibliography* (London: Optician & Photographic Trades Review, 1899), 238.

4. Ball, *The Inventor and the Tycoon*, 30; Gordon Hendricks, *Eadweard Muybridge: The Father of the Motion Picture* (New York: Grossman Publishers, 1975), 71; Mannoni, *The Great Art of Light and Shadow*, 307; Rebecca Solnit, *River of Shadows: Eadweard Muybridge and the Technological Wild West* (New York: Penguin Books, 2003), 139.

5. Hendricks, *Eadweard Muybridge*, 46; Ball, *The Inventor and the Tycoon*, 123–125.

6. Solnit, *River of Shadows*, 185–187.

7. Marta Braun, *Eadweard Muybridge* (London: Reaktion Books Ltd., 2010), 161.

8. Ball, *The Inventor and the Tycoon*, 6, 12–18, 120–123, 307–361, chapter 21; Solnit, *River of Shadows*, 184–185.

9. W.K.L. Dickson and Antonia Dickson, *History of the Kinetograph, Kinetoscope, and Kineto-Phonograph* (New York: W.K.L. Dickson, 1895); Charles Musser, *The Emergence of Cinema: The American Screen to 1907* (Berkeley: University of California Press, 1990; paperback 1994), 45–48; Alvy Ray Smith, *Shuttering Mechanisms of Zoetrope and Zoopraxiscope*, 2015, http://alvyray.com /Papers/ShutteringMechanisms.pdf, accessed Mar. 1, 2020, section 1; Paul C. Spehr, *The Man Who Made Movies: W.K.L. Dickson* (New Barnet, Herts.: John Libbey, 2008), 76.

10. Carlos Rojas and Eileen Chow, eds., *The Oxford Handbook of Chinese Cinemas* (Oxford: Oxford University Press, 2013), 5.

11. Athanasius Kircher, *Ars Magna Lucis et Umbrae* (revised second edition, Amsterdam, 1671), 768; *The Oldest Magic Lantern in the World*, https://www.luikerwaal.com/newframe_uk.htm? /oudste_uk.htm, accessed Feb. 24, 2020; Musser, *The Emergence of Cinema*, 21.

12. Ball, *The Inventor and the Tycoon*, 367; Smith, *Shuttering Mechanisms of Zoetrope and Zoopraxiscope*, section 2.

13. Ball, *The Inventor and the Tycoon*; Solnit, *River of Shadows*; J. D. B. Stillman, *The Horse in Motion* (Boston: James R. Osgood and Company, 1882).

14. Hendricks, *Eadweard Muybridge*, 141–142.

15. Ball, *The Inventor and the Tycoon*, 306, 333–334.

16. Ball, *The Inventor and the Tycoon*, 323.

17. Spehr, *The Man Who Made Movies*, 650.

18. Gordon Hendricks, *The Edison Motion Picture Myth* (Berkeley: University of California Press, 1961), 106–108.

19. Hopwood, *Living Pictures*, 88–91; Paul Pottash, email Oct. 18, 2015; Spehr, *The Man Who Made Movies*, 106, 133.

20. David DiFrancesco, email Feb. 14, 2017; Paul Pottash, email Oct. 18, 2015.

21. Luiz Carlos L. Silveira and Harold D. de Mello Jr., "Parallel Pathways of the Primate Vision: Sampling of the Information in the Fourier Space by M and P Cells," in *Development and Organization of the Retina: From Molecules to Function*, ed. L. M. Chalupa and B. L. Finlay (New York: Plenum Press, 1998), 173–199.

22. Dale Purves, Joseph A. Paydarfar, and Timothy J. Andrews, "The Wagon Wheel Illusion in Movies and Reality," *Proceedings of the National Academy of Science USA* 93 (Apr. 1996): 3693–3697.

23. Hopwood, *Living Pictures*, 226; Laurent Mannoni, *Georges Demenÿ: Pionnier du Cinéma* (Douai: Éditions Pagine, 1997).

24. Donald Crafton, *Before Mickey: The Animated Film, 1898–1928* (Chicago: University of Chicago Press, 1982, repr. 1993); Hendricks, *The Edison Motion Picture Myth*; Hopwood, *Living Pictures*; Mannoni, *The Great Art of Light and Shadow*; Musser, *The Emergence of Cinema*; Paul Pottash, email Oct. 18, 2015; Jacques Rittaud-Hutinet, *Letters: Auguste and Louis Lumière: Inventing the Cinema* (London: Faber and Faber, 1995); Spehr, *The Man Who Made Movies*.

25. Richard Brown and Barry Anthony, *The Kinetoscope: A British History* (East Bernet, Herts., UK: John Libbey Publishing, 2017); Hopwood, *Living Pictures*, 65, 98, 238, 240; Musser, *The Emergence of Cinema*, 91; Spehr, *The Man Who Made Movies*, 106–111.

26. Richard Howells, "Louis Le Prince: The Body of Evidence," *Screen* 47, no. 2 (July 2006): 187, 195; E. Kilburn Scott, "The Pioneer Work of Le Prince in Kinematography," *The Photographic Journal (Transactions of the Royal Photographic Society)* 63 (Aug. 1923): 373–378; E. Kilburn Scott, "Career of L. A. A. Le Prince," *Journal of the Society of Motion Picture Engineers* 17, no. 1 (July 1931): 46–66; Spehr, *The Man Who Made Movies*, 111–117; David Nicholas Wilkinson, *The First Film* (2016), https://vimeo.com/ondemand/thefirstfilm/181293064, accessed Feb. 24, 2020; *Roundhay Garden Scene (1888)*, https://www.youtube.com/watch?v=nR2r__ZgO5g, accessed Feb. 24, 2020.

27. Musser, *The Emergence of Cinema*, 115–116.

28. Spehr, *The Man Who Made Movies*, 115.

29. Walter Isaacson, *Steve Jobs* (New York: Simon & Schuster, 2011), 347.

30. Paul Spehr, email June 15, 2015.

31. Hendricks, *The Edison Motion Picture Myth*, appendix B; Musser, *The Emergence of Cinema*, 63, 67.

32. Paul Spehr, email June 15, 2015.

33. Dickson and Dickson, *History of the Kinetograph*, 4, 54–55.

34. W.K.L. Dickson and Antonia Dickson, *The Life and Inventions of Thomas Alva Edison* (New York: Thomas Y. Crowell & Co., 1894), preface.

35. Spehr, *The Man Who Made Movies*, 9.

36. Hendricks, *The Edison Motion Picture Myth*, 163–168, appendix C.

37. Dickson and Dickson, *History of the Kinetograph*, 54.

38. Alvy Ray Smith, *William Kennedy Laurie Dickson: A Genealogical Investigation of a Cinema Pioneer*, Nov. 3, 2019, http://alvyray.com/DigitalLight/WilliamKLDickson_v2.34.pdf, accessed Mar. 1. 2020.

39. Paul Spehr, email June 15, 2015; *W.K.L. Dickson Filmography*, https://www.imdb.com/name/nm0005690/, accessed Feb. 24, 2020.

40. Gordon Hendricks, *The Kinetoscope* (New York: Gordon Hendricks, 1966), 58–59; Paul Spehr, email June 15, 2015.

41. Paul Spehr, emails June 15, 2015 and Aug. 17, 2015.

42. Paul Spehr, email June 10, 2015.

43. Spehr, *The Man Who Made Movies*, 618.

44. Hopwood, *Living Pictures*, 261; Paul Spehr, emails June 15, Aug. 17, 2015.

45. Mannoni, *The Great Art of Light and Shadow*, 457.

46. Charles Musser, *Thomas A. Edison and His Kinetographic Motion Pictures* (New Brunswick, NJ: Rutgers University Press, 1995), 20; Smith, *William Kennedy Laurie Dickson*, Fig. 12; Paul Spehr, email Sept. 14, 2015.

47. Spehr, *The Man Who Made Movies*, 290–294; Paul Spehr, email Sept. 14, 2015.

48. Hopwood, *Living Pictures*, 36–39; Musser, *The Emergence of Cinema*, 145; Spehr, *The Man Who Made Movies*, 352; Paul Spehr, email Aug. 17, 2015.

49. Mannoni, *The Great Art of Light and Shadow*, 325.

50. Ball, *The Inventor and the Tycoon*, 318–319, 334; Mannoni, *The Great Art of Light and Shadow*, 331; Musser, *The Emergence of Cinema*, 66; Spehr, *The Man Who Made Movies*, 142–147.

51. Spehr, *The Man Who Made Movies*, 138–140, 142–147; Paul Spehr, email Aug. 17, 2015.

52. Mannoni, *The Great Art of Light and Shadow*, 436.

53. Mannoni, *The Great Art of Light and Shadow*, 422.

54. Rittaud-Hutinet, *Letters: Auguste and Louis Lumière*, 16–22, 195–200.

55. Mannoni, *The Great Art of Light and Shadow*, 346–350; Spehr, *The Man Who Made Movies*, 111–117; Paul Spehr, email Sept. 5, 2015.

56. Musser, *The Emergence of Cinema*, 135, 177.

57. Thierry Lefebvre, Jacques Malthête, and Laurent Mannoni, eds., *Lettres d'Étienne-Jules Marey à Demenÿ, 1880–1894* (Paris: Association française de recherche sur l'histoire du cinéma, Bibliothèque du Film, 2000); Mannoni, *Georges Demenÿ*; Mannoni, *The Great Art of Light and Shadow*.

58. Lefebvre, Malthête, and Mannon, *Lettres d'Étienne-Jules Marey à Demenÿ*; Mannoni, *The Great Art of Light and Shadow*, 333–363.

59. Hopwood, *Living Pictures*, 83.

60. Mannoni, *The Great Art of Light and Shadow*, 362.

61. Mannoni, *The Great Art of Light and Shadow*, 417–421, 442–450.

62. Mannoni, *The Great Art of Light and Shadow*, 446–449.

63. Mannoni, *The Great Art of Light and Shadow*, 434–439.

64. Mannoni, *Georges Demenÿ*, 78–83; Laurent Mannoni, email Aug. 18, 2015; Rittaud-Hutinet, *Letters: Auguste and Louis Lumière*, 195–200.

65. Mannoni, *The Great Art of Light and Shadow*, 430; Paul Spehr, email Dec. 9, 2015.

66. Paul Spehr, email Sept. 5, 2015.

67. *Wikipedia, Motion Picture Patents Co. v. Universal Film Manufacturing Co.*, accessed May 17, 2020.

68. Crafton, *Before Mickey*, 12.

69. Crafton, *Before Mickey*, 110.

70. Crafton, *Before Mickey*, 110.

71. Crafton, *Before Mickey*, 232–235.

72. Crafton, *Before Mickey*, 61.

73. Crafton, *Before Mickey*, 112–116.

74. Ibid., 58–89; Donald Crafton, *Émile Cohl, Caricature, and Film* (Princeton, NJ: Princeton University Press, 1990); *Fantasmagorie*, https://publicdomainreview.org/collection/emile-cohl-s -fantasmagorie-1908, accessed Feb. 24, 2020.

75. Crafton, *Before Mickey*, 110, 113.

76. Walt Disney, *The Story of the Animated Drawing*, https://youtu.be/UXDwn2OELMU, accessed Feb. 24, 2020.

77. Crafton, *Before Mickey*, 77.

78. Crafton, *Before Mickey*, 192–200.

79. Crafton, *Before Mickey*, 137–150.

80. Crafton, *Before Mickey*, 150–157.

81. Crafton, *Before Mickey*, 244–246.

82. Frank Thomas and Ollie Johnston, *Disney Animation: The Illusion of Life* (New York: Abbeville Press, 1981), 51.

83. Laurent Mannoni and Donata Pesenti Campagnoni, *Lanterne Magique et Film Peint: 400 Ans de Cinéma* (Paris: Éditions de La Martinière, 2009), 182–183, 249.

84. Crafton, *Before Mickey*, 169–173.

85. John Gentilella, https://www.imdb.com/name/nm0313101/, accessed Feb. 24, 2020.

86. Leslie Iwerks and John Kenworthy, *The Hand Behind the Mouse* (New York: Disney Editions, 2001), 24, 236.

87. Iwerks and Kenworthy, *The Hand Behind the Mouse*, 15.

88. Neal Gabler, *Walt Disney: The Triumph of the American Imagination* (New York: Alfred A. Knopf, 2006), 46–50; Iwerks and Kenworthy, *The Hand Behind the Mouse*, 1–14.

89. Edwin G. Lutz, *Animated Cartoons: How They Are Made, Their Origin and Development* (New York: Charles Scribner's Sons, 1920).

90. Iwerks and Kenworthy, *The Hand Behind the Mouse*, 15–24.

91. Gabler, *Walt Disney*, 112–115; Iwerks and Kenworthy, *The Hand Behind the Mouse*, 53–56; William Silvester, *Saving Disney: The Roy E. Disney Story* (Theme Park Press, 2015), 7.

92. Iwerks and Kenworthy, *The Hand Behind the Mouse*, 55–57.

93. Gabler, *Walt Disney*, 143–144; Iwerks and Kenworthy, *The Hand Behind the Mouse*, 78–84.

94. Iwerks and Kenworthy, *The Hand Behind the Mouse*, 87.

95. Iwerks and Kenworthy, *The Hand Behind the Mouse*, vi.

96. David A. Bossert, *Remembering Roy E. Disney: Memories and Photos of a Storied Life* (Los Angeles: Disney Editions, 2013); Silvester, *Saving Disney*; Alvy Ray Smith, "Notes of the Pilgrimage to Disney on 3 Jan. 1977," http://alvyray.com/Pixar/documents/Disney1977Visit_EdAlvyDick.pdf, accessed Apr. 4, 2020.

97. Crafton, *Before Mickey*, xv, foreword.

98. Crafton, *Before Mickey*, 301.

99. Crafton, *Before Mickey*, chapter 9, 300–321.

Chapter 6

1. I. J. Schoenberg, *Cardinal Spline Interpolation* (Philadelphia: Society for Industrial and Applied Mathematics (SIAM), 1973), v.

2. Tom Porter, email Aug. 4, 2016; https://www.discogs.com/Ustad-Ali-Akbar-Khan-Pandit-Ravi-Shankar-With-Ustad-Alla-Rakha-At-San-Francisco/release/2804789, accessed Feb. 25, 2020.

3. Henry David Thoreau, "Spring," *Walden, or Life in the Woods* (Boston: 1864), 232–233 of 248.

4. Robin Forrest, conversation June 12, 2017.

5. Andy Hertzfeld, *Creative Think*, seminar July 20, 1982, https://www.folklore.org/StoryView.py?project=Macintosh&story=Creative_Think.txt, accessed Mar. 1, 2020; Alan Kay, email July 3, 2016; http://billkerr2.blogspot.com/2006/12/point-of-view-is-worth-80-iq-points.html, accessed Feb. 25, 2020.

6. Edward Taylor Whittaker and George Robinson, *A Short Course in Interpolation* (London: Blackie and Son, 1923), 2.

7. Robin Forrest, conversation June 12, 2017.

8. Tom Porter, email Mar. 17, 2017.

9. Edwin Catmull, "A Subdivision Algorithm for Computer Display of Curved Surfaces," PhD thesis, University of Utah, Dec. 1974, appendix A; Edwin Catmull and Raphael Rom, "A Class of Local Interpolating Splines," in *Computer Aided Geometric Design*, ed. R. E. Barnhill and R. F. Riesenfeld (New York: Academic Press, 1974), 317–326; James H. Clark, *Parametric Curves, Surfaces and Volumes in Computer Graphics and Computer-Aided Geometric Design*, Technical Report 221, Computer Systems Laboratory, Stanford University, Palo Alto, CA, Nov. 1981; Alvy Ray Smith, *Spline Tutorial Notes*, Lucasfilm/Pixar Technical Memo 77, May 8, 1983, http://alvyray.com/Memos/CG/Pixar/spline77.pdf, accessed Feb. 28, 2020.

10. A. Robin Forrest, "On the Rendering of Surfaces," *Computer Graphics* 13, no. 2 (Aug. 1979): 254.

11. Alvin M. Welchons and William R. Krickenberger, *Plane Geometry* (New York: Ginn and Company, 1949), 7, 57.

12. Robin Forrest, conversation June 12, 2017.

13. Jim Blinn, email June 21, 2017; Martin Newell, *The Utilization of Procedure Models in Digital Image Synthesis*, PhD thesis, Computer Science, University of Utah, Summer 1975, figs. 28–29; Ivan Sutherland, email Jan. 24, 2018.

14. Herbert Freeman and Philippe P. Loutrel, "An Algorithm for the Solution of the Two-Dimensional 'Hidden-Line' Problem," *IEEE Transactions on Electronic Computers* EC-16, no. 6 (Dec. 1967): 784–789; Philippe P. Loutrel, "A Solution to the Hidden-Line Problem for Computer-Drawn Polyhedra," *IEEE Transactions on Computers* C-19, no. 3 (Mar. 1970): 205–213; Lawrence Gilman Roberts, "Machine Perception of Three-Dimensional Solids," PhD thesis, MIT, EE Dept., Cambridge, MA, June 1963.

15. Jack Bresenham, "Algorithm for Computer Control of a Digital Plotter," *IBM Systems Journal* 4, no. 1 (1965): 25–30; *Bresenham's Algorithm*, https://xlinux.nist.gov/dads/HTML/bresenham.html, accessed Feb. 25, 2020.

16. Jack Bresenham, email June 14, 2017; James D. Foley and Andries van Dam, *Fundamentals of Interactive Computer Graphics* (Cambridge, MA: Addison-Wesley, 1982).

17. Glen J. Culler and Robert W. Huff, "Solution of Nonlinear Integral Equations Using On-Line Computer Control," *Proceedings 1962 AFIPS Spring Joint Computer Conference*, 129; Brian Dear, *The Friendly Orange Glow: The Untold Story of the PLATO System and the Dawn of Cyberculture* (New York: Pantheon, 2017).

18. Vannevar Bush, "As We May Think," *Atlantic Monthly*, July 1945, 16.

19. Bush, "As We May Think," 19–20.

20. J. C. R. Licklider, "Man-Computer Symbiosis, *IRE Transactions on Human Factors in Electronics* HFE-1 (Mar. 1960): 7.

21. Ivan Sutherland, email Jan. 24, 2018.

22. Douglas C. Engelbart, *Augmenting Human Intellect: A Conceptual Framework*, SRI Summary Report AFOSR-3223 (Menlo Park, CA: Stanford Research Institute, Oct. 1962): ii, abstract.

23. Paul Ryan, *Cybernetics of the Sacred* (Garden City, NY: Anchor Press, 1974), epigraph.

24. Benj Edwards, "The Never-Before-Told-Story of the World's First Computer Art (It's a Sexy Dame)," *Atlantic Monthly*, Jan. 24, 2013; *IBM Sage Computer Ad, 1960*, https://www.youtube.com/watch?v=iCCL4INQcFo, accessed Mar. 25, 2020.

25. Stewart Brand, "Spacewar: Fanatic Life and Symbolic Death Among the Computer Bums," *Rolling Stone*, Dec. 7, 1972.

26. *TX-0 Computer, MIT, 1956–1960*, https://www.youtube.com/watch?v=ieuV0A01--c, accessed Feb. 25, 2020.

27. Stewart Brand, ed., *Whole Earth Catalog* (Menlo Park, CA: The Portola Institute, 1968); Brand, "Spacewar."

28. Steven Levy, *Hackers: Heroes of the Computer Revolution* (Garden City, NY: Anchor Press/ Doubleday, 1984), 157.

29. Levy, *Hackers*, chapter 3 (of part 1).

30. J. Martin Graetz, "The Origin of Spacewar," *Creative Computing* 7, no. 8 (Aug. 1981): 58; Levy, *Hackers*, 18–19; *Wikipedia*, Thomas Stockham, accessed June 8, 2017.

31. Levy, *Hackers*, 45, chapter 3 (of part 1).

32. Herbert Freeman, *Cobblestones: The Story of My Life* (Xlibris Corp., 2009), 17–22, 40–41, 112–115; Herb Freeman, phone call, email Jan. 14, 2018.

33. Freeman, *Cobblestones*, 39–51.

34. Robin Forrest, meeting Sept. 2016.

35. Robin Forrest, email Apr. 5, 2017.

36. Robin Forrest, emails Mar. 20, 22, 2017; Rich Riesenfeld, email Sept. 22, 2017.

37. Daniel Cardoso Llach, *Builders of the Vision: Software and the Imagination of Design* (New York: Routledge, 2015), 56.

38. Jim Blinn, email Apr. 18, 2017.

39. Cardoso Llach, *Builders of the Vision*, 54.

40. Cardoso Llach, *Builders of the Vision*, 54–56.

41. Daniel Cardoso Llach, "A Conversation with Robin Forrest," draft Aug. 9, 2016, 3.

42. Cardoso Llach, "A Conversation with Robin Forrest," 3.

43. *2002 Outstanding Service Award: Bertram Herzog*, https://www.siggraph.org/about/awards/2002 -service-award/, accessed Feb. 25, 2020; Siggraph history, https://www.siggraph.org/about/history/, accessed Feb. 25, 2020.

44. Michel Landry, https://www.ltechsolution.com/lanticonformisme-au-profit-de-la-creation/, accessed Feb. 25, 2020 (source of both epigraphs: the first is my translation, the second was translated by Pascale Torracinta.

45. Rich Riesenfeld, email Sept. 22, 2017.

46. Bézier obit., *Computer Aided Design* 22, no. 9 (Nov. 1990); Christian Boyer, emails, Apr. 11–20, 2020; Edmond De Andréa, "Grandes Figures: Pierre Bézier (Pa. 1927)," *Arts et Métiers Magazine*, Dec. 2005, 52; Dugomier, Bruno Bazile, and Yves Magne, *La Naissance de la Renault 4CV* (Grenoble: Glénat, 2017), 14; Évelyne Gayme, "Les Oflags, Centres Intellectuels," *Inflexions* 29, no. 2 (2015): 127.

47. Pierre E. Bézier, "Examples of an Existing System in the Motor Industry: the Unisurf System," *Proceedings of the Royal Society of London. Series A, Mathematical and Physical Sciences* 321 (1971): 213, figs. 7–8.

48. Cardoso Llach, "A Conversation with Robin Forrest," 2, 13; Robin Forrest, conversation May 3, 2017.

49. Paul de Faget de Casteljau, "De Casteljau's Autobiography: My Time at Citroën," *Computer Aided Geometric Design* 16 (1999): 583–586.

50. Hanns Peter Bieri and Hartmut Prautzsch, "Preface," *Computer Aided Geometric Design* 16 (1999): 579–581; Jules Bloomenthal, ed., "Graphic Remembrances," *IEEE Annals of the History of Computing* 20, no. 2 (1998): 39; Robin Forrest, email Apr. 9, 2017; *Wikipedia*, Paul de Casteljau, accessed Dec. 23, 2019.

51. Robin Forrest, emails Mar. 20, 22, 2017.

52. Ivan Sutherland, "Sketchpad, A Man-Machine Graphical Communication System," PhD thesis, MIT, EE Dept., Cambridge, MA, Jan. 1963; Ivan Sutherland, Skype conversation, Jan. 23, 2018.

53. Timothy Johnson, *Sketchpad III, Three-Dimensional Graphical Communication with a Digital Computer*, MS thesis, MIT, EE Dept., Cambridge, MA, May 1963; Tim Johnson, email Apr. 29, 2017; Ivan Sutherland, Skype conversation May 9, 2017; David E. Weisberg, *The Engineering Design Revolution: The People, Companies and Computer Systems That Changed Forever the Practice of Engineering*. 2008, http://cadhistory.net/, accessed Mar. 1, 2020, chapter 3, 18–22.

54. Tim Johnson, email Apr. 20, 2017; Sutherland, *Sketchpad*, 67–68; Ivan Sutherland, email May 2, 2017; Ivan Sutherland, Skype conversation May 9, 2017.

55. Sutherland, *Sketchpad*, appendix E, 154–160; Ivan Sutherland, email May 2, 2017.

56. James F. Blinn, "A Trip Down the Graphics Pipeline: Grandpa, What Does 'Viewport' Mean?" *IEEE Computer Graphics and Applications* 12, no. 1 (Jan. 1992): 83–87; William Newman and Robert F. Sproull, *Principles of Interactive Computer Graphics* (San Francisco: McGraw-Hill, 1973), 126–127.

57. William A. Fetter, "The Art Machine," *Journal of Commercial Art and Design* 4, no. 2 (Feb. 1962): 36.

58. Walter D. Bernhart and William A. Fetter, *Planar Illustration Method and Apparatus*, US Patent No. 3,519,997, issued July 7, 1970, filed Nov. 13, 1961; Robin Oppenheimer, email June 16, 2017.

59. Jim Blinn, email June 18, 2017.

60. Fetter, "The Art Machine," 36; Robin Oppenheimer, email June 21, 2017; *Wikipedia*, William Fetter, accessed Sept. 29, 2017.

61. Edward E. Zajac, "Computer-Made Perspective Movies as a Scientific and Communication Tool," *Communications of the ACM* 7, no. 3 (Mar. 1964): 169–170; *AT&T Tech Channel*, https://

techchannel.att.com/play-video.cfm/2012/7/18/AT&T-Archives-First-Computer-Generated-Graphics
-Film, accessed Feb. 25, 2020.

62. Zajac, "Computer-Made Perspective Movies," 170.

63. Ivan Sutherland, Skype conversation Jan. 23, 2018.

64. Ivan Sutherland, email Jan. 21, 2018; Ivan Sutherland, Skype conversation Jan. 23, 2018.

65. Tim Johnson, email Mar. 24, 2017; J. C. R. Licklider, "Graphics Input—A Survey of Tech-
niques," *Proceedings 1966 UCLA Computer Graphics Symposium*, 44.

66. Fred N. Krull, "The Origin of Computer Graphics within General Motors," *IEEE Annals of the
History of Computing* 16, no. 3 (1994): 44–46; Weisberg, *The Engineering Design Revolution*, chapter
3, 22–25.

67. Barrett Hargreaves, email Nov. 4, 2014; Rich Riesenfeld, email Sept. 23, 2017.

68. Barrett Hargreaves, emails May 18–19, 2017.

69. Barrett Hargreaves, John D. Joyce, George L. Cole, Ernest D. Foss, Richard G. Gray, Elmer M.
Sharp, Robert J. Sippel, Thomas M. Spellman, and Robert A. Thorpe, "Image Processing Hardware
for a Man-Machine Graphical Communication System," *Proceedings 1964 AFIPS Fall Joint Com-
puter Conference*, 375; Barrett Hargreaves, emails Oct. 13, 2014, May 19, 2017; J Edwin L.acks, "A
Laboratory for the Study of Graphical Man-Machine Communications," *Proceedings 1964 AFIPS
Fall Joint Computer Conference*, 344; Ivan Sutherland, "Computer Graphics: Ten Unsolved Prob-
lems," *Datamation* 12, no. 5 (May 1966): 23.

70. Barrett Hargreaves, email Oct. 13, 2014.

71. Robin Forrest, email Mar. 20, 2017; Barrett Hargreaves, email May 18, 2017.

72. Dear, *The Friendly Orange Glow*.

73. Ivan Sutherland, Skype conversation May 9, 2017.

74. Licklider, "Graphics Input—A Survey of Techniques," 44; *Sketchpad, by Dr. Ivan Sutherland
with comments by Alan Kay*, https://www.youtube.com/watch?v=495nCzxM9PI, accessed Feb. 25,
2020.

75. Johnson, *Sketchpad III*.

76. Tim Johnson, emails Mar. 24–25, 2017.

77. Tim Johnson, email Mar. 30, 2017.

78. Tim Johnson, email Mar. 24, 2017.

79. Roberts, *Machine Perception of Three-Dimensional Solids*.

80. "Retrospectives II: The Early Years in Computer Graphics at MIT, Lincoln Lab and Harvard,"
Siggraph '89 Panel Proceedings, Siggraph '89, Boston, July 31–Aug. 4, 1989, 56–59.

81. "Larry Roberts, Fellow," Computer History Museum (website), https://computerhistory.org /profile/larry-roberts/?alias=bio&person=larry-roberts, accessed Feb. 25, 2020.

82. Sutherland, *Sketchpad*, 132–133, fig. 9.8; Ivan Sutherland, Skype conversation 9 May 2017.

83. Jasia Reichardt, ed., *Cybernetic Serendipity: The Computer and the Arts* (Studio International Special Issue, London, July 1968), 5.

84. Kenneth C. Knowlton, "A Computer Technique for Producing Animated Movies," *Proceedings 1964 AFIPS Spring Joint Computer Conference*, 67–87; *A Computer Technique for Producing Animated Movies*, https://techchannel.att.com/play-video.cfm/2012/9/10/AT&T-Archives-Computer-Technique -Production-Animated-Movies, accessed Feb. 25, 2020; *Programming of Computer Animation*, https://techchannel.att.com/play-video.cfm/2012/9/17/AT&T-Archives-Programming-of-Computer -Animation, accessed Feb. 25, 2020.

85. Grant D. Taylor, *When the Machine Made Art: The Troubled History of Computer Art* (New York: Bloomsbury Academic, 2014).

86. Marceli Wein, email July 3, 2017; http://compellingjewishstories.blogspot.com/2013/03 /fifteen-journeys-warsaw-to-london-by.html, accessed Feb. 25, 2020.

87. Cardoso Llach, "A Conversation with Robin Forrest," 17.

88. *Cybernetic Serendipity*, http://www.historyofinformation.com/detail.php?entryid=1089, accessed Feb. 25, 2020.

89. Reichardt, *Cybernetic Serendipity*, 66–68, 86–90, 92–93, 95–96.

90. Ronald Baecker, "Interactive Computer-Mediated Animation," PhD thesis, MIT, EE Dept., Cambridge, MA, Mar. 1969, 6.

91. Ron Baecker, email Aug. 5, 2019.

92. Baecker, *Interactive Computer-Mediated Animation*, 4; Ron Baecker, emails May 2017, Aug. 5, 2019; *Genesys: An Interactive Computer-Mediated Animation System,* https://www.youtube.com /watch?v=GYIPKLxoTcQ, accessed Feb. 25, 2020; Tim Johnson, email May 2017; Eric Martin, email Sept. 28, 2015.

93. Baecker, "Interactive Computer-Mediated Animation"; Ronald Baecker, "Picture-Driven Animation," *Proceedings of 1969 AFIPS Spring Joint Computer Conference*, 273–288; Sutherland, *Sketchpad*, 132.

94. Ephraim Cohen, email May 25, 2017.

95. Baecker, "Picture-Driven Animation," 278.

96. *Schindler's List*, http://auschwitz.dk/schindlerslist.htm, accessed Mar. 1, 2020.

97. Marceli Wein, email July 3, 2017.

98. Marceli Wein, *Marceli Wartime*, Mar. 11, 2015, a 19-page autobiography, 11–14; Jim Blinn, email June 21, 2016.

99. Intel Corporation, *Excerpts from* A Conversation with Gordon Moore: Moore's Law, http://large.stanford.edu/courses/2012/ph250/lee1/docs//Excepts_A_Conversation_with_Gordon_Moore.pdf, accessed Feb. 28, 2020; Gordon E. Moore, "Cramming More Components onto Integrated Circuits," *Electronics* 38 (1965).

100. Rachel Courtland, "The Molten Tin Solution," *IEEE Spectrum*, Nov. 2016, 28–33, 41; Intel Corporation, *Tri-Gate Transistors Presentation*, Apr. 19, 2011, http://www.intel.com/content/dam/www/public/us/en/documents/backgrounders/standards-22nm-3d-tri-gate-transistors-presentation.pdf, accessed Feb. 29, 2020.

101. Jim Blinn, email Mar. 23, 2019; Arthur C. Clarke, *The City and the Stars* (New York: Signet Books, 1957), 47–48.

102. Ivan Sutherland, "The Ultimate Display," *Proceedings of 1965 IFIP Congress*, 508.

103. Jaron Lanier, *Dawn of the New Everything: Encounters with Reality and Virtual Reality* (New York: Henry Holt , 2017), 43; Ivan Sutherland, "A Head-Mounted Three Dimensional Display," *Proceedings of 1968 AFIPS Fall Joint Computer Conference*, 759; Ivan Sutherland and Bob Sproull, *Virtual Reality Before It Had That Name*, Computer History Museum, Mar. 19, 1996, https://computerhistory.org/ivan-sutherland-virtual-reality-before-it-had-that-name-playlist/, accessed Mar. 1, 2020.

104. Sutherland, "A Head-Mounted Three Dimensional Display," 762.

105. Sutherland and Sproull, *Virtual Reality Before It Had That Name*.

106. Jim Kajiya, email Apr. 24, 2017; Sutherland, "Computer Graphics: Ten Unsolved Problems."

107. Ivan Sutherland, Skype conversation Jan. 23, 2018.

Chapter 7

1. For figure 7.1: GE, *Computer Image Generation*, Simulation and Control Systems Department, General Electric Company, Daytona Beach, Fla., 19-page color marketing pamphlet (including covers), ca. 1977; GE–NASA, Final Report, *Visual Three-View Space-Flight Simulator*, Contract NAS 9-1375, GE, Defense Electronics Division, Electronics Laboratory, Ithaca, NY, Aug. 1, 1964.

2. Gene Youngblood, *Expanded Cinema* (New York: E. P. Dutton, 1970), 252.

3. Youngblood, *Expanded Cinema*, 205.

4. Youngblood, *Expanded Cinema*, 205; Gene Youngblood, email Mar. 12, 2019.

5. Youngblood, *Expanded Cinema*, 252.

6. Jim Blinn, conversations Jan. 2018, email Feb. 9, 2018; Zareh Gorjian, email Jan. 3, 2018.

7. NASA, "Coloring the Mariner 4 Image Data," https://mars.nasa.gov/resources/20284/coloring-the-mariner-4-image-data/, accessed Feb. 26, 2020; NASA, "Mars TV Camera," https://nssdc.gsfc.nasa.gov/nmc/experiment/display.action?id=1964-077A-01, accessed Feb. 26, 2020.

8. Robert B. Leighton, Bruce C. Murray, Robert P. Sharp, J. Denton Allen, and Richard K. Sloan, *Mariner IV Pictures of Mars*, NASA Technical Report 32-884, Mariner Mars 1964 Project Report: Television Experiment Part I. Investigators' Report, JPL, Dec. 15, 1967, xi, 59.

9. Leighton et al., *Mariner IV Pictures of Mars*, 29; https://photojournal.jpl.nasa.gov/catalog /PIA14033, accessed Feb. 26, 2020.

10. GE–NASA, *Visual Three-View Space-Flight Simulator*; Robert Schumacker, email Feb. 22, 2018.

11. GE–NASA, *Visual Three-View Space-Flight Simulator*, 1, 3; Robert Schumacker, emails Feb. 14, 16, 2018.

12. Robert Schumacker, email Feb. 16, 2018.

13. GE–NASA, *Visual Three-View Space-Flight Simulator*, 3; Robert Schumacker, email Feb. 14, 2018.

14. Youngblood, *Expanded Cinema*, Computer Films.

15. Jasia Reichardt ed., *Cybernetic Serendipity: The Computer and the Arts* (Studio International Special Issue, London, July 1968), 65; Youngblood, *Expanded Cinema*, 215–222.

16. *Lapis*, https://www.youtube.com/watch?v=kzniaKxMr2g, accessed Feb. 26, 2020; *Binary Bit Patterns*, https://archive.org/details/binarybitpatterns, accessed Feb. 26, 2020.

17. Youngblood, *Expanded Cinema*, 250.

18. W. J. Bouknight, *An Improved Procedure for Generation of Half-Tone Computer Graphics Presentations* (Urbana: University of Illinois at Urbana, Sept. 1, 1969), iv.

19. Jim Blinn, email Apr. 4, 2019; Bouknight, *An Improved Procedure for Generation of Half-Tone*; GE–NASA, Sixth Quarterly Report, *Modifications to Interim Visual Spaceflight Simulator*, Contract NAS 9–3916, GE, Defense Electronics Division, Electronics Laboratory, Ithaca, NY, July 1966, i, 1, 5; Robin Forrest, emails Apr. 11, 29, 2019; Ted Nelson, *Computer Lib/Dream Machines* (Chicago: Ted Nelson, 1974), 108; Martin Newell, email Apr. 12, 2019; Chris Wylie, Gordon Romney, and David Evans, "Half-Tone Perspective Drawings by Computer," *Proceedings of 1967 AFIPS Fall Joint Computer Conference*, 56–57.

20. GE–NASA, Ninth Quarterly Report, *Modifications to Interim Visual Spaceflight Simulator*, Contract NAS 9–3916, GE, Defense Electronics Division, Electronics Laboratory, Ithaca, NY, Apr. 20, 1967, ii, 1, 6–7; Major A. Johnson, "Electronics Laboratory (1944 to 1993)," *Progress in Defense and Space: A History of the Aerospace Group of the General Electric Company* (M. A. Johnson, 1993), 540; Robert A. Schumacker, Brigitta Brand, Maurice G. Gilliland, and Werner H. Sharp, *Study for Applying Computer-Generated Images to Visual Simulation*, report AFHRL-TR-69–14, Daytona Beach, FL: General Electric Company, Sept. 1969, 113.

21. Don Greenberg, phone call Feb. 2018; Rod Rougelot, email Feb. 21, 2018.

22. Rodney S. Rougelot, "The General Electric Computed Color TV Display," in *Pertinent Concepts in Computer Graphics: Proceedings of the Second University of Illinois Conference on Computer Graphics*, ed. E. Faiman and J. Nievergelt (Urbana: University of Illinois Press, 1969), 264–265.

23. *Evans & Sutherland Computer Corporation History*, http://www.fundinguniverse.com/company-histories/evans-sutherland-computer-corporation-history/, accessed Feb. 26, 2020; Johnson, "Electronics Laboratory (1944 to 1993)," 540–541.

24. Robert Schumacker, email Aug. 11, 2019.

25. Robert Schumacker, email Aug. 11, 2019.

26. Alvy Ray Smith, quoted in Cynthia Goodman, "Art in the Computer Age," *Facsimile* 3, no. 10 (Oct. 2009), 15; *Time* Magazine, Sept. 1, 1986, "Computers: The Love of Two Desk Lamps," 66.

27. Neal Stephenson, *Fall, or Dodge in Hell* (New York: HarperCollins, 2019), 18–19.

28. Rod Rougelot, email Feb. 21, 2018.

29. *Cornell in Perspective*, http://www.graphics.cornell.edu/online/cip/, accessed Feb. 26, 2020; Donald P. Greenberg, "Computer Graphics in Architecture." *Scientific American* 230, no. 5 (May 1974): 98–106; Donald P. Greenberg, "Computer Graphics in Architecture and Engineering," in an unknown NASA publication, apparently paper no. 17, 1975 at https://archive.org/details/nasa_techdoc_19760009741/, accessed Mar. 1, 2020, 358; Marc Levoy, email May 7, 2017.

30. Edwin Catmull, "A System for Computer Generated Movies," *Proceedings of the ACM Annual Conference*, Vol. 1, 422–431, Boston, MA, Aug. 1, 1972; Ed Catmull, emails Apr. 8, May 28, 2019; Henry Fuchs, conversation July 31, 2019; *Futureworld*, https://www.youtube.com/watch?v=QfRAfsK5cvU, accessed Feb. 26, 2020; Marc Levoy, email May 7, 2017; Frederic Ira Parke, *Computer Generated Animation of Faces*, MS thesis, University of Utah, June 1972; Frederic Ira Parke, "Computer Generated Animation of Faces." *Proceedings of the ACM Annual Conference*, Vol. 1, 451–457, Boston, MA, Aug. 1, 1972; Fred Parke, email Mar. 23, 2020.

31. Edwin Catmull, "A Subdivision Algorithm for Computer Display of Curved Surfaces," PhD thesis, University of Utah, Dec. 1974; Wolfgang Straßer, *Schnelle Kurven- und Flächendarstellung auf grafischen Sichtgeräten*, Doktor-Ingenieur dissertation, Technischen Universität Berlin, submitted Apr. 26, 1974, approved Sept. 5, 1974.

32. Lance Williams, "Casting Curved Shadows on Curved Surfaces," *Computer Graphic* 12, no. 3 (Aug. 1978): 270–274.

33. Isabelle Bellin, "Computer-Generated Images: Palm of Longevity for Gouraud's Shading" [as translated], published Sept. 15, 2008 at https://interstices.info/images-de-synthese-palme-de-la-longevite-pour-lombrage-de-gouraud/, accessed Mar. 1, 2020; Henri Gouraud, "Continuous Shading of Curved Surfaces," *IEEE Transactions on Computers* C-20, no. 6 (June 1971): 87–93.

34. John F. Hughes, Andries van Dam, Morgan McClure, David F. Sklar, James D. Foley, Steven K. Feiner, and Kurt Akely, *Computer Graphics: Principles and Practice*, 3rd edition (Upper Saddle River, NJ.: Addison-Wesley Publishing Company, 2014); Bui Tuong Phong, "Illumination for Computer Generated Pictures," *Communications of the ACM* 18, no. 6 (June 1975): 311–317.

35. Dick Shoup, personal interviews 1995–1999.

36. Alvy Ray Smith, *Xerox PARC diary, May 8, 1974–Jan. 16, 1975*, http://alvyray.com/DigitalLight /XeroxPARC_hire_diary_entries.pdf, accessed May 14, 2020, 67, 70–71, 74, 76–78, 85, 94–95; Alvy Ray Smith, *Xerox PARC hiring Purchase Order, Aug. 12, 1974*, http://alvyray.com/DigitalLight /XeroxPARC_PO_Alvy_hire_1974.pdf, accessed May 14, 2020.

37. William J. Kubitz, *A Tricolor Cartograph*, PhD dissertation, report no. 282, Dept. of Computer Science, University of Illinois at Urbana, IL, Sept. 1968; William J. Kubitz and W. J. Poppelbaum, "The Tricolor Cartograph: A Display System with Automatic Coloring Capabilities," *Information Display* 6 (Nov.–Dec. 1969): 76–79; Edgar Meyer, "A Crystallographic 4-Simplex," *American Crystallographic Association Living History—Edgar Meyer, Spring 2014*, 38, https://www.amercrystalassn .org/h-meyer_memoir, accessed Mar. 1, 2020; Joan E. Miller, personal communication July 1978; D. Ophir, S. Rankowitz, B. J. Shepherd, and R. J. Spinrad, "BRAD: The Brookhaven Raster Display," *Communications of the ACM* 11, no. 6 (June 1968): 415–416; Alvy Ray Smith, *Paint*, Technical Memo No. 7, Computer Graphics Lab, NYIT, July 1978, 13, appendix C; https://www .youtube.com/watch?v=njp0ABKwrXA, accessed Feb. 26, 2020.

38. Ramtek, *Programming Manual, 9000 Series Graphic Display System*, Sunnyvale, CA: Mar. 1977, appendix A, 2; Ramtek, *System Description Manual, RM-9000 Graphic Display System*, Sunnyvale, CA: Nov. 1977, ch. 1, 5–8; Richard G. Shoup, "SuperPaint: An Early Frame Buffer Graphics System," *IEEE Annals of the History of Computing* 23, no. 2 (Apr.–June 2001): 37.

39. *The SuperPaint System*, http://web.archive.org/web/20020110013554/http://www.rgshoup .com:80/prof/SuperPaint/, accessed Feb. 26, 2020.

40. Alvy Ray Smith, "Color Gamut Transform Pairs," *Computer Graphics* 12, no. 3 (Aug. 1978): 12–19.

41. Preston Blair, *Animation* (Walter T. Foster, ca. 1940s), http://www.welcometopixelton.com /downloads/Animation%20by%20Preston%20Blair.pdf, accessed Mar. 1, 2020, 22, 24.

42. http://alvyray.com/Pixar/documents/Disney1977Visit_EdAlvyDick.pdf, accessed Feb. 26, 2020; Ron Baecker, email Aug. 5, 2019; Eric Martin, email Sept. 28, 2015; https://www.youtube .com/watch?v=nHkxem785B4, accessed Feb. 26, 2020.

43. David DiFrancesco, email 4 Apr. 2018; http://www.scanimate.net/, accessed Feb. 26, 2020; https://www.youtube.com/watch?v=SGF0Okaee1o, accessed Feb. 26, 2020.

44. David DiFrancesco and Alvy Ray Smith, *NEA Proposal*, https://alvyray.com/DigitalLight /NEA_Proposal_Smith_DiFrancesco_1974.pdf, accessed May 14, 2020.

45. Stewart Brand, "Spacewar: Fanatic Life and Symbolic Death Among the Computer Bums," *Rolling Stone*, 7 Dec. 1972; Tekla S. Perry and Paul Wallich, "Inside the PARC: The 'Information Architects,'" *IEEE Spectrum*, Oct. 1985, 62–75; Smith, *Xerox PARC Personal Diary*, 98.

46. Michael A. Hiltzik, *Dealer of Lightning: Xerox Parc and the Dawn of the Computer Age* (New York: HarperCollins, 2009); Douglas K. Smith and Robert C. Alexander, *Fumbling the Future: How Xerox Invented, then Ignored, the First Personal Computer* (New York: William Morrow, 1988), 176.

47. Jim Kajiya, email Apr. 24, 2017.

48. Laurence Gartel and Joseph L. Streich, "NYIT Puts Computers to Work for TV," *Millimeter*, June 1981, last page.

49. Michael Rubin, *Droidmaker: George Lucas and the Digital Revolution* (Gainesville, FL: Triad Publishing, 2006), 103–112; Alvy Ray Smith, *Schure Genealogy* (Berkeley: ars longa, 2019), http://alvyray.com/Schure/, accessed Mar. 2, 2020.

50. James K. Libbey, *Alexander P. de Seversky and the Quest for Air Power* (Washington, DC: Potomac Books, 2013), 43.

51. Alexander P. de Seversky, *Victory Through Air Power* (New York: Simon and Schuster, 1942); Neal Gabler, *Walt Disney: The Triumph of the American Imagination* (New York: Alfred A. Knopf, 2006); Libbey, *Alexander P. de Seversky*, 95, 163, 212, 273, ch. 13; *Victory Through Air Power* (1943), https://archive.org/details/VictoryThroughAirPower, accessed Feb. 26, 2020.

52. *The New York Times*, "Mrs. Guest Buyer of Du Pont Estate: Wife of British Air Minister Makes Purchase Through Her Brother, Howard C. Phipps: Price Paid was $470,000: Mother Says That Mrs. Guest, Now Abroad, Will Be Suprised [*sic*] to Learn of Acquisition," Apr. 26, 1921; *New York Times*, "Whitney Estate to Become a Campus," Sept. 5, 1963; Diana Shaman, "In the Region: Long Island: 7 Homes Planned at Former Estate Held by College," *New York Times*, July 29, 2001, Real Estate, 7.

53. Rubin, *Droidmaker*, 103–141.

54. Llisa Demetrios, email May 15, 2017; Charles Eames and Ray Eames, *A Computer Perspective: Background to the Computer Age*, ed. Glen Fleck (Cambridge, MA: Harvard University Press, 1973; repr. 1990); Larry Roberts, email May 8, 2017; Ivan Sutherland, Skype conversation May 2017.

55. Edwin Catmull, with Amy Wallace, *Creativity, Inc.: Overcoming the Unseen Forces that Stand in the Way of True Inspiration* (New York: Random House, 2014), 20–22.

56. Gene Youngblood, email July 6, 2018; https://www.studiointernational.com/index.php/thinking-machines-art-and-design-in-the-computer-age-review-moma, accessed Feb. 26, 2020.

57. Christine Barton, email Mar. 12, 2019; http://magazines.marinelink.com/Magazines/Maritime Reporter/198912/content/msicaorf-trains-accidents-200573, accessed Feb. 26, 2020; *Wikipedia*, New York Harbor, accessed Mar. 12, 2019.

58. Joseph J. Puglisi, Jack Case, and George Webster, "CAORF Ship Operation Center (SOC)—Recent Advances in Marine Engine and Deck Simulation at the Computer Aided Operations Research Facility (CAORF)," in *International Conference on Marine Simulation and Ship Maneuvering MARSIM 2000*, conference proceedings, Orlando, FL, May 8–12, 2000, 61, 66.

59. Rod Rougelot and Robert Schumacker, interview Feb. 27, 2018.

60. Christine Barton, email May 12, 2019.

61. Christine Barton, email Apr. 14, 2017; Smith, *Paint*, appendix B.

62. Jim Blinn, email Apr. 6, 2019; Garland Stern, email June 15, 2017; Lance Williams, email June 15, 2017.

63. Henry Fuchs, email and conversation July 31, 2019.

64. Louis Schure, "New York Institute of Technology," *Computers for Imagemaking* (London: Elsevier, 1981), 73–76.

65. Garland Stern, "SoftCel—An Application of Raster Scan Graphics to Conventional Cel Animation," *Computer Graphics* 13, no. 2 (Aug. 1979): 284–288.

66. Alvy Ray Smith, "Tint Fill," *Computer Graphics* 13, no. 2 (Aug. 1979): 276–283.

67. Smith, *Paint*; Alvy Ray Smith, "Digital Paint Systems: An Anecdotal and Historical Overview," *IEEE Annals of the History of Computing* 23, no. 2 (Apr.–June 2001): 4–30.

68. Jim Blinn, email Mar. 30, 2019.

69. Smith, *Paint*, appendix B.

70. James F. Blinn, "Jim Blinn's Corner: How I Spent My Summer Vacation—1976," *IEEE Computer Graphics and Applications* 12, no. 6 (Nov. 1992): 87–88.

71. James F. Blinn, "Simulation of Wrinkled Surfaces," *Computer Graphics* 12, no. 3 (Aug. 1978): 286–292; Jim Blinn, email Jan. 31, 2019.

72. Jim Blinn, email Apr. 6, 2019; Ephraim Cohen, email June 22, 2017; Ruth Leavitt, ed., *Artist and Computer* (New York: Harmony Books, 1976), cover, 61–64.

73. David DiFrancesco, email May 3, 2018; Tom Duff, personal conversation Mar. 2019; Ken Thompson, email 13 Mar. 2019; *Wikipedia*, Unix, accessed May 3, 2018.

74. Bill Reeves, email Nov. 15, 2018.

75. Walter Isaacson, *Steve Jobs* (New York: Simon and Schuster, 2011); David A. Price, *The Pixar Touch: The Making of a Company* (New York: Alfred A. Knopf, 2008).

76. Ralph Guggenheim, email Aug. 5, 2016.

77. Marc Levoy, email May 30, 2018; Smith, "Color Gamut Transform Pairs"; *Wikipedia*, Marc Levoy, accessed May 9, 2018.

78. David DiFrancesco, email Aug. 26, 2016.

79. Alvy Ray Smith, *Vidbits*, a videotape, Xerox PARC, Dec. 1974. Exhibited at the Museum of Modern Art, New York, 1975, and on the WNET television show *VTR*, New York, 1975, accessed on YouTube August 15, 2020, https://www.youtube.com/watch?v=47GSOspoTGo.

80. Jesse Pires, ed., *Dream Dance: The Art of Ed Emshwiller* (Philadelphia: Lightbox Film Center Anthology Editions, 2019).

81. *Wikipedia*, James H. Clark, accessed July 31, 2019.

82. Christine Freeman, email Apr. 19, 2019.

83. Alvy Ray Smith, "Notes of the Pilgrimage to Disney on Jan. 3, 1977," http://alvyray.com /Pixar/documents/Disney1977Visit_EdAlvyDick.pdf, accessed Mar. 2, 2020, 2.

84. Smith, "Notes of the Pilgrimage to Disney on Jan. 3, 1977," 3–4.

85. Gabler, *Walt Disney*, 546, 590.

Chapter 8

1. Ralph Guggenheim, email Aug. 5, 2016.

2. Ed Catmull, email Mar. 19, 2019.

3. Jim Blinn, email Mar. 30, 2019.

4. David DiFrancesco, "High-Resolution Three-Color Laser Scanner for Motion Pictures," *Proceedings of the Photographic and Electronic Image Quality Symposium* (Cambridge: Science Committee of the Royal Photographic Society, Nov. 1984), 126–135.

5. Nick England, "Ikonas Graphics System—The World's First GPGPU," n.d., http://www.virhistory .com/ikonas/index.htm, accessed Feb. 19, 2020.

6. Robert L. Cook, "Shade Trees," *Computer Graphics* 18, no. 3 (July 1984): 223–231; Ken Perlin, "An Image Synthesizer," *Computer Graphics* 19, no. 3 (July 1985): 287–296.

7. Neal Stephenson, *Fall; or, Dodge in Hell* (New York: HarperCollins, 2019), 18.

8. Arthur Appel, "Some Techniques for Shading Machine Renderings of Solids," *Proceedings of 1968 AFIPS Spring Joint Computer Conference*, 37–45; Robert A. Goldstein and Roger Nagel, "3-D Visual Simulation" *Simulation* (Jan. 1971), 25–31; Matt Pharr, Wenzel Jakob, and Greg Humphreys, *Physically Based Rendering; From Theory to Implementation*, http://www.pbr-book.org/3ed-2018 /contents.html, accessed Feb. 20, 2020; Turner Whitted, "An Improved Illumination Model for Shaded Display," *Communications of the ACM* 23, no. 6 (June 1980): 343–349; Turner Whitted, *A Ray-Tracing Pioneer Explains How He Stumbled into Global Illumination*, https://blogs.nvidia.com /blog/2018/08/01/ray-tracing-global-illumination-turner-whitted/, accessed Feb. 20, 2020.

9. *Wikipedia*, Gilles Tran, accessed Dec. 19, 2019.

10. D. R. Williams and R. Collier, "Consequences of Spatial Sampling by a Human Photoreceptor Mosaic," *Science* 221 (22 July 1983): 385–387; J. I. Yellott Jr., "Spectral Consequences of Photoreceptor Sampling in the Rhesus Retina," *Science* 221 (22 July 1983): 382–385.

11. Robert L. Cook, "Stochastic Sampling in Computer Graphics," *ACM Transactions on Graphics* 5, no. 1 (1986): 51–72; Rodney Stock, "My Inspiration for Dithered (Nonuniform) Sampling," in Jules Bloomenthal ed., "Graphic Remembrances," *IEEE Annals of the History of Computing* 20, no. 2 (1998): 49–50; Yellott, "Spectral Consequences of Photoreceptor Sampling."

12. *Hair Simulation Overview*, https://www.khanacademy.org/partner-content/pixar/simulation/hair-simulation-101/v/hair-simulation-intro, accessed Feb. 19, 2020.

13. James T. Kajiya, "The Rendering Equation," *Computer Graphics* 20, no. 4 (Aug. 1986): 143–149.

14. Rob Cook, Tom Porter, and Loren Carpenter, "Distributed Ray Tracing," *Computer Graphics* 18, no. 3 (July 1984): 137–145; *Science84*, July–Aug. 1984, cover.

15. Tom Duff, email Aug. 3, 2016.

16. William T. Reeves, "Particle Systems—A Technique for Modeling a Class of Fuzzy Objects," *ACM Transactions on Graphics* 2, no. 2 (Apr. 1983): 91–108.

17. Jim Blinn, email Mar. 30, 2019.

18. Alvy Ray Smith, "Special Effects for *Star Trek II: The Genesis Demo*, Instant Evolution with Computer Graphics," *American Cinematographer* 63, no. 10 (Oct. 1982): 1038–1039, 1048–1050.

19. Leo N. Holzer, http://jimhillmedia.com/guest_writers1/b/leo_n_holzer/archive/2010/12/15/former-disney-ceo-ron-miller-recalls-his-own-quot-tron-quot-legacy.aspx, accessed Feb. 19, 2020; Ron Miller obit., https://www.thewrap.com/ron-miller-disney-ceo-walt-son-in-law-dies/, accessed Feb. 19, 2020.

20. Ken Perlin, email 17 Feb. 2019; *Tron–Bit*, https://youtu.be/BbBqPkdheFg, accessed Feb. 20, 2020.

21. *Animation World Magazine*, https://www.awn.com/mag/issue3.8/3.8pages/3.8lyonslasseter.html, accessed 20 Feb. 2020; *Popular Mechanics*, Dec. 9, 2010, https://www.popularmechanics.com/culture/movies/a11706/are-tron-legacys-3d-fx-ahead-of-their-time/, accessed Feb. 20, 2020.

22. MAGI/SynthaVision Sampler (1974), https://youtu.be/jwOwRH4JpXc; MAGI Synthavision Demo Reel (1980), https://youtu.be/lAYaX6NuI4M; *MAGI Synthavision 1984 Demo Reel*, https://youtu.be/Ivk_LPQP6Ag, all accessed Feb. 20, 2020.

23. Ken Perlin, email Feb. 17, 2019; Ken Perlin, http://blog.kenperlin.com/?p=2314, accessed Feb. 20, 2020.

24. Jim Blinn, email Mar. 29, 2019; Richard Chuang, *25 Years of PDI—1980 to 2005*, slideshow Nov. 15, 2006, PDI/DreamWorks Animation, https://web.archive.org/web/20170225112150/https://web.stanford.edu/class/ee380/Abstracts/061115-RichardChuang.pdf, accessed Feb. 20, 2020; Richard Chuang, email Mar. 31, 2019; Glenn Entis, email Sept. 2, 2018.

25. Wayne E. Carlson, *History of Computer Graphics and Animation: A Retrospective Overview* (Columbus, Ohio: The Ohio State University, 2017), 180–185; Gary Demos, "My Personal History in the Early Explorations of Computer Graphics," *Visual Computer* 21 (2005): 961–978; Bob Sproull, email 25 July 2019; Ivan Sutherland, Skype conversations May 9, 2017, Jan. 23, 2018.

26. Ed Catmull, email Mar. 19, 2019; David A. Price, "How Michael Crichton's 'Westworld' Pioneered Modern Special Effects," *New Yorker*, May 14, 2013, https://www.newyorker.com

/tech/annals-of-technology/how-michael-crichtons-westworld-pioneered-modern-special-effects, accessed Mar. 2, 2020.

27. *Looker*, https://pro.imdb.com/v2/title/tt0082677/details, accessed Feb. 20, 2020.

28. Mike Seymour, *fxguide*, https://www.fxguide.com/fxfeatured/founders-series-richard-chuang/, accessed Feb. 20, 2020.

29. Carlson, *History of Computer Graphics and Animation*, 181; Loren Carpenter, email June 12, 2018.

30. Ed Catmull, email Mar. 19, 2019.

31. Karen Paik, *To Infinity and Beyond! The Story of Pixar Animation Studios* (San Francisco: Chronicle Books, 2007), 39–40.

32. Documents in my possession: Laurin Herr, reports dated 16 Aug. 1985, 27 Sept. 1984; Shogakukan, notes 27–30 July 1985, Dec. 1985, Jan. 1986.

33. Richard I. Levin, *Buy Low, Sell High, Collect Early and Pay Late: The Manager's Guide to Financial Survival* (San Francisco: Prentice Hall, 1983); W. R. Purcell Jr., *Understanding a Company's Finances: A Graphic Approach* (San Francisco: Barnes & Noble Books, 1983).

34. Document in my possession: "GFX Inc. Animation Services Business Plan," Jan. 1985.

35. Adam Fisher, *Valley of Genius: The Uncensored History of Silicon Valley* (New York: Twelve [Hachette], 2018), 198.

36. Document in the author's possession: "Potential Investors III," June 21, 1985.

37. Document in the author's possession: "Potential Investors I," June 21, 1985.

38. Robert A. Drebin, Loren Carpenter, and Pat Hanrahan, "Volume Rendering," *Computer Graphics* 22, no. 4 (Aug. 1988): 65–74.

39. Document in the author's possession: Signed letter of intent, Nov. 7, 1985.

40. Doron P. Levin, *Irreconcilable Differences: Ross Perot versus General Motors* (Boston: Little, Brown, 1989), 250–261; Marina von Neumann Whitman, emails May 2013.

41. Document in my possession: Pixar's 1986 Stock Purchase Plan, Schedule B-1; Pixar founding documents, http://alvyray.com/Pixar/, accessed Feb. 20, 2020.

42. *Wikipedia*, Computer Animation Production System, accessed Sept. 2, 2018.

43. Christine Freeman, email Apr. 18, 2019; Alvy Ray Smith, *Altamira Formation Journal*, entries for Mar. 6 and Mar. 21, 1991.

44. Jim Lawson, email Apr. 2, 2019.

45. *Infoworld*, May 23, 1988, 6, https://books.google.com/books?id=4T4EAAAAMBAJ&pg=PA6, accessed Feb. 20, 2020; *Wikipedia*, Walkman, accessed Apr. 3, 2019.

46. Rob Cook, email June 1, 2019.

47. Pat Hanrahan and Jim Lawson, "A Language for Shading and Lighting Calculations," *Computer Graphics* 24, no. 4 (Aug. 1990): 289–298; Steve Upstill, *The RenderMan™ Companion: A Programmer's Guide to Realistic Computer Graphics* (Menlo Park, CA: Addison-Wesley, 1990).

48. Upstill, *The RenderMan™ Companion*, vii.

49. Loren Carpenter, email Sept. 3, 2018.

50. Walter Isaacson, *Steve Jobs* (New York: Simon & Schuster, 2011), 244–245.

51. Smith, *Altamira Formation Journal*, entries for July 1, Sept. 6, and Sept. 9, 1991.

52. US Patent No. 4,897,806, Pseudo-Random Point Sampling Techniques in Computer Graphics, issued Jan. 30, 1990.

53. *Burning Love*, https://youtu.be/O7SycLUH-NM; *Locomotion*, https://youtu.be/gATcdqgkWVA; *Opéra Industriel*, https://youtu.be/qLEg_P5Crt0; *PDI Historical Compilation*, https://www.youtube .com/playlist?list=PLJv789O10fmzl_YpDecrd3wI1qUg7XD4M, all accessed Feb. 20, 2020.

54. *Gas Planet*, https://youtu.be/GOHSL250wwQ, accessed Feb. 20, 2020.

55. *Wikipedia*, Pacific Data Images, accessed Mar. 19, 2019.

56. Chris Wedge, https://youtu.be/MFu80MB2tGw, accessed Feb. 20, 2020.

57. *Bunny*, https://youtu.be/Gzv6WAlpENA, accessed Feb. 20, 2020.

58. Fisher, *Valley of Genius*, 203.

59. Pixar IPO prospectus, Nov. 25, 1995, 47; *Wikipedia*, Pixar, footnote 3 ("Proof of Pixar Cofounders"), accessed June 23, 2018.

60. *Oxford Living Dictionaries*, https://www.lexico.com/definition/canon, accessed Feb. 20, 2020.

Finale

1. G. Spencer Brown, *Laws of Form* (New York: Bantam Books, 1973), 3.

2. Darcy Gerbarg (website), http://www.darcygerbarg.com/, accessed Feb. 23, 2020.

3. Jonghyun Kim, Youngmo Jeong, Michael Stengel, Kaan Aksit, Racherl Albert, Ben Boudaoud, Trey Greer, Joohwah Kim, Ward Lopes, Zander Majercik, Peter Shirley, Josef Spjut, Morgan McGuire, and David Luebke, "Foveated AR: Dynamically-Foveated Augmented Reality Display," *ACM Transactions on Graphics* 38, no. 4 (July 2019): Article 99.

4. 68th Scientific & Technical Achievement Awards, Mar. 2, 1996, https://www.imdb.com/event /ev0000003/1996/1, accessed Feb. 23, 2020.

5. Alvy Ray Smith, "Cameraless Movies, or Digital Humans Wait in the Wings," *Scientific American*, Nov. 2000, 72–78.

6. Barbara Robertson, "What's Old Is New Again," *Computer Graphics World* 32, no. 1 (Jan. 2009), http://www.cgw.com/Publications/CGW/2009/Volume-32-Issue-1-Jan-2009-/Whats-Old-is-New -Again.aspx, accessed Mar. 1, 2020.

7. Barbara Robertson, "Face Lift," *Computer Graphics World*, Winter 2019, http://www.cgw.com /Publications/CGW/2019/Winter-2019/Face-Lift.aspx, accessed Mar. 1, 2020; *How These 10 Actors Were De-Aged for Their Movies*, https://www.youtube.com/watch?v=twKiEzjeH-M, accessed Feb. 23, 2020.

8. *Wikipedia*, Deepfakes, accessed Dec. 3, 2019.

9. George Dyson, *Analogia: The Emergence of Technology Beyond Programmable Control* (New York: Farrar, Straus and Giroux, 2020), 184–185.

10. Jun-Yan Zhu, Taesung Park, Phillip Isola, and Alexei A. Efros, "Unpaired Image-to-Image Translation using Cycle-Consistent Adversarial Networks," *IEEE 2017 International Conference on Computer Vision (ICCV)*, 2223–2232.

11. Italo Calvino, *Invisible Cities* (New York: Harcourt Brace, 1974), 96–97.

Image Credits

Creative Commons license abbreviations: CC: Creative Commons, BY: with Attribution, CC0: no rights reserved, NC: Non-Commercial, ND: No Derivatives, SA: Share Alike.

Beginnings: A Signal Event

0.1 Courtesy of the Hispanic Museum & Library.

0.2 *Wikimedia Commons*, public domain.

1 Fourier's Frequencies: The Music of the World

1.1–2, 5–6, 9, 11 By Alvy Ray Smith.

1.3 Courtesy of Ken Power.

1.4 *Wikimedia Commons*, public domain, modified by Alvy Ray Smith.

1.7 By Claudio Divizia, Shutterstock, 1553757458.

1.8 *Indiamart*, https://www.indiamart.com/proddetail/gi-corrugated-sheet-4450703088.html, image downloaded Feb. 9, 2020.

1.10 *Wikimedia Commons*, public domain.

2 Kotelnikov's Samples: Something from Nothing

2.1–2, 4–7, 10–19 By Alvy Ray Smith.

2.3 Vladimir Aleksandrovich Kotelnikov, "O Propusknoi Sposobnosti 'Efira' i Provoloki v Elektrosvyazi [On the Transmission Capacity of the 'Ether' and Wire in Electrical Communications]." In *Vsesoyuznyi Energeticheskii Komitet. Materialy k I Vsesoyuznomu S'ezdu po Voprosam Tekhnicheskoi Rekonstruktsii Dela Svyazi i Razvitiya Slabotochnoi Promyshlennosti. Po Radiosektsii* [The All-Union Energy Committee. Materials for the 1st All-Union Congress on the Technical Reconstruction of Communication Facilities and Progress in

the Low-Currents Industry. At Radio Section]. Moscow: Upravlenie Svyazi RKKA, 1933, 4. Original Russian paper courtesy of Christopher Bissell.

2.8 Richard F. Lyon, "A Brief History of 'Pixel,'" an invited paper presented at the IS&T/SPIE Symposium on Electronic Imaging, Jan. 15–19, 2006, San Jose, CA, 5 (of 16).

2.9 (Left) Thanks to Christopher Bissell, the Russian Academy of Sciences, and the Kotelnikov family. (Right) Photo courtesy of MIT Museum.

2.20 Online several places—e.g., https://www.moscovery.com/aleksandr-solzhenitsyn/, accessed Mar. 4, 2020.

2.21 *President of Russia: Events*, http://en.kremlin.ru/events/president/news/29520/photos, image downloaded Mar. 4, 2020. Thanks to the Kremlin news site.

3 Turing's Computations: Eleventy-Eleven Skydillion

3.1 By permission of King's College Library, Cambridge. AMT/K/7/8.

3.2 CC BY-NC-ND 3.0 Unported license. By Alvy Ray Smith, 2014.

3.3–5, 7 By Alvy Ray Smith.

3.6 Photo by Kolb Brothers, original nitrate negative at Kolb Brother's Trail Photos, Cline Library Special Collections and Archives, Northern Arizona University. Courtesy of Marina Whitman.

4 Dawn of Digital Light: The Quickening

4.1 (Left) Photo by Christopher Riche Evans, ca. 1975, courtesy of his estate. (Right) *Wikimedia Commons*, photo © Carolyn Djanogly.

4.2–3 Tom Kilburn, "A Storage System for Use with Binary Digital Computing Machines," Dec.1,1947,http://curation.cs.manchester.ac.uk/computer50/www.computer50.org/kgill /mark1/report1947cover.html, accessed Feb. 29, 2020, photographs 1 and 2.

4.4 Courtesy of the University of Manchester, Department of Computer Science.

4.5, 7–9 By Alvy Ray Smith.

4.6 CC BY-ND 3.0 Unported license. By Alvy Ray Smith, 2017.

4.10–13, 16, 21–22 Used and reprinted with permission of The MITRE Corporation. ©2016.

4.14 Image courtesy of the Computer History Museum, Mountain View, CA, dated by the museum ca. 1949, gift of Mac McLaughlin, object ID: 102710661.

4.15 Jan Rajchman/RCA Laboratories, courtesy of George Dyson.

4.17 Image reproduced from a publication held by the Museum of Science and Industry, Manchester, England.

4.18 With permission of The Camphill Village Trust Limited.

4.19 A. S. Douglas, courtesy of Martin Campbell-Kelly.

4.20 *Programming for Whirlwind 1*, Report R-196, Digital Computer Laboratory, MIT, June 11, 1951, approved for public release, case 06-1104, 55.

4.23 (Left) Used and reprinted with permission of The MITRE Corporation. © 2016. (Right) By Alvy Ray Smith.

4.24 (Left) Textile sampler, *Wikimedia Commons*, public domain. (Right) Mosaic of Mary and Jesus between Angels in Basilica of St Apollinare Nuovo in Ravenna, Italy, by wjarek, Adobe stock, 310119847, extended license.

4.25 (Left) *Madonna*, author Meyer Hill, Associated Press Operator, Baltimore, MD, 1947, assembled from text by Alvy Ray Smith. (Right) Hammarskjöld, 1962, *Wikimedia Commons*, CC BY 3.0 Unported license, photo by Jonn Leffmann.

4.26–27 By Richard Shoup. With permission of Carnegie Mellon University and Nancy Dickenson Shoup.

5 Movies and Animation: Sampling Time

5.1 *Wikimedia Commons*, CC BY-SA 2.5 Generic license, by Kto288.

5.2 Collection Cinématheque française, photo by Stephane Dabrowski. Courtesy of Laurent Mannoni.

5.3 Back cover of W.K.L. Dickson and Antonia Dickson, *History of the Kinetograph, Kinetoscope, and Kineto-Phonograph* (New York: W.K.L. Dickson, 1895, Library of Congress copy).

5.4 Athanasius Kircher, *Ars Magna Lucis et Umbrae* (rev. 2nd edition, Amsterdam, 1671), 768.

5.5 © Pixar.

5.6 (Left) *Wikimedia Commons*, public domain. (Right) Library of Congress, photo by Frances Benjamin Johnston, ca. 1890.

5.7–9, 15–16, 18 By Alvy Ray Smith.

5.10 CC BY–ND 3.0 Unported license. By Alvy Ray Smith, 2015.

5.11 (Left) Getty Images, 115961049. (Right) Gordon Hendricks Motion Picture History Papers, Archives Center, National Museum of American History, Smithsonian Institution, AC0369-0000009.

5.12 Edison National Park, public domain.

5.13 By Étienne-Jules Marey, 1887, public domain.

5.14 *Wikipedia*, Match cut, fair use.

5.17 By Alvy Ray Smith. Images courtesy of New York Institute of Technology.

5.19 (Left) © Sharon Green/Ultimate Sailing, Windmark Productions Inc. (Right) © Doug Gifford, Doug Gifford Photography.

5.20 CC BY-SA-3.0 Unported license, photo by Judy Martin's (unnamed) daughter.

6 Shapes of Things to Come

6.1 ClipArt ETC Paid Commercial License.

6.2 (Left) Courtesy of Pete Peterson. (Right) Courtesy of Bob Perry.

6.3–9, 12, 23–25, 28, 30, 39 By Alvy Ray Smith.

6.10 *Wikipedia Commons*, CC BY-SA 2.0 Generic license. By Marshall Astor.

6.11 (Right) FAVPNG Commercial License.

6.13 CC BY–ND 3.0 Unported license. By Alvy Ray Smith, 2020.

6.14 (Left) *Wikimedia Commons*, CC BY 2.0 Generic license. By Joi Ito. (Right) Used and reprinted with permission of The MITRE Corporation. ©2016.

6.15 *IBM Sage Computer Ad, 1960*, https://www.youtube.com/watch?v=iCCL4INQcFo, framegrab at ca. 1:00.

6.16 J. Martin Graetz, "The Origin of Spacewar," *Creative Computing* 7, no. 8 (Aug. 1981): 39 (41 of 80 in download), https://archive.org/details/creativecomputing-1981-08/, accessed Feb. 29, 2020.

6.17 Photo by and courtesy of Abbott Weiss, 1964. Reprinted with his permission.

6.18 CC0 1.0 Universal Public Domain Dedication license. By Wojciech Muła.

6.19 By and with permission of Antony Hare P.I., 2010. © Antony Hare.

6.20 (Left) CC BY-SA 3.0 Unported license. Photo by Thomas Forsman. (Middle) CC BY-SA 3.0 Unported license. Photo by Charles01. (Right) Pierre E. Bézier, "Examples of an Existing System in the Motor Industry: The Unisurf System," *Proceedings of the Royal Society of London. Series A, Mathematical and Physical Sciences* 321 (1971): 208, fig. 2.

6.21 By and with permission of Tina Merandon.

6.22 Hanns Peter Bieri and Hartmut Prautzsch, "Preface," *Computer Aided Geometric Design* 16 (1999): 579.

6.26 By and with permission of Dave Coleman.

6.27 By and with permission of Michele Bosi, http://VisualizationLibrary.org.

6.29 (Left) By and with permission of Daniel Pillis. (Middle) *Sketchpad*, https://www.youtube
 .com/watch?v=hB3jQKGrJo0, framegrab ca. 2:30. (Right) Photo courtesy of Larry Roberts.

6.31 © Alvy Ray Smith, 1973.

6.32 Bernhart and Fetter, US Patent No. 3,519,997.

6.33 Edward E. Zajac, "Computer-Made Perspective Movies as a Scientific and Communica-
 tion Tool," *Communications of the ACM* 7, no. 3 (Mar. 1964): 170, fig. 2. With permission
 of ACM.

6.34 *Sketchpad III*, https://www.youtube.com/watch?v=t3ZsiBMnGSg, framegrabs ca. 1:22,
 ca. 1:23, ca. 2:11, ca. 2:55.

6.35 Ivan Sutherland, "Sketchpad, A Man-Machine Graphical Communication System," PhD
 thesis, MIT, EE Dept., Cambridge, MA, Jan. 1963, 133, fig. 9.8, with permission of Ivan
 Sutherland.

6.36 © Ken Knowlton, 1998, collection of Laurie M. Young. http://knowltonmosaics.com/.

6.37 © Cybernetic Serendipity, 1968, design by Franciszka Themerson. With permission of
 Jasia Reichardt.

6.38 Animation by Ephraim Cohen using the *Genesys* system designed and programmed by
 Ron Baecker with the advice of Eric Martin and Lynn Smith. With permission of Baecker
 and Cohen.

6.40 Ivan Sutherland, "A Head-Mounted Three Dimensional Display," *Proceedings of 1968
 AFIPS Fall Joint Computer Conference*, 759, fig. 2, with permission of Ivan Sutherland, Bob
 Sproull, and Quintin Foster.

7 Shades of Meaning

7.1 GE, *Computer Image Generation*, Simulation and Control Systems Department, General
 Electric Company, Daytona Beach, FL, NASA image, public domain. Contributed by Jim
 Blinn.

7.2 NASA/JPL–Caltech/Dan Goods, public domain.

7.3 NASA image, public domain. Contributed by Ronald Panetta.

7.4 NASA image, public domain. Courtesy of Peter Kamnitzer and Gene Youngblood.

7.5–11, 14–17, 19, 28–29 By Alvy Ray Smith.

7.12 CC BY–ND 3.0 Unported License license. By Alvy Ray Smith, 2019.

7.13 (Left) Edwin Catmull, "A System for Computer Generated Movies," *Proceedings of the ACM
 Annual Conference*, vol. 1, 426, Boston, Mass., 1 Aug. 1972. Also https://www.youtube
 .com/watch?v=RBBcPeZ1rgk&feature=youtu.be, framegrab ca. 1:30. With permission of

Ed Catmull. (Middle) Frederic Ira Parke, "Computer Generated Animation of Faces," MS thesis, University of Utah, June 1972, 17, fig. 2.8(d). Also Frederic Ira Parke, "Computer Generated Animation of Faces," *Proceedings of the ACM Annual Conference*, vol. 1, 453, Boston, MA, Aug. 1, 1972. With permission of Fred Parke. (Right) *Cornell in Perspective*, https://www.youtube.com/watch?v=3iQqqv_bcXs, framegrab ca. 0:07. With permission of Don Greenberg.

7.18 By Lukáš Buričin. *Wikimedia Commons*, public domain.

7.20 By Richard Shoup. With permission of Carnegie Mellon University and Nancy Dickenson Shoup.

7.21 Preston Blair, *Animation* (Walter T. Foster, ca. 1940s), http://www.welcometopixelton .com/downloads/Animation%20by%20Preston%20Blair.pdf, downloaded 1 Mar. 2020, cover, 22, 24. Courtesy of the Preston Blair Estate.

7.22–23, 26–27, 33 With permission of New York Institute of Technology.

7.24 *Wikimedia Commons*, public domain, courtesy of Viscountrapier.

7.25 By Ephraim Cohen, 1977, and with his permission.

7.30 *Wikimedia Commons*, CC BY-SA 3.0 Unported license. By Brion Vibber, McLoaf, and GDallimore.

7.31 Courtesy of and with permission of Jim Blinn.

7.32 (Left) With permission of New York Institute of Technology. (Right) *Sunstone*, 1979, directed by Ed Emshwiller, with texture-mapped animation by Alvy Ray Smith.

8 The Millennium and The Movie

8.1 By Alvy Ray Smith. Images courtesy of Pixar Animation Studios.

8.2 M. C. Escher, *Hand with Reflecting Sphere*, 1935. ©2020 The M. C. Escher Company—The Netherlands. All rights reserved.

8.3 Turner Whitted, "An Improved Illumination Model for Shaded Display," *Communications of the ACM* 23, no. 6 (June 1980): 347, fig. 7. With permission of ACM and Turner Whitted.

8.4 Gilles Tran, *Glasses*, 2006. With permission of Gilles Tran.

8.5 J. I. Yellott Jr., "Spectral Consequences of Photoreceptor Sampling in the Rhesus Retina," *Science* 221 (July 22, 1983): 383, fig. $1(B_2)$. With permission from AAAS.

8.6 By Alvy Ray Smith.

8.7 Concept and images courtesy of Thomas Porter. © Pixar.

8.8 Alvy Ray Smith. Concept courtesy of Thomas Porter, Pixar.

8.9 Thomas Porter, *1984*, 1984. © Pixar.

8.10 By Alvy Ray Smith. Images courtesy of Pixar Animation Studios.

8.11 Composition by Alvy Ray Smith, of components by Loren Carpenter, Tom Duff, Chris Evans, and Thomas Porter. Image courtesy of Pixar Animation Studios.

8.12 *Tron* (1982), https://www.youtube.com/watch?v=-BZxGhNdz1k, framegrab ca. 0:29.

8.13 (Left) Photo used with permission of Ed Catmull, Alvy Ray Smith, and Loren Carpenter. Image courtesy of Pixar Animation Studios. (Right) Concept by Craig Reynolds, graphics by Alvy Ray Smith.

8.14 © Pixar.

8.15 By John Lasseter. Images courtesy of Pixar Animation Studios.

8.16 W. R. Purcell Jr., *Understanding a Company's Finances: A Graphic Approach* (San Francisco: Barnes & Noble Books, 1983) and Richard I. Levin, *Buy Low, Sell High, Collect Early and Pay Late: The Manager's Guide to Financial Survival* (San Francisco: Prentice Hall, 1983), collection of Alvy Ray Smith.

Finale: The Great Digital Convergence

9.1 Photo by Alvy Ray Smith.

9.2 *Vibrant Band–L2–205552D2eC2*, © Darcy Gerbarg, 2018.

9.3–4 Jun-Yan Zhu, Taesung Park, Phillip Isola, and Alexei A. Efros, "Unpaired Image-to-Image Translation using Cycle-Consistent Adversarial Networks," *IEEE 2017 International Conference on Computer Vision*, Venice, Italy, figs. 1 and 12, with the authors' permissions.

Index

Page numbers followed by an "f" indicate figures.